Symbolism
ᘒ and Modern Urban Society

Symbolism and Modern Urban Society is the first social history of the Symbolist movement. Sharon Hirsh adopts a variety of methods, including gender theory, biography, visual analysis, and medical and literary history, in order to investigate this esoteric movement and ground it firmly in fin de siècle issues of modernity and the metropolis. Hirsh argues that Symbolism, often associated with notions of individualism, nostalgia, and visual reverie, offers an engaging critique of urbanity. Providing new definitions and theories for Symbolism and Decadence, she also addresses issues such as spatial and street confrontations with the crowd, the diseased city, the New Woman as "should-be mother," as well as the ideal city of Bruges and its social upheaval in the 1890s. Focusing on works by well-known artists such as Van Gogh, Munch, and Ensor, Hirsh also considers the works of artists who contributed in important ways to the Symbolist movement and the cities – Amsterdam, Brussels, Geneva, Oslo – in which they worked.

Sharon Hirsh is Charles A. Dana Professor of Art History at Dickinson College. A scholar of nineteenth-century European art, she is the author of a number of books, including *Ferdinand Hodler,* and served as coeditor of the volume *Art, Culture and National Identity in Fin-de-Siècle Europe*.

SYMBOLISM AND MODERN URBAN SOCIETY

SHARON L. HIRSH

Dickinson College

CAMBRIDGE
UNIVERSITY PRESS

PUBLISHED BY THE PRESS SYNDICATE OF THE UNIVERSITY OF CAMBRIDGE
The Pitt Building, Trumpington Street, Cambridge, United Kingdom

CAMBRIDGE UNIVERSITY PRESS
The Edinburgh Building, Cambridge CB2 2RU, UK
40 West 20th Street, New York, NY 10011-4211, USA
477 Williamstown Road, Port Melbourne, VIC 3207, Australia
Ruiz de Alarcón 13, 28014 Madrid, Spain
Dock House, The Waterfront, Cape Town 8001, South Africa

http://www.cambridge.org

First published 2004

Printed in the United Kingdom at the University Press, Cambridge

Typeface Adobe Garamond 11.5/13.5 pt. *System* LATEX 2$_\varepsilon$ [TB]

A catalog record for this book is available from the British Library.

Library of Congress Cataloging in Publication Data
Hirsh, Sharon L.
 Symbolism and modern urban society / Sharon L. Hirsh.
 p. cm.
 Includes bibliographical references and index.
 ISBN 0-521-81096-5 (HB)
 1. Symbolism (Art movement) 2. Art, European – 19th century – Social aspects.
 3. Cities and towns in art. 4. Europe – Social life and customs – 19th century. I. Title.
 N6465.S9H57 2004
 709′.03′47 – dc22 2003056909

Publication funds for this book have been provided by a grant
from the Charles A. Dana Chair Fund, Dickinson College.

Publication of this book has been aided by a grant from the
Millard Meiss Publication Fund of the College Art Association.

MM

ISBN 0 521 81096 5 hardback

❧ CONTENTS

COLOR PLATES *(appear following page 172)*

FIGURES

∼ ACKNOWLEDGMENTS

This book has taken a very long time to research and write, and I have been the beneficiary of assistance and support for this work for the past ten years. At the outset I thank all of my family, friends, and colleagues who for more than a decade of their lives have listened to my explanations, complaints, and excitement about this project, with unbelievable patience and unfailing support. I also appreciate the very helpful comments of the two Cambridge readers, and thank Beatrice Rehl for her enthusiastic support of the book at an early stage of development as well as for seeing it through all phases of production.

Several colleagues have offered critical readings of portions of this text. Patricia Berman, Sue Canning, Reinhold Heller, Vojtech Jirat-Wasiutynski, Elizabeth Lee, and Sharon O'Brien all deserve my thanks for substantive and insightful critiques. In addition, I thank colleagues Sylvie Davidson, Sura Levine, Dieter Rollfinke, Robert Siebelhoff, Louis van Tilborgh, and Gerard van Wezel for sharing their expertise with me on particular questions, often on repeated occasions, with a shared sense of scholarly interest and incredible good humor.

Initial research for this book was supported by several grants from Dickinson College as well as a research grant from the Pro Helvetia Foundation. I will be forever grateful for a residency at the Center for Advance Studies in the Visual Arts, which allowed me the time, facilities, and assistance to begin my writing. I thank the Millard Meiss Fund Grant of the College Art Association for a generous subvention grant providing the color illustrations for this book, and the Research and Development Fund as well as the Charles A. Dana Chair at Dickinson College for funding toward other reproduction costs.

Curators, archivists, and other library and museum professionals have offered help with distance as well as on-location research for which I am most grateful, especially colleagues at the (U.S.) National Library of Medicine, Stad Brugge Secretarie and Library, Oslo Byakiv, Bibliothèque Royale de Albert Ier, Musées Royaux des Beaux-Arts de Belgique, Van Gogh Museum, Munch-Museet, Schweizerisches Institut für Kunstwissenschaft, Queens University Library and Art Library, Center for Advanced Study of the Visual Arts Library, and the Waidner-Spahr Library of Dickinson College. I thank Hans-Jörg Heusser, Hans Lüthy, Lamia Doumato, Nina Boyd, Rozan Roberts, and Soffi Attramadal for their personal assistance in this research at these archives. I also express my appreciation to all of the collectors and owning institutions that have agreed to make available in reproduction form the Symbolist and related works illustrated here. In particular, I appreciate the assistance, above and beyond the call of their

respective duties, of Maria Fernanda Meza and Julie Scaillet, who so cheerfully responded to my endless questions about collections with prompt and practical answers.

Friends and colleagues at Dickinson College were, as usual, extraordinarily helpful. My gratitude is extended to Peter M. Lukehart; also to Bob Cavenagh, Pierce Bounds, Karen Glick, Joanne Gingrich, Stephanie Keifer; also to Tina Maresco and her Interlibrary Loan staff. My colleagues in the Art and Art History Department, Ward Davenny, Barbara Diduk, and Melinda Schlitt, deserve special mention for their unflagging support of all my research and writing, and for this project in particular. Finally, I thank my wonderful teaching and research assistants and Dana Research assistants who have, over such a long time, offered enthusiastic and much needed help with the seemingly endless details of manuscript editing and preparation: Amy Biasotto, Kathleen Clawson, Adrienne Deitch, Nora Mueller, Shannon Rutherford, Marnie Shimp, Katie Sikes, Shannon Temple, Laura Turner, and Kathy Zupulla.

This book is dedicated to my two favorite men, Neil and Michael.

The topic of this book – the shaping of Symbolist artists by urban culture and the views of urban society in Symbolist art – proposes a point of departure for the study of Symbolist images that in the past have been read as the expression of a completely inner world of ideas and ideals. This study is not intended as a survey of Symbolist art, but rather as a reframing of Symbolist theory and of many Symbolist works in light of their references to life in the late-nineteenth-century metropolis. Because Symbolist art has traditionally been considered asocietal, and its artists asocial beings, I have used a variety of methodologies to approach the art and the artists of this movement. Some biography has been introduced, for example, in an effort to retrieve Symbolist artists from a mythology that has placed them into an esoteric, often even mystical realm disengaged from their own society. In some ways, therefore, this study is an attempt to see the Symbolist artists as more "normal" and to place their art within a timely arena of social relationships and concerns. The artists on whom this study focuses – Vincent Van Gogh, Edvard Munch, James Ensor, Jan Toorop, Xavier Mellery, and Fernand Khnopff, and to a lesser extent Giovanni Segantini and Ferdinand Hodler – were all considered for much of their lives to be absolutely aberrant. They were labeled, by admiring and condemning critics alike, as decadent and degenerate; they were called isolated, strange, and in some cases mad. Yet their response to the detrimental aspects of the new metropolis – to which they were among the first generation exposed – is, although predictably conflicted, a measured, intelligent, and quite reasoned reaction. Although they espoused radical and liberal policies regarding art, they also exhibited numerous conservative concerns typical of their own times. Although adamantly rejecting established art that was commercial, illustrative, or technically brilliant, the Symbolists simultaneously used their own radical art to portray the most entrenched conservative views of gender and class. Of singular importance is the fact their response was neither avoidance nor complete despair. Quite the opposite, they contrived an art that would positively seek to remedy one of the city's worst deleterious effects, one which was not on socialist activists' list of urban ills (such as poverty, crowding, or poor air and water): the loss of the inner life of the individual.

Only since the 1970s have studies of Impressionism offered social interpretations of works once considered to be related only in style; these have established Impressionism's Paris as a city revamped by Baron von Haussmann to accommodate a new middle class,[1] the so-called spectacle society.[2] In works from the mid-1860s through the mid-1880s, Impressionist views of the societal shift that

led from family to café life and from private to public sites imply a tacit acceptance of the new urbanization. In Impressionism, Paris is seen as a setting for the people who dominate it; it is the backdrop against which they are grouped as individuals, interacting with one another. Social histories have also been offered for Neo-Impressionism, suggesting that Seurat's iconography and perhaps even his new style reflected negative opinions of this same Parisian public.[3] Finally, recent studies of certain Symbolist and Art Nouveau artists in fin de siècle culture have sought to frame the art of the late nineteenth century in relation to current social discourses. These have begun to establish Symbolism's key role as one of several movements that were deeply concerned with the complex social upheavals of their day.[4]

The majority of the literature on Symbolist art, however, continues to address the "creative imagination"[5] of the artists rather than the everyday society in which they lived and worked.[6] It is also true that Symbolist art is rarely considered important to studies of the city. While major exhibitions and studies have focused on city views[7] and included a widespread selection of various media, almost no Symbolist works have been included.[8] Perhaps this is because so many studies of the late-nineteenth-century city focus on Paris, and most major Symbolists were not Parisians. Instead, with the notable exception of Gauguin and Segantini who did flee the city, they lived in other major European cities (for example, Oslo, Geneva, Ostend, and Brussels, on which this book focuses), which were at that time undergoing rebuilding as modern metropolises, in direct emulation of the model set by Haussmannian Paris.[9] Exclusion of Symbolist views in city studies is also due, however, to the fact that the Symbolists are generally considered escapists – from life in general and from the city in particular – and thus it is assumed that they never addressed the new metropolises in which they lived. As I hope this study will establish, this presumption could not be further from the truth.

This book presents a rethinking of Symbolist theory in which Symbolism is viewed as an attempt in the visual arts to attain a conduit for regaining what was perceived to be a loss of individuality and "inner being," brought about by the wholly new social pressures and ways of living in urban centers.[10] This concern became the dominant issue of fin de siècle philosophy and sociology.

Since the Enlightenment, the ideal of a balanced, harmonious, developed character that could deal with outer pressures while maintaining an inner, spiritual life had seemingly held sway. This notion of a true individual was the basis of revolutionary constitutions and philosophical proclamations. The rise of a new society of the city, however, with its public crowds, rushed sense of time, and overregulation, threatened to be the demise of the individual, who would instead become an anonymous cog in the machine of urban progress.

At the same time, treatment of gender differences in the nineteenth century also threatened to deny this same sense of the individual by taking the two "sides" that formed a balanced personality and separating it, with increasing stringency,

into the so-called characteristics of sex, delineated as opposites for men and women. Whereas men were considered to be external types, actively working outside in a competitive business world, women were retreating, perceptive but passive figures who were relegated to domestic life. Characteristics that in the past had ideally belonged to the same individual (independence as well as dependence, intuition as well as intellect, bravery, and modesty) were over the course of the century divided and assigned to the separate spheres of men and women. This conflicted arena of distinct and repressive gender identities, as well as the confusion of the two (effeminate men and dangerous women, for example), and its repercussions in Symbolist works are discussed. Furthermore, it is readily apparent that all of the Symbolists discussed in this book are men. Despite recent efforts to enlist women artists of the fin de siècle into the ranks of Symbolism,[11] this study, with its emphasis on both the theory (based on male identification of creativity) and the social goals (based on the dominant male view of gendered society at that time) focuses exclusively on well-known (and therefore male) artists. The fear of women on the part of these male artists resulted in the imaging of specific types of women, such as the well-known femme fatale as well as the not-yet-addressed city woman who engaged in a "flight from maternity" (a type that I here term the "should-be mother"). These types of women, newly recognized as dangerous and on the rise in urban centers, required complicated reconstructions of both masculinity and femininity on the part of the artists as well as their audience.

In addition, I hint at issues of nationalism throughout the book without making them a major emphasis. At times, the role of nostalgia and the past so important for Symbolists coincided with a surge of nationalistic fervor encouraged politically by imperialism and culturally by the phenomenon of World's Fairs. Thus the Belgians' attention to primacy of place and especially siting of interiors has been seen as a nationalistically driven selection of symbols.[12] In the last chapter of this book, I discuss a novel by the Belgian writer Georges Rodenbach; underlying this story is a strong commitment to keeping the old Flanders city of Bruges "intact," not only as a "dead city" of Symbolist spaces but also as a reminder of past Flemish (as opposed to French) Belgian glory. By the same token, Swiss artists discussed here, such as Hodler and Albert Trachsel, allowed nationalistic considerations to affect their attention to city (at times deliberately antiurban) images and even their development of style.

Concurrent with these pan-cultural issues was one that struck each Symbolist personally: living in the "sick city" was a challenge that affected one's response to crowds, nature, body types, and even, as we shall see, self-image. Late-nineteenth-century constructions of illness combined notions of historic epidemics (cholera, for example) with newly recognized and public diseases (syphilis), recent psychological diagnoses (agoraphobia, claustrophobia), as well as socially constructed pathologies (neurasthenia) that engendered a model of cultural sickness, called degeneration. Furthermore, this notion of an entire race

in decline held a special fascination for the Symbolists because both they and their art had been held out as examples of degeneracy in their own time.

Finally, the sensorial world – to which artists are so attuned – had changed radically in the metropolis of the fin de siècle. City streets, the new site of the bourgeoisie and "the crowd," were a tangle of electric and telegraph wires, garish lights, and jarringly loud, alarmingly fast trams. Mapping the city had become almost impossible from any vantage point, but especially from street level, where the usual hierarchies and order of signage had been dislocated, even deconstructed. Not only this disruptive sense of place but also the irregular and disorienting sense of time assaulted the Symbolists, changing their traditional approaches to space and temporal reconstruction in art as well as in their lives.

Into this confusing, conflicted world of the modern metropolis were born the Symbolists. Of primarily middle-class parentage, they approached the problems of their native cities – overcrowding and overstimulation, impersonality, as well as the slippage of gender roles and class identities – with intelligence and creativity. Throughout, they remained very much of their own time. It is no wonder that this approach to modernity was highly equivocal, but absolutely engaged.

In this book, I introduce evidence from a variety of sources – visual and written, popular and scholarly – and from a variety of disciplines. This is not because I have presumed each of these to be analogous or even equally significant or weighty in their evidential support, but rather to show the ubiquity of the concerns discussed in all ramifications of society in which the Symbolists lived. Each chapter focuses on a different artist and on selected works. All of my examples were admittedly chosen as the best representatives of each chapter's theme arising out of the Symbolist city, but they are representative nonetheless. There is also a certain emphasis on the "great masterworks" of western European Symbolism, works that have often been interpreted (some might contend overinterpreted) in prior literature. But this is my point: many of these works do have a strong historical background of life in the metropolis, which only augments the richness of their Symbolist evocations as they might already be known.

As a primary perception of these transitional and conflicted times, I use the writings and ideas of Georg Simmel, one of the earliest urban sociologists. Simmel, whose work has become much more well known in humanities studies of the past few years (and, in fact, since I began research for this book), was a crucial member of the turn-of-the-century generation of intellectuals who took on the task of trying to culminate the thought developed throughout the nineteenth century but also to formulate clear and different directions for the future. Reviewing the basic optimism that underlay most nineteenth-century progressivism, this generation introduced a strong subtext of pessimism as it faced the negative aftereffects of industrialization and urbanization. At the same

time that they rejected positivism and progressivism, however, they were not yet ready to give up on individualism: a great part of their work was devoted to the analysis of modernity's struggle with individuation. In his particularly sensitive and astute understanding of this struggle as well as in his underlying optimism about its resolution in future society, Simmel was, I believe, closest to the basic beliefs and ideals of the Symbolists. Like the Symbolists, Simmel clearly saw the dangers of urbanity, modernity, and the crowd; like the Symbolists, he also maintained, despite such threats, a belief in the potential for a new urban individuality, and the consequential inner identity that might be achieved. Like the Symbolists, Simmel was a thoroughly modern, at times biting, critic of his own time who nonetheless hoped to restore meaning to society and culture. Furthermore, as one of the most insightful of the Symbolists' generation, Simmel was also bound by the same inherent conflicts of those times: wanting to critique current life in order to help the future, he was inevitably constrained by the conservative and conflicted past that he had inherited.

Comparison to Simmel's search for a positive outcome to the potential ills of fin de siècle life can be found, for example, in the Belgian Symbolist Emile Verhaeren's so-called social trilogy, two collections of poems and one play published in the 1890s that together described the destruction of the traditional country (*Les Campagnes hallucinées,* or *The Hallucinatory Countrysides,* 1893), the strangling metropolis (*Les Villes tentaculaires,* or *The Tentacled Cities,* 1895), and the hoped-for resolution of *Les Aubes,* or *The Dawns,* 1898). Despite the overarching imagery in these works of a wicked city spreading its dark and dirty factories as tentacles throughout the countryside, Verhaeren's hope for a healthier future is not a reversion to the rural past nor an acceptance of an inevitably evil metropolitan existence. Rather, his conclusion comes in the form of a compromise, whereby the country can once again prove fertile, while the city can regain its vitality. Like so many other Symbolists who are horrified by the suffocating power of machines and the masses, Verhaeren does not so much reject modernity as seek to reform it.[13]

Thus Simmel and his intellectual cohorts have been identified as heroic in their efforts to be so inclusive yet frustrated in their final efforts, their deliberate universalism failing; but in its attempt they "pav[ed] the way intellectually for the dispersed and specialized thought of the twentieth century."[14] Intriguingly, much the same criticism has been leveled at Symbolism, the universalism and idealism of which immediately identifies its inherent conservatism.

As I demonstrate in this study, the Symbolists were in an ideal situation to take this problem of modernity to task for a variety of reasons, but primarily because of their self-determined "outsider" status in society. In this respect also, they relate to Simmel, who identified a new notion of "The Stranger" in his essay of that title.[15] According to Simmel, being the stranger allows for an objectivity that is special – and implicitly balanced – because the stranger shares enough in common to be informed yet will always remain separate from that being

observed. Simmel, like the Symbolists, proposed this "stranger" as a fin de siècle replacement for the earlier *flaneur*, who always remained one of the observed crowd. Simmel himself, it should be noted, was also a "stranger" in Berlin at the very time he was making the groundbreaking observations about the new metropolitan society: as a Jew, he lived there, belonged there, and yet was always separate. It is significant that in his essay Simmel ends by noting that what stands out about the stranger is what is not common, and that therefore the stranger is always seen as a subgroup rather than as an individual. His example is the Jews of the Middle Ages who, relegated to and punished as a subnormal group, were taxed as Jews rather than being taxed on an income and property basis like everyone else. His point thus seems to be that the stranger, like those medieval Jews, is in an excellent position as one of a group already "set aside" from his society to be the perfect knowing yet outside observer of his own society.[16] As noted earlier, this kind of isolated or even outcast designation was also applied to the Symbolists. Furthermore, Symbolist artists often began their work as decadents, who perceived themselves to be different from the crowd and who produced images imbued with the highly personal, idiosyncratic vision of the hypersensitive outsider. This made them "strangers" who were better able to witness and reflect on the complex strife – what Munch called "Life Anxiety"– of the city. Symbolists shared not only this identification of the outsider seer with Simmel; they also believed as he did in the potential good of the city's impersonal behavioral codes, if only it could allow for private, inner strengthening of the individual. For Simmel and the Symbolists, critique of current society was undertaken to contribute to the great tradition of seeking the meaning of life.[17] For Simmel, this purpose led from sociological analysis to philosophy; for the Symbolists it grew from the experience of modernity to evocative works of art.

My comparisons to literature in this study focus on three books that might serve as motifs throughout; these are introduced in the next chapter. Although it is likely that some of the artists knew of or actually read at least some of these books, I do not want to limit myself with these examples to what historians Norman Bryson and Mieke Bal have termed "humanist" scholarship, by which every historical link between an artist and his or her sources is established or at least suggested.[18] Rather, I use these literary discussions of the city in the same way that I use Simmel's sociological analyses: as sensitive critical perceptions that tell us how the new metropolis was viewed at this time and offer insight into the intellectual and emotional reactions of the Symbolist artists.

The survey in the next five chapters focuses on major issues of urban society in the late nineteenth century: city society as "crowd," the loss of order and structure in the city, disease, and the city woman. The last two chapters investigate two of the favorite Symbolist retreats from these concerns: interiors and the dream of an ideal city (neither of which, ironically, would prove viable). I analyze only a few of the hundreds of appropriate Symbolist works (and limit

them, in this study, to mostly two-dimensional examples) in which these issues are addressed.

Finally, I have not attempted an in-depth analysis of certain aspects of late-nineteenth-century life that were critical, if deeply conflicted; recent publications have addressed two of these. Patricia Mathews's *Passionate Discontent,* about theories of creativity and gender in French Symbolist art, offers a much-needed elucidation of the complicated notions of artistic genius, especially as critiqued by French artists and writers. She also introduces the possibility of women artists who, despite the masculine basis and bias of the movement, "did what they could" within the Symbolist aesthetic.[19]

In addition, there is the issue of Symbolist artists' religious backgrounds and beliefs. We know, for example, that Munch's view of society was partially informed by his father's austere interpretation of biblical text. His psychological and perhaps also his visual interpretation of the newly public and seemingly liberated fin de siècle society that he witnessed was certainly influenced by the clash of his father's strict Protestantism with the bohemian antireligious tenets of the fellow decadent artists who he encountered in Berlin and Paris. Jan Toorop's oscillation between his Dutch Protestant background and the Neo-Catholic revivals of Parisian art finds its reflection in the inconsistent visual references to religion that were only partially resolved by his belief that all faith was in decline. The excellent recent study by Debora Silverman, offering an extended comparison of the diametrically opposite training and views of religion between the Dutch Protestant "modern theology" of Van Gogh and the lapsed, spiritualizing Catholicism of Gauguin, has contributed fresh understandings of their works, including their visualization of each religious mode of thought in their different styles and techniques.[20] A recent study by historian Stephen Schloesser explores the context of nineteenth-century considerations of spiritual "wonder" (rather than institutional religion) for the work of Edvard Munch.[21] I did not attempt to include personal religious backgrounds for every artist addressed in this book, however, to keep the focus of my investigation on secular societal contexts.[22]

Viewing Symbolist art from the standpoint of our own "free-floating and impersonal" times, it is often the hyperbole of such art that strikes us first, and most. This assessment of postmodernism as impersonal is that of theorist Fredric Jameson, who has argued that work by modernists (and his art examples are two Symbolists, Van Gogh and Munch) represent a "waning of affect" that has now been lost. For Jameson, the Symbolists' "age of anxiety" expressed themes of "alienation, anomie, solitude and social fragmentation and isolation" that would epitomize some of the last of the "psychopathologies of . . . ego," but also represented the end of style, "in the sense of the unique and the personal." If we now have a sense of liberation from this anxiety, in our culture and our art, he argues, it may well be because we share a "liberation from every other kind of feeling as well, since there is no longer a self present to do the feeling."[23]

In Symbolist art, we are reintroduced to art as affect, born of fears that now appear valid, and a desperation that is now palpable. In Symbolist art, the "symptoms" of a fin de siècle societal malaise are evident, but so also is the mind-expanding and visually captivating suggestion of consolation that they offer. Faced with the real threat of metropolitan life on the future of the individual, the Symbolists sought an art that would reinstate the idea, and the ideal, of inner life to their metropolitan world. In an artistic tour de force, they used visible images of the external world to evoke an invisible interior realm. Wanting to "make visible the invisible," they bravely, and even audaciously, turned to their own city streets.

I ∽ INTRODUCTION

When Hugo von Hofmannsthal wrote in 1893 that the very notion of "modernism" was the concurrent conflict between two opposite responses to hectic fin de siècle existence, he might have been speaking for the Symbolists. "Today, two things seem to be modern: the analysis of life and the flight from life. . . . Reflection or fantasy, mirror image or dream image."[1] Symbolism was precisely such a bifurcated art: intending to "make visible the invisible," Symbolists sought an art that could imagine and reflect the ideas and ideals of a "higher" world, all expressed through images of the earthly world. Addressing the inner being, it nonetheless used external, real scenes and objects as expressors. It is therefore in their blending of Hofmannsthal's two impulses that the Symbolists are most modern. While working and living in cities that seemed to be robbing them of their innermost being, they sought an art that could not only speak to their souls, but also help to save them. While undergoing the most traumatic transitions of new technological, spatial, and social changes of their own real life, they found solace – but not total escape – in fantasy and dream.

This is not a traditional view of Symbolism. From the time of Baudelaire's *Correspondences*,[2] the Symbolists have been perceived as those who studied nature but not humanity, who traversed forests and the realm of the imagination but not the city. Such escapism is certainly one aspect of the Symbolists' response to society, but it was not (as is commonly thought) so much a flight into fancy as a deliberate search for an alternative to the European urban life that they were living. Symbolism as a movement in the visual arts was short-lived, lasting only from about 1885 until 1905, at which time many of its ideas and approaches morphed into the more strident and stylistically radical art of Expressionism. As the European fin de siècle generation, the Symbolists were born into the extraordinary conditions of the metropolitan expansion of the 1880s and 1890s. They were the first artists, therefore, to respond to such nearly overwhelming changes in society as urban population explosion, fully institutionalized capital exchange, shifting class and gender relationships, and technological developments, as well as the rebuilding and reordering of the city itself. They were subject to new fears, often of each other and of their own environment. Daily subjected to a bombardment of sensory assaults, they walked the boulevards laced with carriage and tram traffic, crowds, and overlapping signs and signage, all garishly bathed at night in the glare of gas or electric street lights. They indulged in gambling, traveled by train, and either braved the crowded, confusing

streets or else slunk, agoraphobically, away from them. It was not a coincidence that the most prolific and well-known Symbolists were male: they came of age just as Victorian patriarchal assumptions were, perplexingly, being both questioned and reinforced. While they experimented with the new "free love" as well as the "New Woman," they themselves were accused of being decadent and effeminate. Perceiving themselves to be denied or deterred from the solace of traditional church or conventional family, they turned to their art as not only a salve for themselves but as a salvation for others in this tortured modern society.

Only by understanding these impressive – and for many oppressive – conditions of the Symbolists' lives can we begin to understand the full implications of Symbolist art. One important clue to these subtext meanings is its basis in late-nineteenth-century reassessment of the seemingly oppositional relationship between "seen" and "unseen," or of "visible" and "invisible," or even of "matter" and "spirit." In what has been termed the "epoch of apparitions,"[3] several areas of Europe reveled in religious revivals as hundreds professed spiritual visions – such as the children who were visited by the Virgin Mary at Lourdes – which testified for millions of believers to the ability of mortals to see immortality, and even divinity. The transferal of this believable "insight" from the natural to the supernatural world was, however, perhaps not as overwhelming as the new visibility of the natural world. Just as the Symbolists proposed their new referential art that would "make visible the invisible," new discoveries in science, for example, proved that a whole inner world – of microbes, germs, biological realities – existed beyond what could previously be seen. The knowledge that these tiny beings could be seen but only by scientists under certain precise conditions[4] lent an added air of mystery to their newfound existence. Psychology, a field that had grown slowly through the century and struggled to attain professional status, was by the fin de siècle claiming to be able to study and, more important, to control the "unknown" subconscious by means of symptoms and symbols newly apparent to the medically trained. What is striking about these various developments is their common claim to have made visible (like X-rays or electrical "waves" streaming through the air) other realities that had up to that time always been considered invisible, or even nonexistent. Thus Symbolism – an art about timeless ideas and feelings that used images referencing the external world only as signs of a more important, inner being – actually had as its impetus this physical, real, and visible contemporary world.

SYMBOLIST STYLE

This difficult goal of using tangible form to reference intangible ideas was accomplished through careful manipulation of both style and subject. The distinction drawn by Silverman in her study of the opposite styles and techniques used by Van Gogh and Gauguin to accomplish this Symbolist goal is instructive here:

she makes a convincing claim that Gauguin sought to "dematerializ[e] nature in a flight to metaphysical mystery," whereas Van Gogh instead worked at "naturalizing divinity" – in order, in his words, to "render . . . the infinite tangible to us."[5] For Silverman, this distinction explains in turn Van Gogh's drive for ever-greater physicality in his painting, from his laborer's hard manual work to the thick paint and even foreign substances (such as eggshells and coffee grounds) used to cover the canvas, while Gauguin strove to make his surface a veil, attempting to imitate frescoes with ironed and washed canvases that would be both degreased in color and matte in finish.[6] Such heavy manipulation, moving away from the glossy thin and detailed application of oil paints favored by the academic painters of the day, characterizes all Symbolist work and might even be a definition of what I elsewhere have termed their "secret style,"[7] a form of noncompliance to traditional rules of representational art. By introducing extreme manipulation of form, color, and technique the Symbolists announced to the viewer that their art was not an illusion of reality but rather a jumping-off image into the realm of ideas.

The Symbolists began, as all their theories affirmed, with the idea or ideal first, and then sought to find in nature some "correspondence" or "equivalence" that might be used (recreated rather than reproduced) in such a way as to announce that this art object was not a replication of that object in nature but rather a vehicle for recognition and contemplation of a higher reality. Thus certain objects, whether the obvious moon from nature or the newer subject of an antique vase in a bourgeois interior, needed to be presented in an iconic way to accomplish this transformation from object to art, from thing to evocation. At times literary devices were utilized: imagery of the *estompe,* or atmospheric conditions such as mist or permeating rain, for example, could blur lines and envelop the objects in haze that made them less material, more evocative. *Attente,* or arrested time, shown by means of frozen poses, stilled water and air, or uninhabited spaces, could also reinforce the iconic nature of the scene, in visual as well as literary terms.[8] By these means, it was possible for the artist, just as it was for the writer, to turn not only to traditional romantic images of nature but also to contemporary cities; any object, whether country or urban, held the potential for evocation. Thus, as historian Donald Friedman suggests, "Spatial paradigms are used to suggest moods of disjunction, isolation, and suffocating disharmony," as shall be seen in Chapter 3's agoraphobic urban crowds, or in Chapter 7's silent canalled cities; at the same time, "spaces of protection and imprisonment" can be used as models of interiority, as we shall see in Chapter 6's focus on quiet domestic interiors.[9]

Another way of immediately announcing this "nonreal" aspect of their art was the Symbolists' embracing of nontraditional genre.[10] Drawing in particular was a favored means of expression. In contrast to centuries-old practice of using drawings as preliminary studies for a finished painting or sculpture, the Symbolist appreciated and exploited the drawing as a unique and unqualified

medium. The finished and self-sufficient drawing that for prior artists would have been a "presentation drawing"[11] – an elaborate, signed work specifically intended to be a gift or an official submission for exhibition or commission acceptance – was for the Symbolist artist the rule rather than the exception. To this finished quality and completeness was often added exceptional size. Fernand Khnopff's pastel *Memories* (Fig. 1), measuring 50 by 79 inches, was intended to make an impression as sizable as that of an oil (and it does). Many other drawings illustrated in this book are of similar size, and were in all cases made for public display. In the exhibitions organized by the Parisian Salon de la Rose + Croix, drawings outnumbered any other media shown.[12] In the exhibitions of the Brussels Symbolist-oriented exhibition society Les XX, drawings were most welcome and quite popular; Xavier Mellery's major series *The Soul of Things,* a focus of Chapter 6, was a set of primarily black-and-white drawings shown there. Through drawings, often using limited color and blurred or tangled lines with matte or textured finish, the Symbolists could establish the imprecise vision of object as symbol that was their goal.

The use of line (outline as well as directional lines of shape and composition) was crucial to the Symbolist as an immediate expedient means of expression. Odilon Redon, who devoted nearly three decades solely to the black-and-white image, wrote that for him the black line was "a force emerging from the depths and pointing directly to the spiritual." In stating this, he echoed a belief in the innate expressiveness of the line, which was becoming increasingly prevalent at the end of the century and which would inform Art Nouveau as well. In the work of Jan Toorop, such as *The Three Brides* (Plate 4), the lines emanating from the two sides of the composition, representing spirit and matter, are given respective appearances (calm and curvilinear versus jagged and angular) that Toorop equated with musical sounds. Toorop's use of line as symbol linking tangible imagery with intangible concepts is, however, only one of its several uses in Symbolist drawing. Indistinctness – the most obvious effect created by a blurred or vague line – is also common and can be seen masterfully handled, for example in the works by Mellery (Figs. 91, 92, 103). It is also employed in the "landscape" that provides an almost abstracted background for Khnopff's *Memories* (Fig. 1), which allows the viewer to realize the unreality of the lawn-tennis game that the women, at first glance, seem to be preparing to play.

Finally, the significance of the Symbolist's manipulation of line is amply revealed in one practice that involved not only the use of line but also choice of media: there is a noticeable absence of lead pencil or pen-and-ink drawing by Symbolists. For their goals, the traditional "line drawing" so favored in the past and still popular at the turn of the century, was a type of drawing eminently suited to quick delineation of precise forms in nature and was therefore almost totally abandoned, while new media such as colored pencils were exploited. The radical nature of such selection was matched by new handling, for similar reasons, of color.

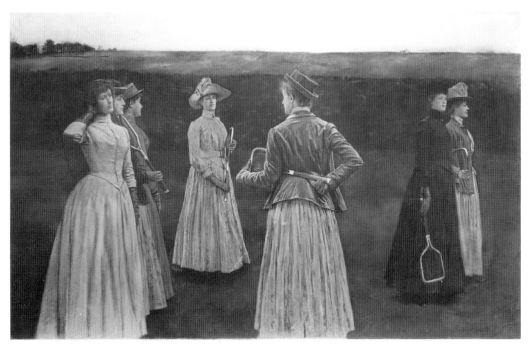

FIGURE 1. Fernand Khnopff. *Memories*. 1889. Pastel, 127 × 200 cm. Musées Royaux des Beaux-Arts de Belgique, Brussels.

Symbolist color also adopted deliberate distortion of the natural as a means to evoke non-nature. As with line, this could be described as an imprecise reference to hues existing in nature, reflecting a heightened sense of color and its evocative powers in the late nineteenth century. Like their Neo-Impressionist contemporaries, the Symbolists were well aware of recent color theories such as those of Charles Henry, who proposed in the late 1880s that each color carried with it psychological effect. But while the Neo-Impressionist Seurat quickly translated this theory into blatant painterly application of Henry's "happy" shades of orange, yellow, and red, or "sad" colors of blue, green, and violet, the Symbolists were more interested in the subtleties of such a theory. With the knowledge of the inherent psychological impact of colors, the Symbolists experimented with antinaturalistic color. Although the "red grass" of Gauguin's *Vision after the Sermon* (1888, National Gallery of Scotland, Edinburgh) is well known, such boldness was not a common ingredient of Symbolism. Rather, by limiting color contrasts to a narrow range of nearly monochromatic arrangement (as in Toorop's *The Three Brides*), or by introducing tertiary, or even "off" colors in opposition to the "pure colors" beloved by the Impressionists, the Symbolists could visualize the obscure but evocative color sense often found in Symbolist poetry. Tonal coloring, using one or two colors at most, also avoids all suggestion of line and creates the illusion of form by arrangements of one soft mass against

another. Through these unusual coloristic manipulations, images managed to suggest natural color while at the same time created symbolic evocations.

In their handling of pictorial space, the Symbolists were perhaps most audacious. In direct contrast to their Realist predecessors, who naturally sought to create a believable illusion of space within the boundaries of their two-dimensional works, the Symbolists reveled in deliberately complex spatial relationships that beautifully expressed an unreal and ultimately spaceless world. Often, as in the work of Toorop, space is compressed so that an entire "scene" appears to occur in a cramped and flattened two-dimensional space. Equally disconcerting, once observed, is the ambivalent handling of space in the work of Munch, who often crops foreground space and compresses background space so that linear perspective is questionable, creating a sense of imbalance or uneasiness, as in *Evening on Karl Johann Street* (Plate 2). Much Symbolist work in this respect seems to be influenced by medieval hieratic scale as well as Mannerist spatial distortion, especially as it incorporates nontraditional perspective and even lack of proportion among objects depicted.[13]

By carefully selecting and manipulating their media, by creating subtle suggestions of color and line to establish a strikingly ambivalent sense of space, the Symbolists were able to make art that was a tangible image of an idea/ideal. When all of these means were applied together, viewers were supposed to be transported to a new reality, of an ideal, without ever falling into the mistaken idea that they were simply observing an image of life. When added to the Symbolist subject – deliberately selected images and objects that in turn were intended to lead the viewer further into the realm of ideas – a release from the contemporary world (as we shall see, the city world) was made possible.

For example, Symbolist artists at times used elaborate medieval and Gothic tracing to cover their images with a veneer referencing what they considered a simpler, communal, and more spiritual era. This began with the prototypical paintings and drawings of Gustave Moreau, a recognized inspiration to the Symbolist generation, and continued in works by Ensor, Toorop, and Johan Thorn-Prikker in particular. In some works, such as Thorn-Prikker's *Epic Monk* (Fig. 2), the images themselves, appearing to evolve out of an overall linear veil, are taken from and refer to medieval (and here also to monastic) life. This drawing was one of four that Thorn-Prikker designed to illustrate the Belgian writer Emile Verhaeren's anthology of poetry titled *The Monks*. Just as Verhaeren's poetry conjured heroic people in honest times, so also Thorn-Prikker sought through image, style, and even media (his drawing is on vellum) to evoke a time that, at least in its nineteenth-century reconstruction, was centered on the spiritual individual as opposed to the mass public lifestyle of late nineteenth-century cities. Thorn-Prikker's intricate, tangled web of lines is deliberately difficult; it required of its viewer an attention to detail and willingness to concentrate that was opposite the process of viewing the beautifully finished and immediately understandable academic art so popular at the turn of the century. In

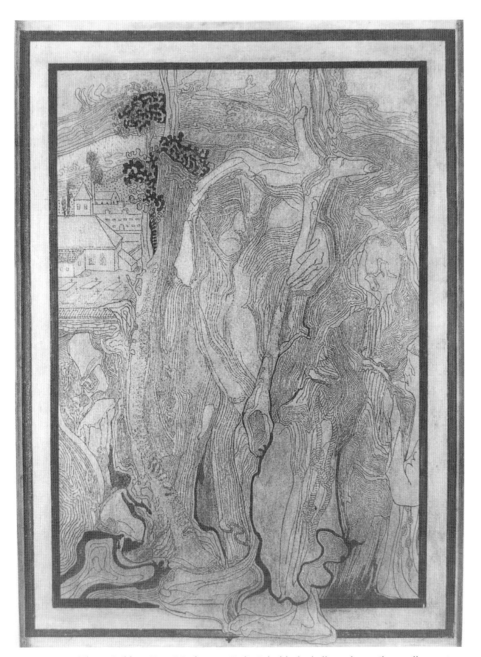

FIGURE 2. J. Thorn-Prikker. *Epic Monk.* 1894. India ink, black chalk, and pencil on vellum, 98 × 72.8 cm. Centraal Museum, Utrecht.

its demanding presentation, *Epic Monk* therefore slows down the viewer's act of seeing and processing the work of art, bringing into question what literary theorist Susan Stewart has called "authorial time versus readers' time."[14] Unlike, for example, Impressionist paintings, which offer with their short irregular and obvious brushstrokes at least the illusion that they have been quickly, even

hurriedly, executed, Thorn-Prikker's web of lines seems to have taken "forever," as both subject (the monk) and object (the drawing) dematerialize before the viewer's gaze. This latter process gives the impression of a slow, almost meditative procedure on the part of the artist and asks a similar deliberation, and length of time (slow enough to be off the scale of modern urban time), from the viewer.

SYMBOLIST SUBJECT

With much the same end and results, the Symbolists also manipulated and often even distorted their subject matter, turning traditional stories, whether mythological, religious, or fictional, into sagas of ideas rather than action. Plots are suspended as one image from a story is frozen in time, while presentation of protagonists is altered to offer new interpretations of character or meaning. For example, Symbolist Salomes (of which there are many) are usually depicted outside the plot involving the dance that led to the beheading of St. John the Baptist. Instead, the wicked Salome appears, alone, with the saint's decapitated head, held in such a way as to emphasize the underlying sexual charge of this woman's motivation, and the suggestion that women bring death through their sex.

Another example of Symbolist manipulation of traditional images can be supplied by means of nature portrayals. These are often landscapes that either are devoid of people or serve as a magnificent natural domain for a solitary individual. As we shall see, Symbolism followed most directly the nature imagery of the Romantics, but at the end of the century rather than at the beginning of it, with a desperation born of a wholly new sense of loss. For the Romantics, nature as well as monasticism was an escape, but an escape to an actual destination – still reachable – where they might find themselves enlightened and refreshed.

For the Symbolists, caught up in the social shifts of the metropolis, however, medievalism as well as nature itself had become unachievable ideals. This became especially important as artists found it more difficult to turn to traditional nature settings: life in the city seemed to have so completely changed lives that one could no longer "go back" – in space or in time – to a better world.

Thus an underlying theme to much Symbolist art is nostalgia. Even as they dreamed of past times and places in which life was more livable, they also hoped to revive an art that was more meaningful. Medically recognized in the eighteenth century and considered often fatal, nostalgia was originally connected to homesickness;[15] by the nineteenth century, however, it was a complex construct of psychological, social, and physical symptoms. Medical treatises on the disease, still considered contagious as well as a cause of mental illness, continued to appear into the era of Symbolism.[16] Theorists included Freud, who linked reminiscences to hysteria and considered the inability to cut oneself off from something in the past to be a sign of pathology.[17] The Symbolists, however,

seem to have developed a more twentieth-century approach to nostalgia as an acceptable, even enviable state of mind endemic to modernity.

Interesting in this regard is the connection from nostalgia to music: early diagnoses and definitions of the "disease" blamed music or sounds as the most likely triggers for symptoms. For the Swiss soldiers who were recognized as the first victims of the disease, the sound of the cow herder's song, or even the sounds of the cow bells themselves, was likely to set off a bout of nostalgia. Included in this concept was the idea that the "missed" time was one of happy and innocent childhood, a *passion de souvenir*.[18] This standard role of nostalgia was given visual narrative in midcentury works such as Holman Hunt's *Awakening Conscience*, in which a malingering young woman is thrust into thoughts of her childhood, as John Ruskin explained, and contrastingly to her sinful present, by the tune her lover plays on the piano. In this popular picture, however, the nostalgia victim was seen in a positive light: rather than making her ill, her nostalgia was about to lead to an awakened conscience and to a healthier moral future. Being connected by nostalgia to the past therefore gradually became understood as an affliction not wholly negative; one might even hope to induce nostalgia where necessary, in those too caught up in the evils of the present.

This notion of an induced nostalgia had immediate appeal for the Symbolists and was made more visual by them. An early work by Khnopff already suggested this, in its image of a woman completely caught up in the reverie of music. *Listening to Schumann* (Fig. 3) puts compositional emphasis not on the performer of the music but rather on the listener, who seems able to transport herself beyond the confines of her Victorian interior. Later Khnopff works are much more explicit in summoning nostalgia, and the formation of organic links with the past as a place to which one might actually connect: *With Grégoire Le Roy. My Heart Weeps for Other Times* (Fig. 4), the title of which is taken from a Le Roy poem about nostalgia, shows a woman attempting to create attachment with a veiled or mirrored image of a past city (probably Bruges) with her kiss. In *Across the Ages,* a Khnopff lithograph of 1894, a woman of the present seeks conversation with a statue of another woman of the past, perhaps her former self. In these latter images, the invoker of nostalgia is no longer a victim needing treatment, but an enactor of her own therapy, seeking spiritual if not physical health through association to the past.

It is significant that only in the late eighteenth century did the work and interest of antiquarians and connoisseurs invoke a new idea of the "past as a different realm," with its own history, separated from the living present.[19] In mid-nineteenth-century works such as Thomas Carlyle's *Past and Present,* the use of the past not only as a comparative guide for but also as a validation of the present was typified. By late century, however, a romantic nationalism that celebrated older folk traditions as a key to present strength encouraged new efforts at conservation and reconstruction and an approach to the past that was more emotional than educational. Even Freud, as David Lowethal

FIGURE 3. Fernand Khnopff. *Listening to Schumann*. 1883. Oil on canvas, 101.5 × 116.5 cm. Musées Royaux des Beaux-Arts de Belgique, Brussels.

points out, used "archaeological metaphors for excavating the psychological past."[20]

This new definition and appreciation led to a new role of "the past" that would afford the Symbolists an additional, and even very meaningful, alternative to their troubled present. The notion of "the past as a foreign country"[21] had its origins here. Evidence of this could be found in World's Fairs, where "villages" of the present displayed foreign (to western Europe) *places'* current lifestyles, but where "historical villages" were designed to show established Western nation's foreign *times* (e.g., the Old Manchester and Salford Village at the Royal Jubilee Exhibition of 1887 in England, or the Old Paris section at the Paris 1900 exposition). By the last quarter of the century, a new tourist industry boomed not only in the up-to-date big cities but also in the small historic towns (such as Bruges, a favorite haunt of the Symbolists). When added to the late-century disease of nostalgia this new identification of the past as a destination rather than as a remembered history was inescapably appealing to the Symbolists.

In the late 1880s and throughout the 1890s, the traditional sense of space and time had disintegrated in the new metropolis to the point of seeming to be

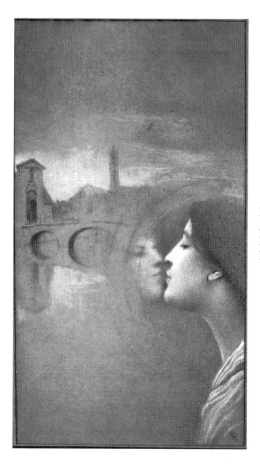

FIGURE 4. Fernand Khnopff. *With Grégoire Le Roy. My Heart Weeps for Other Times.* 1889. Pastel and white chalk, 248 × 142 mm. The Hearn Family Trust, New York.

confused and ever expanding: the Symbolists lived in destructured cities. Roland Barthes has described late-century literature as a field in which "cataclysmic changes" occurred, so that "classical writing therefore disintegrated."[22] The same might be claimed for the "classical" city: whole new idioms, new languages, and new readings were required of the fin de siècle urbanite. Just as new maps were redrawn in the literal sense, so also new mapping was necessitated to navigate mentally the metropolis. Thanks to technological advances that could overcome even the most physical and obstinate of former boundaries to urban spaces, the Symbolists could no longer plan to escape to a purely natural space, but could only dream of such an ideal. Thus, in the most obvious case of Gauguin, a lifelong search for the truly "primitive" – that is, antimaterialistic, nonurban culture – led from Brittany to the South Seas and a career as a professional tourist. But Gauguin's heroization of alternative cultures and religions is an implicit rather than explicit criticism. While he adopted what he considered a native lifestyle and appropriated numerous "primitive" visual forms, Gauguin's artistic statements regarding the western European life against which he was rebelling were restricted to deliberately universal, philosophical works with titles such as the

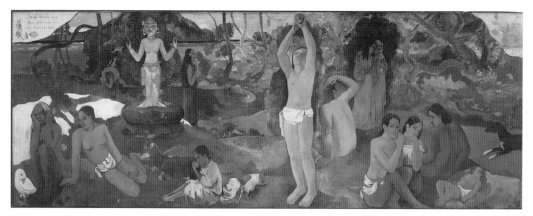

FIGURE 5. Paul Gauguin. *Where Do We Come From? Who Are We? Where Are We Going?* 1897. Oil on canvas, 139.1 × 374.6 cm. Museum of Fine Arts, Boston. Tompkins Collection.

well known *Where Do We Come From? Who Are We? Where Are We Going?* (Fig. 5). This monumental painting, considered a "last will and testament" of the painter, typically placed its author's questions, personal though they may have been at their origin, into a mysteriously evocative composition, filled with images and symbols that were, in Gauguin's explanations and in most viewer's opinions, only partially decipherable.

Thus the profile of Symbolist art as a flight of fancy arising out of the creative imagination of artists disassociated with everyday life is misleading, because the escapism embraced by the Symbolists was in fact precipitated by the analysis and experience of current, real life. The best Symbolists do not exploit full fantasy or simplistic literary images; nor do they, as Robert Goldwater pointed out, resort to simple "puzzles," the iconography of which can be analyzed and sorted thoroughly to make sense. Rather, the two worlds of reality and dream, which had been nicely separated in earlier Romantic and Victorian work (a "fairy picture" was a "fairy picture," and a "street scene" was a "street scene"), are complex and often precariously merged in the Symbolist work. The key – and the challenge – for the Symbolist was to accomplish this blend as a balance of references to both sides of Baudelaire's correspondences: the image from real life but also the dream of another. In his 1886 "Symbolist Manifesto," the French poet Jean Moréas explained this as a kind of delicate line treaded by the artist. Moréas warned first of being too precise and too descriptive (which would effectively deny the role of the image as symbol), but he also warned against overabstraction, or submission to style (because such abstraction, he believed, would lose the reader).[23] Rather, Symbolists had to work with actual images identifiably and believably delineated, but also had to avoid the hyperdescriptive art or literature that had become the accepted fare of the Realists and Naturalists who had gone before them. They also needed to adjust and, to a certain degree, condense and synthesize their language without falling into a "trap" of abstraction – and in

FIGURE 6. Fernand Khnopff. *Altar of Art.* c. 1905. Photograph, 18 × 24 cm. Musées Royaux des Beaux-Arts de Belgique, Archives de l'art contemporain en Belgique, Brussels.

this way the Symbolists clearly missed the avant-garde breakthrough in formal nonobjective language that would soon, in part due to their own influence, succeed them. The poet Stephan Mallarmé, in an interview in 1891, expressed this resorting to dual sources without fully following either the style or the image in a much more poetic way:

> To name an object is to suppress three-quarters of the enjoyment of the poem, which derives from the pleasure of step-by-step discovery; to suggest, that is the dream. It is the perfect use of this mystery that constitutes the symbol: to evoke an object little by little, so as to bring to light a state of the soul or, inversely, to choose an object and bring out of it a state of the soul through a series of unravelings.[24]

Thus, as deliberately abstruse as it usually is, the true Symbolist work inevitably includes references to its own times; as esoteric as they seemed to be, Symbolist artists inevitably responded to the immense pressures of the changing society of which they were a part.

Fernand Khnopff, creator of mystical images and designer of his own hermetic villa, is a case in point. While living in this secluded, aesthetically controlled world where he could be alone with his "altar of art" (Fig. 6), Khnopff

also accepted portrait commissions from upper-middle-class patrons and offered lectures on art history for the socialist worker's union, the Maison des Peuples. As described by friends, Khnopff was a "kind of god with a clear aesthetic goal"; he had "conceived the project of living as a hermit in the midst of contemporary agitations...a hermit who knows the hour of the trains...and also the price of things!" Significantly, Khnopff's friends agreed that this was appropriate, explaining that in their era, "to be anarchist you had to have an income; to be a hermit you must still know the price of things and the hour of trains."[25] Additional evidence of Khnopff's subtle shifting between the world of the imagination and the world of everyday existence can be found in his seemingly esoteric images. Throughout this book, paintings by Khnopff (and others) that might appear at first glance to be about a complete fantasy world, such as *I Lock the Door Upon Myself* (Fig. 96), will be shown to have at least partial or underlying meanings readable when examined through the frame of Khnopff's own society. By the same token, Khnopff's works that evince at first glance a readable image of modern life (such as the tennis players in *Memories*, Fig. 1), become when details are analyzed (such as the look-alike players, who seem to be oddly floating in a landscape space) to reflect not the external leisure world, but rather the inner life of memories.

Finally, as *Memories* reminds us, it was this need for an inner life, and the ability to interpret the contemporary external world as but a system of signs that could lead to contemplation of a higher existence, that makes the Symbolists so modern. Like the Romantics who exerted such a strong influence on them, the Symbolists prized the personal, the interior, and the individual. Unlike the Romantics, however, the Symbolists were living in city conditions with unprecedented physical changes accompanying an urban population explosion, so that the system of signs that they were reading was quite new. For the most astute critics of this late-nineteenth-century situation, a crisis was clear: how to maintain individuality, a unique personality, and, most important, an inner life under such conditions was seen as the dilemma of the day.[26] While many socialists sought reform for those suffering on the lower rungs of this new social structure, calling for work, housing, and sanitation reforms, others looked at the problem more philosophically. For them, the underlying threat of urbanity was the ruining of not merely physical or economic health but rather spiritual and mental health. As we shall see, it was this conflict and this threat that sociologists like Simmel addressed. It was also this threat that most fascinated – and frightened – the Symbolists. Simmel, who included among numerous influences the ideas of Marx on product and fetish, was one of the first to recognize the fact that modernity surrounded the individual with objects that, while serving new consumer needs, were at the same time fundamentally meaningless. He therefore characterized modern man as dominated by cultural objects that, because they are of his (sic) own making, cannot be rejected or repressed.[27] Simmel's logic in these arguments concluded that such increased impersonalisation of

city life and social behavior was essentially negative. Simmel was also attuned, however, to the French and English liberal vision of historical patterns that implied progression from homogeneity to heterogeneity and from group or mass organization to individuality. Based on these premises, he developed his own theory that modern social organization, which allowed one person to belong to numerous and different social groups, could encourage increased individual personality.[28] Simmel's conclusion in most of his writings around 1900 therefore suggested that modernity's impersonisation might *possibly* liberate the individual. This could be accomplished, however, only in the enlightened person who was able to maintain a dual – externally controlled but spiritually enlightened – existence. Simmel's ideas, combining strains of French progressive optimism with Germanic pessimism, were an optimistic interpretation of recent social and psychological theory that claimed less and less individualism in what was termed the "era of the crowd."[29]

The Symbolists, who shared Simmel's varied philosophical and theoretical influences, would have agreed, I believe, with Simmel's slightly later writings, and his ideas offer important insight into their intellectual considerations of the role of art in such a society. Horrified by the dullness of new city life, they proposed an alternative, subconscious, and individualistic inner life as its redemption, not merely its escape. The ideas of William Morris, the late Pre-Raphaelite artist whose work and theories influenced many Symbolists, are instructive in this regard. As Andrew Lees has pointed out, Morris's socialist sympathies were most outraged not by the poverty and ill conditions of the slums, but rather "by his belief that the urban-commercial-industrial environment of his day militated against men's finer feelings and subtler pleasures."[30] In Morris's *Art and Socialism* (1884), he described London as a "spreading sore" with a "befouled river" and sounded like many reformers of his day.[31] Yet his ideal London, described later in the novel *News from Nowhere* (1891), was reactionary rather than futuristic, with an emphasis on the hand-built, more natural (he hoped) environment of a nonindustrial society. In this utopia, urbanites would enjoy aesthetic reinforcement at every turn, and it was their inner health and sophistication rather than their physical situation that Morris most wished to transform. Before the ideas of Morris, as well as those of the English critic John Ruskin, became well known on the Continent, European Marxists were little concerned with the role of art.[32] This new attention to artistic needs for the city dweller became critical, in the 1880s, however, not only to revisionist Marxist applications but also to Symbolist art theory.

In 1895, for example, the Belgian socialist lawyer Edmond Picard, founding editor of the Brussels *L'Art moderne* and leader of both Symbolist exhibition societies Les XX and La Libre Esthétique, offered a "conference" on the subject of art at the service of society. In a Morris-like spirit (Morris and the Arts and Crafts movement arrived first to Europe through Belgium),[33] he did not term such work "social" or "socialist" art, but rather "socialized art," by which he

meant the use of art to enhance the individual, making each person better in character:

> We consider art as something outside real life and believe that the profound emotions that it gives us must not produce anything of a social result; that the heroism that it inspires in us must not and can not be applied in reality. This conception is false. The sole *raison d'être* of art is to exalt us and make us desire a general welfare, it must be mixed into all our actions in such a manner as to influence us in all circumstances.[34]

While proposing this definition of art that must occur in the public as well as private sphere, Picard concluded that "Socialized art will [make] cities and fabulous societies rise up, it will make of our sad towns the dwelling of the gods, at the same time that it renders private life and the home charming, peaceful, and constantly vibrant."[35]

Like Morris and Picard, the Symbolist artists struggled, therefore, with two realities, one of which (the external) was rapidly changing, causing the other, most cherished (the internal) life to be dangerously threatened: the strength of the inner life must be established, and enhanced, if any good were to be accomplished in the external world. Just as Moréas first declared his goal "to clothe the invisible with the visible," Symbolist artists sought to reconcile these seemingly irreconcilable two realities and tried to follow the advice of the poet Rainer Maria Rilke, to "stretch your practiced powers until they reach between two contradictions."[36]

SYMBOLIST SOCIAL IDENTITY

Given these dual leanings toward critical analysis but also correction of the city, then, Symbolist artists as reconcilers present themselves to be appreciated as "other" than the middle class that dominated the economics, activities, and even spaces of the large cities. A cursory review of major Symbolist artists and their social backgrounds proves, however, that this was largely an adopted stance. First, their work was consistently intended for an urban, middle- and upper-class market. According to their notion of reform, the upper classes, whether defined financially or educationally, were as much and possibly even more the victims of modern society as were the working classes. These were the people who had the time and the potential ability to develop a discrete inner core of being; they also were not only people who could spiritually profit from Symbolist art, but were the exhibition-goers who would see it and the collectors who could buy it. Second, the Symbolists themselves varied significantly in their own social upbringing prior to becoming so "elitist" and often anti–middle class in rhetoric.

Gauguin epitomized the conflict inherent in artists who adopted a loathing of the bourgeoisie that had begun with the Romantics, despite the fact that to survive the artists needed to maintain some business contact with the middle class.[37] Most Symbolist artists, however, were in fact more like Ensor, Hodler, or Munch; these artists were from laboring or middle classes who, at least initially and at their most fervent association with Symbolism, constantly struggled to avoid these surroundings. Each evolved, furthermore, his own idiosyncratic lifestyle through which to accomplish this.

Hodler was the eldest son of poor laborers – his mother a seamstress and his father a carpenter – who grew up in the care of a stepfather and a farmer uncle after the early deaths of both parents. When he did achieve fame, he began to emphasize his youthful hardships in official biographies, while moving into new apartments furnished by avant-garde designers. Throughout his most Symbolist period, he further confused the issue of class and public acceptance by reveling in his rebel image (his work was twice banned in Geneva) *and* complaining about the lack of public fame and fortune that he felt should be his, especially in his native country.

Edvard Munch, although the son of a doctor with a relatively comfortable life, was nonetheless in constant contact with the lower and middle classes with whom his father chose to live and work. While acutely aware of the long heritage of his family as a leading one in Norway's intelligentsia (his uncle was a famous historian), he returned repeatedly to images of the working and middle class and to themes of the downtrodden.[38] By the 1890s, he led a nearly nomadic lifestyle, traveling in 1891, for example, to Le Havre, Paris (three times), Nizza (twice), Antwerp, Copenhagen, Hamburg, and back to Christiania (Oslo). At the same time, he avoided what might be considered normal, bourgeois relationships: after the death of his beloved sister Sophie, Munch isolated himself from close family ties and established a love-hate relationship with his father, the outcome of which was lifelong guilt.[39] He also tried out numerous sexual liaisons, but balked at any suggestion of marriage, resulting in a string of short-lived affairs that caused him constant self-questioning and grief.

Ensor's family was in the souvenir business in the seaside resort of Ostend that catered to summer tourists, and it was in this oddly artificial existence that he spent his life, living and painting in the rooms above the shop. But although he later lived by himself – an existence which has been described as being "solitary, fearful of outside contact and fortified against it"[40] – Ensor was far from being a hermit unconnected with his own community. He was trained in Brussels, at the respected Academy, and traveled regularly back to the capital, spending time with his artistic and socialist friends, including Ernst Rousseau, rector of the University, and exhibiting there as a founding member of the avant-garde society Les XX. Treading not so lightly between these various, seemingly irreconcilable social worlds, he devoted himself to a biting satire of the new society in his art. Like Hodler, he constantly tested the limits of what was artistically acceptable,

while expressing consistent amazement and dismay over critical disdain of his work.

Fernand Khnopff, on the other hand, was not of the lower or middle class; he came from a wealthy background, a favored son of a magistrate's family. Yet part of the point made by his friends who contended that he was "a kind of god" (who managed to live with the mere mortals of Brussels) was that all artists – regardless of their social background and despite their self-isolationist ideals – would still have to live their day-to-day existence in the world of the middle class if they lived in any city in western Europe at that time. It had become the only choice: life in the late nineteenth century was an adaptation to these new circumstances.

It was this new and at times tortuous adaptation that was the basis of study of the fledgling discipline of urban sociology. During the period 1880–1918, a time now identified as the "classic era" of urban sociology,[41] there was a surge of inquiry into the interactive social conditions of new city life. As already noted, Simmel began in the 1890s to make his own observations; with other scholars like Emile Durkheim in France and Max Weber, also in Germany, he was among the first to recognize the sociological impact of the new cities and the challenge they posed for traditional social relationships. Despite his esoteric background, then, Khnopff was like most Symbolist artists. Themselves suitable examples of the class slippage that seemed at the root of metropolitan society, these artists gradually crafted lives and lifestyles that essentially isolated them from the ordinary middle class. As they led lives and built careers that straddled at least two classes, however, they were unable to make the kinds of classless adaptations – uniform public behavior that supposedly mirrored private conventionality – which were learned on the new city streets. It might be said that while the average city dweller thus ceded to a breakdown of formerly classed social codes by morphing into a generic "mass class" with its own new and impersonal codes, the Symbolists established their outsider role by intermingling social codes of all classes, resolutely refusing such conformity. Neither esoteric nor common, neither completely elite nor earthbound, they were as artists neither academicians nor bohemians, but some strange mixture of all, embodying the true elision of class that bothered many at the fin de siècle.

Between 1800 and 1910 the urban population of Europe expanded sixfold,[42] but this statistic is more instructive when fixed on particular cities: while there was a doubling of the total population, there was tripling of the percentage that could be classified as urban.[43] Thus spatial as well as population growth in cities soared precisely when the Symbolists were most active. The acceleration took off in the 1850s, when the majority of these artists were born, and continued until around 1910,[44] when many of the artists, then in their fifties and sixties, had either stopped working or changed their art significantly. Furthermore, despite the common linking of industrialization with this growth, it was not the factory town, with actual industries built in or adjacent to the urban center, that

experienced the most growth at this time. Rather, it was the "capital cities" – where the banking and other service professions mushroomed and the art centers blossomed – that saw the most profound development. The changes in these cities were, therefore, not the smoke and slums that stirred calls for reform earlier in the century, but the experience of huge new center-city boulevards accompanied by suburban sprawl, all giving way to a completely new sense of "the crowd" on the streets.

Lastly, the Symbolist artists represented in this study lived and worked in the very cities that, at the end of the nineteenth century, were not the most expansive in western Europe. The largest cities remained London and Paris from 1750 through 1950, while the Symbolists worked in the "secondary" or even "tertiary" cities. These older cities, along with Rome, Budapest, and others, had only recently become important as political centers, so that they were quickly transformed into "capital" as well as "capitol" cities and restructured to look more and more like London and especially Paris.[45] It is further notable that, although most of the Symbolist artists traveled to London, Berlin, or Paris and usually exhibited and marketed their work in at least one of these three cities, they never lived there for any extended period of time. They decided, instead, to remain in their own countries and to deal with the enormous changes taking place in their native cities (Figs. 7 and 8). Brussels, for example, was the home of Khnopff and most of the painters of Les XX; it was ranked thirty-fourth in European cities for size in 1750, with a population of 55,000. By 1830, however, Belgium was one of the most heavily populated (for land available) and industrialized countries in western Europe.[46] In 1850, Brussels was the capital of the new (about twenty-five years old) state of Belgium and the seventeenth largest city in Europe, with a population of 208,000.[47]

As we shall see, this burst in population required extensive rebuilding and restructuring of the city, expanding into wholly new sectors and focusing on new boulevards for increased commercial, leisure, and business traffic. With an ever-incremental emphasis on public activity, less time and space was allowed for the natural and for the individual. Perhaps most important, all of this change was extraordinarily self-conscious. Debates over urban reconstruction raged in the Brussels newspapers. They even played a major role in the leading avant-garde art journal of the day, *L'Art moderne* (a literary mouthpiece for Les XX), which throughout the 1890s ran a regular column titled "Urban Landscapes," to which the everyday citizen was invited to voice her or (usually) his opinions on the latest reconstruction efforts. When the mayor of Brussels published his own brochure, *The Aesthetic of Cities,* describing the enormous effort that must be made (despite the need for more tram space, apartment buildings, and bigger public spaces) to oversee with good taste "the transformation of an old city forced to obey the domineering exigencies of its prosperity," the art journal "rendered homage" to his ideas by publishing the booklet in series.[48] When another Brussels citizen published a critique of the recent city architecture, the

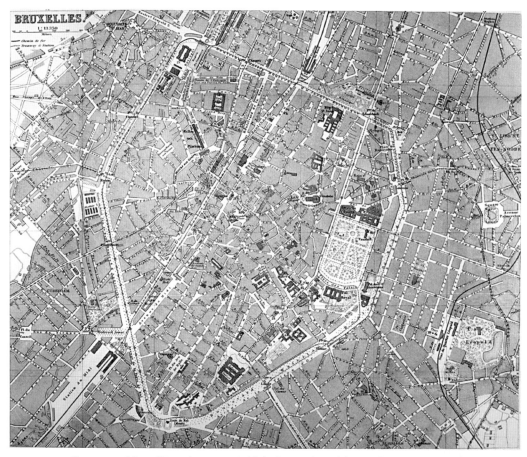

FIGURE 7. Map of Brussels, c. 1891. Published in Karl Baedeker's Belgium and Holland (Leipsic: K. Baedeker, 1891).

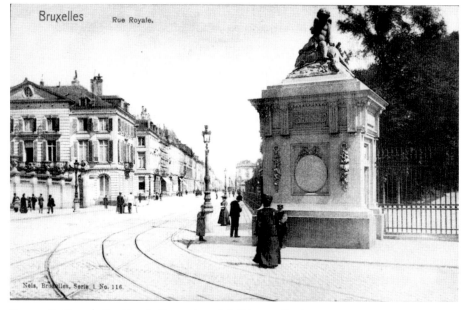

FIGURE 8. Brussels, Rue Royale. Postcard, c. 1898. Private collection.

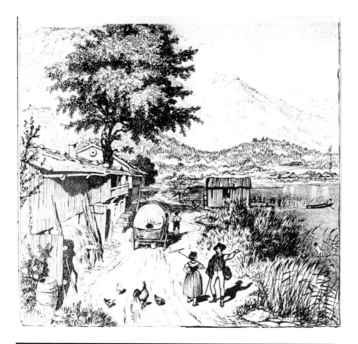

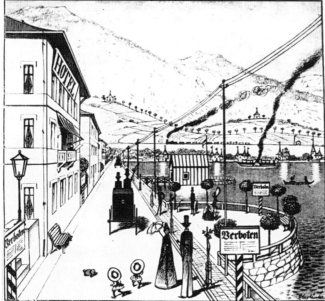

FIGURE 9. "Oberlander," "By the Lake," *Le Globe Illustré* (Brussels), April 5, 1891, page 424. Photograph courtesy of Pierce Bounds.

editors of *L'Art moderne* took offense at his efforts "to prove that all our houses are ridiculous and badly constructed and that modern architects are asses."[49]

Despite these aesthetic battles, however, many in Brussels viewed the recent renovations as urban blight. Even the Brussels family magazines developed a sense of self-deprecating humor about the enormous transformations in their lives. An 1891 two-part cartoon in the Brussels *Le Globe Illustré* illustrated the difference between a walk "by the lake" today compared with one only thirty years earlier (Fig. 9). Now, anything natural was replaced by concrete, spewing smoke, and utility wires; urbanites staying at the new hotel that has taken over the farmstead may as well wear their occlusive city clothes, because all activities other than promenading or riding is "Verboten." One can only surmise that this newly restricted, dismal encounter with nature was supposed to be an "escape" from their overly hectic, mind-numbing, even sickening life in the city; this was precisely why the Symbolists believed that art could accomplish more by way of a reprieve than a day spent "by the lake."

In this book, I use numerous references to Symbolist literature to reconstruct these artists' physical as well as emotional reactions to the Symbolist city. Despite the fact that considerable well-known Symbolist writing follows Baudelaire and relies on nature signs for evocation of inner ideas, there are numerous poems and especially novels that not only address the city as setting, but make it the causal force of the protagonist's action. In Chapter 7, I use two books about Bruges by the Belgian Georges Rodenbach to establish what the ideal city (namely, a dead city) would be for the Symbolist generation. Throughout the next five chapters, however, I focus in particular on three novels, each written in a different decade of the turn of the century, which evoke the Symbolist view of the contemporary metropolis.

The first of these is probably most well known. The French decadent novel, J. K. Huysmans's *Against the Grain* (*À Rebours*) of 1884 is a narrative about the last scion of a French aristocratic family, Duc Jean des Esseintes, who after years of Parisian debauchery flees to his own carefully crafted "cottage" fashioned from art and artifice rather than nature. Even when des Esseintes is at his retreat, all of his thoughts, be they synaesthenic decorating schemes or philosophical analyses of Latin literature, derive from the recognition of Paris (and by default the new metropolis) as the "other" controlling force on his life and even his thoughts.[50]

Another novel that serves as an example throughout this study is Norwegian Knut Hamsun's *Hunger* (*Sult*, 1892), in which a starving writer describes in disjunctive, almost deranged detail his struggle to stay alive, and sane, in Norway's capital, Christiania. The book is about the city and its effect on the sensitive soul, as encapsulated in its first sentence: "All of this happened while I was walking around starving in Christiania – that strange city no one escapes from until it has left its mark on him."[51] The writer admits that in the city, "I was nothing but a battleground for invisible forces, I was aware of every detail of what was going on around me [on the street]."[52] The novel ends, therefore, with his signing on

to work on a cargo steamer, signifying his rejection of purely mental work as well as the city that produced its overstimulation. Still sick and hungry, he is able to recognize the city's appeal while undertaking its remedy. His last words are, "When we were out on the fjord, I straightened up, wet from fever and exertion, looked in toward land and said goodbye for now to the city, to Christiania, where the windows of the homes all shone with such brightness."[53]

Finally, German Rainer Maria Rilke's *The Notebooks of Malte Laurids Brigge* (*Die Aufzeichnungen des Malte Laurids Brigge,* written between 1904 and 1910) has been acclaimed as a classic fin de siècle document because it subtly draws the reader into the Symbolist spirit of the presumed writer, who is able to find truth behind the appearances of things (or as Brigge himself would write, "Things"). But as will be evident in the numerous citations from Rilke's novel in this study, Brigge's meandering musings about his childhood and the meaning of life and death are not triggered in nature; rather, the premise of the novel is his arrival from a Danish country house to the queen of European cities, Paris. Like the works by Huysmans and Hamsun, Rilke's *Notebooks* announces its author's opinion of the metropolis in the first sentence: "So this is where people come to live; I would have thought it is a city to die in."[54] Like Huysmans's des Esseintes (we are never told the name of Hamsun's hero, much less his family background), and also like Munch and Khnopff, Rilke's Brigge is the last of a noble family, now trying to survive the alien life of the city. Like all of the fictional and real Symbolists (and including Hamsun's writer), he is a poet and lover of art and literature. But it is as if this identity – and his very ability to read other truths behind the mundane signs of the city – makes it impossible to fit into new society. An encapsulation of the Symbolist artist, Brigge is able to see things in a way that his fellow urbanites simply cannot. In one scene, for example, he is shocked to see *him* [who must be death] calmly waiting in a small restaurant; this experience immediately drives Brigge

> out again into the streets, which rushed toward me in a vicious flood of humanity. It was carnival-time, and evening, and the people, with lots of time, were roaming through the streets, rubbing against one another. Their faces were full of the light that came from the carnival booths, and laughter oozed from their mouths like pus from an open wound. They laughed and crowded together even more impatiently as I tried to push my way forward. . . . I felt I should have laughed also, but I couldn't.[55]

Thus, while the transformation wrought by metropolises' "modern-ization"[56] between 1870 and 1905 might be interpreted in terms of the sig-nificant changes in scale and density, the city for the Symbolist was not only the buildings and the streets but also its new and, for them, strange society. The Symbolists were the first generation to find themselves in such a complex,

often confusing, and even alarming new world. More important, they were, by virtue of their commitment to know and to communicate the mystery of life that lay beyond this world, singularly well equipped to observe and absorb with extreme sensitivity all the material wrongs of the city, and they were among the first to go against the tide of positivist approbations of progress that had reigned throughout the second half of the century. In their expression of this negative reaction against the new metropolitan social order, they were exemplars of a fin de siècle illness: that queasy, sickening feeling that all was not right, that things were in decay, and that one could not fit into one's own surroundings. The mitigator, if not the cure, for the Symbolists' malaise was their art.

In 1887, Vincent Van Gogh painted *Boulevard de Clichy* (Plate 1). This canvas exists, with the exception of two public garden scenes that are recognizably set in Paris, as Van Gogh's only attempt in painting to show the new revamped and rebuilt metropolis, complete with wide boulevards, buildings, and pedestrians. He had been working in Paris since March of 1886, living with his art-dealer brother Theodore (just around the corner from this scene, on the rue Lepic), and trying to adapt to the fast pace of the metropolis. During this hectic time in Paris until his departure for Arles in February 1888, Van Gogh was bombarded with a barrage of exciting, all-new possibilities for his painting. Fresh palettes and bold techniques were learned from the Impressionists and Neo-Impressionists; these plus a plethora of contemporary cosmopolitan scenes must have convinced him that his work just completed in Amsterdam was hopelessly out of date. Even so, his first essays at painting Paris were not actually of the modern metropolis itself, but rather the small side streets near Montmartre and rural areas on the outskirts of the city. For the majority of these, Van Gogh's point of view was from high above, outlining rooftops and skylines in a manner that was, as we shall observe in Chapter 3, a "safe" distance away from city society and the chaos of the boulevard. It was the same strategy as that adopted by numerous other Symbolists, such as Ensor and Munch, in their early views of the city.[1] Throughout, he seems to have been fascinated with bridges and painted them, almost invariably, from the water, whether he was in Paris or Asnières.

As Van Gogh's only full view of the brand "new" Paris,[2] however, the *Boulevard de Clichy* deserves our attention because it is also one of the most structured and controlled of all of his paintings, and affords important insights into the perspective on the city of an artist who would be within three years described as both a Decadent and a Symbolist. One of the most striking characteristics of the painting is its new use, usually ascribed to the influence of the Impressionists and especially of Pissarro, of a light, predominantly pastel palette; this change, however, is equally evident in several other Van Gogh canvases of the same time. But another new element here – the patterned use of small, even brushstrokes that clearly resulted from Van Gogh's knowledge of Seurat and pointillism – is in the *Boulevard* particularly attenuated.[3] Individual strokes are lined up to match the direction of the architectural form, whether building or pavements, that they define, and further reduced to striations or cross-hatchings that are almost codified in their structures. Even the sky is delineated with varying color strokes that

are uniformly horizontal, encouraging an overall reading of the boulevard scene as highly organized and controlled. It is the point of view, however, that most emphatically exercises a sense of order over the city: the entire scene is seen from a (safe) distance, with no intervening structures or people in the foreground street to confront the viewer.[4] Van Gogh's boulevard is here as comfortingly distanced as were the buildings in his earlier rooftop vistas.

It is notable, therefore, that in the one drawing related to this painting now known (Fig. 10), Van Gogh included two foreground figures seen from the knees upward, who cross from the rightmost corner of the scene directly across the viewer's space.[5] Their inclusion in the drawing reduces the boulevard itself to a mere background scene, while at the same time they offer some human engagement with the viewer on this otherwise impersonal vista. These figures in the drawing were never included in the painting. It is all the more interesting, therefore, to note here that Van Gogh *had* included, in a rudimentary fashion, a different foreground figure in his finished canvas: a single, full-size foreground woman carrying a basket, again toward the right corner of the scene. This woman's form was incised, probably with the tip of a brush handle, into the wet paint.[6] Van Gogh had vacillated between country settings and urban life for the past four years of his life; although he seems to have been tempted by the cultural attractions of cities, he rarely survived their frenetic society for long.[7] Like a metaphor for the painter's own reserve in his engagements with public urban society, the woman scratched into the painting remained an outlined ghostly presence, her potentially confrontational position effectively effaced. In the final version, *Boulevard de Clichy* is an exercise in control and reserve: Van Gogh never did give us a representation of his face-to-face encounters with metropolitan street society. These encounters were traumatic; as his brother Theo explained, Van Gogh "was forbidden to sit and work in the street & because of his volatile disposition this repeatedly led to scenes, which upset him *so* much that he became completely unapproachable & by the end of it all he'd had more than enough of Paris."[8] When he did depart, Vincent was the first to agree with his brother that city life had taken its toll on him: "I was certainly on the right path to have a stroke when I left Paris. . . . Good Lord, the depression and the prostration of it all!"[9]

By the time Van Gogh left Paris, however, for the rejuvenation of "the south" ("Now, however, hope is breaking for me vaguely on the horizon," he explained from Arles),[10] he had accomplished an incredibly rapid maturation in his use of color and brush. He had also gained the self-confidence to begin to paint images not as they might appear in a camera lens, but as they spoke to his own idiosyncratic and emotion-laden perspective. As Van Gogh painted the world around him – fields, gardens, and the small street with the yellow house that he had rented – he began to paint with new-found freedom and exaggeration. In Arles, he developed the highly individual, moody approach to painting that abandoned the earlier compositional and brushwork control

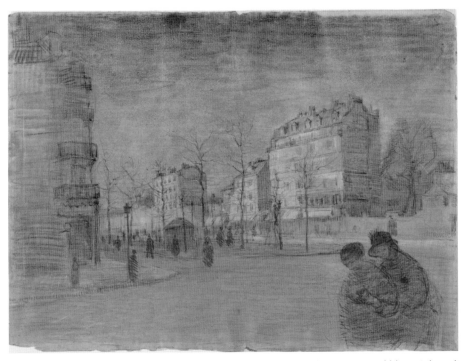

Figure 10. Vincent van Gogh. *Boulevard de Clichy*. February–March 1887. Pen and blue, pink, and white crayon on yellowish-brown paper, 39.8 × 54 cm. Rijksmuseum Vincent van Gogh, Amsterdam. Vincent van Gogh Foundation.

to an increasingly turbulent surface. Ironically, even as he sought to be further removed from what he termed "this hurried and feverish modern life,"[11] he created what was soon described as "intense works"[12] that paid new attention to his own eccentric view of things, announcing in his letters that his painting now "had no system."[13] As has been pointed out, this later period of his work is also identifiable in its adoption of antimodernist, and antiurban, imagery: a major aspect of the appeal of the Arles area for the painter was that it could be portrayed, even in its very traditionalism, as "exotic." This iconographic decision in turn informed both his heightened colors and his newly open compositions that sought to put Arles imagery in direct contrast to the city.[14] As art historian Vojtech Jirat-Wasiutynski has explained, "in all of Van Gogh's agricultural images the city is the invisible other, motivating the intense antimodern experience of the exotically coloured landscape."[15] By the time Van Gogh died, in Arles in 1890, he had seemingly left Paris, and the metropolis, far behind him.

In this chapter, I examine the discomfort with and eventual move away from the city, so condensed in the short career of Van Gogh, as a social phenomenon in the life and work of Symbolist artists. Their malaise in the city found varied expression that not only affected stylistic maturation and imagistic choices, but also impelled the very goals of their art.

As we shall see, it was fin de siècle society, with its new emphasis on social codes and impersonal crowds on the streets – "a bourgeoisie that has wads of banknotes for brains and a gold ingot for a heart," according to a contemporary writer[16] – that is most negatively reflected in Symbolist art. As is indicated by the amount of autobiographical relevance to many of the Symbolists' images, these artists were, inevitably, a part of their own society, despite their desire to escape it through imagination. Like the Romantics, the Symbolists stressed the individual, but by late nineteenth century *maintaining* that individuality was seen, by sociologists, crowd psychologists, and the Symbolists alike, as a rare struggle. By the 1890s, one no longer sought to be an individual among *other* individuals, but rather needed to be the exceptional individual in order to escape the hegemony of an increasingly homogenous society. When the Symbolist poet Jules Laforgue died penniless, of consumption, in 1887, the critic Gustave Kahn denounced the common fate of the artist in modern times: society now, Kahn claimed, "only allows more delicate beings to live if they pay society the price of an occupation which makes them like all the rest, recognizing good and evil after the fashion of an accountant."[17] For Kahn, as for other Symbolists, this was a fate worse than death.

DECADENCE, SYMBOLISM, AND THE EXPRESSION OF MALAISE

To understand the complex nature of this intense reaction to city society, it is necessary to analyze as social conditions the two terms most commonly used to identify the idea-laden art of the late nineteenth century, Decadence and Symbolism. These are two of the most difficult art historical terms to define, let alone distinguish from one another, even when considered in context of literary efforts. "Decadence" was a designation early proposed for the new school of literature that, around 1882, reacted against naturalism and began to emphasize personal sensation, esoteric language, and mysterious ideals. Only with the "Symbolist Manifesto," written by Jean Moréas in 1885, was the term Symbolism proposed with the persuasiveness that made it the preferred label for these new writers.[18] But as art historian Reinhold Heller has established, by 1890 the term Decadence had acquired a specific and generally accepted meaning. Critics at that time used it to describe the hypersensitive, idiosyncratic writing of poets like the Belgian Maurice Maeterlinck, "a poet for those who know how to dream and who feel through their nerves."[19] By 1891, the time of this quote by the critic Max Dauthendey, however, the term Symbolism was being used to describe the deliberately symbolic language of many of these writers and had already been applied to the visual arts. In April 1887, an article on Fernand Khnopff written by poet-critic Emile Verhaeren was titled "A Symbolist Painter"; most well known is G. Albert Aurier's later (1891) article on Paul Gauguin, titled "Symbolism in

Painting."[20] From this time on, distinguishing between the earlier "Decadence" and the slightly later "Symbolism" – especially in the visual arts – has been difficult, but such distinction is important in shedding light on the Symbolist generation's response to society.

One of the very best if basic distinctions was offered by Gustave Kahn, one of many Parisian writers who sought to further explicate the ideas set forth in Moréas's Symbolist "Manifesto." Only ten days after the publication of Moréas's piece, Kahn wrote a "Response of the Symbolists" which had as its purpose the answer to protests raised by the new Symbolist ideas. Although Kahn specifically proposed a contrast between Symbolism and earlier Naturalism, because he begins with Emile Zola's definition of Naturalism as "nature seen through a temperament," his final contrast might also be seen as one between Decadence and Symbolism, for Decadence was, if anything, a heightening of the temperament. In a now famous passage, Kahn concluded that "The essential aim of our art [Symbolism] is to objectify the subjective (the externalization of the Idea) instead of subjectifying the objective (nature seen through the eyes of a temperament)."[21] By this, Kahn implies that former art (Romanticism, Naturalism, and, I suggest, also Decadence as an extreme Romanticism) begins with the object, in nature, but presents it as seen through a particular (and, in Decadence, radical) personal temperament and vision. Symbolism, Kahn declares, completely switches this process of artistic production: the Symbolist begins only with an idea, a totally subjective feeling, and then seeks to find appropriate symbols, or "clothes" from the real world by which to suggest this ideal. This was an iconoclastic definition, arguing both against all former mimetic art, no matter how personally informed it may have been, and toward the more thoroughly subjective art (Expressionism and Surrealism, for example) of the early twentieth century. Kahn's distinctions work if one accepts the identity of not simply Naturalism and Romanticism but also Decadence as a kind of art that still, for all of its excesses, remained within the realm of a nature-subjectifying art.

By further addressing this issue from a social point of view, some additional distinctions can be made between Decadence and Symbolism, because the two terms can actually define two separate "phases" of most artists' response to their increasingly problematic society. First, I identify an early, introspective "perspective" on society that stressed isolation and rejection. By the late 1880s, this was termed "Decadence," as seen in works such as Edvard Munch's *Night* of 1890 (Fig. 11). As has been established,[22] it was this painting that, for Munch, garnered precise criticism as "Decadent," and with good cause: it summarized the notion of Decadence as a highly personal view of the world, inviting the viewer into the composition to share in the feelings that overwhelmed the painter. Munch's painting, imbued by blues and blacks with soft, elusive lines and deliberately vague forms, reveals upon quiet inspection a single figure, his profiled face in deep shadow, staring out of a window at a single boat floating on the Seine.[23] The entire painting exudes melancholic meditation and suitably expresses Munch's

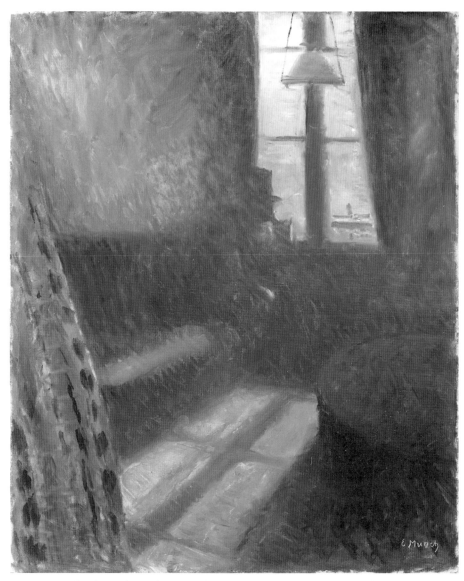

Figure 11. Edvard Munch. *Night*. 1890. Oil on canvas, 64.5 × 54 cm. Nasjonalgalleriet, Oslo. © 2003 The Munch Museum/The Munch-Ellingsen Group/Artists Rights Society (ARS), NY.

own eccentric vision of the world at the time, as he struggled with his faltering career as a painter, his loss of faith, and especially the death of his father. The painting is therefore about melancholy and grief, but it is a very personal grief that, as critics were quick to point out, carried a burden of oversensitivity with it. The viewer is induced to share in these feelings, rather than encouraged to confront directly and think about the issues at hand.

Only later did a second, more socially interactive "view" of the Symbolist artist develop: this second type of work continued to some degree the

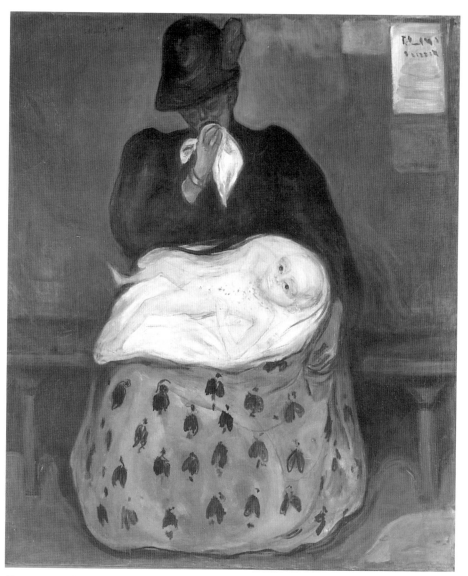

FIGURE 12. Edvard Munch. *The Inheritance*. 1897–9. Oil on canvas, 141 × 120 cm. © 2003 The Munch Museum/The Munch-Ellingsen Group/Artists Rights Society (ARS), NY.

intense personal psychological investment in the work's subject, but also stressed evocative statements or comments on society, with deliberate manipulations to make them universal. In this art, objects were still depicted but in such a way that they would act as symbols; the French critic Aurier called them "signs" or "verbs" of an idea.[24]

In a later article, the Nabi artist and theorist Maurice Denis, while claiming that Aurier's definition was never that well understood by painters, offered a definition of Symbolism whose two "stages" may be helpful here. According

to Denis, a first part of the Symbolist work was a "subjective deformation," "the exaltation of the individual sensibility," in which nature served only as the "opportunity" for a "creation of our spirit." Such art is very like Decadence as explained earlier. As Denis concluded, "thus we liberate our sensibility; and art, instead of being a copy, becomes the "deformation of nature." A second step or stage for Symbolist art was necessary according to Denis, however, and this was the further adjustment on the part of the artist to render the final work "decorative, aesthetic, and rational," as a "counterpart" or opposite, a "necessary corrective" to make the earlier expression of personal sensibility into a valid "symbol." This second step Denis called "objective deformation," requiring even more manipulation on the part of the artist. As Denis summarized, "the symbol of a sensation [i.e., what is here called Decadence] must make of that an eloquent transcription, and at the same time an object composed for the eye's pleasure."[25] If we apply Denis's distinctions to Symbolism as response to society, then the personal decadent alienation *must* find a "counterpart" or "corrective" in the manipulations of style that are hallmarks of Symbolist art in order to make the work go beyond idiosyncratic antisocial expression and become a universal statement about society.

This last kind of art, which transforms the personal sensation of nature into a universal, synthetic expression can, I think, be more properly termed "Symbolist," as seen in works such as Munch's *Inheritance* (Fig. 12).[26] In this painting, two figures dominate the almost square space of the canvas: a seated woman who cries over her dying syphilitic child. Although the concern over inheritance of illness was one that worried Munch for the sake of his own family,[27] this painting is no longer solely his individual perception. And although based on the artist's own experience of seeing such a woman and child in a Paris hospital, it is much more than a mere recollection of his feelings. Rather, it is a confrontational composition that forces viewers to take in the painting as a whole and deal both with its repulsion and its implications for themselves and all humanity. Unlike *Night,* which by means of its two framing devices, the diagonals of the curtain on the left and the wall on the right, encourages slow and quiet access to the scene, *Inheritance* offers no easy intake of its central image. The viewer is not invited to approach the figures but rather is visually attacked by them. The form of the child is even tilted forward on its mother's lap, unrealistically, so that the full horror of the red-flecked, tiny and emaciated body is gruesomely exposed at the very middle point of the canvas. The child's open eyes, two dark holes in a cloud of sickly white, stare with a direct, challenging gaze. This work is not about sharing feelings but about instigating them. It is also about the high infant mortality rate then causing consternation in most western European cities, the dangers of sex presented by an exploding venereal disease epidemic that was also correlated to cities, and the overall concern that modern ways of life would spell the end of the race. Munch's *Inheritance,* in other words, is a Symbolist work full of powerful evocations and delivering a

strong message about love and life, made all the more compelling by virtue of its universal means. With his works of the 1890s, Munch had shifted from the distilled view of his own very personal perspective to a more outward-going message demanding to be confronted by all who viewed his paintings.

It is rarely noted,[28] but significant nonetheless, that almost all of the artists who are now grouped under the term Symbolists had begun working by the early 1880s, and were attracted not to then-current Impressionism but rather to earlier social Realism. Van Gogh, for example, had an early interest in social issues and imagery. He admired, copied, and sought to emulate the work of the French Realist Jean-François Millet; he remained committed throughout his life to an "art of the people." By the late 1880s, however, the personal approach of Decadence began to develop in these artists' work, and they moved away from stark statements of Realism toward sentiment-laden, moody depictions. This was not merely a turn away from working class and rural depiction, however (Van Gogh in particular never gave this up); it was more a defensive shift against the middle class, precisely as would be described by fin de siècle urban sociologists. Decadence was therefore a first step for many Symbolists: the rejection of, and self-isolation from, the new city society, a socially constructed psychological process that underlay the seeming static "categories" of Decadence and Symbolism.

Two characteristics of this social rejection are already discussed in Moréas's 1886 essay, the "Symbolist Manifesto." The first is a highly individual interpretation of reality, which Moréas terms "subjective distortion" (and it is he who probably provided this term to Denis's later writing). To explain this notion, Moréas cites the character in a typical Decadent novel who "struggles in an environment deformed by his own hallucinations and his temperament: in this deformation lies the sole *reality*." The second characteristic of social rejection is offered in Moréas's description of this same character isolated by virtue of his hypersensitivity in a moblike, monotonous society: "Beings with mechanical gestures and silhouettes in shadow bustle around the single character; they are but pretexts for his sensations and conjectures."[29] Moréas's description of this "character" in fact fits most closely the Decadent artist.

The Decadent therefore was someone singularly gifted to see, feel, and create differently – someone who refused to be one of the crowd. Already in 1881, in his article about Baudelaire, "Essay on Contemporary Psychology," the Parisian critic Paul Bourget had defined Decadence as historically meaning "the state of a society that produced too many individuals ill-suited to the work of the community." He saw this as an aesthetic positive, because although such citizens tended to be "inferior as toilers for the grandeur of the country," they were, by virtue of this, "superior as artists delving into the depth of their own souls."[30] It was, therefore, the very antisocial nature of the Decadents that made them so ill suited to their world, and their art so good. In a very early (1883) review of the work of Khnopff, Verhaeren implied that it was this "perceptor" role

that lent to Khnopff's work an exceptionally sensitive air: "He sees his modern world up close (*de très pres*), like a primitive would see his own, and in delivering the same sincere and real impression, [he attains] the same intimate and penetrating note."[31] Less than a decade later, the Viennese critic Hermann Bahr defined Decadence as "Romanticism of the nerves"; he also identified Decadents as antibourgeois, with "their mocking air of superiority towards the common taste of the noisy mob, in their honest contempt of 'business.'"[32] One of the best French definitions was offered by means of fiction, Huysmans's *À Rebours*. As noted in the introduction to this book, the protagonist Des Esseintes isolates himself from society in a transformed cottage full of artificial oddities in order to heighten his already overloaded sensibilities. This is a place where he could be, as Huysmans tells us, "divorced from modern times and modern society," in a district thankfully "still unspoiled by intruders from Paris."[33] We need to remember that, for this character, Huysmans established a telling social background: the hero is a member of the dying aristocracy who has no more rapport with his own kind than with the new businesspeople, "men of pleasure," who have "taken over Paris."[34] Like the real-life Comte de Montesquiou-Fezensec on whom Des Esseintes was based,[35] such retreat involved rejection of the bourgeois norm.

This social identification of the Decadent is critical to an understanding of Symbolism, which was commonly preceded in artists' work by a Decadent phase. It establishes the early introspective and antisocial nature of the Symbolists' personalities, which led both to the rejection of the bourgeois norm *and* to the statement-oriented evocation of later Symbolism. For the Decadents, whose sensibilities would not allow them to become one of the crowd, who struggled to maintain individuality, images of society could be presented only through subjective distortion.

It was, I suggest, precisely this identification of the Decadent that permeates the first critical notice of the work and personality of Vincent Van Gogh. When Aurier wrote his insightful review of the Dutch artist, he essentially established the image of Van Gogh which has been maintained, almost uncontested, to the present day. The full title of Aurier's article reveals the extent to which he sought to describe Van Gogh – without ever using the actual term – as a Decadent: Aurier called his essay "The Isolated," and described the painter as "always on the brink of the pathological . . . showing clear symptoms of hyperaesthesia." In other respects, however, Aurier shifts his discussion of Van Gogh and his art toward a recognizably Symbolist approach. Notably, Aurier's introduction of his topic has him (the writer) wishing to escape to such art: "as I find myself staggering back into the muddy hubbub, the filth and the ugliness of real life and its dirty streets . . . [I try to recall the paintings of Van Gogh]." Aurier's further description of the impression left on his urban-overwrought retina is now justly famous. Using a torrent of highly charged adjectives evoking a real, yet almost supernatural landscape that was sumptuous and terrifying all at the same time,

Aurier envisions an art of reprieve – the "strange, intense, and feverish works of Vincent Van Gogh."[36]

But Aurier's final determination of Van Gogh as a Symbolist is most obvious when he as critic does use this term and when he discusses what the goal of this art is meant to be. Aurier claims that Van Gogh "most often considers . . . matter as only a kind of marvellous language designed for the translation of the idea. He is, almost always, a Symbolist."[37] By shifting the significance of Van Gogh's work from the filtered, overwrought, and intense vision of a sick (but divinely sick) individual, to an artist who knowingly translates nature into symbols, Aurier comes close to describing the Dutch artist as one of the very few blessed to express the "Correspondences" outlined by Baudelaire.[38]

Aurier's assessment in 1890 seems to have been inclusive of recent Van Gogh paintings, in which the artist's visual exaggerations were extreme and most Symbolist. Aurier's description of Van Gogh's canvases as portraying "a strange nature, at the same time truly real and almost supernatural, of an excessive nature where everything . . . [shrieks] in extraordinarily intense and savagely shrill tones"[39] more accurately characterizes a painting such as *The Sower* of Autumn 1888 (Fig. 13) than even a slightly earlier (June 1888) depiction of a similar motif (Fig. 14). According to Silverman, there is evidence in the earlier work – in which the sower walks across a field of nearly abstracted stokes of blue, white, tans, and yellows and against a patterned row of wheat and bright orb of a central sun – that Van Gogh's efforts to "naturalize divinity" "connected for the first time to Symbolism and to the aspiration for a modern sacred art."[40] Although her assessment that this painting might well have served as an important step on Van Gogh's arrival at Symbolism is certainly accurate, I argue based on the distinguishing characteristics in this chapter that Van Gogh was still, at this point in June 1888, painting primarily as a Decadent, and that it is the slightly later, but much more radically abstracted canvas (Fig. 13), that is truly Symbolist. In the later version, painted on heavy, coarse canvas that emphasized its two-dimensionality,[41] the perspective and inviting space are confounded by the strongly outlined tree that cuts across and flattens the whole space, much like the tree in Gauguin's 1888 *Vision after the Sermon* (National Gallery of Scotland, Edinburgh). Van Gogh's result is a painting that, like Munch's *Inheritance,* refuses sympathetic entrance of the viewer into the artist's personal world and forces instead a single overall confrontation with exaggerated forms. The sun and the tree in particular require the viewer to accept these forms as signs made of nature, as symbols. In the earlier *Sower,* already taking advantage of the possibilities of exaggeration, the sun appears as a huge, dominant orb; its radiations through the world of the sower appreciated only as a personal interpretation. In the later painting, however, the sun has become an almost nonobjective circle that takes up one-fifth of the canvas and reads as a flat orb more than a believable object hanging in a natural sky. In each, the artist is acting as a Baudelairean "revealer" of truths seen by him, and as "interpreter" of these truths in his art.[42] But while

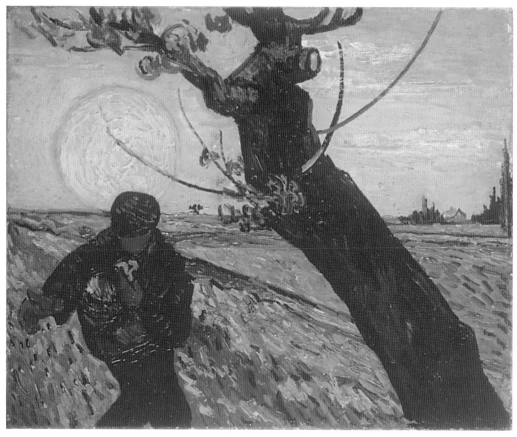

Figure 13. Vincent van Gogh. *The Sower*. Autumn 1888. Oil on canvas, 32 × 40 cm. Rijksmuseum Vincent van Gogh, Amsterdam. Vincent van Gogh Foundation.

the early *Sower* remains wondrously Decadent in its subjective distortion of the sower in the fields, only the later canvas – with its added simplification and exaggeration[43] – arrived at full Symbolism. It is notable that Aurier's analysis of the *Sower* deliberately references several versions of the figure – "whom he painted and repainted so often" – as proof of the role of the sower as symbol. The Symbolism could be, however, both personal (as in Decadence) and universal (as in Symbolism). Van Gogh himself offered evidence that the sower was a personal symbol for himself as artist; for example, he regarded making numerous preliminary sketches for a painting important because "I consider the studies to be the seed, and the more one sows, the more one may hope to reap."[44] But he also spoke of the sower in much more Symbolistic fashion when he spoke of working on that motif as an expression of "a longing for the infinite, of which the sower, the sheaf are the symbols."[45] It was therefore in his last paintings that Van Gogh achieved his Symbolist goal of fully manipulating tangible nature to achieve symbolic representation of the intangible.[46]

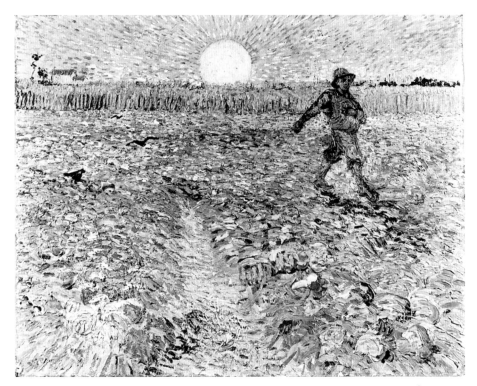

FIGURE 14. Vincent van Gogh. *The Sower*. June 1888. Oil on canvas, 64 × 80.5 cm. Rijksmuseum Kröller-Müller, Otterlo.

Finally, this transition in Van Gogh and his art – typically moving from the Decadent who sees the world through his own idiosyncratic lens to the Symbolist who is able to translate the idea behind those visions – was aimed toward a redemption of modern society. This goal behind the process of transformation is summed up in Aurier's association between Van Gogh and the image of the Sower. Aurier claims that the Sower must be a symbol for Van Gogh (and for the informed viewer): "a thought, an Idea" that is the "essential substratum of the work" and gives it meaning.[47] Aurier even questions that "If one were to refuse, in effect, to admit that under this naturalist art there existed these idealist tendencies," then "a great part of the work that we are studying would remain totally comprehensible." Aurier concludes, furthermore, that the only empathic reading of Van Gogh's *Sower* is one that recognizes the figure as a redemptive symbol, expressing "the urgent need for there to come a man, a Messiah, sower of truth, who will regenerate the decrepitude of our art and, perhaps, of our idiotic and industrialized society."[48]

The shift that Aurier undergoes in his description of Van Gogh was, in effect, the same mental modification as that of many artists who, having begun with a Decadent outlook, were later able to act as translator of this vision for the viewer. There must have been a point in each artist's development when

the preciousness of their own Decadent vision seemed problematically related to the superficiality of the overly sentimental, late Romantic work so popular at the time. Munch's friend the Polish writer Stanislaw Przybyszewski at one point complained about the inability of such art to convey real depth of feeling, "All this depiction of moods is so shallow, so meaningless. . . . If only they were moods that, no matter how naive, present something of the naked life of the soul. . . . I want life and its terrible depths, its bottomless abyss."[49] As Przybyszewski was calling for a stronger expression of deeper emotions and stronger ideas, many artists (like Munch) were in the process of changing their art. They were becoming less tied to illusionism and adopting radical stylistic strategies to express, in a visual way, the "invisible." As their singular "perspectives" developed into a broader "view" of society, the Symbolists changed their Decadent "subjective distortion" into "objective distortion," or Symbolism.

As this process continued, the Symbolists as well as their work were maturing, just as the venues for displaying and marketing their work developed from early participation in regional exhibitions to international, specialized exhibition societies. Through participation in exhibition groups founded with the purpose of showing avant-garde, idealist (and Symbolist) art – such as Les XX in Brussels or the Salon de la Rose + Croix in Paris – the Symbolists were able to reach an increasingly receptive audience for their message about changing individual consciousness within the conditions of city society. As they did so, images that had been for others a modernist dream became a nightmare, and the "spectacle society" became in their work a "specter society" instead.

URBAN IMAGES AND "THE CROWD"

The Symbolist's negative views can be discovered in specific images closely reflecting their own environment: the modern versus the antimodern city, new technologies and lifestyles, and especially the new metropolis society itself.

If the Impressionist city was a hub of human interaction, the Symbolist city is often silent, bare, and uninhabited or, worse still, overpopulated by bestial, inhuman, alien crowds. The Impressionist image offered "normal" city society, as analyzed by the earliest urban sociologists. Even when the Impressionists left Paris, they usually went only so far as the day-trip spots made accessible by the economic boom of the city and the growth of the French railroad system. In their depictions of this leisure society, the Impressionists placed their emphasis on the middle class arranging themselves to see and be seen. These scenes were, furthermore, restrictive; they usually omitted all signs of industrial or commercial intrusion to the tourist idyll.[50] Such bustling views of Paris and leisure life in French tourist areas must be contrasted, however, to the two types of city views found in Symbolism. Although opposite one another, these had in common their rejection of the interactive, politely "normal" Impressionist urban life.

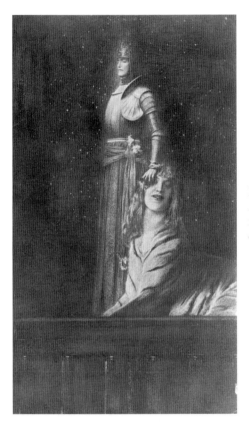

FIGURE 15. Fernand Khnopff. *Angel (with Verhaeren)*. 1889. Photograph with hand tint, 10.5 × 8 cm. Musées Royeaux des Beaux-Arts de Delgique, Brussels.

One Symbolist city was the medieval ruin; the other was the menacing and mobbed modern metropolis.

In the fin de siècle city, it was the urban population that was of the greatest concern and, in Symbolist rather than Decadent images, this society is criticized on a more universal than personal level. For example, prostitution was a worry that was perceived as uncontrollable by the 1880s. In her historical study of the French crowd, Susanna Barrows establishes that both alcoholics and feminists were on the rise in the 1880s and were newly recognized as intertwined threats to the establishment. By the time of Symbolist images, the issue of prostitution was being related by many to the middle class's adoption of separate spheres of the sexes and its resulting double standard. Although early works by several Symbolists include overt, realist depictions of alcoholism or prostitution (Ensor and Toorop are two examples),[51] their later, true Symbolist work was more evocative, yet still readable. Khnopff's *Angel* (Fig. 15), with its exotic knight's figure and sphinx woman paired in unlikely détente before a sparkling night sky, was cited in his own day as the hope of rationalism (the angel) over modern society's temptations of the flesh (that is, prostitution), as represented by the seductive sphinx.[52]

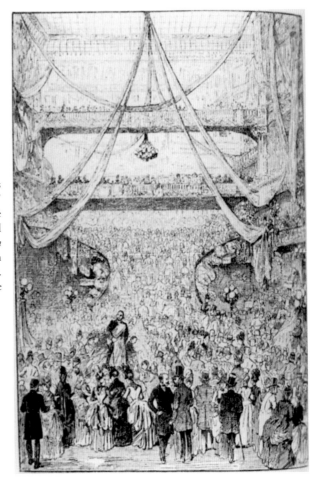

FIGURE 16. "The rue de Sèvres staircase during the blanc" (1887 agenda, Bon Marché department store). Published in Michael Miller *The Bon Marché* (Princeton: Princeton University Press, 1981), figure 7. Photograph courtesy of Pierce Bounds.

But it was not only the prostitutes, destitutes, or alcoholics that concerned these artists. Rather, the Symbolists, perhaps as former Decadents who were still quite capable of taking everything into personal psychological consideration, were likely to see *all* of the spectacle society, and not just these few well-identified victims supposedly limited to the lower classes, as suspect. When Giovanni Segantini departed from Milan to the tiny Swiss town of Maloja in 1894 (only soon to move to an even smaller town, further into his beloved Alps), he wrote that he simply had to flee "the all-too-busy life and noise in the city."[53] The heart of the issue was the crowd and what at that time had only recently been "proven" to be the base instincts, the "crowd psychology" of the city mob. Several recent studies have established that at this time the crowd was a common fear: irrational, uncontrollable, led easily to drinking, strikes, and anarchy, the crowd might well result in national genocide.[54]

One brief example of this notion in Symbolist art can be provided by the work of Ensor. As discussed in Chapter 4, Ensor's work often addressed the sick

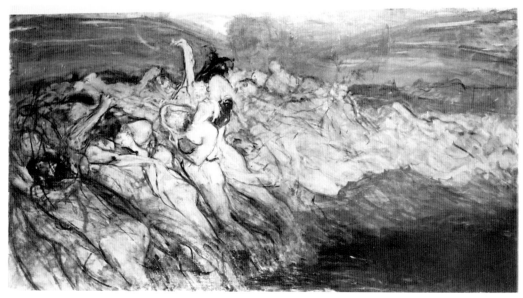

FIGURE 17. Wojciech Weiss. *Obsession*. c. 1900–1. Oil on canvas, 101 × 187 cm. Muzeum Literatury, Warsaw.

city, and his depictions of an ill society often took the form of a degenerated mob. Ensor's direct connection between the crowds and references to the need for socialist reform in his *Entry of Christ into Brussels in 1889* has been well established,[55] but other images of the mob abound in his oeuvre. His many versions of *Cathedral* have been, for example, related not only to Balzac's "Jesus Christ in Flanders," but also to Huysmans's *À Rebours,* where Des Esseintes complains, "The bourgeois were guzzling like picnickers from paper bags among the imposing ruins of the church. . . . Could it be that this slime would go on spreading until it covered this old world with its pestilential filth?"[56] But although images such as Ensor's crowd may have had some literary origins, his favorite representation of a crowd that spilled into public spaces had its visual sources not only in prior caricature but also in contemporary commercial illustration such as advertisements for department stores (Fig. 16). Commonplace representations like these need not have even been present in print for Ensor; they were regular sights constantly presenting themselves to him in his hometown of tourist-driven Ostend. In 1887, Octave Maus included in his report from Brussels for *La Revue independante* the sarcastic quote of French writer Catulle Mendès[57] regarding the "new" Ostend: "how charming [is the beach at Ostend] . . . for an elegant woman to be able to promenade . . . with infinity on her right and the casinos on her left!"[58]

Such associations of the crowd with base instincts abound in fin de siècle, as in Edvard Munch's lithograph *Lust* (1895), in which faceless, bestial men crowd around a single woman, groping at her with greedy hands. Barrows,

41

while charting concerns about the crowd in France, has established their so-
ciological underpinnings and political causes in the late nineteenth century's
rash of workers' strikes and anarchical uprisings.[59] In 1878, the French histo-
rian Hippolyte Taine proposed his notion of the "sickness of the crowd"; he
described a special germ of irrationality that quickly spread through the mob by
what he called "mental contagion."[60] Given the history of revolution in France
throughout the century, coupled with the fact that Paris had existed as the locale
(and often the cause) of most of this turmoil, it is not surprising that the French
made a clear connection between problematic crowds and cities. As commen-
tator Louis Wuarin noted of his own fin de siècle urban life, while speaking
of strike as a kind of civil war, "residence in cities is conducive to agitation, to
outbreaks."[61] Wuarin's countryman and scholar of urban conditions Paul Meu-
riot further summarized this connection in 1897, claiming that the urban crowd
always revealed "a more tumultuous character" that could bring harm to society;
according to Meuriot, people were conditioned by their urban life to be more
spontaneous, and therefore less controllable than their peasant counterparts.[62]

But non-French observers of fin de siècle society were equally convinced
of the sheer violence of mob psychology when stirred up by urban desires.
Influenced by Przybyszewski, whose novels froth with teeming crowds under
the spell of their own carnal drives, the Romanian-born painter Wojciech Weiss
painted *Obsession* (Fig. 17). Across the broad expanse of this huge canvas streams
a seemingly endless flow of bodies carried together as if on a wave of their own
obsessions. The only identifiable figures are two central women, one of whom
points the way forward while the other, wearing a blindfold, clutches a baby in
one arm and with her other exerts a stranglehold grip on the neck of the man in
front of her. As other red-hot bodies flow around them, the background seems
to be dominated by a vaguely defined, winged demon that rises above horizon
and city skyline.

Much has been written about the influence exerted not only on writers
and artists but also on the conventional wisdom of the day by Gustave Le Bon's
1895 book *Les Foules,* a study that was almost immediately translated into other
languages, titled in English *The Crowd: A Study of the Popular Mind.* Le Bon,
a medical doctor, approached his topic as an urban anthropologist and even
psychologist and encouraged an emotional, negative response to the new "era of
the crowds." He contended that people in mobs – limited in personal space and
associating claustrophobically only with each other – could be encouraged to
act irrationally and against the well-being of their own community. They could
desire – and accomplish – "nothing less than . . . to destroy society completely."[63]
In Ensor and Munch's crowds, we see this threat given life, and populated; in
Symbolist views of a deserted Bruges can be found their hope for retreat. As
we have seen, Van Gogh avoided the crowds of Paris altogether; unwilling to
confront them in his painting, he sought a calmer and more compatible life in
Arles.

SYMBOLIST SOCIOLOGY AND THE DEFENSE
OF THE INDIVIDUAL

The Symbolist view of urban society was in keeping with its historical, literary and philosophical zeitgeist. A disdain for, and even fear of the new crowd in European cities characterized a common response on the part of many who saw the control of society, formerly managed through political as well as church functions, being slowly but surely relinquished to the sheer numbers of urban working- and middle-class inhabitants.[64] In addition, by the late nineteenth century not only traditional fields but also new disciplines were devoted to the study of mass urban life: both crowd psychology and urban sociology were founded in the fin de siècle. The current term "stressor" is used by urban sociologists to refer to "stimulation that represents an adaptive threat or potential adaptive threat" to humans in a city environment.[65] This is precisely the reaction that was most studied in the late nineteenth century and most reanalyzed since that time.[66] As art historians Debora Silverman and Richard Shiff have determined, the debate about levels of subjectification in fin de siècle French criticism and the arts was directly related to social theories addressing the debilitating effects of urban stresses on the life of the mind.[67] A concern about the amount of visual and aural stimuli, when added to urban-initiated issues of materialism, consumerism, and even contagion was paramount to late-nineteenth-century questioning in every Western nation, however. The most consistent theme underlying these concerns was the loss of the individual, a loss that seemed to occur on every public level. As soon as contagion was established as fact by the scientific community in the 1870s, to cite just one example, medical and legal communities urged immediate governmental control over individuals, in the name of public health and safety.[68] Given the significance of individualism to western European Enlightenment, Romanticism, and even Naturalism, such loss was viewed as cataclysmic.

The notion that city distractions worked directly against individual thought goes back at least as far as the early-nineteenth-century writings of Arthur Schopenhauer, encapsulated in his tirades against the distracting cracking of whips in towns.[69] Schopenhauer's philosophy was best known to the Symbolist generation through his principal work *The World as Will and Representation*, written between 1814 and 1818, but virtually ignored until near his death in 1860. At that time, most of the essays were translated and subsequently became popular in the 1880s and 1890s. Schopenhauer's pessimistic worldview, stressing suffering as a basic fact of human existence without recourse to God or any other higher ideal, had tremendous appeal to the Symbolists. Although the Symbolist emphasis on subjectivism has been properly traced to a variety of influences,[70] it was Schopenhauer who clearly associated the need for such subjectivity to social pressures and to mass and urban populations. Schopenhauer's philosophy was, at its core, an essentially isolating one that would lead to the fin de siècle

despairs of Friedrich Nietzsche as well as to twentieth-century existentialism and the writings of Jean Paul Sartre in particular. "All three writers have a certain contempt for the evasions which most men practice in order to escape the true view of their condition. All propose as an ideal the lonely, solitary individual with the courage to embrace the suffering and – in different ways – transcend his situation."[71] In this respect, it was Schopenhauer who already proposed that this individual would be one of greater intelligence than the masses and who would eschew any conformity with them. For Schopenhauer, want (or desire) is the basic condition that must be overcome in humanity, and "want is the scourge of the masses."[72]

Later writers maintained this association of higher states of being with the privileged individual who could rise above the populace. The Danish writer Georg Brandes, influenced by Schopenhauer as well as Nietzsche, advocated what was called "Tendens," or social activism in favor of change from the conventionality of European life in the late nineteenth century. Especially through his 1889 book *An Essay on the Aristocratic Radicalism of Friedrich Nietzsche,* Brandes sought to explain for a broad European readership – his work was well known to Symbolists outside his native Scandinavia as well as Germany, where he lived[73] – those ideas of Nietzsche that most agreed with his own, centered on his "anger with the deference paid by modern historians to the masses." As a correction to this problem, he proposed the solitary intellectual as one "chosen" to lift Western society out of the vacuous mire of materiality.[74] Agreeing with the popular notion that a true genius could only be distilled from 30 to 40 million otherwise mediocre humans, Brandes proposed that the masses should be content to work for that single person's benefit rather than their own, because only then will true culture be achieved. As Brandes summarized, "the want of artistic courage and intellectual boldness . . . [is caused] above all by the disintegration of the individuality which the modern order of society involves."[75]

Another timely example of this philosophical concern about the individual in the context of modern society can be found in the diary of the Swiss writer J. Frédéric Amiel, where the demise of the individual was viewed, typically, as a substantive danger that arose directly from urbanism and the worldliness it engendered:

> Materialism is the auxiliary doctrine of every tyranny, whether of the one or of the masses. To crush what is spiritual, moral, human – so to speak – in man, by specializing him; to form mere wheels of the great social machine, instead of perfect individuals; to make society and not conscience the centre of life, to enslave the soul to things, to de-personalize man – this is the dominant drift of our epoch.

For Amiel, the answer is a constant struggle to reach the soul: "To defend the soul, its interests, its rights, its dignity, is the most pressing duty for whomever

sees the danger. What the writer, the teacher, the pastor, the philosopher has to do, is to defend humanity in man."[76]

Although the journal of Amiel was published in several translations following its initial 1883 Geneva printing upon the philosopher's death, this quiet Swiss writer's ideas were not nearly as well known as the exhortations of the controversial Max Nordau in Germany. Nordau, a physician who analyzed the ills of the late-nineteenth-century society from a presumed medical but in reality more sociological point of view, published his *Conventional Lies of Our Civilization* in 1883. The book focused on what the author considered the unnatural practices (such as modern bourgeois marriage) of Western urban civilization and suggested radical solutions to them.[77] Overall, however, Nordau in *Lies* proclaims the true malady of the century to be that of cowardice, and the inability of the individual to do what is right. This same theme was further addressed in his infamous study *Degeneration,* published in 1892, which purported to be a medical study of deviancy in art and literature and especially of "degeneration as it was causing a decline in health and national strength in the city."[78] He was insistent that he knew the symptomatic appearances of degeneration in Europe in his own time; he was equally sure that the cause was the urban environment and its insurmountable toll on the average person's sensory, moral, and spiritual fiber. He blamed this endemic situation on two factors: the unfortunate ability of a small sector (the degenerates) to unduly influence the rest of reasonable society and the distressing ability of the city environment to wear down this same population just by virtue of existing. As he explained,

> The great majority of the middle and lower classes is naturally not *fin-de-siècle*....It is only a very small minority who honestly find pleasure in the new tendencies.... But this minority has the gift of covering the whole visible surface of society, as a little oil extends over a large area of the surface of the sea. It consists chiefly of rich educated people, or fanatics.[79]

Furthermore, even if the masses were to avoid such artistic or literary contagion, they would be weakened anyway by their life in the city. The decay, Nordau reasoned, can be seen not only in the artists themselves but in their art, and it was a corruptive process mimicked by urban society in general, where people age faster (with their teeth falling out) and are prone to crime and suicide.[80]

> The inhabitant of a large town, even the richest...is continually exposed to unfavorable influences which diminish his vital powers far more than what is inevitable.... All these activities, however, even the simplest, involve an effort of the nervous system and a wearing of tissue. Every time we read or write, every human face we see, every conversation we carry on, every scene we perceive through

the window of the flying express, sets in activity our sensory nerves and our brain centers. Even the little shocks of railway traveling, not perceived by consciousness, the perpetual noises, and the various sights in the streets of a large town, pour suspense pending the sequel of progressing events; the constant expectation of the newspaper, of the postman, of visitors, costs our brains wear and tear. In the last fifty years the population of Europe has not doubled, whereas the sum of its labours has increased ten-fold, in part even fifty-fold.[81]

Nordau's influence was extraordinary and sparked a spate of tracts addressing what was called a "crisis of spirit,"[82] including the English historian Frederic Harrison's study of cities titled *The Meaning of History*. Harrison's laments about the modern city, although offered from a historical perspective that began in Western antiquity, sound remarkably like those of Nordau and others, so that a pattern of complaints quickly became a fabric of concern:

we, who make everything by machinery, except beauty and happiness, – we who cannot drink a glass of water, or teach children to read and write without an army of inspectors, Acts of Parliament, and amateur Professors of Social Science, to show us how to do it – . . . we lead, in some of our huge manufacturing cities, lives so dull and mechanical that Pericles or Coriolanus would have preferred exile.[83]

Harrison's account of the organizational difficulties of the city is instructive: his overall lament is the deleterious effect of urban society on the individual. Calling London "one of the great diseases of English civilization," Harrison concludes that there is in the modern metropolis

nothing to recall the dignity and power of a great city – with a population so movable and so unsociable that they are unknown to each other by sight or name, have no interest in each other's lives, cannot be induced to act in common, have no common sympathies, enjoyments, or pride, who are perpetually hurrying each his own way . . . That is not life, nor is it society. These huge barracks are not cities.[84]

The significance of crowded cities for breaking down rather than encouraging intersocial communication was also noted as critical by those with anarchist sentiments.[85] For them, the stark contrast of the classes in Europe was only magnified in the city, and alienation rather than individualism was heightened on the city street. The Symbolist poet (and anarchist) Laforgue described streets in Paris, for example, in colorful but distressed terms: "One can't hear the music for the din of the street swarming with cabs and people, with the alleys devouring

and vomiting people incessantly, and the hawking of programs in front of the Variétés." Pausing to describe the upper-class dancers that he sees through a window as "men in black tails with white shirt fronts, revolving to the music, holding ladies, blue, pink, lilac, white, holding them ever so lightly, so correctly, one can see them pass, to and fro, with serious, unsmiling faces," Laforgue then explains that when turning from the window "the hell of the boulevard continues, the cabs, the cafes, the gaslight, the shop windows, more and more pedestrians."[86] Beyond the sensorial appeal of Laforgue's description is his emphasis on the one quality that the two classes have in common: their incommunicativeness. Just as he notes the "serious, unsmiling faces" of the upper class seeming to be "having fun," so also he admits at the end of this passage that "I have just won a bet. In the heart of Paris I have spent three days alone, without addressing a word to my fellow man, without opening my mouth. Try it, you'll be surprised what it's like."[87]

This common reaction to the new society was as notable in small cities as in large. The overall disdainful attitude is summed up by two of the most self-conscious of Parisian elitists, the de Goncourt brothers, who in their diaries gleefully recorded their impressions of the ponderous state funeral orchestrated for Victor Hugo upon his death in 1885. At one point, they cite a conversation in which it was suggested that the Republic "now had at its disposal for its great occasions a public of a million spectators, roughly the number of pilgrims which the Catholic festivals in Rome used to draw in the fifteenth century." But they took greater pleasure in recounting that on the night prior to the funeral, the celebration had belonged totally to the crowd itself, which proceeded to act in disorderly, almost bestial fashion: "a kind of Fat Tuesday proceeding the day of mourning . . . [during which] a wholesale copulation, a priapic orgy, with all the prostitutes of Paris, on holiday from their brothels, coupling with all and sundry on the lawns of the Champs-Elysees."[88]

That this could occur in Paris – site of revolutions, strikes, and other mass uprisings on a regular basis – was perhaps to be expected. But similar occurrences were recorded, and similarly outraged interpretations offered, in small cities elsewhere in Europe. The tiny town of Bruges was beloved by the Symbolists as a "perfect" town because, as noted earlier, it was medieval, without industry, commerce, or growth. And yet a description of the city in the early years of the twentieth century – written about Bruges as a desirably backward, medieval town and the ideal tourist destination – concluded that similar misdoings by the Belgian crowd could occur when they were left to their own (uncontrolled) devices. Here, author George Omond describes whole families dressed in their finest and wearing their most pious expressions until, in this case, the religious rituals were over, at which point the crowd headed to the bars and cafés: "On the night of the Procession of the Holy Blood [the religious festival for which Bruges was most well-known] they are crowded to the doors."[89]

As religious occasions for the masses were accompanied by (and sometimes replaced by, as the de Goncourts suggest) other occasions that were solely social, an important distinction differentiated this development from similar mass celebrations of, for example, the Middle Ages (such as the Fat Tuesday feasts of which the de Goncourts spoke). This difference was one of density, seen in the sheer volume of people involved, but also apparent in the increasing commonplaceness of public events. While the funeral was a singular occasion (and once in a lifetime for Hugo), and while the Procession of the Holy Blood occurred only annually in Bruges, numerous other holidays – state, business, and tourist impelled – began to crowd the urban calendar. Added to these special times were the new mass locales – the boulevards, public museums, and even department stores – that were built to accommodate the crowd. Whether private or state-invested, these events and places thrived on bureaucracies of every kind, and had a significant effect on the life, and perceived ultimate death, of the individual.[90]

URBAN SOCIOLOGY

Studying this effect were the new disciplines of urban psychology and sociology. Each major city had its analyzers and commentators, and it is the Parisian Emile Durkheim, who joined the faculty of the University of Paris and became a lecturer at the Sorbonne in 1892, whose ideas are most often cited in recent studies. A disciple of the positivist social philosophy of Auguste Comte, Durkheim is regarded as the founder of the French school of urban sociology, and his theories of the city individual have had enormous influence on twentieth-century social studies. While he wrote about a variety of forces newly challenging the modern European, he had noted already in his 1893 *De la division du travail social,* the observed phenomenon of what he termed *anomie,* or total boredom with and reclusion of any outward relationships in the overly ordered urban dweller. For Durkheim, the idea of anomie – inclusive of both boredom and apathy – was a new trait characterizing the lost individual in modern urban society.

In Germany there also developed a new school of urban sociology. At the very time when the change to society wrought by the economic and physical structures of the city became fully evident, these writers attempted a less emotional, more analytical (although still greatly intuitive) study of urban mentality. An influential background to this work was provided by Ferdinand Tönnies's *Gemeinschaft und Gesellschaft (Community and Civil Society),* a sentimental and reductivist comparison of country and city life that was nonetheless widely accepted. In his study, which despite its romantic tone was capable of good analysis, the notion of city society as "all business" was linked to consequential superficiality, lack of tradition (or even traditional time), and more mechanical than human behavior. In Tönnies's estimation, city life led to personal isolation

and "internal frictions."[91] This same phenomenon continued to be the focus of the early German school, including Max Weber, Oswald Spengler, and Simmel.

Of all late-nineteenth-century sociology, it is the work of Simmel that seems to be the most appropriate model by which to study the Symbolist. He shared with them very similar concerns about the urban crowd and its effects on community relationships, but he also allowed, as they did, for the possibility of a deeper, spiritual growth of the individual within urban society. Particular to Simmel's sociology was the notion that the new urban society was not so much the cause of further ills but rather the result of the new solitude and essential ruthlessness of the city dweller. According to Simmel, the urbanite, faced with discordant chaos, and being "one of the crowd" was forced not to do evil (as Tönnies had suggested), but rather to develop a reasonable psychic defense against the "intensification of nervous stimulation" in the metropolis. This was, for Simmel, not necessarily a cause for consternation. Rather, contemporary city societal development had a potentially positive response to such negative influences. For Simmel, human identity and freedom *could* still occur in large public societies, but only for individuals who, of necessity, built a shell around themselves, adopted a uniform code of routine but distant behavior, and quietly maintained – somehow – an inner life.[92] That this uniform behavior could, in turn, lead to Tönnies's "mechanical aggregate and artifact" was inevitable, perhaps, but not lamentable: within the city conglomeration, individuals might be able to live highly sophisticated, if isolated, inner lives. As such, Simmel's analysis of urban society's problems comes quite close to the negative ideas of many Symbolists; his ideal of possible inner psyche development, however, reiterates the Symbolists' most cherished goals.

In Oswald Spengler's later theories, however, the crowd would overcome society, as Spengler's well-known cyclical theory saw urban growth as unredemptively unhealthy, with human relationships institutionalized to the point of automaton existence. For Spengler, fin de siècle society *was* spiraling toward overcivilization and would eventually revert to barbarism: this was the beginning of the end. Many Symbolist images of the crowded, zombie-populated city, such as Munch's *Anxiety* (Fig. 18), may at first *seem* to illustrate Spengler's worst predictions. But it is, I contend, Simmel's analysis of urban society – foretelling the potential demise of traditional life but suggesting a new type of ideal and inner individualism – that comes closest to the dual message signified in most Symbolist art. For example, in *Anxiety* and other street scenes from this time, as we shall see more concretely in Chapter 3, careful compositional manipulation on Munch's part causes the viewer to take on the role of the individual "other." Faced by the ghostly crowd, the viewer is the "character" mentioned by Moréas who can still perceive, and defend against, the threat of overhomogenization and its resultant anomie.

Simmel was also adept at analyzing some of the clearly negative consequences of the new anonymity because he viewed the city as inextricably bound

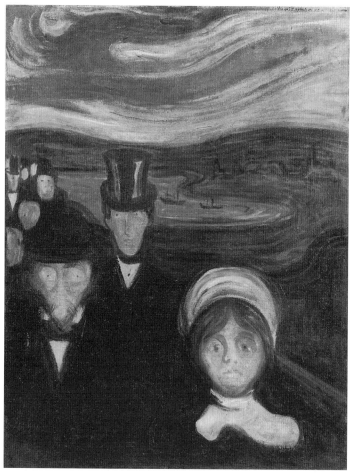

FIGURE 18. Edvard Munch. *Anxiety*. 1894. Oil on canvas, 94 × 74 cm. ©
2003 The Munch Museum/The Munch-Ellingsen Group/Artists Rights Soci-
ety (ARS), NY.

by market economy. He observed that in the modern metropolis, producers no
longer know purchasers, and customers no longer have anything to do with sup-
pliers; each could go a lifetime without ever personally confronting each other,
let alone knowing each other. They therefore no longer needed to "fear any
deflection because of the imponderables of personal relationships." As Sim-
mel summarized, "The matter-of-fact attitude [of city society] is obvi-
ously . . . intimately interrelated with the money economy, which is dominant
in the metropolis."[93]

Although Simmel's are admittedly late (1902) observations, it is nonetheless
interesting to note that while city shoppers are prime subjects for the Impression-
ists of the 1870s and 1880s, the shops chosen for depiction are old-fashioned ones.
For example, Edgar Degas poses Mary Cassatt as the customer *At the Milliners*

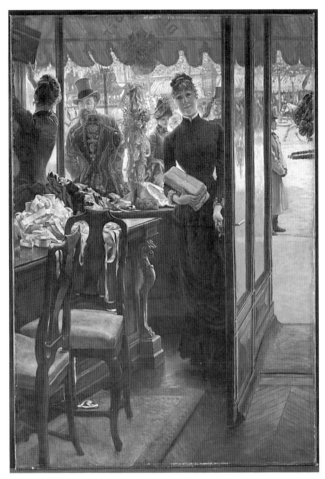

FIGURE 19. James Tissot. *The Shop Girl* from the *La Femme à Paris* series. c. 1883–5. Oil on canvas, 146.1 × 101.6 cm. Art Gallery of Ontario, Toronto. Gift from Corporations' Subscription Fund, 1968.

(c. 1882, Museum of Modern Art, New York), with the shopkeeper, who may be the milliner herself, anxiously helping her customer in fitting and selection. While we are not struck by a direct relationship between producer and customer in Degas' pastel, there is certainly more than anonymity in the portrayal. What we do not see in Impressionist views – namely, the huge new department stores where one might purchase a complete assortment of household and clothing goods in complete anonymity – is also instructive.

In his analysis of metropolis life, however, Simmel seems to underestimate the new kinds of relationships that are not only possible but also even encouraged by city society – the potential for the *flaneur* to turn voyeuristic, in newly safe ways. The fact that Simmel does not address this potential is an important omission to note here, because I suggest that the Symbolist often adopts this very pose – not the *flaneur* coolly observing the crowd but one of the "degenerates"

of the crowd methodically and often sarcastically observing city society from the position of outsider, or even outcast.[94] We get some idea of this aspect of the new world of shopping in *The Shop Girl,* a painting by James Tissot, an artist admired by many Symbolists (Fig. 19). In this scene, we cannot be sure if the viewer, who takes the space and role of someone who has just made a purchase – the clerk holds both the package and the door so that we might pass through to the waiting carriage on the street – is male or female, although women would be the usual patrons of this shop selling frilly pink silks and undergarments.[95] But the other gaze that we are encouraged to note is that of the two male passersby who look in with obvious interest at the "goods" displayed in the shop window. For them the object to be consumed is not the jacket or ribbons on display but rather the clerk on the left who, with raised arms holding a box to a top shelf, is displaying something else. As is common in such male voyeuristic views, a third passerby, a woman with eyes focused carefully on the pavement before her, provides the feminine contrast to the ogling males; outside the public sphere of influence, this woman is presumably oblivious to the opportunity afforded the city men. Tissot's painting was one of fifteen canvases that he devoted to the subject of *La Femme à Paris,*[96] designed to show Parisian women in various locales and dress; the subject was on display, however, for male rather than female viewers. In Tissot's scene, the conditions of anonymity and impersonality in the city afford the men not the new inner life that Simmel hoped for, but rather an unprecedented opportunity to leer in public. And it was this side of the era of the masses that also fascinated the Symbolists: the self-centered and often cruel existence that one could adopt in the city, in opposition to the interior life that one should develop.

In addition, there was at least one other consequence of fin de siècle society that Simmel completely ignores in his essays. Even in his treatise *On Money,* he addresses the new, open, and impersonal handling of money, but not the rise of public gambling in late nineteenth century. Simmel summarized his discussion of the effect of the money economy in the new city as having established "through the calculative nature of money a new precision, a certainty in the definition of identities and differences, an unambiguousness in agreements and arrangements. . . . Punctuality, calculability, exactness are forced upon life by the complexity and extension of metropolitan existence and are . . . intimately connected with its money economy and intellectualistic character."[97] Gambling, however, effectively opposes all of these traits, introducing chance and incalculable loss or gain of money; only in the nineteenth century did this become a form of public rather than private entertainment. Furthermore, although for a newly broadened middle-class clientele, the gaming "palace" might produce high levels of emotion and even passion within the individual gambler, the "code of conduct" about which Simmel speaks as existing on the street is nowhere more evident than in the casino as depicted in Symbolist work. Here, the emotions are shared by everyone around the table, enforcing a different, but equally impersonal

relationship between the gamblers who have pitched their inner emotions to a higher level, yet have learned to be completely neutral about it when in public. Although gambling was commonly linked in the popular press with violence (suicides and murders),[98] many Symbolists were fascinated not so much by the dramas of money won or lost as by the emotional and spiritual bankruptcy that could occur in the game. In Munch's series of paintings *The Roulette,* a progression of compositional changes highlights this new, emotionally charged anonymity. Munch had regularly played at the Monte Carlo Casino during his visits there in 1891 and 1892; he was fascinated by the game of roulette and at one point even believed that he had discovered his own winning system.[99] Although he tells how painful it was to find out that his ideas would not work, Munch also describes his observations about his fellow gamblers, captivated by the careful coding of responses that he saw:

> Beside me a man and woman played together – They had heaps of money gold pieces and bills – they are absolutely impassive but one sees their nostrils vibrate and the hands of the man trembling. A young Brit imperturbably lays down his gold pieces – there is a series of black – and now he has won a huge pile – There is silence around the table – and then suddenly it is like an explosion – arms become taut – everybody talks at once – this is someone who has picked up the winnings of another – crying, screaming and then the calm abruptly reestablishes itself. – only the noise of the roulette – and the monotonous "Faîtes le jeu Messieurs et ça va plus."[100]

Intriguingly, Munch's point of view in his paintings of the gamblers is to some degree participatory. In one of the two versions of *At the Roulette Wheel* (Fig. 20),[101] a man on the right stares directly out of the canvas at the viewer, casting the scene with the other gamblers into a background pattern. An earlier version, however, had eliminated the man and, by cropping the gamblers' figures at knee length and showing all of the foreground players from behind, actually invites the viewer into the scene as a potential participant. This inclusionary effect is heightened in the last canvas (Fig. 21). Here, the point of view is that of the young man on the left, who may well be Munch himself, with his back angled toward us. The viewer is now put in a position of standing directly over the table, peering over the shoulders of the other players. From this angle, it is possible to focus on the central numbered squares of the table, lighted by the overhead lamp and seeming to float, as a grid, toward the viewer. For Munch, the experience of gambling at Monte Carlo may well have been a rare moment of being, indeed, "one of the crowd," even as he described his own responses in a very individual way, while adroitly describing other's reactions as carefully coded. But while drawing in the viewer, Munch also recognizes the immense swing of emotions that must underlie this controlled play: "The Paris journals

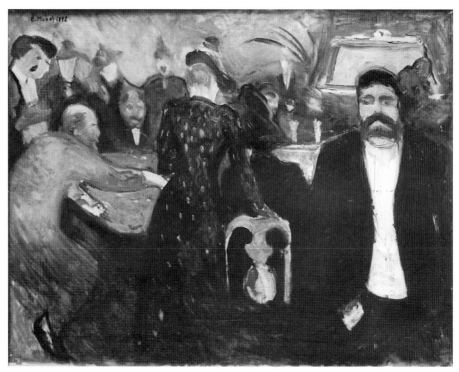

FIGURE 20. Edvard Munch. *At the Roulette Wheel (II)*. 1892. Oil on canvas, 73 × 93 cm. Idemitsu Museum of Arts, Tokyo. © 2003 The Munch Museum/The Munch-Ellingsen Group/Artists Rights Society (ARS), NY.

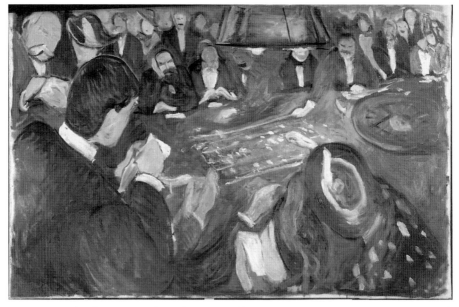

FIGURE 21. Edvard Munch. *At the Roulette*. 1892. Oil on canvas, 74.5 × 115.5 cm. © 2003 The Munch Museum/The Munch-Ellingsen Group/Artists Rights Society (ARS), NY.

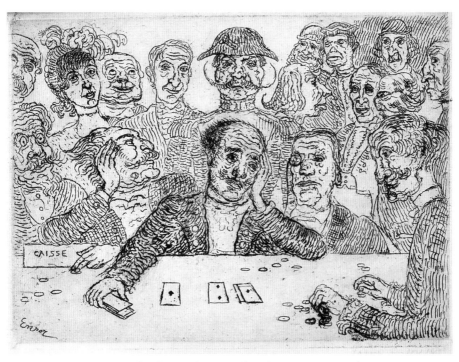

FIGURE 22. James Ensor. *The Players. The Point of Bankruptcy.* c. 1890. Etching, 114 × 155 mm. Museum of Fine Arts, Ghent. © 2003 Artists Rights Society (ARS), New York/SABAM, Brussels.

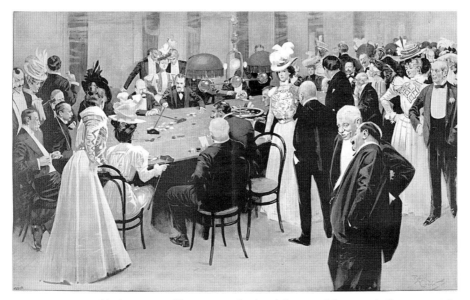

FIGURE 23. Reginald Cleaver. *Gambling at Ostend: The Club Privé of the Kursaal.* Illustration, *The Graphic* (London). October 23, 1897, 545.

announce that in the course of last month there were thirty suicides committed – three here – Nothing can be done. One enters a first time only in order to watch – one plays a little – and one is lost."[102]

In a similar way, in an etching titled *The Players. The Point of Bankruptcy* (Fig. 22), one of a series of works about the Ostend Casino, Ensor depicted the gamblers in his hometown with some sympathy for the loser, who is characterized, like the gendarme approaching him from behind, with some individuality. In liberal Belgium and especially in the ever-expanding capitalist Ostend, the merits versus the vices of the gambling casino were continually debated, and challenged in referenda throughout the 1890s. Intriguingly, Edmond Picard, editor of *L'Art moderne* and a founder of Les XX, was one of many lawyers in favor of the establishment, presumably because of the portion of profits that by mandate went to charitable organizations.[103] Ultimately, however, games of chance were not legislatively regulated in Ostend until 1902; as Verhaeren commented, the city became in summer "perhaps the most beautiful of these momentary capitals of vice that adorns and luxury that bores."[104] In Ensor's drawing, however, the unimpressed, uncaring faces of the crowd surrounding the loser are caricatured and wear fulltime masks of disdain. Both Ensor and Munch are able to look at this society in ways entirely different from the elegant, emotionless elite that they were supposed to be. Comparison to an 1897 illustration of the gaming tables at Ostend (Fig. 23) – to accompany an article extolling to London readers the advantages of the new resort – makes the Symbolist works seem to have originated from an entirely different world. As such, the Symbolists' renderings illuminate what was most important to their artists: to reveal through their carefully chosen images (even including, as here, pedestrian images of contemporary society) the important thoughts, ideals, and states of being deep inside the individual. As Munch proclaimed in 1889, he could not do otherwise: "No longer would interiors, people who read and women who knit be painted. There should be living people who breathe and feel, suffer and love."[105]

If Simmel failed to address all of the nuances of the new urban economy that visual artists at the time clearly saw, the Symbolists – who avoid the image of the shopper altogether and turn only to the passionate irreverent use of money in gambling – certainly appreciated Simmel's underlying point. With the new monetary system of the metropolis, inner passions might flare, but external estrangement of one kind or another was sure to follow.

SYMBOLISM'S SOCIAL GOAL

In 1898, Khnopff wrote about his own rapturous escape to an individual, spiritual world in front of a painting by Edward Burne-Jones, the Pre-Raphaelite painter whose work he admired:

How perfectly delightful were the hours spent in long contemplation of this work of intense beauty!... The spectator was enraptured by this living atmosphere of dream-love and spiritualized fire, carried away to a happy intoxication of the soul, a dizziness that clutched my spirit and bore it high up, far, far away, too far to be any longer conscious of the brutal presence of the crowd, the mob of sightseers amid whom my body fought its way out again through the doors. This artist's dream, deliciously bewildering, had become reality; and at this moment it was the elbowing and struggling reality that seemed a dream, or rather a nightmare.[106]

With this description, Khnopff passionately summarizes Symbolism's true social goal, which was the direct enhancement of the individual in modern society. Reference to the ills of modern society was not an end in itself: that had been the goal of the realists before them, whose attempts to portray with visual acuity the negative constituents of modern life and whose pedantic preaching of socialist reforms the Symbolists rejected. Rather, the Symbolists' recognition of the problems of modern society was not a goal but a base, a source from which their idealist art sprang. They proposed art not as a remedy but as a salve for modern urbanity.[107]

A primary identifier of this Symbolist role for art was Schopenhauer, who identified art as being able, at least temporarily, to alleviate the endless suffering of the "will" to live and the consequential subservience to desire: this identified artistic process was one of the only activities that could raise the consciousness of individuals above or beyond their (usually) finite thought and sensations. Art, for Schopenhauer, could never allow complete peace from the suffering of the will, but it was the only thing that could offer so much as a respite, and even then only for those rare, talented individuals, for whom art could serve as a "fleeting dream."[108] Later writers took up Schopenhauer's role for art and tied it more closely to urban modernization. In his 1874 essay intended to honor *Schopenhauer as Educator,* for example, Nietzsche began with a call for education as liberation and identified contemporary city life and a lack of individualism (born of laziness, he proposed) as the primary stumbling blocks to such education. Asking "what compels an individual to fear his neighbor, to think and act as a part of a herd...?", Nietzsche claimed that the answer must be indolence or convenience, and the ease with which one can follow "a neighbor who demands convention and wraps himself inside it." As an example of the bad (and he hopes, transient) opinions of his own day, he points to the "frightful houses" on "the new streets of our towns" that will have collapsed in a century. Nietzsche's only praise, in this early essay, is for "those who feel that they are not citizens of this time," and for Nietzsche, these individuals will be artists:

Artists alone despise this aimless drifting about in borrowed manners and superimposed opinions, and they expose the secret, everyone's bad conscience.... They dare to show us how man, down to each twitch of his muscles, is himself, himself alone ... beautiful and worthy of contemplation, as new and incredible as any work of nature, and anything but boring.[109]

In other words, if the individual could be saved from the perils of modern urban society, it would be through art. But it would be neither Realist art, which merely depicted current situations, nor Decadent art, which could at best illuminate private and idiosyncratic responses to those situations. Rather, it would have to be engaging, spiritually enhancing art that would provide the individual with a focus, and a process of independent existence. As Amiel was, around the same time, similarly to conclude,

The age of great men is going; the epoch of the ant-hill, of life in multiplicity, is beginning. The century of individualism, if abstract equality triumphs, runs a great risk of seeing no more true individuals. By continual leveling and division of labor, society will become everything and man nothing.... As the floor of valleys is raised by the denudation and washing down of the mountains, what is average will rise at the expense of what is great. The exceptional will disappear ... on the one hand, a progress of things; on the other, a decline of souls.

Amiel blames this loss on the inertia of the city and prays that there may come into being "a new kingdom of mind, a church of refuge, a republic of souls." Conceding that "the animal in us must be satisfied first," Amiel nonetheless optimistically predicted the possibility of such an ideal city in the future. For this to occur, however, he turns to artists: it is the artist who can lead society out of this present morass, and who must strive to keep ideals alive, and to maintain individuality.[110] As Amiel's compatriot Albert Trachsel was to summarize in a treatise of 1896, good art was absolutely essential to combating modern materialistic life: "[I]f humanity has no art, no philosophy, no science, if it is composed only of commercialists, financiers, industrialists and agriculturists, if it cares about nothing but eating, drinking, sleeping, making money, such humanity will not be very interesting."[111] Symbolist art, an art that avoided simple description of such menial matters, could therefore serve as an antidote to urban alienation, a role shared by the revived interest in folk art around the same time.[112] Verhaeren, in a defense of Khnopff's ultimate modernity, offered a summary of this point, contrasting what he considered good "modern art" with that of modern illustration:

Under the pretext that one paints best that which one sees rather than what one recollects, everybody has become a "contemporaine". . . . An innumerable number of "swells," of coquettes, of gas-lit smoke-filled rooms, of trams that file by, of street corners, of mahogany pianos, of carafes with syrups, bitters, golden wines, of knick-knacks, of cupboards with polished panels. It is believed that this is not a component, but a condition of art. . . . In our opinion, it is impossible to *not* be modern since it is impossible to be conscious outside of the times and the epoch in which one is living. Each one of us is *modern* . . . [when we] sense the past with our ideas. With our tastes, with our sympathy for the vague and the shaded, [our desire] to express it is more modern than to paint a man in a black outfit or a woman in a hat and pointed boots. The first of these two works goes much further in sentiment and in intelligence than the second; it touches our soul, the other [touches] our eyes.[113]

Khnopff himself, in a discourse on "Fashion in Art," written for the London *Magazine of Art* in 1896, also explained, in a different way, the Symbolist approach to this spiritual challenge in an age of materialism. In his article, Khnopff derides the ostensible intellectual precision of critics and theorists who, like Roger de Piles in the early eighteenth century, proposed ranking the great masters according to a numerical system. Such artificial regulation was, Khnopff argued, antithetical to true expression, on the part of the artist and also, interestingly, on the part of the viewer, because it was "this inspiration [that] no erudition can ever counterfeit."[114] Art for Khnopff had its sources deeper within, so that it should always rise above any temporary system of "taste." At the conclusion of the article, Khnopff turns to a comparison, namely that of the city. He cites his contemporary Paul Bourget's Scotland travel diary in which the critic complained of "the odious presence of the swarms of tourists: the ugliness, the commonness of men and women, which struck him more forcibly against those horizons of tranquil waters and green woods; it was a painful effort to appreciate the exquisite beauty of the scenery beyond the raveling-caps, waterproofs, and knickerbockers of his traveling companions."

Bourget, who as a novelist and critic was always closer to Symbolism than to Naturalism, had earlier written what has been called "the first manifesto of Decadence"[115] and was someone who shared Khnopff's concerns about the nature (or lack thereof) of modern society. But Bourget also was a fervent believer in the idea that, no matter how corrupted and complicated modern life became, art at its best could rise above the material. It was this underlying belief that Khnopff reiterated at the conclusion of his article. While commiserating with Bourget's dismay over the hoards of tourists, Khnopff defended the eternal role of nature over all: "Though there, as everywhere, the tide of modern civilization effaced almost all else, the bare line of the glorious mountains will still survive

and dominate over every civilization present or to come." His important pronouncement about Symbolist art comes only after this declaration, when he concludes by claiming that art, in fact, shares with nature this eternal, healing role: "the inaccessible absolute of art will ever soar supreme."[116]

By virtue of its nonrealistic, nonmoralizing and also not decadently personal nature, therefore, Symbolist art – the ideal "absolute" art – could accomplish more social reform than all the descriptive, detailed and didactic popular art of the nineteenth century put together. As the Belgian Symbolist and Art Nouveau designer Henry Van de Velde explained in an 1893 lecture, social art (which he described as paintings and sculptures "whose subjects were drawn from more or less pitiful occurrences in the lives of the underprivileged") would never achieve positive social improvement. "The error of their creators is to believe that the art of the future will borrow motifs from the people, when, in fact, art will give itself to the people."[117] For this reason, it became increasingly important that Symbolist art first reach its intended audience, primarily upper-middle-class patrons who might not only buy the art but who, by seriously viewing it might most benefit from it, and in turn help to improve all of society. Heralding a new art that would truly enhance the modern individual, Van de Velde spoke of a Symbolist response (and he most likely was thinking of Khnopff):

> And when those who had increasingly become confined to the tallest [ivory] tower by an infinite disgust with material things and an overwhelming uneasiness in the face of ordinary human dealings recognized this new potential [of art], they joyfully sacrificed their isolation and went to the Maison des Peuple.[118]

For Khnopff, who built his own elitist "Palace" of Art at the end of the century, the purpose of all good art was to be a part of the life of a people. In a speech for the Brussels socialist organization the Maison des Peuple (where he often gave critical and art historical lectures on art), he explained that he abhorred what he termed the "plague" of the French school – the "useless" museum tableau intended only for prize-winning and state purchase for some provincial museum. Praising English art over this French artificiality, Khnopff claimed that art that was part of life had true power.[119] Art should be part of contemporary life, but should enrich rather than describe that life.[120] We are also reminded of Aurier's article on Van Gogh in 1890, where the critic began by describing his coming to the exciting, invigorating paintings as a refugee from "ignoble hubbub of the dirty streets and the ugliness of real life."[121] By using external reality to reference an inner truth, the Symbolist was accomplishing this most difficult – and modernist – of goals. Khnopff's 1898 description, cited

earlier, of his own enhancing engagement with a Burne-Jones painting, proves that this goal could be reached.

Art as "correction" to the streets was, however, perhaps best summarized by J. K. Huysmans, in his explanation of the curative nature of an exhibition of works by Gustave Moreau. Huysmans's lengthy summary deserves complete citation here, because it provides the most fulsome explanation of the power of Symbolist art to entice viewers into pure sensorial and private worlds, to enhance their individuation, and to sustain them during their ongoing assault by the de-humanizing modern city:

> Out of that gallery [housing the Moreau exhibition], in the bleak street, the dazed memory of these works persisted, but the scenes no longer appeared in their entirety: they became unremittingly fragmented into the minutiae of their strange details. . . . all this surprising chemistry of super shrill colors, which, having reached their ultimate stage, went to the head and intoxicated the sight, causing the departing visitor, totally blinded by what he still saw projected along the new houses lining the street, to grope for his way.
>
> On second thought, as I went on strolling, as my eye found a new serenity and could look at, and size up, the shame of modern taste, the street – these boulevards where trees that have been orthopedically corseted in iron and fitted by the trussers of the Department of Public Works in cast-iron wheels [railings and circular grates placed around trees in Paris to protect them]; these roadways shaken by enormous horse-drawn buses and ignoble publicity carts; these sidewalks filled with a hideous crowd in quest of money: with women degraded by successive confinements, made stupid by horrible barters, with men reading vile newspapers or dreaming of fornications or of fraudulent operations [as they walked] along the shops and offices from which the officially sanctioned crooks of business and finance spy, the better to prey on them – one understood better the work of Gustave Moreau, which stands outside time, escapes into distant realms, glides over dreams, away from the excremental ideas oozing from a whole populace.[122]

As established here, the Symbolists did not wish to analyze or seek to reform – with the precision of earlier Realists and positivists – their contemporary city society. Nor did they resort to the total escapism of earlier Romantics. Rather, just as the new fields of "antipositivist" inquiry sought to establish tenets according to scientific discipline (psychology is perhaps the most well-known example),[123] the Symbolists, following Baudelaire's theory of correspondences but not always staying in the "*forests* of signs," lived firmly in one world while

constantly maintaining their dream of another. They were, indeed, victims of urban malaise; they did not "fit in." But as artists they sought to express or even redeem their malaise through their art. Early blessed – or cursed – with the sensitivity of the Decadent, who could analyze life from a highly critical view, the Symbolists added a new perspective of maintaining individuality in another, inner realm.

3 ⌘ THE DE-STRUCTURED CITY

Around 1893, Edvard Munch completed *Evening on Karl Johan Street* (Plate 2).[1] This was not his first painting of that motif; he had developed views of this famous boulevard in Oslo in several versions over the previous decade. In this new painting, however, Munch made a radical shift, not only in presenting the scene for the first time at night, but more importantly in placing his point of view – and that of the viewer's gaze – directly *on* the street. It was, I argue here, a move that most Symbolists at first wanted to reject. For this generation, the city street, and particularly the broad new boulevards, presented an alien structure, especially for artists who sought truths behind appearances, that they were not prepared to read. When Munch does, in *Evening on Karl Johan Street,* descend to street level, he produces a viable but nonetheless almost hallucinatory view of the city, its structures, and its society.

By the time of Munch's painting, the artists who had regularly and seemingly without such fear gone to the streets were the Impressionists, beginning with Edovard Manet and other Parisians as well as visitors such as Adolf von Menzel. They followed Baudelaire's call for a "painter of modern life" and adopted the *flaneur* attitude (one of the crowd, coolly observing the crowd) in order to study and replicate the new city spaces, as well as the new inhabitants for which they were designed.[2] They also established a model of city streetscapes that would feed a painting industry in every large European city by the end of the century. Of these, the city views of Gustave Caillebotte seem to have held a special fascination for Munch, as it is probable that he borrowed compositional approaches from the older French painter. Caillebotte has been credited as the Impressionist who addressed most "directly ... and persistently ... the street,"[3] and his city scenes are clear documents of a man who felt at home in the new Paris. Yet nothing could be further from the street view of Munch. To understand how different Munch as Symbolist was from the Impressionist Caillebotte, a comparison between Munch's *Evening on Karl Johan Street* and Caillebotte's *Paris Street: Rainy Day* (Fig. 24) is instructive. Kirk Varnedoe, with Peter Galassi, has established connections between these two artists, suggesting that Munch may have known Caillebotte, and that they shared a source in Armand Cassagne's 1858 treatise on photographically informed perspective. But each artist sought disparate goals served by such similar means. Despite a shared *perspective,* each artist's *view* is decidedly different.

Varnedoe describes Caillebotte's scene as being about the "new Paris and by extension the modern city." He and others have also, however, suggested a

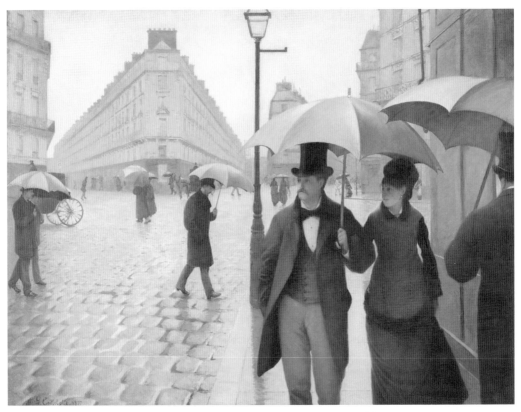

Figure 24. Gustave Caillebotte. *Paris Street: Rainy Day.* 1877. Oil on canvas, 212.2 × 276.2 cm. Charles H. and Mary F. S. Worcester Collection, 1964.336. Image © The Art Institute of Chicago.

negative undercurrent that is perceptible in the "regimentally aligned strangers: strolling somnambulants, bound to a repetitious similarity of dress, carriage, and pace that echoes their modern environment"; this is focused on the "uncommunicative isolation" of the foreground couple.[4] This reading of the city's reserved repetitions is, however, perhaps only negative for today's city dweller. Caillebotte's work, when considered from a then-contemporary sociological perspective, can be seen as revealing its maker as one who still accepts rather than rejects metropolitan life. The dominating structures and codified demeanor here are woven in with a fascination with city life. Caillebotte's main couple seems at least capable of a reaction. The viewer may feel about to bump into them, but they look as if they will make way. They are, after all, other people, with faces; they are individuals. It is, in fact, interesting to note that in Caillebotte's preliminary drawings and sketches for *Paris Street,* he only bothered in a few to add any details or even features to the faces; this is true even of the most complete and finished oil sketch.[5] Clearly, this was an important addition to the final canvas, however, as the figures all have definable identities. Furthermore, although they don't talk to each other, they do interact. The foreground woman

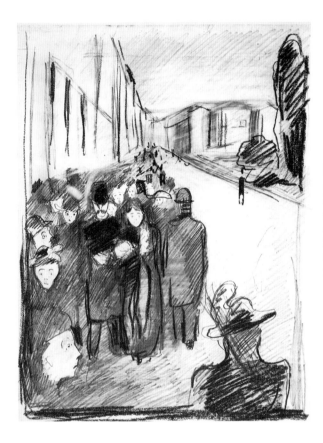

FIGURE 25. Edvard Munch. *Evening on Karl Johan Street.* Preliminary sketch, 1889. Pencil and black chalk on paper. 370 × 470 mm. © 2003 The Munch Museum/The Munch-Ellingsen Group/Artists Rights Society (ARS), NY.

holds the man's arm, and he carries the umbrella over her, as they both look with interest toward something to their right. Most pedestrians here walk in groups, or in couples. Even single figures are given individual faces, poses, and gestures, as noted with approval by reviewers at the time.[6] Finally, in the Caillebotte, another walker striding "with" the viewer makes it easy to find a comfortable space in the scene: to the right, seen from the back, a man is "going our way." Ultimately, we are "one of them." Caillebotte, it is claimed, "declared streetscape to be the landscape of his art,"[7] and his comfort with both the people and the place of the street is manifest here.

Caillebotte's comfort is all the more palpably apparent in comparison to Munch's disturbing vision of a Norwegian bourgeois "parade." In the Munch painting, people who seem to be zombies, their pale faces staring at nothing, walk directly toward, and almost attack, the viewer. Munch's preliminary sketches for his painting, furthermore, were opposite those of Caillebotte in process and in effect. In one drawing (Munch Museum, Oslo), the people on the street appear as they would in an Impressionist work, walking in both directions, mostly away from the viewer, and with the two foreground figures walking toward us being a woman and a child with nonemotional but still pleasant expressions. In another (Fig. 25), a figure "going our way" was even included – much as the one

in Caillebotte's painting – to our right. In addition, the crowd was originally shown full figured, a strategy that required a slightly raised point of view, in turn allowing at least some room for the nervous viewer. The closest figures had some individualization: the man in the top hat was given a mustache, while the boy to the left – another figure in the viewer's space whose profile acts as a buffer from the crowd – has a surprised expression.[8]

In the finished painting, however, Munch's transformation is complete, as he has accomplished the opposite of Caillebotte's sketches' progression toward the figures' individuation. In the final painting, additional figures with standardized, ghostlike faces have been interjected into our space, while the mustachioed figure is no longer distinguished by it but rather reduced to it. Even the figure on the left – our one hope of company – is without features.[9] In the face of this facelessness, we are now, as viewers, *not* one of the crowd.[10] Instead, the area depicted in the preliminary sketches has been in the painting broadly expanded to the right and now includes a tall thin figure seen from behind, walking away from the crowd and in the opposite direction. This figure is somewhat out of proportion – it is larger than the street orthogonals suggest that it should be – and is briefly sketched in with one single dark blue color. The effect is that this figure, which, when seen from behind, should offer some comfort and placement for the viewer, simply does not. Rather, its awkwardly floating appearance only reinforces the sense of alienation suggested by the oncoming throngs. We, as viewers, are alarmingly different from "them."

In Munch's work we are, therefore, given a new viewer identity with regard to the crowd. Since Baudelaire's identification of the *flaneur,* painters and poets of the street had offered the point of view, presumably, of the "objective insider": one who was a native to the metropolis, who was at home with the "base crowd" yet, because of difference in class or education was able to observe without being overtaken by the crowd. As Walter Benjamin suggested, Baudelaire's complete ease with the metropolis crowds was often most evident in the fact that he never directly addressed the crowd in his poetry, but rather had all his description hinge on the "fact" of the crowd.[11] In the very first line of Baudelaire's "A Une Passante" ("To a Passerby"), for example, he suggests the pressure of the crowd with the statement "The deafening street was screaming all around me"; and yet the rest of the poem is devoted to a beautiful stranger "whose glance all of a sudden gave me new birth."[12] For Baudelaire, the screaming street is the crowd, which delivers the ultimate gift – glimpses of total strangers who, because they will never be known, provide his city-paced, instantaneous infatuations. As Benjamin concluded, "To move in the crowd was natural for a Parisian. No matter how great the distance which an individual cared to keep from it, he still was colored by it. . . . As regards Baudelaire, the masses were anything but external to him: indeed, it is easy to trace in his works his defensive reaction to the attraction and allure."[13] In Caillebotte's painting, as in Baudelaire's poem, we are presented with the insider's comfortable observation of the city crowds.

But, as again Benjamin observed, "Fear, revulsion, and horror were the emotions which the big-city crowd aroused in those who first observed it."[14] In Munch's work, as in the work of so many other Symbolist artists who were not Parisians or Londoners, we have been presented this initial, but still lingering and horrifying point of view.

In these contrasting views of society painted by Munch and Caillebotte can also be found the two (opposite) personality developments proposed by Georg Simmel in his 1903 "Metropolis and Mental Life." It is no real surprise that Caillebotte emerges as the well-adjusted urbanite of the two. As Simmel suggests, the "metropolitan type of man ... develops an organ protecting him against the threatening currents and discrepancies of his external environment. . . . He reacts with his head instead of his heart."[15] He even admits that what we call "reserve" in the urban dweller might actually contain a slight aversion for others in the midst of such an "extensive communicative life." But for Simmel this was not necessarily a negative response. On the contrary, Simmel points to this as an important phenomenon of social adaptation: gestures, gazes, and eye contact are all "reserved," but for the sake of a polite, smoothly interacting society: "What appears in the metropolitan style of life directly as dissociation is in reality only one of its elemental forms of socialization."

Furthermore, for Simmel this very adaptation is what makes possible another "mental phenomenon" of the metropolis, namely, that the anonymity itself grants to the individual "a kind and an amount of personal freedom which has no analogy whatsoever under other conditions."[16] For Simmel, then, such reserve served to protect the city individual in two ways. First, a discrete outer veneer of conventional social behavior could insulate the inner, "real" personality from too much external and random stimulation. Second, it served to free an inner spiritual life that could be quite individualistic for the very fact that no close social relationships (such as those within family or small town conditions) were needed in the city. This is the carefully codified and controlled world of Caillebotte's *Paris Street*. As historian Alan Krell has observed, the foreground couple in this painting seems to be "forced into an intimacy imposed by their umbrella, but yet remain emotionally worlds apart. A genteel, orderly, controlled sexuality."[17] That contemporaries read Caillebotte's presentation in this sanitized way is revealed in the commentary of the critic who, viewing the work at its first exhibition, noted its freshness and cleanliness, as if Caillebotte's city was really the capital of the future with its "meticulously clean paving stones . . . [and] an umbrella that seems freshly taken from the racks of the Louvre and the Bon Marché."[18] Agreement with this point of view is further evident in the adoption of Caillebotte's presentation of the street by the numerous artists and illustrators who produced street images for popular consumption in the late 1890s. Such illustrations – usually prints, to accompany tourist descriptions, sheet music, and other publications about particular cities – invariably adopt an on-the-street point of view. They also, almost always, use the same other

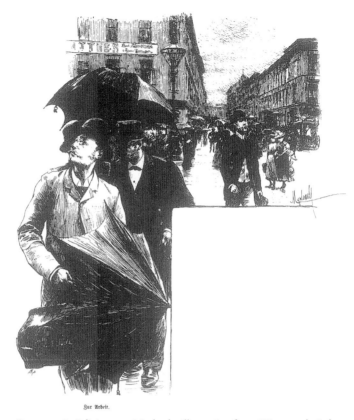

Zur Arbeit.

FIGURE 26. Felician von Myrbach. Illustration from *Wienerstadt. Lebens-bilder auf der Gegenwart* (Vienna 1895), p. 22. Photograph courtesy Robert Cavenagh.

manipulations (securely spaced, codified behavior) that Caillebotte used to portray the city in its safest, if not always friendliest, mode.[19] The umbrellas in Caillebotte's scene have appeared to some as possible "weapons"; contemporary language described them as a kind of "defensive arm," implying that "[u]mbrellas impose social separation, carving out private from public space."[20] This is true, but for this very reason they might be argued from a Simmelian point of view to be important city adapters. As the number of street-level views intended for popular illustration increased at the fin de siècle, a remarkably high percentage of them showed the city in the rain, and took full advantage of the formal possibilities of the repeated rounded shapes of the umbrella. Typical, for example, were the illustrations by Felician von Myrbach for the 1895 volume *The City of Vienna: Pictures of Contemporary Life*. Here, in numerous wood engravings, the bustling modern city was put on display, with two scenes in the book inviting the reader to stroll along a rainy, crowded, but friendly street. In one (Fig. 26), the viewer encounters on the sidewalk a man who is quite close to the picture

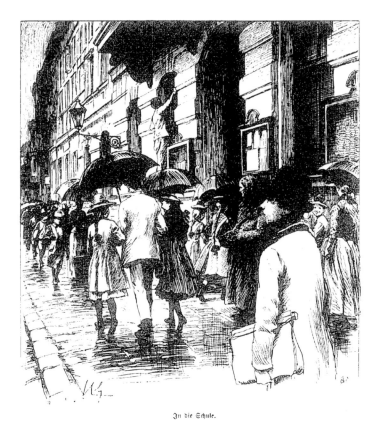

In die Schule.

FIGURE 27. Felician von Myrbach. "Vienna in the Morning Hours." Illustration from *Wienerstadt. Lebensbilder auf der Gegenwart* (Vienna, 1895), p. 23. Photograph courtesy Robert Cavenagh.

plane and even cropped as in Munch's confrontational view. But here, the pose only affords a little design drama: the man looks up, away from the viewer's gaze and to the clearing skies, as he holds out a partially folded umbrella, the perfect modern "shield" to protect him – and the viewer – from any closer interpersonal relationship. In the other (Fig. 27), "Vienna in the Morning Hours" is shown at its best, with a scene of children and the adults who accompany them pouring into the entrance of a school. In this composition, the viewer is once again on the sidewalk, but with a clear view of a threesome seen at a reasonable distance, full figures striding ahead, and with the same boy seen in three-quarters length to the right that had appeared in Munch's early sketch. In this print by Myrbach, who was well known for his appealing illustrations, the boy serves as a comfortable visual entrance into the scene, a fellow pedestrian with whom the viewer can walk. All faces are averted and concentrated on their task, with the exception of one small child on the far right who glances directly at the viewer with an inviting smile. This was "the crowd" at its most polite; managing this street would

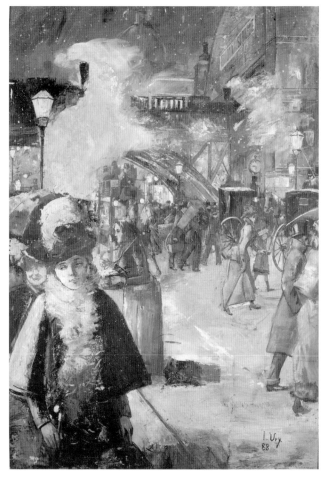

Figure 28. Lesser Ury. *At the Friedrichstrasse Station.* 1888. Opaque watercolor on board, 65.5 × 46.8 cm. Stadtmuseum Berlin, Berlin. Purchased with funds from the Museumstiftung Dr. Otto and Ilse Augustin.

not only be one of many strategies that could make external metropolitan life livable, and (according to Simmel) a core individuality stronger, but could be absolutely pleasant as well.

Munch's view, on the other hand, is a rejection of Simmel's "metropolitan type" with a vengeance.[21] Munch shows that there is no newly liberated, free spirit behind the reserve; indeed, there is nothing. Onto the one known lithographic print of his *Evening on Karl Johan Street,*[22] Munch added a section to the bottom of the composition. Arranged as if on the predella of an altarpiece (where an entombment might traditionally be located), there is a line of flat, hollow masks, emblems of the nonreality, or even symbolic death, of the city figures above. Rather than having an adjusted exterior, with a free personality within, as Simmel

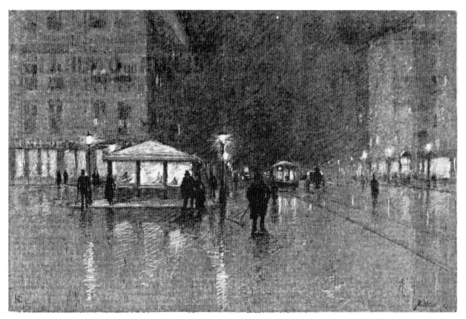

FIGURE 29. Michelet. *Brussels at Night – Boulevard Anspach (Bourse)*. Wood engraving published in *Le Globe Illustré* (Brussels) May 23, 1886, p. 396. Photograph © Bibliothèque Royale Albert 1er.

might claim, this composition suggests that the street strollers have no inner being, let alone spirituality, at all.

Finally, it is remarkable that Munch accomplishes this hallucinatory view of the city dwellers in a composition at night. Contrary to Victorian Gothic literary associations of nightfall with evil, or ugliness, several late-nineteenth-century depictions of cities had begun, with the help of electric lighting, to glamorize evening street spaces. In Lesser Ury's *At the Friedrichstrasse Station* (Fig. 28), the combination of snowfall and pole lights helps to cast the lively scene into dramatic contrasts of light and dark. Even as the composition includes the newly built station, individuals from a variety of social classes seem absorbed in their own thoughts (as would soon be observed by the Berliner Simmel); they pass nonetheless through a visually enchanting, sparkling nighttime display.[23] Other evening scenes rendered the city as a romantic site. *Brussels at Night* (Fig. 29), a wood engraving by Michelet showing the brand new ultra-wide Boulevard Anspach – constructed in emulation of Parisian business streets and already attracting negative comments – transforms the simple city structures, and even the approaching tram, into twinkling lights reflected in the shiny streets. Robert de Sizeranne, art critic for the *Revue des deux mondes,* described the change that occurred in fin de siècle Paris with nightfall, as the busy "feelings" of the city were blunted, while the ugly details of the day were effectively masked. During the day, Sizeranne noted, the city was clogged with "superfluous, ignoble, lamentable ornaments"; but with twilight and artificial lighting, "these trifling

or irritating profiles are melted in a conflagration of apotheosis. . . . Everything takes on another appearance."[24] In many late-century depictions of city plazas, therefore, it is the glow of lights in the evening twilight that serves to soften and romanticize the scene as well as the people in it.

In Munch's nighttime scene, however, Karl Johan Street, on which the brand-new electric street lamps were only first lit on December 13, 1892 (dramatically, at 5:15 P.M.), is pictured as still without them.[25] The night darkness in the background retains its ominous feeling, and the only lights are those glimmering from inside the buildings and the intense one that Munch imposes on the foreground faces of his walkers. In Munch's painting we are not treated to a vision of the sophisticated inhabitants of a twinkling urban world, but rather face a crowd whose external superficialities and inner void seem to have been unmasked by the artificial glare. As Munch explained about his experience of the Paris streets when he visited there in 1889, "I was outside again on the blue Boulevard des Italiens – with its bright electric lamps and yellow gaslights and the ghostly faces of a thousand strangers glowing under the electric light."[26] Although the glare in Munch's walkers has been explained by some as the setting sun,[27] they certainly seem to glow as if in the painter's remembered effect of artificial lights. In Munch's vision, the urbanites wear their new technology like a mask, just as they also come out at night not to enjoy the outdoor nature, but rather to walk like zombies – the living dead – through the city streets. In this regard, it is interesting to note that Munch's reading of this new society was echoed not only by Simmel in Berlin but by others across Europe. The phenomenon of the crowded new street society was so evident in Brussels for example, that *L'Art moderne* ran in 1897 an advice column titled "Aesthetic of Human Contact," by a woman who astutely ascertained that it was now considered necessary to take on a disengaged air on trams, to keep all other people at a distance, "as if the proximity of one's neighbors was odious," while she herself found it offensive to deal with such an aloof society's "deformed faces."[28]

It is significant that, to accomplish this increasingly common vision as a visual image, Munch had to recognize both his own Decadent reading of street society as well as the deadly homogeneity of the individuals who, according to the Brussels writer as well as the contagion theory of Taine and others like Le Bon, now coalesced, with shared symptoms, in a group psychopathology; the Symbolists were among the first to make this transition from individual to group (indeed, mob) psychology with meaningful visual signification.

In this way, Munch's *Evening on Karl Johan Street* perpetuates an earlier nineteenth-century image of the evil city that was firmly established in art and literature. In Munch's work, however, lies an important new distinction about the city as evil. In prior depictions, from Dickens through Rossetti,[29] the evil city served as setting for *individual* drama (murder, theft, prostitution). By the time of the Symbolists, however, the evil city deserved its reputation as the breeder

of *mass* personality dysfunction: here, people don't go wrong; they lose their identities altogether.

READING THE CITY

The notion of the city as something that required careful reading has a long history that in many ways culminated in the eighteenth-century "Enlightenment City," one intended to be a utopian model but one that quickly led to dismay when compared to the reality of the "Industrial City." Metaphors of order that had been identified in the former (grid sections and streets, geometrical architecture, etc.) were discovered to be nonexistent and undermined by new similes of filth and disease (narrow streets, open sewage). As J. J. Rousseau complained of his first sight of Paris, "I saw nothing but dirty stinking little streets, ugly black houses, a general air of squalor and poverty."[30] In the nineteenth century, European cities underwent even greater transformations, a fact that has encouraged several efforts at urban history classification for different "eras" of the city.[31]

The primary factor of this change was spatial reordering. Cities prior to the Industrial Revolution were not only smaller, but were usually formed around a single monument such as the cathedral, with definitive parameters and axes: by the time of the Enlightenment, this notion of structure was so clear that J. F. Sobry, in his *De l'architecture* of 1776, could proclaim "a city without walls is not a city."[32] It was this type of city that historian Carl Schorske, in his essay titled "The Idea of the City in European Thought," calls the "city as virtue," identifying the articulate structure of the city with moral as well as physical and social meaning.[33] But all this changed with the Industrial Revolution: as industry expanded without clear integration of former city structures, cities quickly became a jumble of signs, less definitely ordered and more difficult to read. By 1805, Wordsworth in *The Prelude* called the city of London nothing but "blank confusion,"[34] and this was the beginning of what Schorske has termed the "city as vice."[35]

A further step in the morphology of the city occurred by mid–nineteenth century, as two additional factors evolved. The first was increased segregation of the city by race, labor, and class. The well-known Haussmannization of Paris, begun in the 1850s, not only restructured Paris's medieval organic sprawl into geometric sections enclosed by broad boulevards, but also effectively insulated the dominant middle class from poorer and older sections of the city. As Friedrich Engels pointed out, this segregation had already occurred in England (his study was about Manchester).[36] But it also, ironically, often resulted in more rather than less confusion on the part of its inhabitants. As one critic claimed about the new Paris, for example, "The city is becoming monotonous; all the *quartiers* look the

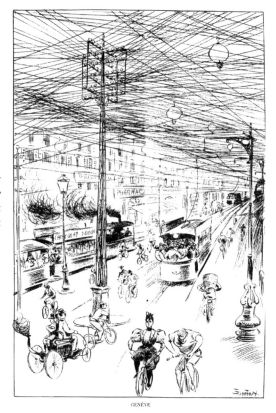

Figure 30. Godefroy [pseudonym for de Georgina]. "Geneva," Caricature in *Le Carrillon de St. Gervais* (Geneva), August 11, 1894, p. 3. Photograph courtesy Robert Cavenagh.

GENÈVE

same; everywhere the same big streets, straight, cold, bordered by immense edifices constructed after the same plan."[37] As this comment reveals, the century's urban planners often produced effects other than those intended. Historian Richard Sennett, recently reviewing this phenomenon, begins by explaining the Enlightenment conception of the city as arteries and veins accommodating the individual city dweller's movement. He then traces developments in nineteenth-century urban design (such as Haussmann's Paris) which, when executed, further "enabled the movement of large numbers of individuals in the city, and disabled the movements of [dangerous, e.g., revolutionary] groups."[38] But with new means of traffic (above and underground), however, these well-planned arteries for individuals within the city perimeter quickly became the means of escape out of it. Ironically, then, it was these new structures intended for individual's ease of movement within the city, that soon encouraged uniform architecture, mass transportation, huge public activities, and mass conformity. As architect Charles Garnier concluded by 1892, this was especially abhorrent to the artist: "these long vistas of regular facades, adorned in vulgar ornamentation and always identical to each other, get the admiration of the crowd and the ear of the landlords, but sometimes sadden the eye of the artist."[39]

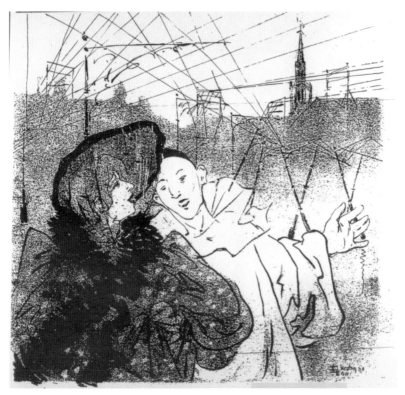

FIGURE 31. "Voila! The Aesthetic of Cities!" Caricature in *Le Diable au corps* (Brussels), April 1, 1894, cover. Photograph courtesy Pierce Bounds.

The second factor of city change in the late nineteenth century was a massive and nearly incomprehensible expansion of the idea of the city itself by means of new technology. As just noted, advances in transportation changed forever the notions of city boundaries; even Thoreau noted "the noise of the trains as they passed by Walden Pond."[40] This phenomenon was compounded by the introduction of new means of communication, especially the telegraph, telephone, and electricity. The technical matter of these held the potential of thoroughly altering the sense of real space within the city itself, especially considering the miles of city streets now clogged with trams (about which the Brussels' *Le Globe Illustré* invented the word "tramomanie").[41] Geneva was portrayed as having its sky replaced by a "ceiling" of wires (Fig. 30), as *L'Art moderne* complained about the "vandalizing [of] our boulevards by the abominable electric . . . [lines] like those of the Brussels' Tramways,"[42] a sentiment echoed by a Brussels artists' journal that showed its clown mascot explaining the new "aesthetic of cities" (Fig. 31). The new communications themselves also shattered, however, the very sanctity of Sobry's walls and represented an irreversible intrusion of the city into the countryside. In the eighteenth century, Schopenhauer had lamented his inability to ponder great issues of philosophy because of the noise distinct to city

FIGURE 32. "In the Country." " – Adorable! This solitude . . . You don't often get bored here? – Oh no, this is the first time." Caricature in *Le Diable au Corps* (Brussels), May 28, 1893, cover. Photograph courtesy Pierce Bounds.

spaces; for him, the cracking of whips was "a truly infernal thing when it is done in the narrow resounding streets of a town."[43] By the time of the Symbolists, however, even this distinction was no longer possible; forever changed was not just the association of certain sensations with the city or country, but the very sense of space separating the two as well. Even as humor continued to be based on the supposed distance between the country cousin and the city slicker (Fig. 32), the sense of where the city ended – and even what it was – had been rendered impossible to determine.

Thus Schorske has identified a third development of the modern city that he terms, with reference to Nietzsche's decadent philosophy, "the city beyond good and evil" – a megalopolis that can no longer allow a metaphoric reading. He cites fin de siècle artists and writers as the originators of this most recent idea of a city that has no strong moral identity at all. This new city embodied a spatial and societal chaos that seems to have continued into the twenty-first century: "multiplicity of meaning, loss of sequential or causal connection, breakdown of signification, and dissolution of community."[44] Certainly, these conditions in the culture of the city already existed for, and were recognized by, the Symbolists, who often address the rupture of communication and community at the hands of the new urbanization.

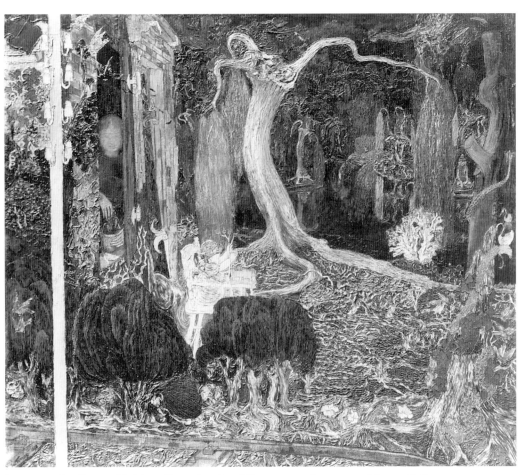

FIGURE 33. Jan Toorop. *The Young Generation.* 1892. Oil on canvas, 96.5 × 110 cm. Museum Boijmans-van Beunigen, Rotterdam.

In Jan Toorop's *The Young Generation* (Fig. 33), nature is posed as a dying realm. A child in her high chair sits in front of a house overgrown with plant life[45] and menacing new inventions. Meditation, represented by the Buddha lost in the growth on the right, seems no contest for the encroaching technology of the railway lines and the electric pole in the foreground. According to Toorop, the woman in the doorway "symbolizes the mother (the preceding generation) who tries to revive her flowers which are drooping, but her house falls slowly into ruin."[46] The limp flower is emblematic of the devastating effect of technology. In many of Toorop's works, the rise of urbanization finds expression in compositions crowded by gaunt figures; in drawings like *Disintegration of Faith*[47] they drown in the mire of their own materialism. It was probably this iconography that most recommended Toorop to Sâr Péladan, founder of the Rose + Croix, a neo-Catholic exhibition society in Paris; *The Young Generation* was included in its first show, where it met with great success.[48] But while the Sâr's message against

materialism could be expressed as a battle between higher and lower realms of being, as it was by Carlos Schwabe in the design for the first Rose + Croix Poster (see Fig. 52),[49] in *The Young Generation,* the encroachment of technology is presented most forcefully as a matter of real space. The horizontal line of the railroad tracks and the vertical electric pole effectively form an additional frame, and even barrier, to the rest of the scene. This not only encloses the two figures' space, but also prevents viewers from entering the seemingly enchanted world of nature and meditation. Because the two figures (mother and baby girl – Toorop's wife and daughter) are female, a Rousseauian gendering of locales occurs here, as the women in nature are controlled by [male] culture, a theme discussed in Chapter 5. Overall, however, Toorop's dying nature remains so enchanting, and at the same time so irrevocably cut off by technology, that the Symbolist sense of alienation dominates the composition.

This estrangement had as its impetus the two aspects of late-nineteenth-century city change just outlined – segregation and expansion – that made the city for many almost illegible. What Haussmann and others had imposed on the new modern city model was spatial propinquity without communication proximity: people could readily find the boulevards but could not easily relate to them or to others on them.[50] Already in 1887, the poet Emile Verhaeren, in a sensitive assessment of "A Symbolist Painter: Fernand Khnopff," wrote about Paris as "an immense algebra the key to which was lost."[51] This sense of confusion resulting from structural disorganization was more forcefully exhorted by Frederic Harrison, in his 1894 *The Meaning of History.* For Harrison, one of the losses in modern reconstructed history was history itself. Speaking of the old Paris buried under Haussmannian improvements, he grumbled:

> With all this prodigious wealth of historic record beneath our feet as we tread over old Paris, how little do we think of any part of it, as we stroll about new Paris to-day? We lounge along the boulevards, the quays and 'places,' with thoughts intent on galleries and gardens, theaters and shops, think as little of the past history of the ground we tread as a fly crawling over a picture by Raphael thinks of high art.[52]

Bitterly calling those who had so recently rebuilt the cities of Europe "aesthetic Huns and Vandals," Harrison decried the modern city as essentially lacking character. The city had become for him "an amorphous amoeba-like aggregate of buildings, wholly without defined limits, form, permanence, organization or beauty – often infinitely dreary, monstrous, grimy, noisy, and bewildering."[53] And as Simmel would soon point out, this confusion that was metaphorically evident in the disintegration of city structure was just as apparent in social (non)structure.[54]

Understanding this structural confusion – on all levels – provides some insight into the popularity of the new points of view often adopted in

late-nineteenth-century city scenes: from the interior, safely framed and separated by windows, or from high above, on balconies, terraces, and even roofs. Such views allowed the distance necessary to reestablish the organizational plan and consequent cohesion that was missing down on the street. Notably, Caillebotte's two great masterworks of the street, the *Paris Street: Rainy Day* (Fig. 24) and its pendant, *Pont de l'Europe* (1876; Geneva, Petit Palais), were his last two important paintings from the street-level view. By the time Munch reacted to the Frenchman's work, Caillebotte himself had moved up and off the street, painting from the balconies and rooftops of Paris. By 1880, Caillebotte had ascended the heights of the modern city to paint *A Traffic Island, Boulevard Haussmann* (private collection), an oddly skewed high view[55] of one of the new safety-zoned concrete constructions built into widened boulevards. Not only does the viewpoint, from this distance, safely reduce the few figures to streaks of paint, but it also allows for a geometricization of the space's structure, rendering the cityscape horizonless and flat, with an emphasis on simple, ordered structure. In other words, as Caillebotte painted this urban "island," which in French would be titled a "refuge," he may well have been seeking his own.

The issue of a view from significant height as a locus of power has been explored by Michel Foucault, particularly in "The Eye of Power," an essay written about the Panopticon, a device invented in the late eighteenth century that established surveillance architecture (whether a factory, a prison, or a school) as a ring of lighted cells surrounding a central tower.[56] With this arrangement, Foucault claimed, "the principle of the dungeon is reversed," affording much more power to the overseer's gaze than any previous relegation of the subjugated to darkness. Most important was, however, the new recognition of the authority of spaces in this configuration: the constructed space gave whoever occupied it new visual command. Foucault later admitted that his discovery of the Panopticon occurred as part of his own research into "architecture of power"; he concluded that late-eighteenth-century buildings shifted from making power "manifest" (as in designs for churches and government buildings) to making power functionally possible.[57] These observations might lead to the conclusion that the upper floors of late-nineteenth-century, taller urban buildings to which artists had recourse might therefore have bestowed the same kind of surveillance power in an evolved way. But the experience of power was, in effect, quite different. In the case of the eighteenth-century surveyor, it was the eye of the tower's occupant that was singularly unrestricted: even as the overseer could "know" all of the activities of each individual cell, he himself was in turn restricted to the tower, in power but isolated. For the fin de siècle artist establishing a point of view from far above, however, only the isolation was shared: here the artist's only power would be in the form of refuge, as he now looked down on masses of structures and people, and now actually, perhaps thankfully, seeing and knowing less of their individual activities. As the nature of that which was "surveyed" changed, therefore, so also did the nature of the overseer's "power." The only

power that could now be claimed was a temporary isolation, and the transient ability to order at least visually all that which in the modern city was disordered and unknowable.

This was because, by the late nineteenth century, the city street was where real sensorial and semiotic confusion reigned. Some Symbolists simply avoided this theater in their work, retreating not only to interiors (see Chapter 6) but also to nature, islands, and mountains. But at the time that Caillebotte increasingly sought refuge in height and distance, Munch had begun his descent to the streets.

KARL JOHAN STREET

The Karl Johan Street that so fascinated Munch was fairly new, in a city that had only recently become urbanized in the grand manner (Fig. 34). Although the original city of Oslo can be traced to pre–Bronze Age, the Christiania (as it was then called) of Munch's time was a more modern city established by King Christian IV on a new site following a demolishing fire in 1624. The new, Baroque city of Christiania had grown slowly through the eighteenth century and only witnessed a burst of growth after the separation of Norway from Denmark in 1814, soon followed by union with Sweden. It was the latter political change that required, suddenly, a huge building program of public architecture (a parliament, university, and palace). But it was the Industrial Revolution, which in Norway only took hold around midcentury, that required, equally suddenly, the residential and trade expansion of the city with the banks, theaters, and avenues to accommodate them. The population of Norway almost doubled in the fifty years following 1815 (the highest national rate of growth for all of western Europe during that time), and a significant portion of these new citizens settled in Oslo.[58] Another major fire in 1858 included the new Karl Johan Street; whole areas required new buildings,[59] and this resulted in the street that Munch would have known in the 1890s. Of all the new boulevards in Christiania, Karl Johan was central to the new urban society: a grand straight sweep of three separate areas, a sidewalk, a paved street for vehicles, and another treelined path for pedestrians, majestically led up to the Royal Palace. One could ride in a carriage on the main road or (as of 1894), take an electric tram through the lower part of it. But this was above all a street for walking, with a choice of going down the building-lined sidewalk, past the grand hotel, or on the "nature" side, on paths carefully cut as an aisle between rows of trees. In several earlier paintings, Munch had painted the street from above, taking a point of view that made the actual figures on the streets negligible, but emphasized the planned, perfectly balanced nature and buildings of the street itself. In *Evening on Karl Johan Street*, however, Munch not only chooses nighttime, but also moves his point of view to that of one of the pedestrians – presumably himself, or the viewer, who now sees, peripherally, the great vista of the city planner's intent but also must face

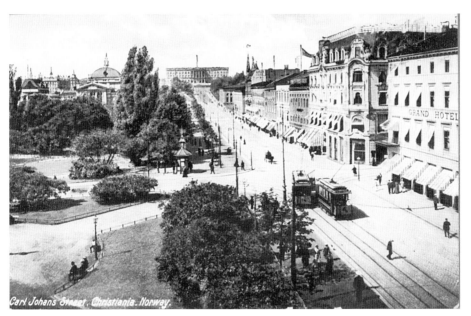

FIGURE 34. Postcard of Karl Johan Street c. 1900. Private collection.

the head-on protruding structures and crowd of the street itself. Significantly, Munch in this later painting also alters sides of the street: earlier views were from the "nature" side of the street, but here he is not only on the paved, and crowded, sidewalk, but the parklike scene across the street is reduced to a large, dark green amorphous configuration that rises, from one area only, as an ominous looming form.[60] Leaving behind the structured elegance of the city as seen by planners and photographers perched high above the city, Munch moves to the street and thus reveals how very different, confusing, and even terrifying that structure could be when living and walking on it.

New fears of urban spaces were diagnosed throughout the last quarter of the nineteenth century; these were identified as individual diseases, generally within the classifications of neurasthenia[61] already named by physician George Miller Beard in 1880 or hysteria, as defined by the great Parisian clinician Jean-Martin Charcot. Agoraphobia, or fear of open spaces, was recognized by numerous physicians in the late 1860s; the first published descriptive account was that of Berlin psychologist Carl Otto Westphal in 1871, and by the mid-1880s, the term for the phobia as well as its symptoms was generally accepted throughout Europe.[62] There was a recognized standard such as that described in one of Westphal's three case studies, where the phobia presented as a fear in the patient that

begins as soon as the houses of a street leading to an open area increase their distance from him. Suddenly, a feeling of uneasiness occurs in

his heart region as if one were terrified. It also feels as if something were to grab his heart, and he begins to blush and become hot in his face: an anxiety then conquers him that could turn into mortal terror. A feeling of insecurity appears, as if he were no longer walking secure, and he perceives the cobble stones melting together. . . . he is simultaneously frightened by the thought that his condition could attract attention. . . . Only when fear reaches its climax, does he feel as if the bottom were rocking.[63]

It is interesting that the patient described further revealed that the Dohn-hofsplatz in Berlin was the "most unpleasant square" of the city, and that although he felt some relief once he reached the "candelabrum" in the middle of the square – much like the relief of the viewer in focusing on Caillebotte's "refuge" – he nonetheless still preferred to go back instead of forward from it. Giles de la Tourette, a student of Charcot, described agoraphobia in 1898 as a type of "neurasthenic vertigo," presented as "a sensation of cerebral emptiness accompanied by a weakness of the lower limbs. . . . A veil spreads before the eyes, everything is grey and leaden; the visual field is full of black spots, flying patches, close or distant objects are confused on the same plane." When victims were forced to go into the streets, they were "pushed to creep along walls, follow houses, and flee the crossing of wide squares."[64]

One of the most important, aspects of agoraphobia in correlation to Symbolist images is, however, its connection to the crowds that especially in Munch's work assault the viewer from Symbolist streets. As Anthony Vidler has recently explained in his study of architecture and space, agoraphobic dysfunction was in the nineteenth century commonly linked to its seeming opposite, claustrophobia, or fear of small places and crowds.[65] Although the conditions exacerbating the symptoms were antithetical, the symptoms themselves – of acute, often incapacitating nervousness – were often extraordinarily similar. Most important, despite constant medical debates regarding the relationship of agoraphobia and claustrophobia, arguing case studies' diagnoses, terminology, and hereditary relationships, no one questioned the shared theatre for these two new diseases: the metropolitan city.[66]

This was also the position taken by Simmel in his early essays on the metropolis. Like Munch's painting, and like the psychologists investigating the new spatial pathologies, Simmel raised questions not about the actual construction of the city, but about the new way that the city is engaged – or not – in the 1890s. In an essay titled "Sociology of Spaces," published in 1903, Simmel further identified particular urban spaces as catalysts for specific and often oscillatory mental reactions. The large city "places" could therefore be an arena where city crowds could exercise their "impulsiveness and enthusiasm," but also be a trigger locale for agoraphobic fear.[67] For Simmel, only the "metropolitan type" of intellectual was capable of managing with equanimity a mental accommodation

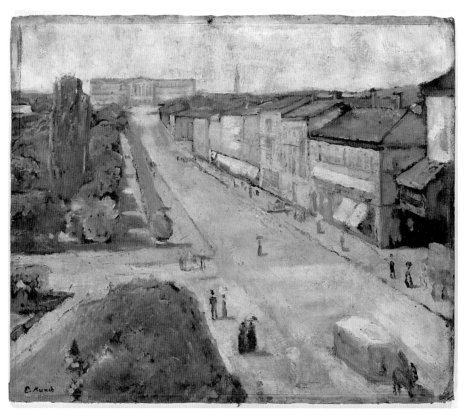

FIGURE 35. Edvard Munch. *Karl Johan Street in the Rain*. 1886–9. Oil on board, 36 × 42.5 mm. Private collection, Oslo. © 2003 The Munch Museum/The Munch-Ellingsen Group/Artists Rights Society (ARS), NY.

to these new spaces, in part by tuning out the city from certain points of view, in part by adopting uniform codes of minimal interaction with both the street and street society.

Munch and several other Symbolist artists seem to handle this adaptation by means of reductionism, and careful control of viewpoint. The city seen from above, as in Munch's and Caillebotte's views of the 1880s, is often seen from a high window or even balcony, affording distance, lack of confrontation, and even protection (in some cultures, balconies with screens allow those – usually women and children – not allowed in the street to observe "public" life vicariously). Because Paris was the model for so many later capital cities, it is interesting to note that Haussmann had in the 1850s prohibited balconies or any other protrusion to exist on the major buildings of his new Parisian streets, with the idea that any overhang onto the street should be eliminated.[68] This ordinance was eventually repealed, with the result that balconies and bay windows proliferated, just as many felt they needed them, in the following decade.

As Simmel pointed out, however, problematic social intercourse occurred not when viewing the street from protected spaces, but rather when one entered the street, engaging the public in the same space and time. It was here that Simmel's "metropolitan man" made his best adjustment; it was here that the Symbolist struggled most. These "on the spot" views were what Munch began making around 1892, whether in the claustrophobic casinos of Monte Carlo (see Chapter 2) or on the crowded boulevards of Christiania.

Munch's earliest city views began with Christiania and surroundings; these had mimicked in palette, texture, and elevated point of view the Impressionist scenes that Munch knew. In *Karl Johan Street in the Rain* of 1886 (Fig. 35), for example, Munch adopted a broad perspective seen from high above the park side of the street. For such canvases, Munch either worked from the exact position of numerous photographers before him (see the postcard photograph, Fig. 34), or possibly from one of the many photographs that had made that particular view "the most well known in all of Norway."[69] In adopting the same stance, then – both physically and psychologically – Munch in these early paintings presents a planned, ordered street with safely distant strollers. Such a view, furthermore, managed to bring together both a ground plan view and a skyline sweep – the two most popular structural approaches to city depiction prior to the nineteenth century.

MAPPING THE CITY: PLAN AND SKYLINE

The idea of a ground-plan view of an urban area (only called a city to indicate a very large town, distinguished from rural areas since the sixteenth century)[70] is as basic as mapping, offering in one panoramic view the axes of the city. Using the ground plan, the general patterns of the city's thoroughfares and even major buildings could be indicated regardless of the city in question being either an "organic" plan (one that followed natural boundaries and irregular lines), or the "grid" plan (one that followed predetermined mathematical orthogonals). The function of the plan, in other words, was to reveal urban order. With the eighteenth- and nineteenth-centuries' growth of central portions of cities containing increasingly tall and distinctive building shapes, there evolved a second favorite view of the city in the skyline. Although use of the term "skyline" to refer to city structures did not occur until 1875,[71] this use of the term and views based on it became popular early in the nineteenth century, and commonplace by the 1890s. Like an elevated plan, the skyline offered different information about its subject, the city, but with the same purpose of ordering and reducing for easy readability.

Nonetheless, both the ground plan or panorama and the skyline had their basis in landscape portrayal, and although they were adapted over the years to

the "townscape," they failed in critical ways to function for the late-nineteenth-century cityscape. On one hand, the street's planned directions, especially in the older sections of cities, were being constricted, blocked off, or even disregarded. In his 1845 description of the city of Manchester, for example, Engels lamented "the fantastic way in which the houses have been packed together in disorderly confusion in impudent defiance of all reasonable principles of town planning," calling it a "crazy layout" that made no sense.[72] This meant that the landscape "plan," or panorama, with the horizon line as its organizing principle, no longer worked for cities. On the other hand, the skyline of traditional city centers was also quickly degraded by new industrial structures, low to the ground. Ironically, architects sometimes tried to ameliorate the problem by adding towers and other vertical masses to public buildings – even to railway stations – regardless of their lack of function.[73] Although A. W. Pugin's 1841 *Contrasts* study of Gothic architecture versus the building of his own day was originally intended to reveal "the present decay of taste," his *A Christian City in 1440 and 1840* (Fig. 36) now makes explicit the degradation of skyline that began around that time. It is obvious that his "modern" vista fails as an order-giver, as factories, mills, tenement housing and even prisons overtake the earlier, more homogenous, and readable view. Here, neither a classical landscape formula utilizing geometricized patterning[74] nor a romantic emphasis on meandering ("wild") forms provided perfect compositional solutions. Although centuries of Western landscape aesthetics had encouraged some type of picturesque control over the scene, even nature's irregularities were not easily translated into urban chaos.

As the cities themselves grew more chaotic, a mélange of traditional and modern signifiers, so also did the usual methods of mapping become less capable of their original organizing function. By the time of Munch and other Symbolist artists approaching the city, this problem was unavoidable and was further exacerbated by the fact that the artists had been trained and inclined, by that training as well as their own Symbolist leanings, to work with nature or landscapes. This was important: in many ways the traditional means of mapping the city for Munch were the very models now most problematic. Nothing in his visual background offered any alternative for painting the contemporary city. The move to the streets from traditional landscape structure was in fact a shift that all early city painters had to make. As has been noted by art historian Wanda Corn about the so-called Ashcan School of New York artists in the early twentieth century, solutions were originally attempted by adapting landscape points of view. For example, to imbue a sense of both order and awe about the new city, many artists borrowed directly from their predecessors in Romantic landscape. The new "corridor streets" – straight streets lined with tall, uniform buildings rising from a shared setback – became "canyons" of new, industrial masonry.[75] The most common view of the city by the end of the century, therefore, was

THE SAME TOWN IN 1840.

1. St Michaels Tower, rebuilt in 1750. 2. New Parsonage House & Pleasure Grounds. 3. The New Jail. 4. Gas Works. 5. Lunatic Asylum. 6. Iron Works & Ruins of St Maries Abbey. 7. St Evans Chapel. 8. Baptist Chapel. 9. Unitarian Chapel. 10. New Church. 11. New Town Hall & Concert Room. 12. Wesleyan Centenary Chapel. 13. New Christian Society. 14. Quakers Meeting. 15. Socialist Hall of Science.

Catholic town in 1440.

1. St Michaels on the Hill. 2. Queens Crofs. 3. St Thomas's Chapel. 4. St Maries Abbey. 5. All Saints. 6. St Johns. 7. St Peters. 8. St Alkmunds. 9. St Maries. 10. St Edmunds. 11. Grey Friars. 12. St Cuthberts. 13. Guild hall. 14. Trinity. 15. St Olaves. 16. St Botolphs.

FIGURE 36. A. W. Pugin. *A Christian City in 1440 and 1840.* Published in *Contrasts* (1841). Photograph © Board of Trustees, National Gallery of Art, Washington.

the view from above, limiting the now senseless skyline and mapping from a distance only a partial, and presumably still readable section of thoroughfare.

During his stay in Paris, in 1890–1, Munch adopted this recurrent blend of overview, nature comparison, and safe distance to several views of the French city,

FIGURE 37. Behind Christian Krogh Street. c. 1900. Photograph. Oslo Byarkiv.

producing works parallel to those of the Impressionists. During one of Munch's short returns to Norway, then, it is not surprising that he even attempted the application of a Neo-Impressionist technique to his favorite motif of the Karl Johan Street. In these canvases,[76] the high point of view of the earlier scenes was dropped somewhat, so that the foreground figures are larger and the view is only slightly from above. On the other hand, the viewer's gaze is still not that of someone on the street. Especially because the closest figures are shown walking away, with their backs to the painter or viewer, the emphasis remains on the long stretch of the street, houses, and trees as structure of the city. It is also the case that Munch here exercised a first choice of a suitable subject not unlike landscape artists who would carefully select their motif from the hundreds of possibilities offered by a single site: he focused on one of the most modern areas in Christiania. Boulevards like the Karl Johan were intended to be the new "face" on the modern city; like the facade-renovation projects of twentieth-century Olympic city routes, there was rarely a sustained newness, or modernity, to these streets once one rounded a corner, or went to the back of these buildings. A photograph of the rear of Christian Krogh Street in Christiania from around 1900 (Fig. 37), for example, reveals how close the older roots of the city remained to Munch's modern vision. Like the masks of the spectacle society that populated them, these new areas were the modern masks on the old city, rising out of rubble from the shores of the fjords.

For the singular view of Munch's 1892 version of *Evening on Karl Johan Street,* however, there was a more recent, Impressionist model for Munch to consider. The Impressionist *flaneurs* had lived on the street level, and used the straightforward, head-on composition of their realist predecessors to look, directly, at the city. This strategy immediately put all of the physical spaces that had been so important to structuring the great cities of the past into the role of background settings for the new city, which was essentially city society, out on the street itself.

In Impressionism, the "painter on the street" was most often engaging in and with the crowds, and was essentially one of them. When we enter the spaces of a cafe presented by Auguste Renoir, for example, we approach friendly figures with a comfortable sense of space between us; we are given room to move, to join them at the table or on the dance floor. Griselda Pollock has convincingly established that this kind of public engagement is essentially male, and that women Impressionists (Mary Cassatt, Eva Gonzales) did not have the same access to the new Parisian public spaces, in their own lives or in their paintings. The women often demonstrate a different sense of space within this Impressionist viewpoint, portraying figures enclosed by railings or other furnishings, or otherwise separated in important ways from the truly modern culture of the city.[77] Despite this distinction, however, there is still the sense of *comfortable* habitation of an area in the women Impressionists' work. No matter where the viewer's stance may be, they are able to maintain their own space within the framework of the canvas.

In Symbolist works, however, this sense of space is substantially altered and made both more focused and less comfortable. Munch's perspective, compositional structure and entire point of view in *Evening* was now truly confrontational. Munch's notes confirm his anxiety on the street; in his diary of 1889, written in the customary third person, Munch describes a terrifying evening on the boulevard:

> All the people passing by looked so strange and queer and he felt that they were looking at him so – staring at him – all these faces – pale in the evening light – He tried to hold onto a thought but couldn't – he had a feeling of mere emptiness in his head – and then he tried to fix his gaze on a window high up – and then once again the passersby got in his way – His whole body trembled and the perspiration poured off it.[78]

As has often been noted, Munch's description comes remarkably close to that of the haunted hero of Hamsun's *Hunger,*[79] and to the generic response that Simmel was to outline and decipher. For Simmel, this highly idiosyncratic response to a sea of pale faces epitomized the metropolitan man's "difficulty of asserting his own personality within the dimensions of metropolitan life."[80] It

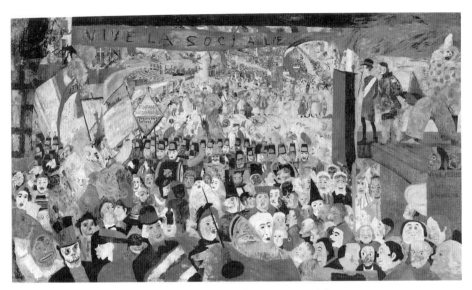

FIGURE 38. James Ensor. *Christ's Entry into Brussels in 1889.* 1888. Oil on canvas. 252.5 × 430.5 cm. The J. Paul Getty Museum, Los Angeles. © Estate of James Ensor/Artists Rights Society (ARS), New York.

also had to do with space. Simmel at one point claims that "the most significant characteristic of the metropolis is . . . [a] functional extension beyond its physical boundaries." By way of explanation of this notion that "a city consists of its total effects which extend beyond its immediate confines," Simmel uses the example that the individual person "does not end with the limits of his body or the area of his immediate activity. Rather [he is mentally extended] . . . by the sum of effects emanating from him temporally and spatially."[81] Munch assumes this notion of the individual's space and its reinterpretation in the modern city; his viewer must take the place of the unadapted city dweller and is visually pushed into others' space. Despite a longstanding precedent of portraits presenting sitters full-faced, the idea of having a character in a narrative painting stare directly out of the canvas and engage the viewer with full-face, confrontational gaze seems to have reemerged in nineteenth-century art, at least, in Manet's infamous *Olympia* (1863, Musée d'Orsay, Paris). Munch, however, takes Manet's confrontational gaze one step further by placing his staring figures at the immediate forefront of the composition, cropped at least at the knees and often near the waist: a compositional device that pushes the gaze, and sense of physical body space, dangerously close to the viewer. It is notable that, although Munch also utilizes this arrangement in *The Scream,* his first usage of it for a narrative format exists in the two paintings of the early 1890s that dealt most specifically with city society: the *Evening* canvas as well as *At the Roulette Wheel II* of 1892 (see Fig. 20). For the figure in the gambling scene, Munch must have been referring to the story of a man who had lost everything at Monte Carlo and went berserk, a story

that he relates several times in his writings at the time of his own casino visits. By making the man confront the viewer with the space-encroaching, staring gaze, however, Munch turns the story into an emotional encounter, with a new sense of the issue of space as a metaphor for the alienation and the struggle for identity that characterized the metropolis. The same metaphor is at work in *Evening on Karl Johan Street*.

ENSOR'S STREET

The effectiveness of Munch's visual adaptations becomes apparent when *Evening on Karl Johan* is compared to another well known Symbolist street scene, Ensor's *Christ's Entry into Brussels in 1889* (Fig. 38). Like Munch's painting, this canvas also presents a parade of citizenry who march down a large city boulevard toward the viewer. Unlike Munch, however, is Ensor's overt polemical intention, announced in the banners claiming "Long Live the Social" that are festooned across the parade space and delivered in the hundreds of bodies that spill, cartoonlike, into the foreground. This painting's connection to contemporary social issues has been well established, and Ensor's concern about the modernization of Brussels and Ostend, his hometown, was openly expressed in his later writings; in the twentieth century, he finally vented all his hatred of "illusory progress," calling the changing of any of his precious dunes or beaches "an act of vandalism."[82] But as Patricia Berman has demonstrated, Ensor's attack on the modern Belgian city in this work is in the form of a parody: of Belgian carnivals, of King Léopold II's rebuilding programs, of religious and civil celebrations, and even of other "parade paintings" (a popular Belgian genre) at the time.[83] As parody, *Christ's Entry* presents the street as site for caricature and makes wickedly clever use of overstatement by means of visual manipulation. Overly fat and thin figures jostle with one another on a street filled to capacity and beyond, while lewd costumes and leering masks reveal that they are military, clergy, and businesspeople (everyone but rural laborers) who use carnival for exercising in a Bakhtinian way their many excesses.[84] Voicing a deeply felt and serious rebuke against the overcongestion and overconsumption of the city, *Christ's Entry* uses satire as its delightfully appropriate means. Comparison to Munch's composition, for example, reveals the efficiency of Ensor's slightly high point of view that avoids Munch's spatial entrapment. Ensor's viewer stands outside and above the crowd, in a comfortable position to appreciate the follies of the "others."

While these brilliant manipulations identify Ensor's abilities as a biting, hard-edged caricaturist, they also reveal by contrast how subtle Munch was about his street scene. Ensor's urban masses wear Ostend carnival masks to hide their quotidian identities; Munch's middle class have lost so much of their identities that their faces have become their own "real masks," equally brittle and artificial but so permanent that they can never be removed. This terrifying

result of the detachment process studied by Simmel and Durkheim was the same as that described by Rilke in his *Notebooks of Malte Laurids Brigge.* The protagonist, Brigge, tries throughout the novel to adapt to life in Paris. Everyone, he observes, wears masks; while some people wear their dog's face, other dogs wear their master's faces. At one point Brigge struggles to take off a mask that he has tried on himself, and he cannot; he fears that there is nothing behind it.[85] By showing us, in *Evening on Karl Johan Street,* the face which is a mask, hiding nothing, Munch proposed a still-viable visual code for the existential isolation of urban life.

MUNCH'S "LIFE ANXIETY"

By the time he painted *Evening on Karl Johan,* Munch's response to the pressing crowd was also personal. He was infatuated with a "Mrs. Heiberg" and described, again in his diary and in the third person, his relentless search for her on the crowded Karl Johan Street:

> And there she came at last. . . . The people passing him looked so strange and unfamiliar and he thought they were looking at him – staring at him – all these faces – so pale in the evening light. He was trying to hold on to a thought but could not. . . . I'm about to fall and people will stop and there will be more and more people – a frightful crowd.[86]

The fact that Munch's infatuation was an illicit one ("Mrs. Heiberg" was the artist's secret name for his cousin by marriage, Millie Thaulow) may well have made this search especially frightening and explains in part the hallucinatory scene at night. Munch later admitted that when Millie gave him his first kiss, she took "the sweetness of life from me," that "everything that I had previously seen in a rose-colored mist now seemed empty and gray to me."[87] Curiously, this was Munch's reaction despite the fact that his attraction to his married cousin might well have been encouraged as a beneficial "experience" by Hans Jaeger, informal leader of the group of bohemian Norwegian artists and writers known as the Christiania-Bohème with whom Munch associated. In contrast to Munch's association with sexual knowledge as an immediate dimming of his vision of the world, Jaeger had encouraged free love with an opposing ratio-nale, calling for total freedom of "godlike people . . . in contrast to the miserable creatures that now creep around on the earth's surface, hiding themselves, each separate and alone, in the dark cellular holes of decrepit freedom-suffocating institutions . . . frightened of the strong, stimulating daylight of an open, free society."[88] What for Jaeger was a perfect match of sexual and societal freedom was

for Munch fraught with contradiction and despair. Searching for Mrs. Heiberg among the "frightful crowd," Munch's vision of society was already hopeless.

The experience – personal and structural – of *Evening on Karl Johan Street* soon led to a spate of similar crowd images that eventually constituted a major series, now known as the *Frieze of Life*. The images were thematically as well as stylistically connected. *Anxiety* of 1894 (Fig. 18), for example, uses the same steep perspective and eye-to-eye focus on ghostlike faces as those of *Karl Johan* but has the figures on a bridge overlooking the fjord, as in *Scream* (Fig. 39) of one year earlier. It is significant, but overlooked, that Munch himself linked these society paintings together, and even considered them as an integral group within his *Frieze of Life*. When Munch finally exhibited his full series of paintings, he did so in Berlin in 1902. There he titled the series *Frieze: Cycle of Moments from Life* and arranged the selected twenty-two paintings according to subthemes displayed on separate walls. Three of the walls were labeled as major, recognizably Symbolist themes: Seeds of Love, Flowering and Passing of Love, and Death. The fourth wall, however, Munch called "Life Anxiety"; here, he offered roughly one-fourth of his *Frieze* paintings as examples of the trauma caused by modern society. In addition to *Karl Johan* were displayed *Anxiety, Red Virginia Creeper, Last Hour* (or *Golgotha*), and *The Scream*. Of these canvases, *Golgotha* (Fig. 40) was the last painted (1900) and the only overtly symbolic, fantastic scene. In it, a man who has regularly been identified as Munch himself is being crucified, surrounded below by figures seemingly of his own life and making. The foreground face is that of Munch's friend the socialist writer Przybyszewski, while the figure to his right has been identified as the playwright Gunnar Heiberg and the last, bearded face on the left resembles that of Christian Krogh, Munch's early teacher. On the right of the composition are further figures whose identities as real people have been suggested but who also appear as figures out of the artist's own earlier paintings.[89]

In *Golgotha*, Munch reveals his self-identification as Christ-figure, a martyr to his critics and, indeed, to his own art. Berman has established the significance of Munch's inscription on the painting's upper right-hand corner: "Kornhaug Sanatorium 1900" as further self-association with sickness, disease, and fin de siècle decadence that would readily be recognized by his audience. The martyr image would appeal especially to fellow artists and writers for whom this decadent code of aesthetics, with the artist as antisocial outsider, was well known and which is addressed in Chapter 4.[90] Munch's inclusion of this image of suffering at the hands of a mass public, who arrange themselves like the many mobs or "frightful crowd[s]" in Munch's other street scenes is therefore important. Like the undistinguishable, mask-wearing figures in *Anxiety*, the background bodies move toward the artist as if greedily seeking a closer experience of the crucifixion; only one seems to raise his hands in prayer. Instead, the outermost figures of the mob reach out with long hands, like the groping figures of Munch's 1894 *Lust* as if to grab a piece of him for themselves.

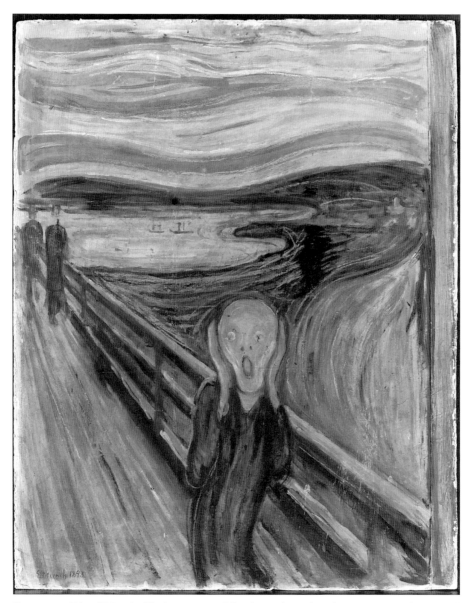

FIGURE 39. Edvard Munch. *The Scream*. 1893. Oil and gouache on board, 91 × 73.5 cm. The National Gallery, Oslo. © 2003 The Munch Museum/The Munch-Ellingsen Group/Artists Rights Society (ARS), NY.

With *Golgotha*'s last image of immolation at the hands of the crowd, Munch brought to a close his wall of "Life Anxiety," aligning this aspect of life – social alienation – as equal to the emotional estrangement brought on by passions and love: all three sections in the exhibition led, inevitably, to the last wall of death. It has been noted as significant that Munch in this first full exhibition of the *Frieze* altered the order of his themes, ending with death as the "final scene" rather than

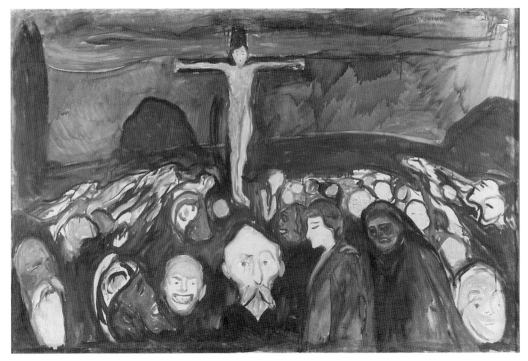

Figure 40. Edvard Munch. *Golgotha.* 1900. Oil on canvas, 80 × 120 cm. © 2003 The Munch Museum/The Munch-Ellingsen Group/Artists Rights Society (ARS), NY.

using it as an ironic beginning as it had been originally arranged in 1893.[91] It seems equally important, however, to recognize that the section on "Life Anxiety" had been integrally included as part of the Frieze, consistently, from the beginning.[92] The other paintings leading to death (the canvases included on the Berlin 1902 exhibition's left and front walls) displayed the heartbreak, and often separation and isolation, of internal, instinctual, and natural psychological states: *The Kiss, Ashes* (about rejection of the man by the woman), *Jealousy, Melancholy,* and so on. In all of these, Munch underlines the instinctive quality of these passions by showing the figures undergoing them in natural, outdoor settings:[93] woodland and water scenes, or as the artist himself succinctly explained, "Jealousy – a long empty shoreline."[94]

Munch saved for his "Life Anxiety" paintings, however (with the notable exception of the summation piece, *Golgotha*), a city scene, linking those crises of psyche not with nature but with society. Even the *Red Virginia Creeper* (Fig. 41), a deeply disturbing image of a man's staring face in the foreground, with a large house behind him that is being taken over by a blood-red plant, is in a city or suburb setting. The environment that has caused this man's distress is implied to be that of the neighborhood in which the "creeper" house is set. In the "Life Anxiety" paintings, the psychological distress is linked not to "love" (a

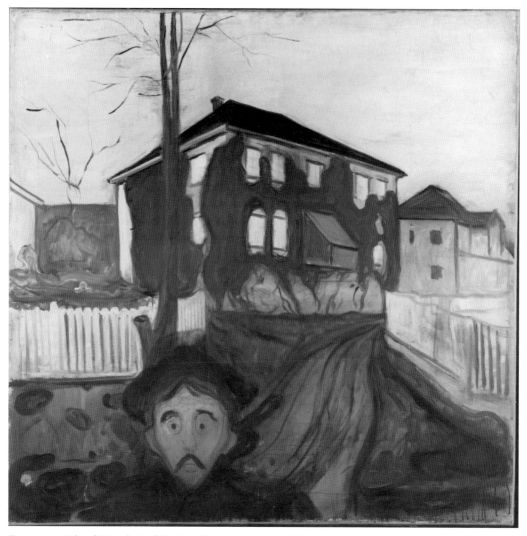

FIGURE 41. Edvard Munch. *Red Virginia Creeper.* 1898–1900. Oil on canvas, 105 × 178 cm. © 2003 The Munch Museum/The Munch-Ellingsen Group/Artists Rights Society (ARS), NY.

name given by Munch to the series at one early point in 1892) relationships but rather to "life" relationships.

According to notes presumed to have been written by Munch himself in 1927, his first exhibition of the partially completed series in Berlin, in 1892–1893, was arranged under the title "Eighteen Motifs from the Modern Life of the Soul." With this thematic designation, the relationship of these disturbed psychological states to modern metropolitan life was perhaps at that time more obvious than it is now. All of the "Life Anxiety" paintings exhibited, in fact, classic presentations of the new city-spatial diseases, agoraphobia as well as claustrophobia. Although one suggestion that both diseases be grouped together under the

term "topophobia" was never accepted, the two pathologies were, as we have seen, linked in the late century as heightened forms of neurasthenia, and therefore twin neuroses of the city and its spaces.[95] As Carl Westphal already noted in his early treatise on agoraphobia, this condition was largely different from other, seemingly similar pathological disturbances because it was "tied to external situations and conditions."[96] Munch's famous *Scream* thus takes place – as it presumably did for Munch himself – as he walks across the fjord by Christiania. Munch later wrote that as his friends walked on, he saw "blood and tongues of fire" in the sky "above the blue-black fjord and the city."[97] And about *Anxiety* (which Munch had alternatively titled "Red Clouds" and "Insane Mood," and which visually serves as a cross between *Karl Johan Street* and *The Scream*), Munch also wrote, in his folio of *The Tree of Knowledge of Good and Evil*:

> I saw all the people behind their masks – smiling, phlegmatic – composed faces – I saw through them and there was suffering – in them all – pale corpses – who without rest ran around – along a twisted road – at the end of which was the grave.[98]

For Munch, nature was the inherited, biological source for the sexual drive and the inevitable psychological beating that resulted from it; but the more existential psychotic state of being – in which the entire world disassociated itself from the individual by means of structural as well as psychological imposition – came directly from the city streets.

It was the shift from above the metropolis to the street level that allowed Munch to see the city in this way, a move that was difficult for most Symbolists. Ensor, for example, only rarely attempted city scenes in his early work; when he did they inevitably adopted a high vantage point, ending with two paintings in 1885 showing only the *Rooftops of Ostend*, most seen from the vantage point of his studio situated on the corner of the Rue de Flandres and the Boulevard Van Iseghem.[99] In all of these, human figures are eliminated or restricted to a few shadowy forms on the edges of both the streets and the canvases. It seems significant, then, that Ensor's first effort at showing the inhabitants of these city streets was in his first essay depicting Brussels and its customary mobs of people, in the *Carnival in Brussels* of 1888.[100] Although this scene is still shown from above, the vantage point is closer to a second-story window than a rooftop, as if Ensor was staving off the psychological and structural precariousness of a full descent to the pavements. And it is therefore all the more striking to note that Ensor's next city work (and possibly his very next painting) was the *Christ's Entry into Brussels in 1889* (Fig. 38). Although, as noted, Ensor's point of view here is still from slightly above the crowd, it represented for Ensor the most direct confrontation with the frightening masses he ever attempted. Conspicuous also is that Ensor here for the first time paints city society as he uniquely sees it: wearing actual or metaphorical masks, the crowd streams toward the artist and

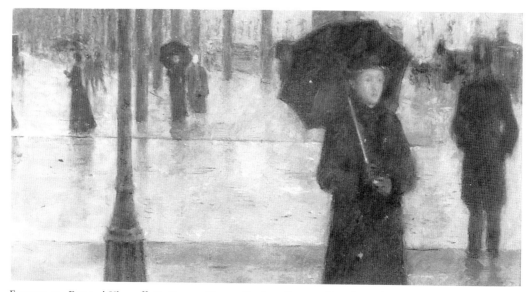

FIGURE 42. Fernand Khnopff. *En Passant* (Regent Boulevard). 1881. Gouache and watercolor, 9 × 17.2 cm. Private collection.

viewer in a seemingly unending and unstoppable mass. This is also Ensor's first city image in which the structures of the city – bordering buildings, horizon line, and even the pavement demarcations themselves, have been lost in the chaotic jumble of placards, banners, and bodies of the street. Thus for Ensor as for Munch, the final descent was a true de-gradation of the traditional landscape-oriented view. Once there, they produced major Symbolist evocations of the de-structured city.

KHNOPFF'S *EN PASSANT*

One final example of the Symbolist who attempted a new depiction of states of being on the streets is that of Khnopff who, when he began to draw city scenes around 1880, following by a full five years his landscape essays, immediately adopted the "safe" formula used by that time. The cityscape was seen from above, and at a distance, or even though a high window.[101] Only on one occasion did he descend to the streets to produce a work that at once seems to retell in a Symbolist manner the popular rainy-day images of the city and to foretell Munch's psychologically compelling composition. In 1882, Khnopff's first street scene was a large pastel titled *En Passant,* perhaps with Baudelaire's poem in mind. It was later titled *Regent Boulevard,*[102] and was presumably destroyed and known now only by description and a preliminary watercolor and gouache sketch (Fig. 42). It was Khnopff's major work of that year, and he exhibited it immediately with the L'Essor exhibition in Brussels.[103] In the sketch, Khnopff

presents Caillebotte's rainy-day scene, but with it actually raining. His emphasis on the repetitive vertical structures of the city, and even his inclusion of a modern-city street lamp in the very foreground of the work, is reminiscent of Caillebotte (Fig. 24). But the differences are important also: in the Khnopff scene, single figures walk, alone, and are seen from a radically cropped and enclosed point of view that makes a forest of the lampposts and tree trunks, all blending together. In the Khnopff, no skyline is visible; indeed only one indicator of an actual building, in the right background, is included, resulting in an atmospheric scene of figures that seem to float through an endless and not completely real haze. Especially when compared with the purposeful glances and intentional strides of the Caillebotte figures, Khnopff's single woman in the foreground, who is the only figure with a visible face, is lost in reverie. In choosing the Boulevard Regent, Khnopff had already decided on a noncommercial emphasis because the street at that time was extremely wide and lined on one side with a treed strip of land, not unlike Karl Johan Street. It made as such an elegant boundary for strollers between Le Parc, an "attractive spot" that served as "a fashionable resort in summer on Sundays" and the new Quartier Léopold. The latter sector was described, kindly, by the Baedeker guide in 1891 as "modern and handsome, but somewhat monotonous" residential section of the city;[104] when the mayor of Brussels wrote about it two years later in his *Esthétique des villes,* however, he called it "a striking example of the errors that one can commit when laying out the plan of a new district."[105] The Regent, however, was one of the older boulevards in Brussels, created when the former outlying ramparts of the old city were leveled around 1800. This was the most common city transformation of the nineteenth century, a move that took advantage of the earlier Baroque bastions that originally were treelined ramparts marking a boundary between city and country. The trees, which for the original military builders were included for their roots, to give extra strength to the barricades, were soon seen merely as shading structures by promenading citizenry.[106] In choosing the older, more natural concourse, Khnopff rejected the much newer "inner boulevards" that were the "entirely modern feature"[107] of the Lower Town, constructed over the bed of the Senne River in 1867–1871; he also avoided any visual references to the problematically new Léopold section of the city.

Earlier in the century, the construction of a railway on the major through-street, the Allee Verte, was the first change to usher in a new age of industry for Brussels. At the same time, stations and factories were built near the old town, causing the middle classes to move to the Upper Town, actually outside the old city. The Léopold quarter was constructed next, around 1845, with the vast commercial Avenue Louise developed soon thereafter.[108] This transformation would have begun exactly at the height of Brussels's growth, which between 1850 and 1900 burgeoned into one of the largest and most populated cities in Europe.[109] In emulation of Haussmann's Paris, the promoters of the twenty-year project of the Boulevards went to great lengths to ensure the modernity of

all buildings connected to these boulevards, even offering premiums to the twenty finest new facades built on the streets.[110] But while the new thoroughfares were the favorite location for public parades and festivals – including the posh woodland area of the Bois de la Cambre where Khnopff would later build his own house[111] – Khnopff here turned instead to the older boulevard, in the rain.

Reviewing Khnopff's first exhibition of the finished pastel in 1881, Verhaeren considered *Regent Boulevard* "the most beautiful work by Mr. Khnopff that I know," and described it as if it were a traditional landscape that set a mood for the viewer. The work "produced an excellent impression. This work of art makes us think and hope. The damp time of winter, the soaked soil, the faded green of the trees, the uniform gray of the atmosphere are sincerely and successfully rendered."[112] Upon Khnopff's exhibition of the work again in 1886, when the critic wanted to highlight the painter's "pure modernity,"[113] Verhaeren focused on the work as a cityscape, claiming that taking on this very modern topic provided a special challenge, if it were also to reveal the spirit of the painter himself. And yet, Verhaeren claimed, Khnopff accomplished just that:

> The preoccupation of the lifelike scene, to give the physiognomy of a small piece of the city, reveals the soul of the artist. He takes as his task to render the ambient air, the trees, the washed out green of their bark, the look of the pavements, the facade of the houses and above all the walkers, the flaneurs, the passersby, each with their own carriage, step, gesture, or "*gait.*" At first glance a simple work, in truth inextricably difficult.[114]

Verhaeren, in turning here from the viewer's reaction to the artist's intentions, makes an interesting exchange of frames for his comments about the work, but he affirms throughout his reading of the boulevard in terms of emotional indicators of private states of being. In his close-cropped, mood-imbued portrayal of the *Regent Boulevard,* Khnopff, like Munch and Ensor, turns the metropolitan street into a space encouraging a psychological response to modernity.

TIME AND MEMORY

There were, however, actually two constructs that became, in the modern metropolis, destructured, for not only was the sense of place and physical space altered, but also the sense of time. Just as Munch's different views of Karl Johan Street demonstrate how emotional space changes drastically with differing points of view, so also time sensation can change according to physical engagement. In *Evening on Karl Johan Street,* it was not only the change of a physical point of view but also a time shift, from day to night in glaring light that instituted a different psychological point of view. In Hamsun's *Hunger,* a starving writer is

overwhelmed by the destructured city, the "inextricably difficult" metropolitan world. Throughout the novel, the young man is constantly confronted with clocks, watches, and other timepieces, yet remains hopelessly late for appointments, even those with a potential lover or for a job (both of which he desperately needs). His physical hunger, a metaphor for his searching for some spirit or soul in the city, only exacerbates this condition. As he summarizes a day on the street:

> Despite my alienation from myself at that moment, and even though I was nothing but a battleground for invisible forces, I was aware of every detail of what was going on around me. A big brown dog ran across the street, toward the trees . . . it had a small collar made of mexican silver. Farther up the street, a window on the first story opened and a girl with her sleeves rolled up leaned out and began polishing the panes on the outside. Nothing escaped my eyes, I was sharp and my brain was very much alive, everything poured in toward me with a staggering distinctness as if a strong light had fallen on everything around me.[115]

In his 1902 essay, Simmel addressed this dual attack of urban hyperawareness and simultaneous disembodiness, focusing on "how the personality accommodates itself in the adjustments to external forces."[116] He notes that what he calls the "contrast of phenomena" might seem to be only visual but is equally related to a disjunctive sense of time. The difference between momentary and lasting impressions is alarmingly clear in the city, but this realization not only occurs continuously but is persistently using up (or, alternately, saving) the urbanite's "brain time." As Simmel summarizes, the sense of time as a "rhythm of life" was, by 1900, one that was completely different in the city.[117] This was not a simple matter of time "passing faster," given the new speed of everyday activity; it was more a matter of completely new processing of time. Thus, just as the theme of silence became a favorite Symbolist motif about which much has been written,[118] so also did the role of memory.

The role of the past, as has been already discussed and which is a recurring theme throughout this book, was both an alternative and a justification for the Symbolists in their amelioration of the present. But the *remembrance* of the past, as an activity, had the added advantage of linking by process the one who reminisces with not only a past time but also a past notion of time as stopped, eternal. This is perhaps what Khnopff had in mind when he had inscribed above the door to his idealist (but built in Brussels) villa: "Passé – futur," linking the past as memory to the future in a seamless continuum that notably included everything but the present. Gauguin was one of many Symbolists who thought it better to work from memory because that would make the work "your own; your sensation, your intelligence and your soul will then survive."[119] Munch also

summarized this process when he claimed, "I paint, not what I see, but what I saw."[120] Using memory as a filter, to allow time to cut out the details of the transient, was also an idea inherent in Symbolists' use of photography. At first, it may seem that the photograph, with its ability to capture precise lighting and details of "the moment," might be alien to the Symbolists' wish to avoid the clutter of contemporaenity. But the photograph in fact was able to do what Simmel and others claimed to be nearly impossible in the modern metropolis – to stop time altogether. Trapped in a single composition, not moving, ready to be realigned or even appropriated to other compositions, or colored in (as Khnopff often did), the photograph's world was arrested in time.

In Khnopff's *Memories* (Fig. 1), it is the pastiched composition that reinforces the notion of stopped or altered time suggested by the title: onto a vaguely defined countryside landscape are superimposed, as if cut out and pasted there, seven women, five of whom carry tennis racquets. Dressed as they would be in the city, the women are oddly set into the country. Carrying attributes of sport that signify action, they are strangely inactive. Based on photographs taken by Khnopff, they are at once located in time but arranged here beyond time. By the odd juxtaposition of detail and vagueness, tennis and meditation, and city versus country, the entire large pastel – sized like a painting but chalky matte in surface – is a remarkable study in opposites. Like the woman in white on the left, who does not wear a hat, does not carry a racquet, and who gestures with her hand toward her own inclined head in thoughtful expression, we are seemingly suspended in memories, with neither spatial nor temporal boundaries. Seeking steadier structures, Khnopff reorders but never really integrates the constructs of space and time.

The Symbolist attempt to stop time and control space was a search for cohesion and synthesis in a world that seemed to have none: for them, the image of the city was Babel, a cacophony of overstimulation, competing sensations, all in a fractured syntax. In Symbolist city street images, therefore, is a visualization, a kind of naming of the problem that while recording the disintegration of control also exercises some ownership over it. The process of reading all this and then restating it in a meaningful way was that of Symbolism itself. When Verhaeren spoke about the city as "an immense algebra the key to which was lost," he suggested this as a challenge to the poet who should be able to produce a mental image, an "evocation" that will succeed far better than "any description or enumeration of facts." He then explained that this was, indeed, the role of Symbolism: "The symbol, therefore, purifies itself through the process of evocation as it becomes an idea; it is a sublimation of perceptions and sensations."[121] In this last phrase, Verhaeren seems to recommend Simmel's ideal of the truly liberated metropolitan man, who can overcome the transient, disconnected, and meaningless details of modern city life through sublimation and the formation of a synthetic world of ideas.

If Simmel's call for a codified behavior – itself an unachievable notion for the sensitive Decadent-Symbolist – was the means to this sublimation of the material, then artists like Munch, Ensor, and Khnopff certainly felt that metropolitan society had failed. In Munch's *Evening on Karl Johan Street* are painted people whose sublimation has gone too far, beyond sensations to the very core of individual feeling itself. Munch's own approach to this painting began with sketches that date from 1891 or 1892 and ended with a vision of the street as Munch had remembered it "feeling": without street lights and without the heavy vehicle traffic, but with those ghostly faces. Recognizing the anomie of actual life on the boulevards, he had turned to his inner self and his art as recourse. The Symbolists were perhaps the only ones to consider and attempt so thoroughly this adaptation to the modern street.

4 ⌒ THE SICK CITY

I n 1899, James Ensor painted his own farewell to the century in *Self-Portrait with Masks* (Plate 3), a tribute to his sense of self as degenerate artist. Wearing a gaudy red jacket and matching flowered, plumed hat, he warily confronts the viewer with clear eyes staring out of a pasty-white face. He is encompassed, furthermore, by a seemingly endless, claustrophobic mass of masks which collectively present symptoms of disfiguration, blindness, infection, insanity, and even death itself. He shows himself surrounded, but not yet overcome, by the sick city. Ensor's self-image here models the "afflicted" artist of the fin de siècle. Described by critics such as Nordau, Symbolists such as Ensor were not only dandies and decadents, but also degenerates containing within themselves and their art all the symptoms of late-century illnesses ranging from neurasthenia and syphilis to insanity. In the 1890s, both medical and social discourse had managed to interweave all of these illnesses into a single, horrifying construction that linked the metropolis with the decline of the European race. Ensor, appearing in the midst of the garish masks, thus presents himself in a time-honored position of artist as mediator to the public, himself both victim and purveyor of disease.

Ensor's 1899 work was a reprise of an 1883 self-portrait to which he had added a flowered felt hat in 1887–8.[1] The appendage of the hat has been iconographically linked to both sexuality and death, associations that suited Ensor's interests, in the art historical prototypes to the image, in hoped-for liaisons with women, and in the romantic traditions that mysogynistically linked the two.[2] I would further suggest, however, that by the time of Ensor's second version at the end of the century, Ensor had fully assimilated all the medical and social developments of the decade and presented himself as much more than the artist who merely illustrated this well-known association of woman and death. By 1899, he stood accused, as a Symbolist artist, of being one of the sick, degenerate outcasts of the modern metropolis.

Ensor was well aware of disease, and the explosion of medical discoveries and opinions about it that occurred in the last two decades of the nineteenth century (Ostend was host to the Belgian "Hygiene Exposition" in 1888, and through his friends the Rousseaus, Ensor was connected to the medical community at the Brussels Free University).[3] As such, he was typical of late-nineteenth-century urbanites who were constantly assaulted by news – good and often bad – from a newly empowered medical community; in Belgium, Brussels was a center for medical research.[4] Belgians were typical, in fact, in using the metaphor of

Figure 43. James Ensor. *Ensor and Death.* December 25, 1887. Pen-and-ink drawing on a letter, 10.4 × 12.4 cm. Archives of Contemporary Art in Belgium, Musées Royaux des Beaux-Arts de Belgique, Brussels. © 2003 Artists Rights Society (ARS), New York/SABAM, Brussels.

disease as a modern descriptor, even of art. In 1888, articles in *L'Art moderne* began using the satirical term "Belgica-Morbus" that was, as was explained, the same as "Choléra-Morbus" (Fatal Cholera) in that the tendency toward morbidity was a national "malady, an epidemic, with the characteristic that those who communicated it didn't die from it, on the contrary." Suggesting that this "disease" of Belgium infected its artists, the article charted the illness's progress. "The action is slow, but sure. A moral phthisis, developing in the soul granulations of doubt and caverns of despair."[5] Ensor may well have been one of the artists caricatured in such an article: his letters carry references to being ill and also to being persecuted as an artist, while his drawings and prints feature numerous depictions of doctors, illness, and death. On Christmas day in 1887, for example, Ensor drew, with his usual self-sacrificing sarcasm, a sketch above a short letter to Octave Maus, head of Les XX, showing himself being led from his bed by a jaunty top-hatted figure of death – to the city and, presumably, his final demise (Fig. 43). In the sketch Ensor is emaciated; in fact he had been

FIGURE 44. James Ensor. *Peste Dessous, Peste Dessus, Peste Partout (Plague Here, Plague There, Plague Everywhere)*. 1888. Black and red chalk, 220 × 300 mm. Koninklijk Museum voor Schone Kunsten, Antwerp. © 2003 Artists Rights Society (ARS), New York/SABAM, Brussels.

sick, probably still depressed over the death of his father and possibly with the digestive tract irritation that regularly plagued him. Recurrence of illness in the 1880s and 1890s has led many to comment about Ensor's presumed obsession with his own health;[6] in this case, illness had resulted in his missing a meeting of Les XX (about which he asks in the note to the society's leader). One year earlier, at the age of twenty-six, Ensor had reported, "I am not happy. Ideas of survival haunt me,"[7] and by Christmas day 1887 it must have seemed, as he left his sick room, that only one more trip to the city might be the end of him.

This letter's sketch was highly personal; in 1888 he produced, however, a summary of much more public concerns with specific reference to late-century diseases in a drawing devoted to the "Plague" (or "Pest") (Fig. 44).[8] In the drawing's center, seated on a wooden bench, are four well-dressed bourgeoisie, two men and two women, seemingly conversing with one another in a manner not unlike the courting couples in Ensor's etching *The Garden of Love,* of the same year.[9] Above them, however, is the menacing face of a sun-god, from whom issues the words "Peste dessous, peste dessus, peste partout!" Traditionally translated

as "plague here, plague there, plague everywhere," Ensor's announcement of the ubiquity of disease is readily implicated by the figures that surround this central group. On the right stands a woman in tattered clothing and bare feet, holding a bestial-faced baby, while to the left are two men, also barefooted, dressed in rags and waving dead fish at one another. That these surrounding figures are carriers of disease is clear: the two framing figures have huge trails of dark mucus hanging from their noses, while bugs – or tiny specks of dirt or mucus in the air – seem to fly around the woman;[10] the seated beggar has left dirty footprints where he has walked. But the central four figures are also in a direct line of other contagion: as one man (modeled by the painter Willy Finch) coughs sputum at the face of the artist's sister Mitche, there is a pile of steaming feces located right below the bench on which they sit.

This odd grouping points to Ensor's class consciousness and seems to imply that the lower classes are a direct threat to the well-being of the proper Belgians in the center. A more precise translation of Ensor's title for this drawing, however, reveals Ensor's knowledge of recent discoveries about disease in the 1880s, and to new threats: Ensor's bannerlike title might be also translated as "plague below, plague above, plague everywhere."[11] Art historian Susan Canning has noted that Ensor's title, flying as a banner above the entire scene, is ambiguously, and typically for Ensor, rather mischievously placed. The "pest[s]," if interpreted to mean human carriers, might be *either* the hygieneless lower classes *or* the primly dressed bourgeoisie.[12]

The blame for disease by the 1880s could no longer be placed firmly on any one class, in fact: it could easily be detected in all of them.[13] Developments in medical research in the second half of the century had greatly increased professional understanding of disease which, due to the politicization of medicine by means of international congresses, was announced and discussed on an increasingly public stage.[14] This led to an explosion of new ideas, theories, and even treatments, about which the reading public, especially in cities with numerous papers seeking to publish the latest news, was well informed. Significantly, these discoveries occurred for both contagious and inherited diseases. In addition, medical discourse by the late nineteenth century paid increasing attention to mental as well as purely physical ailments. Critical to an understanding of the general reaction to disease at this time is, however, the fact that in the 1890s all of these aspects of illness – mental and physical, contagious and inherited – were recognized as interrelated. External symptoms of the mentally ill were studied, the course of syphilis as both a sexually transmitted and congenital disease was better known, while whole new diseases such as neurasthenia were diagnosed as conditions that linked inherited sensitive disposition with external stress, causing physical as well as mental symptoms. Finally, almost all of this new knowledge of disease (still far from complete, and in no cases producing a cure until the twentieth century) reinforced the realization that all were exacerbated by conditions of the city.

Thus for fin de siècle urbanites, life was a constant, often futile, but new kind of self-preservation, as they tried to avoid obvious sources of illness but now knew that many were not even apparent. This condition is well denoted in the myriad images in Symbolist art and literature of "death in the crowd." Rilke's Brigge, of course, sees *him* who is death throughout the city, often blending in with the crowd, smiling as if he is one of them, as in images by Ensor (such as in the *Self-Portrait with Masks*), or in Albert Besnard's etching "Death in the Crowd," of the same year, in which death appears as a dapper fellow wearing a knee-length overcoat and carrying a walking stick. As soon as one encountered a group of people, there was, lurking in the sick city, disease and death. As Verhaeren's 1887 poem about London concluded,

> And all at once, death steals through the crowded streets,
> O my soul of evening, this black London languishing within you.[15]

The dirty, dripping people in Ensor's "Peste" drawing harbor deadly germs that they casually deposit with their touch or breathe into the air. The untreated waste beneath the bench, although supposedly better disposed of at the century's end, was still in evidence in every European city.[16] But Ensor's two leisurely couples were actually just as suspect; they might well be already infected by venereal or other disease and possibly even in a latent stage in which no signs or symptoms were apparent. In addition, it might be the case that the city itself made one sick, for one could easily develop neurasthenia, a nerve disease brought on by the overstimulation of modern life.[17] Lastly, any one of Ensor's gathering – or perhaps all of them – might turn out to be a late-century "degenerate," a weak-minded and gene-tainted individual who, with others of this kind, signaled the overall decline of the European race. At any time, in any strata of metropolis society, one could encounter the sick city.

Artists' intrigue with illness was also very personal. Most had grown up with exhaustive family sickness and death common at that time; as young artists surviving into their twenties and thirties, they had evaded several of their own health crises but were haunted by their memories. Hodler, who had by 1889 (at the age of thirty-six) lost his father, mother, and all five of his siblings to tuberculosis, later explained, "It seemed that there was always a corpse in the house, and that it just had to be that way."[18] He summarized his own fear of death as a young man in *Night* (1890, Kunstmuseum, Bern), depicting himself as the central sleeper who awakens to discover a black-draped phantom of death upon him. Munch's many depictions of death and dying had their inspiration in the early deaths of both his mother and sister from tuberculosis, and he continued to be concerned that he had inherited the mental illness that he thought plagued his family. About his early image of his sister sitting on what would be her deathbed, he avowed, "there can be absolutely no question of influence on my Sick Child other than the one that wells forth independently from my

home.... Because I was not the only one to sit there, there was everyone I loved."[19]

The nineteenth century was one of epidemic disease: the bubonic plague was only finally described as an epidemic with a known means of transmission in 1898,[20] and fatal illnesses such as cholera and influenza were experienced as unexpected and uncontrollable attacks on whole populations, shared in waves of contagion. On the cover of Brussels's *Le Diablotin,* a satirical journal published by Symbolist-related artists and writers there, at the time of the Belgian epidemic of 1892, a hefty woman rushes down the street, trying to escape a bat with a woman's face; below the drawing, a caption reads, simply: "Cholera...on its way!!"[21] Many diseases were revisitations of ancient scourges; smallpox remained extant, and leprosy was still incidental in certain pockets of Scandinavia at the end of the century.[22] In some cases, inoculation for diseases such as smallpox, available throughout most of Europe since the late eighteenth century, was only addressed as a public health issue and distributed to the masses one hundred years later.[23] Mental illness seemed to be on the rise, while venereal disease, especially syphilis, had become as commonplace as the often blind and crippled children that it produced. While each disease had its own history of research and treatment protocol, the common flashpoint was its ubiquity and the feeling of total helplessness when faced by it. In the early 1880s, tuberculosis had been discovered to be caused by a particular germ: but this meant that, instead of being a disease that was either hereditary or caused by a predilection, it was seemingly unavoidable: it was in the very air. In the meantime, doctors' recommendations for how long syphilitics should wait before marriage varied between six months and six years after first symptoms.[24] While there was an effort (without any medical knowledge as its basis at that time and without beneficial effect) to prevent the spread of syphilis to partners, no one knew at all how to curb the rise of congenital syphilis. As more was known about disease, it seemed, there was only more to fear.

Ensor's *Plague Here, Plague There, Plague Everywhere* is, in its satirical attitude but especially by means of its very ambiguity, thus revealing of the anxieties about disease in his time because it demonstrates not only knowledge of, but also new fears about diseases and the people who might carry them. In addition, by the 1880s, new scientific instruments, including improved microscopes, made it possible to "see" a previously unknown, hidden world that encouraged both fascination and fear.[25] The mystery of unknown and intangible sources that cause real, physical pain and visual disfigurement, held a strong fascination for the Symbolists. The microbelike organisms that float through so many prints by Odilon Redon suggest the special allure of these unseen "beings." As art historian Barbara Larson has noted, Redon's 1890 print *On the Backdrop of Our Nights, God with His Knowing Finger Traces a Multiform Implacable Nightmare* suggests the wondrous but potentially deadly presence of infected dust surrounding the sleeper. Redon, who sent a complementary copy of his lithographic series *Les*

FIGURE 45. Advertisements from the Classified section of *La Réforme* (Brussels) no. 185, July 2, 1885. Photograph courtesy of Pierce Bounds.

Origines (1883) to his hero Louis Pasteur,[26] spoke of his fantasies as rooted in nature, so that he submitted himself to "the fatal rhythm of the impulses of the universal world which envelops [one]."[27] With 1870s findings about germs by Pasteur and others, and with 1880s discoveries of actual bacilli, such as the cholera and the tubercule bacilli isolated by Robert Koch, came new respect for diseases that to that time had been considered unknown acts of God. Thus the Symbolists' resort to interior spaces as either a comforting or a confounding correspondence to their search for an interior spirit was nevertheless subject to an uneasiness that came from the recognition of yet another, horrifying "interior" – the new world of microbes – all now known to exist in cramped urban spaces and even within the seemingly healthy body itself.

As Michel Foucault's study of the rise of the medical profession has suggested, this was a social as much as a scientific dominance,[28] so that medical and social discourses were increasingly embedded into each other. Dealing with disease required less the religious acceptance that viewed illness as a natural part of a divinely instigated cycle of life and more a societal responsibility, shared by patient and medical community alike. As doctors exercised increasing authority, in practice and in law, they gradually took responsibility for a deluge of complex social and medical issues, which were in many European nations called

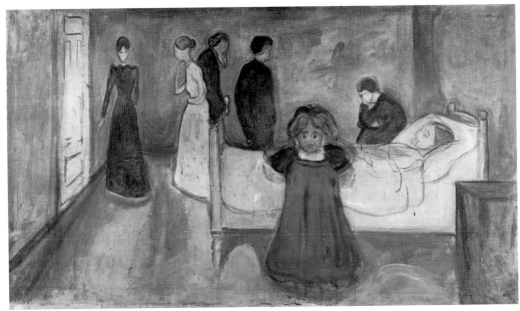

FIGURE 46. Edvard Munch. *The Dead Mother and Child.* 1897–9. Oil on canvas, 105 × 178.5 cm. © 2003 The Munch Museum/The Munch-Ellingsen Group/Artists Rights Society (ARS), NY.

"the Social Question." These included how research discoveries were made, announced, and disseminated, who was ultimately responsible for ordering and carrying out quarantines, the legality or morality of contraception and abortion, and even who should be liable for the care of orphaned or abandoned children, the aftermath of disease who were the future generation.[29]

By the late century, these medical issues had spilled out from the doctors' offices and into the street, and discussion of previously private medical conditions became banal. On the typical classified pages of the popular Brussels socialist paper *La Réforme* in 1885 (the year Khnopff wrote a letter to the paper)[30] (Fig. 45), an advertisement announcing cures for "overexcitement, diminished virility, enfeebling of the nervous system, maladies of the bladder, kidney, and the prostate, dropsy, etc. etc." was published alongside announcements for a folding screen, petroleum, and even, as we shall see in Chapter 5, coded notices for abortions. Above the name of "Dr. Richald" an ad displays dramatic bold and italicized lettering signaling "Urinary tracts" as the doctor's particular specialty. Every family had its medical stories, which they were increasingly willing to share.

Throughout the 1890s, Munch chronicled the family experience of disease and death in an extended series of drawings, prints, and paintings. Having in earlier works addressed the fact of illness in formal, institutionalized settings (an infirmary, a morgue),[31] he then turned as a Symbolist to the emotional and spiritual experience of death and dying. In almost all of these, the emphasis is on the survivors – the ones who have to grapple with the meaning of death.[32]

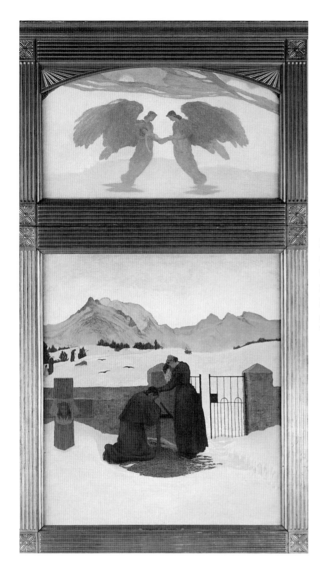

FIGURE 47. Giovanni Segantini. *Consolation through Faith*. 1896. Oil on canvas, 151/131 × 84.5/ 132 cm. Hamburger Kunsthalle, Hamburg. Freunde der Kunsthalle E. V. Photographer: Elke Walford, Hamburg.

In *Dead Mother and Child* (Fig. 46), the living family members (including the one man who behind the bed adopts the hunched position of melancholy) all assume poses that render them vertical, in stark contrast to the dead mother who lies in harsh horizontality on the bed. The rift between living and dead is further visualized by differences in color and mass: while the living are depicted with intense solid forms (including the woman in white whose printed dress offers some tangible weight), the dead mother and even the bed on which she lies are briefly sketched, pale and flat, as if already a disembodied presence in the room. This in turn makes Munch's juxtaposition of the mother's form with that of the little girl, in a bright red dress and with staring dark eyes, all the more compelling. Between the child and her elders, represented by the old woman

and man behind the foot of the bed, the now-deceased mother is the visible "missing" generation in the family tree,[33] a situation common to these times of rampant early death. Either depicted or implied in Munch's paintings of the dead and dying is that this experience is more spiritual than physical. Like the blind grandfather in Maurice Maeterlinck's 1890 drama *The Intruder* (who is Death), those attuned to the spiritual presence are able to experience death as an actual, fearful but palpable being.[34] In Munch's work, the doctor has done what little he could, the family has tried to make the dying one more comfortable, and it is now the metaphysical concept that really invades *The Death Room,* as Munch titled several of his works.

To these transcendental questions, with their underlying emphasis on the inevitability of death, each Symbolist brought his own personality and style. It is significant that those few Symbolist artists who devoted their imagery to country and peasant life emphasized in their death scenes not the details of the illness – and never the scientific, human attempts to remedy them – but rather the survivor's religious acceptance of the fact. In his early *Consolation through Faith* (Fig. 47), the Italian-Swiss painter Giovanni Segantini constructed a vertical diptych of a dead child being carried to heaven by angels while the parents mourn in a mountain cemetery below. As Segantini's title implies, these rural folk still dealt with illness and death, even of an innocent child, as a religious event, the will of God. But in Ensor's work, which often adopts the humor of traditional memento mori and *danse macabre* imagery,[35] a satirical eye is cast on the all too human inadequacies of late-nineteenth-century medicine. In *The Bad Doctors* (Fig. 48), five doctors, the models for whom were esteemed professors of medicine at the Free University in Brussels,[36] squabble over a patient who, with most of his intestines pulled out and lying on the floor, is going to die anyway. That this end is inevitable is clear not only in the display of the nastiest of medical tools – including a saw, bloodstained knives, and still dripping sphincter – but also in the doctors' comportment, or lack of it, as they jostle with one another, tripping over the intestines that entwine several of their legs and as one manages to pickpocket the other. That such misdeeds are a regular part of the medical profession is implied by the spilled open notebooks and ledgers of the doctors that lie in the front of the composition. These read:

> "I made a mistake/nothing to give to P"; "Received 1000/Good client/Should take my time on this/Woman C croaked at seven o'clock"; "Dispatched X/Nothing received/Waiting for Z"; "I left a sponge in/the stomach/Peritonitis broke out."[37]

Death, smiling, enters the "surgery." Painted immediately after the cholera epidemic that struck Belgium in 1892,[38] death here shows the strains of a busy year, wearing a togalike outfit that has been patched, with a (still-fleshed) foot that

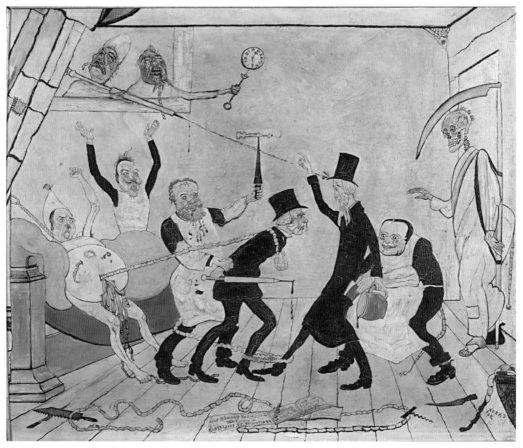

FIGURE 48. James Ensor. *The Bad Doctors*. 1892. Oil on panel, 50 × 61 cm. Collection of the Free University, Brussels. © 2003 Artists Rights Society (ARS), New York/SABAM, Brussels.

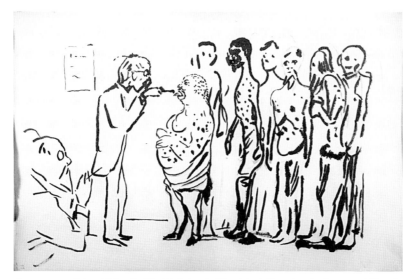

FIGURE 49. Edvard Munch. Untitled sketch (Physician's Examination). c. 1907? Sketchbook T 139. © 2003 The Munch Museum/The Munch-Ellingsen Group/Artists Rights Society (ARS), NY.

is bandaged, and carrying a shoulder-strapped bag that drips more intestines, presumably the untidy leftovers from the previous victim. In this as in so many of Ensor's works, the usual Symbolist "style" of suggestion is heavily laced with satire. Using the well-known doctors as stereotypical medical figures (rather than as portraits carrying specific complaints against them), Ensor emphasized his biting characterization of the seeming uselessness of contemporary medicine by means of "sick"colors and shocking contrasts.[39] Against a sky-blue backdrop of wall, the figures appear as cutouts in black and white, while the patient's bedding seems to rise around him in angry colors of off-red and orange. The painting itself is, like most Symbolist works, highly manipulated but here caricatured to the point of distortion, a precursor of later Expressionist and New Objectivity social satires.

Finally, in the urbanite Munch's work, the mundane, unidealized and even dehumanized existence of patients in a city clinic became the means of making tangible the netherworld of the sick. In an undated sketch (Fig. 49), Munch depicted a motley lineup of patients, each being seen in herd like fashion by one doctor while at least one other observer looks on. The men, stripped to underwear, range in figure types from severely emaciated to a heavy "fat cat" – a type often used by Munch to represent the lustful capitalist. They wait in line for their examination, which seems to be restricted to a study of the fat gentleman's mouth. Even this care seems useless, however. Each of the patients is covered with spots over his entire body, exhibiting signs of smallpox or syphilis, contagious diseases that they now present well beyond the initial stage. At the end of the line stands death himself, smirking at this humiliating and ineffectual clinical procedure.

This latter understanding of the city's mishandling of sick masses was shared by Rilke's hero Malte Laurids Brigge, the young visitor to Paris whose startling analysis of faces worn like masks was recounted in Chapter 3. Brigge actually introduced the city in the very first sentence of his presumed "notebooks" as a locus of illness:

> So this is where people come to live; I would have thought it is a city to die in. I have been out. I saw: hospitals. I saw a man who staggered and fell down. A crowd formed around him, sparing me the rest. . . . The map had marked Val-de-grâce, Hôpital militaire. . . . The street began to smell from all sides. It smelled as far as I could distinguish, of iodoform, the grease of pommes frites, fear. . . .
>
> . . . That is simply what happened. The main thing was, being alive. That was the main thing.[40]

Soon, the sick city becomes more personal for Brigge:

> I was afraid. One must take some action against fear, once one has come down with it. It would be horrible to get sick here, and if

someone thought of taking me to the hospital, I would certainly die there. . . . This excellent hospital is very old, already in the time of King Clovis people were dying here, in a few beds. Now there are 559 beds to die in. Like a factory, naturally. With production so enormous, each individual death is not carried out very carefully; but that isn't important.

It's the quantity that counts.[41]

When Brigge himself must seek a cure for his overwrought nerves, a condition that has developed only since his arrival in Paris, he is sent for electrotherapy to no less a clinic than the Salpetrière (where Doctor Charcot, famous for his hysteria studies, had practiced). This process, with its relegation to the public waiting room, reinforces his recognition that, in Paris, he has now been branded as one of the nameless sick:

> There was a wooden bench in front, along the whole length of the wall, and on this bench they were sitting, who knew me. Yes, they were all there. When I had gotten used to the dim lighting, I noticed . . . these people sitting shoulder to shoulder on an endless line. . . . The air was foul, heavy, filled with clothing and breath. . . . It occurred to me that I had been directed *here,* among these people, to this overcrowded public waiting-room. It was so to speak, the first official confirmation that I belonged to the category of outcast.[42]

After waiting hours, Brigge is interviewed by several doctors, all in a hurry; he is returned to the waiting room to be called for a treatment, but he can no longer stand the sights, the stench, and the screaming. He leaves the hospital running.

In Munch's *Women in Hospital* (1897, Munch Museum, Oslo), Brigge's horror of anonymous mass medicine is visualized. Three women stand, stripped to the waist, with stooped shoulders and stilled poses that emit both pain and boredom. The main figure, completely nude, is the only one with an articulated face, and she allows the viewer to see the apathy of her demeanor as she paces like a caged animal in the common waiting room.

As huge numbers of illnesses came to be treated in increasingly public ways, it was society itself that was seen as sick. Often, critiques were voiced by members of the upper and middle classes, aimed at the lower classes. Only in the 1880s was attention paid to the scourge of tuberculosis that had overtaken miners: the fact that these were the very people who had at the same time begun to call strikes, which were violent at times, only lent to the air of anxiety that now surrounded them. The quasi-scientific study of lower-class crowds had its basis in political and social upheavals that encouraged further understanding of the working class as a means of knowing as much as possible about a potential enemy, and the terminology of this crowd study was etymologically peppered with the rhetoric

of disease. Nineteenth-century historians Hippolyte Taine, Gabriel Tarde, and Scipio Sighele all wrote about the "insanity" of crowd behavior;[43] Taine in particular built up a pathology of the crowd and even suggested that there was a "germ" that might allow the crowd's "passion" to spread unchecked if it were not governmentally (and one suspects medically) controlled; he called this the "law of mental contagion."[44]

But a dread also developed of those in the middle and upper classes who led secret debauched lives, leaving in their wake a progeny that was physically and morally impoverished. The practice of eugenics – a term deriving from the Greek *eugenes* ("well born") – stemmed directly from these fears. The movement's founder, Sir Francis Galton, cousin of Charles Darwin, combined his belief in Darwin's natural selection with nineteenth-century theories of heredity, and advocated eugenic marriages and "breeding" of a new, stronger race. In this way, eugenics joined other protest movements, including feminists and public health organizations, in social hygiene reform.

Lastly, because the final quarter of the nineteenth century was also the time of vast growth in the new tourist industry, that population too became suspect. Even as government and businesses worked to encourage tourist income, fears of these strangers – now suspected to carry disease with them – began to arise. In the early 1890s, Albert Trachsel joined other artists in Geneva who railed against the new cog railways that were increasingly clogging the mountains and bringing with them hoards of tourists.[45] At the turn of the century, however, Trachsel added to his tourist nemeses the thousands of patients who thronged to Switzerland for its famous Sanitoria. By 1912, he complained bitterly about the fact that Switzerland had become, despite the objections of others like him, "a giant hotel, a giant hospital, or a giant sanitarium."[46]

Ensor's *Plague Here, Plague There, Plague Everywhere* therefore offered con-flicted indictment of both the lower classes with their filth and germs and the upper class with their ability to travel and carry further their own, at times im-morally gotten, infections. The ignorance of Ensor's framing figures is matched by the complacency of the two central couples,[47] and both classes were recog-nized to be most dense and dangerous in the cities.[48] As inheritors of one of the most slum-ridden aftermaths of the Industrial Revolution, London Victorians produced the first real study of this correlation, in Edwin Chadwick's *Inquiry into the Sanitary Condition of the Labouring Population of Great Britain of 1842*, which spelled out in unforgettable detail the filth, poverty, and illness of that time. Chadwick's classic treatise was one of the first to use comparative death rates as well as lurid description to make his point regarding the role of over-crowding and unsanitary conditions in disease. Although in England this report led to the establishment of the Board of Health in 1848, decades passed in other European countries before increasing fears would accomplish similar results.

The latter reforms were related to a spate of influential studies, such as that published by George Hansen in Munich in 1889, which argued for the

superiority of country born and bred citizens as a condition for national health and military strength based, he claimed, on firm statistical evidence. According to Hansen, the city was slowly engendering its own decline, inevitably ending in social death. First, he established that the city-born lived in the poorest quarters of the city while the country-born populated the wealthiest. Second, the city-born worked in lowest occupations and thus maintained the lowest classes. Third, born urbanites constituted a large portion of the population's degenerates (identified as criminals, lunatics, and suicides). Fourth, cities with lowest rates of natural (internal) increase, accomplished this because of a deficit of healthy births.[49]

Summarizing only ten years later the entire century's distrust of dark, dank, and dense cities was Adna Ferrin Weber's statistical analysis of population in western Europe. Weber's study, a "classic pioneer work," set the standard for scientific statistical studies.[50] Weber was perhaps rightly critical of those who had analyzed the same conditions before; for example, he called Nordau an "extremist" for his claim that the growth of cities had increased the proportionate number of degenerates in the last half of the century.[51] Weber was also critical of prior statisticians who jumped to assumptive conclusions, correctly pointing out the many flaws in Hansen's earlier statistics.[52] And yet he thoroughly agreed with Hansen's conclusions defending country against city. He even worried, as Hansen and Nordau had, about the future health of the race, agreeing that this was due to more than mere physical frailty. In the chapter titled "Physical and Moral Health of City and Country," Weber concluded that his study of death rates had clearly established what so many previous commentators had intimated:

> This life of the great cities is not the natural life of man. He must under such conditions deteriorate physically, mentally, morally. . . . That the townsman on the average is shorter-lived than the countryman is incontrovertibly established; and it is commonly believed that the city man is also less healthy, vigorous and capable, both physically and mentally, than the countryman. In short, cities are the site, and city life the cause, of the deterioration of the race.[53]

Weber borrowed from another predecessor, G. B. Longstaff, the colorful description of the sickly city dweller:

> That the town life is not as healthy as the country is a proposition that cannot be contradicted . . . the narrow chest, the pale face, the weak eyes, the bad teeth of the town-bred child are but too often apparent. It is easy to take an exaggerated view either way, but the broad facts are evident enough; long life in towns is accompanied by more or less degeneration of race.[54]

Weber elaborated on this notion with specific statistics to back Longstaff's claims, including his finding that insanity was an illness that "prevails chiefly in cities"[55] and that even physical stature was already showing the deleterious effects of city life: "[The height of men in] the city of Hamburg is below the average for Germany, Geneva below the average for Switzerland, and Madrid has almost the shortest male population in all Spain."[56]

Weber concluded by calling city slums virtual "death-traps,"[57] and thus ended his clinical statistical study with an impassioned plea for legislation for cleaner water, good paving, drainage, and generally improved city conditions.[58]

Reform measures were therefore on most city planner and legislative minds in the 1890s. The age-old metaphor of the city as body – an organism whose traffic and transportation patterns were represented as veins and arteries, whose inhabitants represented inner organisms, and which could become diseased socially and politically as easily as physically – became newly, scientifically appropriate. In the twentieth century, this metaphor would change from bodily terms to those of nuclear and atomic science, from biology to physics as an indication of the switch from organically intact readings of the city to new recognition of its inability to function as a whole.[59] In the 1890s, however, there occurred the apex of the biological metaphor, but a negative one, presenting the city itself as a diseased body. As we shall see in Chapter 7, Rodenbach provided the most well-known example in his novel *Bruges-La-Morte,* in which the town of Bruges became for Rodenbach's hero a transmogrification of his dead wife: its clogged canals appeared to him to be her diseased arteries. Thus, by the 1890s, the European metaphor of the sick city was almost complete. As this idea, along with the new knowledge of germs carried in water and air, became widely accepted, however, one of its primary consequences included city planning that sought to "cure" the sick city. In the latter quarter of the nineteenth century, most European cities underwent revision to allow greater transportation traffic, as noted in Chapter 3, but also attempted the rebuilding of antiquated water supply systems and sewage disposal, while emphasis was put on green city spaces to allow for air circulation.[60] Trachsel's nativist booklet of 1912 still carried suggestions for new Swiss handling of the water supplies, remaining critical of the practice of damming natural streams for industrial hydro that created an easy breeding ground for typhus.[61]

But recent city upgrades seem not to have dimmed the metaphoric power of the sewer; rather it only made the problem of waste obvious to artists and their viewers. The historian Donald Reid, writing of the consistency of the sewer as a symbol in late-nineteenth-century literature, has pointed out the oddity of this timing, in that "the long-standing meonymic use of sewer for filth . . . [occurred] at precisely the time when open and overflowing sewers became things of the past. The sewer's improved capability to concentrate urban waste ironically enhanced its attraction as a signifier for all that was rotten and fetid in modern society."[62]

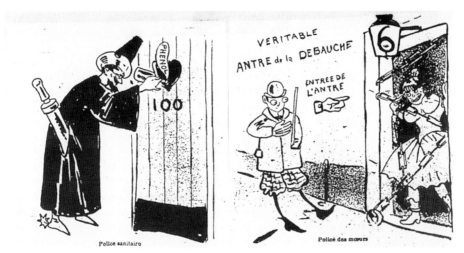

FIGURE 50. "Sanitary Police" and "Morality Police." Caricature in *Le Diable au corps* (Brussels). February 25, 1894, cover. Photograph courtesy of Pierce Bounds.

One of the most interesting examples of city planning in the 1890s, typical of a tertiary capital city, was Geneva. Switzerland had one of the most agrarian European economies in the nineteenth century and was the slowest of Western nations to move toward urbanization of industry. Nonetheless, there was by the 1890s an increased growth of city population. According to Weber's 1899 study, this growth came mainly to towns of over 10,000 people, and jumped from 9.4 percent of the population living in such areas in 1850 to 16.5 percent by 1890. In cities like Geneva and Zurich, with populations over 10,000, the growth was more significant, expanding from an average population of 24,600 in an 1822 census to 480,388 by 1888.[63]

In 1896, when the Swiss National Exposition was held in Geneva, the Swiss celebrated their conservative nostalgia with a "Swiss Village" on the outskirts of the exposition area, but they also heralded the future with a new city water system.[64] This bifurcated approach was telling because both the folk and water celebration fed directly into Swiss desires for a healthier future, especially in their cities. At first, the suggestion that an entire Swiss village complete with live cows, a constructed waterfall, and even fabricated Alps – in conjunction with an already cosmopolitan Geneva[65] – was derided. But it turned out to be a grand success,[66] doubtless in great part due to its already sentimental appeal for the many urbanites who were chief contributors and visitors to the fair. Longing for a simpler life, plainer politics, and important nationalistic associations with "authentic" peasantry, city dwellers by means of these connections accepted the fact that village life, even while ironically re-created in Geneva, was indeed healthier than their own. The other star of the exposition, the water system, was an equal success and also played to the citizens' acknowledgment of the need for urban hygiene; for the Geneva show, a special bridge had to be constructed over

waterways to allow fair-goers' viewing, and this spectacle drew crowds.[67] Thus the image of healthy nature was located right in the city (in the "Village") and was now running by means of pipes and paths through the city; both health ideas had been transformed into visual imagery for easy consumption. Significantly, many Symbolist artists, writers, and musicians took part in this festival. Albert Trachsel even proposed a "[P]roject for an enlargement of the city of Geneva" that was intended to make Geneva more like Paris, or the new Brussels, with straight, planned boulevards leading to new public centers.[68] His plan, one of the few practical proposals for city improvement ever submitted by a Symbolist, seems never to have been seriously considered. In the next few years, however, he responded more symbolistically, drawing an ideal city in his *Fêtes Réelles*. Trachsel's *Fêtes* was completely idyllic, however, conspicuously unpopulated, and constructible only on paper and in the dreamer's mind.

Meanwhile, Brussels – the city in which Ensor did most of his exhibiting – endured ongoing but typical controversies over public health, sanitation, water supply, and prostitution,[69] with regular references to these issues in visual form. In one caricature, the "sanitary police" and the "morality police" are only two of several measures suggested to get some artists in Brussels to "clean up" their art (Fig. 50). Ensor's own self-portrait as "The Pisser" (1887, etching), following in the scatological traditions of northern art and literature as well as mimicking the city's own "hero" Manneken-Pis,[70] must be appreciated also in light of the continual public discussion of waste and water.

While Ensor acted out his unhygienic response to municipal authorities as "The Pisser," Trachsel imagined a perfect city without people; Segantini moved from Milan into the Swiss mountains, and Gauguin remained in Tahiti. The vast majority of Symbolists, however, continued to address the sick city, known to them all too personally. But in a Symbolist work, individual and narrative underpinnings of the traditional illness depiction – telling something of the victim, the family, or even symptoms of the disease – are often suppressed to evoke more fully the issues and even concept of disease, as well as the intangible yet very real presence of death itself.

VISUAL CODES OF DISEASE

Thus underlying notions about the sick city in the late nineteenth century gradually found their way into visual codes. The presentation of these codes may well have been subconscious on the part of artists, yet they were readable for Symbolist viewers, especially those who lived in the same metropolitan areas. Symbolist art offers constant commentary on the sad state of affairs in the sick city and also proposes evidence of the engagement of Symbolist artists with medical discourse. The idea that the body was a mass of signs, and the assumption that every body could therefore be read (or multiply read) had its basis in ancient illustration but

was given new authority in the nineteenth century, observable in medicine's concentration on phrenology, physiognomy, and public illustrations.[71] Symbolist artists therefore sculpted, adorned, or marked the bodies in their art with codes as contributing signifiers to their compositions as a whole. To understand the full significance of these embedded meanings, three different "codes" of body appearance will be charted. First, there was the development in the second half of the nineteenth century of the ethereal figure, portrayed with a slender body, pale white face, and burning bright eyes. This figure usually appears alone or in a small group of like figures, and represents a higher world. Second, there was the syphilitic figure, emaciated and often disfigured, who evinced nonetheless the sexual appeal that had led an amoral victim to an ignominious death. Lastly, there were the "street people," the degenerate, unsound and unhealthy beings who most often appeared in droves, like the animals they presumably resembled, but who represented the real-life inhabitants of the sick city. What is remarkable about these different codes of appearance is, however, that all three are based on notions of specific sicknesses. The first is an inverted code of consumption (the nineteenth-century term for tuberculosis) that proposes the idealized and romanticized symptomatic appearance of the tuberculosis victim as an ethereal type. The second code arose from social mores rather than medical realities, and even applied a gendered (female) blame for illicit and diseased sex. The third code was based on current notions of degeneracy, and especially the city dweller as moral degenerate.

TUBERCULOSIS AND "BEAUTIFUL DISEASE"

A prime example of the first code – referencing ethereality by means of a "consumptive" figure – is Ferdinand Hodler's *The Consecrated One,* completed in 1893–4 (Fig. 51). Here, six svelte angels hover over an extremely thin, frail child. The huge painting was intended for exhibition in Paris, and reveals the strong influence on the artist by the Parisian Salon de la Rose + Croix, with which he exhibited in 1892 and 1893. Carlos Schwabe's *Rose + Croix esthétique* poster (Fig. 52) printed for the first exhibition in 1892, had already set the consumptive model for the many French as well as foreign artists involved in that society. Echoing the tall, slender shape of the poster itself, two immaterial, lithe figures ascend the stairway to an ideal world, leaving behind a lone figure, still chained to this world and mired in the dark waters of materialism. Already pale, these rising women are so bathed in light that the guide figure seems to be "fading away" – a common platitude for the final wasting stage of tuberculosis, which had the advantage of a connotative crossover to nostalgia's wasting sensitivities. Hodler's work, although related in theme to several of his earlier compositions, introduced a new body type closely resembling that of Schwabe, and one that he would have also seen in earlier Rose + Croix exhibition catalogues.

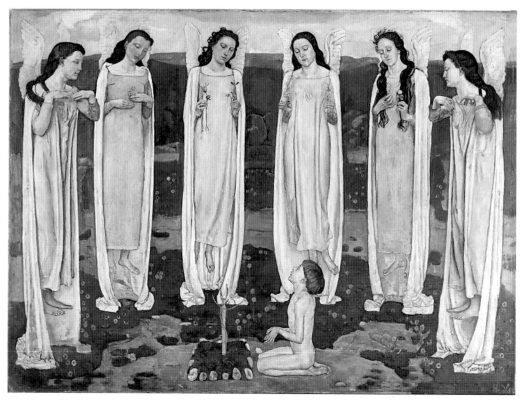

FIGURE 51. Ferdinand Hodler. *The Consecrated One*. 1893–4. Oil and tempera on canvas, 219 × 296 cm. Kunstmuseum Bern, bequest of the Gottfried Keller-Stiftung.

The composition, for example, is related to that of Alexander Séon's *Perfume of the Flowers* (Fig. 53)[72] included in the 1892 exhibition and reproduced in the printed catalogue. From such sources, Hodler borrowed not only poses and compositions but also, as is clear in Séon's figure types, thin Rosicrucian physiques.

While *The Consecrated One* – with its pastel colors, delicate lines and thin forms – was appreciated by the French as well as those Geneva supporters with clear Parisian connections, it was seen as sickly by Swiss-German critics. When the painting was first exhibited in Geneva and Paris in 1894,[73] Hodler's Swiss friend Mathias Morhardt, living in Paris as a Symbolist writer and providing art critiques for that city's *La Semaine Littéraire,* devoted most of one review to the work, describing the child as having "an emaciated nudity shivering in this inhospitable landscape" and identifying the canvas as establishing Hodler "among the modern masters."[74] Many of the French critics interpreted the child as Christ, or at least as divine;[75] Paul Gsell, in *La Revue parisienne,* praised the scene, describing it as "a dead child surrounded by angels."[76] Finally, one reviewer for the *Genevois* actually noted the connection to Schwabe, but suggested that Hodler could not match the frail beauty offered by his fellow Genevean now living in Paris. "Symbolism for Symbolism, we prefer those of

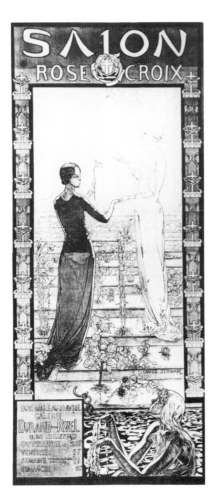

FIGURE 52. Carlos Schwabe. Poster for the First Salon de la Rose + Croix. 1892. Lithograph, 199 × 80 cm. Collection of Marla H. Hand and Jim T. Nyeste.

Mr. Carlos Schwabe, who draws heads and bodies more graciously emaciated and more suavely impalpable."[77] Thus Parisian-based readers of Hodler's painting all read the overstated thinness of Hodler's figures as a sign of other-worldliness, and even of divinity. As we shall see, such correlation of these markers of disease with ethereality was directly related to assumptions about illness in the city.

By contrast, the only review written that exhibition year by a Genevan living in Switzerland is instructive because in this case the slender figures were considered slightly ludicrous, and furthermore related to the evils of Symbolism and the art of Paris. The author here suggested that these figures, which seemed to have lost their life, were overstated. It was humorously remarked that because the poor child of *The Consecrated One* was so naked and so thin, he *must really need* those six angels: "three couturiers and three good cooks." Following this, however, the reviewer called Hodler's recent "mysticism and Symbolism" a "dangerous game," while calling him a "good Bernese" gone wrong.[78] By citing Hodler's roots as farm and country boy ("Bernese" here referred to the Bernese

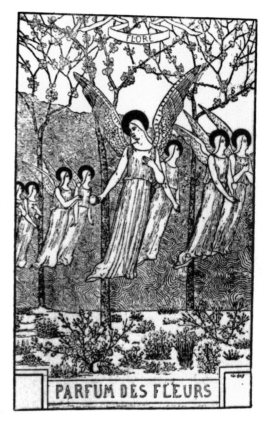

Figure 53. Alexander Seon. *Perfume of the Flowers*. 1892. Illustration to the catalogue Salon de la Rose + Croix esthétique, 1892, plate 53.

Oberland, rather than to the city of Bern), and by claiming that his turn to Symbolism – especially in this huge, made-for-Paris painting – was not only wrong but dangerous, the Geneva critic established a level of attack that would soon be taken up by other Swiss.

In 1895, a critic from Bern was even more explicit in denouncing Hodler's Parisian and unwholesome ways. Writing of Hodler's frail child motif, this anonymous reviewer professed that she or he had had enough of these "Rosicrucian seizures of modern Decadence," especially from an artist who had painted "the powerfully muscular Swiss wrestlers," a reference to Hodler's award-winning painting of 1882, in which heavily muscled athletes fill the canvas. That this Swiss-German writer knew of the Rose + Croix and had read the coded figures as related to 1890s diseases, was evident in a final tirade about Hodler's painting.[79] Here, it was suggested that Hodler must have been overcome by the "neo-Catholic, consumptive anachronisms [dreamt up in] the absinthe-drunk brains of Parisian artistic candidates for the nerve disease clinic." The critic thus managed two diagnoses. The Parisian artists were decadent "nerve" patients presumably suffering from city dwellers' neurasthenia, while Hodler's figures themselves were "consumptive." Ultimately, Hodler was urged to abandon this "hospital art" and to remember his "good Swiss blood."[80]

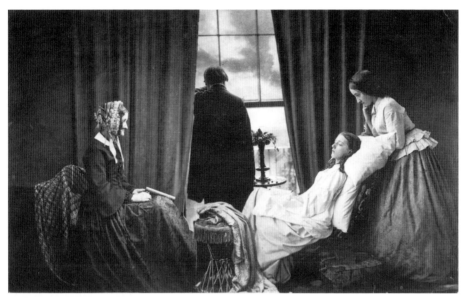

FIGURE 54. Henry Peach Robinson. *Fading Away*. c. 1880. Composite photograph, Albumen Print. Courtesy of George Eastman House.

Trachsel's concerns about sharing Switzerland's fresh mountain air must be remembered here: the area attracted not only tourists but also patients to the baths and sanitoria, especially for tuberculosis.[81] For the Swiss who were about to celebrate their National Festival with a dual homage to new water hygiene and healthy village life, the Parisian style of slimness – perhaps especially when used to signify divinity – was a sign of pathological urbanity.

By virtue of these differing critical responses to the same visual symbol, Hodler's painting also exemplifies the difficulties encountered by numerous Symbolist artists who, while continuing to live in their native cities, so often sought exhibition success in Paris. Hodler had declared already in 1887 that his goal was "to be known in Paris,"[82] and he believed that only by this route would his reputation in provincial Switzerland be secured. But Hodler's Swiss critics, by focusing on his Parisian "hospital art" seem to have missed the optimistic point of this painting. By means of the child posed before an iconic life tree enclosed in a tiny garden, and the guardian angels who carry bulb flowers in their hands, the painting presents a multileveled message about the coming of spring, youthful promise, and spiritual redemption.[83] But until the Swiss critics pointed it out, Hodler seems to have been unaware of the irony of using ill-looking figures to symbolize healthy physical and even spiritual growth, let alone the conflicted reference to nature's revivifying powers by means of sickly city conditions.

For while Hodler's use of the "code of consumption" to establish ethereality seems clear in this composition, it is also true that he, like many other artists at the time, may well have simply borrowed the svelte style without being fully aware of its disease derivation. What Hodler had seen in the Rose + Croix

catalogue were typical works of that salon, which featured delicate figures based on Pre-Raphaelite models. Fernand Khnopff's elegant forms followed the example of his friend Burne Jones and were in turn beloved by Péladan, the Salon's founder. They served as one of many direct links between Pre-Raphaelitism and Symbolism, especially in Paris, for the code's immediate transferal. Dante Gabriel Rossetti's work in particular was well reviewed and well known in Paris; by the 1880s his reputation was matched by that of Burne Jones, whose thin, pale, and subservient women appealed to French aesthetic tastes.[84]

The visual source for this "code of consumption" had actually been invented in earlier depictions of tuberculosis itself such as *Fading Away,* a photograph by Henry Peach Robinson (Fig. 54). Robinson's work was typical of pictures that were so popular by the third quarter of the century that Munch called it the "pillows time... the time of sickbeds and of quilts."[85] In these depictions, a contrast is usually suggested between the healthy attendants whose animated faces glow with "color," and the victim's paler, emaciated beauty. As in *Fading Away* – where the patient is framed by a window leading to "another world" – the consumptive's destiny to enter soon a higher life and a world to which they are more suited, is suggested. In addition, subtle ameliorations to figure and scene highlight the victim's appeal, while at the same time hide any of the uglier, often disturbing signs of consumption: no blood stains the pillow, and the patient (almost always female) is shown languidly at rest, offering no evidence of painful or distortive wracking coughs. If these young women were, in fact, suffering from pulmonary tuberculosis, then it is the early and slowly degenerative aspects of the disease that are seen here. These visual depictions of the disease, furthermore, record not only the code of consumption, but also the early stage of the illness when the patient herself was most likely to believe in it.[86] Robinson's 1858 composite photograph was one of the first of his famous moralizing pictures and set the standard for sentimentalized Victorian images of death and dying, especially by the "beautiful disease" of tuberculosis.[87]

The basis of this reductionist code has been traced to Romantic literary depictions of tuberculosis victims in the first half of the nineteenth century.[88] Here, there evolved a notion that one "caught" tuberculosis because one was destined for it. According to this supposition, the perfect candidates for consumption were individuals who were so refined and so sensitive that normal life was beyond them. Romantic depictions defined the disease as spiritualizing, taking over the body in a "strange and exciting seduction" that implied that the victim was either inherently – or made by the disease to be – sublime.[89] In her study *Illness as Metaphor,* Susan Sontag refers to Schopenhauer's claim that "the presence of disease signifies that the will itself is sick" and suggests that this creative, causal theory for tuberculosis evolved from the idea that the "disease fits the character" (of the patient) to the "disease expresses character."[90] This in turn insinuated that writers, artists, and musicians were more likely to get

tuberculosis than, for example, a baker or a miner, lending additional glamour to the consumptive image. What the Greeks originally called *spes phthisica* – the nervous energy erratically enjoyed by tuberculosis victims – was seen by romantic writers as enhancing intellectual and especially creative achievement.[91] Historians Rene and Jean Dubos identify this creative cause, or what might be termed the "character predilection," as the most commonly held view of tuberculosis in the nineteenth century, and cite examples found in the literature of that time. But in some of these literary descriptions can also be found hints of a visual "look" for tuberculosis: pale, quiet, thin figures became a new ideal, while the contrast of emaciated bodies and burning eyes signified an inner, spiritual fire,[92] as eventually adapted to Hodler's *The Consecrated One*.

Hodler's painting was therefore typical of Symbolist works using this consumptive code in images that were not really about disease. For example, most depictions of comely consumption also carried implications of class: it is the middle and upper class, believed to be able to afford such spiritual leanings, and not the working class, that suffers so quietly and so beautifully. In addition, the code of consumption could be readily applied to images about the status or role of women. The coalescence of the nineteenth-century patriarchal ideal of the submissive woman with delicate beauty and illness as paired representatives of "a weakness of the feminine body" has been recognized in several studies.[93] As historian Lorna Duffin has nicely summarized, "The image of the perfect lady, in time, became the image of the disabled lady, the female invalid. The agent of conspicuous consumption [in Victorian times] became the conspicuous consumptive."[94] The basis of this image was the ideal of woman as embodiment of both leisure and weakness, and therefore uselessness, with an underlying rhetoric of illness. Given the evolution of the code of consumption in the nineteenth century, it is not surprising to discover that tuberculosis would be the disease of choice for such combination with male-preferred female beauty and subjection (and a "fading away" of any real identity on the part of the victim). As such, this code of consumption was essentially the opposite of the cholera aesthetic that had developed around the epidemic of 1832 and fueled Romantic associations of the grotesque with artistic imagination.[95] As cholera was politicized as a working class disease, it was thus related to the aberrant: to imagination rather than spirituality, and to repugnance rather than an ideal (and was therefore exemplified overwhelmingly by men), as victim, genius, or both.[96] By midcentury, however, the code of consumption had not only commingled with its own "sister" constructions such as delicate beauty and female subordination; it could also be completely inverted, to denote the concept of spirituality itself.[97] Originally intended as a signifier of the "beautiful" death, the code of consumption persisted in many Symbolist works through the turn of the century, implying not the presence of disease but rather the empyreal character that was believed to have caused it.[98]

This code of consumption might have changed, however, with the 1882 announcement by the Berlin physician Koch proclaiming the discovery of the tubercle bacilli and proving, finally, that the disease was caused by germs rather than by heredity or inner nature. For those accepting Koch's discovery (for example, Ensor in *Plague Here, Plague There, Plague Everywhere*), the notion of tuberculosis from an upper-class, artistic "passion" shifted to a lower-class disease of filth. In his print *Exterminating Angel* of the following year, Ensor proposed death as a germ dispenser, a scruffily bearded angel riding a horse and brandishing a sword who soars above the masses below. While this image may carry vestigial references to the apocalyptic tradition, the angel in Ensor's print seems to spew behind it small particles into the air. These infective agents in turn are greeted below by naked figures squatting and defecating, even as they raise their arms in greeting to death above. In most European minds, tuberculosis now joined epidemics like cholera as ugly diseases, to be fought in campaigns promoting containment and denouncing poor hygiene, rather than to be emulated in works of art. Finally, it was possible by the late century, for the appealing female tubercular to appear dangerous, if she was sexually attractive enough to hold the promise of procreation: in this case, understanding of the disease behind the consumptive beauty made thoughts of reproduction repugnant.[99]

Intriguingly, this response was *not* mirrored in Paris, where Symbolists continued to portray the ideal (and, notably, de-sexed) ethereal being as a woman with consumptive beauty. The code was maintained, in other words, despite that city's early lead in the treatment of tuberculosis, and despite the fact that a Parisian physician and researcher, Jean-François Villemin, had already in 1867 proposed a germ theory for tuberculosis.[100] But while Villemin battled the French Academy for years to have his theory of a contagious agent accepted, Koch's later confirming discovery of the bacillus itself was presented in a public forum and celebrated as a national victory. As Villemin lamented in a letter to Pasteur: "Twenty years [of my work] have passed and all this has become merely ancient history! Koch's bacillus, of which the Germans are so proud, has obscured the memory of what the French scientists had already accomplished."[101] Given the extent to which Koch was deplored in post–Franco-Prussian War France, it is not surprising to discover that the French fight against tuberculosis as a contagious disease actually slowed, while images maintaining the consumptive body as an ethereal symbol continued in French and Francophile Symbolist art.[102]

At the same time, a book written about Segantini reveals that the old "code" had not been given up entirely in other Symbolist pockets of activity. Italian author Luigi Villari in a 1901 book could still describe an emaciated figure in the painting *Vanity* (*The Source of Evil*; 1897, private collection) as "a nude figure of the most exquisite grace and charm."[103] In the same book, he also invoked the code in its opposite application – assuming that health and weight in figures imply a lack of spirituality. Addressing Segantini's *The Fruit of Love*,[104]

a painting that, with its robust mother and child, would by that time be worthy of healthy admiration, Villari concluded that "there is in the figure a suggestion of stoutness which prevents it from being truly graceful . . . the child, moreover, has nothing ethereal about it. It is much too sleek and well; it is merely a jolly fat baby."[105]

To return one more time to the example of *The Consecrated One,* it is ironic that Hodler was probably unaware that his extraordinary thin figures of the early 1890s stemmed from images of tuberculosis, for he had suffered enormous family losses to that very disease. In *The Consecrated One,* Hodler therefore posits his son Hector as a consumptive alter-ego image, as one who might prevail and outlive the scourge of tuberculosis that was still ravaging late-nineteenth-century families. Paradoxically, Hector survived his father by only three years and died, in 1921, of tuberculosis.

SYPHILIS AND "MORAL DISEASE"

While connections between tuberculosis and the young woman were spurred by romantic and paternalistic associations of pale female beauty with death and dematerialization, other correlations made between women and another disease, by many late-nineteenth-century men and certainly by the conservative male Symbolists, were even more condemning. This disease was syphilis, an ancient illness that had, nonetheless, a sparse history of attention, from doctors, writers, and artists alike. As historian Claude Quétel correctly notes, it is surprising, in light of the epidemic proportions of the disease in the nineteenth century, to find little mention of it in the masterworks of social realism, yet it is central to the Symbolist movement, "petrifying the writer and mirroring his own modernity to him."[106] I suggest that the reason for this was that syphilis had become, only in the mid-1880s, a public issue. In this decade, the British Contagious Diseases Prevention Acts of 1864 (focusing on venereal disease) were vociferously argued against, in highly publicized forums. In France, the leading specialist on syphilis, Philippe Ricord, was finally recognized only toward the end of his life; in 1886, he headed the Academy of Medicine's first commission to study prophylactic measures against venereal disease. The first wax-work museum including syphilitic specimens along with dermatology examples opened in 1889.[107] The terms "syphilology" and "syphilologist," coined in the 1840s, only received official approval and usage in the 1880s, and the First International Congress on Syphilis was held in 1889 (in Paris), with the First International Congress on Prophylaxis of Syphilis and Venereal Diseases following ten years later (in Brussels). Incidence of the disease was increasing, but perhaps most important was the fact that by the 1890s, discussion of syphilis had not only come out of hiding, but had become a cornerstone of social issues including prostitution, abandoned children, marriage and divorce, and feminism. That

these issues were well known to Symbolist artists is suggested by the common-place inclusion of references to the disease in publications supported by them. For example, a caricature showing a man confronting a heavily veiled woman as they both are entering the offices of "Doctor Moth – Specialist" by crying out "What! My wife also!!!" visually played out a common understated "joke" about the secret spread of syphilis in the bourgeoisie. The cartoon appeared in 1892, in *Le Diablotin,* the journal launched that year by Brussels Symbolists.[108] Thus Ensor's numerous mob scenes – in which teeming humanity takes over a given public locale, be it the streets of Brussels or the Ostend beaches (where the Brussels' paper claimed everybody from Belgium was by August anyway)[109] – always include as signs of sickness not only the free exchange of germs but also the seemingly free indulgence in sex. In the various c. 1890 versions of his *Baths at Ostend,* for example, there is a foreground focus on a particularly mangy couple enjoying in a slobbery French kiss, with another couple in the water, engaged in sodomy, near in the center of the composition. As art historian Patrick Florizoone has said of this series of drawings and prints, it is as if Ensor "has depicted his own Karma Sutra. . . . [The poses] offer the following variations: flirting, kissing, profound kissing, exhibitionism, voyeurism, cuddling, dogs copulating, . . . fellatio, sodomy."[110] Ensor's awareness of these venereal links to disease should have been keen: Ostend officials were for years complacent about the rise of brothels with the building of the resort and even established *maisons de tolerance* under police control, but in 1890 began to enforce antiprostitution laws in response to public outcry regarding its moral and health decay.[111]

Knowing the sudden ubiquity of syphilis, in the population as well as in the press, provides important insight into the well-known fin de siècle phenomenon of the "femme fatale." In light of the earlier portion of the century's history of portraying woman as the "handmaiden of death," either succumbing (beautifully) to it or else, following legendary precursors like the Sphinx, Medusa, or the Sirens, actually causing death to males, the Symbolist belief that the woman was inherently "fatal" appears logical. We rarely question, however, exactly *how* she was so lethal; rarely in Symbolist depictions, for example, does the female wield a weapon, or physically strike down her opponent (invariably, a man), even when she is replaying one of the classical myths. Rather, as Verhaeren said of the woman in Khnopff's *A Beguiling,* this was a "very modern image of woman, . . . always audacious, dominant, imposing herself, victorious through her *body.*"[112] Knowing that women's overt sexuality was in the nineteenth century pathologized, so that it was a sickness, a perversion, or both, suggests that it is her very sexuality that is lethal.[113] Whether in scenes of seduction or betrayal, with prostitutes or a married middle-class woman, the man is commonly the victim, while the woman is the sinner and carrier of death.[114]

Thus the Symbolist woman is portrayed in a variety of ways in which her most dangerous act is exposing herself and her gender to her victim: it is, in fact, her sex that kills. In most of the (numerous) Symbolist depictions of Salome,

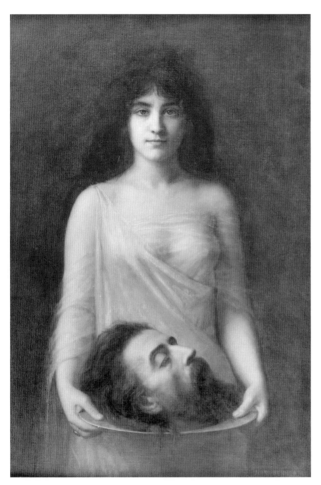

FIGURE 55. Jean Benner. *Salome.* c. 1899. Oil on canvas, 117.3 × 80.9 cm. Cliché P. Jean-Ville de Nantes, Musée des Beaux-Arts.

for example, only a few, like Gustave Moreau's prototypical *The Apparition* (c. 1875: Paris, Gustave Moreau Museum), show her actually performing the dance that led, in the biblical account, to the request for St. John the Baptist's head. More commonly, as in Jean Benner's painting of 1899 (Fig. 55), Salome brings death ineluctably by means of her sex alone: usually with at least one breast exposed, the Symbolist Salome holds, caresses, or morbidly plays with the decapitated head of the male saint, almost always held at the level of her genitals, making the point emphatic.[115] As Robert Rosenblum has observed, the scourge of venereal disease by the 1890s meant that the femme fatale "had her deadly roots in medical reality."[116] The dance and subsequent demand of the head are reduced to a symbolic substitution for the sex act, the real cause of death. Beardsley's infamous version of Salome does not in this way make overt the sexual nature of the death, as his is a rare Symbolist Salome who is fully clothed. But as an illustration for Oscar Wilde's play, in which the woman's

monologue verbalizes this fatal substitution, it is unnecessary. As she says to the bloody head, "Ah! Thou woudst not suffer me to kiss thy mouth, Iokanaan. Well! I will kiss it now. I will bite it with my teeth as one bites a ripe fruit,"[117] the image of women as infectious, deadly vermin is complete. Beardsley's illustration, which shows Salome floating in the air, holding the Baptist's head before her was titled "The Climax," making crudely clear the fact that this killer's pleasure was sexual.

In Valère Bernard's bizarre *Six Engravings* portfolio of c. 1897, a set which instructively begins with a sphinx who kills by crouching on her victim's genitals and ends with a witch portrait titled "Horned Woman with Claws," plate 3 is now titled *A Man in Bed with a Skeleton*.[118] But the one figure is actually not a skeleton; only her face seems skull-like, with deep hollows for eyes, a bony nose (two of the most common markers of syphilis in the nineteenth century), and wide grimacing mouth.[119] The body is instead a voluptuously fleshed-out figure, with pendulous breasts; it is this female who makes obvious the manner in which she will bring death to the man whom she straddles and pins down with her body. By late nineteenth century, the female was considered to be the primary vehicle of venereal disease. In Bernard's print, the disease-empowered fin de siècle woman will kill the male by having sex with him.

Blaming women for these virulent diseases was only one factor of Victorian patriarchal constructions, biased assumptions that certainly also played a part in the medical misunderstandings about venereal disease and its etiology that persisted throughout the century. At the beginning of the 1800s, syphilis was generally considered identical to gonorrhea, a scourge from God that confounded medical efforts at identification and treatment. It was only at the very end of the century that syphilis was clearly established with singular symptoms that attacked the body in three distinct stages. The earliest manifestation, which could appear within days of contagion, was the outbreak of chancres (lesions), usually at the site of infection. Often these were pale and painless, and went unnoticed; after ten to forty days, they would heal without a scar. The secondary stage included chancres, rashes, and other skin disruptions that were followed by a latent period, which might last only a few years or extend for a lifetime. About one-fourth of all patients developed tertiary syphilis after this latent period; for roughly one-half of these, the last stage was fatal.

Given the diverse development of the disease, the challenge that syphilis presented in diagnosis and treatment is understandable. Throughout the century, misunderstandings about the disease, often growing into myths, prevailed. Syphilis was on various occasions proposed as noncontagious, controllable through vaccination, found only in men, transmittable only through women, considered hereditary (rather than congenital) and, because some in the latent stages seemed to have returned to health, self-curable. For each of these ideas, social ramifications abounded. The latent period, in which patients had no scars and appeared healthy, was especially contradictory, and no doctor – especially

when consulted "off the record" by middle- and upper-class clients – wanted to diagnose syphilis mistakenly. The ethical and medical argument over whether the patient should even be told about the diagnosis raged into the twentieth century.[120] Mostly men were protected, especially married men. Women, on the other hand, were vulnerable to misdiagnosis. Because many women in apparent health gave birth to infants with congenital syphilis (having themselves had the initial chancres internally, or unnoticeably), it was assumed that they were only the evil carriers of an inherited disease.

On the other hand, those who believed that the disease was fully contagious and sexually transmitted were in a position to blame prostitutes, as the only perceived purveyors of multiple sexual experiences who were publicly, and often legally, recognized. Because the blood-serum test that diagnosed the presence of the syphilis spirochete in the body was not discovered until 1906,[121] the Symbolist city was plagued with the worst developments of all of these ramifications. New efforts at controlling prostitution were in full effect, requiring dehumanizing physical examinations of prostitutes. Fathers of brides-to-be carried the added responsibility of demanding from prospective son-in-laws a clean bill of health before turning over any dowry; and persons in the tertiary and fatal stage of syphilis, often suffering from dementia, were treated like lepers or, in some cities, not treated at all.[122] Behind the glitter of city life, everyone was suspect; accompanying every sex act was the threat of death.

An insistence on sexual transmission of death can be found in Munch's *Young Woman and Death* (Fig. 56). This image is usually related to Munch's adherence to Monism, a biologically based philosophy of unity in life and spirit proposed by professor of zoology Ernst Haeckel. Monism predicated a universal force that ruled the cycle of life and, through conception of the next generation, death. Munch himself concluded about his own death, "I would be united with [the living] . . . and from my rotting body, plants and trees would sprout. . . . That is eternity."[123] But it must also be noted that underlying Haeckel's popularization of biological cycles and even evolution was a firm recognition of its opposite. Haeckel proposed a 'biogenic law,' for example, which claimed that each individual passed through the same developmental stages as those of the race or species as a whole: "[the] history of the embryo (ontogeny) must be completed by a second, equally valuable, and closely connected branch of thought – the history of race (phylogeny) . . . this arises from the reciprocal action of the laws of heredity and adaptation."[124] Or, as Haeckel famously summarized, "ontogeny recapitulates phylogeny."[125] This in turn not only identified the fully developed individual as the "standard bearer" of the race, but also labeled those perceived to be developmentally fixed at some earlier stage to be aberrant signifiers of degeneration.[126] Thus while a synopsis of Monism's cyclical principles is an important component of much of Munch's oeuvre *Young Woman and Death* can also be related to contemporary fears about disease (which, as we shall see, were bound together in a model of degeneration).

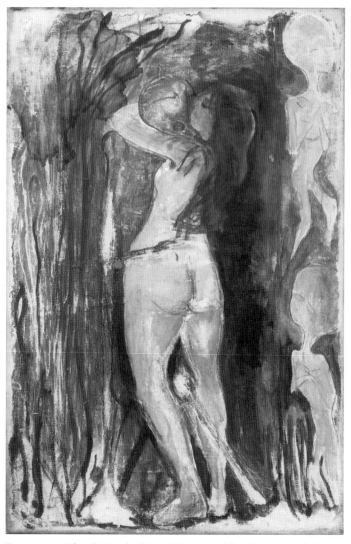

FIGURE 56. Edvard Munch. *Young Woman and Death*. c. 1894. Casein on canvas, 128.5 × 86 cm. © 2003 The Munch Museum/The Munch-Ellingsen Group/Artists Rights Society (ARS), NY.

Furthermore, references to venereal disease may also exist. When compared to Hans Baldung Grien's *Death and the Woman* (Fig. 57), a prototype in the long tradition of death and maiden depictions to which Munch's work belongs, the modernity and also the aggressiveness of Munch's woman are striking. In Grien's sixteenth-century work, it is death who attacks the maiden, grabbing her from behind and trying to kiss her as she attempts to shield herself by pulling up her robe. In keeping with the formulaic presentations of dance of death depictions since the Middle Ages, then, it is a male death who does the stalking and (less commonly, but certainly here) introduces the sexual overtones to the death. In

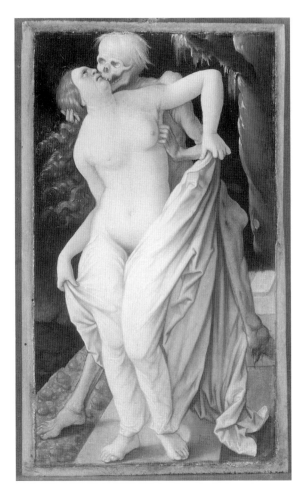

FIGURE 57. Hans Baldung Grien. *Death and the Woman.* 1518–19. Oil on panel. Oeffentliche Kunstsammlung Basel Kunstmuseum. Photograph: Martin Bühler.

Munch's painting, however, it is the notably thinner woman who pursues death: with her arms clasped behind the skeleton's head, she leans her head back as she thrusts her pelvis onto his. As the two figures are framed on the left by streaming sperm forms and on the right by two fetal bodies,[127] the woman assumes the central role accorded her not only by Monism's insistence of the biological urge to procreate, but also by the 1890s view of congenital syphilis, which came to be equated with physical as well as moral decrepitude.[128]

The syphilitic child, often blind or crippled at the knees, had become after decades of secrecy a public issue and image in the 1890s. The painting *Sad Inheritance* (1899, Collection, de Ahorros de Valencia, Castellón y Alicante 'Bancaja') exhibited by Joaquin Sorolla y Bastida at the Universal Exposition in 1900, was originally called *The Children of Pleasure,*[129] a title that made its moral statement about the priest helping a group of homeless and crippled boys on the beach with striking clarity. The choice of only male children for this pathetic portrayal further underlined for the late-nineteenth-century viewer the ultimate risk that

these diseases posed to the race. The projection of venereal disease onto children was the cause of growing alarm during the second half of the century. In a paper titled "On the Waste of Infant Life," syphilis in particular was called "an hereditary disease . . . [that] appears to be on the increase." Hospitals recorded treating infants for congenital syphilis "by the hundreds"[130] and blame was laid firmly at the foot of their parents' bed. Condoms were distributed, and not only Paris had its public displays: exhibitions of wax figures displaying the various syphilis symptoms traveled regularly from Germany through Scandinavia. Despite increasing public awareness, however, the disease spread.[131]

Again, as we have seen visualized in Ensor's drawing *Plague Here, Plague There, Plague Everywhere,* class consequence remained a major consideration in the medical treatment of syphilis, causing upper- and middle-class victims to be as secretive about their diseases (and their offspring) as possible, while approving of homes for abandoned or orphaned sick children as aiding the plight of the poor. When this distinction in practice was added to the nineteenth-century bourgeois male assumption that prostitution was necessary to protect the purity of upper- and middle-class wives and daughters, it resulted in a general notion, shared by medical communities, that the source of syphilis resided in the lower classes whose women became prostitutes. At one point, an English physician, Thomas Ballard, attempted to correct these class-based misunderstandings, to discourage improper diagnoses of congenital syphilis in cases of poor and ill-kept babies who suffered, he maintained, only from poor hygiene. In an 1874 pamphlet, Ballard recounted cases in which "syphilitic" babies were being diagnosed on the basis of sores and lesions of the thighs and buttocks, but who were actually only victims of severe diaper rash; he expressed concern that these children were being mistreated with fatal medicines. But he also railed against physicians' presumptive diagnosis of syphilis due to their patients' lower-class status:

> Syphilis is not more prevalent among the poorer than the better classes of society. The cases of supposed congenital syphilis are principally observed among the poor and dirty people, who take their children to hospitals and dispensaries. And amongst whom the causes to which I assign the symptoms [i.e., harsh diapers, lack of hygiene, etc.] are in force in much greater intensity; yet I am accustomed occasionally to see precisely the same in the nurseries of the wealthy. No one supposes that the effects of the syphilitic virus would be altered by the condition in life of the sufferer; we should therefore look for the same phenomena in all ranks of society, and thus I have found it.[132]

Ballard's misguided conclusion was that congenital syphilis did not exist; he could not have been further from the truth. Given what is now known of

the disease and its history – that only a small percentage of women with syphilis were properly diagnosed in the late nineteenth century as well as the fact that the probability of fetal infection in untreated maternal syphilis is nearly 100 percent[133] – the situation in Ballard's time was exactly the opposite of his conclusions. Yet his comments on diagnoses of syphilitic babies bear interesting light on the most well-known image of syphilis in Symbolist art, Munch's *Inheritance*, known in two versions (Fig. 12).[134] The child remains in each marked with red chancres on chest and legs, rather than the buttocks area, as was usually seen in medical illustrations and which Ballard had questioned. As Munch has painted him, the dying infant is shown fairly accurately to be a "syphilitic runt," as these poor babies were cruelly labeled, with an oversized head and eyes set wide apart. Attention to the medical condition of the congenital syphilis victim had only recently begun to grow, with published studies in the 1880s. The work of Parisian Alfred Fournier – one of the earliest to put firm emphasis on the degenerative changes of syphilis – produced the first accurate clarification of acquired versus congenital syphilis symptoms in 1886, including descriptions which introduced an entirely different "look" of the syphilitic than had been previously known.[135] Fournier distinguished between syphilis that developed after conception ("hereditary syphilis," usually blamed on syphilis carried in the sperm) and the disease acquired at conception (with symptoms at birth, acquired from the mother) as congenital syphilis, and emphasized that the latter was the most serious, and often fatal, condition of the two.[136] In "the most influential European texts on congenital syphilis of the mid–nineteenth century,"[137] the physician P. Diday described the infected infant as looking like "a little old man," presenting "decrepitude in miniature."[138] Thus, Munch's baby – who shares this description with the small fetus that figured in the first print version of his *Madonna* (Fig. 70)[139] – is recognizable as an infant destined for an early death or degeneration through related illnesses.[140] Notably, this baby, also like the fetuses in Munch's *Young Woman and Death* (Fig. 56) is a male: the little boy, with frail legs that will never be strong, is emblematic of the future of the race.

The setting of the tragedy of *Inheritance* is assumed to have been the Salpetrière, where Munch, who wrote of wanting to capture the mother and child exactly as he had seen them in a hospital in Paris, could have been visiting his friend Dr. Paul Contard.[141] Given that such a clinic, like the maternity hospitals that were established in most large European cities in the nineteenth century, were initially charity institutions for lower classes,[142] it is interesting to note that the mother in each of Munch's versions is painted in different ways, with indications of her class changing from middle class to lower – as indicated by her dress, demeanor, and facial characteristics[143] – from Munch's first version of this painting (Fig. 12) to his second. The middle class, following a century-long tradition of calling in private physicians (and usually, like the working classes, not requiring physician attendance for sick infants at all),[144] by

the 1890s had recourse to the specialty clinics that were increasingly required for venereal disease. *The Inheritance* mother's bright red face and hollowed eyes serve to implicate her in both versions, however unwittingly, in the degenerate cycle of life; recognizing that her baby has syphilis is admitting her own physical and moral disease. Thus, like the male child being devoured by the snake of syphilis in Rambert's 1851 *Debauchery and Luxury* (Fig. 58), in which the syphilitic finally leaves behind the orgies of his past and (carrying his container of mercury as supposed cure) enters the hospital, Munch's boy embodies the end, or at least further degeneration, of his familial line. In Rambert's more moralizing illustration, he introduces the victim of congenital syphilis as a kind of frame, or commentary, on the main action of the picture, but has the infant falling forward, into the viewer's (society's) space, along with the warning scroll of the title. In this respect Munch's presentation of the deadly aftermath of sex is more subtle, and by means of the crying mother, less blame-laden, perhaps hoping to suggest, if not promise, an alternative, healthy Monistic future. Finally, as noted in Chapter 2, the frontal placement of the infant is the composition's most compelling component: the decay of the innocent body from this insidious "social" disease takes on a symbolic character, forcing the viewer to confront the entire image with empathy rather than sympathy or mere understanding.

Such a presentation was more Symbolist than the Realist and shocking social commentary about congenital syphilis offered in numerous literary sources in the 1890s. Sarah Grand's *The Heavenly Twins,* one of the first so-called New Woman novels, was one of the most popular books of the time. Its story of three bad marriages focused on the one that was fatal, and presented the dying wife, who already knows that her infant son is also syphilitic, denouncing the men "who represent the arrangement of society which has made it possible for me and my child to be sacrificed in this way."[145] The most infamous exposé of congenital syphilis was, however, that given by Henrik Ibsen in his drama *Ghosts,* the first Norwegian performance of which Munch probably attended.[146] In this play, a woman realizes too late that she has stubbornly defended her licentious husband, to the point of paying someone to adopt his illegitimate daughter. Having kept her husband's wicked past a secret even to her son, she now faces his own syphilis. Because he blames himself for his infection, she finally tells him that it is surely hereditary. Recognizing that he will die the last of his lineage, he declares "all that recalls [my] father's memory is doomed. Here am I, too, burning down."[147] In the final scene, he commits suicide. Written in 1881, Ibsen's *Ghosts* waited eighteen months to see production, having been turned down by every major Scandinavian city theater. When it was finally produced in Sweden in 1883, international controversy ensued, with most countries banning the play for at least a few years. For the Symbolist generation, in the 1890s, it was a favored and well-known drama that publicized syphilis as an object lesson in heredity.

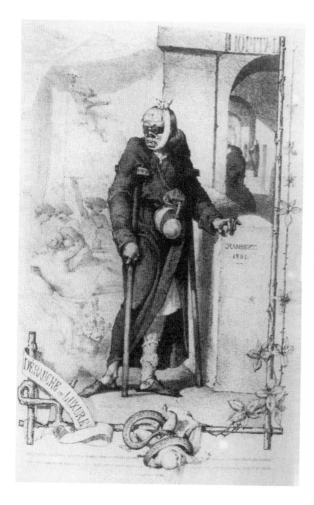

FIGURE 58. Rambert. *Debauch-ery and Luxury.* 1851. Engraving. Bethesda, Maryland: United States National Library of Medicine.

Identification of the "innocent" victim of disease immediately implied blame on others, however: perpetrators of the disease who were knowing, and deliberate. A prime target for blame, as noted earlier, was the prostitute whose life and work was on the streets.[148] Thus the terms "social disease" for venereal disease and "social evil" referring to prostitutes came to be used interchangeably in the nineteenth century;[149] implicit in this linking was also the site of the city. The German poet Oscar Panizza summarized this in his 1895 play about the "invention" – by God with the help of the Devil – of syphilis as punishment for "the city . . . [which] has become addicted to horrible abominations; women run with bare breasts, shamelessly lewd, through the streets; . . . one atrocity follows another."[150] In the play, the disease is delivered to earth in a meaningful way: a self-infected Satan mates with Salome, then sends her to become a "divine prosti-tute," delivering disease to the world.[151] In the art of a Symbolist-sympathizer like Albert Besnard, the visual connection between disease and prostitution could

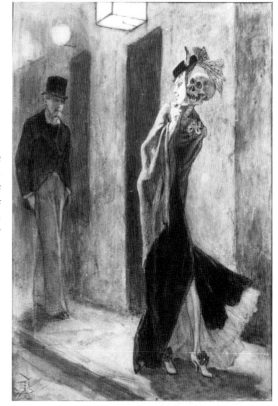

Figure 59. Félicien Rops. *Human Comedy (At the Street Corner)*. 1878–81. Pencil, from the series *Cent légers croquis sans prétention pour réjouir les honnêtes gens,* 22 × 14.5 cm. Hérve de Bonvoisin Collection, Paris. Photograph courtesy of Speltdoorn.

be made on a practical level. In *Prostitution,* one plate of Besnard's etched series on *The Woman,* for example, the courtesan walks down a city street, facing the viewer, while passing one man on her left and a Pharmacy Shop on her right; another man, in shadow, approaches her.[152] Artists more closely aligned with Symbolism's desire to raise the message of their work to a higher level of conception, however, could leap to a visual metaphor of the prostitute as not merely the diseased, or agent of disease, but as the disease itself. The Belgian Symbolist illustrator Félicien Rops's *At the Street Corner* (or *A Human Comedy,* as it was sometimes titled, Fig. 59) depicts a man approaching the prostitute in a dark and narrow alley; only the viewer can see that the woman's beautiful face is a mask behind which death hides, waiting to spawn disease. In its subtlety, this image was as emphatic, if not as explicit as Rops's *Mors Syphilica (Death on the Pavement)* with its lingerie-attired skeletal prostitute beckoning from the brothel door, drawn more than twenty years later.[153]

In Jan Toorop's 1891 *Vil Animal,* which may well be his first Symbolist work, the references to syphilis are, at first glance, more obtuse (Fig. 60).[154] As a woman stands in a library, and in front of someone who plays an organ, she presents her back to the viewer as she looks through a window, to a landscape

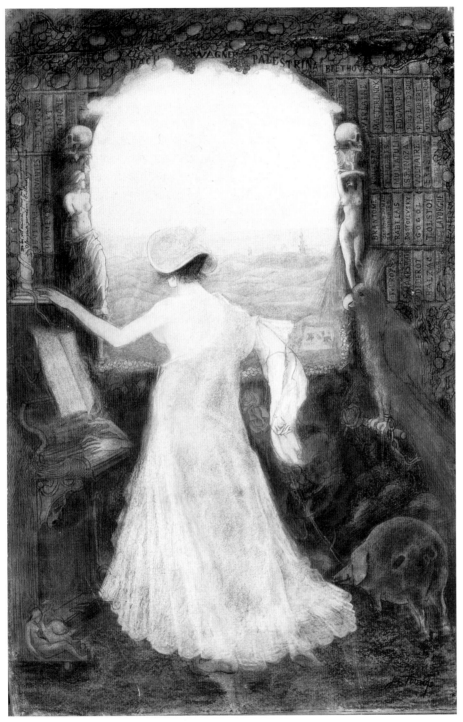

FIGURE 60. Jan Toorop. *Vil Animal (Woman with Parrot)*. 1890. Black and colored chalk, pencil and colored pencil, heightened with white. 54.4 × 35.4 cm. Private collection. Photograph courtesy of Gerard van Wezel.

vista, the rolling hills of which lead toward a city. The key to the meaning of this early painting was provided by the artist himself, in an extended description written on the verso, which identifies the source of the title as Baudelairean verse: both the phrase "vil animal" as well as the longer subtitle "You have placed the entire universe by your bed" are taken from Baudelaire's cycle of poems "Spleen and Ideal," a part of his *Fleurs du Mal.* The window is framed by figures that suggest the sacred and profane, with a draped classical female sculpture called by Toorop "Venus de Milo" on the left (her hand touches a column with a tiny serpent coiled around it), and on the right a nude woman seductively posing with hands above her head, termed by Toorop "the modern woman, Baudelaire." The artist further identified a "spirit play[ing] (the hands on the keyboard)" as well as "the woman hold[ing] a pig by a ribbon (pornocratie)." Thus the woman, half-dressed in typical city clothing and standing next to a pig, a snake, and a large parrot, all animals often associated with lascivious women in mid- to late-nineteenth century art, is a prostitute. She stands, furthermore, in a library that establishes the whole of Western civilization as her realm: she is surrounded by books whose author's names offer a curriculum of literature and music ranging from ancient times (beginning with Homer) through the "moderns," as Toorop explained. The latter included Russian and French literary figures (Tolstoy, Gogol, Dovstoyeski, Balzac, Diderot, Rabelais) as well as composers (Beethoven, Palestrina, Bach, Wagner). On the spine of another book on the far right appears the name of another author responsible for much new thinking in the nineteenth century: Darwin. There is also, however, a specific reference to a visual artist in the book in the lower right corner labeled "Fel. Rops," acknowledging the Belgian artist already in 1890 attracting criticism and controversy as a great artist of pornography.[155]

By reducing the prostitute here to a faceless, timeless everywoman figure, Toorop implies that all women should be viewed in this context. As shall be further discussed in Chapter 5, this association of women with Darwinian bestiality had become fairly common in the fin de siècle. The literary connection to prostitution and the woman with death's head on the frame, however, is the basis for the further identification of the female as fatal animal. Toorop's inscription begins with the statement "[T]he death of an artist caused by woman," alluding to a Brussels musician friend who had committed suicide because of his venereal disease.[156] If, as has been suggested, Toorop suspected that he was infected by syphilis,[157] then this symbolic tribute had, like Hodler's references to tuberculosis, a very personal significance. Yet the woman here remains the everywoman – the infected beast – as established historical fact. In *Vil Animal,* Toorop emblematizes the cause of syphilis with the well-dressed prostitute, like Panizza's Salome, in control of the world as she looks beyond great Western and male culture.

Or, as Huysmans's Des Esseintes summarized, "Everything is only syphilis. . . . Ever since the beginning of the world, from fathers to sons, all living

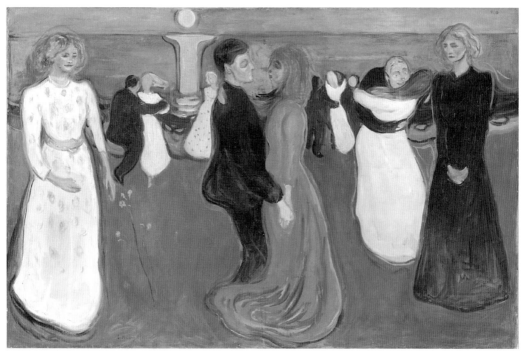

FIGURE 61. Edvard Munch. *The Dance of Life*. 1899–1900. Oil on canvas, 125.5 × 190.5 cm. National Gallery, Oslo. © 2003 The Munch Museum/The Munch-Ellingsen Group/Artists Rights Society (ARS), NY.

creatures were handing on the inexhaustible heritage, the everlasting malady which has ravaged the ancestors of man.... Never wearying, it had run down the centuries, still today it rages."[158] In Munch's *Dance of Life* of 1900 (Fig. 61), the inevitability of death following sex is portrayed as a waltz of passions, from which neither man nor woman can escape. This work, which has so often been interpreted in both pessimistic as well as Monistic terms, seems to incant the connection between copulation and death. This is represented by the central couple who, even as they draw together, evince the deep-socketed eyes and pale cheeks of death, as they conceive by virtue of their union the new generation. The painting may also, however, have for Munch's contemporaries subliminally alluded to the seemingly inevitable course of venereal disease, as the young woman in a yellow-flowered white dress on the left is a vision of the perfect bourgeois daughter, always assumed to be a virgin before marriage. Notably, all the other dancers in the background are women also in white, despite the fact that the virgin closest to the foreground is dancing with a man whose face is distorted with lust – or with disease. He has no hair, bulging eyes, a pinched nose, and an intense green complexion – a favored image of the syphilitic in numerous prophylactic-social novels of the 1890s. Paul Vérola's 1891 infected hero of *L'Infamant,* for example, envisions his future appearance in a nightmare, as

a syphilitic with "a head of a living death, without nose, without lips, with decomposed and greenish cheeks."[159] The emaciated (but not very old) woman on the right, already wearing widow's black, is the image of the infected innocent, who, knowing the cause of her illness, stares at the middle pair. The central man in this dance of disease is the one who therefore couples knowingly with the woman wearing prostitute's red; their union will bring a fatal conclusion not only to his own family; they also will bring about, by virtue of their role in the "dance of life," both the next generation and their own death. Like the doctors' dinner party described in Léon Daudet's 1894 novel *Les Morticoles,*[160] Munch's dancers are compelled to dance. In the novel, Daudet's doctors (and accompanying women) had endured already a mortifying dinner discussion at which the host, a wealthy but crude syphilologist, has drunkenly revealed that his fellow doctors are also his secret patients. Fearful of leaving and becoming in their absence the featured subject of further abuse, the doctors retire to the library, where they dance with their "young ladies" in front of shelves lined with books whose spines spell out all the symptoms (for example, "*On the chancre . . .*") of their hidden disease.[161]

This pessimistic message about the inevitability of venereal disease and degeneration does not completely argue with others' interpretation regarding the role of Monism and a search for a healthy future generation in Munch's work at this time, however. Most literary discussions about syphilis around this time were aimed at prophylaxis: by emphasizing the current state of infection, they hoped to encourage abstinence, safe practices, and control of the evil means of infection. Eugenics, Monism, and other philosophies of health at the end of the century were direct responses to this situation. Munch's 1900 message about the dance of disease and dance of death (called by Munch the *Dance of Life*) might also suggest, therefore, the morality lesson of Ibsen's *Ghosts,* encouraging a reconsideration of the role of heredity for the future.

As the painter Alfred Kubin was completing, around 1900, *The Bride of Death* (Graphische Sammlung Albertina, Vienna) depicting a white-veiled woman with skeletal proportions but dressed in a fashionable fin de siècle gown, feminist and eugenic campaigners were complaining, "We look around and see the sickly girl uniting herself with an equally sickly man. We know that in the families there are fatal tendencies to horrible disease . . . and even worse. We see the nervous hysterical woman marrying a worn-out, vicious man. . . . Heredity."[162]

DEGENERACY: THE OVERALL AND UNDERLYING DISEASE

With the connection between disease and heredity came for many the conclusion that the European race was, in the 1890s, in a state of degeneration. In this single

term could be understood all of the diseases of the era. Foucault has claimed that "[t]he medicine of perversions and the programs of eugenics were the two great innovations in the technology of sex of the second half of the nineteenth century"; in this way he establishes a background for this linking of health fears with sex, calling that construction a "perversion-heredity-degenerescence system."[163] In the late century, in other words, the distinctions between one illness and another, as well as one behavior or appearance rather than another, were less distinct than we might imagine, with numerous "conditions" classified or imprecisely grouped together. As historian Robert Nye has explained about French nineteenth-century medical studies, for example, an array of pathologies – including tuberculosis and syphilis as well as depopulation, crime, mental illness, prostitution, and suicide – began in the last quarter of the century to be commonly associated, creating by the 1890s a model of cultural crisis based on the general notion of degeneration. This theory, introduced in the widely read books on degeneracy written around 1860 by Bénédict-Augustin Morel,[164] allowed for a concept of progressive adaptation that could gradually develop, in succeeding generations, weak or morbid functions, resulting in degeneration (thus opposite the regeneration of the Darwinian model). By the 1890s, it was therefore common for doctors to identify "clusters" of symptoms such as 'degenerate insanity' or 'hérédo-tuberculeux' in which one disease was linked, through degeneration, to others.[165] The relationship between previous diseases and the recent identification of "social disease" was spelled out by Enrico Ferri, author of numerous writings on sociology and criminality at the end of the century:

> The nineteenth century has won a great victory over mortality and infectious diseases by means of the masterful progress of physiology and natural science. But while contagious diseases have gradually diminished, we see on the other hand that moral diseases are growing more numerous in our so-called civilization. While typhoid fever, smallpox, cholera, and diphtheria retreated before the remedies which enlightened science applied by means of the experimental method, removing their concrete causes, we see on the other hand that insanity, suicide, and crime, that painful trinity, are growing apace.[166]

Eventually, there developed a generic degenerate who was to be feared for his or her ability to destroy the health of the race. Furthermore, because of the complex and overlapping medical constructs of this condition, the degenerate was especially horrifying because his or her disease almost always included mental deterioration. Early on, Morel's "Law of Progress" had claimed that because of the hereditary factor, each succeeding generation would have increasingly deleterious symptoms, usually ending in insanity. This process of degeneration into dementia acquired yet another potential complication when, in the 1890s,

Fournier's further research identified the increasingly common condition called GPI (general paralysis of the insane) as a condition of tertiary syphilis. Thus, by the 1890s, there was neither a cure to the many diseases implicated in degeneration nor a hope of control over the degenerate faction of the population because they were all, at one point, "imbeciles or idiots."[167] Finally, these conditions were linked to urban population, also on the rise and seemingly uncontrollable. "The world of civilization," Nordau proclaimed, "is an immense hospital ward."[168] Together, these newly connected diseases spelled the end of evolved civilization in which he and so many others had wanted to believe.

But how could one identify the degenerate? How could the healthy, alarmed citizen recognize degenerates in order to avoid them at all costs? Intriguingly, because all of those writing about degeneration claimed a medical basis for their diagnoses, visual symptoms or "stigmata" were considered imperative to study. Throughout the second half of the nineteenth century, since the time of Morel and his diagnosis based on physical appearance as well as moral and mental "inferior" deformations, a visible map of degeneracy had been sought. By the time of the Symbolists, these symptoms – like the various diseases linked to degeneration – were commingled into a "look" of the degenerate. Morel had arrived at his early formulations of a hereditary devolution by studying cretinism, an inherited thyroid deficiency. Morel observed in cretinism common mental retardation as well as numerous developmental defects and several nonrelated illnesses. Hernias, goiters, pointed ears, absence of secondary teeth, stunted growth, cranial deviations, deafness and muteness, blindness, albinism, "clubfeet," elephantitis, scrofula, tuberculosis, rickets, and sterility were identified as secondary results of cretinism and were in turn exacerbated by the effects of alcohol, tobacco, and opium.[169] The actual appearance of the cretin was, however, according to Morel, close to that already imagined in literature as a base animalistic creature, such as the dying cretin seen by Balzac's *Country Doctor:* a being with "deep circular folds of skin, on the forehead, the sodden eyes resembling those of a cooked fish, and the head, with its short, coarse, scantily-growing hair . . . [who] had neither the graces of an animal nor the mental endowments of a man."[170]

Historian Daniel Pick has asserted that the "cretin's body became the degenerate's body."[171] Susan Spongberg, on the other hand, has suggested that the syphilitic body was the degenerate body[172] and offers as evidence the late-century changed view of the prostitute. If prostitutes were no longer victims of economic hardships or puerile seduction (the explanation of prostitution earlier in the century) and were instead considered themselves to be morally degenerate, then this presence of disease was "inscribed on her body as congenital deformity."[173] But by the 1890s, these and other distinct conditions had become conflated into one disease of degeneration, while at the same time, the mentally ill as well as any other outcasts of society were recast as moral degenerates. No less

a researcher than Fournier himself summarized in a 1904 study that "[I]t emerges from recent research that syphilis can, because of its hereditary consequences, debase and corrupt the species by producing inferior, decadent, dystrophic and deficient beings. Yes, deficient."[174] It was Nordau, however, who in his 1892 book considered himself able to list most of the physical characteristics collectively proposed by his predecessors and what emerges is a vivid visual description of the "perfect" degenerate. Although he decried the use of the term stigmata, he nonetheless believed in such physical markers (these included the criminal stigmata observed by Nordau's revered predecessor, the Italian physician and criminologist Cesare Lombroso because Nordau considered them a subset of degeneracy). Nordau listed these with typical quasi-scientific terminology:

> Deformities, multiple and stunted growths in the first line of asymmetry, the unequal development of the two halves of the face and cranium; then imperfection in the development of the external ear, which is conspicuous for its enormous size, or protrudes from the head, like a handle, and the lobe of which is either lacking or adhering to the head, and the helix of which is not involuted; further, squint eyes, hare-lips, irregularities in the form or position of the teeth, pointed or flat palates, webbed or supernumerary fingers . . . etc.[175]

To this list must be added the psychological "manifestations" of the degenerate, which were also visually observable as conditioned behavior: alcoholism, excessive sexual drive, and of course insanity itself. The beauty of these symptoms, as art historian Shearer West has pointed out, was that they are so numerous and so general that they could be manipulated to apply to almost anyone, and particularly to Nordau's enemies – a fact that George Bernard Shaw noted when he complained, "I could prove Nordau to be an elephant on more evidence than he has brought to prove that our greatest men are degenerate lunatics."[176]

THE ARTIST AS DEGENERATE

The most frightening but fascinating aspect of degeneration for the Symbolists must surely have been, however, the fact that they themselves were implicated: creative faculties had been connected in a scientific model, by physicians as well as psychologists, to "madness" and thus to degeneracy.[177] The Symbolists in particular, however, had become for many the prime examples of degeneracy itself. It was Nordau who made this connection most forcefully in his various writings: Chapter 3 of *Degeneration* was devoted to "Symbolism." Although his analysis here is of literature, he addresses most of the writers who had the strongest connections to Symbolist artists (accusing Mallarmé's poetry, for example, as "the

stammerings of [a] ... weak mind").[178] Thus his diatribes against the writers could be and were easily applied to their like-minded associates in the visual arts:

> The Symbolists are a remarkable example of that group-forming tendency which we have learnt to know as a peculiarity of 'degenerates.' They had in common also the signs of degeneracy and imbecility: overweening vanity and self-conceit, strong emotionalism, confused disconnected thoughts, garrulity ... and complete incapacity for serious sustained work.[179]

In his diagnoses of Symbolist artists, Nordau also pathologized their work:

> The Symbolists, so far as they are honestly degenerate and imbecile, can think only in a mystical, *i.e.* in a confused way. The unknown is to them more powerful than the known; the activity of the organic nerves preponderates over that of the cerebral cortex; their emotions overrule their ideas. When persons of this kind have poetic and artistic instincts, they naturally want to give expression to their own mental state.[180]

There is some evidence that many of the Symbolists accepted at least some elements of this argument. Even Gauguin, presumably having divorced himself from the degeneracy of Western civilization when he escaped to Tahiti, returned often to the image of the degenerate artist (sometimes himself) who appears in contrast to the untouched primordial beauty of the island natives. In his late *Barbarian Tales* (Fig. 62), the figure representing the debauched, voyeuristic Westerner was based on Gauguin's painter-friend Meyer de Haan. Most often noted as a sign of Haan's (and the Westerner's) depravity is his one exposed foot which has been given an animal's claw, an image usually related to the fox, symbol of lewdness especially in Breton lore. But animalistic features had been identified with degeneracy since Morel's first studies of cretinism. In addition, the oversized head, slightly slanted eyes, nonsymmetrical features and pointed ears that are consistently emphasized in Gauguin's portraits of de Haan, as they are here, were all physiognomic characteristics of degeneracy. As Nordau in 1892 would summarize about the latter feature: "long pointed faun-like ears. ... After Darwin, who was the first to point out the apish character of this peculiarity, Hartmann, Frigerio, and Lombroso have firmly established the connection between immoderately long and pointed external ears and atavism and degeneration; and they have shown that this peculiarity is of especially frequent occurrence among criminals and lunatics."[181] Gauguin, by means of his characterization of de Haan, visually suggests that "Symbolist artists" be

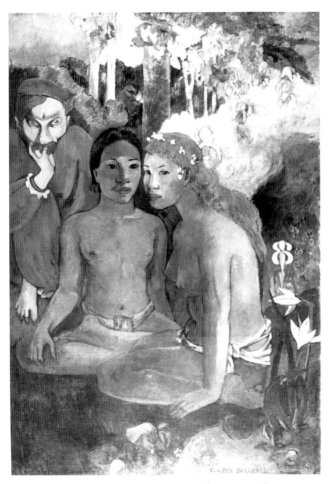

FIGURE 62. Paul Gauguin. *Barbarian Tales.* 1902. Oil on canvas,
131.5 × 90.5 cm. Museum Folkwang, Essen.

added to this list. Other artists paid tribute to the role of heredity in this de-
generacy model. In Munch's diaries, for example, he dramatically and morbidly
wrote:

> Two of mankind's most horrible enemies were granted to me as an
> inheritance. An inheritance of tuberculosis and mental illness. Sick-
> ness and insanity were the black angels that guarded my cradle. A
> mother who died young gave me a weakness for tuberculosis; an
> overly nervous father, so pietistically religious as to be almost insane,
> the descendant of an ancient family, gave me the seeds of insanity.
> From the moment of my birth, the angels of anxiety, worry, and death
> stood at my side.[182]

For the Symbolists, implication of themselves in this devolution had become a public issue; connections between theories of degeneration and their type of art had begun to appear in the press, and, as we have already seen in the case of Hodler, in art criticism. On the occasion of the banning of Munch's exhibition in Berlin in 1892, for example, the critic Georg Voss, defending Munch in a sarcastic article on "Art and Science," proposed that Nordau's very recent publication of *Degeneration* was a point of contention between the young and the old (defenders and attackers of Munch) at the Berlin Academy. Voss suggested that

> this book [*Degeneration*] should be most heartily recommended to all art philistines who like to link health and brutality. Mr. Nordau also works with the speed with which the "great Lombroso" brings together all sorts of materials for the sake of zealots for the truths of superficial knowledge, in order to prove the theory of the insane genius. He constructs for himself his own healthy normal artist, according to the feelings of the good petit-bourgeoisie and according to its much-praised healthy human understanding; what lies beyond is degeneration, hysteria, [and] madness . . . and the old guard in the artists association has made use of weapons similar to those of Mr. Nordau when they showed Munch and his works to the door.[183]

Finally, Van Gogh was not only aware of Lombroso's and others' theories, but expressed a fascination with them as well as in the general question of artists and illnesses. According to the research of art historian Aaron Sheon, Van Gogh considered himself vulnerable to neurasthenia and related his own diagnoses of epilepsy to degeneration.[184]

Nordau in his 1892 *Degeneration* had gone much further than Lombroso in identifying the decadent art and literature of the 1890s itself as a sure sign of degeneracy on the part of its authors. After listing the visual bodily deformities, or stigmata, of the degenerate, Nordau explained that this diagnostic recourse was not actually needed for artists, because "the asymmetry of face and cranium finds, as it were, its counterpart in their mental faculties, which in turn are evident in the works themselves. Some of the latter are completely stunted, others morbidly exaggerated." While Morel cited "emotionalism" as a chief characteristic of degeneracy, however, Nordau in 1892 focused more on the artists' moral degeneracy: "That which nearly all degenerates lack is the sense of morality and of right and wrong. For them there exists no law, no decency, no modesty."[185] Like the prostitute's body, therefore, the artist's work would inherently carry the signs of degeneracy in its very choices of subject and style. Overly emotional, "sick" art could result in insanity on a cultural level. As Mathews has convincingly argued, this logic was one built up in several stages and over different disciplines, on a theoretical basis that was accepted conventional

wisdom by the fin de siècle. As she concludes, "Evolutionary degeneracy was fundamental to the idea of genius as physiological capital."[186]

While the complexity of scientific theories and medical diagnoses continued to amass in the 1890s, therefore, the linkage to creativity seemed increasingly clear, as more and more commentators assumed these constructs in their approach to writing about art and artists. The history of Jules de Goncourt's illness and death, one of the most celebrated diagnoses of an artist in the late nineteenth century, is instructive here. Because his early bout with syphilis had gone undiagnosed and had been followed by an extended latency, de Goncourt's later illness, including brain deterioration (GPI, as noted earlier) and a paralysis proven only posthumously to be a condition of tertiary syphilis, remained at the time of his death a famous mystery. Based on the de Goncourts' *Journal,* later diagnosticians were likely to claim that he had died of neurasthenia, induced by the overwork and exhaustion brought on by Paris, his work, and even the stress of his writer's personality.[187] Even those who disagreed with this diagnosis still admitted that such a sensitive writer would have been predisposed to numerous toxic infections and, of course, to abuse of alcohol and drugs.[188] With this last linkage – of a writer's occupation and excessive substance consumption, hypersensitivity, nervousness, and exhaustion – the construction of an "artist's disease" in the late nineteenth century occurred. This could imply neurasthenia and "latent" tuberculosis as well as syphilis. Ultimately, and most important, it identified the artist as a degenerate.

In literature, the multiple symptoms of this overarching artist's condition are revealed not only in Ibsen's *Ghosts* (the son, Oswald, was a painter returning from Paris), but also in the creative decadence of Des Esseintes and the later heroes of Hamsun and Rilke. Hamsun's writer, although supposedly plagued only by hunger, presents as a neurasthenic who teeters on the edge of insanity. He who had developed early in his city life the ability to "be aware of every detail" later admits that "everything I saw obsessed me" and is soon experiencing hallucinations and severe paranoia. Throughout, death is a constant companion, from the moment he arrives in the city and encounters his first advertisement declaring "Shrouds available, Miss Andersen, Main Entrance, to the right," a notice that he sees repeatedly throughout the city and the novel.[189]

For Rilke's poet Brigge, the specter of death is ever present, and more palpable: it is what he muses about most in his childhood, and he sees "*It*" (or "*him*") everywhere when he arrives in the city. Rilke acknowledges much more precisely, however, the late-century medical factors in his character's inevitable march toward death: Brigge is a writer and a decadent who is able to see things differently and is therefore immediately recognized by the other "outcasts" in the city. Still wearing his "better clothes" from his past life at the country house, Brigge assumes that he can still "walk into any café I felt like, possibly even on the grand boulevards" and yet the other outsiders wink at him, see through him, and "know that in reality I am one of them." The "insane" on the street begin

to do things that he sees as "a sign for the initiate, a sign only outcasts could recognize," and he is amazed that he can read these. "And the odd thing was that I couldn't get rid of the feeling that there actually existed some kind of secret language to which this sign belonged, and that this scene was after all something I should have expected." Brigge gradually acknowledges that these "signs" occur daily, and he worries that he will soon be one of them, who are not simply poor, or "different"; they are outcasts because destiny has rendered them sick:

> Then it was clear to me, that they are outcasts, not just beggars: no, they are really not beggars, there is a difference. They are human trash, husks of men that fate has spit out. Wet with the spittle of fate, they stick to a wall, a lamp-post, a billboard, or they trickle slowly down the street, leaving a dark, filthy trail behind them.

That these scrofulous outcasts are also sick city degenerates is clear; the woman who seemed to give him most of the "signs" is described "as if she were trying to recognize me with her bleary eyes, which looked as though some diseased person had spat a greenish phlegm under the bloody lids." It is also apparent that Brigge has himself joined the outcasts in this respect as well. Toward the end of his notebooks, Brigge realizes that the fear of death "has overtaken me in crowded cities, in the midst of people, often entirely without reason,"[190] but he also had already recorded at the very beginning of his account of Paris his gradual succumbing to neurasthenic symptoms and the kind of meltdown crisis of nerves described by medical diagnoses of agoraphobia, claustrophobia, and other sensory mental disorders:

> Electric trolleys speed clattering through my room. Cars drive over me. A door slams. Somewhere a pane of glass shatters on the pavement.... These are the noises. But there is something here that is more dreadful: the silence. I believe that during great fires such a moment of extreme tension must sometimes occur.... Everyone stands and waits, with raised shoulders and faces drawn together around their eyes, for the terrifying crash. The silence here is like that.

He concludes, "I am learning to see. I don't know why it is, but everything enters me more deeply and doesn't remain standing where it once used to. I have an interior that I never knew of. Everything goes there now. I don't know what happens there."[191] In this single description, Brigge the poet acknowledges his new life as an urbanite, at once bombarded by both the horrible noise and the dreaded silences of the city, and already beginning to develop the inner core of Simmel's "metropolitan man." But with this development, born of the hypersensitivity of the outcast (the city lights appear to him, as they did to Munch

in Paris, "too brightly lit"),[192] comes the recognition of himself as the outsider, the decadent, the diseased. It is not surprising, then, that when the poet finally reports to the hospital (where he offers the livid description of his fellow outcast patients, noted earlier), it is at Salpetrière hospital, famous for its doctors' work on hysteria and neurasthenia.[193] The fictional (but somewhat autobiographical for Rilke) Brigge was fully fitted into the role assigned to writers and artists. In the novel, arriving as the last in a dying line of aristocracy to Paris as a poet, he was already facing death as a degenerate.

It is Huysmans's Des Esseintes, however, who offers the most striking example of the "artistic type" who is doomed to degeneration and the threat of terrible death. The penultimate aesthete, he is so overwrought with the symptoms that would soon be called neurasthenia that he has to flee the city. His cottage in the country is not only a haven for artificial beauty and art, it is also designed as a rest cure: felt rugs are installed in the lower portions of his cottage, for instance, so that no sound of the servants' footsteps would hurt his sensitive hearing. By the end of the novel, it is clear that these accommodations are not enough. Des Esseintes gets sicker and is reduced to a "diet" of enemas (the "recipes" for which, of course, interested him enormously) to find relief. Further description of Des Esseintes's "nervous malady" suggests neurasthenia but also, with its eye distortions, syphilis.[194] Finally, he exhibits dementia. "After nightmares, hallucinations of odors, vision troubles, a hacking cough, with the regularity of clockwork, a beating of the arteries and heart with cold sweats; then, delusions of hearing, these deteriorations that present themselves only in the last stage of illness."[195] Typically for a physician at that time, his doctor, by ordering him to leave this esoteric life and return to Paris and "take part again into common life," does not, by means of this therapy, diagnose syphilis but rather neurasthenia. Typical also is the mélange of diseases to which Des Esseintes is told he can look forward to if he does not follow this doctor's orders: "insanity complicated at short notice by tuberculosis."[196]

But it is Des Esseintes himself who offers the most frightening vision of disease, in this case syphilis that would be his particular, degenerate end. In a proto-Surreal passage describing Des Esseintes's most horrifying nightmare, Huysmans images the über-disease of degeneration, here delivered to man through sex. The nightmare begins with a plebian-looking woman, wearing a servant's apron but having "the look of a saltimbanque at a fair." Although at first she seems to be someone Des Esseintes "had never seen before," he soon realizes that she has "for a long time [been] intimate with him, and in his life." As he is puzzling over this woman, however, they are both accosted by a horse-riding figure of disease. When he and the woman flee into a tavern, Des Esseintes can see the eerie horse outside the window, and realizes that the animal's eyes offer "the horrible gaze of syphilis which weighed on him." The finale to this nightmare is a "very pale, naked woman, green silk stockings molding her legs...her hair frizzled, with broken ends.... tints of boiled veal shone in her half-opened nostrils."

As she continues to change before his eyes, she takes on flamboyant colors, in eruptions resembling syphilitic chancres as, for example, "the pimples on her breast burst, glazed like two pods of red pigment." Thus, before his eyes, the woman breaks out in flower-forms reminiscent of the hot-house flowers he had been studying earlier in the day. But the red flowers illuminating her lips and nipples are actually a "terrifying irritation," and are accompanied by stains on her body; even as he is horrified by her, he is fascinated and cannot fight the impulse to go to embrace her, seeing "the savage Nidularium blossom under her meager thighs," now bleeding. The dream ends with death through sex; as Des Esseintes "caressed with his body the hideous wound of this plant; he felt himself dying."[197]

Although Des Esseinte's early vision of disease is fashioned after similar figures from the biblical Horsemen of the Apocalypse, an image often revived by late-nineteenth-century artists for disease depictions,[198] the later female apparition is Symbolist, with her syphilitic chancres as bloody flowers and her vulva appearing as a blossom brandishing castrating blades.[199] The submersion of sex and disease in this last vision is as complete as that in Munch's *Vampire* (*The Kiss*) (1893–4, Munch Museum, Oslo), about which August Strindberg wrote: "The fusion of two beings, the smaller of which is carp-shaped, and seems about to devour the larger, after the fashion of vermin, microbes, vampires, and women."[200]

As Des Esseintes's nightmare recurs over the next months, he realizes that his own degeneration has taken full, diseased possession of his body. Syphilis was but one possible factor in a seemingly inevitable decline in his health. The reader in turn is reminded that this pitiful character had been introduced, in the first lines of the book, by means of a denigrating comparison between Des Esseintes and his own original ancestors who appeared in the family portraits as "stalwart veterans" with "broad shoulders" and "steady eyes." Following these strong ancestral portraits, there was, however, a gap filled by only one face, an effeminate weak and rouged face that represented "the vitiation of an exhausted race." Explaining that "no doubt the decadence of this ancient house had regularly followed its course, [and] the effemination of the males had accentuated," the protagonist was thus introduced as the "sole surviving descendant of this family."[201] With this genealogy as well as the identification of his hero as a recluse devoted to art and literature, Huysmans neatly established for his fin de siècle readers the ultimate demise of his decadent, degenerate hero.

Knowing both the accusations and self-acceptances of artists as degenerates lends insight into the phenomenon of the Symbolist martyr complex. While there are many substantive reasons behind Christ-martyr alter ego of many Symbolist artists (their work was repeatedly criticized, and even banned, for example, so that notions of persecution were not entirely unfounded) – there may well have been additional "medical" reasons for their attitude as well.[202] Although the depression so many of them experienced in conjunction with critical

dismissal of their work might be considered reasonable, the artists themselves were described as degenerates, while the radical nonconformity of their work was explained as a visual symptom of their own disease within. Munch's *Golgotha* (Fig. 40) has been discussed as his symbolic death at the hands of the crowd, but this and many other references to his own death, such as the 1895 lithograph *Self-Portrait with Skeletal Arm,* are well known. Just as Ensor painted himself and other artists being served up as decapitated delicacies by the Brussels critics,[203] so also do his numerous self-portrayals as Christ serve as livid reminders of his strong martyrific notions. (Even his calling card in the 1890s depicted his name on a coffin being carried by pallbearers). Most of Ensor's self-portrayals carry overtones of satirical humor about his own death. In *My Self-Portrait in 1960,* for example, he displays a coy skeletal vision of himself as degenerate dandy, curly wisps of hair still sticking out of the smiling skull, and wearing tiny elegant slippers. As noted, all of the artistic types presented by Hamsun, Huysmans, and Rilke were haunted by thoughts of death. Ensor's morbid humor is also evident, for example, in *Hunger.* Shot through Hamsun's tale of the writer whose work was not accepted and who regularly assumed that he was eventually going to be insane, and was dying, was the notion that he must accept his condition (as artist) with aplomb: "I went to bed in my wet clothes. I had a dim feeling that I would probably die during the night, and I used my last energy to smooth up my bed a little so it would look decent around me in the morning. I folded my hands and chose a good position."[204]

REGENERATION

As we chart the divergent codes of tuberculosis, venereal disease, and degeneration, we have to wonder if there could ever be, for the Symbolists, a cure for the sick city? Just as Nordau's *Degeneration* prompted its own critics, including an anonymous book titled *Regeneration: A Reply* in 1895 and George Bernard Shaw's *The Sanity of Art* in 1908,[205] so there also exists in some Symbolist art a concerted effort to counteract the effects of the sick city. In Fernand Khnopff's idealized faces – as in those of his own family's portraits and the paintings of Burne-Jones that served as his models – can be found the antidote to the urban degenerate. Highly regular and delicate features, often emphasized by symmetrical hair arrangement, grace small heads, with normally formed ears and classically proportioned bodies. In Khnopff's numerous portraits of upper- and middle-class children, almost always posed formally, with framing devices that emphasize their interior, protected settings, perfectly proportioned faces with intelligent eyes stare out at the viewer, as in his *Portrait of Germaine Wiener* (Fig. 63). As if rewarding the fervent hopes of the eugenicists, these children seem the progeny of perfectly matched couples, who were, notably, almost all artists and musicians. As art historian Michel Draguet has noted, these children are, in their reserve,

FIGURE 63. Fernand Khnopff. *Portrait of Germaine Wiener*. c. 1893. Oil on canvas, 50 × 40 cm. Musées Royaux des Beaux-Arts de Belgique, Brussels.

their psychological distance, and their poised comportment, "underneath their child physiognomies, . . . [already] adults."[206] They serve as the well-behaved, predestined promises of a healthy future race. In other Khnopff works such as *With Grégoire Le Roy: My Heart Weeps for Other Days* (Fig. 4) the woman with the ideal, nondegenerate face has the same evocative reference to purer, healthier, past times, as does the vacant setting of Bruges, to which she relates through an alter ego (past) self reflected in the mirror.[207] Even in these beautiful renderings, however, might be found the fin de siècle penchant for illness, for even nostalgia, the cause of her weeping, remained listed as a disease in medical dictionaries at that time.

Many Symbolists, precursors of the Expressionists to follow, sought to strip the occlusive dress of city society and return to nature and the sun. In the 1890s vegetarianism and nudism were heralded as a return to nature, in response to

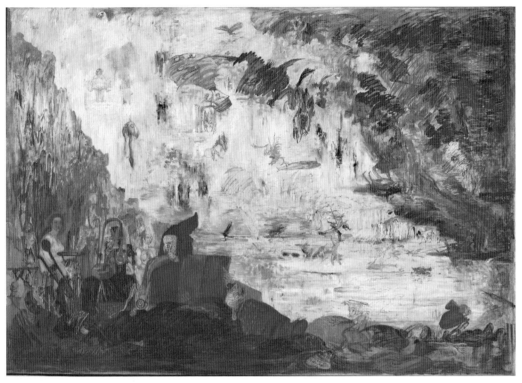

FIGURE 64. James Ensor. *The Tribulations of St. Anthony*. 1887. Oil on canvas, 46 3/8 × 66 in. Museum of Modern Art, New York. © 2003 Artists Rights Society (ARS), New York/SABAM, Brussels.

enthusiasts as diverse as feminists, eugenicists, and even medical authorities, all hoping to redetermine the course of the species, and to turn degeneration into regeneration. Symbolists engaged in this rhetoric adopted a new body image: large, muscular men and women appearing in open-air nature settings, precisely as had been prescribed for tuberculosis patients. Often these shone with an emphasis on sunlight, which had in turn been recommended as restorative for all germ-infectious disease prevention by Pasteure's followers. Thus while some artists became interested in specific new health protocols, ranging from Ensor's endorsement of the benefits of sea bathing and salt air[208] to Charles Maurin's *The Serum Treatment* (1895, Musée des Hospices Civils, Lyons),[209] many avowed renewed admiration for Hans von Marees's virile male nudes. Hodler, who would share honors at the 1904 Vienna Secession with both Munch and Hans von Marees, had already changed his style and figure type in 1896, probably in response to the Swiss critics' clear reading and denouncing of his code of consumption. In works immediately following that year – significantly works with a revisited focus on Swiss history and myth – Hodler invigorated his brushwork and brightened his color, while his figures fairly exuded their "good Swiss blood."

In the meantime, his countryman Trachsel devoted plate nine of his *Fêtes Réelles* to a "Temple of the Rising Sun."[210] Munch had already portrayed a young tubercular woman in full sunlight in his *Spring* (National Gallery, Oslo) of 1889, making reference in his writings to the sun's restorative powers.[211] By the time of his Oslo murals (1909–12), the image of the sun prevailed, becoming the dominant form of the paintings, an icon from which all humanity sought strength. In the meantime, Munch's individual figures – toward the end of the nineteenth century and most clearly by the early twentieth – grew notably muscular and healthy.[212]

ENSOR, DEGENERATE GENIUS

But for many Symbolists, and especially for Ensor it seems, it remained difficult even at the turn of a fresh century to ignore the sick city. In 1887, Ensor painted *Tribulations of St. Anthony* (Fig. 64) in which he had replaced the biblical desert of temptations with all the symptoms of a modern urban hell. Into a hallucinatory landscape are crowded traditional icons of deadly sin, including a "beautiful" woman, monsters, and the boat of Charon crossing a churning river Styxx. Closer inspection, however, reveals additional and especially modern means of torture, in little-disguised references to disease that are here strongly associated with the city. Throughout the lower land portion of the scene are dirty figures, human and animal, from which infected body fluids seem endlessly to flow: with noses running, open sores, and public defecating, the contagious mob surrounds the saint, marker of modern man. Charon's boat is crawling with bugs, while flying figures above – half human, half animal – display Ensor's common lack of concern about their emissions, adding their own flatulent germs to the fetid air. The saint himself, crouching in dismay in the left corner of the composition, looks over this swarming mass of disease toward a dubious doctor figure at the very right corner of the canvas. Although the doctor holds a gigantic hypodermic needle (or possibly an equally oversized sphincter) and seems to aim it at the masses, his own white coat is filthy, and his own nose is running out of control. That urbanity now represents the greatest temptation to a modern saint is perhaps best suggested by the inclusion of a flying air balloon in the sky above – a sight incorporated into numerous images of modernity following its introduction by Manet in his view of the Paris Exposition of 1867.[213] Most important, however, is the fact that Anthony is seated in a modern cafe from hell, where the supposedly enticing but actually disfigured Venus serving drinks wears a halo of blood red, and the odd band of entertaining degenerate musicians (one green figure uses his crab claws to stroke Orpheus' lyre) are covered with sickly spots. The modern saint need not seek out temptations in the desert; they are all available, full of disease and decay, right on the city street.[214]

Thus in the same spirit, Ensor caustically capped the century with his *Self-Portrait with Masks* (Plate 3). As we now realize, Ensor surrounds himself here with the dregs of society – Brigge's "outcasts" who carry the stigmata of their own degeneracy as well as the diseased seeds of future generations, all painted with the color and technical distortion belying, according to Nordau, the artist's own sick state. Several of the faces/masks have wall eyes or no eyes (optical paralysis and decay being a common side effect of tertiary syphilis); numerous features are deformed and asymmetrical, especially the two faces with twisted mouths at the bottom right of the canvas (disfigurement being related specifically to syphilis but also to criminality and degeneration). One female mask, located below Ensor and to the viewer's left of center, wears a garland of flowers (with their connotation of sexuality shared by the decorations on the painter's own hat), but she is hollow-eyed and has her nose eaten away, similar to numerous depictions of syphilitic wasting. The fulsome, fleshy mask of a black-haired, crooked-nosed woman that is one-third cropped on the right of the canvas, by contrast, seems fashioned after the Russian photographs of criminals and prostitutes published by Lombroso.[215] Immediately to Ensor's right are black masks, which have been related to the Belgian Congo,[216] geographically representing the spread of venereal disease and the newly colonized world to which was brought, as the press punned, "civilization and syphilization."[217] In this respect, both evolutionary theory and racial anthropology had coalesced by the last quarter of the century and were used to identify the nonwhite races as degenerations from the ideal physical characteristics of whites as well as "unprogressed" civilizations waiting to be developed.[218] To this, finally, must be added at least two masks whose noses are either elongated or "hooked," such as the prominent mask in the middle left of the canvas; these, although of course never cited by the Jewish Nordau, were common caricatures of the Jew, taunted as an outsider and clearly considered as a degenerate in numerous caricatures appearing in Brussels artists' journals.[219] The final end of Ensor's degenerate crowd is spelled out in the three death heads that appear, leering, in the background row.

As clear as these references to medical definitions of degeneracy are, however, they are even more potent as signifiers of artistic degeneracy, as outlined in particular by Nordau. As noted earlier, Nordau declared that the degenerate has "no modesty," and identified the degenerate artist as one with an excessive "emotionalism," given to "rambling imagination" and "mysticism."[220] The most obvious symptom found in degenerate art itself was related to these personality defects, namely, a love of garish color – a stigmata already mentioned by Lombroso. Nordau describes the degenerate as even dressing like one, and thus the opposite of the normal middle-class man who would properly choose a sartorial "uniform" of black and white as signifier of his paternal and business seriousness.[221] Nordau's portrayal of the decadent could describe Ensor here, wearing "the red dress coat with metal buttons . . . with which some idiots

in...gardenia try to rival burlesque actors." As Nordau summarized this, he verbally presented an Ensor-like crowd:

> the common feature in all these male specimens is that they do not express their real idiosyncrasies, but try to present something that they are not...they seek to model themselves after some artistic pattern which has no affinity with their own nature, or is even antithetical to it. Nor do they for the most part limit themselves to one pattern, but cop several at once, which jar one with another. Thus we get heads set on shoulders not belonging to them, costumes the elements of which are as disconnected as though they belonged to a dream, colors that seem to have been matched in the dark. The impression is that of a masked festival, where all are in disguises....[222]

By the 1890s degenerates were commonly viewed – despite their origin in medical texts discussing the individual (cretin, criminal, etc.) – as an entire subset, or underworld, of society itself, particularly visible in urban crowds.[223] Ensor's crowd represents the degenerate masses about which Nordau specifically warned: "Thus a regular concourse is established about a victim of degeneration. One hysteric joins another.... And this crowd, because it is driven by disease, self-interest and vanity, makes much more noise and bustle than a far larger number of sane men who...do not feel obliged to shout out their appreciation in the streets."[224] For Nordau, this tendency to band together – whether in "the association of neuropaths, the founding of aesthetic schools [or] the banding of criminals" – explains current art "schools." And "today," declared Nordau, "they are the Symbolists."[225]

But if Ensor here portrays himself as Symbolist among the other degenerates with whom he was critically cast – like a colorful carnival version of Lombroso's own charts of "Faces of Criminality" or "Types of Deliquents" (Fig. 65) – he makes a point of nonetheless distinguishing himself from them.[226] Although some have described Ensor in 1900 as newly "paranoid," especially about his art and his health,[227] he does in this self-portrait exude some confidence. Despite his dandified, decadent dress, his is the one face in this crowded composition that retains three-dimensional reality, and some normalcy. While all the other faces are painted with thick paint, crudely mixed or even smeared on the canvas, Ensor's own complexion is delineated with thinner, more feathered strokes of blended colors. In this composition, typical of many of Ensor's later works, the colors are so blatant and garish (white-pinks, for example, that glare from the canvas) that they work as a caricature of "normal" color; but the artist's own face is, remarkably, simply pale. In contrast to the eyes of his surrounding crowd – which are either vacant or wall-eyed, Ensor himself delivers a penetrating gaze, with naturalistic eyes that hold a clear focus, toward the viewer.

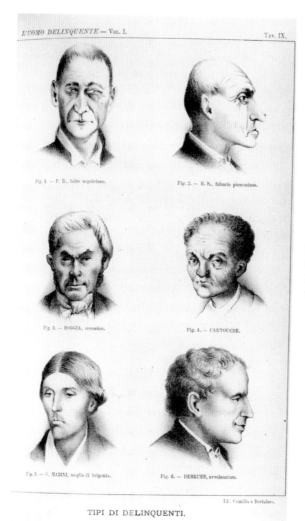

FIGURE 65. "Types of Delinquents." Plate IX of Cesare Lombroso, *L'Uomo Delinquente*, vol. I. Milan: Hoepli, 1876.

When this self-identification as healthy, and "normal" in appearance is added to the hat's reference to his predecessors in famous Flemish and Dutch Baroque art (both Rubens and Rembrandt painted themselves in elaborate costume and with feathered hats),[228] then Ensor's self-image here is one who has been relegated by others to the ranks of degeneracy but who sees himself perhaps as an exception that Morel suggested and on which Lombroso had expanded. In his original treatise on criminality and the insane, Lombroso had allowed that in some very rare cases, as a genetic quirk, the bad genes of degeneracy might combine to produce the opposite: the genius, who was nonetheless a result of heredity, along with his fellow degenerates.[229] While Lombroso's followers subsequently refused this anomaly, it was a notion that Nordau applied with renewed vigor, claiming, however, that unlike Lombroso's genius who might well help

the progress of humankind, such a genius was the worst of degenerates who would be capable of extreme harm if left unchecked.

As we have seen, the Romantic image of the artist as genius was imbedded into Symbolist theory, based on the aesthetic of artist as seer, or even priest, and able to make the "correspondences" necessary for great art. The Symbolist genius, however, was one who, according to their theory at least, was completely above the crowd (and normalcy) rather than below it.[230] In terms of actually living in society, however, this Romantic concept of the genius (which had also been predetermined, since one was "born" an artist) had been of necessity "different" from regular society; the midcentury development of the artist as bohemian was predicated on this assumption. By the time of the Symbolists, therefore, the reified aesthetic of the artist as priest had its own history of artist as bohemian, living a lifestyle dangerously close, as Brigge noted, to the outcasts and degenerates on the street. Ensor's self-identification as the genius among the degenerates, therefore, was one that aptly described the position with which the Symbolist artist identified in the sick city.

Although exhibiting some of the so-called symptoms of degeneracy, and making art that had been itself accused as symptomatic of disease, the Symbolist artist was actually the self-identified genius among the degenerates. He was no longer the *flaneur*, this was clear. But he was instead a new interpreter of the sick city, and therefore its new martyr. Cast as one of the degenerate crowd, he devoted his art to visually capturing the crowd, and by this means, reconciling himself to it. For Ensor, awareness of the sick city around him only attenuated his ability to see the masks, and beyond the masks; he was the Symbolist diagnostician.

5 ⌒ THE CITY WOMAN, OR THE SHOULD-BE MOTHER

Jan Toorop's *The Three Brides* (Plate 4) has become an icon of the "Symbolist woman," a complex combination of good and evil, the brides of both God and Satan. On the left, a wide-eyed nun in virginal white leans toward her attendants who hold white lilies and whose hair forms the curving Art Nouveau lines that represented for Toorop the symbolic sounds of dulcet music and spiritual sweetness. On the right is her opposite: a cat-eyed, skeletally thin woman bedecked in a snake headdress and a skull necklace. This woman seems to listen only to her inner evil, as her attendant pours blood into the bowl that she holds, while the musical "waves" emanating from her side of the composition twist themselves into angular contortions evoking dissonant sound. Toorop's interest in music was longstanding: he retained friendships throughout his life with numerous musicians, and portrayed them as well as their music in his art. His efforts to correlate by means of visual signs the correspondences between emotions and ideas expressed through art and music most likely developed, however, through his involvement with the Symbolist circles with which he began to associate upon settling in Amsterdam in the early 1880s.

Toorop had been born in the East Indies, of mixed parentage who nevertheless considered themselves Dutch; he had been sent to the Netherlands as a young man for a European education and career. After attending several schools in various cities, he ended his art training with courses in 1880 at the Fine Arts Academy of Amsterdam. The city that he encountered then was a thriving metropolis in the throes of expansion. A new residential district was established, for example, in the south part of the city for a burgeoning affluent citizenry, arranged around new public boulevards and especially museums (the Stedelijk Museum, Rijksmuseum and Concertgebouw were all built in this area at this time). Development continued as Toorop participated in exhibition and other artistic opportunities in the city. Amsterdam, like so many other cities with Symbolist connections, was being refaced for increased public consumerism with a self-conscious urban image.[1]

In 1882, Toorop moved to Brussels; in 1883, he became a member of the exhibition group L'Essor, and, the following year, Les XX. His first trip to England was in the company of writers Jules Destrée and Emile Verhaeren; here he was introduced to the work of Morris and the Arts and Crafts Movement. Despite further trips to England, where he met his wife, Annie, however, Toorop accomplished most of his long-term work in Belgium and the Netherlands. He moved first to The Hague upon his marriage in 1886, and in 1890 chose

the quieter ambiance (and more reasonable standard of living) of the small fishing village of Katwijk by the Sea, while keeping fresh his artistic contacts in Brussels, Amsterdam, and The Hague. In late 1892, he moved to Loosduinen, just outside The Hague. In Brussels, he had joined the circle around Edmond Picard, publisher of *L'Art moderne;* it was at the Picard salons that he probably met Félicien Rops as well as began a long friendship with Verhaeren. He continued to travel to Brussels, furthermore, for preparation of exhibitions and to renew personal contact with artistic and literary friends.

Brussels was only one Symbolist center for Toorop, however. Amsterdam, where Toorop arranged and installed exhibitions of both Les XX and Van Gogh, was quickly developing a milieu that would also serve as a cauldron for Dutch literary Symbolism. The bustling metropolis was the home of an important group of young writers and artists who in 1885 began working on the periodical *De Nieuwe Gids* (*The New Leader*).[2] Like a Geneva group that published the Symbolist *Revue de Genève* in the same year, the Amsterdam Symbolist generation sought to free their city from its perceived provincialism by introducing foreign, specifically French and British, culture to their readers. At the beginning, their literary and artistic inspirations were varied, and reflected the differing approaches to "new art" of its two primary editors Willem Kloos and Alfred Verwey. Although Toorop knew both men, he was closer to Verwey, as a friend and in terms of their shared artistic beliefs. Notably, Verwey's ideas were not only very similar to those of Belgian and French Symbolism, but also included socialist ideals. In 1890, these differences led Verwey to resign from *De Nieuwe Gids,* and to establish a new periodical, *Tweemaandelijksch Tijdschrift,* in 1894. This new journal heralded a significant shift toward Symbolism as its focus, with strong ties to contemporaries in Paris and Brussels, as well as sought to address the need for art to respond to society's problems. Eventually, *Tweemaandelijksch Tijdschrift* would address many of these ideas in a more religious and even mystical manner, and have a significant influence on Toorop.

By this time, however, Toorop had already painted his *Three Brides,* so that the religious references in the work were probably most directly the result of the painter's new association with Rosicrucianism. Péladan had arranged to lecture in Amsterdam and other Dutch cities in 1892, overlapping his tour with that of Parisian Symbolist poet Paul Verlaine, whose visit to Holland had in turn been arranged in great part by Toorop.[3] Toorop participated in most of the events surrounding these visits. This was the year in which the Sâr Péladan founded his neo-Catholic Salon de la Rose + Croix, and he must have been very persuasive: both Toorop and his friend Johan Thorn-Prikker were named members of the Salon society during the visit, and began almost immediately to incorporate overtly religious images into their art.[4] Finally, Toorop's friendship with the Dutch poet Henriette Van der Schalk, whose work premiered in the pages of *De Nieuwe Gids* and who infused her writings with staunch socialist beliefs, affected his ideas.[5] As Toorop entered into his most productive stage of

Symbolist work, as he was most fully influenced by socialist and idealist goals, and as he became, in the words of art historian Robert Siebelhoff, "the single most important link between the Netherlands, Belgium and France" for their Symbolist interactions, he conceived of and produced *The Three Brides.*

An extensive literature exists about the stereotypical fin de siècle woman's two exaggerated identities, as either virgin or whore and as presented in these two Toorop figures.[6] Often overlooked in this equation, however, is the fact that Toorop's work was about three brides rather than two. Toorop's most important figure is the central woman who is in many ways much more than a simple compromise between the other two.

This is the medial figure who, in a transparent full wedding veil that combines the sexual allure of Satan's partner with the purity of devotion that characterizes the bride of Christ, is the "bride of man." As British critic Walter Shaw Sparrow wrote upon the work's first exhibition, "the third Bride, the maid who seems to triumph, is the type of guilelessness, innocence, lowliness, humility; in a word, she is the Bride of what is most divine in human hopes and thoughts and inspirations."[7] Sparrow's first list of four characteristics, which might have been taken directly from an encyclopedia list of stereotyped "characteristics of sex" for the female, as I discuss later in this chapter, implies that he saw in the central woman all that a man would want: it is in this way that she "triumphs." The exact means of this triumph has been overlooked in prior literature, however, despite its visual evidence: the "Bride of Man" displays through her transparent veil a swollen belly, and she furthermore folds her arms on top of it, in recognition of its importance. When Toorop included for Octave Maus a brief description of the work as it was to be sent for Les XX exhibition in 1894, he described it as "symbolizing the birth of beauty marrying the spiritual world (on the left of the drawing) and sensual world (on the right)."[8] Because most of Toorop's explanations of the work emphasize, as this one does, its nonrealistic, symbolic design and the "eternal beginning" arising from "an everlasting source"[9] that comes forth from the earth, into the wavy lines of the composition, it may well be that on one level, the appearance of the middle woman was intended to be purely emblematic. But for viewers like Shaw at the time of its production, it is also the case that the perfect and triumphant bride of man is, in this Symbolist vision, pregnant.

Exactly why this identification was so important to many Symbolists is a question that raises issues about gender and procreation that, while not unique to the late nineteenth century, were certainly exacerbated concerns at that time. Although Toorop eventually developed a self-identification, and even a pictorial style, that included his East Indies background, he was thoroughly European in his approach to the traditional family. Just as his devotion to his own wife and daughter is apparent in his numerous depictions of them, so also do his typical male concerns about the future of this family emerge in works like *The Three Brides.* By the 1890s, the existence of the "New Woman" – as

middle-class feminists were then called, accused of being products of the metropolis[10] – threatened the very future of families such as his.

The conflicted iconography of the woman as what I am calling the "should-be mother" in the 1890s had a long gestation but the representation of pregnancy and motherhood took on specific societal inferences at mid–nineteenth century, as city life brought to public attention questions of procreation practices. These included eugenicist exhortations to "breed" healthy children, discussed in the last chapter, but also alarms about the New Woman who was denying her very nature.

At the same time that motherhood was offered as a "sure panacea" for the ills of complaining feminists,[11] there was a rising fear that lack of motherhood was causing a precipitous – especially for nationalistic causes – decline in the birth rate. The increasingly professional medical establishment had even, since midcentury, identified the disease of "puerperal insanity," a form of mental illness that struck a new mother with such intensity that she rejected not only her infant but usually her entire family, especially her husband. Significantly, this disease is now recognized as a socially constructed one that had only partial relationship to the illness now known as postpartum depression: puerperal insanity was, instead, a melancholic condition that could attack a woman in pregnancy, recent motherhood, or lactation.[12] Its most egregious symptoms were, furthermore, behavior that might today be viewed as "acting out": incessant talking, lack of personal care, neglect of domestic and maternal duties, often exposing oneself, uttering obscenities, and anger at or fear of one's husband. Although some physicians recognized that the victim might actually do harm to her family, the majority of case descriptions stressed the noncompliant and "unseemly" nature of the "most shocking" symptoms:[13] disclaiming children or husbands (or both) and using vulgar language, all by women who prior to this illness were "perfect" wives and mothers. As more was known about the nonrelationship of these "symptoms" with physiological (specifically gynecological) problems, and as the disease as vaguely defined by behavioral symptoms was increasingly doubted, both the case incidence and the diagnosis of puerperal insanity faded, until it was eliminated completely from medical definitions in the early twentieth century. But while it remained a medical certainty in the second half of the century, cases flourished, with sympathetic reactions encouraged by medical and social caregivers alike. This has led some to conclude that the disease allowed women to rebel, even if only temporarily (most cases were "cured" in a matter of months; it also became a major defense for infanticide).[14] Thus in a complex but unequal sharing of complicity, "[w]omen presented these symptoms and acted out their rebellion; male physicians who for ideological and professional reasons were disposed to define women's behavior as insanity, legitimized women's rebellion as illness."[15] Recovery from puerperal mania was viewed as a return to perfect motherhood, described in terms of "redemption."[16] The century ended with a final spate of this disease of motherhood-rejection.

Although fears that race genocide might in fact result from this new affliction, or even from a female citizenry that was overly educated,[17] the primary focus of such suspicions rested on the woman taking her own steps against her motherhood and the future of her race, through contraception, abortion, infanticide, and the abandonment of children. The fact that all of these actions were in some areas perhaps not actually on the rise at the turn of the century is less relevant here than the fact that they all were perceived to be so. This situation in turn was the result of the fact that all such practices, traditionally handled by women in private, were becoming increasingly involved with a more public and notably male domain. As we have seen, this was the Symbolist world.

ROPS AND THE CITY WOMAN: NEW FEARS

Some indication of this new situation, and the new attitudes that accompanied it, is provided by the late-century reception of an earlier (1879) etching executed by Toorop's Brussels-Parisian colleague Félicien Rops.[18] It has been suggested that Rops must have introduced to Toorop the writing of one of his own favorite poets, Baudelaire,[19] whom the Dutch artist then quoted in his *Vil Animal* (Fig. 60). Rops's etching titled *Satan Sowing Weeds* (Fig. 66) was completed before he met Toorop; it depicts a huge skeletal death figure striding across the earth and dispensing "weeds" from the pouch of his peasant's blouse. Rops's fascination with the theme of the sower had begun in 1867 with an oil painting of the same title.[20] In the later print, however, Rops made two important additions. Here, Satan no longer strode through a barren countryside, but rather trampled over a cityscape, recognizable as Paris by the inclusion of the Seine and Notre Dame, onto which Satan steps with a very heavy foot. As has been seen in the work of Ensor, the notion of troubles falling to the city like rain was a favorite device suggesting the airborne disease of the sick city. In Rops's print, however, Satan dispenses another kind of problem to grow into weeds that will choke healthy growth. Out of Satan's pouch are strewn handfuls of small nude bodies, what the artist called "WOMEN . . . the disastrous seeds of crime and human despair."[21] Like so many of the artists discussed in the last chapter, Rops's association of women, Satan, disease and the city was strongly influenced by Baudelaire's early decadent poems published as *Fleurs du mal;* his correlation between the urban woman and crime echoes the efforts of writers like Lombroso to link physical characteristics of gender to crime and prostitution.[22] In this print, originally intended as an illustration to his own book about modern woman and her collusion with the devil, Rops helped to establish visually this favorite Symbolist theme.[23] The work as such appealed to Symbolists in the 1880s and was the focus of considerable admiration in the 1890s. In 1896, Huysmans was still fascinated with the picture, extolling the "larvae of swarming women . . . these germs of evil [that are strewn] on the mute city."[24]

Despite Huysmans's use of the term "germ" here, however, I argue in this chapter that there was much more at stake in his 1890s interpretation of the city woman as evil than the male-accepted connection between women and disease. By that time, medical discourse had also established a classification of the female that coupled her biological characteristics with her destiny as mother.[25] As we shall see, this resulted in a Madonna cult that enshrined the female who followed this "natural" route; but it also branded as evil those who denied their vocation. By the 1890s, when most Symbolist works addressing this theme were created, the city woman was in particular implicated as inherently evil if she chose to forego motherhood. The whole idea of the woman as *seed* – strewn by Satan himself – appealed to the fin de siècle concern over proper procreation, and the need to find someone to blame for perceived crises in this regard.

That this additional interpretation was made of Rops's earlier print is evident in other tributes added to Huysmans's article in 1896, included in a special issue devoted to the artist in the Parisian journal *La Plume*. Especially cogent was a poem offered by Pierre Caume:

Great, great like Evil, this immense Giant,
And ugly like Vice with its obscene grimace,
Under his tramp's hat, the hate-maker
And like a banished man, has acid sparkles in his eyes.

Notre-Dame resists his hardened feet
But the Opera collapses, and his sick fury
Rashly confuses Heaven and Hell
The temple without shame, and the temple blessed.

He passes through, sowing into the fertile furrows
Of corrupted Paris, poisoned grain
That produces brambles and penetrating herbs.

He sows, merciless tyrant, upon the willful man,
The stupid and ungrateful bourgeois (these snakes),
Women, the best accomplices, Damned![26]

In Caume's analysis, the full implications of the woman as "seed" (or, in an intriguing alternate translation, "semen") – rather than the man – for future European races is made clear. The woman is the poisoned seed who will produce when added to fertile ground only brambles or, worse, evil herbs; for Caume, they are as such the perfect match not just for Satan but for the "stupid bourgeoisie" who are going to spell the end of the race with their lack of responsibility. As we shall see, interpolations such as this incorporated all the fears of the fin de siècle woman rejecting her job as the "should-be mother." It was, furthermore, the bourgeois woman on whom the burdens of healthy heredity, in these

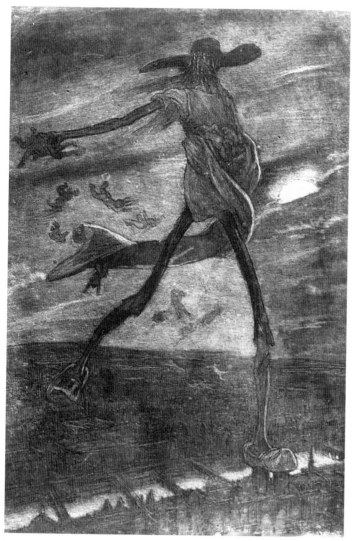

FIGURE 66. Félicien Rops. *Satan Sowing Weeds.* 1879. Etching. 27.8 × 20.9 cm. Musée Félicien Rops, Namur. Photograph courtesy: Schrobitgen.

post-Darwinian times, firmly rested. As the issue of fecundity became an important factor of nineteenth-century censuses and surveys, and as the "birth rate" versus "infant mortality" became political terminology in nationalistic efforts to control and increase population, most analyses concluded that it was the middle class that must provide solutions to recent warnings.[27] The peasantry was quickly disappearing, ironically in the face of the numerous statistical reports that recommended rural males for the military and country females for wet-nursing. Working-class women, associated in public proclamations with dangerous crowds, alcoholism, and prostitution, were certainly not the mothers of choice for the furthering of the race. For them, in fact, the metaphor of

"contagion" was applied, as it was to so many other groups noted in Chapter 3: women's factory work was said to lead by infective contamination to "morally abandoned children."[28] Aristocratic women, on the other hand, were presumed to suffer from the same degeneration that had resulted in sickly males like Huysman's fictional Des Esseintes. As Weber concluded in his supposedly statistical survey of 1899, "while the 'upper' classes are capable of producing large families, they either consciously refuse to do so, or else marry heiresses who are of course hereditarily unproductive."[29] This left the middle-class woman who, saved for her marriage, trained to domestic duties, and, most important, healthy, should not only accept motherhood but embrace it. Even this conservative argument was, however, complicated by some who, like Nordau, thought that the only truly healthy child would be, in fact, a "love child" born of intelligence and passion and not, therefore, in typical wedlock. But once in the city, it was argued, the New Woman – who was not the prostitute already evil but rather a potential bourgeois wife gone bad – was distracted by her own pleasures to the point of relinquishing all motherhood, the occupation for which she was destined.

Such interpretations had advanced Rops as the perfect illustrator for the Sâr Péladan, known for both his literary war on modern materialism and his misogyny. In 1891, Péladan had issued for his Rose + Croix esthetique an extensive list of dogmatic rules. Rule two was aimed specifically against modernity; as a postscript, Péladan added that "Following Magical Law, no work by a woman will ever by exhibited or executed by the Order." Needless to say, the "Magical Law" was Péladan's own.[30] Péladan's admiration for Rops was therefore based on what he perceived to be in agreement with his own assessment of society's ills. Rops's image of the downfall of modern Paris by means of women was, for the critic, the perfect art for an imperfect age; Péladan also in the 1896 *La Plume* issue reappreciated Rops' print, with a nod to Lombroso's theories of hereditary criminality, as Satan "sowing evil beings, detestable newborns who will be[come]perverse [criminals]."[31] Of course, Péladan was not alone in his fear and hatred of women. A strong link between Symbolism and anarchism is, for example, their common antifeminism,[32] which had been a convention of anarchist thinking since J. P. Proudon's early assertion that, as a part of his utopian society, women would have no role beyond the home and cradle.[33] But Péladan had put together these antimodernist and antifeminist notions into appealingly lascivious literary forms for Parisian and most Symbolist readers. In a group of stories that he published under the title *Femmes honnêtes,* Péladan recounted the sexual adventures of women who were anything but "honest." In the early (c. 1885) version of the text, some of the women are courtesans, but others are equally "evil" due to their obsession with worldly goods and pleasures and their devotion to selfish occupations. In the book's later publication (1888), the women are more overtly and self-consciously (willfully) evil, and the connection between feminism and the city, as well as to antimarriage and antimaternity stances, is fully made.[34]

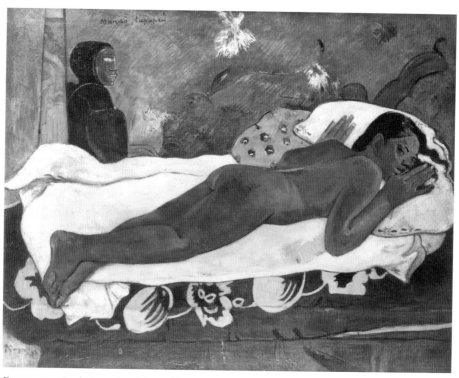

Figure 67. Paul Gauguin. *Manao Tupapau* (*Spirit of the Dead Watching*). 1892. Oil on burlap, mounted, 73 × 92 cm. Albright-Knox Art Gallery, Buffalo, New York. A. Conger Goodyear Collection, 1965.

Thus Rops's shift in his print version of the *Sower* to both women as cause of evil and the setting as city is significant because it elucidates one more element of his later attraction for other Symbolist critics and artists, exemplifying as it did the reactionary and often misogynist core of most Symbolist art in depictions of city women. Patricia Mathews has reviewed, for example, the special issue of the French *Revue encyclopédique* of 1896 dedicated to feminism, which attempted to canvas contributions from male and female commentators across the spectrum of opinions ranging from feminist to antifeminist. As she summarized, "The Symbolists exposed [in their contributions] their conservative side in this debate. They fell squarely within the dominant camp of those who preferred to maintain the status quo as far as women were concerned."[35]

As art historians Carol Duncan, Griselda Pollock, and others have established, modernism had at its base a masculinity that posited the artist as man and possessor and the woman as both "sexual prey and artistic cipher."[36] Pollock's study of Gauguin, for example, establishes his identity as artist-tourist and his position as male/imperialist as the basis for his construction of an idyllic world – at least idyllic for the white European male – far away from western women. Gauguin exemplifies the negation of the city because he not only flees urban

society with its middle-class morality, but also flees the European city woman. Speaking of Gauguin's *Manao Tupapau* of 1892 (Fig. 67), in comparison to Manet's *Olympia* (1863, Musée D'Orsay, Paris), to which Gauguin's painting refers, Pollock points out that "[t]he Tahitian woman on Olympia's bed is in fact Olympia's very antithesis. She signifies the opposite of that corrupted, venal, tainted metropolitan woman of the streets whose body is the conduit for sexual discharge and the flow of money. The Tahitian country girl has her sisters not in Paris but in the imaginary countryside of rural Europe where the bodies of European peasant woman were painted to signify the promise of sex freely given as part of nature's bounty."[37]

Gauguin's refuge in a constructed place called "the tropics" and his seeking out "native" women has been properly related to his acceptance of imperialist theory and practice. But it also makes clear that the city woman was threatening not merely as a diseased streetwalker but in all walks of life, as someone not "natural." To be natural, the woman should be a mother and caregiver, more heart than mind, located in the home and in the country. The image of the woman as natural, or even nature, had been a powerful metaphor throughout the nineteenth century,[38] crystallized in encyclopedia and dictionary definitions that stereotyped aspects of the opposing "character of the sexes." The woman, more emotional, dependent, modest and retiring, belonged in the protected confines of the home, an image that had been visually persuasive since the eighteenth century's beginning separation of gendered spheres.[39] With J. J. Rousseau's further identification, however, of man's sphere as "culture" and woman's as "nature," there was established not only a clear role for women to play but a clear space in which she should act on it. By this reasoning, women, if they did have to live in a city, should at least not be publicly engaged in it: hence, the proliferation of private spaces, usually inside the home, with elaborate rituals of domestic duties to occupy the nineteenth-century woman. As historian Bonnie Smith has pointed out, the new "business" of servants, fashion, and furnishings – requiring separate forks for pickles and for tomatoes – "expressed the symbolism of the household, serving simultaneously functional and metaphorical purposes,"[40] not to mention kept the middle-class woman busy.

This constraint of women to the home, along with other restrictions regarding their morality and proper decorum, began to be evident in Western visual arts precisely at the time of development of capitalist towns in early Renaissance. Although in the Middle Ages the Church had taken primary responsibility for the moral conduct of Christians, by the fifteenth century, with the establishment of cities of fairly independent means, town councils and other urban organizations began to establish laws meant to enforce middle-class morality: adultery was punished and prostitution either condemned or controlled.[41] As studies on Renaissance portraits of women (often in profile, robbed of their own gaze) have shown, this was also the time and the place of early capitalist cities, and the careful restraint of the wife, as a property of her husband, to the home.[42] The

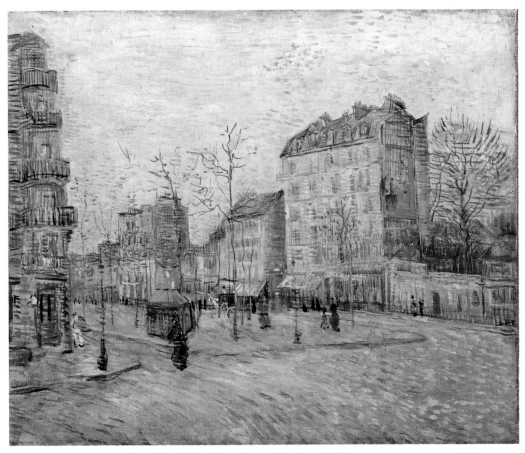

PLATE 1. Vincent van Gogh. *Boulevard de Clichy*. February–March 1887. Oil on canvas, 45.5 × 55 cm. Rijksmuseum Vincent van Gogh, Amsterdam. Vincent van Gogh Foundation.

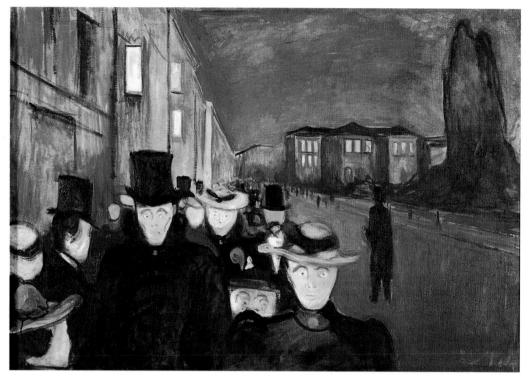

PLATE 2. Edvard Munch. *Evening on Karl Johan Street.* 1892. Oil on canvas, 84.5 × 121 mm. Rasmus Meyer Collection, Bergen. © 2003 The Munch Museum/The Munch-Ellingsen Group/Artists Rights Society (ARS), NY.

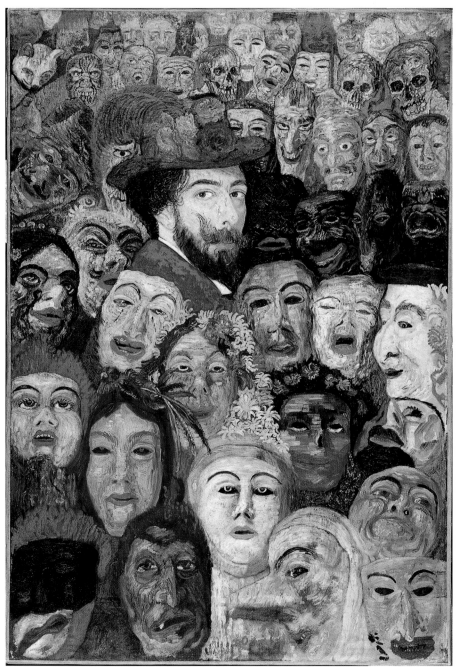

PLATE 3. James Ensor. *Self-Portrait with Masks*. 1899. Oil on canvas, 119.5 × 80 cm. Menard Art Museum, Aichi, Japan. © 2003 Artists Rights Society (ARS), New York/SABAM, Brussels.

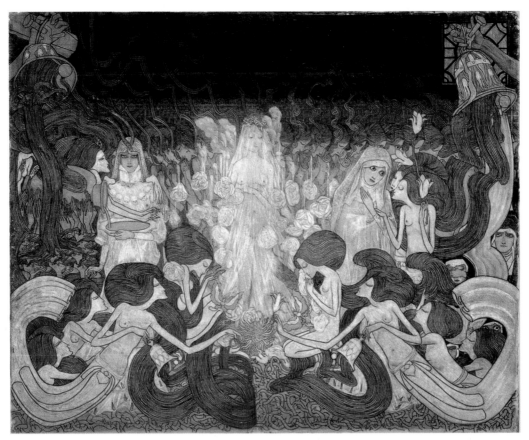

PLATE 4. Jan Toorop. *The Three Brides.* 1893. Pencil, black chalk, and color on brown paper, 78 × 98 cm. Collection Kröller-Müller Museum, Otterlo, The Netherlands.

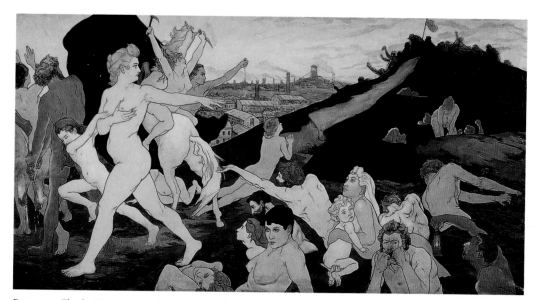

PLATE 5. Charles Maurin. *The Dawn of Work.* 1891. Oil on canvas, 79 × 148 cm. Musée d'Art Moderne, Saint-Étienne.

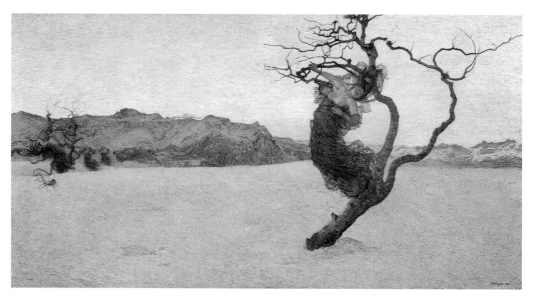

PLATE 6. Giovanni Segantini. *The Evil Mothers*. 1894. Oil on canvas, 120 × 225 cm. Österreichische Galerie Belvedere, Vienna.

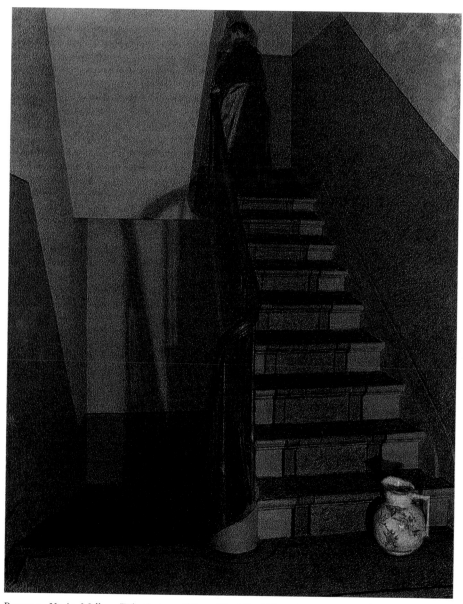

PLATE 7. Xavier Mellery. "The Staircase" from *The Life of Things* (renamed *The Soul of Things*). 1889. Chalk on paper, 57 × 45 cm. Koninklijk Museum voor Schone Kunsten, Antwerp.

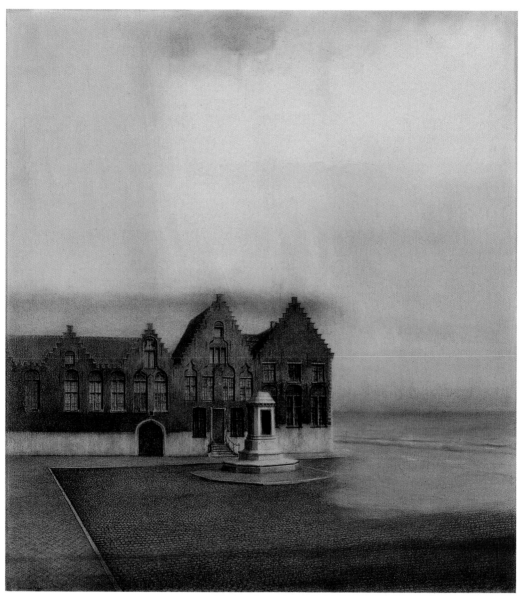

PLATE 8. Fernand Khnopff. *Abandoned City.* 1904. Pastel and pencil on paper, mounted on canvas, 76 × 69 cm. Musées Royaux des Beaux-Arts, Brussels.

most severe regulation of the woman to the domestic sphere, in other words, has historically in the West accompanied the growth of the city.

By the late nineteenth century, the depiction of middle-class women in domestic spaces had, especially in Realist and Impressionist works, arrived at a narrow range of tropes. Whether shown indoors or out, she is seated or at rest, rarely engaged in any significant physical activity. What she does do is restricted also: pouring tea, reading a book, or sewing, she only engages in activities using small movements and implying a comfort with these confining surroundings. As noted in Chapter 3, these portrayals of the woman at rest, and at home, were also often painted by women, primarily for the good reason that these were also their spaces, to which they were allowed and in which they, as middle-class women themselves, felt comfortable;[43] these were also the female and family representations that graced middle-class business advertisements.[44] The male Impressionists, on the other hand, were more likely to paint women of the "spectacle society" out of doors, in cafés and on the streets – all with carefully coded occlusive or revealing dress and averting or confronting demeanor to signify the woman's respective place in city society.

By the time of the Symbolists, however, the longstanding middle-class as-sumptions of the separate spheres were beginning to be questioned, not only by the burgeoning women's movement but by writers, artists, and social critics alike. Specifically, the sham of the middle-class marriage – ironically the same in-stitution in which hopes for healthy procreation seemed to rest – was denounced by some as an immoral and unhealthy practice. In his 1883 *The Conventional Lies of Our Civilization,* Nordau had condemned the traditional middle- and upper-class marriage as corrupt and designed for degeneration. Calling modern marriage practice the "Matrimonial Lie," Nordau contended that if these people continued to marry for money or position, they would thus refuse to marry for love and sexual attraction. Healthy females, like the three women of the New Woman novel mentioned in Chapter 4, Grand's *The Heavenly Twins,* would be pressured by society to marry old, immoral, and already infected men, rather than the fit youth to whom they were attracted. They would not want to have children by these feeble corrupt men, but if they did, they and their progeny in turn would be tainted into the next several generations. The result, Nordau predicted (as it was also the conclusion in the novel), was nothing short of a reversal of Darwin's evolution, as the unfit would start to outbreed, and outlast, the fit. Hence middle-class marriage was seen as a selfish manipulation, in which the man bargains for a dowry and image, and the woman works toward the same materialistic goals, interested neither in each other nor children. Nordau was one of the first, but by no means the last, to label such a woman raised to husband-hunt "a prostitute":[45] she had simply sold herself for more than cash.

> And wherein lies the difference between the wretched creature who
> sells herself to some stranger for a trifling amount, and the blushing

bride who is united before the altar to some unloved individual, who offers her in return . . . social rank and dresses, ornaments and servants . . . ?[46]

That Nordau's ideas were common assertions is proven by the various types of writings in which they were repeated. Peter Kropotkin's *Words of a Revolt* was typical, as he argued that even young girls of the bourgeoisie, taught by their mothers to behave and dress in a manner appropriate only for the boudoir, were therefore responsible for ruining by example the (purer) morals of working-class girls.[47] Like Nordau's, Kropotkin's anarchist appeals were voiced in reactionary language; like the Symbolists' expression of nostalgia, they were calling for ideals that they believed were held in the past. Nordau called for an unrealistic return to a more primitive state such as that in Europe's "other" – the colonies or even some isolated idyll – where relationships between men and women could be, like everything else, more "natural." Nordau's presumptions were even repeated, as noted, by the demographic statistician Weber: the city's middle class was incapable of perpetuating itself because of its unhealthy social mores and conducted these, furthermore, as business practices.[48] At least one female voice was heard on this matter in Brussels, where a woman wrote of the importance of "Love" in the old-fashioned manner, using instinct to help select a mate and allowing monogamy as well as maternity to continue its evolutionary role; this angry writer in one of her earlier columns admitted that, as a woman who felt only at one with nature, she wanted to declare "Death to Cities!"[49]

Symbolist depictions of women in interiors visually express the same reactionary response. Unlike Impressionist women who, while rarely working, are usually depicted as doing *something,* the Symbolist bourgeois woman is often alone, in muted light, stiffly posed, and unusually quiet. As is discussed in the next chapter, interiors for the Symbolists were spaces for meditation and often, when inhabited, showed women. Some of these portraits, however, are especially melancholic as if reflecting a condition of the sitter as bourgeois woman. Khnopff emphasized in his portraits of women their formality and reserve, in expression as well as space. In the *Portrait of Marguerite Khnopff* (Fig. 68), his sister is posed in a tightly corseted, high-collared dress, along with fashionable long gloves that completely cover her arms; he further surrounds her with a series of formal enclosures that read like an entrapping encasement. She appears within a door frame, the door, and a hanging cloth which has been related to the "honor cloths" that were painted behind the virgin in fifteenth-century paintings.[50] In the earlier religious examples, the cloth when added to an enclosed garden emphasized Mary's separateness, and also her virginity; Marguerite, in her white dress, is the modern Virgin, separated by human-made divisions, in her own reclusive shell. Michel Draguet has proposed that the front seam of her dress, fastened like a sutured wound in this white covering that is like a skin, suggests

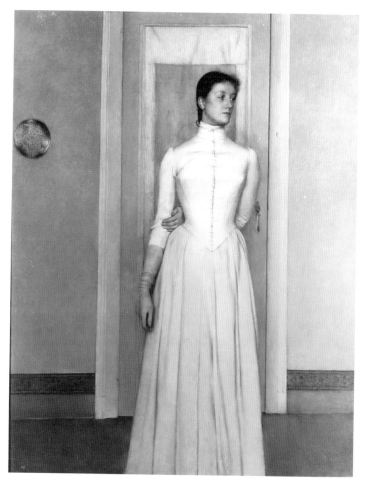

FIGURE 68. Fernand Khnopff. *Portrait of Marguerite Khnopff.* 1887. Oil on canvas, mounted on panel, 96 × 74.5 cm. Fondation Roi-Baudoin collection, on deposit at the Musées Royaux des Beaux-Arts de Belgique, Brussels.

an enforced virginity.[51] By the time of his sister's portrait, Khnopff had developed this composition into a pattern for most of his female portraits of the late eighties and early nineties, with Whistlerian subtleties that served to emphasize the encasing role of the interior spaces, even for young girls, as in his *Portrait of Germaine Wiener* (Fig. 63).[52]

Recognizing the city bourgeois woman as Symbolist object over whom male control was required helps in understanding exactly how reactionary this desired role for women was. As historian George Mosse has pointed out, traditional definitions of masculinity were also undergoing revision at the fin de siècle. Recurrent associations between the New Woman and castration of their male "enemies" laced both metaphorical literature and political rhetoric of the late nineteenth century: women would achieve not equity but dominating power

by eliminating the very manhood of their "other."[53] The phrase "New Man" was thus invented to counter the New Woman: a strong male – healthy in body, stalwart in morality and normal in sexuality – was what was needed.[54] As we have seen, however, the Symbolist artist was by the 1890s often associated with decadence and therefore was the anti–New Man. Just as the corruption of manhood was equated with the sickness of society, so also the Symbolist artist – who often began as an emotional and even overly sensitive decadent – was labeled according to this rhetoric not only sick but also not a true man. Faced with the perceived need of more "manly men" to save modern society, effeminate or physically weak men were newly suspect; lack of conventional social graces were seen as kind of disability, and emotional "artistic temperament" was often linked with homosexuality (the perceived ultimate state of unmanly men).[55] For most Symbolist artists, the Baudelarian themes of lesbianism and homosexuality and the decadent obsession with androgyny[56] held a strong fascination; such interests were precisely those that threatened the New Man. Mathews has argued that the Symbolists' usurpation of feminized interests such as these, as well as in their aesthetic, with its "feminine" characteristics such as intuition required some protection from accusations of effeminacy. Such protection was provided by their overstated objection to women having any claims to genius.[57] I would add that this same reasoning also helps to explain the Symbolists' need to resort to images proclaiming the importance of the should-be mother.

At the same time that even bachelorhood was questioned, as a perversion of the natural paternal role "required" of men for their race,[58] some Symbolists seem to have invested in their works the identity of progeny that they were unable, for one reason or another, to produce. For example, Munch considered his art to be his descendents, writing that for "my work, my art . . . I have sacrificed my happiness, that is, what others call happiness – prosperity, a wife, children."[59] Van Gogh wrote about his "spermatic paintings" that bore witness to his virility, despite his admiration and even envy of those artists who, like Gauguin, could produce both art and children at the same time.[60] This romantic medical notion of a "spermatic economy" claimed that the male's "passion" had a finite capacity, and therefore must be spent judiciously. It created an additional burden for many artists just as the new masculine ideal was situated as an opposite of those qualities with which Symbolist artists identified. Not only were they unmanly men because they were Symbolist artists, but the more they devoted themselves to their art, the less likely their manhood would ever be proven through children. Given this gender identity conflict, the Symbolists' reactionary and conflicted attitude toward women is at least more understandable.

Nowhere in Symbolist art is this conflict more clear than in depictions of motherhood, or the lack thereof, on the part of the city woman. Not only in Toorop's *Three Brides* (Plate 4) but also in Munch's *Three Stages of Women* (Fig. 69), for example, can be found the two extremes of the female identity as well as a third, interim stage of development. Munch's version of the three stages of

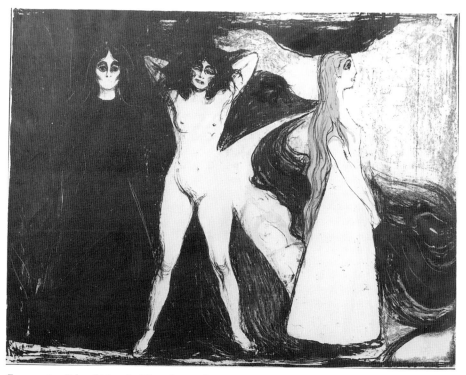

FIGURE 69. Edvard Munch. *Three Stages of Women (The Sphinx)*. 1899. Lithograph, 447 × 591 mm. © 2003 The Munch Museum/The Munch-Ellingsen Group/Artists Rights Society (ARS), NY.

women is, however, not as positive overall as that of his Dutch counterpart: in each stage, the woman is simply controlled by passions, and the Nietzschean fate that awaits her body. For Munch, the "first stage" virgin is not a true identity of woman, but rather a waiting stage that must occur before sexual maturity, which in turn brings conception and consequential death; the "dance of life" was one of sexual linking, conception, and with the inception of the next generation, the inevitable death of the present. What links Munch's vision to that of Toorop, however, is that in each case, there is an emphasis on the middle woman as mother. In the Munch, the combination of intercourse, conception, and death is built into the central woman just as it is in his well-known versions of the *Madonna* (Fig. 70).

In these male portrayals of the woman of the 1890s, the implication is that her most important role is as mother. Separate studies in the 1980s by Wendy Slatkin and Kristie Jayne suggested that Munch's emphasis on the woman as site of fertility was not, as some earlier biographical accounts had claimed, purely personal misogyny on Munch's part, but rather that these notions had deep "cultural roots" for men in late-nineteenth-century Europe. "Munch's (and other Symbolist's) preoccupation with sexuality and fertility thus can be situated in the historical context of a society and economy that placed a renewed and

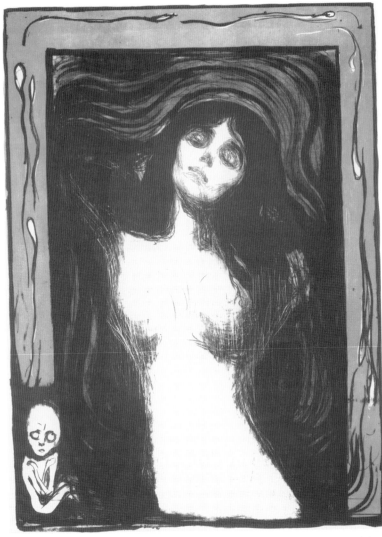

Figure 70. Edvard Munch. *Madonna.* 1895. Color lithograph and woodcut; lithograph printed from three stones in beige, red, and black; woodcut printed from one block on blue (Shiefler 1907 33.A/b/II) 60.1 × 44.0 cm. National Gallery of Art, Washington D.C. The Sarah G. and Lionel C. Epstein family collection. © 2003 The Munch Museum/The Munch-Ellingsen Group/Artists Rights Society (ARS), NY.

concerted emphasis on the female roles of wife and mother."[61] Slatkin and Jayne relate Munch's ideas to scientific and philosophical culture, citing "agreement with ideas propounded by voices as different as Darwin and Haeckel,"[62] as well as the social changes that put women in the gap between workplace and home. They do not relate them, however, to one additional social, legal, and increasingly medical force: the high rate of abortion, infanticide, or abandonment of children that had become a public issue in the late 1880s, even in Norway, where

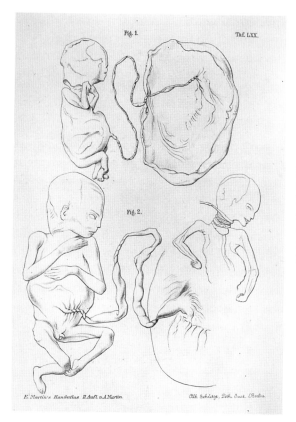

FIGURE 71. After F. Hille, "Fifteen Cases of Twisted Umbilical Cord." Plate LXX, Eduard Arnold Martin, *Hand-Atlas der Gynäkologie und Geburtschülfe*. Berlin: Hirschwald, 1881 (orig. 1862). Collection National Medical Library, Bethesda.

large-scale emigration to the United States beginning in the late 1860s added extra strain to concerns about lowering birth rates.[63]

Jayne's article ends by identifying the "biological substances" in Munch's print version of the *Madonna* (and these images were presumably also attached to the painting by means of a frame now lost),[64] – the fetuses and sperm that border the image of the Madonna herself – as confirmation that "her primary function is the physiological process of reproduction."[65] Munch's most well-known statement about the painting has been cited as further proof of this interpretation: "Now life reaches out its hand to death. The chain is forged that binds the thousands of generations that have died to the thousands of generations yet to come."[66] The importance of continuing the race through procreation is certainly one basis for Munch's comment, especially when "nature" is understood as a "cure for the sick city," as already discussed. But it does not fully address what many at that time would have read as the distinct possibility of the healthy chain *not* being forged. For these alarmed individuals, the death in too many cases was that of the mother dying in childbirth, and the child being born sick or worse, aborted or born into unwanted circumstances.[67] Munch's images of distressed fetuses, in fact, – whether occupying the frame of *The Madonna* or *Young Woman*

and Death (Fig. 56), are very similar to those found in medical treatises of the latter half of the nineteenth century that illustrated common problematic fetal positions (Fig. 71). When Munch's friend Przybyszewski reviewed the painting of the *Madonna,* he offered an enigmatic but telling description of her wearing "the halo of the coming martyrdom of birth."[68]

FALLEN WOMEN

A strong visual background to this theme was established in Victorian narratives, in which the errant woman, be she prostitute or middle- or upper-class adulterer, was punished by becoming pregnant, always with dire and usually fatal consequences. Both Linda Nochlin and Susan Casteras have addressed the image of the "Fallen Woman" in mid- to late-nineteenth-century art and demonstrate that the women are victims in these portrayals, but justly punished victims nonetheless, in Victorian opinion, what has been termed "a kind of metalepsis" of the fallen woman as cause and effect.[69] A primary basis for this attitude was the perversely logical sanctioning of prostitution as necessary for the Victorian maintenance of separate spheres: if the man was supposed to be "experienced" at the time of his marriage, but the wife was expected to be virginal, then the job of initiation of males into sexuality fell to women outside the male's class boundaries.[70] As Casteras explains, "the stability and sanctity of the home and of the family itself rested to a considerable degree on the existence of prostitutes, to whom gentlemen might resort because of the taboos of gentility and the idealized, nearly sexless purity ascribed to the 'angel in the house.'"[71]

But despite the acceptance of prostitution and male adultery in this manner, society did not excuse the woman from bearing the brunt of its consequences, especially an unwanted child. Numerous literary examples of this, including the influential "Bridge of Sighs," a poem by Thomas Hood with its archetypal narrative of a young woman gone astray in the city, are well known.[72] As several artists, including Gustave Doré and John Everett Millais, both of whom were admired by the Symbolists, made illustrations to Hood's poem, they established important precedents for relating the fallen woman to a river and even to a sewer as an inevitable end. Hood's prostitute commits suicide by jumping from a bridge, and Millais's illustration, for example, shows the girl contemplating the deed with the bridge against the city skyline and lights, illuminating the obvious real cause for this tragedy.[73] Only slightly earlier, the prostitute Martha Endell of Dickens's *David Copperfield* had offered her complete identification with the Thames: "Oh, the river! . . . I know it's like me [and] comes from country places, where there was once no harm in it – and it seeps through the dismal streets, defiled and miserable."[74] Knowing that the Thames was, like most rivers running through major European cities at this time, the city's former main sewer helps to identify a continuing association of the fallen woman with sewers through

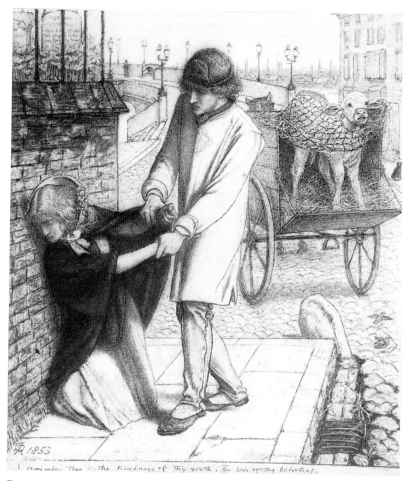

I remember thee : the kindness of thy youth, The love of thy betrothal.

FIGURE 72. Dante Gabriel Rossetti. *Found.* 1853. Pen and brown ink, brown wash, and India ink with white touches. Trustees of the British Museum.

Symbolist and even early Expressionist depictions. Certainly, it had seemed customary for William Acton, in his 1870 essay of *Prostitution, Considered in Its Moral, Social and Sanitary Aspects,* to speak of the derelict prostitute "cowering under dark arches" most commonly found beneath city bridges.[75] Acton's French predecessor in this endeavor was Alexandre-Jean-Baptiste Parent-Duchatelet, who followed his study of Paris sewers with his important book *De la prostitution dans la ville de Paris* in 1836 and concluded that "[p]rostitutes are as inevitable in an agglomeration of men, as are sewers, garbage dumps, and rubbish deposits."[76]

As historian Alan Krell has interpreted these concerns, Parent-Duchatelet hoped that "both the prostitute – in her capacity as 'receiver' of male ejaculation – and other sites/receptacles of human waste required close monitoring and control."[77] Casteras further cites at least one critic who assumed that the victim in George Frederick Watt's *Found Drowned* (a title using coroner's terms)[78] was

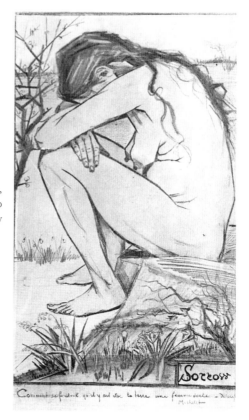

Figure 73. Vincent Van Gogh. *Sorrow.* April, 1882. Pencil and black chalk on paper, 445 × 270 mm. The Garman Ryan Collection. The New Art Gallery, Walsall.

a fallen woman who had chosen suicide rather than bear an illegitimate child.[79] And although associations in France were similar and are reflected even in critiques of Manet's *Olympia* (where no reference to sewer or street are visually included),[80] the most clear association of these elements – bridge, sewer, and fallen woman – occurs in Dante Gabriel Rossetti's c. 1854–9 *Found,* where a wayward girl is discovered, cowering before a background bridge. To the right of the drawing version of this composition (Fig. 72) there is a sewer, on the grate of which lies a wilted flower, symbol of the fate of the woman herself.

For a brief period in the early 1880s, Vincent Van Gogh devoted not only much of his work but also his life to enacting the fallen woman myth. Living in The Hague, he met Sien Hoornick, an unmarried mother (only one of her three children to that time had survived) who was suffering from venereal disease, working as a prostitute and, again, pregnant. It was this woman who modeled for Van Gogh's early depictions of the city poor. She also became his rescue project, as he explained to his brother Theo: paying her rent, feeding her, taking her in and eventually trying to establish a "family" with her child and her newborn son. In *Sorrow* of 1882 (Fig. 73), Sien posed as an icon of the fallen woman, crouched, nude, in a profiled melancholic posture that allows an emphasis on two parts

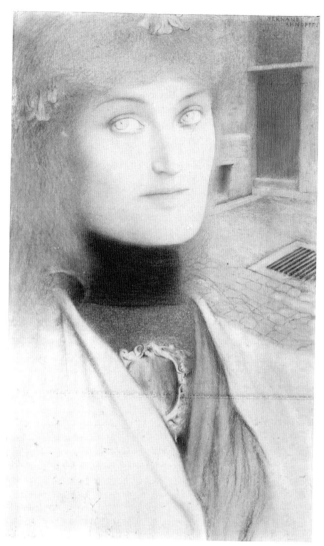

FIGURE 74. Fernand Khnopff. *Who Shall Deliver Me?* 1891. Colored chalk, 8 5/8 × 5 1/8 in. Private collection. Photograph courtesy Galerie Patrick Derom, Brussels.

of her body, sagging breasts and a swollen abdomen, which announce that she either is pregnant or has recently given birth. Neither situation, given her pose of absolute despair, is a happy circumstance. That Van Gogh appreciated this motif and the story it implied is established by his admiration for the prints he saw in the British magazines that illustrated it: he collected pictures from the *Illustrated London News* and the *Graphic,* and he compared the figure of Sien Hoornick to those drawn by "Holl or Fildes" (see Fig. 81).[81] As art historian Carol Zemel has pointed out, a primary literary influence on Van Gogh was the writing of Jules Michelet, the French historian who offered, in his books

titled *L'Amour* and *La Femme* some of the earliest guidelines of conservative male rhetoric regarding the domestic role that was critical to the well-being of any young woman in the city.[82] Just as Van Gogh later symbolically portrayed the virtues of "natural" motherhood in his depictions of Madame Roulin as a full-breasted, rocking mother, in his *La Berceuse*,[83] so he began his maternal images with the pregnant, fallen woman.

Fernand Khnopff's *Who Shall Deliver Me?* of 1891 (Fig. 74) also fits into this tradition, of which he must have been fully aware. Khnopff, who counted among his friends numerous English artists and writers, frequently addressed English arts in articles for Belgian periodicals and in public lectures at the Brussels Maison du Peuple. He also wrote articles, in English, for the London-based periodical *The Studio;* many of these reveal his respect for Victorian artists and especially the Pre-Raphaelites of the latter half of the nineteenth century. As many have established, one important aspect of Khnopff's admiration for English art was the underlying social ideals for art of writers such as William Morris and Walter Crane.[84] In *Who Shall Deliver Me?* Khnopff used as his title a line from a poem by Christina Rossetti and presumably left the title in English.[85] In the painting, a woman is seen from the chest up, with her figure cropped on all sides, so that the point of view is extremely close. Although arranged in a potentially confrontational composition, this woman on the street is not as frightening as the featureless faces of Munch; we seem to be viewing her slightly from above (and therefore from a taller, male perspective?) and her expression is beseeching. Behind the woman, however, is an equally cropped view of a city alley or street – the cobblestones and light blue water as well as close-quartered stone wall around the street clearly mark it as, if not an old street, certainly not a wide modern boulevard. Most remarkable, however, is the inclusion of a large sewage or water drain right in the center of the street and close to the center of Khnopff's composition, jutting into the viewer's space from the right and directly opposite the woman's high-collared neck. The association seems to be clear, given the precedents of the trope, that the woman is fallen and seeks deliverance from the filth, physical and moral, of the city gutter.[86] Reference to the drain might also signify even further degradation, through thoughts of past and future infanticide: rivers, waterways, and city sewers were often the site of discoveries of small bodies.[87] The overt visualization of a similar situation occurred later, in Lyonel Feininger's 1908 *The Manhole* (private collection), which the artist originally titled *The Infanticide.* As other early street workers look on, seemingly in derision, the woman's awful deed – the small fetus lying on the pavement next to the manhole – has just been discovered.[88]

In titling his much more subtle painting in the form of a question, Khnopff was following a recent English tradition of the "problem painting" – pictures that deliberately set up a scene for psychological drama, but without a set interpretation. The title of the work would often be phrased as a question, and

delineated with ambiguous, even deliberately dichotomous situations. A good example of this is Frank Dicksee's *The Confession* (1896, London: Roy Miles Gallery). In this painting, as Joseph Kestner has argued, there is a deliberate "series of dichotomies (male/female, black/white, shadow, light, hands separate, hands together) encoding a harsh separation of the male from the female" that makes it impossible to determine who is confessing to whom.[89] As such, the prevalence of these "problem pictures" in the mid- to late-nineteenth century serves as an important correlation to the Symbolist's desire to evoke states of being rather than to illustrate reality. Although the British critics accustomed to these problem pictures would have offered various solutions and definitive interpretations, Khnopff's pastel, when it was first exhibited at the Exposition du Cercle Artistique in Brussels, was by an anonymous reviewer simply termed – more appropriately for a Symbolist work – a "suggestive composition."[90] Nevertheless, *Who Shall Deliver Me?* offers ambiguity and an invitation for the viewer to enter into the "problem."[91] Thus even Verhaeren, often inclined to long analyses of Khnopff's work, was admiring but only vaguely implicating in his explanation of the work, claiming that "[t]he grate of the sewer appearing in the simple and unadorned courtyard where the person has been immobilized, adds to the signification of her solitude ... [the work] is reduced to no riddle (rébus) and the halo of red hair, strange halo, surrounds her in the memory of the understanding visitor."[92]

Following the tradition of the "problem painting," Khnopff avoids the fully moralizing stance of other, non-Symbolist artists who, especially in the Victorian tradition, sought to spell out exactly what the problem was and suggest solutions or, like the much later Feininger, at least suggest an ending.[93] What these conclusions made explicit – that doom and death await the illegitimate or unwanted child and its mother – was repeated throughout the 1880s and 1890s in print cycles that dealt with the new, fallen, or errant woman. Of significant influence on later Symbolists were the graphic cycles of Max Klinger, an artist who blended stark realism, often with explicit social commentary about urban issues, with idealizations and flights of fantasy.[94] Already in his earliest drawings, Klinger had summarized the plight of the contemporary woman in his sketch of a pregnant woman being coerced by a skeletal demon of death to jump into a freshly dug grave (Fig. 75).[95] That Klinger was sympathetic to the current deleterious conditions for mothers was later proven in his 1883 *Dramas*, a set of etchings that was illustrative of contemporary political and social issues. Three of these prints tell the story, based on court proceedings published in the Berlin press, of an actual case.[96] In "A Mother," we see, in sequence, the woman and her young child being threatened by a man, the aftermath of her murder-suicide attempt, from which she is saved but in which her child has drowned, and finally the trial at which she sits, in a forlorn trance. In 1884, Klinger published yet another series, *A Life,* about the tragedy of a woman who, when abandoned

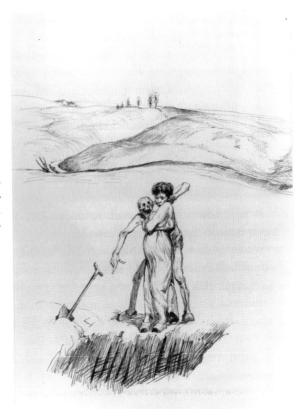

FIGURE 75. Max Klinger. *Death and the Maiden (Death at the Grave)*. 1874–7. Etching and engraving, 43.8 × 28 cm. Museum der bildenden Künste, Leipzig.

by her lover, is forced into prostitution. In one of these prints, "Into the Gutter!" (Fig. 76), Klinger adapts the well-known attributes of drowning and sewers into a particularly damning image of city society: the woman is pushed by a mocking crowd into a huge gutter that lies directly below her, ready to carry her along with the other city filth. The series ends with pessimistic condemnation, as the woman, in death, is returned "Back into Nothingness."

Although the early *Dramas* had been showered with awards, *A Life*, exhibited only one year later, was called "disgusting" and "vulgar."[97] Klinger's next cycle, *A Love* (1887), had one print removed from exhibition at the Berlin Academy on grounds of indecency, causing the artist to remove the entire series from display.[98] In *A Love*, the story that Klinger tells is less about love than about death, of a woman and her baby; in this series he fully confronts the issue of the unwanted child. Only three plates are devoted to the lovers' meeting and courting; these are followed by one "Night," subtitled "Happiness." In subsequent plates the lovers demonstrate guilt and foolish dreams of future contentment. But in the eighth plate, we see the woman in "Awakening" (Fig. 77), in which she sits at the side of the bed and stares in horror at a small vision of a fetus

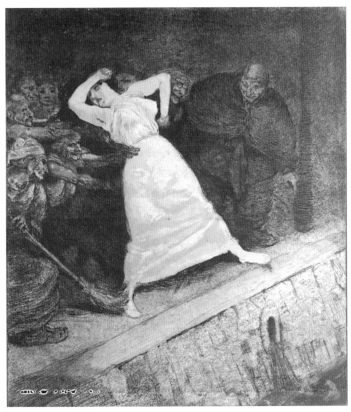

FIGURE 76. Max Klinger. "Into the Gutter!" from the series *A Life*. 1883.
Etching and aquatint, 207 × 189 mm. Museum der bildenden Künste, Leipzig.

hovering over the bed: she realizes that she is pregnant. Plate nine spells out society's usual reaction to this situation, in "Shame" (Fig. 78), in which the woman walks alone, accompanied only by a specter or shadow of her guilt; significantly, several women are looking at her over the wall above her. These women, and especially one mother with her young daughter who are directly above the guilty woman, represent the middle-class morality to which she must presumably answer. In the last plate, however, Klinger presents a much more sympathetic image of the woman as ultimate victim. She lies dead, now mourned by her lover, while death itself cradles the dead child in its arms, about to carry it away. Although some interpretations of this scene refer to a stillborn baby and death in childbirth, the possibility of death from abortion, a common tragedy especially in such circumstances, cannot be ruled out.[99]

Klinger's prints were well known to the Symbolists of the 1890s; early in that decade, six of his series, including the three addressing women in society, were reissued. If, as has been suggested by many, Klinger's image of the woman's "awakening" was a possible source for Munch's later *Puberty* (1894–5, National

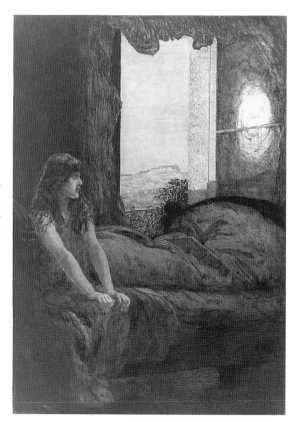

FIGURE 77. Max Klinger. "Awakening," plate 8 of the series *A Love.* 1887. Etching and engraving, 458 × 314 mm. Museum der bildenden Künste, Leipzig.

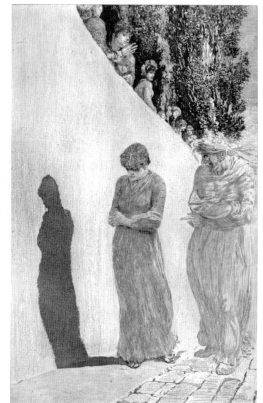

FIGURE 78. Max Klinger. "Shame," plate 9 of the series *A Love.* 1887. Etching and engraving, 458 × 318 mm. Museum der bildenden Künste, Leipzig.

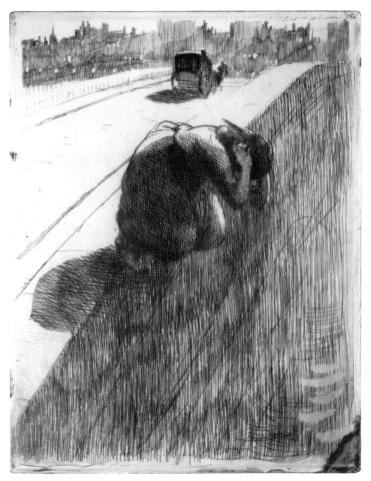

FIGURE 79. Albert Besnard. "The Suicide." From *La Femme*. c. 1886. Etching.
31.3 × 24.5 cm. National Gallery of Art, Washington D.C.

Gallery, Oslo), then Munch's poignant image might not be only about sexual awakenings but the concurrent awareness of the consequences of such arousals.[100] Victorian medicine had for decades conflated women's health and women's fertility. In medical advice guides, women were told that onset of menstruation was the "threshold" of womanhood. Womanhood, in turn, was equated not with sex but with motherhood.[101] Thus for Munch, as for Nietzsche and other late-nineteenth-century males, sexuality meant mental pain and even eventual death for the male, but for the late-nineteenth-century woman, it also meant pregnancy, the burdens of motherhood, and a likely early death, not only for her but also for the child.

Munch may also have found sources for his *Frieze of Life* paintings in the prints of the Frenchman Albert Besnard, who regularly focused on women's issues (including rape and suicide), and whose works were shown often, as

series, in Paris as well as Brussels, where he was a close associate of artists of Les XX.[102] In particular, Besnard's series *La Femme* of 1886–7 illustrated scenes from women's lives at that time. Although the titles of the plates read in order imply a single "life," – leading from love, lunches, and flirtations through rape, misery, prostitution and suicide (Fig. 79) – the artist insisted that he wanted to accomplish more than a simple plot. As Besnard explained in a catalogue of 1898:

> I have searched in these twelve etchings to fix some impressions of humanity: young and passionate love, the kiss of love, the triumph; the rich and happy woman, the center of admiration; the death of a child in its miserable room, the mother forced to take off her own clothes in order to cover her child, losing with him the sole defense against a life of prostitution driving towards disgrace and death.[103]

Like Munch in his later *Frieze,* Besnard hoped to avoid the narration of an individual woman's life and instead to evoke the stages and states of being for the modern woman. Lacking in Besnard's series, for example, is the overt socialist moralizing of other series at that time.[104] Besnard's series also lacked the dark satire of later caricaturists such as Heinrich Zille, who in a 1906 drawing titled *In the Water* for the German caricature journal *Simplicissimus,* portrayed a poverty-stricken pregnant mother headed to the river at the foot of a bridge. As factory smokestacks spew black soot into the air of the background city, the mother answers the question of her toddler, who is obviously going to accompany her mother in the plunge: "Mother, isn't it too cold?" – "Be quiet – the fish always live in there."[105] In his more personal and subtle intent as well as in many other characteristics, then, Besnard is an artist whose work was Symbolist in many ways.

Munch's 1891–3 series of drawings preliminary to his *Frieze of Life,* so fulsome that they were exhibited in 1893 as a self-contained series, titled *A Human Life,*[106] share both themes and compositions with those of Besnard.[107] Munch's drawings also include scenes of a kiss as well as a wedding, high and low society, and images of despair and fear. Underlying many of these Symbolist states of being were, in other words, the social pressures that caused them, and even the hint of social evils such as abortion that was the woman's only remedy.

ABORTION AND INFANTICIDE

Although many historians have concluded that abortion was widespread throughout the 1800s, the majority of studies have been based in England and the United States.[108] In 1862 the British sociologist Henry Mayhew noted as part of an extensive survey "the immense number of embryo children who are

made away with by drugs and other devices."[109] Mayhew associated this practice primarily with prostitutes, who regularly resorted to abortion or to "baby farming" – paying someone to raise a multitude of illegitimate children – as a normal course of life and trade.[110] For one reason or another, infanticide was so much on the rise, the *Lancet* claimed that recent British history "out Herods Herod."[111] The police, it was reported, "think no more of finding the dead body of a child in the street than of picking up a dead cat or dog."[112]

There was a common association of infanticide with urban lower-income classes, partly due to the assumption that these people would be more likely to have illegitimate children, although recent research suggests that such illegitimacy may have been more problematic for economic rather than moral reasons.[113] The lower classes were considered culpable, however, especially in connection with the widespread practice of so-called burial insurance, which could be taken out for very little money to cover costs of a proper burial for children who died before age two. This practice, initially established to help those in need with high infant mortality rates, was soon criticized as encouraging even higher infant mortality: complete neglect that caused death by lack of nourishment was determined to have a direct correlation to parents who carried burial insurance on the child.[114] In a less well-known tract of the same time by William Ryan, however, the prevalence of infanticide and abortion was more specifically related to location – the city – than to class.[115] Finally, Foucault's argument that the bourgeois "body" was most fragile with regard to any sexual issues is important. If, as Foucault claims, the aristocracy could always view sex as "blood," and therefore related to past lineage, then the bourgeois approached sex as the means to progeny, and the future. It was this bourgeois concern over sexual conduct that resulted in the increased legal and medical regulation of the nineteenth century.[116] Given Foucault's argument that the real power in this case was obtained through social encouragement (rather than coercion),[117] and that "normal" sex was best for the future of the race (and the middle class), then the killing of a "body" resulting from sex would be viewed as especially harmful and in need of control.

The exact nature of nineteenth-century abortion – whether procured or self-induced, and whether induced by instruments or by ingesting abortives – is not well established. Historian R. Sauer has established three separate phases in the century, concluding that until 1840 abortion was fairly uncommon because of the lack of knowledge and the medical dangers posed, and that from 1840 to 1880 abortion rose proportionately with population growth. From 1880 to 1900, however, Sauer claims that the new desire to limit the number of children in a family, together with the development of anesthesia and antiseptics, may have led to a rise in abortion and a fall in infanticide.[118]

Accompanying these developments, however, were increased attempts to control both practices by law. One of the first and most publicly influential of these was religious law, established in 1869 when Pope Pius IX officially

eliminated all references to an "ensouled fetus" from Catholic doctrine regarding abortions. Prior to this time, Christian belief had followed Aristotelian teachings, which established that the embryo was ensouled (truly alive – often called "quickening," or the first feelings of the mother of motion by the fetus) not at conception, but at some point after conception (40–80 days, depending, amazingly, on gender). This meant that the Church accepted abortion of an "unsouled" (or inanimate) fetus as completely different from the later abortion of an ensouled fetus. Pius IX's 1869 proclamation established, however, that anyone who procured any abortion at any term of pregnancy would be excommunicated, what has been termed "a revolution in theological thinking."[119] In addition, the extension of criminal law was influenced to a considerable degree by the emerging medical profession, which both condemned prior non-professional handling of abortion and recommended reforms. The successful implementation of these recommendations appears to have been due to the increasingly authoritative position of the profession as a social group and to the scientific prestige with which their criticisms of the law were clothed. It was also attributable to medical recommendations that coincided with the steady consolidation of laws related to abortion and the people involved – the person who performed the illegal abortion as well as the woman who had it.[120] Throughout the century, the management of unwanted children was gradually taken out of the family and into the medical profession, with the law against all others, particularly the mother. In Belgium, for example, an 1810 law against mothers who aborted remained in place throughout the century; in Norway, there already existed a Danish-Norwegian law enforcing a death sentence for individual abortion, which was changed to a prison sentence only in 1902.[121]

By the late century, the debate over women's "flight from maternity" had been raging in most areas for more than thirty years. Stringency of criminal and canon law, as well as professed public opinion, resulted in secret traffic for both contraceptives and abortion (which were commonly considered together, as two solutions to the same problem).[122] Drugs could be obtained from a chemist; most of these, like quinine, rarely worked. Pills of all kinds (often candy) were advertised with placards on the street and in newspaper classifieds.[123] One mail-order business sold drugs to 12,000 women between 1896 and 1898.[124] By the 1890s, the consumption of lead pills became popular, because it was believed to be effective, relatively cheap, and could be mixed with other ingredients to form so-called black sticks. Women were known to consume huge quantities of these, so that doctors, "when called in to see a woman who had aborted, invariably examined the gums for lead poisoning."[125]

One of the rare explicit Symbolist pronouncements sympathetic to the woman's implication in these practices was offered, with appropriately decadent cynicism, by Huysmans in *À Rebours,* where Des Esseintes voices a disgust that must have been shared by at least some at the time for the absurdity of the situation. Explaining that, in his opinion, abandoned children should not be

Figure 80. Advertisements for midwives/abortionists. *La Réforme* (Brussels), July 2, 1885.

rescued for a harsh future, but rather be "left to perish quietly without being conscious of anything amiss," Des Esseintes rails against the ironic unevenness of current law with regard to abortion:

> Justice found completely natural the ways men use to trick Nature in the marriage bed; it was a recognized, admitted fact; there was never a household no matter how wealthy, that did not commit its babies to "washing," or use contrivances that can be bought easily in the shops – all artifices it would never occur to anybody to disapprove. And yet, if these means, or if these subterfuges proved insufficient, if the trickery failed, and one had recourse to more effective methods in order to repair the insufficiency, then ah! there were not enough prisons and gallows . . . to lock up the people condemned . . . by other individuals who, that same evening in the conjugal bed cheated their best in order not to have children of their own![126]

A surprising aspect of Huysmans's commentary is its recognition of the middle-class use of abortion, calling those who condemned abortion equally

guilty of contraception and infanticide in the privacy of their own homes; this was in contradiction to conventional press that persisted in blaming most abortion on the lower classes. That Huysmans's claim that the middle and upper classes were actively practicing contraception was in fact true is evidenced by the advertising of remedies in city newspapers. Although research on these is almost exclusively on British practices, they in fact occurred throughout western Europe and followed a shared "code" of using a seller's name, either "Madame..." or "Widow..." who had pills "for the lady." Often the "Madame" was further identified as a midwife, as it was commonly known that midwives often performed both live and deliberate stillbirths and that even women performing only abortions still called themselves by that title.[127] In Brussels newspapers, for example, these advertisements were numerous and filled columns of the classified section, often promising "secret consultations" (Fig. 80; see also Fig. 45). The French medical profession complained about the "filthy advertisements which lie on every breakfast table"[128] and tried to have them outlawed.[129] One French doctor was still, in 1907, explaining these ads to his peers in terms of the code-words and names ("discretion," "wise woman," "madame"), claiming that he had himself written to five of the listed addresses, the answers to which left no doubt that they were offering abortion.[130]

One reason for alarm on the part of late-nineteenth-century males about abortion was that its public acknowledgment was so new. Contemporary commentators admitted that until that century, the belief that life did not exist until "quickening" was largely held by all, but especially by women who were thereby allowed to exercise their own discretion in dealing, early on, with an unwanted pregnancy. To have had the definition of fetal life changed, as well as "diagnoses" turned over to the medical profession and punishments meted out by the Church and civil authorities – in the face of centuries-long traditions of all such questions being handled by women – was a shock that only really hit urban dwellers in the late 1870s (and it must be noted that the Catholic Church's antiabortion policy was further strengthened in four additional promulgations between 1884 and 1902).[131] Perhaps most shocking, however, was that the advertisements (aimed at literate women) as well as the mail-order businesses (which were more expensive than a visit to the chemist's shop) were obviously dealing with a middle- and upper-class clientele.[132] Whereas in the earlier part of the century, abortions were commonly assumed to be the result of single women seeking to rid themselves of evidence of their out-of-wedlock sex, abortion in the latter part of the century demanded recognition as a recourse of the married. And this was no longer a married woman in an adulterous relationship, but rather "well-married" middle- and upper-class women, the very women who were held to be, according to eugenicists and nationalists, the most important "breeders" of the future.[133] Most important for this study was the fact that the real common denominator of communal condemnation was the situating of these errant women in urban life. Abortion, infanticide, and even contraception

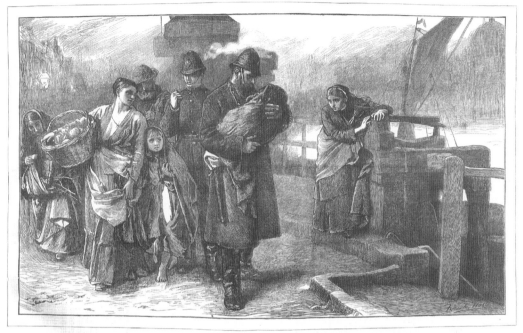

LONDON SKETCHES—THE FOUNDLING

FIGURE 81. Frank Holl. *The Foundling.* Frontispiece to *The Graphic,* VII (April 26, 1873).

were linked to the city, where such information and services were available, and where women were more tempted to have recourse to them.[134] The proliferation of the "flight from maternity" as it was called,[135] was therefore linked by moralists to a lack of responsibility, an aberrant love of urban occupation and luxury, and a rejection of all that was natural.

ABANDONED CHILDREN VERSUS THE LOVE CHILD

At the same time, this reasoning also blamed city evils for the "epidemic" of abandoned children, as toddlers died from sheer neglect and babies were left behind, on the doorsteps of hospitals and churches, and in every protected corner of the metropolis.[136] By the late 1890s, the Belgian journal for mothers gave precedence to this issue in some of its first offered advice, encouraging young mothers to say to their babies, "[t]here, my baby, I am not going to abandon you," and then declaring, "happy [will be] mothers who can say this."[137] As with the fallen woman, earlier popular illustrations usually presented the story of the abandoned child narratively and sentimentally, and within the context of the "bad," (usually fallen) mother and the bridge, as can be seen in Frank Holl's *The Foundling,* an 1873 painting from which the print was made as a frontispiece to *The Graphic* (Fig. 81). The scene is typical of Holl's moralizing:

for the policeman in the background, this seems a common occurrence, for he is hardly interested, but a young mother and her child are placed strategically to see and learn the lesson of the scene, while the other young woman – the forsaken mother who has been driven to this – stares wild-eyed at her baby even as she herself seems ready to descend to the waters below the bridge. Other late-century depictions such as Eugène Robert's sculpture *The Awakening of the Abandoned Child* (1894, Museum of Public Assistance, Hospitals of Paris), show only the infant lying in the corner of an ornately decorated doorway. Here the moral is expressed by means of well-fitting baby clothes and lacy blanket: the wealthy abandoner (that is, the mother) could have and should have cared for this beautiful child.

Increasingly, however, the real situation was much more grim, as an alarming percentage of abandoned babies were left because they were already sick, usually of syphilis. The struggles of Foundling Hospitals in every major city in Europe with the legal and moral dilemmas of sending infected infants to healthy rural wet nurses – a contagious situation that was recognized since the sixteenth century – became a political disaster, as wet nurses and their families who claimed to be infected began to sue the hospitals and as more wet nurses were, in turn, accused of being syphilitic themselves.[138] Such dilemmas' rising costs, legal battles, and human interest elements made the topic of abandonment a continual news story in the 1890s.

Symbolist references to the issue are more sublimated, of course. Hodler's *The Consecrated One* (Fig. 51), with its "code of consumption," for example, had as its theme the renewal through faith and nature and a hope for the child's healthy future. It was also, however, related to the contemporary Swiss "Question Sociale" that raged in the Geneva press throughout the 1890s. This image of Hodler's illegitimate child – born to his companion Augustine Dupin and accepted fully into their home – was painted during the debates in Geneva over laws establishing governance and responsibility for a growing population of abandoned children. Finally passed in 1894, the year of the completion of Hodler's work, was a new law that placed more responsibility on the father as well as set up a government department to oversee placement of unwanted children.[139] Only two years later, an article had appeared in *La Revue blanche,* so beloved by Parisian Symbolists, which argued for "Future Mothers." As a sarcastic reply to recent feminist congresses, the author and anarchist Symbolist art critic Paul Adam suggested a new law by which all children would be given, immediately at birth, their mother's name only, with absolutely no attention paid to the father. He presumed that this would solve a variety of problems, including the unnecessary distinction of illegitimate children, the obsolete notion that paternity is needed for a family and even the precarious future of the French "race." As he satirically stated, "Paternity, it is said, is an act of faith. . . . But in our Positivist Times, the mother alone appears to be the undisputed criminal, who is doomed to the horror of the struggle [with] a human embryo." Nature,

he explained, has obviously been the accomplice here, and women should finally accept this: "if the battle is the glory of the man, maternity should be that of the woman." Finally, Adam asserts, "[t]he battle for emancipation must be, on the contrary, engaged also with the principle of the liberty of love."[140] Thus women who did not mother, or mother well, were "unnatural," a term repeatedly used in news articles describing children abandoned for one reason or another.[141] The inversion of logic in Adam's argument – whether posited here as sarcasm or not – illuminates the backwardness of many of the Symbolist males who sought to tackle the "problem" of the city woman: faced with the gender issues of modernity in the city, they almost always revert to nature as the basis for their arguments.

As late as 1910, twenty-nine year old Gustave van de Woestijne, one of many Belgian Symbolists to participate in the art colony of Laethem-Saint-Martin, a social-reform-based school where laborers, students, and artisans of the village worked together toward a medieval guild ideal, still emphasized this in his painting of *The Two Springs* (Fig. 82). Like many other Symbolist images,[142] Woestijne's sought to contrast the city woman – plump and pasty, here bedecked in the feathers often associated with prostitution, makeup, and veils – with the country woman, simple, unadorned, and yet possessing character and health. Usually overlooked, however, is the fact that this is actually a comparison of mothers. This is revealed by the fact that the country woman has a small portion of her dress pulled aside from its buttoned middle, as if she has recently been breast-feeding a (certainly healthy) child. As the brand-new Brussels publication *Journal des Mères* summarized in its 1898 article on nursing, "this is a duty which nature has assigned [the mother]."[143] For Woestijne, the woman's association with the country and "nature" implies health and children, while the city woman breeds only wanton pleasure, barrenness, and eventual death.[144]

Such connections are nowhere more clear than in the work of Segantini who, as the urbanity of Milan became too difficult to handle, had moved ever further into the mountains of Switzerland, each relocation resulting in higher altitude and fewer neighbors. In this respect, Segantini is the exception, like Gauguin, to his fellow Symbolists who chose to remain in their native cities. As artists like Ensor and Khnopff adapted to this situation by establishing self-enclosing and aesthetic environments, however, Segantini became a "mountain man," living in comfortable style with his common-law wife and four children in a rustic wooden chalet, while making painting campaigns into the mountains of the Engadine Valley. Like Gauguin, he made a point of his "natural" life and paternity; like Gauguin his liberal ways and nonmarried status caused some consternation on the part of his fellow "natives."[145] In his work, Segantini glorifies the peasant and nature. In his extensive series on motherhood, he is one Symbolist who seems to have no ambivalence about his own traditional views of gender identity and glorifies the absolute bond of the woman as mother to nature.

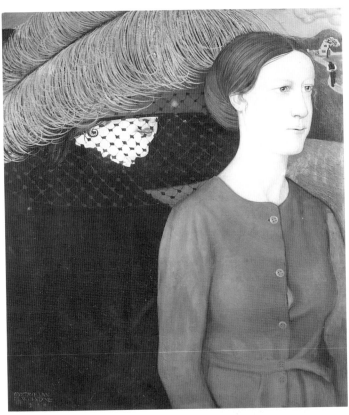

Figure 82. Gustave van de Woestijne. *The Two Springs.* 1910. Oil on canvas, 73 × 63 cm. Koninklijk Museum voor Schone Kunsten, Antwerp.

In Segantini's *The Fruit of Love* (Fig. 83), a mother and baby are placed in a tree, with a natural landscape, including grazing cows, behind them. In this depiction the mother, although gazing at her child, seems somewhat weary, while the child is delightfully exuberant. The attention and devotion that is required to give birth to and then raise this "fruit of love" – in or out of wedlock – is the moral here. The composition expresses all the notions that, long before medical research, Darwinism, or Eugenicism, had filled the pages of popular marriage guides: "children of the old are sickly, but the children of love, even if bastards, are beautiful."[146] Thus not only motherhood, but the right kind of motherhood remains, for Segantini, an uncontested duty, and represents the responsible side of the abandoned child issue. In another, later drawing, for example, there appears a secular version of the annunciation, in which an angel speaks directly into the ear of a young pregnant woman, who calmly listens, while seated before an enclosing wall beyond which is a stream like that in Segantini's *Source of Life*.[147] The angel delivers a positive, encouraging message to this seemingly unattached, waiting woman, comforting her with the promise

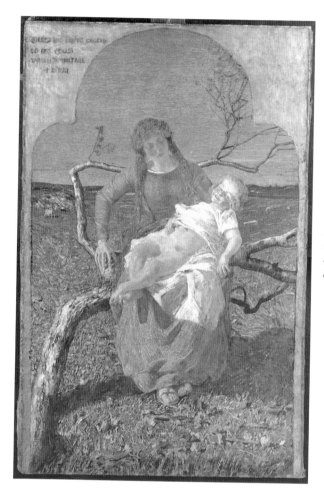

FIGURE 83. Giovanni Segantini. *Fruit of Love.* 1889. Oil on canvas. 88.2 × 57.2 cm. Museum der bildenden Künste, Leipzig.

that because this baby was the fruit of passion and not an arranged marriage, he will be healthy and do well. As Segantini notes, in verse, on the drawing:

> the child of your love will be
> beautiful in love
> strong in battle
> considerate in victory.[148]

Segantini, who cited Nordau as a favorite author in his own writings, provided vivid images of the "perfect" mother to his late-century viewers.

MODERN MADONNAS

In many of his paintings, Segantini models what was to be considered correct motherly duties, such as religious education: in *Kiss at the Cross* (c. 1883,

Amsterdam, Stedelijk Museum),[149] a mother out in the field with sheep pauses to lift her child to kiss the wayside shrine. In *Family Scene* (c. 1881–3, present location unknown), a mother holds her baby at the doorway, so that her daughter on the way out to school can kiss the infant goodbye. Segantini also sought to illustrate a proper response to the natural death of a child, in the grief-burdened posture of the mother and the dark empty spaces of *The Empty Cradle* (1881–3), one painting of a series on that subject; in *Consolation through Faith* (Fig. 47), both parents grieve at the snow-covered grave, as above them the dead child is seen being lifted to heaven by two angels.[150] Just as the eighteenth century had placed emphasis on the mother as primary educator of children, so the late nineteenth century assigned children's health, and health care, to her. Often, new efforts at treatment and inoculations discussed in Chapter 4 focused on children; in the hundreds of illustrations of these it is almost invariably the mother who brings her child to the hospital or clinic.[151]

Segantini also specialized in Madonna-like images of the perfect mother, beginning with a work titled *Ave Maria (Crossing the Lake)*[152] that depicted a peasant mother with her child being rowed over the water in a boat filled with sheep, and continuing through works with heroicizing titles such as *Angel of Life*. The perfect concordance of such motherhood to nature is manifest in none-too-subtle juxtapositions. As the mother of *Ave Maria* sits in the boat, for example, two small lambs are at her knees; *The Angel of Life* actually sits contentedly and even triumphantly, like the earlier *Fruit of Love* mother and child, in a tree. Comparison has been made of this motif to earlier Christian depictions of the Madonna and child surrounded by the "Tree of Life."[153] It should be noted, however, that in these Christian precedents, Mary is more specifically related to the life of the tree, while in Segantini's paintings, it is the life of the child that is most important. In three out of four versions of his *Angel of Life*, he posed the angel-mother, with one breast exposed and cupped in the closest hand of the baby. Thus, Segantini's image here, and the social message that accompanied it, is closer to another earlier Christian depiction of the *Madonna del latte*. Notably, these earlier depictions of the Virgin as lactating mother have been related to contemporary social fears of women abandoning their traditional roles in Renaissance cities.[154]

Segantini's focus on the mother's role as actually bestial is unambiguous in his two compositions titled *The Two Mothers*. In a series of works beginning in 1882,[155] Segantini showed a weary mother holding her child as she walks home from the fields at the end of the day; behind her walks a sheep, accompanied by her lamb. The notion of the woman having a biologically fixed state, to the point of sharing this condition with animals was more forcefully stated in the painting version of 1889 (Museum of Modern Art, Milan). Here, a mother has fallen asleep with her baby while keeping her cow and new calf company. It is night, so the idea of motherhood as a full-time natural occupation is reinforced. Although the woman is not still nursing the child, this important role is clearly signified by

the full utters of the mother cow, brightly lit by the lantern and occupying the very center of the canvas. The painting's comparison suggests their proximity, according to Darwin, on the (slow, compared with man) evolutionary scale: women, as passive conveyors of heredity, were closer to the "lower species."[156] The comparison also visualizes contented motherhood as woman's natural state,[157] a lesson in imagery that began with the eighteenth-century portrayals of the perfect stay-at-home mother.[158] It culminated in such Symbolist works as *Nature* by Leon Frédéric (1897, Ypres, Van Raes-Tyberghien), a five-panel monumental painting presenting the seasons represented by small children, often hundreds, who act out the activities of nature. For "Spring," in which nature nourishes itself, four children are shown surrounding one large and beautiful mother; all of them are bedecked with flowers as one suckles thirstily at the mother's exposed breast. Fréderic's polyptych was well received and won a gold medal at the 1904 World's Fair.

The emphasis on nature in such works – to the point of personification – may also be taken, however, as a direct rebuttal of late-nineteenth-century women's complaints about the unfairness of nature in relegating to them the role as bearer of the unwanted child. As a distraught woman in the 1906 play *Waste* would lament upon discovering herself pregnant by a married politician, "[o]h, the physical curse of being a woman . . . no better than any savage in this condition . . . worse off than an animal. It's unfair."[159] Surprisingly to readers today, the "Waste" of the play's title refers not to the woman (who does threaten to "jump into the Thames" but then dies during an illegal abortion), but rather the politician who, by committing suicide, denies his nation a great leader. Written entirely from the fin de siècle male's point of view, the play's sympathy is devoted wholly to the "wicked" woman's husband (to whom she refused any progeny) and the politician, who bond in their grief over the loss of a child who might have borne their name. For the husband, her crime was "the fear of the burden of her woman-hood . . . what are men to do when this is how women use the freedom we have given them? Is the curse of barrenness to be nothing to a man?"[160] It was on this reactionary level that Segantini worked.[161]

In 1888, *L'Art moderne* published an excerpt from a newly printed collection of critical essays by the Belgian author and Symbolist sympathizer Camille Lemonnier. Although Lemonnier's article on "Painters of Woman" was one of the older essays in the book, it was this article that was chosen for reprinting in the avant-garde journal. In the article, Lemonnier turns to two earlier-nineteenth-century artists to summarize the vision, good or evil, of the woman in art. Lemonnier claims that the women painted by Alfred Stevens and François Millet offer the full range of women's nature: "like two twin sisters of whom one has left for the city and the other stayed in the country," they speak of two types, "exalted by Stevens to [a level of] intelligence, she descends in Millet's work to the level of bestiality." Lemonnier's favorite model is, of course, the Millet woman who, because she works with the earth and has children, "participates in

the grand animal life like the cows and the bulls. . . . She is the dairy who gives birth and who nourishes, and her bosom pumps a pure milk for a hardy race like herself." For Lemonnier, Millet's peasant woman is a direct continuation from the first Eden, "the fecund nursery of the country" because, as he proclaims, "[t]he woman of Millet is above all the mother." Stevens, on the other hand, "leaves the rustic Eve to arrive at the worldly Galathee," the city. "The womb of the she-wolf is infertile: it removes the sacred fullness and this makes her suffer for the absence of the child. . . . She is the black side of the woman of whom Millet reproduces the white side. While the woman of Millet is maternity, the woman of Stevens is love (l'amour)." Lemonnier warns his readers that Stevens's city woman is given away by her mouth of a sphinx that smiles, with "cruel teeth," and concludes that "[t]he woman of Millet does not live, she makes life. That of Stevens lives, but she brings death."[162]

The perceived need to emphasize Millet's earlier and Segantini's Symbolist lessons about the naturalness and happiness of the maternal state resulted in a proliferation of "maternity" images at the end of the century. Popular salon imagery was dominated by images of idealized maternity, either in Neo-Catholic revivals of the Madonna or in secular scenes that developed from anecdotal portrayals in the 1880s to full religiously imbued Madonna images in the 1890s. At that time, renewed admiration for Renaissance Madonnas, a boost in Catholic Marian theology, anthropological interest in the ancient cult of the mother goddess, and even Protestant acceptance of a "Madonna-type" woman resulted in a "merger of culture-art-religion" that art historian Nancy Mowll Matthews has termed the "Modern Madonna."[163] In Paris, the hazy dreamlike images of mothers and babies of Eugene Carrière were regularly praised by Symbolist and non-Symbolist critics alike. In 1892, the correspondent writing to the Brussels *L'Art moderne* claimed that Carrière's *Mother Embracing Her Baby* was "the excuse" or real reason to go to the Champ-de-Mars exhibition that year, describing at length the inimitable beauty of a mother holding her child.[164] But the intensity of Carrière's mothers' often anxious expressions was also interpreted to be particularly modern by a critic who named him "the only painter right now whose work reflects the torments, the anxiety, the complex aspirations of the modern soul, the soul which, with images of reality, has known to evoke for our spirit the infinity of the dream."[165] In Holland, Carrière's equivalent was H. J. Haverman, known for intense close-ups of mothers and their children and described in 1902 as having introduced "a new concept of giving birth" in which children would have gratitude for their parents and the mother would devote her life to her babies.[166]

Many of these favored images depicted not just mothers caressing their children but actually nursing them,[167] as proper lactation methods and the mother's duty to nurse her own children became a moral imperative in the 1890s. The degree to which these private moments, in prior decades either not depicted or relegated to the wetnurse,[168] were now acceptable and even laudable

imagery might be indicated by an article appearing in *L'Art moderne* in which an anonymous writer, presumably a female, offers an extended comparison between the modern mother and the cow. Titled "What Cows Think," the article begins with a fervent plea that if the author were a cow, she would love nothing more that to give all her milk to her own calf in order to sustain it until fully grown. The domestication of the cow – by which such single-minded supplying of milk to one's own offspring is prevented – is then compared to the modern woman who was often encouraged to cut short her natural state of nursing. Thus, "[c]ows arrive at degeneration by too much bondage and women by too much intellectual personality."[169]

One strong factor in this 1897 argument was the beauty of nursing: the eyes of a nursing mother are more beautiful than any others, for example, because only this state allows her to exist perfectly in harmony with nature. That a striking sculpture of *Maternity* (1900, present location unknown), in which a naked mother bends over to nurse her standing, older toddler, and thereby looks more animallike than discreet in her motherhood, was praised rather than shunned for this very "natural" quality proves the acceptance of this extended nursing. The marble, by Charles Van der Stappen, was cited upon its inclusion in the 1908 La Libre esthetique exhibition as the perfect antidote to the usual "Bather," whose joy was that of the flesh (what tempted women of the city): here there was a moral and social preoccupation that explained the extraordinary beauty of the piece.[170]

Such Symbolist-like visions of a perfect maternity stood in complete contradiction to reality, however. Contrast can be made, for example, to a completely different view of women and children from the early 1890s by Charlotte Bouten, titled *The Poor* (Fig. 84). In Bouten's drawing, stylized somewhat in the linear and two-dimensional manner of her Dutch contemporary Toorop, a parade of the poor pass by the viewer: women and children march in the front file, as the only two men, in the background, seem both old and infirmed. In the center a woman walks, behind one child and in front of another, while holding a sack of belongings carried on a dog's back. The woman is the only stalwart figure in the group; if they survive it will be, despite her emaciated body, because of her. She is also, however, with complete illogic to the grim scene, bare-breasted, as if to note her role as mother and nurturer. In the background, rising ominously almost to the top of the picture plane, is the complex skyline of a city, with cathedral in its center and spewing smoke stacks in its outskirts. Bouten was only in her twenties when she completed this drawing.[171] She recognized the proletariat woman (who was usually, in Griselda Pollock's words, considered "as almost synonymous with the prostitute")[172] as a modern heroine, not only the carrier but also the saver of a future. Perhaps this was a view of maternity that could only be imaged by a female artist.

But the vision of maternity as a natural, and therefore not only a preferred but singularly blissful state representing the future of the middle class, was the

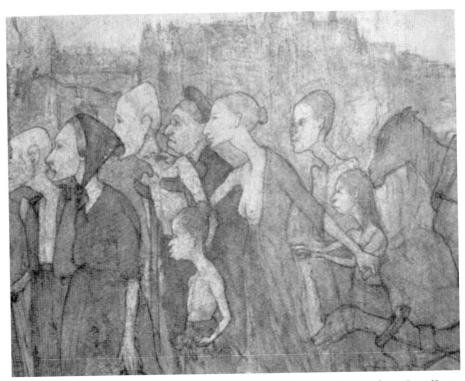

FIGURE 84. Charlotte Bouten. *The Poor.* Drawing. Present location unknown; from *Onze Kunste,* 1902, p. 64.

image that dominated most Symbolist work. At century's end, Charles Maurin painted *Maternity* (Fig. 85). Only one woman in this painting seems doubt ridden: the red-haired woman who, with hand over her mouth, stares out of the right side of the painting, anguished by her childlessness. But she is surrounded by images of maternal care, even in the hesitant young girl above her who must be coaxed by Cupid or the bereft mother directly beside her who holds her dead child in her arms; all blend into the natural landscape that surrounds them. With images of mothers and children forming even the winds (from another, higher world), the painting's clear focus is on the mother as natural nurturer. The central figure, a nursing mother, is shown in a kind of aura that reflects the beliefs of the *goutte de lait* movement, launched in 1892 by the Pasteur Institute, encouraging mothers to breast-feed or use sterilized milk. Another, possibly pendant painting, Maurin's *The Dawn of Work* (Plate 5) makes clear the urban enticements for women that threaten this natural state. Here, Eve-like women awaken to an army of laborers marching toward them from the city. One primary figure – a woman being pulled away from this horrifying scene by a child, offers her rationale for escaping the city with her gesture, as she cups one breast in her right hand.

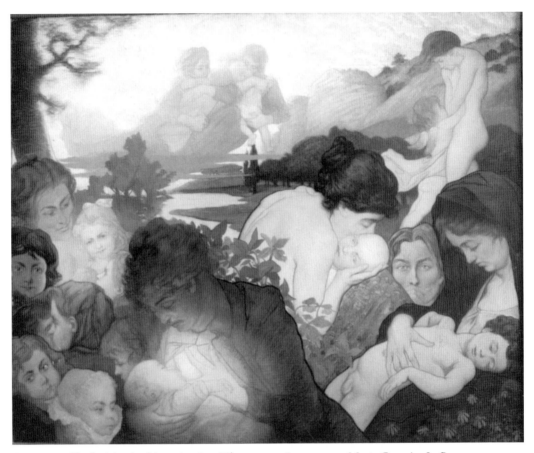

FIGURE 85. Charles Maurin. *Maternity.* 1893. Oil on canvas, 80 × 100 cm. Musée Crozatier, Le-Puy-en-Velay.

Finally, some attention should be paid to the figure type so often used by Symbolist artists referring to motherhood: this is, in contradiction to the overly slender body types discussed in the last chapter as signifiers of ethereality, disease, or deformation, a rather "normal" body, neither fleshy nor thin. The mother figure was, in fact, the healthy body. It is notable, furthermore, that no Symbolist portrayals of women adopt the most fashionable figure of the late nineteenth century, the hourglass figure that has often been read as a "symbolic form of maternal femininity," with wide breasts and hips emphasized by a tiny waist. Symbolists' avoidance of this commonly known figure did not, however, acknowledge the perversion of such imagery (that such a figure is not close to a real nursing or pregnant woman and thus, as Susan Bordo has claimed, advertises a reproductive sphere, rather than a reproductive body).[173] Rather, it seems more likely that for the Symbolists this hourglass figure evoked urbanism and its deadly reverence for fashion and frivolity. Such urban inventions were temptations that could turn a good woman into an evil mother.

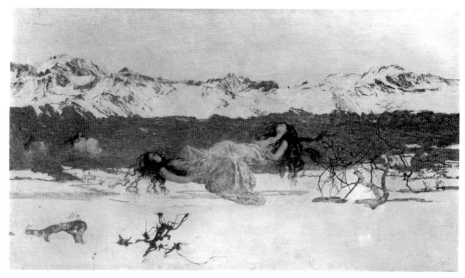

FIGURE 86. Giovanni Segantini. *The Punishment of Lust.* 1891. Oil on canvas, 99 × 173 cm. The Board of Trustees of the National Museums and Galleries on Merseyside (Walker Art Gallery, Liverpool).

EVIL MOTHERS

Symbolist visions of the absolute natural devotion of motherhood – and not necessarily parenthood – could be seen as a direct reaction against the mother who preferred her own pleasures. Segantini's most forceful outcry about this issue occurred in paintings of the 1890s that addressed how nature would punish the women who enacted such rejection. In *The Punishment of Lust* (Fig. 86),[174] Segantini portrayed what would happen to those women who disdained their maternal roles: in a barren mountainous plain, covered only with snow and dead or dormant trees float several women, suspended in the air and seemingly in a trance. The entire painting – women, trees, air, nature – is painted in icy blue and white and in thick, encrusted layers of paint, presenting the women as if freeze-dried, in a world as barren and sterile as they have chosen to be. It is again nature that surrounds the women, here to punish rather than enthrone them. Finally, in Segantini's *The Evil Mothers* (Plate 6), a painting which has also been called *Infanticide,* the full narrative of the woman's past and her punishment is presented: in the foreground is a woman who is pilloried to a twisting, leafless tree, in a cold landscape similar to that of *The Punishment of Lust.* Segantini's inspiration for these paintings is said to be a poem called "Nirvana," written in 1889 by Luigi Illica, in imitation of Asian texts and related to an Indian legend in the *Pangiavahli.*[175] In the poem, women who have become mothers because of their lust but reject that role out of selfishness are doomed after death to exist in a wintry, barren limbo until they feel remorse and in turn are forgiven by their children. Historian Kate Flint has suggested that the facial expression of the

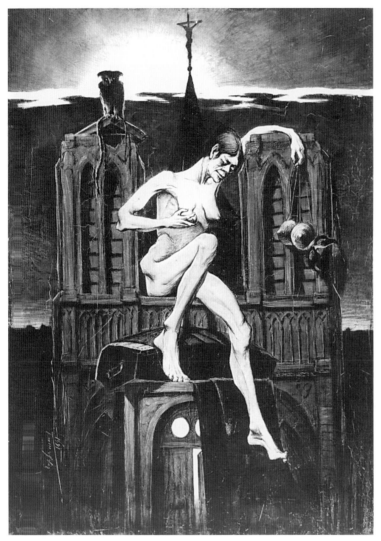

FIGURE 87. Eugene Laermans. *After Fleurs de Mal.* 1889. Private collection.

foremost woman of *The Evil Mothers* "is unmistakably one of sexual ecstasy,"[176] so that the reasons for her children's abandonment are clear. Flint furthermore has made the important connection between this notion that such sexuality (and abandonment) was connected to the all-encompassing threat of degeneracy, as established by the 1893 study *The Criminal Woman* by Lombroso and Guglielmo Ferrero. This book "scientifically" explained that excessive ("abnormal") sexuality could cause women to be "bad mothers" who would very likely end up getting abortions or committing infanticide.[177] In the painting as in the poem, however, this woman's bare breasts are exposed and below her upraised arm can be seen the head of a baby who manages, finally, to suckle mother's milk. In 1898, the

Paris *Gazette des Beaux-Arts* reported that the painting had spurred "furious discussions in all the foreign capitals" and that the version just installed in the Liverpool Museum "was explained to the public in three days of public discussions," so relevant was the moral of the "eternal myth" of "mother and murderer."[178]

In 1889, the Belgian painter Eugene Laermans, newly graduated from the Academie des Beaux-Arts of Brussels, was briefly influenced by his countryman Félicien Rops and by Rops' love of Baudelaire.[179] That year, he produced six paintings based on the French poet's *Fleurs de mal,* strongly influenced by Rops' series *Sataniques.* Of these, three formed the triptych *Perversity* (1889, private collection), in which a "modern woman" – her red hair tied up in a tidy bun and absolutely at ease with her nudity – is shown on a pedestal, reigning over death and destruction in the world below. From the left panel, she gazes out at the viewer, as the rising sun illuminates a barren landscape populated only by statues and guillotines. In the center panel, as she is surrounded by skeletal heads and stands under the blinding, but artificially lit sun, she encounters a second nude woman, as if, as has been suggested, to fight with her,[180] or, as the title might have suggested to readers of that time, to embrace her. The third panel shows the return of night and a slivered moon, as the woman on the pedestal gazes out, back to the viewer, onto a serene if simple water and mountain landscape. Laermans's suggestion of the complicity of woman, due to her perversity, with sin and death in the world is a homage to, but fairly derivative of, Rops. In another painting of the series, however, Laermans presented an original image of the should-be mother (Fig. 87). The subject of his painting, recently published with the title *After Fleurs de Mal,* can be identified as the same one described by Laerman's biographer Armand Eggermont as

> an old nude woman, debilitated by alcohol and debauchery. She leans against the towers of Notre Dame. Her left hand dangles the playthings of vanity, the right hand presses her wasted breast. Her right foot rests on a black coffin while the left leg, excessively thin, rests suspended before a mortuary drape. . . . The harlot – hallucinatory *écorché* [anatomical figure model] – plunges her bestial face on *humanity* and sneers.[181]

What is instructive also is what this description does not include: the Parisian skyline. Because the figure is perched on the towers of Notre Dame,[182] this monstrous woman is, once again, the city woman. In addition, what Eggermont calls "the playthings of vanity" are actually two types of masks, which the woman suspends from their strings, displaying them as attributes. One, a half mask such as those worn for masquerades, she has used to belie her worn face. The other, a breastplate replicating firm breasts with protruding nipples, she has used to mask her spent and sagging breasts. Further, she is, as described, resting

one heel lightly on a coffin; but this coffin might be considered very small, as if to hold a toddler or small child.[183] Finally, as noted, she pinches with her right hand one of her own "wasted" breasts, but this gesture seems, in tandem with her "masquerade" and the small coffin, to reconfirm for the viewer that there is no milk, no nurturing, no life there. Although very small breasts were included as symptoms of the dreaded "man-woman" – both insane and degenerate – by medical men in the 1890s,[184] these breasts would be considered even more deadly because their sickness imposes itself on the future. Laermans's woman reminds all that, if the role of the female should be motherhood, and if the mother is therefore the "normal" woman, then any other is, by definition, "deviant":[185] the should-be mother here flaunts that her normalcy is all a façade, that she is the deviant city woman underneath it all.

The series of six Baudelairean images was Laermans's only true Symbolist exercise. The artist subsequently turned to images of the countryside and to a peasantry still possessing the things lost in the city – faith, meaningful labor, and family, as in *The Last Believers* (1895; location unknown), depicting a simple church crowded with peasant families – creating an iconographic pendant to his earlier despairing of urban modernity.[186] Notably, many of Laermans's later works monumentalize the peasant mother. In *The Baby* (1894, private collection), the infant is shown at its mother's breast. The mother, sturdy, assured, and dominating the country landscape around her, is in turn surrounded by country women of all ages, who admire the baby in celebration of her natural role.

TOOROP'S PERFECT WOMAN

For Jan Toorop, the "woman's issue" in contemporary European urban society was a recognized aspect of current affairs; we know, for example, that he was present at one of the meals held in honor of Pélandan's visit to Amsterdam at which the Frenchman's attitude toward women was discussed.[187] He had also depicted the dilemma of the mother forced into prostitution in his *In de Nes* (1889, private collection), in which the mother of a small girl allows another woman to take the child as she gets ready to join her peers in an Amsterdam brothel.[188] But Toorop rarely engaged in his work such specific and overt political agendas.[189] Rather, it is more likely that his adoration of the mother and child expressed his Symbolist, defensive adoption of the most conservative stance on questions of gender. It also derived, however, from his experiences as a married, middle-class man of the fin de siècle with family issues of his own. In the year following their marriage, Toorop and his wife Annie endured the loss of their first child, a baby girl; Toorop suffered a complete physical and mental breakdown. In September the next year, he wrote to his parents about his inability to work "for several months" and his eagerness to move back to Brussels, concluding

"[w]e have spent this last year in Holland but never again. I have caught so many diseases over here, lost a child, and hardly sold anything."[190]

Despite his convictions that they should settle in Brussels, Toorop and Annie in fact moved back to the Netherlands in 1890, but this time to the much smaller village of Katwijk by the Sea; they stayed there until 1892 and then returned for five more years in 1899. In the late 1880s, Katwijk was still a fishing village absent even rudimentary urban facilities like sewers. Just as they moved there, however, the area had begun to attract artist residents, and it slowly developed in the 1890s into "a fairly stylish seaside resort."[191] Arriving in 1890, distant from the art politics and other stresses of the big cities, as expressed in several lyrical views of the village and its peaceful position in nature,[192] Toorop accomplished a decisive shift in his work, creating his first truly Symbolist work in which all form was crystallized into two-dimensional linear design for the expression of idealistic subject matter. Here, also, the couple had a second child, Charley, who posed as the baby of several new compositions, all celebrating the "modern Madonna." In *Motherhood* of 1891 (Kroller-Muller Museum, Otterlo), a monumental mother nurses a new baby while no less than six other children – all girls – react to one another, surrounding her. In *Katwijk* of 1892 (also titled *Madonna and Child*, Stichting Hannema-de-Stuers Foundation, Heino), a drawing that has been related to *The Three Brides*,[193] a mother and child who must surely be Toorop's own family sit in a traditional Madonna and child pose atop a hill outside the town. That these figures are icons of the spiritual significance of the family in the face of the hardships of life (the population of the village can be seen working outside their houses) is confirmed by a similar composition, *Tramps in the Dunes* (1891, private collection, the Netherlands), in which the entire family is grouped atop a similar foreground dune. Behind is nestled a house with enclosed garden but in front of them, symbolically barring them from the viewer's (and future's) space are the wires of an imposing telegraph pole. Finally, baby Charley also appeared in one of Toorop's most clear expressions of concern for the future sanctity of the family in light of new urban technology in *The Young Generation* (Fig. 33). For the devoted father Toorop, the loss of a child – especially as the result of a mother's "flight from maternity" – would have seemed one of the greatest tragedies of his conflicted times.

It is instructive also that when Toorop, who drew illustrations for numerous contemporary novels, once turned to an ancient Indian play, *Shakuntala,* which was enjoying revived interest, he produced a little-known drawing that focused on one of the unseen acts of the story, in which the rejected mother weeps, alone with her newborn, in a dark and foreboding forest (Fig. 88). The play, based on a legend of a king who marries a hermit-girl in secret but then, under a curse, rejects her, ends happily with the spell lifted and the family reunited. Interwoven into this plot, constructed around a familiar contrast of city business versus the pious simplicity of the hermit life, however, are several points about motherhood and womanhood that would have rung true for late-century viewers

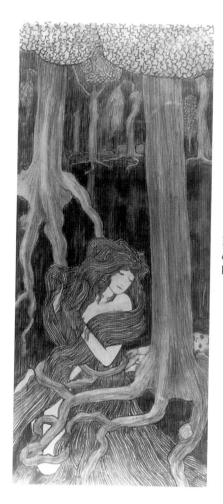

Figure 88. Jan Toorop. *Shakaluna*. Black and white chalk on paper. 56.8 × 25.6 cm. Present location unknown; formerly Van der Plas Collection, Katwijk.

expecting the dominant theories of the day. When the bride Shakuntala presents herself, fully veiled and pregnant (like the central of *The Three Brides*), before her secret husband, he says to himself that "[i]t is just such women, selfish, sweet, false, that entice fools," echoing the femme fatale myth, while the bride herself reminds him that "[I am] your wife/Husbands have power for good or ill/O'er a woman's life." Of additional resonance to fin de siècle readers would have been the king's own remonstrances about not having produced (he thought) a child who could carry his royal name.[194] Toorop's single drawing sums up many of these concerns by showing the rejected mother appearing to be entrapped by her own body-length hair and the entwining roots of a tree; nature itself is her doom. Beside her, and behind the tree, lies the beautiful child; the baby's masculine identity and the woman's one exposed breast can be related to the significance of heredity for the "Fin-de-Race" – which was the title of an article that Toorop had illustrated for *La Basoche* in 1885[195] – and the "failure to thrive" of children born to overly sensuous, materialistic mothers.

In 1895, Toorop was commissioned to design a tile mural for a Dutch insurance company. Although never executed, Toorop's cartoon stands now as a final homage to the significance of motherhood for himself, his nation, his homeland, and his own times (the De Ruiter family, the Hague). In shrinelike arrangement are three panels with women: to the left are a mother and her baby, representing the Netherlands, to the right another pair signifying the Dutch Indies. In the center, a female angel who wears a surveyor's compass on her bodice symbolizes the new trade link between these two: the Suez Canal. Surrounded by stylized flowers of blossoming nature, the industrial accomplishment appears not as a technological wonder encouraging new trade between civilized societies but rather as an important link in the biological chain that connected the Netherlands to her colonies: good mothers and healthy children were the real future of this modern world.

Thus the perfect model for the should-be mother was the middle woman of Toorop's *Three Brides.* A complete interpretation of this complex drawing has been attempted only by Robert Siebelhoff, who has deciphered its Symbolism according to literary references, preliminary studies, and Toorop's own (admittedly overly complicated and at times conflicted) explanations.[196] Siebelhoff concludes that the "central section of the drawing is concerned with the interaction of spirit and matter," with the left bride representing pure spirit, as delivered by the seraphim, and the right bride signifying matter. Thus "[t]he central bride is born of spiritual forces – seraphim – which themselves emerge from matter – thorns. The bride, by coming into this world, comes into contact with its material dimension, and generates forces through her inescapable suffering which in turn undergo a complete transformation from matter into spirit."[197] The most forceful explanation of this transformation can be found, according to Siebelhoff, in Toorop's own words, when he describes the entrance of the center bride into the world as "a new mystery begins, the suffering of the soul . . . [which] goes *so* far till the world is nothing to her anymore and a life of complete seclusion emerges, a life of the highest consecration and the highest abstinence from matter, where the highest-purest love, mystical love is born."[198]

This interpretation of the central woman representing a personification of the victory of spirit over matter, based in part on the artist's own attempts at an explanation, gains credence by comparison to a remarkably similar symbology in Khnopff's *Angel* (Fig. 15), in which the angel-knight figure placing a calming and controlling hand on the head of the female sphinx was interpreted by Maria Biermé, a contemporary who actually interviewed the artist, as symbolizing "the battle of Idealism [the angel] against materialism, represented here by a sphinx with a woman's face."[199] In both works, however, emphasis should be placed on the strong social understandings underlying the symbolic figures, and especially Toorop's protagonist as pregnant bride. As we have seen, no higher consecration or purer love could be offered, at least in this world, than that of the perfect mother of the 1890s; in modern Madonna depictions, it was the highest, mystical

love that was born in the new mother. The struggle of the foreground figures of *The Three Brides* could also be, therefore, the subtle recognition of every "good" mother's need to overcome the temptations of matter – or materialism, as Toorop elsewhere identified it as the primary enemy of spiritualism.[200] That this combat between pure spirit and materialism is played out on Toorop's iconic foreground, in front of a straight line of modern houses – what Toorop referred to as signifying "our so positive period, where everything must be the same and of identical shape"[201] – further identifies it as a battle of modernity. The mystical bride (the nun) is described by Toorop as fearful of being presented with "lilies (symbol of purity)," because they, along with the seraphim who carry them "are thus an echo of the pure-mystical era, which is no more and characterizes the degeneration of it."[202] The central bride, however, is described by Toorop as "symbolized in bridal array around nude purity (which means that she has come into contact with the world)." The term "nude purity" actually serves well to describe the "pure" woman of then-contemporary rhetoric who, because she has come into contact with the world, is about to become a mother.

Siebelhoff has established a relationship between *The Three Brides* and a slightly earlier drawing by Toorop that was intended as a wedding present and that presents a male-constructed idealized image of the perfect couple.[203] In this work, *Aurora, Marriage* (c. 1892, private collection), the groom is no less than a new St. George, who stands before an arbor of roses as he has just slain a dragon-monster who lies at his feet. He protectively reaches around the shoulders of his maiden-bride, who stands nude before a thicket of thorns, used commonly by Toorop as symbols of materialism. If in fact this is the perfect bride, modeling for Toorop's newlywed friends the proper behavior for late-nineteenth-century women, she should also be preparing for maternity, which she is. With her long hair flowing around her, modestly covering her nude body, reminiscent of *Shakuntala,* the bride pours liquid from one rounded vessel into another, symbolically enacting the process of conception in her own womb. As the artist – who complained about the "unpleasant[ness of] this kind of clear description" for Symbolism that was meant to be "beautiful poetry"[204] – nevertheless attempted to explain in 1894, "The knight in armor symbolizes inner male strength. Standing beside him is the eternally feminine, holding two bowls, pouring the greater content of the one into the other, in order to maintain the balance between [the male and the female]."[205]

In much the same symbolic fashion, the central woman of *The Three Brides* – to whom Toorop referred as "the eternal feminine," just as he did the bride of *Aurora, Marriage* – wears an announcement of her future motherhood: in contrast to the mystical bride with her lilies or the materialistic bride with her skulls, the bride of man is crowned with a wreath of roses and orange blossoms, symbols respectively of pure love and, most important, fertility.[206] On one side of her stands the "nun-bride," representing the Symbolist virgin who is essentially de-sexed; what Mikhail Bakhtin called the "classical" or absent body. On the

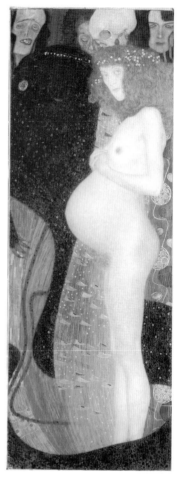

Figure 89. Gustav Klimt. *Hope I.* 1903. Oil on canvas, 189.2 × 67 cm. Museum of Fine Arts, National Gallery of Canada, Ottowa.

other side is the femme fatale, a type called by Bakhtin the "grotesque" body, overdeveloped for sex, who by her pathological sexuality proved the need for control over women's bodies.[207] In between these two types, the central bride fulfills her determined, controlled fate.

Thus the pure, healthy, alluring and pregnant (or in this Symbolist work signifying the predestiny of pregnancy) central bride embodied all that the late nineteenth-century male imagined was her "nature." As historian Ludmilla Jordanova has pointed out, the eroticizing of women's pregnant bodies was a strong tradition in medical discourse of the nineteenth century, readily seen in the wax models used by doctors and later in medical museums.[208] Toorop's fully but transparently veiled woman also follows a nineteenth-century trope of the explicitly sexual modesty of women. The complexity of this teasing veil, which has been cited by Leo Steinberg as having religious roots, has been related by Jordanova to the common metaphor of Nature or Science unveiling "herself."[209] Inviting the (male) viewer to metaphorically "strip" the veiled bride, as if reading

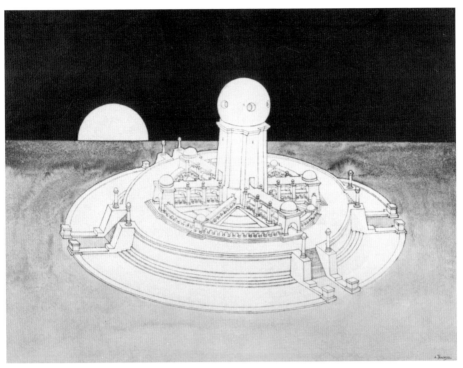

Figure 90. Albert Trachsel. *Festival of Nature* from *Les Fêtes Réelles,* 1897, plate 10. Private collection. Photograph courtesy of the author.

succeeding layers of meaning into the pregnant body, this single figure reveals in succession purity, worldliness, and procreation that spelled the future.

Toorop's perfect pregnant bride would soon seem overly Symbolist and unnecessarily Romantic when compared with Expressionist views of women only ten years later. Just as Toorop was considering his conversion to Catholicism and a shift to religious painting as an almost exclusive genre, the Viennese painter Gustav Klimt painted *Hope I* in 1902 (Fig. 89), a blatantly pregnant naked woman who flaunts her condition as an icon of truth before doubters, ghouls, and even death in the background. Although they are immediately behind her, these threatening figures cannot reach her; Klimt has painted them in a flattened, stylized, and stylish way, as if appearing from behind a screen, in another world. The woman, however, is painted, typically for Klimt, in a highly realistic, modeled, and massive manner, so that her face and body – her radiant flesh – illusionistically emerge from the surface of the canvas and appear to exist in the viewer's space. With her bright red decoratively painted hair cascading from head and genital area, she is a bold, unencumbered, contemporary woman. Klimt's painting, astonishing to almost all who first saw it, coincided with the publication of Otto Weininger's notorious book *Sex and Character,* in which the female was defined as preoccupied with her own sexual body and therefore

of an entirely material character (as opposed to a more spiritual, intellectual man). Weininger's book, although controversial at the time of its printing, now seems so misogynist as to be unprintable. But his insistence on defining the woman as an object for sex and procreation only, and especially his obsession that this was the true "character" of the woman, now also epitomizes the extreme of the fin de siècle fixation with this idea. And the Klimt work, which even today elicits gasps from viewers who recognize this as the predecessor to late-twentieth-century pregnant movie stars "baring all," was of course both understood and appreciated by male commentators at the time. As one Vienna reviewer effused, "[h]ow proudly the young woman walks in the sacredness of her condition, surrounded by sordid, scowling faces, by the lascivious, blaspheming demons of life ... but she rears no attack, she treads undeterred the path of horrors, preserved unblemished and unblemishable by the hope in the womb."[210]

The critic writing these words, Ludwig Hevesi, clearly admired the forthright stance of Klimt's image of pregnancy. Even when compared with this bold image, however, Toorop's perfectly constructed woman was, for the Symbolist expression of late-century "hopes," both more suggestively and more effectively presented. That the veil was placed over the entirety of the bride – including her eyes, her gaze, her mind as well as her beautifully swollen body, offered the male fin de siècle viewer the opportunity to completely possess and contain, and thereby control the body of the "should-be mother."

The most radical Symbolist "cure" for the should-be mother may remain, however, that of Trachsel, in his *Fêtes Réelles.* In these architectural drawings, lyrical as they may be, there is a notable absence of humanity; the buildings stand alone, masonry construction impermeable to external threats, be they natural, political, or social: the buildings stand in clear if vacuous light. Ironically, for Trachsel, the defender against foreign invasion and disease, the underlying issue – the regeneration of the race – is reduced to symbolic, phallic dominance over all. In only two exceptions, the *Palace of Fertility* (*Fêtes Réelles* Plate 16) and the *Fête of Maternity* (*Fêtes Réelles* Plate 17), rounded domed forms with nipplelike cupolas on top symbolically represent the supposed maternal representation in this utopian city. For all other buildings, however, Trachsel designs minuscule entrance ways (no throbbing masses or crowds here) that lead to massive tomblike structures or vessels, surmounted by large vertical towers that are the only objects that can truly "penetrate" the building. In his *Festival of Nature* (Fig. 90), in which the codification of forms into round female structures and huge phallic surmounting tower is complete, can be found a summary of Trachsel's late-nineteenth-century patriarchy. In his attempt to valorize the role of nature, Trachsel essentially eliminated it. With no sign of life, the search for future health – in terms of reproduction and the regeneration of the race – has been reorganized into efficient male architecture that in its clean minimalism might be deconstructed as sterility.

6 ᴄᴏ CITY INTERIORS AND INTERIORITY

"It can be added," wrote a critic for *L'Art moderne* in 1890, "that complete solitude bestows long patience, rugged tenacity, [and a] fixed plan in order to attain certain dreams, to take them by the wings and to attach them onto canvas."[1] This poetic description of the abilities of the Belgian artist Xavier Mellery helped to establish his lyrical work, and his isolated life, as exemplary of the solitary inner life of Symbolists. Only one year prior to this critique, Mellery had first exhibited several of a series of drawings collectively titled *The Life of Things.* In these drawings of mixed, matte and tactile media (often combining ink, pencil, wash, and charcoal on thick or textured paper), Mellery presented wholly normal scenes, which nonetheless spoke eloquently about the inner life of inanimate objects that could be awakened and appreciated by proper contemplation. In *The Bedroom* (Fig. 91), for example, black, white, and deep grays cast the composition into muted tones and establish a veil of quietude over the scene. Just as Rodenbach's 1891 book of poems *The Reign of Silence* was praised for its monotonous repetition of Alexandrian verse that seemed to express rhythmically his "excessive preoccupation with calm," so that, as one critic claimed, "silence is gray,"[2] so Mellery had visualized this overriding stillness with his tightly controlled range of *grisaille*. As the 1890 *L'Art moderne* critic observed, this had the effect of enticing the viewer to accept Mellery's work as a being unto itself and of "never showing the hand that had executed it," as if the making had deliberately dissipated, leaving the work a mystery on its own. As this idea was, again, poetically explained, "[t]he created work of art exists with a life to itself so totally that one wouldn't like to know the man . . . who profited from one hour of his transitory life in order to steal eternity."[3]

In this realm of silence in *The Bedroom,* careful framing within the composition introduces increasingly smaller and enclosed areas of space. From the antechamber, one is visually led into the sleeping room, where a formal hat sits atop a high bed. No human presence is needed; the hat itself seems to be alive, with a personality, an occupation of space, and a sense of control over the heavy air. The top hat, the type of image that would later be identified by Freud as a symbol of male potency,[4] is also emblematic of the city, and was well known in visual depictions of the latter half of the nineteenth century as the essential urban headdress, the costume of choice for the *flaneur.* Positioned on the bed in Mellery's drawing, however, this emblem of male urbanity is ensconced in soft bedding, in spaces that had become increasingly feminized in rhetoric and

practice, as a counterpositioning to men's dominance of the external public areas of the city.[5]

Both the gender and spatial contrasts suggested by Mellery's *The Bedroom* are important because they point to the significance of the city's actual interiors – the insides of urban dwellings – as new refuge sites for the city-sick Symbolists, even as they became new symbols for the mental and spiritual interiority that the Symbolists sought. As we shall see in this chapter, the bourgeois interior had been by the late nineteenth century reinvented in several ways. It was in the process of continual technical revision by means of new water distribution, gas lines, indoor plumbing and for some even electricity. It was also, however, the new domain of the middle- and upper-class wife, who was restricted to, but at times empowered by domestic activities; it was the so-called foyer of disease, the first line of defense against epidemic illness; and it was the one place in the city where, it was hoped, the individual could continue to thrive. Foucault has called the "history of *spaces*" a "history of *powers*," by way of explaining the role of spatial organization as primary provider of control.[6] As explained in Chapter 3, some Symbolists like Munch had given up the compromised and in any case temporarily elevated overseer spaces of power to face the urban nightmare of the street. This experience was then countered by seeking out new spaces – and new power – in interiors. Although the early twentieth century would see in some large cities a reversal of this trend, with the advent of motor cars and suburbs that kept people outside of their houses for longer times, the 1890s remained the apex of the domestic interior.

For many Symbolists, indoor spaces in city houses took on a sense of spirituality that had formerly been reserved for churches, temples, and sites in unspoiled nature. For them, the quotidian objects of daily life could become sacred vessels or potent icons of the world within. Baudelaire's suggestion in his *Correspondences* that the initiated being could "hear" the voices and "see" the hidden lives of trees and other natural things was in this respect now outdated. For the fin-de-siècle urbanite, interior spaces and the objects they held became the new signifiers of another world. These new meanings were shared with the viewer by means of presentation: we are invited to enter the Symbolist interior with newly initiated perception and to contemplate them rather than view them, with fresh understandings of the "life of things." Eventually, most of the Symbolist artists examined in this book created their own special interiors with this ideal in mind. These ranged from the object-packed rooms of the house inherited by Ensor, where he could live with his beloved masks, skulls, porcelains, and art, to the elegant art palace built by Khnopff, where whole rooms served as perfectly designed installation sets for his art, his "altars" (see Fig. 6), and his own meditation.

The thrust of the Symbolist movement as a whole, in the words of historian Donald Friedman, "was to suggest through indirect discourse the secrets of interiority, thereby creating an enduring zone of aesthetic experience distanced

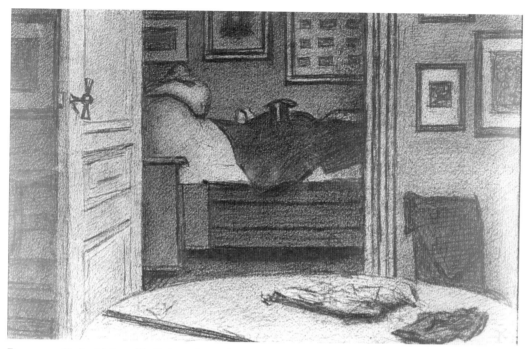

FIGURE 91. Xavier Mellery. *The Bedroom* from *The Life of Things* (renamed *The Soul of Things*), 1889. Mixed media drawing. Musées Royaux des Beaux-Arts de Belgique, Brussels.

from the banality and materialism of society."[7] This is the idea communicated by the well-established theme of silence, as in the poems by Rodenbach collectively titled *The Reign of Silence,* and in paintings by Khnopff that were self-consciously titled *Isolation, Secret, Solitude,* or *Silence.*[8] The favorite Symbolist town of Bruges was called "the quietest city in the world";[9] while images of the distant past – the dry world of the Egyptian sphinx, for example – call in Symbolist art for eternal quiet. It also was the purpose behind numerous statements by Symbolist poets such as Victor Remouchamps, who in 1894 wrote of "The Interior World" by claiming that "we have everything within us. The mind is an ocean of sensations, a universe of visions; but it is necessary to know how to explore it."[10]

The Symbolist exploration of silence and interiority found resonance in a plethora of different but equally eloquent images; the least recognized of these, however, is that most directly related to urban society, the domestic interior itself. It is important to recognize that things in domestic interiors were always "signs" – of class, easily read by those who lived with them and encountered them on a daily basis.[11] Thus the Symbolists were not inventing new symbols out of domestic objects and spaces, but rather adding onto the levels of signified for which they could serve. As a capitalist economy encouraged consumption, and as a newly self-conscious psychology (Freudian or otherwise) placed an emphasis on nonnature objects as surrogate images for subconscious impulses, the fin de

siècle bourgeois society put increasing stock into things of their domestic interior as substitutes for the self.

In this chapter I discuss various artists' approaches to the domestic interior, from Mellery's adoption of the old-fashioned interior as sign of "the isolated one," as many Symbolists were known,[12] through Ensor's outsider role as satirist of the bourgeoisie by means of inverting the usual interior codes. No matter how different in approach, however, Symbolist interiors share a reliance on the common reading of signs, as noted earlier, assumed by the middle class. For this reason, Symbolist interiors argue cogently for that class to be the real audience for Symbolist art. Despite some claims that Symbolism adopted deliberate esotericism, these images of the home interior could only be successful as Symbolist evocations if they were already understood as signs by an essentially bourgeois viewer.[13] With their infusion of new meaning into the everyday stuff of middle-class life, the Symbolists reached the audience most in need of reinvigoration of an individual inner life.

THE NEW INTERIORS

The interiors imaged by the Symbolists reflect numerous late nineteenth-century developments in housing. Two very different types of urban reform, the Garden City and the Linear City, sought to establish spaces outside the inner metropolis where single-family, often detached dwellings could once again be built and where some contact with nature was reestablished. Despite their differences (the Garden City strove to reestablish a "village" as a suburb of the city, while the Linear City intended to be a direct extension of the metropolis, but along public transportation routes), both emphasized privacy as an essential goal. Garden Cities were designed with cul-de-sac lanes, while Linear Cities insisted on significant setbacks from the street.[14] Although most of the Symbolist artists discussed in this book either remained in their relatively secluded family housing or else, like Munch and Khnopff, arranged for themselves once they could afford them, suburban havens, they also developed early on an appreciation for the peace and quiet possible even within the "nonreformed" city. This Symbolist reverence for interior scenes, everyday objects and domestic spaces occurred precisely at the time when the city's public spaces – the shops, parks, and boulevards – became the most frightening and alienating of locations. But with the mythology of the "should-be mother" came the "perfect home," both believed to work in tandem as antidotes to the external world. Thus, although the proliferation of specialized domestic objects in the mid- to late-nineteenth century has been related to the establishment of the home as the new "business" for the bourgeois woman,[15] it is also true that the interior of a middle-class house was seen as the ultimate refuge not only for her children but also for the weary businessman husband. As the influential John Ruskin claimed in his 1871 lectures,

This is the true nature of home – it is the place of Peace; the shelter, not only from all injury, but from all terror, doubt, and division. In so far as it is not this, it is not home; so far as the anxieties of the outer life penetrate into it, and the inconsistently-minded unknown, unloved, or hostile society of the outer world is allowed by either husband or wife to cross the threshold, it ceases to be home . . . it is a sacred place, a vestal temple, a temple of the hearth watched over by Household Gods.[16]

Not only the Pre-Raphaelites (who so faithfully followed Ruskin) but also their successors the Symbolists held in awe the home as a metaphor for the constantly threatened inner life. As urban historian Richard Sennett has concluded, "'home' became the secular version of spiritual refuge; the geography of safety shifted from a sanctuary in the urban center to the domestic interior."[17]

Reviews of Khnopff's early *Listening to Schumann* (Fig. 3), for example, established what would be a common appreciation in Symbolist portrayals for the interior of a private home as a place for quiet meditation, possessing a kind of spiritual ambiance. Although Khnopff's scene of the woman listening to a piano rendition (the player is visible only by the inclusion of one hand, cropped at the left of the composition) might bear resemblance to a genre or Impressionist scene, his particular portrayal of the woman (his mother), "almost alone" with the music, head bowed into her hands, was interpreted as a spiritual reverie. As one anonymous reviewer in 1883 explained,

He has tried to express, in a scene of daily life, the elevated sensations which sometimes pass through our human-ness and lift it from the earth. In a comfortable bourgeois salon a piano resonates. . . . Subjugated, softly enervated by the pathetic chants of the German master, a young woman, sunk in an armchair, forgets herself, abandons herself, and lets her soul depart for the passionate regions. One can sense the magic in the room. One is won over by the contagion of that poetic emotion.[18]

Verhaeren's reading, offered in the pages of *L'Art moderne* three years later, maintained that *Listening to Schumann*

is the only work of pure modernity signed by Fernand Khnopff which pleases us. Why? Because it carries [us] beyond the exterior and because it reflects a wing of today's soul. It is only over the last few years that music was thus listened to – not with pleasure; [but] with meditation. The effect of art, of our art, is to influence a vague attraction towards a melancholy, momentous ideal. This picture renders that effect visible.[19]

The poet's comment that music should be listened to for meditative purposes (and not mere pleasure) has been related to correlations of music and religion that accompanied the Wagnerian revival then sweeping Belgium.[20] Most important for the point of this chapter, however, is Verhaeren's further equivalence of this depiction of an interior to go beyond the exterior, precisely as music that is intended for meditation must reach beyond the physicality of performance or entertained listener. The whole idea of the emotional effect of music – always seen by the Romantics as the "most romantic of the arts" – is here related to the enclosed interior of the home, a sanctuary that must be cultivated in these stressful times. Carefully modulated and compositionally manipulated interior scenes could therefore serve the Symbolist as ideal correspondences for interiority; they need go no further in their search for symbols than their own homes.

For Mellery, who was Khnopff's early mentor (Khnopff was his only student),[21] the "states of being" of an everyday place, as well as humble household objects, became a lifelong theme. In his drawings, interiors were based on two locales, each of which was a haven of silence, a quality that, like music, provided the proper ambiance to modern meditation. For his drawings Mellery studied primarily the Beguinange, a uniquely Belgian retreat for nuns, and his parent's house (where he lived and had his studio) in the small Brussels suburb of Laeken. Having been born in the latter, he lived on through his parents' deaths until the house's demolition in 1898. In that same year, he built another house in Laeken, and died there himself without changing much, a fact noted by admiring critics.[22] Like Gauguin with his nativism, Mellery was honored by other Symbolists because he seemed to have actually followed through on their efforts to escape not only the city but the metropolitan society that thrived there. Mellery's self-hermeticism appealed to the Symbolists' search for silence; encouraged by Mellery's own statements, the image of the reclusive artist who rarely left his house or suburb grew into a self-affirming myth. In 1898, the artist began a lengthy letter to *L'Art moderne* concerning his conviction that artists should work alone, rather than take part in constant exhibitions with others, with the declaration that "I work in the silence of the studio to conquer my ideal, my principal occupation."[23] Already in 1892 – following the first exhibitions of his *Life of Things* – he had been called the "severe and biblical artist of interiors."[24]

Mellery's background to this revered role is informative. Around 1878, he had been asked by Charles De Coster to illustrate, along with another artist, a volume on the Netherlands for a series published in the journal *Tour de Monde*.[25] For these, Mellery spent considerable time on the island of Marken, appreciated by many as a "primitive" locale. This experience was followed by a series of drawings illustrating Camille Lemonnier's *La Belgique,* aimed at describing the customs of the "real" people of Belgium,[26] thereby continuing his search for a more primitive and rural lifestyle. One of several artists invited to participate in

this latter project, Mellery actually accompanied Lemonnier to different places, and ultimately was responsible for most of the illustrations. In these, Mellery continued an emphasis on rural areas, while developing an "intimiste" approach that drew the viewer into softly delineated vignettes of everyday moments. Views of everyday life were cast in tonal coloration and in muted light, often at dusk, making the scenes less narrative and more contemplative.

An 1892 critic seeking to explain the remarkable effect of Mellery's recent drawings fixed on these experiences as formative ones that enabled the artist to allow "a mysterious strange past to insufflate faith and force into his works." Conferring on the Marken life the nostalgic peasant morality that many French Symbolists read into the Breton area, the critic expounded on Mellery's ability to understand the complex character of the nearly forgotten past:

> He is the last pictorial bard of Flamandes in black mantles, who are like the "weepers" of the dead cities: he is the rare draftsman, at once morbid and healthy, who perceives [reality] beneath the plump and placid visages, to fathom the languid sadness of an archaic and decayed land, and mixes with the splendor of an unalterable nature the inexpressible and subtle regret of a region long since torn away from the zenith of its power and its wealth.

Having suggested that Mellery, because of his early "living with the past" on the isle of Marken, was the perfect interpreter of Belgium's old and precious towns, this critic then summarized his ideas. Comparing Mellery's "intimate and severe" art with that of the "grandiloquent and solemn" productions of a popular Salon-decorated contemporary's work, it was concluded that these two would be "Babylon on one side, Bruges-la-Morte on the other."[27] Or, in the oft-cited words of Mellery's friend Paul De Vigne, "Mellery is a saint in the middle of the skeptics and the profane."[28]

By the early twentieth century, these characterizations had grown to the level of legend. Mellery was "a contemplative" who seemed to speak above all else to himself, and for whom "solitude was precious and dear."[29] His house, called a "tranquil hermitage," was described as being "situated in a deserted street," and Lemonnier's claim that "he would leave his suburb only three times a year!" was regularly repeated.[30] The artist's own assertion that he regretted not having any companion or loved one who could have been a help or inspiration but that he remained content with his life and art was interpreted as "aggravating his voluntary isolation, enlarging the emptiness around him."[31] Mellery's time spent in Marken, in the meantime, was deduced as a transformative turning point, because

> The spectacles that were offered there to his view, the imperturbable and calm flow of the hours, the existence made of tradition and

of the placidity of beings and things, must have appeared to him as a sort of materialization of his ideal, like the self-same image of the contemplative art from which he unconsciously nourished his vocation. Marvelous sanctuary, for the digression of modern life; the refuge from this brutal, agitated, feverish, life, all stirred up by the ferocious struggles for existence, the contact of which, obstinate dreamer that he was, he always forced himself to avoid . . . all this, in this isolated corner [that was Marken] placed before him the image of hidden and profound life, of tranquil permanence, in opposition to the superficial and fugitive world where we live.[32]

By 1932, Mellery's Marken experience had been transformed into a Gauguin/Tahiti-like deliberate escape:

The isle of Marken was not then, like today, a theatrical organization [made] for the intention of foreigners, a décor whose gaudiness is too easily perceived, and where there evolve figures or rather actors in a vast commercial exploitation. It was, in the era when Mellery was there to paint, a still virgin islet, where a colony of fishermen had conserved their particular manners and customs, their costume and their freshness. The artist lived for some time among these rare people isolated from civilization.[33]

For a 1937 exhibition in Brussels, Mellery had achieved full posthumous Symbolist status, as biographers crafted his development within the perimeters of degeneration: Mellery was said to have suffered, with his obsession with silence and his own interiority, a "crisis of neurasthenia" so serious that one "feared for his sanity."[34]

Although this romanticized narrative has recently been demythologized (Mellery was trained at the Brussels Academy of Fine Arts; he won their Prix de Rome and traveled throughout Italy, gaining an education in the classics for three years, then returned to Brussels and formed part of the Les XX and *L'Art moderne* avant-garde group there),[35] the image of the silent, lone artist certainly held in his own time. Despite his engagement with the great Belgian intellectuals of his day, he was called the "Solitary of Laeken."[36] In 1885, he exclaimed to Lemonnier that a small corner of his simple studio, adorned by a few humble objects, was "beautiful, like a portrait." When Lemonnier recounted this story, he used it as a way of explaining what he believed to be Mellery's theory of art, what would soon be identified as Symbolist. Lemonnier pointed out that what actually happened in Mellery's subtle drawings was a revelation of what the artist had the special gift to see: "the mysterious expression concealed beneath the surface of things."[37] For Lemonnier, Mellery's reverence for quiet and his belief that only in stillness can things be truly perceived was beautifully expressed

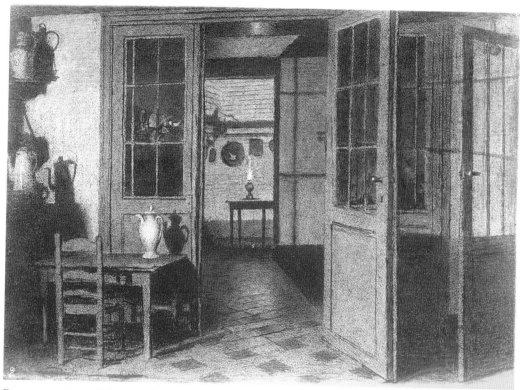

FIGURE 92. Xavier Mellery. *Kitchen Interior* from *The Life of Things* (renamed *The Soul of Things*), 1889. Mixed media drawing. 18 × 24 cm. Koninklijk Museum voor Schone Kunsten, Antwerp.

in his drawings. For urban viewers, the works were a gift of "sight" from a true seer.

In *Kitchen Interior* (Fig. 92), one of Mellery's favorite rooms is portrayed as a sanctuary. As in *The Bedroom,* the viewer is led through doorways and passageways into smaller spaces, all populated by objects that have clear identity, solidly occupying their spaces and casting mirror shadows onto the walls. Although this handling of spaces from large to small could be related to Dutch seventeenth-century house scenes, it is significant that Mellery's views never lead, as might a Vermeer, to a background narrative or drama. Rather, uninhabited compositions like *Kitchen Interior* appear almost dreamlike, with an emphasis on deliberate, careful discovery. The matte surface of the drawing certainly aids in this effect: in opposition to the shiny and seemingly clear illusionism of the academic oil and varnish surface of most paintings of the time, Mellery's drawing offers a tactile invitation to enter the suggestion of this room. Only by entering this interior space, quietly and with respect, can one begin not only to see but also to perceive these objects and the life within them. In another of Mellery's series, *The Staircase* (Plate 7) – one of numerous drawings featuring a stairway – this idea of a journey through the spaces of the house as a passage from the

outside world to a higher spiritual plane is made explicit. With three-fourths of the stairway area reduced to geometric planes that play light and dark shadows onto Mellery's interior world, the only part of the house that we see is one intermediate set of steps. On the landing above these, a woman clad simply and with an apron tied around her waist seems to pause, before turning to ascend the next flight. Having walked from darkness below, she turns toward a stairway that is identified only by its bright white wall. One single household object – a white pitcher decorated with painted leaves or flowers – exists as a signpost along the woman's journey, an icon of discovery for this ascending initiate who climbs through the still air of the stairs, farther and farther from the city street below.

THE SOUL OF THINGS

Only three of Mellery's drawings were first shown under the title *The Life of Things* in 1889, at the Brussels exhibition of Aquarellistes; the following year he showed a larger group at Les XX. In 1895, however, he exhibited the drawings once again, at Les XX's successor, La Libre Esthetique, under a new title: *Emotions d'Art, l'âme des choses* (*Emotions of art, the soul of things*). At that time, he wrote to Octave Maus and asked him to check the new title with Verhaeren, who knew and would understand the drawings.[38] Verhaeren presumably would understand the new title because he had used the phrase "the soul of things" in an 1889 review of the work of Seurat, who was exhibiting at that time with Les XX. The term was used, in addition, by Jules Destrée, in a review of a Les Aquarellistes exhibition in 1889.[39] Art historian Sarah Faunce has suggested that Verhaeren most likely discovered the term in a prose poem by Hector Chainaye, now little known but at that time a rising young poet who published regularly in the 1880s; his *L'Ame des choses* appeared in 1887 in the important literary journal of Brussels, *La Jeune belgique*.[40] In this fantastical poem, Chainaye narrates how a young widow is brought out of her nearly fatal grief by the "voices" of the simple things around her.[41]

What Mellery intended in his title "the soul of things" seems therefore to have been close to what Verhaeren intended when he first used the term. Enthusiastic about Seurat's work, the poet defended the French Neo-Impressionist's pointillist technique against other Belgian accusations of being overly scientific. Verhaeren described the slow, precise technique of Seurat as truly "reflective," claiming that

> [t]he will to work surely and coolly means that one penetrates more
> deeply into the intimacy and as it were into the soul of things; one
> analyzes them, one connects with what is accidental; one isolates

from them the transitory, the individual, the ephemeral, and without necessarily setting out to, one ends in a synthesis.[42]

Mellery also sought this: his later title for works done in the 1890s was *A Modern Synthesis*. In seeking to uncover the "soul of things," however, he differed markedly from the French Neo-Impressionist to whom, by virtue of his new title and its recent source from Verhaeren's review, he might have been suggesting comparison. Whereas the Parisian Seurat visually investigated the new and modern public spaces of the metropolis, Mellery turned to interior, evocative, and nostalgic settings. For Mellery's search to uncover the "soul of things" was also about the "loss of things," a common lament in the new age of mass production.

In great part due to this modern sense of loss, the term "interior" by the mid–nineteenth century often referred less to the inner being of the individual and more to the heart of the home, as the one true locale of identity.[43] If, earlier in this century of revolutions, "space was symbolically divided; inside meant family and security, outside meant strangers and danger,"[44] then the late-century interior continued to signify safety, but from the modern dangers of metropolitan society. Thus the age of the Symbolists was also, not coincidentally, the age of interior design. The importance of proper decoration of interiors began, in fact, as both an aesthetic and a social impetus, as the desired goal of Aestheticism, the Arts and Crafts movement, and later Art Nouveau.[45] Influenced by Ruskin's mid-century writings on the moral imperative of hand-wrought forms,[46] leaders such as Charles Eastlake and William Morris encouraged hand-made, finely crafted, and professionally designed simple objects not simply to restore the role of the craftsman, but most importantly to enhance the private life of the common individual. Thus Eastlake's popular *Hints on Household Taste* began with an assessment not of the home interior but with a condemnation of the average "street architecture," which he found, even in Paris (still better than London), to be "cold and formal in general effect. In detail it is somewhat garish, but more often simply uninteresting . . . [becoming] wearisome even in the widest and loftiest of streets." The subsequent essay was therefore an attempt to raise standards of taste as well as design for interiors, in order to offset such miseries of the modern street.[47] As Morris summarized, if craftsmen become once again true artists, they would be happy, and

that happiness will assuredly bring forth decorative, noble, *popular* art. That art will make our streets as beautiful as the woods, as elevating as the mountain-sides: it will be a pleasure and a rest, and not a weight upon the spirits to come from the open country into a town; every man's house will be fair and decent, soothing to his mind and helpful to his work.[48]

Thus from the beginning, the Arts and Crafts movement had as a primary goal the Symbolist objective of reinvigoration of the individual, specifically the modern individual in the city, by providing a private aesthetic environment. Countering this effort, however, was the commercial enterprise of fin de siècle interior design, attracting hundreds of thousands of middle-class customers to mass-produced objects by means of department stores and new decoration advice magazines.[49] The Belgian follower of Morris, Henry Van de Velde thus railed against the "churn[ed] out works . . . that can only increase the decorative discord in our homes."[50] It must be noted, in fact, that almost all of the Belgian Symbolists were, like Van de Velde, believers in the Arts and Crafts movement and that this was only one of the reasons for their strong advocacy of decorative arts and interior depictions. As Susan Canning has concluded, "[d]ue to Les XX's support of neo-impressionist and Symbolist theory and social art, their involvement with decorative art was almost inevitable." She points out that both Symbolism and Neo-Impressionism were concerned with "art-making," including the artificiality of interior decorating.[51] Thus Picard promoted the decorative arts; *L'Art moderne* regularly carried articles addressing this new "field," following socialist advocacy that this was an appropriate and relatively easy route by which to introduce aesthetic uplifting for the masses. By 1888, Les XX's exhibitions featured expansive decorative art sections, including panels, ceramics and glasswork. In 1893, two complete rooms were set aside for "applied art." In the same year, Khnopff gave a lecture on just-deceased William Morris and called for new Belgian attention to applied art on the English model;[52] he continued, meanwhile, to submit regular articles to the London *Studio*, just as the British journal focused on the ideal of the "Modern Cottage," that should be aesthetically complete.[53] The last three Les XX shows included tapestries, posters, and even furniture. Often these objects were displayed with paintings and sculpture, on pedestals that established them as equally valid vehicles for evocation, making Les XX's approach a precursor to, and perhaps even a necessary introduction to the precepts of Art Nouveau.[54] With a late-century surge in international journals on decorative and applied art,[55] the rise of the finely crafted interior object as "art object" was complete.

But there was also, by the 1880s, an additional interior design argument – and strong new market – for antiques. These were not the "antiquities" of Greece and Rome sought by the eighteenth-century collector, but rather the slightly old, now replaced household objects of former (and presumably better) times.[56] Objects inherited from great-grandparents were suddenly chic, and by the late century furniture makers engaged in reproductions of earlier nineteenth-century pieces.[57] In an 1888 issue of Brussels' *Le Globe Illustré*, there appeared two "Portraits of a City – Then and Now," the type of comparative eras commentary of which the Belgians were fond (see Fig. 9). In this illustration, the subject was the marketplace in "Old Anvers" compared with the "New." In Old Anvers, shown as a single full-page illustration, can be seen a street corner populated by

peasants and merchants, gathered around vegetable stands and a fish market. New Anvers is, however, depicted as several different vignettes overlapping one another in the page's illustration, as if it were now too large and too confusing to be visually presented as a single scene. A few of these pages, arranged as if they were snapshots in a tourist's scrapbook, show the same fish and farm stands, but most show "things," still lives of used objects piled up on rugs, all details of the new popular flea markets.[58] Making the same connections between past perfect society and the objects that were left from it, the artist Georges Le Feure produced several prints illustrating Bruges; here he included along with typical Symbolist scenes of darkened canals and streets a corner of the Bruges flea market, already in the 1890s selling bits of the past as souvenirs to nostalgic tourists visiting the "dead city."[59]

This new importance of commercial antiques would be readily explained by Simmel, in his essays first published in 1896 and 1900,[60] on the role of capital as a key to regularizing the establishment of value by means of exchange. For Simmel, the value of any object was set only in relationship to the "exchange" (be it labor, money, or another actual object, for example) that had to be given up for it. By such reasoning, the new craze for antiques lent them value because they were now less available (thus adhering to the "scarcity theory") and that more had to be "lost" in exchange to obtain them. What is most interesting in Simmel's theory for the Symbolists' new "valuation" of simple domestic objects, however, is his seeming exception to the exchange value rule for objects that were "dissolved in the subjective process as an immediate stimulator of feelings."[61] The embodiment of "feeling" that Symbolists imbued into domestic objects – objects that could then trigger nostalgia and mental solace – was so subjective an "exchange" that it need not fit into the normal rules of value. We know, and will in this chapter see evidence of, the fact that Ensor collected Chinese porcelain and that Khnopff built an environment for himself filled with the works of others; these collections would have been obtained by means of Simmel's normative exchange of value (by trading their own works, labor, or money for them). But the establishment of cherished value in very simple objects often at hand and not by any means scarce or difficult to obtain (Khnopff's single flower in an ordinary simple vase, or Ensor's masks, for example) was based more on the reciprocity of feeling (or, to use Robert Vischer term, as will be discussed later in this chapter, *Einfühlung*) than any capital exchange. Mellery did not have to purchase such items for his *Soul of Things* drawings, in other words; he lived with them in his old-fashioned family home and gave them new life as well as new value – for himself as well as for his viewers – by means of his art alone.

Often combined with these prized objects were plants or flowers, appreciated as beautiful markers of nature especially in city houses, and combined with new types of larger windows in an effort to bring nature indoors. The plants were usually grown by the house inhabitants themselves, the result of a surge of interest in gardening and horticulture made possible with new

leisure time and commercial products. For well-to-do enthusiasts, greenhouses or conservatories – indoor gardens that had been popular since midcentury – became in the 1880s an integral space in private homes, thanks to higher-quality glass, steam heating, and modular designs. Intended not only as a workspace for the hobbyist but as a refuge for the entire family from unhealthy city life,[62] the domestic conservatory could extend even the city home into backyard gardens. For those of similar aspirations but lower incomes and less space, Wardian cases – the original glass box or bottle gardens – were invented, and a new business of artificial flowers and "houseplants" flourished.[63] As the son of a gardener at the Royal Palace at Laeken (where a great greenhouse was built in the 1880s),[64] and as one initially apprenticed to a decorator, Mellery would have been well aware of these trends.

Finally, there had been in the nineteenth century introduced to the average home a new level of "comfort." Innovations in upholstery resulted in spring-bottomed, cushioned, and overstuffed sofas and chairs such as the occupied one in Khnopff's *Listening to Schumann*. By the 1840s, the upholstered club chair was called the "comfort chair" and held a place of pride in workers' or middle-class homes, signifying the homeowner's deserved break from the stress of the outside world.[65] From the comfort chair to the greenhouse, the weary urbanite might repeat a line from Rodenbach's *Reign of Silence:* "Sweet is the room! – a gentle, secluded harbor."[66]

INTIMATE SPACES

In addition to the furnishing and decorating of the personalized interior, the house itself became, in the second half of the nineteenth century, increasingly closed and isolated from neighbors and the street. Central heating was a condition which, without proper insulation (not really accomplished until the 1920s), required most to close or seal windows for several months of the year;[67] after a while, this became fashionable even for houses without it.[68] Furthermore, the inside spaces were segmented and, it was hoped, the rooms more private. Interiors seen in most Symbolist images were of this new style, deliberately segregating and formal in design. Around 1850, interior spaces were broken up and assigned to separate functions, just as the complex social effect of such changes became apparent. The numerous small rooms of new or renovated houses might have originally seemed to afford more privacy for the family as a social unit (as opposed to servants, relatives, and even visitors sharing spaces, as was common in earlier times). But the individualizing rooms often accomplished the opposite effect, discouraging rather than encouraging domestic intimacy. As a German writer in 1853 explained, the older town houses of the sixteenth and seventeenth centuries always opened up to large spaces that were intended for everybody in the house. But, he continued, "In the *modern* residences of the wealthy citizen...all the

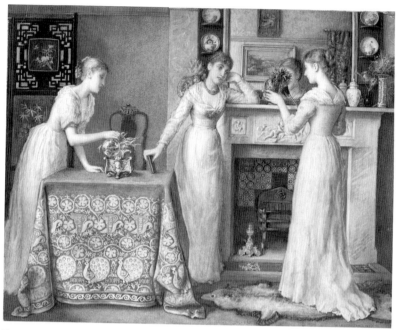

FIGURE 93. Gustavus Arthur Bouvier. *In the Morning. Three Young Ladies in an Aesthetic Interior,* 1877. Watercolor and bodycolor. 34.3 × 42.5 cm. Christopher Wood Gallery, London.

spaces belonging to the *communality* of the family and household have been reduced to the least possible ... [so that] the separate rooms of the members of the family become every day more numerous and distinct." Concerned about the unnaturalness of this arrangement, the author explained: "Parents dwell separate from each other, and the cradle of the children stands no more close to the couch of the mother. The nursery, especially, cannot be distant enough from the abode of *polite* parents."[69] Thus, although in some cases the separation of interiors in working-class homes implied comfort or even morality,[70] in middle- or upper-class homes, this led to single-function, highly specialized spaces like the "breakfast room" or the "smoking room." This seems to have occurred earliest in England; in 1864, John Kerr's *The Gentleman's House* offered a brief history of the best new houses on this plan. Kerr followed this with suggestions for contemporary interiors, including no less than fifty separate rooms for separate functions – and these were just for the family, with servant's quarters discussed elsewhere.[71] Kerr's plans included numerous rooms designated for the gentleman, and only one for women: the boudoir, or "Private Parlor for the mistress of the house."[72] The "public" parlor, of course, was the front room intended for family relaxation and for entertaining visitors. This is the room depicted in Khnopff's *Listening to Schumann.* With its heavily upholstered chairs, carpeting and tables cluttered with arrangements of *objets d'art,* the room is designed for quiet reading and

listening to music, the two most popular activities, besides conversation, for late-nineteenth-century inhabitants. In Khnopff's painting, the woman's meditative pose is reinforced by the heavy sound-absorbing furniture; in this early work Khnopff also introduced his already noted device of framing the figure with "the comfortable" armchair, the carpet, and especially the fireplace. The relationship between the woman, the hearth (commonly referenced in nineteenth-century fiction and advice books as symbolic of the female's domestic and childbearing duties)[73] and the receptivity to music reflects a commonplace of gendered characterizations at that time; it also suggests that this emotionalism should be developed, however, by the male who, forced to leave the comfort, isolation, and spirituality of the home, therefore needed it all the more.

A significant result of the new domestic spacing was one that the Symbolists seem to be one of the first groups to address: the creation of *very* private areas of the house suitable for occupation by only one person inclined to quiet introspection. Images such as Ensor's *Somber Lady* (1881, Musées Royaux des Beaux-Arts de Belgique, Brussels), and Khnopff's *Portrait of Marie Monnom* (1887, Musée d'Orsay, Paris), are only two of numerous examples. All portray single figures in handsomely decorated but quiet rooms, alone with their own thoughts. The prototypes for these compositions' interior views are readily found in the plethora of late-century paintings depicting the new "aesthetic interior" to best advantage, as in Gustavus Arthur Bouvier's *In the Morning. Three Young Ladies in an Aesthetic Interior* (Fig. 93).[74] The differences, however, are also informative: in the aesthetic interior, the emphasis is on carefully arranged furniture, objects, and decorations as setting for human interaction and activity. Single figures are engaged physically with the interior, playing an instrument, peering out a window, or even anxiously awaiting someone else's arrival, and, like Bouvier's, are multifigural, so that the people in the interiors work with the objects, playing cards, watering plants, or other minor activities. In Symbolist depictions, however, the aesthetic or artistic middle-class interior is the subject rather than the scene; the objects and decoration serve as important visual and other-sensual mediators to meditation. The implication that these spaces should be a new alternative to romantic emoting with nature seems clear. Munch's earlier *Melancholy* (1891–92, Munch Museum, Oslo), depicting in traditional melancholia pose and setting the lone male sufferer by the sea, finds its urban counterpoint, therefore, in his later image of his sister Laura, institutionalized for schizophrenia after being deserted by a lover, seen alone inside Munch's rented rooms in the country outside Kristiania. In *Melancholy (Laura)* (1898, Munch Museum, Oslo), Laura sits with her back to the two large windows that could have afforded her a view of nature and stares instead at the potted flowering plant carefully placed on the table before her.

As cities became more hurried and harried in public spaces, recognition of the house as the one space still allowing for individuality, quiet, and perhaps most important, control over sensory experience took hold. There was a certain

irony in this. Just as many urbanites decried the increasing materialism of the age, condemning the capitalist urge to consume "things," they also sought – not only with energizing new designs but often just with "things" – to create a compatible surrounding for themselves in the haven of their own homes. As the 1870s and 1880s trends toward heavier furniture and more and more clutter in every interior room (as if to imitate the density of the street but on one's own terms), the 1890s saw a backlash in a move away from clutter. Like a reform church that vowed to restrict distracting embellishments, the "enlightened" house was literally lighter and open, as if in recognition of the truly meditative role of each room.

INTERIOR METAPHORS

Aesthetic appreciation for the domestic interior was, furthermore, enhanced by new claims that these spaces could serve as a healthy haven for the family. With the multitude of concerns about disease at this time, as discussed in Chapter 4, came new resolve on the part of public service to offer regulatory controls for prevention of illnesses, especially epidemics that could sweep through a city. Throughout the last quarter of the nineteenth century, debates ensued between civic engineers (to whom the high-powered job of restructuring cities with better water and airflow had been entrusted) and hygienists (who were increasingly public figures in charge of disease prevention). At one point in the controversies launched by these two newly professionalized groups over whether "everything should go in the sewer," and "where the sewer should go," there occurred an important shift of both logic and emphasis from public to private site. Geneva's 1896 exposition, featuring a whole new water system for the city, for example, was actually a fairly late development. In most European cities, by the 1880s, the central arena in the civic battle against disease was no longer new boulevards or water systems, but rather the individual home.[75] Although each city had its own political impetus to consider such new foci of attention, the underlying lesson was indisputable: the inside of one's home was now sacred in terms of physical health. Already in the 1870s, new attention was paid to the middle-class home, with efforts to educate the public about the "sanitary house."[76] The private home could be either a "foyer of disease" or the ultimate safety zone, where urban filth and bad air could be kept at bay. When this health factor is added to the emotional and spiritual enhancement afforded the urban dweller by the properly appointed private spaces, the image of the domestic interior as shrine emerges.

Symbolist enshrining of domestic indoor spaces established a new metaphor for personal interiorization that continued into the work of numerous early Modernists who inherited not only Symbolist theories but also the Symbolists' search for solace from the city. Max Klinger's influential essay on *Painting and Drawing*, privately published in 1891, for example, proposed "Raumkunst,"

or "room-art" as a concept originally aimed at exhibition spaces, but proposing that in any case it was the overall aesthetic and spiritual effect of any room, focusing not on "the single work of art but the 'artistic unity' of the room and the spiritual environment provided by the art and the surroundings" as most important for its effect on the viewer, a concept that was advocated in turn of the century Germany as well as Vienna.[77] In France, Nabi artists took advantage of the contemporary rage for comforting, enveloping patterns in their prints and paintings of the late 1890s and also emphasized single figures reading by lamplight or sitting in a quiet corner of the house. Their influence on the work of Henri Matisse and other Fauve artists of the early twentieth century is well known, but such domestic arenas of new spirituality were common throughout Europe at that time.[78] Such works seem, with their appreciation of evocative interiors, to be related to the changes of style and theory overtaking architecture and interior design itself, in great part accompanying the interest in the nervous system and psychological reactions to the city discussed in Chapters 2 and 3 of this book. As Deborah Silverman has argued in her study of the origins of Art Nouveau, such quiet, specially designed interiors were considered "a soothing anaesthetizer of the citizen's overwrought nerves."[79] It has been recently argued, in fact, that not only Art Nouveau but all the new emphases on private interior architecture at the turn of the century (rather than the more well-known public monuments and buildings) formed a primal wellspring for modernism's focus on the individual and the role of art as a redemptive force.[80]

One little-recognized source for this development was the writing of the German theorist Robert Vischer who, influenced by the new science of empirical psychology, proposed in 1873 the idea of *Einfühlung*. This notion, one that occupied a central role in fin de siècle German theory and that had significant influence on twentieth-century architecture and art criticism, placed a new emotional and tactile emphasis on the knowledge of space. For Vischer, there were two kinds of seeing: a passive viewing and a highly aware, personally invested gazing that invests the viewer in the object. For this latter type of seeing, the hand worked as a second organ, allowing touch to be a basic seeing and, in turn seeing to be a refined sense of touch.[81] Just as children learned depth perception by touching and feeling, Vischer suggested, so also adults continued to experience space in physical but also emotional ways, making such traditional notions as space and time, movement, or projection important only as they related to personal responses. "What are Forms," he asked, "if the red blood of life does not stream in them?" In addition, for Vischer, the basic outreach of the soul was "feeling," so that in seeking to respond to the "life" in space and things, as he explained, it is the individual who infuses objects, rooms, and space in general with their own "soul."[82] This was not an innate "soul of things," such as Hegel would claim, but rather the result of a self-projection by an individual observer, such as a viewer of Mellery's drawings.[83]

It should be clear why a theory such as Vischer's, which emphasized the individual's ability to "see" and experience the "soul of things" would resonate with Symbolists: in many ways, it offered a theoretical and psychological basis not only for Baudelaire's claimed "Correspondences" but for the whole of Symbolist art itself. Vischer himself addressed his theories to the creation of a work of art, and his second, emotional and intense type of seeing was, when added to the sensibility of space that came from "seeing" with touch, close to the Symbolist idea of the artist being able to "see" below the surface of things and to work, as Vischer said, "from outside to inside."[84] In addition, however, Vischer's ideas about viewing overall could also be applied to the audience for Symbolist art, suggesting in terms of psychology what would later be developed as "empathy" within a broader aesthetic theory by Theodore Lipps. Thus Vischer's early construction of his idea of "feeling" is important to an understanding of the Symbolists' reverence for objects. While Lipps applied this idea to the reception of an object of fine art (and distinguished between optical and aesthetic observation), Vischer began by addressing the inculcating of a "soul," by means of the observer, into *anything* (whether art, objects, or plants, for example) that was worthy of such infusion.

The simple objects of domestic interiors meant much more than utility, therefore, to many artists of the 1890s. Instead, these objects existed as their own important self-identities, with meaning that encapsulated the past: by describing them, in word or image, with recognition of this meaning, their significance as part of the past was fixed in time, just as they became powerful signifiers for ideals of the future. In his poem series *Serres chaudes,* Maeterlinck proposed as symbol of the soul a bell-jar or greenhouse where "vegetations of symbols" could grow.[85] And as Paul Cézanne, whose oeuvre centered on so many still lives, wrote,

> People think that a sugar bowl has no physiognomy, no soul. But that also changes from day to day. One has to know how to take them, flatter them, these gentlemen. These glasses, these plates, they speak to each other, they are always exchanging confidences.[86]

Cézanne, who was a confirmed antimodernist (who wrote of the "invasion of the bipeds, who do not give up until they have turned everything into horrible embankments with gas lamps and . . . electric lighting"), was convinced that he should be able in his still lives to uncover the true "soul of things." The degree to which Cézanne was able to accomplish this and to which his ideas corresponded to others at the time is at least partially discernable in the enormous influence that his still lives had, when shown at his first posthumous retrospective in 1907, on Rainer Marie Rilke. For this writer, who was in the process of writing of *The Notebooks of Malte Laurids Brigge* at that time, Cézanne's nuanced paintings

of seemingly everyday objects were a revelation. Rilke in many of his later works elaborated on ideas regarding the loss of true perceptions of things due to the desensitization of mass production; these ideas had their origins in his writings immediately following the Cézanne experience.[87] He hoped to achieve, with words, what Cézanne had accomplished with paint: somehow to preserve the "thing" that was quickly being lost and thus "fix" it into memory, and permanence. As Rilke himself later explained, "The things, which are animated, which we experience, which *are aware of us as well*, go into a decline and can never be replaced. *We are perhaps the last people to know such things.*"[88] This comment was made in 1925, expressing Rilke's dismay over the "sham things, mock-ups of life" that were pouring into Germany from America; but the Symbolists who so influenced him were already in the 1890s convinced that the same kind of transformation and a renewed appreciation for lost "things" must take place. Artists like Mellery found new impetus not only to make palpable the "soul" within things, but also to preserve it, visually, so that it might not be lost forever. The whole point of visual Symbolism was to use tangible things, including the work of art itself, to reintroduce meaning, not only to art but also to life itself.

How this was accomplished differed from one work and one artist to another. Mellery, as noted, actually invites the viewer to make the discovery of the real life and soul of things within the carefully emptied but being-infused spaces of his drawings. In the work of James Ensor, however, the secret life of domestic interiors is given actual substance, notably in his series of paintings and prints devoted to "inhabited" furniture. In these depictions, the viewer is treated to an X-ray vision of ornate, heavy furniture, through which the real life of ordinary interior objects reveal themselves only to the discerning "inner eye," often that of a single figure in the drawing and always that of the viewer. Despite their titles, Ensor's depictions have little to do with the ghost stories that became popular in the mid–nineteenth century, in which actual figures, human or otherwise, appeared to the unsuspecting living. Illustrations to these, like Gustave Doré's wood engraving for Poe's *The Raven* (Fig. 94), typically allow only the viewer to see the haunting figures, here crouched behind the two flung-wide doors. If the figures *are* visible to the person they are "haunting," then the haunted one is shown in a terrible state of fear. In Ensor's work, however, it is the objects themselves that are possessed, by meaningful beings; the perceivers, like Ensor's little girls, are at most surprised, always intrigued, and often enchanted, by their mystical experience. In Ensor's *My Sad and Splendid Portrait* (etching, 1886), the artist has emoted with such deep "feeling," as Vischer would term it, that he himself has become one with the "life" of an elaborate sideboard.

In Ensor's *Haunted Furniture* (Fig. 95), it is a little girl who is capable of seeing the sundry faces, masks, and skulls as they emerge from the ornately carved Victorian furniture that surrounds her, and quietly, humbly approach her. The girl looks up from her reading, as if to calmly ascertain whether the viewer

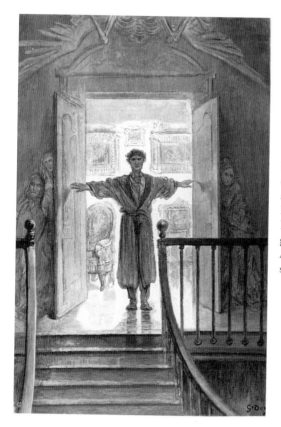

FIGURE 94. Gustave Doré. "Here I opened wide the door: – Darkness there and nothing more." 1883. Illustration to Edgar Allen Poe, *The Raven* (New York: Harper and Brothers, 1883). Wood engraving by H. Claudius. Courtesy of the Archives and Special Collections Dickinson College, Carlisle, Pennsylvania.

perceives this hidden life of things as she does; beside her, her mother continues to sew, oblivious to the secret drama playing in the room. This narrative follows the romantic tradition that established the child as endowed with the sensitivity of the seer, gifted by virtue of her naiveté and closeness to the eternal world from which she just arrived. By the late nineteenth century, this notion would also have agreed with the newfound appreciation of the theories of Giambattista Vico about metaphor, and its reliance on naive, childlike associations.[89] Finally, having the little girl serve as a clairvoyant provides yet another form of nostalgia, representing one more element of the interiorizing mechanism of Symbolist art, especially if it is recognized that childhood memories are most often reinvented. As recently argued by psychohistorians Joel Pfister and Nancy Schnog, it is the reinvention of childhood that is the most common *cultural* production of nostalgia.[90] In the plethora of girl and (mostly) boy stories of the fin de siècle could often be found the celebration of carefree innocence, but also unrestrained freedom and sense of self that their readers found so lacking in their adult urban lives. As has been pointed out by many, such narratives "helped readers accommodate to an alienating and reified present they did not understand,"[91] through what T. J. Jackson Lears has called an enactment of

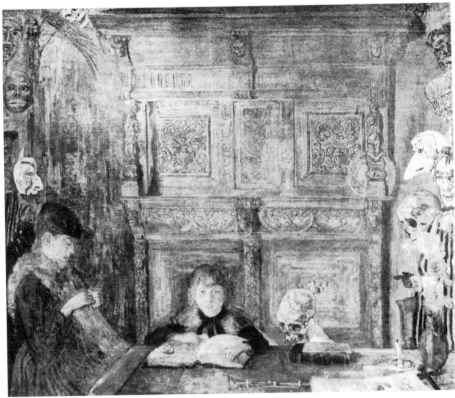

Figure 95. James Ensor. *Haunted Furniture* (original title: *The Old Dresser*). 1885. Oil on canvas, 89 × 103 cm. Formerly Stedelijk Museum voor Schone Kunsten (destroyed WWII). © 2003 Artists Rights Society (ARS), New York/SABAM, Brussels.

"sentimental regression" from a troublesome present.[92] In Ensor's drawing, the little girl plays the same mediating regressionary role: through her, the viewer is encouraged to reinvent a childhood experience that already engaged the "soul of things" in everyday interiors in a meaningful way that corrected the stultifying existence outside in the city.

LOCKING THE DOOR

The Symbolist yearning for interiority, expressed by means of objects arranged in domestic interiors, is perhaps best summarized in Khnopff's *I Lock the Door upon Myself* (Fig. 96). Although much has been written about this work and its imagery,[93] the painting is above all else about interior states. The pose of the young woman with unseeing eyes, the statue of Hypnos behind her, the round mirrors on the wall to her right, and even the chain that hangs immediately to her left, dangling a small gold crown (the type of jewelry used to induce

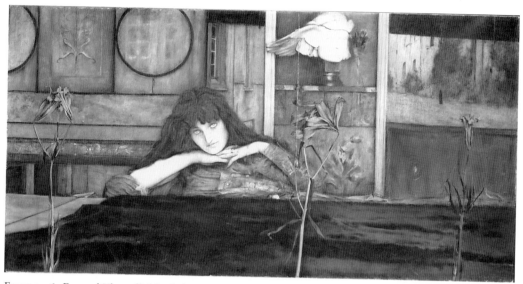

FIGURE 96. Fernand Khnopff. *I Lock the Door upon Myself.* 1891. Oil on canvas, 72 × 140 cm. Bayerischen Staatsgemäldesammlungen, Neue Pinakothek, Munich.

hypnotism), all refer to the woman's contemplative state. Furthermore, she does not meditate as she would have had she been a figure in a Romantic composition, either in nature or staring out of a window to nature. Rather, she is encapsulated by Khnopff within a room; her escape, instead of to outside nature, has been to another interior. Even the one image in this painting that seems to be an outdoor vista – in fact, a romantically silhouetted figure strolling through a medieval town – is not an actual view of a scene observed through a window, but rather a canvas that hangs inside the shuttered room, suspended by two thin wires against the back wall of this enigmatic dwelling. All the other "natural" objects in this room are also rendered artificially. The plucked red flower next to the sculpted head and the stylized plant design hanging to the picture's left are emblematic of the deliberate arrangement of the space as a reflection of the woman's state of being. The withered day lilies that form a frieze over the foreground of the painting remind us that this is not daytime (when the flowers would be open, in bloom), but unnatural, or suspended time that reigns here. All are also arranged in a rather dingy, older room, an interior "left behind." This antiquated and worn aspect of Khnopff's interior is rarely noted in twentieth-century analyses of the painting but relates closely to the connection between nostalgia in the Symbolist sense (going beyond "homesickness" and extending to an inspired condition of quiet retrenchment from modernity) and aged interiors. The association was established by William Morris in his famous *News from Nowhere,* in which the hero (the writer himself), having been taken to the utopian land of Nowhere, is led through the "perfect" old house. There,

he experiences a spiritual transportation brought on by the suspended sense of time in the aged room. As he recalls,

> We sat down at last in a room . . . still hung with old tapestry . . . now faded into pleasant grey tones which harmonized thoroughly well with the quiet of the place. . . . I asked a few random questions . . . but scarcely listened to . . . answers, and presently became silent, and then scarce conscious of anything, but that I was there in that old room. . . . My thought returned to me after what I think was but a minute or two, but which, as in a vivid dream, seemed as if it had lasted a long time. . . . [94]

For Morris, age provided the muted sensory stimuli that, in this peaceful old interior, created the perfect dream space, and a respite from, as he declares, "the sordid squabble, and the dirty and miserable tragedy of the [modern] life I had left."[95]

Khnopff's similar establishment of an age-worn interior as trance-inducing space in *I Lock the Door upon Myself*, although not noted in current literature, was highlighted by Verhaeren in an 1892 review of the work when it was first exhibited with Les XX:

> And all the voluntary solitude, the abandonment of others for the recovery of oneself, rest in this figure with fixed eyes, gaunt features, immobile and tense pose, while the dilapidated walls, the dried up lilies, the faded wood and colors, and above all this escape to this place of silence and mustiness, framing the old-fashioned sorrow of things close to their ruin.[96]

Verhaeren's use of the phrase "recovery of oneself" is important here. Having interpreted this, with Symbolist discretion, as "voluntary solitude," he knows exactly what the woman is hoping to accomplish by "locking the door" upon herself: the development of inner life and power. This is precisely the point, in fact, of the poem "Who Shall Deliver Me?" by Christina Rossetti, from which Khnopff's title was taken:

> God strengthen me to bear myself:
> That heaviest weight of all to bear
> Inalienable weight of care.
>
> All others are outside myself;
> I lock my door and bar them out,
> The turmoil, tedium, gad-about.

I lock my door upon myself
And start self-purged upon the face
That all must run! Death runs apace.

If I could set aside myself,
And start with lightened heart upon
The road by all men overgone!

God harden me against myself,
This coward with pathetic voice
Who craves for ease, and rest, and joys:

Myself, arch-traitor to myself;
My hollowest friend, my deadliest foe,
My clog whatever road I go.

Yet One there is can curb myself,
Can roll the strangling load from me,
Break off the yoke and set me free.

Rossetti's poem, which had also inspired Khnopff's pendant painting *Who Shall Deliver Me?* (Fig. 74) is about the need of every person born into these times of "turmoil, tedium [and] gad-about" activity, to develop an inner being. Recognizing her potential to be her own worst enemy (an "arch-traitor" to herself), the poet calls herself "hollow," as if she is, without this inner strength, the kind of zombie that Munch had observed on Karl Johan Street. If we turn again to Khnopff's *Who Shall Deliver Me?,* the "problem painting" that left the precise nature of the woman's troubles tantalizingly unclear despite the coded inclusion of the city sewer, we nonetheless can now recognize that it is a modern, urban dilemma in which she finds herself. The Symbolist solution to the situation is therefore offered in Khnopff's *I Lock the Door,* just as it is in the poem: the "One" who can help must be God, from whom she asks in the first line for strength, but the only way to reach such a level of spiritual force is to "lock the door" upon the external life that is not really geared to the individual or to "oneself."

In *I Lock the Door upon Myself,* the staged interior is proposed as the Symbolist answer to the dilemma of the angst of life on the city street. This is, furthermore, an interior that has been set up as a personal shrine to nostalgia – either designed to look as if it is old or in reality an already "faded" room that has been in either case packed with "things" that can be markers on a journey to inner being. The room itself has aged, perhaps, like the melancholy chamber of a Rodenbach poem which portrays a room in fading light as an animated youth, not wanting to grow old with the night:

The chamber, sad and weary, has at last grown resigned,
And abandons itself to the evening...

Everything withers in the growing darkness;
The chamber is entirely prey to the evening;
And it seems that all at once the chamber has grown old.[97]

Rodenbach's work appeared in 1896 as part of a collection of poetry entitled *The Enclosed Lives.* Just as the room here is allowed to feel emotions, and to age, so also viewers of Khnopff's painting appreciated the room itself as well as its "population": prints, flowers, statues, and even the deliberately ambiguous coffinlike shape (called both a table and a grand piano at the time of its initial exhibition)[98] on which the woman rests her elbows – as appropriate companions (rather than attributes) of the woman who has chosen to "lock the door" upon herself. It was this interior world, as a mental state and physical space of the past, filled with signifiers of nostalgia and meditation, that represented the Symbolist goal of reinvigorating the lost soul of modern life.

The recognition that objects – and especially artworks – have a life of their own and can therefore influence the person who inhabits "their" room was cleverly expounded in the first tale of Verhaeren's *Midnight Stories,* published in 1884. Called "The Fleshy Tale," the story tells of a decadent aesthete who collects only images of debauchery and bacchanalia, indulging in their appreciation as the impetus of raucous day and night dreams. When he inherits a severe gothic *Crucifixion,* however, and proceeds to install it with his collection, not only do his fantasies change but his formerly beloved fleshy figures revolt, and begin to melt, as dripping fat, all over his carefully furnished retreat. By disturbing his hedonistic shrine with a Christian icon, he had upset not only his own inner being but also that of the paintings themselves.[99]

Further examples of this concept of creating meditative shrines in, and being able to discern other lives in the objects of, domestic settings abound in other Symbolist literature but may be surveyed in the three works focused on in this book by Huysmans, Hamsun, and Rilke. In the latter's *Notebooks,* the novel which as we now know was greatly influenced in its final form by the experience of seeing Cézanne's still lives, Brigge's emphasis on the terror of the streets (related in Chapter 3 of this book) is consistently countered by the "escape" to an interior. After his harrowing encounter of the carnival crowd, he is relieved to pronounce "but now it's over. I have survived. I am sitting in my room, near the lamp." He then continues to explain – seemingly to himself as much as to the reader – how accommodating this dingy rented room has become for his individual thoughts, off the street:

I am sitting and thinking: if I weren't poor, I would rent another room, a room with furniture that isn't so worn out and full of former tenants as this furniture is. At first I found it really difficult to lean my head on the back of this armchair; for there is a certain greasy-gray hollow in its green slipcover, which all heads seem to fit into. . . . [but]

I have discovered that it's all right the way it is and that the small hollow fits the back of my head perfectly, as if it had been custom-made.[100]

It is significant that Brigge's ruminations on his own room followed a morning's tour of one of Paris' quarters that was still in the throes of reconstruction and demolition. His understanding of the remnants of these buildings' interiors as signifiers of the lives that had inhabited them in the past is palpable. As he describes the one remaining side of a block of torn-down row homes:

the most unforgettable things were the walls themselves. The stub-born life of these rooms had not let itself be trampled out. It was still there; it clung to the nails that were left, stood on the nar-row remnant of flooring, crouched under the corner beams.... And from these walls, once blue, green, and yellow, and now framed by the broken tracks of the demolished partitions, the air of these lives issued.... There the noons lingered, and the illnesses, and the exha-lations, and the smoke of many years.[101]

Brigge's sensitivity to the hidden lives of domestic interiors began in child-hood, with an experience not unlike that of Ensor's little girl who is privileged in knowing the inner beings of the *Haunted Furniture.* As a child crawling under the table to retrieve a dropped crayon, Brigge, as described by Rilke, was stunned to see coming out of the wall toward his own little hand, another hand, trying to reach him and, he initially feared, to pull him into the life behind the walls of his old country home. As Brigge recalls this incident, he reveals that for him it was an initiation. It is what now, in Paris as the "outsider observer," made him especially astute, for his life had been "full of truly strange experiences that are meant for one person alone and can never be spoken." His realization that such seer abilities must be relegated only to inner knowledge is clear when he concludes, "I pictured to myself how a person could walk around silent and full of inner happenings."[102]

An appreciation of the comfort and individual creativity of one's own in-terior space in the midst of a hectic city is also apparent in Hamsun's unnamed hero. Here, the starving writer has a room whose only distractions are the news-paper advertisements that have been used to paper the walls (which in turn take on an almost premonitory importance). Faced with a letter of eviction, he accepts his fate by reminding himself that "this really wasn't any room for me; the curtains on the windows were a very ordinary green.... In short, this room was simply not furnished in a way appropriate to intellectual effort."[103]

The classic example of the perfectly constructed Symbolist interior as-sembled aesthetically for the sole purpose of encouraging the enhancement of interior states is, however, that undertaken by Huysmans's Des Esseintes. The

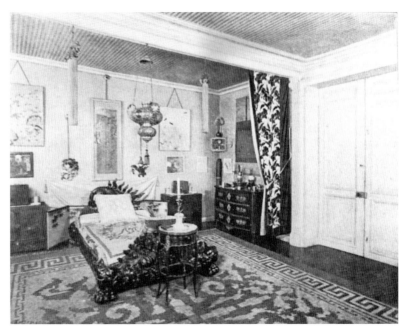

Figure 97. Bedroom of Count de Montesquiou-Fezensec. c. 1890s. Photograph. Private collection.

whole purpose of this protagonist's flight from Paris and seclusion in a cottage at Fontenay-aux-Roses was not only to escape, and then lock out, the frivolous distractions of public city life but also to "lock in" an inner life. To that end, Des Esseintes spends most of his time throughout the novel in the act of decorating his library of books; he expends enormous time and energy tracking down the exact shade of Moroccan leather for his walls. For his greenhouse, he orders plant "monstrosities," selected because of their extraordinary, and not conventionally, beautiful appearances. He buys a large tortoise, and has it gilded and then encrusted with semiprecious jewels, to have it wander around his living room, a moving contrast to the variegated colors of his Oriental carpet.

Des Esseintes's decorating obsession is significant for understanding Symbolist interiority in two ways. First, it consistently emphasized the artificial, human-made environment as superior – for his purposes of self-confinement and personal enhancement – to nature itself.[104] The flowers were deliberately cultured to *look like* they were made of wax, and the turtle so unnaturally embellished eventually died, "unable to bear the dazzling luxury imposed upon it."[105] Every element of this overly sensitive urbanite's décor, in other words, was chosen not for its normal function, nor for its naturalness, nor even as conventional aesthetic enhancement, but rather for the specific purpose of triggering empyreal meditation.

Second, it was quickly recognized that Des Esseintes's house – outrageous though it was – paid homage to recent aesthetic environments that had been

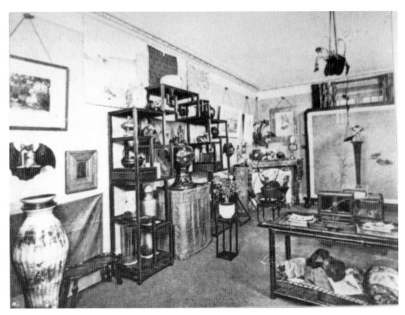

FIGURE 98. Curio Room, home of Count de Montesquiou-Fezensec. c. 1890s. Photograph, Private collection.

actually built, such as the one described in Edmond de Goncourt's *The House of an Artist,* a fictionalized account of the authors' own remarkable house in Auteil. Furthermore, although de Goncourt's influence on Huysmans is often cited,[106] another actual interior may well have served as a source for Huysmans. Des Esseintes's real-life model, the Count de Montesquiou-Fezensec, lived in his own exotically designed interior, with a greenhouse and rooms encrusted with eclectic but thought-provoking objects. Two photographs of Count's living quarters in the 1890s (Figs. 97 and 98) reveal tastes not unlike those of the fictional Des Esseintes. The bedroom, with its ornate Asian woodwork and its hanging church lantern (or incense holder), among a host of other wall decorations is an interior to dream by, while the curio room promises endless exotic meditations.

SEEKING THE FEMININE

It is interesting, in light of this devotion to interiors, which had been in the mid–nineteenth century as well as in numerous recent studies identified as "feminine sphere," that Huysmans not only never married but was derisive of his colleagues who did.[107] Of the Symbolists discussed in particular in this book, only Toorop married conventionally and had a traditional (for those times) family.[108] The majority, in fact, never married, and as Mellery declared of himself, seemed to have felt it necessary to lead a single (if not celibate) life to maintain the solitude

necessary for their art. On the other hand, most of the Symbolist portrayals of interiors when peopled at all feature women. Susan Canning has suggested that, in the case of Ensor, this representation is proof of "the artist's own social status and convey[s] his acknowledgement of the validity of the female sphere," in direct contradiction of common accusations of Ensor as a misogynist.[109] But the posing of the artists' female relatives in domestic interiors proves, as has been illustrated here, to be a Symbolist pattern. And while these works at once recognize the bourgeois interior as a space where the artists' sisters and mothers feel comfortable, they also claim the same spaces as their own, taking over the house interior as a "new" space for the sensitive male city dweller. By selecting the perfect interior, and visually furnishing it not only with meditative objects but also with a planned presentation – to invite others like themselves into these compositional spaces – the male Symbolists were not only taking over "female" space but also implied that they were taking over at least some of the "sex characteristics" that accompanied women and their domestic sphere as well.

As noted in Chapter 5, the separation of spheres had been accompanied by a distinct assignment of characteristics to each sex, so that along with the domestic life for the female went weakness, modesty, dependence, and emotion. But it also identified such virtues as intuition, perception, spirituality, and especially possession of an "inner life" as the woman's destiny, in sharp contrast to the male's external world of energy, power, and ambition. As Mathews has explained, the Symbolists, with their aesthetic of intuition and emphasis on feeling, allowed some slippage in their own gender identification to occur; as noted in the last chapter, this may help to explain the extreme conservatism and even fear in addressing the image of "woman" in Symbolist works. For Symbolists, however, the coveted space of a so-called "feminine interior" was too important to surrender; the artists appropriated this image, needing it just as they had needed the faculty of intuition in order to maintain an inner world. For most living with mid- to late-century gender ideology, however, the contrast of gender and assigned spaces persisted, despite the fact that the external world was in so many ways now recognized as dangerous and frightening. Instead of breaking down the barriers of former characteristics of the sexes, this development only rarified it in popular rhetoric: the male was still identified stereotypically with the hostile outside world and it became the woman's duty, therefore, to offer comfort in her interior world to him.[110] As the German historian K. Biedermann expounded in 1856,

> Only an intelligent woman can ensure that the man, when he returns from his difficult business tasks, exhausted, seeking repose, to his hearth, finds the rest he needs, that he is surrounded by domestic comfort... and that a harmonious and agreeable environment soothes his worried brow.[111]

This role of comforter and spatial spirtualizer is taken over by the best Symbolist works that, like those of Mellery, visually provide a mental place for meditation, at times by means of a female figure in the composition but more often, without her. Subtle usurping of feminine space must therefore be added to the Symbolist self-image as decadent and degenerate, as well as a conflicted view of women, as further evidence of the elision of gender identification by the Symbolists.

Ultimately, it was only one's own, private room, furnished with whatever one could afford but always invested with personal meaning, that fulfilled this important setting for the development of an inner life. When seeking quiet comfort in Paris, Rilke's Brigge regularly escapes to a special public space, the Bibliothèque Nationale. But even here, amid like-minded souls and a roomful of books, Brigge is not completely content: it is a public haven, and he fears that the other "outcasts" who smile at him and pursue him on the street, will soon discover this place, and follow him right into the library. In the end, he is only totally safe, and completely at peace with the objects around him, when he can claim "but now it's over. I have survived. I am sitting in my room, near the lamp."[112]

ARTISTIC INTERIORS

For the Symbolist artists who visualized the inner by means of the interior, decorating their own homes became a meaningful, nearly sacred enterprise. Following a turbulent and peripatetic youth, culminating in his self-remanding stay at the Kornhaug sanitorium, Munch in 1916 purchased a 7.5-acre property outside of Oslo. Here he set up an indoor as well as an open-air studio (walls only, despite the raw Norwegian weather) in which the arrangement of his own work was the most important aspect of his environment.[113] Hodler, on the other hand, responded to his hard-won acceptance and fortune in his own land by hiring one of the most fashionable avant-garde decorators, the Viennese Werkstatte architect Josef Hoffmann, to design, down to the teacups, the spaces and furnishings of his Geneva lake-front apartment.[114] As Edgar Allen Poe had declared, in his 1840 *Philosophy of Furniture,* the proper arrangement of a room should be like a fine painting in its composition because "nothing could be more directly offensive to the eye of an artist than an interior [poorly arranged]."[115]

In Ensor's *My Favorite Room* of 1892 (Fig. 99), the artist presents his own source of inspiration, a cozy room in the upper quarters of his family's home. Ensor considered his "interiors" as a major category of his work,[116] but this particular interior is clearly special, furnished with table, sideboard, and mantel, with some of his favorite Asian pottery, a sleeping dog, and, most important, his own art. Featured above the large harmonium is a portrait of the artist by

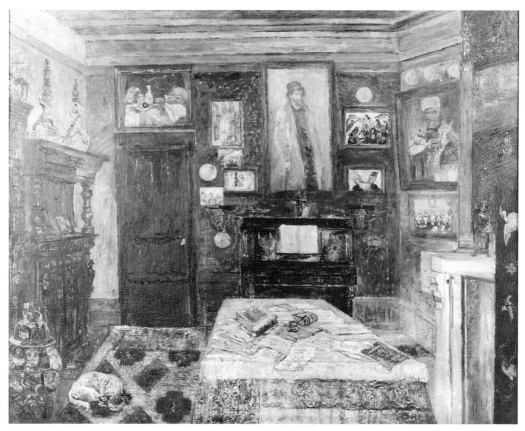

Figure 99. James Ensor. *My Favorite Room*. 1892. Oil on canvas, 80 × 100 cm. The Tel Aviv Museum of Art © 2003 Artists Rights Society (ARS), New York/SABAM, Brussels.

Isidore Verheyen, signifier of this as "his" room. In the portrait he is dressed with top hat and overcoat, as if ready to go out on the streets, yet here his portrayed self oversees the true world of the interior. All of the other paintings are his own, and include several of his most recent controversial works (such as *Two Skeletons Fighting over a Herring,* to the portrait's bottom left, and *The Good Judges,* on the right wall next to the mantle).[117] Prominent are two large still lifes, seen here as microcosms of the space – room as still life – itself. The painting's warmly colored, detailed, and painstakingly worked surface all attest to this image as a memorial to Ensor's ability to concentrate and meditate in this interior.

With its encrusted surface and packed space, Ensor's painting pays homage to the interior scenes of a favorite older Antwerp painter, Henri de Braekeleer.[118] In de Braekeleer's typical *The Card Game* (1887, Musées Royaux de Beaux Arts de Belgique, Brussels), for example, two children sit in an interior jammed with objects, seemingly overwhelmed by them. On a table in the foreground sit two fancy hats and one mask; the mantle behind them holds urns, candlesticks,

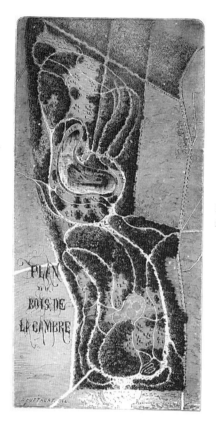

FIGURE 100. Plan of the "Bois de Cambre" development. Illustration in *La Belgique Illustrée* 1891, p. 122.

ornate clocks, and no less than seven small plates. All this is surrounded by cloths, drapery, and wall designs that seek to crowd out the objects and of course the human inhabitants. Braekeleer's surface articulation, with thin but nonetheless painterly strokes that establish their own weblike facture that can obscure at points the forms delineated, adds to the effect of subsuming the two figures. And yet the children concentrate on their game, contentedly, as if protected and inspired rather than diminished by this overstuffed interior.

Despite Ensor's inspiration from work such as Braekeleer's, *My Favorite Room,* like the room itself, is entirely Ensor's own. His surface, equally effective as a two-dimensional veil through which one has to perceive forms, is thick, impastolike, and teeming with brushstrokes that add their own sense of busyness to the image of the room. In addition, the handling of space within this tightly restricted arrangement offers, like Mellery's compositions, a carefully controlled tour for its audience. The viewer, to arrive at a full confrontational level with the portrait of the artist on the back wall, must visually traverse the fabric-covered table strewn with signs of his intellectual diversions (books, paper and pen, and small brush) as well as take in the entirely art-covered walls of the room. Notably, the doorway – which in a Mellery work would be open, inviting

investigation and discovery of other areas of the house – is here closed, as in Khnopff's *I Lock the Door upon Myself,* in acknowledgment that this space is meant to be completely shut off from the rest of the world and devoted to interiority. Over the years, Ensor rearranged the paintings as well as objects (often including "still life" arrangements of masks and even skulls) in this house and his next house,[119] as appropriate triggers to his own contemplation as well as attributes for his own art.

But it was Fernand Khnopff who built, as William Morris termed his own earlier aesthetic house, a "palace of art,"[120] and who carried the belief in an aesthetic interior as sole urban solace to its extreme. Around 1900, Khnopff constructed for himself an extraordinary villa in the Bois de Cambre, a fashionable new area on the outskirts of Brussels. An elite suburb that included a small lake and path-lined woods (Fig. 100), the Bois de Cambre, developed in the early 1890s, was attracting the urban nouveau riche who could afford to move to calmer locales. This included, according to an enthusiastic report of 1891, "several prominent artists," and it was hoped that the area might be completely populated by such fabulous homes.[121]

Khnopff's house was, even in such company, exceptional (Fig. 101). Although construction details were handled by the Brussels architect Edouard Pelseneer, Khnopff has been given credit for the vertical, geometric, and starkly white façade, and most accounts tell of his involvement with every aspect of the interior.[122] As art historian Jeffrey Howe has pointed out, the "artist's home" as a work of art was becoming a minor tradition in the late nineteenth century, following the examples of Morris, Lord Frederick Leighton, and James McNeill Whistler in England, Otto Wagner in Austria, and Franz von Lenbach and especially Franz von Stuck in Germany.[123] Khnopff knew many of these houses, and was in addition well informed about the architectural applications of Art Nouveau in the work of Brussels master Victor Horta. For inspiration for his own home, however, he looked to the Secession style of the same Viennese architect to whom Hodler turned, Josef Hoffmann, whose Secession building and galleries had impressed Khnopff when he exhibited there in 1898.[124] But none of these artists' homes or even the exhibition building approached the idea of structure as shrine to art and individual aestheticism to the degree that Khnopff's villa did. As a reporter for the London *Studio* in 1912 gushed, while acknowledging its existence as a haven from modernity, "To speak of the Villa Fernand Khnopff is to speak of one of the artist's greatest works; it is the expression of his own personality which he has built for his own satisfaction; it is his immutable "self" which he has raised in defiance of a troubled and changing world."[125]

Like the fictional Des Esseintes, Khnopff fashioned each of the interior areas to be meditation spaces; he even had a turtle (ungilded) that was bronzed and kept in his studio upon its death.[126] Unlike Des Esseintes, however, Khnopff maintained an almost minimalist approach to decoration throughout the villa, with the effect of making the few objects there – and most of these were works

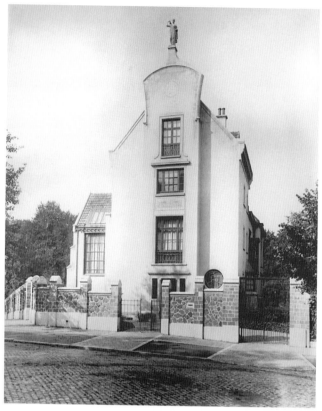

FIGURE 101. Fernand Khnopff's Villa, Bois de Cambre, completed 1902 (Photograph 1907).

of art – into select shrines for his own and visitors' contemplation; in this respect his design was entirely in keeping with the new fashion of lighter open spaces, a manner which he could afford, as he had less heavy upholstery and drapes but also less traffic and noise from the streets. As Maria Biermé, in her 1911 account of a visit and studio tour, explained, the house exuded "[s]ilence so profound that instinctively we were silent, from the moment we penetrated into the little entrance room, all white."[127] Against walls of highly polished white stucco were arranged paintings, drawings, emblematic objects, and even three "altars," vertically arranged constructions of yet more symbolic articles. In the entrance hall, for example, were arranged a stuffed peacock, a Greek statuette, and a blue column. Above a replica of Khnopff's painting *White, Black and Gold* (a 1901 replica of his earlier *Blue Wing*) was written the single word "Soi" [Self]. Thus the entire house was dedicated to the entry into art, and into oneself. The theme continued in the long corridor that led from this vestibule through the remainder of the downstairs: lit by clearstory windows of Tiffany glazed glass, it bore additional paintings as well as the inscription "Everything comes to him who waits."

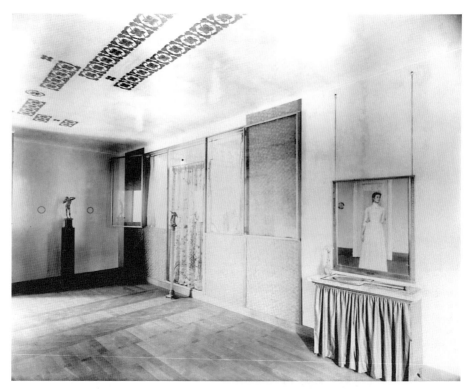

Figure 102. The Blue Room, photograph of Fernand Khnopff's Villa, c. 1901.

The degree to which Khnopff arranged this contemplative temple – that nonetheless served as a domicile – was extraordinary. No photographs or even descriptions of the sleeping quarters exist, testimony of their relative unimportance. The dining room, however, was located logically off the front corridor, available to guests, and yet was furnished with only a few white chairs which, according to Biermé, did "not invite repose," as well as a single corner table "just big enough to hold a vase in which a single aster raises its delicate head."[128] The dining room table – the one interjection of real life that must invade this ethereal room – was removed after every meal and only set up immediately before the next one.[129]

Much more decorative attention was devoted to the studio spaces, to which one ascended by way of white marble stairs. At the stairway was Khnopff's altar to Hypnos, featuring a Tiffany-glass base, topped by a copy of a fourth century B.C. head of Hypnos, such as that which appeared in *I Lock the Door upon Myself*.[130] According to one visitor to the studio, there was even a ceremony intended for any newcomer: Khnopff's butler would, after the painter himself had entered the studio, lower a bar before the entrance, and lift it only after an appropriate time had elapsed, in order to allow visitors to "collect themselves" before entering.[131] Once inside the studio, visitors were treated to a display of Khnopff's own works as well as those by other artists and an assortment of small

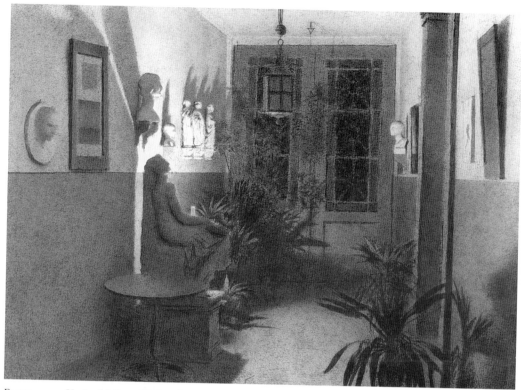

FIGURE 103. Xavier Mellery. *My Vestibule. Effect of the Light* from *The Life of Things* (renamed *The Soul of Things*), 1889. Pencil drawing, 54 × 76 cm. Private collection, Ghent.

objects intentionally displayed for their aesthetic and meditative enhancement capabilities.

The most "Symbolist" room of Khnopff's studio-house was the Blue Room (Fig. 102). This was the artist's ultimate sanctuary, set up with the care with which the fictional Des Esseintes had arranged his own library and art. Painted blue with gold and white decorations, the room held several works by other artists, a specially arranged hanging of his own portrait of his sister (see Fig. 68)[132] and only one blue divan, on which Khnopff would recline in evenings to escape into his own thoughts. Often this was accomplished with the enhancement of music: one wall of the Blue Room ended in large windows that could be opened to look over the studio, and a piano, below. Khnopff was able to be surrounded by tones of blue and of music, indulging reverie. According to Biermé, retiring to the Blue Room to listen to music was a nearly religious ritual that Khnopff followed regularly.[133] Alone, in this perfectly arranged inner sanctum, Khnopff could achieve total escape from the hectic life of the city, only a tram ride away.[134]

In another drawing of Mellery's *Life of Things*, titled "My Vestibule. Effect of the Light"[135] (Fig. 103), is a scene of real life, hidden and spiritual. As the most public and yet least lived-in space of his house, the entranceway hall was newly

emphasized by decorators as the most important room of the house for making a first impression.[136] The sculptures on the wall, the prints carefully framed and hung, even the plants placed for ambiance in the area where a visitor would stand, seem to be animated, vital and watching. The lighting of this and all of Mellery's scenes is important: presumably from a flame of one kind or another, the shadows in this world are invariably soft, the complete opposite to the new gas lighting fixtures that were immediately denounced by decorators for their harsh effect.[137] Another key to this drawing is the life-size sculpture of a woman. Titled *La Poverella,* and sculpted by his friend Paul Devigne, it can be found in several of Mellery's drawings; here it is placed to one side, the figure's head held back in reverie, while facing the entrance to the vestibule. This figure becomes the great unknown in the drawing, and serves as its pivotal signifier. As Mellery summarized in 1895 about his drawings, "these are corners, the majority from my own house; they are intimate and profound and possess, I believe, the life, the soul of inanimate things."[138]

Thus Symbolism's use of the everyday interior was a new artistic iconography built in part on the increasingly common cultural and class assumption that one's interior held objects that could take the place of an inner self. Symbolism, however, inverted this notion to make the things of the house not only the signs of self, but the means by which the self might be reengaged. Their barely inhabited, still-life interiors were in fact the antithesis of the thousands of illustrations of "modern life" in fin de siècle popular press. In Brussels's *Le Globe Illustré* (originally called the *Family Journal*), for example, could be found throughout the 1880s and 1890s page after page of "everyday" images. But these were consistently public events: in the city gardens, with the family at the beach, on the city street, or entertaining in the home. The Symbolist interior was clearly not meant to describe such scenes but rather reinvent them as ritual of discovery for the already-acclimated viewer.

The differences in presentation of the interior by the Symbolists – from Mellery's quietly mysterious interiors through Khnopff's seemingly (at first glance, at least) naturalist and believable rooms, to Ensor's raucously autobiographical chambers – remain, however, to be addressed. Mellery's recourse to deliberately simple old-fashioned objects and spaces, with muted or monochromatic tones, has the effect of making the interior a still life and therefore, as Susan Stewart has said of the still life, "concealing history and temporality, . . . engage[ing] in an illusion of timelessness."[139] Important too is Mellery's stylistic manipulation, noted by the critic discussed at the beginning of this chapter, to make his own hand "disappear" from the work, leaving the interior for the viewer alone to enter, and discover the objects there as rich signs of another level of being.

Khnopff's *Listening to Schumann* and even *I Lock the Door upon Myself,* on the other hand, offer seemingly normal arrangements of interiors: the muted colors (associated with middle-class dwellings),[140] for example, blend the

hanging prints, various objects, and furniture into a single space inhabitable for the viewer. It is the details of Khnopff's interiors, however, that spell out the evocative differences: the figure's pose or gaze, or the specific objects (hanging crown on a chain, the piano player's cropped hands), which endow the scene with the potential of Symbolist signs. In both works – both about nostalgia as key to inner life – there is in addition an absent impetus that allows the viewer to take the signs as his or her own. In *I Lock the Door,* the missing stimulus is the outside hectic life (what Rossetti in her poem called "turmoil, tedium, gad-about"), which the viewer has not seen or experienced. In *Listening to Schumann,* the motivation is, of course, the music that the viewer cannot hear. In each case, then, there is a deliberate stopping of any narrative and a control of the viewer's senses so that these details can be slowly studied, and connected, as the signs that they are.

Finally, Ensor's outsider role results in interiors whose hierarchies of codes and symbols, already utilized for class and culture meanings, are denied. Garish colors, overly thick, at times smeared paint and crudely drawn lines make clear the fact that his *Favorite Room* is his alone. Ensor approaches the bourgeois interior with a very authorial point of view, tackling the subject (as he tackles all subjects) from a Bakhtinian carnival level – making humorous the fact that he, from lower society, is dominant, at least here.[141] Ensor always in this way puts himself above the crowd (just as his point of view on the street, as noted in Chapter 3, remains slightly above the crowd, in the perfect position for the satirist). In Ensor's painted room, viewers are informed about what to find, and appreciate; the painter's own room is presented as a model, rather than offering a visual space in which viewers can discover interior signs for themselves.

Despite the intriguing glimpses offered by Ensor, and the critical success of Khnopff's paintings, therefore, it is Mellery's scenes that are perhaps most successful as Symbolist interiors. Sacralizing the interior at precisely the nonactive times and as experienced by the solitary, sensitive individual, Mellery's soft and quiet spaces with signs had no equivalent in popular portrayals, which is perhaps why these evocations aroused such strong, admiring reactions. These drawings took full advantage of the assumed significations of the bourgeois domestic object as self image and adjusted them to become signposts on a discovery of self.

Henri Matisse's 1908 *Notes of a Painter* included the famous and often maligned pronouncement that he dreamt "of an art which could be for every mental worker...a calming influence on the mind, something like a good armchair which provides relaxation from physical fatigue"; this statement deserves some re-consideration here. As Steven Levine and Joseph Masheck have established, the direct source for Matisse's armchair imagery was Baudelaire's *Salon de 1846,* in the preface addressed "To the Bourgeois," in which Baudelaire tells them that art "is an infinitely precious good," something they need to "restore the stomach and the spirit at the end of a day." Art can, Baudelare claims, relieve them of their

tiredness, and save them from nodding off into the cushions of their armchairs with a "more active reverie."[142] Matisse agrees with Bauldelaire's identification of art as carrying a moral and utilitarian, therapeutic role for the urban man (Baudelaire cites lawgivers or businessmen), and he agrees as well with the site of this society-saving art: in the home, on a daily basis, as an "everyday" thing. But with his suggestion that the armchair was *not* something from which art would allow the viewer to escape, but rather as a co-producer of spiritual enlivening, Matisse was more likely embellishing on the Symbolists' connection between solace of the metaphorical meditative interior and the viewer-enhancing powers of an affective work of art. We must remember here the woman of Khnopff's *Listening to Schumann,* who, "sunk in an armchair, forgets herself, abandons herself, and lets her soul depart for the passionate regions."[143]

In Mellery's "The Bedroom," the still and shadowy image with which this chapter began (Fig. 91), it is not only a sense of control that is embodied in the top hat, as it sits above bedding and blankets, but also a sense of calm and comfort. Although Mellery here emphasized, as usual, many simple objects of everyday life, the viewer gradually becomes aware in the drawing of the numerous works of art that cover every wall. Framed and matted prints or drawings, these works serve as invitations, and intermediaries, to meditation. Surrounding the bedchamber, where one might merely go to sleep, they are inducements to another very precious and Symbolist kind of sleep, that of subconscious and spiritual dreams.

7 ᴄᴏ THE IDEAL CITY, THE DEAD CITY

f the new metropolis represented for the Symbolists the most negative site
of modernism, was there any possibility of a positive urbanism? Was there
any alternative to the city other than opposite environments such as the
Provence commune proposed by Van Gogh, the mountain havens inhab-
ited by Segantini, or the island life sought by Gauguin? In Frederic Harrison's
book of 1894 that outlined the social ills of the new city, the author predicted
the ideal city of the future. It would be small and self-consciously kept that
way, with good water and ecology arrangements (Harrison, the historian, rec-
ommended a return to Roman systems). He also listed specific improvements
to reorganize industrial life and even pragmatically tackled the delicate subject
of death and dying, recommending cremation and suggesting that city hospitals
be moved outside of towns, where relatives would be discouraged from visiting
the sick, thereby reducing the spread of infection. With his emphasis on small
structures, interaction of healthy residents, and green spaces, Harrison's ideal city
already foretold the Garden Cities of only a few years later. But by the 1890s, as
many historians, architects, and social reformers like Harrison were proposing
new city plans and ideals, the Symbolist artists for the most part continued to
address only the ideal inner life that would soon be buried, they feared, un-
der the complex materiality of new urban construction. As noted earlier, only
one Symbolist artist, Trachsel, actually attempted a practical reform of a real
city, Geneva, in 1896. For most of his fellow Symbolists, the task of finding or
producing a new city, a real and yet an ideal city, seemed by the 1890s to be
impossible.

Thus the perfect city for a Symbolist like Fernand Khnopff would be, in
fact, a noncity, or a dead city – one that had existed, at one point in time, without
the confusing technology, the accelerated time, and especially the crowds of the
modern metropolis. For Khnopff, the ideal city was "The Abandoned City," as
evoked in a lyrical drawing of 1904 (Plate 8). In muted shades of blue, Khnopff
in this work envisions a dream of an uninhabited city, because this was Bruges,
a city of the past that might still be known in the present.

One of the major lures of the past is that it is known: when we visit the
past, we already know the plot, and what we are doing, so that it can be the
perfect antidote to present-day insecurities.[1] Acquiring a sense of one's own
past life was, furthermore, important in establishing an individual identity, as
opposed to being, in the modern city, one of the masses. In the nineteenth
century there had developed a new notion of the role of the past, influenced

by the upheavals of revolution, rejection of ancient traditions and privileges, as well as manufacturing advancements. By the late century, this resulted in a general rejection of the past as solution to social and material questions (as had occurred, for example, in Carlyle's earlier *Past and Present*), while encouraging an embracing of it in spiritual and aesthetic theories.[2] Despite the competing lure of the artistic avant-garde, and in the face of writers like Nietzsche who questioned most attention to history,[3] the appeal of the past imbued most Symbolist works. Seeking in the past ways to make the terrifyingly disorienting present more familiar – to make a link with the past rather than to escape completely to it – became a Symbolist goal. In Khnopff's *With Grégoire Le Roy: My Heart Weeps for Other Days* (Fig. 4),[4] a woman of the present attempts to kiss, and thus connect, with a reflective vision of her ideal past; she does not try, however, to leap into this world gone by. Perhaps this was because it was the Romantics who had first established the past as a viable alternative to the present;[5] since their time it had been the occupation of numerous writers and artists to describe scenes from the ideal past in such striking and seemingly realistic detail that the idea of "going" to such a "place," as if one present day could replace another, became less appealing. Rather, it was the unattainable ideal of the past that most attracted the Symbolist.

For Symbolists, the ideal but actual city was therefore not ancient ruins that had so stirred Romantics, but rather medieval cities still extant – if they remained unmodernized – "in all their originality and without a modern taint," as the writer Thomas Hardy declared in 1881.[6] Towns from the Middle Ages had served as models for architectural and urban planning reforms since the time of Pugin's *Contrasts* (Fig. 36); medieval life as an ideal of self-sufficiency and friendly community had been proposed by Morris's *News from Nowhere*. Very few locales in Europe met these requirements, however. In the late 1890s, the hamlet of Visby, on the island of Gotland, enjoyed a revived interest on the part of Swedish artists and poets who were influenced by their native National Romanticism's celebration of medieval cities as well as their Symbolist love of quiet places for contemplation. In Richard Bergh's *The City Walls of Visby* (Fig. 104), a pastel drawing of a funeral procession wending its way toward the white towered walls of the town, uses soft lines and muted colors to convey a sense of stillness and peace, the most appealing qualities of the old town. The Scandinavians who loved Visby were also influenced, however, by contact with the premiere medieval city of Symbolist lore: Bruges.[7]

Bruges, beloved as "the dead city" by the Belgians, was consistently evoked by the Symbolists as an image of the past, of isolation, and ultimately of death. For the antimodernist yearnings of the Symbolists, Bruges's identity as a true medieval city could be appreciated as the antithesis of the superficiality and materiality of their own times. That the city seemingly had survived into the nineteenth century unscathed by the industrial revolution, unaffected by the population explosions of most urban areas, and untouched by modern technologies

FIGURE 104. Richard Bergh. *The City Walls of Visby.* 1893. Pastel on paper, 67 × 53 cm. Nationalmuseum, Stockholm.

and mechanisms suggested it as the perfect place for artists seeking solitude. That it had also, however, since the late eighteenth century achieved a certain renown for this very quaintness, and since the early nineteenth century acquired a tourist status made newly accessible by roads and railroads, suggested that it was an increasingly bittersweet, or even impossible escape. By the 1880s, in fact, it had become clear that the Symbolist vision of Bruges might be soon lost forever, because the city at that time was on the brink of modernity and bound to change. Bruges, by 1890, was the dead city about to be reawakened to modernization.

In the canvases of William Degouve de Nuncques, we find the perfected Symbolist city. Bruges appears suspended in time, its medieval structures rising above canal water in a dreamlike combination of mysterious vagueness and surprising detail. In *Night in Bruges* (1897, private collection), it is the city of the past which is evoked: lights within the buildings suggest human occupancy, but even more light seems to emanate from the walls of the buildings and the bridges than from the interiors themselves. Overall, it is the water that is emphasized: taking up the lower third of the canvas, the canal appears to be carrying the suspended city with it, floating through the night. De Nuncques' typical horizontal format emphasizes the tranquility of the scene and its complete quiet. In Degouve de Nuncques' Bruges, usually shown at night, the city is the antidote to its modern sister, Paris. Here, no one walks the streets, no large public areas are seen, and single lights peek from only a few windows – in upper, even attic stories – that all speak to the solitary wakefulness of the individual rather than to the public interaction of the crowd.

Much the same icon of solitude is found in the imagery of the acknowledged master of Bruges, Khnopff. In works such as *Memories of Flanders: A Canal* (Fig. 105), for example, compositional and thematic emphasis, like that in the De Nuncques work, is placed on the water, always still rather than moving, always dominating the nearly uninhabited buildings. The silence is pervasive: unpopulated, the scene seems suspended in a vacuum, with not even a breeze to disturb the flat waters. Khnopff's personal attachment to this notion of Bruges is well known. It was the city of his childhood (he lived there from 1859 to 1864), and friends later rehearsed stories revealing how adamant he was about never wishing to return to Bruges, in order to maintain only his remembered views of the city. As Khnopff explained, "I passed my childhood in Bruges (which was then a true *ville morte,* unknown to visitors), and I have kept many memories of it, distant but precise."[8]

Khnopff's scenes of Bruges were based not only on his own memory but also on a series of photographic illustrations published in the first edition of Georges Rodenbach's 1892 *Bruges-la-Morte,* for which Khnopff designed the frontispiece.[9] It was this book that crystallized the image of Bruges into a seductively morbid place of the past. In Rodenbach's novel, the primary character Hughes Viane is a widower who has moved to Bruges in his mourning, having decided that the melancholic city suitably echoed his inconsolable heartache. As the story of his grieving in Bruges evolves, it includes the discovery of his wife's "double" – a heartless dancer who shares only superficial similarities with his dead wife – and her eventual murder. But the city itself is the real protagonist: Bruges is not merely a mirror for Hughes's melancholic misery but actually becomes for him a surrogate spouse. At one point, Hughes completely inverts the Enlightenment conception of city streets as healthy arteries and veins allowing traffic that flows from one sector to another.[10] Interpreting Bruges' sluggish canals as a kind of sickly circulatory system, he imagines that "Bruges was his wife, while she was Bruges."[11] The undercurrent of disease and death, a seductive combination that would be later applied to Venice by Thomas Mann, presents throughout Rodenbach's writing a hauntingly dark vision of Bruges – itself called the "Venice of the North" – that matches the city's evocations by Khnopff.

Significantly, Rodenbach in this book introduces Bruges as "a city associated with states of mind,"[12] a claim that resonated, in a decidedly perverse way, with then current sociological theories: this is a city that plays an important psychological role in the lives of its inhabitants. Bruges, in this novel, is much more than a setting for others' activities; rather it is the primary motivator of the entire plot.[13] As Simmel and others were beginning to analyze the new city for its pervasive influence on the psychology of the "modern metropolitan type of man"[14] and suggesting that this influence is an overstimulating, and ultimately a desensitizing, one, Rodenbach establishes the opposite effect as that of *Bruges-la-Morte.*

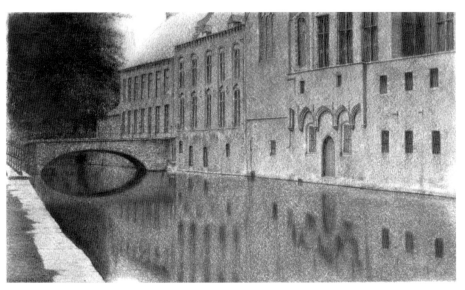

FIGURE 105. Fernand Khnopff. *Memories of Flanders. A Canal.* 1904. Pastel on paper, 27 × 43.5 cm. The Hearn Family Collection, New York.

Rodenbach's celebration of Bruges as this type of city, furthermore, can be understood as a direct rebuttal to many in Belgium who were eager to change their native cities to match other European capitals where, they believed, the "crowd," as they said, was afforded its rightful entertainment and happiness. In 1891, just as Rodenbach was writing his *Bruges-la-Morte,* for example, there appeared in *L'Art moderne* a long article singing the praises of "récréations populaires." The anonymous author began by admitting that when one spoke of "the pleasures of a capital," it was "not exactly what has been squandered on us in Brussels for several years." Citing first the great public entertainment center that Paris had become, the author moves on to London, where vast constructions – "palace[s] of the people" – now offer everyone a distraction after work. Perhaps more impressive, it is claimed, are the cities of the north – Copenhagen, Stockholm, and Christiania – where gardens, walkways, and permanent fairs are established in the city center, where each evening throughout the summer there are held concerts, dramas, nautical festivals, fantastic illuminations. Here, the author claims, "the people amuse themselves, replenish their energies, evenings and Sundays, for the work to come: there is a smile on their lips and gaiety on their faces; one doesn't think there of dead cities!" The article ends by claiming that "perhaps more than any other social state, democracy needs popular recreation." But in Belgium, the author laments, "what necropoles we are."[15]

Rodenbach's response to this assertion, written in *Bruges-la-Morte,* is that the crowd is better accommodated in the old, quiet, medieval city precisely because the individual, and not the crowd, is sustained, and allowed to flourish. According to Rodenbach, Bruges, the antimodern city, is able to make the

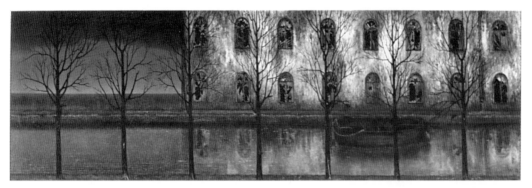

FIGURE 106. William Degouve de Nuncques. *The Canal.* 1894. Oil on canvas. Kröller-Muller Museum, Otterlo.

individual more sensitive to the emotional "contagiousness" of the waters, more aware of their own internal lives, rather than less sensitive to fellow humans. Rodenbach had, in fact, already introduced this theme in his *L'Art en Exil,* a novel of 1889 set in Ghent, another Belgian medieval city not far from Bruges. In the earlier work, Rodenbach's hero, a refined, sensitive artist, struggles to resist the materialism of his province. Here also the city plays a significant and influential role in the unfolding of the artist's drama.[16] In *Bruges-la-Morte,* however, the city is more specifically a psychological depressor, not simply reflecting but actually producing moods of melancholy and mourning.

Rodenbach's powerful interpretation of *Bruges-la-Morte* can be found in Khnopff's drawings of the city, most of which were executed a full twelve years after the appearance of the book, but immediately following Khnopff's designs for the stage set for a German production of *Le Mirage,* Rodenbach's own stage adaptation of *Bruges-la-Morte.*[17] But it was the original book that is consistently cited as the most important inspiration to Khnopff's drawings. As is now recognized, many of Khnopff's drawings from around 1904 are cropped, but otherwise fairly literal transcriptions of the Bruges photographs originally published in Rodenbach's 1892 edition. In Khnopff's scenes, like those of the photographs but also like the paintings of De Nuncques and the literary descriptions of Rodenbach himself, no stirring of life or nature interrupts the stillness of the water which ultimately can be read as stagnant. Although a dominant romantic motif, the Bruges canals here are not so much streams of life as carriers of death: beautifully peaceful, they are dark, and hint at city stench. In *The Canal* (Fig. 106) by De Nuncques, the beauty of the canal in moonlight is overtly related to decay, in the cracked and broken windows of the Gothic building facing the canal. Such couplings of gothicism, ruins, and water avoid identification as simplistic topos, however, because De Nuncques adds another image of decay – sewer-borne disease – in the two rats that climb over and about the boats in the water.

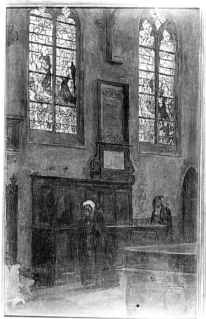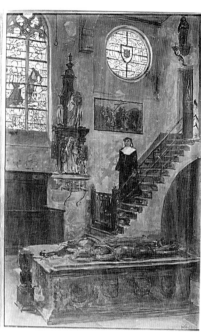

FIGURE 107. Xavier Mellery. *Bruges*. Triptych, before 1907, oil on canvas. Musées Royaux des Beaux-Arts de Belgique, Brussels.

Even these images of putrefaction, however, only emphasize the conviction of Bruges as untouched by modernism: the focus of these artists is not only on the stillwatered canals but also on the isolation of the environment. We see this same Bruges in several triptychs made by Xavier Mellery in 1891–2, precisely the time of the controversy over the "need" of Belgians for a dead city.[18] Notably, Mellery avoids in these religiously oriented tributes any real depiction of the actual city of Bruges itself. In a three-part drawing of 1892, for example, he portrays, unpeopled, the simple stuccoed Bruges houses, but only those in outlying areas of the city, next to canals that lead into (or out of) the city.[19] In a more well-known oil triptych (Fig. 107), Mellery reduces his view of *Bruges* to two large side panels depicting solitary figures walking through the dusky interior of the church of Notre Dame, seeming to make the least possible intrusion on the lives of the statuary, the stained glass, and the sculpted tombs. But the key to Mellery's approach is offered in the slim central panel, where a female figure, with her back to the viewer, sits atop what might easily be yet another pedimented sculpture base in the church. With her pose inviting the viewer to take her place and look over her shoulder, she is gazing toward the spired, towered buildings of the city beyond her, a medieval Bruges. In one hand she holds a bow, in the other a violin, both dropped to her side and both now still, to match with their lost music the forever stilled world of Bruges. As Jules du Jardin commented on the occasion of the drawing's first showing, at

the Brussels exhibition of Les XX in 1892, Mellery's "comprehension of Bruges is personal and suggestive. . . . He has rendered all the sadness that is engendered in the soul of the artist by the view of a dead city at the hour when the shadows, vague and glacial, are understood in the evening, at twilight."[20] By eliminating all reference to the actual city streets of Bruges themselves (where hoards of tourists might have been roaming), Mellery conjures up the environment of old Bruges, unchanging, and open to the individual seeker of inner truth.

This Bruges was the historical center of old Flanders, a city with one remarkable event in its medieval history that left it encapsulated in the past. During the Middle Ages, Bruges was indeed the "Venice of the North." At one time it was the major seaport of the Western World: with a population of roughly 40,000, it was second only to Florence in inhabitants. The population, and its prosperity, was due to the Zwyn, a huge inlet that already in the ninth century provided a primary passage to the sea, establishing Bruges as a preeminent port. This easy sea access, when combined with the strong textile industry that surrounded the waters, established Flanders' cloth worldwide; eventually Bruges weavers had to import additional wool from England to meet export demands.[21] By the eleventh century, Bruges was the main seaport for ships to Asia, as its population grew and prosperity continued. At the end of the fourteenth century, Bruges was still one of the largest and wealthiest cities in Europe, with fifty-two guilds and 150,000 inhabitants, more than either London or Paris at that time.[22]

It was Bruges' dependence on foreign wool and the sea which, however, brought its eventual decline. Constant warring between France and England made Flanders' political and economic position uneven, and dependent on increasingly irregular importation. More important, the sea itself began to abandon the town of Bruges. Gradually, over centuries, sands of the sea began to seep into the Zwyn, and the silt eventually caused the quays in the city to dry up. Despite additional foreports built to accommodate the changing waters, the city of Bruges was by the fifteenth century completely arid, and ships were forced to use Antwerp and other ports for trade. In vain were new links between Bruges and the sea suggested; the population soon deserted the city, landlocked and poor, leaving it frozen in time.

By the nineteenth century, Bruges was the poorest market and trade city in Belgium, wholly deprived of its earlier prosperity.[23] At the same time, however, a new industry had begun. Following Waterloo in 1815, Bruges became a tourist destination for a new stream of foreign travelers, especially the English, who loved the idea of returning to the picturesque beauty of the Middle Ages from the comforts of a canal boat tour. The city seen through this Romantic filter continued to appear in literature, "a superb ruin, sad, full of an indescribable poetry" where one could live and die "in peace and obscurity."[24] By 1870, it was most commonly known as the "ville de silence,"[25] soon to be evoked by Rodenbach: "This was Bruges-la-Morte, the dead city, entombed in its stone

quays, the arteries of its canals chilled to death at the cessation of the great heartbeat of the sea."[26]

Bruges at the time of Rodenbach's 1892 book was, however, far from uninhabited, and was in fact subject, by the early twentieth century, to quite different impressions and interpretations. For example, while one tour book of 1903 continued to proclaim that this was "the quietest city in the world,"[27] another by English author George Omond, published in Belgium in 1908, told a contrasting story. Omond the tourist reported that he had seen the renowned medieval, presumably picturesque and pious Bruges on a feast day when peasants still came into town, but he also had witnessed a very different Bruges by night. These nocturnal scenes were "worth seeing, they contrast so strangely with all this fervor of religion." Once services ended, Omond relates, church doors were closed and all went down to the fish-market section of town, where "every second house, if not every house, is a café."[28] Here, those who had spent the day as "pilgrims saying their prayers" now drank at tables set out on the pavement "or in the rank, poisonous gutter":

> The hot air is heavy with the smell of decayed fish. Inside the cafés men and women, old and young, are dancing in the fetid atmosphere to jingling pianos or accordions. The heat, the close, sour fumes of musty clothing, tobacco, beer, gin, fried fish, and unwashed humanity, are overpowering. There are disgusting sights in all directions. Fat women, with red, perspiring faces and dirty fingers, still clutching their rosaries; tawdry girls, field-workers, with flushed faces, dancing with country lads, most of whom are more than half tipsy; ribald jokes and laughter and leering eyes; reeling, drunken men; ... all sorts of indecency and hideous details.[29]

Thus the silent Symbolist image of Bruges in the late nineteenth century – Bruges as an encapsulated, ideal past – had a historical basis but was essentially flawed. It was already a Bruges that existed no longer. Khnopff's insistence on working "from my memory," and his description of the Bruges of his childhood as "the truly dead city – unknown to visitors" acknowledges his recognition of this contradiction. It further explains the anecdote that on one occasion when the artist felt obliged to return to Bruges for a banquet, he made a point of entering and exiting a cab wearing blackened glasses, so that he would see none of the new, changed Bruges.[30]

One of Khnopff's most poignant images of this "lost" Bruges is *Abandoned City* (Plate 8). In this delicate pencil and pastel drawing appears a detailed view of the houses that stand on one side of the Place Memling in Bruges. But in the drawing the Place appears not as it exists, in the middle of the town, but rather as if it were adjacent to the sea. On the right side of the drawing is a wash of water, seeping in over the cobblestones of the square. Despite the presence of a

few waves, the effect of overwhelming quiet is retained; there are no figures, nor even the statue of Memling which in reality dominated the large central pedestal. Scholarly debate has continued about this drawing, which was exhibited in 1904, and its ambiguous title: who is abandoning whom? Visually, it reads for most as the sea taking over the city (according to the direction of the waves), as if the town had been abandoned *to* the sea.[31] Recently, the drawing has been related to the historical actuality of Bruges, and it has been suggested that, if this is the medieval city, then the sea would be withdrawing, and that the town is here shown abandoned *by* the sea.[32] All these interpretations seem to insist, however, on a single truth regarding the relationship between the city and the water that is no more accurate for Khnopff's drawing – which may be read either way – than it is, as it happens, for Bruges in 1904.

In the drawing, an overall structure of expansion is established by the high, open sky in the upper half of the paper and by the large open cobblestone plaza that, by means of the strong perspective orthagonal, extends from the edge of the plaza at the base of the buildings down to the bottom of the drawing and presumably into the viewer's space. Onto this open and relatively static structure are imposed, however, two strong horizontal forces of movement. From the right, as noted, the blue lines of the sea crest in small waves at the edge of the plaza and extend onto it as if moving toward the middle of the drawing, and toward the pedestal. From the left side of the drawing, however, there is an equally strong movement toward the right, in the form of the row of houses that become darker, more precisely delineated, and more solid as they extend just past the central pedestal. Despite the title, in other words, neither the sea nor the city move away from each other but rather seem ready to collide. At the point where this should occur, on the right-most edge of the buildings where town "meets" the sea, there is a single line of white chalk, all along the right wall profile of the house, that effectively diffuses the solidity of the building and refuses any blending into the water. In *Abandoned City*, therefore, neither the sea nor the town is the proper entity abandoned, or the agent affecting the abandonment. Instead, the two entities remain interlocked with one another, full of implied movement, dominance, and abandoning that will never occur. Only the solid, vertical pedestal – a curiously blank index for the artistic presence actually sculpted for its top – seems immune from this countermovement and conflict. The deconstructive potential of the drawing finds, furthermore, actual historical ambivalence about the city and the sea that has been hitherto overlooked. The sea did, in the Middle Ages, abandon the city, but by the time of Khnopff's drawing in the early years of the twentieth century, there had occurred an ambitious effort to bring, in remarkable modernist fashion, the sea back to Bruges. In 1904, Bruges was building a new seaport.

The plan to build a new Bruges Port-de-Mer, one that would be deep and wide enough for modern ships, had been mentioned as early as 1843, but was seriously proposed in 1877.[33] At that time, Auguste de Maere, the engineer who

would later be described as "the indefatigable and eminent promoter of Bruges port-de-mer,"[34] published a small brochure titled *About a Direct Communication from Bruges to the Sea*. Within a year, commissions of politicians and engineers were established to study the proposal, and a "Cercle de la Bruges-Port de Mer" was founded, publishing between 1880 and 1885 their own periodical, *La Belgique Maritime*. The British quickly joined the ranks of enthusiasts, and the *English Syndicate Bruges Port de Mer* set up temporary offices in Bruges from 1882 to 1887;[35] their alternative plans caused de Maere to threaten to resign the project and sparked a bitter public controversy. In addition, the plan for Bruges was countered by proposals to make Ostend – already the site of a flourishing tourist trade and without the dire unemployment problem of Bruges – the primary port for the Belgian coast. In November 1889, however, Léopold II finally declared that the project would be de Maere's, and it would be at Bruges.[36] De Maere on his part was quick to proclaim that "the financial side of the question of the 'Bruges, port de mer' is, today, resolved, as has the technical side been for a long time.... There is nothing to oppose [the idea that] the execution can immediately begin."[37] De Maere's optimism proved excessive, however; the debate over exactly how the construction was to occur, and by what means it would be paid, raged into the 1890s. Admitting that the whole question of establishing a new, profoundly sized, human-made port of water was "one of the most difficult of the art of the engineer," long lists of previous efforts, successful and not, were cited, and various schemes of financial and engineering merit were argued. Significantly, these debates carried huge costs, in Belgian francs as well as personal esteem; they were proposed and carried forth on very public levels, with printed pamphlets and newspaper articles the vehicle of choice: the arguments over Bruges and its port were constant common knowledge.[38] In 1891 a commission was established to further engineering plans for the port. Two engineers, Louis Coiseau in Paris and Jean Cousin from Brussels, were put in charge of the project, and they submitted their plans – for an even more ambitious coastal seaport – in 1892. In 1894, at the opening of Rodenbach's *Le Voile* at La Comedie Française in Paris, King Léopold himself supposedly said to the author: "I know that you are the author of a very good book, Bruges-la-Morte. Well, be calmed, this will not be Bruges-la-Morte for much longer: we are going to put tramways and life in there."[39]

In 1895, the Belgian parliament legislated the funding for the project to reclaim passages to the sea and to rebuild a Bruges harbor whose inner port would connect, by large canal, to a new outer port, See-Brugge (or Zeehaven) as the new extended area was called. In the same year, construction of massive proportions already began. In Zeehaven, a hotel and workers' housing had to be built; more than 300 children of workers attended school there.[40] The project required two new "service" train stations, one in the further locale of Heyst, and one in Bruges. Work on the 7.5-mile canal in Bruges itself began in 1896.[41] The port would allow large ships to dock at any tide and predicted the arrival of

modern trade, and life, to Bruges. In July 1902, Prince Albert visited Bruges, with much ceremony: schoolchildren greeted him in the streets, singing songs about the Belgian fatherland composed especially for the event.[42] On the morning of May 29, 1905, an English steamer entered the new port at Bruges, its first ship since the Middle Ages. "The carillon rung from the Belfry, guns were fired, and a ceremony in honour of the event took place in the City Hall."[43]

Khnopff, who probably did visit Bruges at least once, in 1902 for an exhibition of Netherlandish painting,[44] therefore preserved in his series of 1904 drawings his own memories of the medieval city he loved. Here, he envisioned one more time the old Bruges, the "dead" Bruges, being abandoned not only in the sixteenth century but once again in his own time.

From the vantage point of his esoteric villa outside Brussels, Khnopff could afford to mourn the passing of the medieval ideal city. In the city of Bruges itself, however, the idea of modernization was for the most part eagerly encouraged and awaited: for the Bruges inhabitants, the new port meant not only new "life" but also such tangibles as new jobs and higher wages. In 1894, when the plaza in front of the Bruges City Hall was the scene of an honorary greeting for Cousin and Coiseau who had just arrived to work on the canal, workers took advantage of yet another layoff to march there, carrying banners in remembrance of the "Poor Widows and Orphans" of the city.[45] And in 1907, a year when the periodical *Vers l'art* featured a photograph of an impoverished man titled *Without Work, Bruges, 1907*,[46] the inauguration of the new port was hailed by politicians, townspeople, and many local artists alike as the economic boon that they needed. Their response was not Symbolist, but futurist: they found it difficult to live in a city of the dead.

The inauguration itself followed a weeklong "Festival of the Inauguration of the Port of Bruges." King Léopold led an entourage of dignitaries on the first ship piloted to the completed Zeehaven new port, connected by canal to the city on July 28, 1907. As the local business paper *La Patrie* reported, with delight, there was "an astonishingly dense crowd" in the streets, which "gave the ancient city an extraordinarily joyous air of festival. And one would have to search far into the most remote quarters in order to find some recollection of Bruges-la-Morte, sung by Georges Rodenbach."[47] In a poster for the event (Fig. 108) can be seen an image of Bruges that in many ways is the exact opposite of that presented by Khnopff in 1904. With the medieval city in background, Bruges appears in bright sunshine that glimmers on the water. The area on the right that is eerily vacant in Khnopff's *Abandoned City* (where the sea seeps in from the right of the drawing's frame), is in the poster crowded by figures symbolically welcoming the giant steamer into the new port: laurels of victory are offered by a personification of Bruges, while a bear holds a shield with the arms of Bruges.[48] In the 1907 work, the ship with accompanying tugboat is seen coming in, rather than abandoning, the town. A sense of strong movement and action – in the gesturing of the figure, the nodding heads of swan and

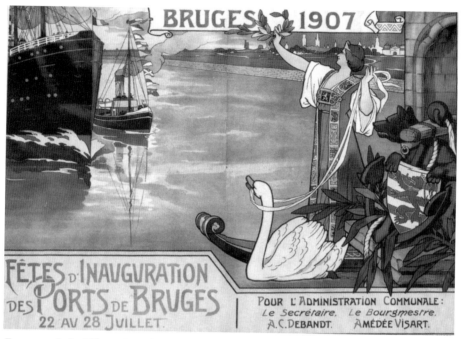

FIGURE 108. J. Gilbert. *Fêtes d'Inauguration des Ports de Bruges.* 1907. Poster. J. B. Lithographie Artistique, Bruges (copyright Collectie Roland Florizoone). Photograph courtesy of Stad Brugge, Cel Fotografie.

bear, and the skimming of water by the huge ship – replaces Khnopff's hazy stasis and silence. For the poster, about newness, future, and hope, the artist Gilbert emphasized a horizontal composition. Perhaps only by comparison to this traditional format is Khnopff's side-to-side but radical confrontation of cityscape against sea properly understood in its overall vertical structure: here, at least on paper, is stopped forever the conundrum of city versus sea, and with it, modernity.

Unlike Khnopff, who lived an increasingly self-controlled existence in the Bois de Cambre, the opening of Zeebrugge was for most artists native to Bruges a life- and city-saver. Already in 1894, Bruges sculptor Gustav Pickery began his monumental *Bruges' Awakening* (Fig. 109), featuring an larger than life-size female personification of the city lifting the shroud of her long sleep and looking forward into the sun.[49] Pickery posed her on a typical Bruges edifice, standing on the arched bridges of the canals that Khnopff also loved, when quiet and deserted. Here, however, Pickery presents the canal as the carrier of a boat laden with goods, and with anchor ready to drop. In the medallion above the canal are inscribed the profile portraits of de Maere and Count Visart Bocarmé, mayor of Bruges.[50] As a Brussels *Le Globe Illustré* report enthused, "this beautiful and strong woman . . . well personifies the reawakening of the city that lives after all the battles, triumphs, failures, prosperity and luck."[51] Pickery, known for

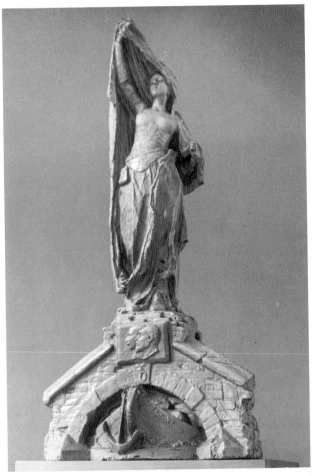

FIGURE 109. Gustave Pickery. *Bruges' Awakening.* 1894. Presumed destroyed. Photograph courtesy of Stad Brugge.

his public sculpture, was the creator of both the Jan van Eyck and Memling monuments in Bruges; it is therefore his earlier sculpture, ironically, that is so notably missing from its pedestal in Khnopff's *Abandoned City*. It is a further irony that Pickery's *Bruges* sculpture was placed in the Palace Hotel in Zeebrugge at the time of the artist's death in 1921 but subsequently disappeared and is presumed destroyed.[52]

In 1910, Charles Rousseau completed his monumental *Homage to the Creators of the Port of Bruges* (Fig. 110), a polyptych in keeping with the city's medieval identity that nonetheless celebrated the new modern Bruges. Decorating the surround panels are framed portraits of the principal collaborators of the project, suitably highlighting, on the right panel of the triptych, de Maere and, on the bottom of the rightmost side panel, Coiseau. Portraits of the two Cousin engineers who worked on the port appear next to each other in the inner

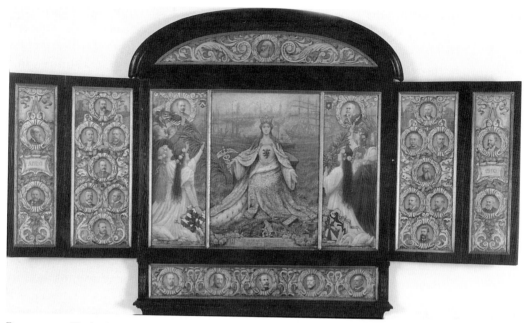

FIGURE 110. Charles Rousseau. *Hommage to Creators of the Port of Bruges.* 1910. Oil on canvas and oak, 158 × 262 cm. Groeningemuseum, Brugge.

left panel. All of these portraits serve as extensive frames to the central triptych. Here, the symbolic queen of Bruges sits at the edge of the sea, strewing before her roses and treasure chests spilling out their contents of pearl jewelry, icons of the riches of the sea arriving, once again, to the Bruges port. Above is seen the portrait of Léopold II, along with a banner that announces the inaugural day of Zeebrugge. The optimistic tone of the celebratory panel is summed up in the large inscription of the main panel offering "homage to those who have revived the city of Bruges."[53]

In 1904, when Khnopff exhibited his series of drawings centered on Bruges as the ideal medieval city abandoned by the sea, the young Belgian artist Gustaaf de Smet painted his own vision of the town. Born into a family of painters and photographers, de Smet received early training at the Academy of Fine Arts in Gand and had begun independent work around 1898. Known for his dandy-styled attire,[54] he seemed destined to become a Symbolist, but around 1901 he left Gand for the Laethem-St. Martin School. Then, in 1904, de Smet produced what seems to be an answer to Khnopff, to Rodenbach, and to the reactionary vision of a city left behind: a canvas he titled *Bruges the Dead, Bruges the Living* (Fig. 111). Using the thick paint, simple forms and vibrant colors for which he would later become well known, de Smet portrayed a landscape and a lifestyle divided in half. On the right is a view of the old town of Bruges, small houses nestled together opposite a wooded park, while on the left, water

(presumably the soon-to-be completed canal to Zeebrugge) flows past large factories. Although, like the Symbolist views of Bruges, de Smet's is also without visible population, his painting exudes signs of life, not least of which are the factory smokestacks, gusting forth industrial fumes that waft in a strong wind over the city. Intriguingly, a church is the structure that divides the two parts, old and new, dead and living, of Bruges, implying that traditions would help to connect the two. The strongest suggestion of linkage in de Smet's vision of a new Bruges was, however, that between water, industry, and a new "Bruges the living": with the building of the Zeebrugge, he predicted, the Symbolist city, Khnopff's ideal city of the dead, would be forever lost.[55]

In 1903, one year before Khnopff's drawing of the *Abandoned City,* Rodenbach's *Bruges-la-Morte* was translated for the first time into English. In his introduction to the volume, the translator Thomas Duncan, acknowledging that it was Bruges with which the name of Rodenbach "is now inseparably linked," laments the "maneuvers of the civic fathers" who had recently refused to approve a statue to the writers' memory.[56] Thomas suggests that the reason for the current Bruges' leaders' enmity was that for Rodenbach, the city was "not so much Bruges as an abstraction of Bruges" which allowed him to ignore the "horror of prosaic realism" evident in the real, modern city:

> The existence of an egregious English colony – tawdry, flaunting, brawling, and ubiquitous – the pinchbeck nature of many of the house restorations; the bi-weekly turmoil of a vast and unsightly market; the monthly saturnalia of a fair of unsurpassable vulgarity, are ignored [by Rodenbach] with sublimity of indifference.[57]

In fact, Rodenbach had given the city leaders much more to reject in his writing: in 1897, Rodenbach wrote another novel about Bruges, now as then lesser known than *Bruges-la-Morte,* but a book even more outspoken against the modernization of the city. This small book[58] was probably most responsible for the adverse reaction on the part of the Bruges city council as well as the subsequent treatment of Bruges as a theme in the work of Khnopff. If, in the earlier Bruges novel, Rodenbach had sought to evoke the mystery and the medieval quiet of the old city, then in this second work, titled *Le Carillonneur (The Bell Ringer),* he portrays the destruction that comes about by efforts to modernize it.

In *Le Carillonneur,* Rodenbach continues his earlier evocation of Bruges as a "dead city," but specifically tells a story of its intended reawakening – its transformation into a "Bruges-la-Vie" by means of the modernization project of Bruges Port-de-Mer. This novel elucidates not only the changing face of Bruges in the late 1890s, but also explicates Rodenbach's and his friend Khnopff's reactions to it. In the novel, the protagonist Joris Borluut is introduced as the man who, at a contest to hire the best new city bell-ringer, wins the competition

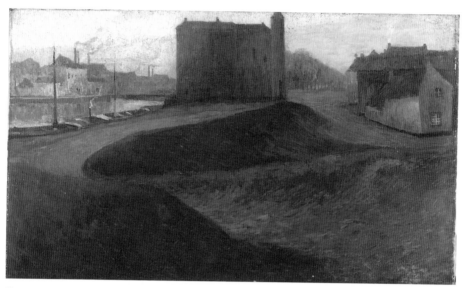

FIGURE III. Gustaaf de Smet. *Bruges the Dead, Bruges the Living.* 1904. Oil on canvas, 61 × 100 cm. Groeningemuseum, Brugge.

by means of his ability to play old Flemish folk tunes. Borluut thus represents the "artist" who wants Bruges to remain dead, a symbol of the past, an ideal city because it is, precisely, a dead city.[59] Borluut lives the dream of Khnopff, who posited above his Villa doorway his own allegiance to the "Past" and "Future," but never mentioned the present. For the character Borluut, it was the machinations of the civic rulers, and especially the ambitious plans of the businesspeople wanting to modernize Bruges, who represent evil, the demise of his beloved city and ultimately of himself. Although this 1897 story is overlooked in almost all Rodenbach and Khnopff literature,[60] it is extremely important to an understanding of both the author's feelings about this city as well as the artist's early-twentieth-century images of Bruges.

In Rodenbach's novel, the last published before his premature death in 1898,[61] Borluut is set up to fight an impossible battle – against the inevitable tide of modernization, which now threatens his home town of Bruges-la-Morte. As the novel's hero, Borluut the Bruges carillon player soon makes a reputation as a restorer of old buildings and becomes the primary designer of the city's architectural restoration. This identifies him as a true artist, an activist restorer. His specific interest in historic preservation made him a hero for sensitized and sympathetic readers to whom Rodenbach's book was undoubtably aimed (in 1892, an article in *L'Art moderne* praised the recent Bruges initiative of subsidizing new and restoration projects in the "beautiful [old] Bruges style," but lamented that these were being utilized only by bourgeois and upper-class, not working-class, homeowners).[62] Borluut in addition was a standard for the Symbolists who were so sensitive to the past: in 1894, Ensor, for example, organized a

write-in campaign to save the "charming church of Mariakerke," near Ostend, from destruction.[63] Borluut gradually becomes part of a coterie of Flemish compatriots who, meeting every Monday at the home of a clock collector and restorer, pledge themselves to the maintenance of a medieval Bruges. For them, Bruges is uniquely "intact," an "integral Flemish soul," unlike so many other Belgian cities that have suffered from foreign interventions.[64] For Borluut, the bell tower is his escape from present life; tall, white, and removed (not unlike Khnopff's villa), it represents the one place where Borluut can rise "above life."[65] He also, however, falls in love with the clock collector's two daughters – one, the sensitive, pale, spiritual daughter he admires, and one, the "Spanish-born" dark-haired beauty to whom he is passionately attracted. There ensues a convoluted love affair, in which Borluut marries the hot-blooded sister who represents pure passion, illuminated for him by the old Bruges bell of *Luxury* (on which erotic scenes are inscribed), but eventually has an affair with his wife's quiet, ethereal sister. In the end, however, Borluut is left alone with his first love – Bruges-la-Morte – to sustain him. At one point, he realizes that "[i]t is the beautiful cities, without doubt, that make beautiful souls."[66] He therefore devotes himself to the one cause that most threatens his ideal of Bruges: the business-oriented modernization of the city by means of the new Port-De-Mer project. But he is defeated, as the government first approves the plan, then appoints engineers, and finally decrees the funding. After a night of revelry for the promoters of the port, during which the celebrants raid Borluut's house, symbolically breaking all glass and mirrors that offer his own reflection, the bell ringer plans his suicide. Carefully reviewing all of the bells, including the notorious *Luxury* bell that tempted him so with the passions of the real world, he chooses the August bell – the large, old bell that sounds the hours – and hangs himself by its inside rope, so that "from that day on the tower played automatically hymns and hours, without anyone knowing, among the ingrate city, that there was a soul among the bells."[67] In a final overlapping of time and death signifiers, Borluut becomes a part of the old Bruges that now rings periodic reminders of passing time for the modern city below.

Throughout this late novel, which specifically identifies the current efforts of modernization by means of a new port of Bruges,[68] the ideal city as a dead city is manifest. Borluut's whole restoration plan is based on this aesthetic: he wants Bruges to stay dead.

> Bruges was always beautiful, when seen from the bell towers . . . [and] reminiscent of other times. Lethargic peace! Sadness of renouncement! Queen in exile and widow of history, who desired only, at the base of it, to sculpt her own tomb! Borluut had contributed to this. . . . Without him, the city would be in ruins, or repudiated for a young city. . . . He was the embalmer of this city. Dead, she was decomposing [but]. . . . He had made her a mummy, in bandages of

her inert waters, her regular smoke.... It was thanks to him that Bruges was this triumphant, and beautiful in her decorated death.[69]

Thus, although Rodenbach's well-known novel *Bruges-la-Morte* is usually considered Khnopff's most important Bruges inspiration, it is also likely that Khnopff was directly responding in his drawings of 1904–5 to the more recent book by Rodenbach, *Le Carillonneur.* Symbolist sympathies with old villages or "dead" cities can be established, whether it is Hodler and friends objecting to the cog railways in the Alps while supporting a "Village Suisse" reconstruction in Geneva, or Ensor, encouraging others to join him in decrying proposed demolitions. In the earlier novel, Bruges as the dead city was immortalized, and the city can be read as working in sympathy with the forlorn character of Hughes. In the later novel, however, the oppositional forces of death and life, maintenance of the past and resuscitation for the future work equally well in the present-day dilemma that was Bruges. As an anonymous reviewer in *L'Art moderne* sarcastically summarized,

> *Bruges-la-Morte* celebrated the past.... *Le Carillonneur* establishes the present.... Instead of this [earlier book's] ideal Bruges, here is the real Bruges: a city consumed by desire to pick up again the new, to recoup itself a small commerce, a little situation in the business world, to excavate of itself a port, gathering around it offices, warehouses and cranes, and to wait for the universe to come and visit. To realize this project is a task for mediocre people, without any lofty goals, without any impetus, without any understanding.[70]

This opposition is further identified in the book itself as a tension between the desires of the materialists who sought the new port, and the dreams of artists who sought an inner life. When Borluut at a public hearing objects to the league of civic voters for Bruges-la-Mer, he is derided by the masses for spouting ridiculous "reasonings of an artist!"[71]

In March 1907, in honor of the new seaport opening, the Brussels newspaper *Le Soir* published a special edition.[72] As the second half of the issue was taken up with articles, diagrams, and photographs of the immense industrial project, the first half, a reminiscence of the old Bruges, was written by Symbolists. In a long introductory article about "The Dream and Life," emphasizing that the "dream life" was a part of Bruges that did not need to be reawakened, Lemonnier explained that "Bruges surrenders herself neither to the glorious nor to the simply curious: she wants to be approached with a deference and humility like a princess on a bed of sadness."[73] Maeterlinck supplied a story about the past Bruges victories of "The Battle of the Gold Spurs," while Verhaeren's poem "The Windmill" was reproduced, set into a photograph of the Bruges windmills lining an old canal. Rodenbach's poem *Le Beguinage* appeared, illustrated by a

photograph of the old convent building as well as Lévy-Dhurmer's famous portrait of the poet in Bruges.[74] Counterbalancing the Port-de-Mer's section, with its clean-lined, sparse engineer's plans and the formal portraits of the Cousins, Coiseau, and others were the Symbolist pages of poetry in verbal and visual evocation. It was a bittersweet farewell.

Years later, during World War I, Verhaeren still mourned the passing of Bruges as the city of mysticism, so threatened by her new port and further imperiled by the Germans; he prayed for the survival of "La ville mystique et la ville sensuelle."[75] In the 1890s, not only Khnopff but also many other Symbolist artists identified with this basic opposition of the mystical and sensual city of the past with the active and physical city of a new twentieth century. But with the twentieth century, Bruges the dead, the only actual city onto which the Symbolists had imposed so much of their antimodernist dreams of the past, was about to join the ranks of the living, and the horrifying crowds.

In point of fact, it already had. In the pages of the provincial *Journal de Bruges* can be found a story of gradual invasion in the 1890s – not only by the Symbolist artists and writers (other than Khnopff), but also by the tourists, the businesspeople, and the engineers, all of whom brought their metropolitan modernity with them. The paper did carry in serial form the entire text of Rodenbach's *Bruges-la-Morte* in 1892.[76] But in the midnineties, the small-formatted paper also carried ads for tobacco and cigars, artificial teeth, new but conservative books, and cures for "all that ails you" – including all the illnesses about which generations had complained (the grippe, rheumatism, "maladies de femmes," and even headaches) – but nothing concerning the new city diseases. Occasionally an ad for bicycles began to appear, but without any New Woman posing beside it. In addition there were habitual notices of business having to do with the Port project, only irregularly taking the form of an interrogation of progress, or lack of it, and what the government was going to do about it. By 1895, the advertisements had grown larger in some cases and more numerous. Added to proposals for services by dentists and music teachers, and cures for eczema were, however, ads for special wines and for rentals in the picturesque town. Running all year, in addition, was a commercial notice from London, promising "no more gray hair."[77]

By 1904 – the year of the *Abandoned City* – the paper was published in large format, just like the gazettes of Brussels and other large cities, and its endpages, cluttered with large ads, tell the story of a changed Bruges. In bold typeface, and appearing for much of the year, was the announcement of a new book about *The Sexual Hygiene of Men,* which promised to be based on "recent experience" and with "numerous illustrations... [an] indispensable guide for general nervous and sexual afflictions caused by excess of depraved habit, etc." In December 1904, this ad appeared directly above a new one for "Mme. Debled," an "experienced midwife," whose services were moderately priced and "recommended in the best society." The most telling sign of the new

modern Bruges was, however, the promotions for a special elixir guaranteed to ameliorate the ravages of the ultimate metropolitan condition, neurasthenia.[78]

Into Bruges, the Symbolist city of stilled canals, hushed walkways, and isolated lives, had come Simmel's "metropolitan type of man" with his crowds, his spatial chaos, his diseases, his problematic and even threatening women, and his search for an inner peace. In 1904, Khnopff's lyrical, delicate Symbolist drawing evoked a perfect city that could exist only as an inducer of nostalgia and a site of memory. As Khnopff drew his last elegy to an *Abandoned City,* Bruges was thrust forever into modernity.[79]

PREFACE

1 The history of Haussmann's rebuilding of Paris that continued on a monumental scale from the 1850s through the 1880s is best found in Chapman and Chapman; see also Haussmann; Pinckney. Early discussants of Haussmann's Paris and contemporary art include Clark and Reff.

2 DeBord. Studies of Impressionism's iconography and social significance began with Clark; see also Robert Herbert, and *A Day in the Country,* exh. cat.

3 See, for example, Thomson, *Seurat;* also Nochlin, "Seurat's *La Grande Jatte,*" in *The Politics of Vision.*

4 I am indebted to all of these studies for their insights and information, and especially their methodological frameworks. In addition to other studies cited elsewhere, these include Silverman, *Art Nouveau in Fin-de-Siècle France;* West; Berman, "Edvard Munch's Self Portrait with Cigarette" and *James Ensor;* Goddard, exh. cat.; and Canning, "The Ordure of Anarchy" and "In the Realm of the Social." Two specific studies are Barbara Larson, "Microbes and Maladies. Bacteriology and Health at the Fin de Siècle," and Rodolphe Rapetti, "From Anguish to Ecstasy: Symbolism and the Study of Hysteria," in *Lost Paradise: Symbolist Europe,* exh. cat., 385–95 and 224–34. Patricia Mathews has included Neo-Impressionism with Symbolism in her analysis of gender, society, and the Symbolist ideal of creative genius.

5 This quote is from Cassou, 7, and is typical of the view of Symbolists through the 1970s and 1980s. Another example is that of Olander, who wrote of Khnopff's "awareness of the spiritual ennui of existence, tendency to eschew rationalism in favor of the dream, and deliberate withdrawal from all things external," 116.

6 Goldwater, 72, concluded his introduction with a two-page summary of "Symbolism and 'L'Art Social'" by admitting that some Symbolist artists and critics had social concerns and even socialist views but that ultimately "the problems raised by these outgoing socially communicative impulses, . . . were contrary to Symbolism's other, more introspective tendencies." He thus approached his study of Symbolism as an art of the other, nonsocietal images. This approach to Symbolism is also adopted by Burhan, 17–18. Here, the Symbolist interest in states of soul is interpreted as connected to the occult and science but antithetical to images of and concern with society. The exhibition organized by the Montreal Museum of Fine Arts in 1995 continued this approach to the movement and was suitably titled *Lost Paradise: Symbolist Europe.* In his introduction to the catalogue, 20–1, Jean Clair identified Symbolism as the "final flare of *Naturphilosophie,*" a direct descendent of Romanticism that attempted to retain traditional ties of humankind and nature in the face of an increasingly negative, disenchanted science. Thus, for Clair, Sigmund Freud is "perhaps the last of Symbolism's intellectual heirs," and the goal of the Symbolists is identified as an essentially internal, psychological, and philosophical struggle of the imagination, all as a self-encapsulated, mental and spiritual process. The exhibition was organized around topics such as "The Cycles of Life" and "The Self Beyond Recovery" and included a section on "The Waning of Culture" that was focused on myths, legends, Satanism, and mysticism, restricting "culture" to intellectual rather than social culture. Such an approach is no more incorrect than the recent survey of Symbolism by Michael Gibson that presented Symbolism as "less an artistic movement than a state of mind" and as the crucible of modernism in the early twentieth century. But such surveys are, however admirable in their scope, still

incomplete with regard to an understanding of the Symbolist work also as the product of a fascinatingly complex and rapidly changing social construct. Even the recent exhibition *1900: Art at the Crossroads* (see Stevens and Dumas), while extraordinarily inclusive of all types of art produced around the turn of the century, nevertheless incorporated no Symbolist works in its large section on "The City" and only a few as "Social Scenes."

7 These include Fanelli and the huge exhibition on *La ville, art et architecture en Europe 1870–1993* organized in 1994 under the direction of Jean Dethier and Alain Guiheux.

8 Fanelli's work focused on popular prints, and few Symbolist works would have been appropriate. The *La ville* exhibition, on the other hand, attempted an enormous range of artists and media, yet included only a few Symbolist works (Ensor, Munch, Rops) and included none of Munch's "on the street" scenes, such as *Evening on Karl Johan Street* or *Anxiety*.

9 See Benevolo, ch. 12, "The 'Post-liberal' City," 765–839.

10 A recent exception to this rule is the excellent study by Patricia Mathews. While her focus on French art is the exact opposite of mine (all but French and Parisian Symbolism is considered here) and she therefore has somewhat different interpretations of themes that were especially important to the French, our definitions of the basic aesthetic of Symbolism, based on a reading of what I term here their "social goal," are the same. Mathews also makes the point that I raised earlier about the ambivalence of the Symbolists in maintaining liberal theories but being inevitably swayed by "normative conservatism" of their day (38–41).

11 See Patricia Mathews's chapter "Symbolist Women Artists" in *Passionate Discontent,* 127–60.

12 Donald Friedman, "Belgian Symbolism and a Poetics of Place," in Goddard, 126–37.

13 For further analysis of these Verhaeren works as well as references to a variety of literary interpretations, see Ogata, 2–4.

14 Simmel, *Schopenhauer and Nietzsche.* Trans. and Introduction by Helmut Loiskandl, Deena Weinstein, and Michael Weinstein, xi–xii.

15 From *The Sociology of Georg Simmel,* reprinted and edited in Sennett, *The Psychology of Society,* 150–6.

16 Ibid., 150–1 for theory; Jews mentioned 155–6.

17 My statement here relates to a similar assessment of Simmel's thought by Loiskandl et al., in Simmel, *Schopenhauer,* xi–xiv.

18 I credit Summers, 158, for reminding me of this historical sleuthing pitfall, with his lament and fictional case in point: "for example, this manuscript was in this monastery, and the artist may have stayed with a friend of a friend near the monastery when he is known to have visited the city."

19 At times my interpretations of this question, especially in relation to the question of illness, insanity, and degeneration, disagree with Mathews's, in part because of the differences in French and non-French fin de siècle culture; these differences are addressed within the context of my discussions in the book.

20 Silverman, *Van Gogh and Gauguin,* chap 5. 1–3.

21 Stephen Schloesser, "From Spiritual Naturalism to Psychical Naturalism: Catholic Decadence, Lutheran Munch, *Madone Mystérique,*" in Howe, *Edvard Munch. Psyche, Symbol and Expression,* 75–110.

22 Silverman, *Van Gogh and Gauguin,* 3–14. See also Silverman, "On the Threshold of Symbolism," in *Lost Paradise,* exh. cat., 104–14. Silverman's book, urging a "need to reemphasize the critical role of religion in the development of modernism, to bring religion back into the story of artists' mentalities and formations," (13) was published as I was more than half way through my own research. I hope that my more secular social history of Symbolism will provide a firm basis for further integration of solely religious considerations in future projects. I disagree, however, with Silverman's proposal that the key to modernist abstraction can be found only in French Catholic art theory of the late 1880s; as is clear from the work and theory discussed in this book, numerous other artists from distinctively different national and religious backgrounds were working on the same theories at the same time.

23 Frederic Jameson, "Post-Modernism: or the Cultural Logic of Late Capitalism," *New Left Review* (London) 146 (July/August 1984): 53–92, as exerpted in Harrison and Wood, 1049 and 1051.

CHAPTER I

1 Hugo von Hofmannsthal, "Gabriele D'Annunzio," in *Gesammelte Werke* (Stockholm: Bermann-Fischer, 1946+), *Prosa* (1956) I, 149, as cited and trans. by James McFarlane, in Bradbury and McFarlane, 71.

2 This now-famous poem, written by Charles Baudelaire around 1852–6, suggests the possibility that all in nature is but a sign for some higher ideal and that the artist is singularly gifted to "translate" these signs for others. For an excellent summary and the text in the original French (as well as an English translation), see Dorra, 10–11. In all citations, I have indicated sources such as this that include extant translations into English; but unless otherwise noted, all translations are mine.

3 J. B. Estrade, *Les apparitions de Lourdes: Souvenirs intimes d'un témoin* (Lourdes: Imprimerie de la Grotte, 1911), 1, as cited by Silverman, *Van Gogh and Gauguin,* 101–2.

4 The discovery of the tubercle bacillus, for example, did not mean that many people immediately knew what the bacterium looked like. Rather, the practice of screening for the germ was left to scientists or physicians willing to go through a complicated and rather tedious staining and microscopic procedure to make it "visible." See Ott, 62, for an explanation of the procedure. Nonetheless, drawings offering "pictures" of the bacterium soon appeared in the popular press.

5 Silverman, *Van Gogh and Gauguin,* 50. Citation from Van Gogh, letter to Bernard, end of July 1888 in Van Gogh, *The Complete Letters,* vol. 3, 503, B 12.

6 Silverman, *Van Gogh and Gauguin,* 2.

7 Hirsh, *From Imagination to Evocation,* 3–12.

8 See Donald Friedman, "Belgian Symbolism and a Poetics of Place," in Goddard, 129.

9 Ibid., 127. Again, Friedman writes here about literary devices, which I am comparing to visual manipulations.

10 A groundbreaking article on Symbolist surfaces was that by Reinhold Heller, "Concerning Symbolism," 146–53. Specific conservation work and media information has also been provided by Jirat-Wasiutyński et al., *Vincent Van Gogh's Self-Portrait.* Most recently, Silverman, *Van Gogh and Gauguin,* has offered intriguing new interpretations of the work of these two artists based in part on an understanding of their media and surface differences.

11 Leymaire, Monnier, and Rose, 34, offers a full explanation of the "presentation" and other types of drawings.

12 As Rule VIII of the doctrinaire "Rules" of the exhibition society proclaimed, "The Salon de la Rose + Croix admits all forms of drawing from simple lead pencil studies to cartoons for fresco and stained glass." See *Péladan, Salon de la Rose + Croix.* Although this factor of dominant drawings in the first exhibition of 1892 might easily be explained by virtue of shipping arrangements, especially for participating foreign artists with last-minute entries, the preference for works on paper there persisted throughout its history over the following five years.

13 This is noted by Silverman, *Van Gogh and Gauguin,* 105.

14 Stewart, *On Longing,* 8–9.

15 The most noted and first diagnosed victims of nostalgia were Switzerland's mercenary soldiers, making the proper treatment of "nostalgia" an important issue in military procedures. How to prevent nostalgia (by removing reminders of the homeland from the soldiers) and how to treat the disease (by incarcerating or, alternatively, allowing the afflicted soldier to return home on a medical leave) were hotly debated as armies strove to keep uniform numbers. See Starobinski, 95–7.

16 For example, the treatise of 1873 by August Aspel, as cited in Starobinski, 99–100. See also Ogata, 4–5.

17 Michael Roth, 337. At first this was part of Freud's view: reminiscences that cause hysterical suffering are historical and stem from actual traumas in the patient's life, a passive experience that was later sexualized. Later, he abandoned this "seduction theory" in favor of a science of interpretation that made meaning out of memory in the service of the present. Roth points out that Freud did hold onto his original idea, repeating it in his 1909 lectures at Clark University, claiming "Our hysterical patients suffer from reminiscences."

18 Starobinski, 93.

19 Lowenthal, xvi.

20 Ibid., xviii.

21 This phrase is borrowed by Lowenthal from L. P. Hartley's *The Go Between*.

22 Barthes, 9.

23 Moréas, n.p., reprinted as "Le Symbolisme Manifeste de Jean Moréas" in *Les Premières armes du Symbolisme* (Paris: Leon Vanier, 1889), trans. Akane Kawakami, in Harrison and Wood, 1015–16. See also Dorra, 151.

24 Stephan Mallarmé, in Jules Huret's interviews which first appeared in *L'Echo de Paris* (March 3–July 5, 1891), as trans. by Dorra, 141.

25 "Les Trois Moustiquaires," n.p.

26 Nord, 480–1, points out that from the era of the July Monarchy to the Third Republic in France, for example, public acclaim went to the "individual of outstanding ability: the genius, the notable, the captain of industry," whereas by the end of the century "victory went not to individuals so much as to organizations."

27 Simmel, "Der Begriff und die Tragödie der Kultur," in *Philosophische Kultur*. 264, as cited by Coser, 192.

28 Coser, 192. Coser here identifies Simmel's theoretical dualism as conflicting facets (German versus French and English) of his own *Weltanschauung,* as noted in my text.

29 This was the title of Gustave Le Bon's introduction to *The Crowd*.

30 Lees, 179.

31 Morris's lectures as quoted by Ashworth, 171.

32 Egbert, 583, points out this change in attitude on the part of Marxists, noting that most early Marxists assumed that because the proletariat's needs were so egregious, they would not be capable of thoughts about art until their practical needs and wants were met.

33 Ibid., 584.

34 Picard, 109.

35 Ibid., 110.

36 Rilke, *Ausgewahlte Werke,* vol. I, 364, as cited by Bradbury and McFarlane, 72.

37 Even Felix Fénéon, as we now know, maintained his bureaucratic clerk's job at the ministry of war while praising in his art critiques an art of pure imagination, and leading the double life of an anarchist who bombed the type of middle-class establishments that provided his daily income. For evidence of Fénéon's participation in bombings, see Halperin.

38 Munch's genealogy dated back through at least the eighteenth century and included military officers, clergy, and poets, as well as numerous artists. His uncle, Peter Andreas Munch, was a well-known "historian mythologist, archaeologist, linguist, geographer, poet, cultural critic and art historian." See Heller, *Munch. His Life and Work,* 12–14.

39 Ibid., 54–5.

40 Lesko, 3, claims this for Ensor's youth and early maturity (c. 1877–99) but explains that "Ensor's art both epitomized the era and remained unique, idiosyncratic, and highly personal."

41 See Hohenberg and Lees, 217.

42 Bairoch, 1–42.

43 Hohenberg and Lees, 217.

44 Bairoch, 1–42 (charts).

45 Olsen, 4. The excellent study of cities by Lees is, typically for histories about this period, focused on the "main" countries of England, Germany, France, and the United States. Lees admitted

that he left the further study of "other countries to the labor of others" (Introduction, x). Most of the Symbolists worked in these other countries.

46 Ogata, 10–11, and n. 50, outlines numerous sources for information about the population and economic growth of Belgium in the nineteenth century.

47 See the chart of "Leading Cities of the European Urban Hierarchy, 1750–1950," in Chandler and Fox, 322–8, and 337–9.

48 Buls's book was reproduced serially in *L'Art moderne* (January 28, 28–9; February 4, 37–8; February 15, 54–5; and May 6, 1894, 144). The quote is from the first issue, 28. The editors of the journal continued to use Buls's title for their own ongoing comments about Brussels rebuilding; see, for example, July 1, 1894, 207. As is demonstrated in Chapter 7, heated discussions about all the other Belgian rebuilding also took place in Brussels papers, as well as in the smaller cities' own newspapers; these were extensive, for example, in regard to the major changes proposed for Bruges in the 1880s and 1890s. For more on Buls, see Ogata, 59–62.

49 Cattier, as reviewed in *L'Art moderne* (7 June 1891) vol 11 no. 23, 180–81 (quote from 180).

50 Huysmans, *A Rebours*. The best English translation is *Against the Grain,* trans. Robert Baldwick (New York: Dover, 1969; a reprint of the 1931 edition published by Three Sirens Press, New York). All Huysmans translations in this book are, however, my own.

51 Hamsun, 3.

52 Ibid., 15.

53 Ibid., 232.

54 Rilke, *Die Aufzeichnungen,* 7. An English translation is *The Notebooks of Malte Laurids Brigge,* trans. Stephen Mitchell (New York: Random House, 1983), 3. All Rilke translations in this book are, however, my own.

55 Ibid., 37.

56 It should be remembered that the words "modernism" and "modernity" are themselves quite modern: although the word existed in the early nineteenth century, it was not listed as a word in dictionaries until the Third Republic. Koop, 50–5.

CHAPTER 2

1 See, for example, F227–F233; F261–262, F264–265; and F266; all "F" references to reproduced Van Gogh works are from de la Faille. One exception to Van Gogh's city street rule is a sketch from one of his Paris sketchbooks, a muted image of nine figures walking along a street, and seen from the street. It is not unlike Khnopff's *En Passant,* discussed in Chapter 3. See Van der Wolk, #143 (SB 4/4), 140.

2 There are only a few exceptions to this rule in Van Gogh's drawings from Paris; one of these is a *Woman Walking Her Dog (A La Villette)*, which includes pedestrians walking on the street behind the main figure, whose large frame fills the composition as she strides toward the viewer. This drawing seems related to popular Parisian culture, however, almost as a caricature or illustration attempt. In his paintings especially, Van Gogh avoided such direct communication with urban society. See Vellekoop and van Heugten, 107–111.

3 *Boulevard de Clichy* has been related to Van Gogh's identification of himself as a painter of the little boulevards ("du petit boulevard") as opposed to the Impressionists' attachment to the "Grand Boulevard." Inherent in this identification is Van Gogh's association with the younger generation of Neo-Impressionists, as well as Bernard and Toulouse-Lautrec. See *Vincent Van Gogh and His Time,* exh. cat., 135, entry 5. This was also an area where both Seurat and Signac lived and worked. *Van Gogh à Paris,* exh. cat., 90.

4 The "softness" of the painterly style here has been related to Van Gogh's stated "desire 'to belong to' and 'to be accepted by society.'" *Vincent Van Gogh Painting and Drawing,* exh. cat., 32.

5 Vellekoop and van Heugten, 221, claim that "It is unlikely that the drawing was the model for the painting (or vice versa)" based on the point of view and perspective of each being slightly

different; see also 26 and 223. This drawing has also been seen as a homage to Degas, who lived nearby; see Richard Kendall, "Evangelism by Other Means: Van Gogh as a Painter," in *Van Gogh's Van Goghs,* exh. cat., 60. This drawing (F1393) is one of a set of six drawings with similar city motifs, all executed on the same type and size of laid paper. Van Gogh Museum Archives F292.

6 This figure is noted here for the first time. I am grateful to Dr. Louis Van Tilborgh, curator, Van Gogh Museum, for his consultation and confirmation of this figure.

7 Van Gogh hardly settled in Nuenen in 1883 when he began planning a move to Amsterdam. After only a short time in Amsterdam, however, he moved (in 1886) to Paris. He would soon begin to plan his "escape" to Arles. For a good summary of his time in Amsterdam and Paris, see Vellekoop and van Heugten, 10–31.

8 Theo Van Gogh, letter to Jo Bonger, 14 February 1889 (Paris), trans. in Van Crimpen, 160–1. I thank Louis Van Tilborgh for bringing this letter to my attention.

9 Van Gogh, vol. 2, LT481, 557.

10 Ibid., vol. 3, LT 544a, 63.

11 LT161, as cited and translated by Zemel, 31.

12 G. Albert Aurier, "Les Isolés," 25. An English translation of the article by Peter Collier can be found, in Harrison and Wood, 948–52. (This translation mine).

13 Letter to Emile Bernard, April 1888 (B3, 478) as translated in Chipp and Rookmaaker, 32.

14 See Zemel; also, Robert Rosenblum's summary that "Escape from society, from the city was always one of the great motifs of modern landscape painting," in Stevens and Dumas, *1900,* 46.

15 Vojtech Jirat-Wasiutyński, "Van Gogh in the South: Antimodernism and Exoticism in the Arlesian Paintings" in Jessup, 184.

16 Eekhoud, 162.

17 Gustave Kahn, *Symbolistes et décadents* (Paris: L. Vanier, 1902), 64.

18 Jean Moréas, "Un Manifeste Littéraire," *Supplement Littéraire du Figaro* (Paris, September 18, 1886). An English translation can be found in Harrison and Wood, 1015–1016. (This translation mine.)

19 Max Dauthendey, Letter of June 5, 1891, in *Ein Herz im Lärm der Welt Breife an Freunde* (Munich: A. Langen/G. Müller, 1933), 15–16, trans. and cited by Heller, "Edvard Munch's 'Night,'" 86. Heller's "'Night'" offers a history of the European definition of Decadence, 65. It is important to note that this definition of the word "decadent" was very different from one accepted today, thus the Symbolists considered the new metropolitan society too business-oriented, impersonal, and materialistic but would not have considered it a "decadent society," as, for example, is stated by Patricia Mathews, for example, 57.

20 An English translation can be found in Chipp and Rookmaaker, 89–93; also in Harrison and Wood, 1025–29. (Translations here mine.)

21 An English translation can be found in Harrison and Wood, 1016–17.

22 Heller, "Edvard Munch's 'Night,'" 86.

23 The model for the figure was not Munch himself but the Danish poet Emanuel Goldstein (1862–1921), who lived near Munch in St. Cloud at this time. Prelinger and Parke-Taylor, 74.

24 Aurier, "Le Symbolisme en peinture," 162.

25 Denis, "De Gauguin," 266, 267 note 2, and 268.

26 Munch's *Night* was identified as "decadent" at the time of its first public exhibition; see Heller, "Edvard Munch's 'Night,'" 80–105. The distinction between this introspective work as Decadent and Munch's later works as Symbolist, especially those of his *Frieze of Life,* as more outgoing, with the communication of a lesson, or idea as its goal, is my own.

27 Heller, *Munch: his Life and Work,* 168.

28 This is noted by Hans Luthy in *Die Welt des Giovanni Segantini,* exh. cat., 19.

29 Jean Moréas, "Un Manifeste littéraire," n.p.

30 Bourget, as trans. by Dorra, 129.

31 Verhaeren, "Exposition du Cercle Artistique," as reproduced in Aron, *Emile Verhaeren,* 89.

32 Hermann Bahr, "Die Decadence" c. 1891 (publication date is disputed), as cited and trans. by Heller, "Edvard Munch's 'Night,'" 85 and n. 48.

33 Huysmans, *À Rebours,* 35.

34 Huysmans, *À Rebours,* 32–3.

35 This identification is well accepted, based on contemporary accounts of the count, including the de Goncourt brothers in their journal; see entry of Wednesday June 18, 1882, in de Goncourt, 317.

36 Aurier, "Les Isolés," 25.

37 Ibid., 27.

38 See Introduction n. 1.

39 Aurier, "Les Isolés," 24.

40 Silverman, *Van Gogh and Gauguin,* 82.

41 Ibid., and persuasively ascribed to sharing experimentation with rougher canvases with Gauguin, 269.

42 For Van Gogh, this revelation of truth was always tied to nature and reality, never the result of the imagination, to be expressed in "invented" forms. Yet he comes close to describing his ability to "see" things in nature like the seer of Baudelaire's *Correspondances:* "At times there is something indescribable in those aspects – all nature seems to speak.... As for me, I cannot understand why everybody does not see it and feel it; nature or God does it for everyone who has eyes and ears and a heart to understand. For this reason I think a painter is happy because he is in harmony with nature as soon as he can express a little of what he sees. And that's a great thing." Van Gogh, 1, LT 248, 495.

43 As has been noted by numerous art historians, this increased abstraction on Van Gogh's part was due to myriad influences, including that of Gauguin (with whom he was sharing the "studio of the south" and working at the time), his own collection of Japanese prints, and even literary discussions.

44 Van Gogh, 3, LT B7, 493, as cited by Silverman, *Van Gogh and Gauguin,* 441, n. 71. Silverman here, 79–81, offers additional writing and pictorial references for Van Gogh's assumption of the sower figure as an autobiographical symbol.

45 Van Gogh, 3, LT B7, 492.

46 See also Debora Silverman, "On the Threshold of Symbolism," in *Lost Paradise,* exh. cat., 104–14.

47 Aurier, "Les Isolés," 27–8. Aurier returns to this idea of the Symbolist work having an important underlying meaning when, in 1891, he writes of Gauguin and claims that, by comparison, the realist work of Courbet and others is the exact opposite: "The substratum and the final goal of their [Realist] art is the material thing, the real thing." Aurier, "Le Symbolisme en Peinture," 157.

48 Aurier, "Les Isolés," 27–8.

49 Stanislaw Przybyszewski, *Overboard,* as cited by Heller, *Munch: His Life and Work,* 232, n. 32.

50 Richard Brettel, "The Impressionist Landscape and the Image of France," in *A Day in the Country,* exh. cat., 27–49.

51 Ensor's *The Drunkards* (1883, The Art Institute, Chicago) is a well-known example of several versions of this early composition; Toorop made two paintings called *Alcoholism* (oil on canvas, 1888; current location unknown; and a gouache and pencil on paper alternately known as "Two Workers," current location unknown). Toorop's narrative and obvious depiction of prostitution in *In de Nes* is discussed in Chapter 5 of this book; his later, Symbolist portrayal of the abiding evil of prostitution in *Vil Animal* is discussed in Chapter 4.

52 Walter Shaw Sparrow, in "English Art and Fernand Khnopff," *The Studio* (March 1894), 204, claimed that the work "touches a social problem that saddens us in our city." Biermé, 100, was more precise, claiming that the Angel "also symbolized the battle of Idealism against materialism, represented here by a sphinx with a woman's face."

53 Segantini, in a letter to Pellizza da Volpedo, December 28, 1894, from Maloja, cited by Quinsac, *Segantini. Trent'anni,* 627–8.

54 Barrows, ch. 2; see also Van Ginneken, ch. 2, 3, 4; and West, 86–87.

55 See McGough; also Lesko, 52. Lesko's Belgian-context interpretation was suggested prior to the new interpretations of Seurat's *Sunday Afternoon on the Grande Jatte* (1884–6, Chicago Art Institute); a further comparative study is offered by West, 52. See Chapter 3 of this book for an analysis of this painting as a street scene.

56 Huysmans, *À Rebours,* 219, cited in connection with Ensor by Lesko, 86.

57 Mendes (1841–1909) was one of the founders of Parnassian literature; although overall a minor writer, he was popular in Parisian Symbolist literary circles and was involved in the Wagnerian revival in that city. In the 1890s, he authored the so-called medieval stories of *L'Evangile de l'enfance,* illustrated by Swiss Symbolist Carlos Schwabe.

58 Maus, 278.

59 See Barrows, especially ch. 1.

60 Ibid., 77–8.

61 Wuarin, 888, as cited by Lees, 171.

62 Meuriot, 344–54.

63 Le Bon, 24–5.

64 As Silverman, *Art Noureav,* 43–51, points out, this reaction in some areas provided impetus for new political parties and systems.

65 Cohen, 1, n. 1. Cohen's premise is that "The modern day urban dweller is bombarded with a wide range of environmental stimulation. Unlike rural or small town counterparts, the city resident continuously encounters complex, intense, surprising, and threatening stimuli. . . . These conditions have long been recognized by social critics as well as the urbanites themselves and are often alleged to produce behavioral and physical consequences inimical to man."

66 Gay, *Art and Act,* 23, already gave one of the most interesting "hints" of how to approach late-nineteenth-century society and psychology. Although he called for better, more normative and collective (rather than pathological and individual) psychohistory specifically for an examination of fin de siècle Europe, he does not address that period in his primary "case study" examples. About early-twentieth-century artists, Gay claims, "Rapid social change, the traumas of migration, the bewildering effects of technological inventions, the unprecedented exigencies of urban life, the emergence of new political powers and new political classes – these and similar clusters of events, far more general and far less sensational than the usual concerns of psychohistory, were the daily fare of the late nineteenth and early twentieth centuries . . . decades in which exhilaration with the new did combat with regret for the old: when an effervescence of thoughts and feelings generated heady designs for Utopia, strange new religious cults, sober proposals for reform, stubborn resistance to innovation, anxious withdrawal from the world, gloomy head-shaking about anomie. . . . The emergence of sociological terms like alienation and anomie, nostalgia for organic society, and programs for the 'restoration' of harmonious community were in part rational responses to unprecedented fragmentation. But they were also a collective orgy of regression calling for a psychology which recognizes that mechanism as part of normal, or at least predictable, behavior" (23). Notably, Gay uses Munch's *Madonna* and *Vampire* (23) as examples that require such reading.

67 Silverman addresses this phenomenon in *Art Nouveau;* Shiff focuses on the writings of Octave Mirbeau; see Richard Shiff, "To move the eyes: Impressionism, Symbolism and well-being, c. 1891," in Hobbs, *Impressions,* 193–4. It must be noted that these studies address only French developments.

68 Aisenberg, 4–5.

69 Schopenhauer, "On Noise," in *The Pessimist's Handbook,* 217.

70 Burhan offers the work of psychophysicist Hermann von Helmholz, the historian Taine, and the lectures of Jules Soury, who taught a course on psychophysics, among others, as examples

of available theory and information that was more accessible than Schopenhauer; such writings and lectures could have "distilled" Schopenhauer's ideas for French Symbolists (22).

71 Ibid., 77. Burhan notes that most French enthusiasts were not really knowledgeable about Schopenhauer. She offers as evidence the analysis of Theodule Ribot's *Philosophie de Schopenhauer* (Paris: Librairie Germer Baillière, 1874), which was recommended in the *Revue Wagnerrienne* (Paris) by T. de Wyzewa. She suggests that most French commentators sought to wed Schopenhauer's brand of idealism to contemporary studies in psychology (Ribot, for example, compares Schopenhauer to Helmholtz, 76).

72 Schopenhauer, *World as Will and Representation,* 323–5.

73 See, for example, the laudatory notice offered for Brandes and his playwright brother Edouard in *L'Art moderne,* 403. It should be noted that Brandes saw himself as a messianic antihero in this modern tradition.

74 Georg Brandes, 14 and 8–9. For an explanation of Brandes's ideas on other Scandanavian, as well as German, writers, see Kent, 61–2.

75 Brandes, 10. Interestingly, Brandes's exceptions to this formula – geniuses emerging from small nations – were three writers influential to the Symbolist artists: Ibsen, Maeterlinck, and Verhaeren.

76 Amiel, June 17, 1852 entry, n.p.

77 To correct this modern dilemma, Nordau advocated radical solutions: open marriages and love-children were to be encouraged. Despite the fact that these ideas were based on notions commonly proposed by popular press (as will be discussed in Chapter 5), Nordau's publication of them as "medical" solutions led to the book being banned in Austria and Russia, publicly burned immediately after publication, as well as much later by Hitler, and condemned by the pope. Anna Nordau and Maxa Nordau, 394. The Nordau daughters' biography of their father was an effort at justifying some of his early excesses (especially in the book *Degeneration* – excesses that they claim he also recognized) by virtue of his noble work for the later Zionist movement.

78 Max Nordau, *Degeneration,* 2.

79 Ibid., 7.

80 Ibid., 39.

81 Ibid., 35–9.

82 This phrase is that of a North American example; Strong, 14.

83 Frederic Harrison, 224.

84 Ibid., 241.

85 Many have drawn connections among Symbolist art, theory, and socialism and anarchism. See, for example, Eugenia Herbert; Shiff, in Hobbs, 190–1; Aubrey, 39–47; Howe, "Fernand Khnopff's Depictions of Bruges," 126–31; Howe, *The Symbolist Art of Fernand Khnopff;* Block; and Canning, "In the Realm of the Social." See also Aron, *Les écrivains belges et le socialisme,* as well as "Le Symbolisme belge et la tentation de l'art social," and Patricia Mathews, *Passionate Discontent,* 42 and n. 60. Finally, recent publications on Ensor have drawn convincing ties to anarchism – especially from the point of view of anarchists appreciating the artist, without proclaiming Ensor a political anarchist himself; see Clerbois; also van Langhendonck, 33, 36–7, and 39.

86 "Inédits de Laforgue," notes written c. 1885, published by Fénéon in *The Revue Blanche* (15 April 1896), 371–4, and *Entretiens* (January 1891), 10. Translation taken in part from William Jay Smith, 203, as cited by Halperin, 33, and n. 33.

87 Halperin, 34.

88 de Goncourt, 326–7.

89 Omond, 35.

90 See, for example, the study of department stores versus independent shopkeepers in Nord, conclusion, 478–96.

91 Tönnies, 232.

92 See especially Simmel's "The Metropolis and Mental Life," in Sennett, *Classic Essays.*

93 Simmel, *Philosophie des Geldes,* as cited by Sennett, *Classic Essays,* 49–50.

94 This is despite the fact that, as some have observed, Simmel himself had the "advantage" of studying mainstream urban culture from the position of an outsider, as a Jew in Berlin in the 1890s. See, for example, Coser, 195–6.

95 Garb, 106–7, claims that the purchaser would definitely be female. See also the long interpretation of this painting, on which Garb bases hers, offered by Clayson, 124–5.

96 See Wentworth, 160–73.

97 Simmel, in Sennett, *Classic Essays,* 50.

98 Florizoone, 151.

99 Munch describes the system, as well as his emotional reaction to winning in his diary (T2760, 57–59). Although originally claiming that "I cannot play – if I lose I don't have anything to end the month," he then admits that he went anyway and began to play: "Again, I am breathing the suffocating air of the game room – I stop at a table – wait calmly – in coming I reflect on a method – I only play when one color emerges four times – I note it on my notebook." With this system, he wins sixty francs, but leaves, as he had promised himself, as soon as he lost for the first time: "I was flushed and it was marvelous to be in the fresh air." See French translation, *Munch et la France,* exh. cat., 360. Later, he admits that he could hardly sleep that night, having become convinced that he had discovered an infallible method; he returns, only to lose every day.

100 T2813, Munch Museum archives. French translation from *Munch et la France,* exh. cat., 361.

101 The two versions of this painting have been differently dated by Eggum. In *Edvard Munch,* 78, he identifies the Munch Museum version as *The Roulette II,* 1892, while in an essay in *Munch et la France,* exh. cat., 1991, 136, he identifies the Munch Museum version as *Roulette I,* dated 1891–2. The first dating is presumably that accepted by Tøjner, 82, in which he illustrates the private collection version as the earlier painting; I am here agreeing with Heller, *Munch: his Life and Work,* 97.

102 Munch archives N 20; French translation in *Munch et la France.* exh. cat., 353.

103 Floorizone, 155.

104 Verhaeren, *James Ensor,* 11.

105 Munch, archives, as cited and translated in Heller, *Munch: his Life and Work,* 64.

106 Khnopff, "In Memorium: Sir Edward Burne-Jones," 522. The article was written by Khnopff in English.

107 In stating this as Symbolism's goal, I am agreeing with Patricia Mathews's *Passionate Discontent,* 14 ff. Mathews's claim that the Symbolists at the same time developed an "ideology of disengagement," however, is one that may make sense only for the French theories that she is investigating; it does not apply to the artists, all non-French, discussed in this book. It must be further noted that Mathews's study has as its basis the theoretical impulses behind French Symbolism rather than the social investment of the works as well as the artists that I address here. Within this frame, Symbolism attempted a very reasoned reintegration of inner life, offsetting materialism, into urban life.

108 Schopenhauer, *World as Will and Representation,* 314. Reinhold Heller, "The Art Work as Symbol," 10, suggests that Schopenhauer's philosophy proposed a Symbolist social goal as well as a less illusionistic style for their art because the more realistic art would inevitably be "hallmarks of earthy limitations and deficiency, the sources of dissatisfaction and suffering" according to Schopenhauer. For another comparison between Schopenhauer and Symbolist aesthetics, see Howe, *The Symbolist Art of Fernand Khnopff,* 12–15; Legrand, "Fernand Khnopff: Perfect Symbolist," 284; and Burhan, 72–77.

109 Nietzsche, "Schopenhauer as Educator," 163–5.

110 Amiel (September 6, 1851), 28–30.

111 Trachsel, *Réflexions à propos de l'art Suisse,* 196.

112 See Patricia Berman, "Norwegian Craft Theory," 157–8.

113 Emile Verhaeren, "Silhouettes d'artistes. Fernand Khnopff," *L'art moderne* 3 parts: (September 5, 1886): 289–90; (September 12, 1886): 281–90; (October 10, 1886): 321–3. Reproduced, with additions and editing, as a brochure titled *Quelque notes sur l'oeuvre de Fernand Khnopff* (Brussels: Madame Veuve Monnom, 1887). The latter is reproduced in Aron, *Emile Verhaeren,* 253–66; quote on 259–60.

114 Khnopff, "Fashion in Art," 242. The article was presumably written in English by Khnopff.

115 Dorra, 128.

116 Khnopff, "Fashion in Art," 242. This ideal role of art was adopted by many and continued into the twentieth century, often with nationalistic underpinnings. A 1907 Belgian art book claimed art as an antidote to Belgian materialism, stating that "The religion of art presents, among hundreds of advantages, a diversion from (business) matters with which current preoccupation offers, alas! to pervert our national spirit and to divert us away from intellectual progress. It [art] battles against the encroachment of industrialism, an outrage that soils everything that it touches and becomes a danger for Belgium. . . . the nation, under pretext of individual prosperity, of expansion and of industrialism is seeming to slide . . . down the slope of bourgeois, commercial, financial and marketable materialism. See de Taeye, "Intro. to Leon Tombu", I. De Taeye's nationalism was actually a call for Wallon (or Flanders) supremacy in Belgium; he therefore specifically wanted to encourage good idealizing art produced by and for the Flemish constituency of his nation. See Chapter 7 for a further discussion of this issue in the writing of Georges Rodenbach.

117 Henry van de Velde, Lecture to La Libre Esthétique, 1893, published as a booklet titled *Déblaiement d'art* in 1894, as reprinted and trans. by Dorra, 123.

118 Van de Velde, in Dorra, 122.

119 Fernand Khnopff, *Annuaire,* n.p.

120 At one point, it was the "painted reveries" of the French painter Puvis de Chavannes, often seen as an important precursor to Symbolism and inspiration to its artists, that were termed for this reason "truly modern": such ideal harmony as might be found in Puvis's work could only be imagined but had to be nonetheless presented as it was "reflected in a modern soul." André Michel, "Le Salon de 1886" *Journal des Débats* (May 6, 1886), as cited by Jennifer Shaw, 84.

121 Aurier, "Les Isolés," 24.

122 Huysmans, *Certains,* 17–20.

123 For a good listing of these two opposing developments in late nineteenth century, see Bradbury and McFarlane, 74–7.

CHAPTER 3

1 This dating (rather than the usually published date of 1892) is that of Reinhold Heller, who argues that Munch's style and technique in the painting – especially the thin washlike surface of the canvas – is closer to Munch's work of one or two years later (1893–4). The first time that the painting was exhibited with a clear, identifiable critical description was as *Abend* in the Ugo Barroccio exhibition of March 3–25, 1895. I am grateful to Reinhold Heller for this information, as well as for an enlightening discussion of the painting as a whole.

2 See Charles Baudelaire, "On the Heroism of Modern Life," trans. Jonathan Mayne and reprinted in Harrison and Wood, *Art,* 302–5.

3 Julia Sagraves, "The Street," in *Gustave Caillebotte. The Unknown Impressionist,* exh. cat., 64.

4 Varnedoe 90, and Sagraves in *Gustave Caillebotte. The Unknown Impressionist,* exh. cat., 72.

5 Oil sketch, Marmotton Museum, Paris. Several of the sketches are illustrated together in *Gustave Caillebotte. The Unknown Impressionist,* exh. cat., 119–39.

6 See for example E. Lepelletier, "Les Impressionistes," *Le Radical* (8 April 1877), reproduced in French and translated in English in Varnedoe, 187–8.

7 Sagraves, in *Gustave Caillebotte. The Unknown Impressionist,* exh. cat., 64.

8 Munch clearly considered several alternatives to the Karl Johan crowd; see also Munch daybook T2761 page 65 (Munch Museum, Oslo), in which no intervening figures are included but in which there is ample foreground space allowed for the viewer.

9 This change may have occurred as pentimenti in the process of the painting itself: recent technical examination of four Munch paintings (X-ray and infrared) by the Oslo National Gallery establish that Munch made numerous changes in compositions, figures, and details while painting. In Munch's *Death in the Sickroom* (National Gallery, Oslo version), for example, the woman who faces directly forward has in the finished painting a masklike, bleached face with hollow orbs for eyes. Infrared photography reveals, however, that she originally had on not only a very different dress, but that she had a carefully modeled face and deep-set, but detailed eyes. See *Below the Surface of Edvard Munch,* exh. cat., 31 and 44.

10 The significance of the foreground figures having faces and individual personalities is clear when compared with contemporary street scenes that combine Munch's head-on confrontational walker with a careful realist depiction of that figure, such as in George Hendrik Breitner's *The Bridge over the Singel at Paleisstraat, Amsterdam* (1896–8, Rijksmuseum, Amsterdam). With an identity and a personality, the potentially confrontational foreground figure here is immediately recognized as a fellow walker who adds, like the energetic dog on the left, to the bustling activity of the street.

11 Benjamin, 133–4.

12 The poem is reproduced, in the original French with an English translation, in Ibid.

13 Ibid., 132–3.

14 Ibid., 139. Benjamin in fact cites the crowd imagery of James Ensor as his example.

15 Simmel, "The Metropolis and Mental Life," trans. H. H. Gerth with assistance of C. Wright Mills, in Sennett, *Classic Essays,* 48.

16 Ibid., 53.

17 Alan Krell, "Dirt and desire: troubled waters in Realist practice," in Hobbs, *Impressions,* 145.

18 E. Lepelletier, *Le Radical* (8 April 1877), as cited and trans. by Varnedoe, 187–8.

19 For numerous examples, see the excellent study by Fanelli.

20 Sagraves, in *Gustave Caillebotte. The Unknown Impressionist,* exh. cat., 72.

21 "The passionate hatred of men like Ruskin and Nietzsche for the metropolis is understandable. . . . Their natures discovered the value of life alone in the unschematized existence which cannot be defined with precision for all alike." Simmel, in Sennett, *Classic Essays,* 51.

22 This is a unique hand-colored lithograph (Collection of Nelson Blitz Jr. and Catherine Woodard).

23 Bilski, 119, suggests that the foreground figure portrays a "melancholy and self-absorption" that, with other signs in the watercolor, invoke Simmel. See also the essays by Paul Mendes-Flohr and Barbara Hahn in the same book.

24 "La beauté des machines, à propos du Salon de l'Automobile," *Revue des Deux Mondes* (December 1, 1907) 5th per., 42, as trans. and cited by Rosalind Williams, 89.

25 I am grateful to Soffi Attramadal, of the Oslo City Museum, for this information.

26 "Notes, St. Cloud 1889," as reproduced by Munch in his 1918 exhibition (Blomquist Gallery, Christiania). Translated in *Edvard Munch. The Frieze of Life,* exh. cat., 12.

27 Ingebjørg Ydstie, in *Edvard Munch. The Frieze of Life,* 93.

28 Anonymous, "Esthétique du contact humain," 139.

29 See, for example, Nochlin's analysis of the evil city depicted in Rosetti's *Found* in "Lost and Found," 139–53. Also see the chapter "The Wayward and the Fallen Woman," in Casteras, *Images of Victorian Womanhood.*

30 Rousseau, *The Confessions,* 155.

31 Analysts have arrived at slightly different terms but remarkably similar ideas in identifying three phases of the modern city. For example, Schorske calls them (1) the city of virtue, (2) the city of vice, and (3) the city beyond good and evil. (See Carl Schorske, "The Idea of the City," in Handlin and Burchard, 96–97.) Sharpe and Wallock, 16–18, also identify three phases of

morphology and metaphor of the city: (1) early-nineteenth-century and industrial explosion, (2) late-nineteenth-century and increased segregation, and (3) deterioration and decentralization of the city in the twentieth century.

32 As cited by Spiro Kostof, *The City Shaped,* 38.

33 Schorske, in Handlin and Burchard, 96.

34 Wordsworth, 256 (line 695) and 257 (line 722).

35 Schorske, in Handlin and Burchard, 96–7.

36 Engels, 54–6.

37 Marius Vachon, *La Crise industrielle et artistique en France et en Europe* (Paris: La Librairie Illustré, 1886), 76, as cited by Nord, note 20.

38 Sennett, *Flesh and Stone,* 324–338.

39 Garnier and Amman, 811.

40 Henry David Thoreau, as cited by Sharpe and Wallock, 14.

41 Anonymous, "Ville de Bruxelles," 51.

42 Anonymous, "Paysages Urbains," 12.

43 Schopenhauer, "On Noise," in *The Pessimists's Handbook,* 217.

44 Sharpe and Wallock, 11.

45 These were probably influenced by Maeterlinck's plays, in which trees become animated beings, according to Spaanstra-Polak, 17.

46 Toorop's marginalia on his copy of A. Plasschaert, *Jan Toorop* (Amsterdam: J. H. de Bussy, 1914), which had been presented to him by the author in 1925, as cited by Geneviève Lacombe, entry on "La Jeune Génération 1892," in *Le Symbolisme en Europe,* exh. cat., 231.

47 1894, Charcoal on paper; Rijksmuseum, Amsterdam.

48 *J. Th. Toorop: de Jaren 1885 tot 1910,* exh. cat., 18.

49 Here the lost soul of modernity, struggling to climb out of the murky waters of materialism, is given some hope by the angel who reaches to her from the higher, brightly lit and ideal world of Sâr Peladan's Symbolism. See Hand, 40–5.

50 This occurred in almost all growing cities in the late nineteenth century. See, for example, the analysis of a similar process in St. Petersburg in Kaganov. For an excellent overview of the history and structures of city growth in Europe, see Eric E. Lampart, "The Nature of Urbanization," in Fraser and Sutcliffe.

51 Emile Verhaeren, "Un Peintre Symboliste," *L'Art moderne* (24 April 1887), reprinted in Sarlet, 111. Translation here from Dorra, 61–4. As Dorra points out (326 n. 92), Verhaeren put this phrase in his own quotes, but no direct source has been identified other than Verhaeren himself. The phrase in fact seems to be Verhaeren's suggestion of what the Symbolist would say about the city of Paris.

52 Frederic Harrison, 372.

53 Ibid., 240.

54 In the second half of the twentieth century, studies focused on this structural confusion and ways to correct it have proliferated. See, for example, the extensive study by Rapoport.

55 The traffic circle's distortion to an oval has been compared to effects produced by stereoscopic photographs (see Scharf, 176), but the effect might be merely the result of Caillebotte's unusual point of view, which seems to be almost tipping over the scene.

56 Foucault's "L'oeil du pouvoir" was first published as a preface to a new facsimile edition of Bentham.

57 Michel Foucault, "The Eye of Power," a conversation with Jean-Pierre Barou and Michelle Perrot, in *Power/Knowledge,* 147–9.

58 Drake, 41 and chart on 42. Surprisingly, this was almost entirely due to a major decline in the death rate; see 75.

59 Forty-one buildings were burnt to the ground. "Oslo Fire Company History" (www.brann.oslo.no/Historie/history.htm.).

60 This shape is often compared to the similar and equally menacing shape in Munch's *Puberty*. See, for example, *Edvard Munch. Frieze of Life,* 93. It may also be compared, however, to an equally dark shadow that grows from a group of bourgeoisie, satirically drawn by Munch, on a city pavement as they greet one another "good aften, good aften" (Munch Museum T 1325). Here the shape also seems menacing and to have developed a life of its own. I am very grateful to Pat Berman for her insightful discussion and sharing of ideas with me, of *Karl Johan Street* in front of the painting in Bergen, August 2000.

61 See Chapter 4, n. 17.

62 Knapp and Schumacher, Introduction, 33.

63 Carl Friedrich Otto Westphal, *Die Agoraphobie. Eine neruopathische Erscheinung* (1871), as trans. and cited by Knapp and Schumacher, 10–71.

64 Georges Gilles de la Tourette, *Les états neurasthéniques* (Paris: J.-B. Baillère, 1898), 15–16, as cited and translated by Vidler, *Warped Space,* 32. The first chapter of this book is a revised version of his earlier "Psychopathologies of Modern Space: Metropolitan Fear from Agoraphobia to Estrangement," in Roth, 11–29. My discussion of agoraphobia and claustrophobia throughout this chapter is indebted to Vidler's excellent study.

65 Vidler, *Warped Space,* 32–5.

66 Vidler (*Warped Space,* 31) points out that by 1883, agoraphobia was defined at times as "a sort of madness in which the patient fears the presence of crowds and, for example, cannot decide to cross a busy street." (He cites Emile Littré, *Dictionnaire de la langue française* [Paris: Hachette, 1883], "Supplement" 355).

67 Simmel, "Sociologie des Raumes," *Jahrbuch für Gesetzgebung, Verwaltung und Volkswirtschaft im Deutschen Reich* (1903) 27–71, as cited by Vidler, "Psychopathologies of Modern Space," in Roth, 20.

68 See Perrot, 360–1.

69 Eggum, *Munch und die Photographie,* 31.

70 The term "city" as identifying a large populated area dates from around the thirteenth century; Raymond Williams, 55.

71 Before that time, it referred to the meeting of land and sky.

72 Engels, 57.

73 Kostof, 302.

74 The work of Ildefonso Cerdà is a case in point: Cerdà, an architect and engineer who sought to apply the best of Haussmann's reforms (which he studied first hand) to Barcelona, was apparently the first to propose a theory of "urbanization" (his term) as well as the first to try to apply city planning the socialist ideas of Saint-Simonians and the philosophy of Pierre-Joseph Proudhon. In his *General Theory of Urbanization,* which unfortunately was never well circulated and had little if any influence on other European architects and city planners, he stressed that the city was more about life and organicism than simple materiality. (Ildefonso Cerdà, *La Teoria general de la urbanization.* Madrid, 1867); see Bergdoll, 261–4.

75 "Like their European counterparts who had depicted Paris, these artists were particularly attentive to sensations that were novel and modern." Wanda Corn, "The Artist's New York," in Bender and Schorske, 277.

76 See, for example, *Spring Day on Karl Johan Street* (1890, Museum of Art Bergen).

77 Griselda Pollock, "Spaces of Modernity," in Broude and Garrard, 245–268.

78 Eggum, *Edvard Munch,* 81 (no citation).

79 See, for example, Heller, *Munch: His Life and Work,* 43. A typical description of Karl Johan Street in *Hunger* is the following: "It was about eleven. The street was rather dark, people were wandering about all over, silent couples and noisy groups mingled. The great hour had begun, the mating time when the secret exchanges took place. . . . Rustling petticoats, one or two quick sensual laughs, swelling breasts, heavy breathing." Hamsun, 123.

80 Simmel, in Sennett, *Classic Essays,* 57.

81 Ibid., 56.

82 Ensor, *Mes ecrits*, 104–5. For an analysis of some of the socialist connections in this paint-ing, see also McGough. Additional Ensor comments in *Mes ecrits* are translated and cited by Berman, *James Ensor*, ch. 2. See also Canning, "In the Realm of the Social," 75–80, and Van Langhendonck, 39–42.

83 Berman, *James Ensor*, 5.

84 Bakhtin's theory of carnival was the liberating allowance, when "living in" the carnival world, for the masses to be truly free, as it was perfectly normal to turn the usual hegemony of ruling power upside down during this time. As such, "while carnival lasts, there is no other life outside it . . . life is subject only to its laws, that is, the laws of its own freedom." For Bakhtin, this was a necessary condition for "the world's revival and renewal," a "special condition of the entire world." See *Rabelais and His World*, 7–8ff.

85 Rilke, *Die Aufzeichnungen*, 75–77.

86 Manuscript T 2761 (EMII), Munch Museum Archives, Oslo, as cited by Ydstie, in *The Frieze of Life*, exh. cat., 94. For an explanation of Munch's writing style in fragments such as these, see Heller, *Munch: His Life and Work*, 228, n. 4.

87 MS T 2770 (EMII) Munch Museum Archives. trans. Heller in "Form Formation of Edvard Munch's Frieze of Life," in *The Frieze of Life*, exh. cat, 28.

88 Hans Jaeger, as cited by Heller, Ibid., 37, n. 13.7 and as cited by Naerup, 233.

89 Figures from the paintings include the young man from *Melancholy* (1895, Rasmus Meyer Col-lection, Bergen), an older woman reminiscent of several figures in Munch's death images, and the leering green face of the right male figure in *Dance of Life* (also painted 1900). Identifica-tions of actual people include the *Melancholy* man as young Munch himself (as in fact many identifications of the *Melancholy* painting also suggest), and the woman as Munch's aunt, Karen Bjølstad, by Iris Müller-Westerman in *The Frieze of Life*, exh. cat, 104.

90 Berman, "TB Tourism." For Munch's Christ-self-identification in late nineteenth century, see Hougen.

91 Heller, in *The Frieze of Life*, exh. cat., 34. Heller notes earlier that in the very first exhibition of this series, organized under the title "Study for a Series: Love," in Berlin 1893, the installation began with *Death in a Sick Room* "displayed at the top of the entrance stairway as an introduction to Munch's new work" (30–1).

92 In March 1895, Munch exhibited fourteen paintings from what he called the "Love Series" in Berlin; grouped together were the "Life Anxiety" works *Evening on Karl Johan, Anxiety*, and *The Scream*. See the listing of all fourteen works, plus a "vignette" (*Metabolism*) in Heller, in *The Frieze of Life*, exh. cat., 33. This was also the arrangement continued in the Leipzig 1903 exhibition of *The Frieze of Life*.

93 One slight exception to this is Munch's *The Kiss*, which in its earliest version (1892, Oslo National Gallery, Oslo) took place in an interior next to a window overlooking city buildings. It is interesting to note, however, that Munch's highly synthetic 1897 version of this painting still indicated an interior but virtually eliminated the window (with no view to the outside), and his 1897–8 woodcut reduced the kissing pair further and arranged them in an undecipherable void.

94 MSN 30, Munch Museum Archives. Trans. by Reinhold Heller, who suggests that the date of the writing must be close to the Berlin exhibition of 1895, in *The Frieze of Life*, exh. cat., 34 and 37 (n. 35).

95 The suggestion was that of American George Miller Beard, credited as one of the first to identify neurasthenia as the disease of modern life. Vidler, *Warped Space*, 32.

96 Westphal, as trans. and cited by Knapp and Schumacher, 79.

97 Munch's statement about his experience depicted in *The Scream* exists in several versions of his diaries and in numerous translations. This one is by Heller, in *Munch: His Life and Work*, 105, and taken from the border of a charcoal drawing of *Despair* (Munch Museum T2367): "I was walking along the road with two friends. The sun set. The sky became a bloody red. And I felt a touch of melancholy. I stood still, leaned on the railing, dead tired. Over the blue-black fjord

and city hung blood and tongues of fire. My friends walked on and I stayed behind, trembling with fright. And I felt a great unending scream passing through nature." See also Heller, *Edvard Munch: The Scream*, 104 and 107 and 76–7 for another version and dating arguments.

98 MS T2547, Munch Museum Archives. Translated by Gerd Woll's "The Frieze of Life: Graphic Works," in *The Frieze of Life*, exh. cat., 98. The painting was reworked as a lithograph in 1896, in reverse composition, and was submitted in Paris to Vollard's graphic portfolio *Les Peintres-Graveurs;* Munch also did a simple woodcut version that same year.

99 See, for example, Ensor's earliest city street paintings *The Cab* (1880/1882, Société Mutuelle des Administrations Publiques, Liège), *Rue de Flander in the Snow* (1880, Fondation Socindec, Bern), *Boulevard van Iseghem in the Snow* (1881, Stedelijk Museum voor Schone Kunsten, Ostende), and *Rue de Flander in Sunlight* (1881, Private Collection, Brussels); Tricot, *James Ensor. Catalogue Raisonné,* entries 122, 151, 194, and 195. *Large View of Ostend* (*Rooftops of Ostend*) (1884, Koninklijk Museum voor Schone Kunsten, Antwerp), and *Rooftops of Ostend* (1885, Fondation Socindec, Bern); also including mostly rooftops is the *Brussels Town Hall* (1885, Musée d'Art Modern, Liège). These are illustrated as Tricot entries 255, 256, and 260.

100 Private collection; illustrated as Tricot, *James Ensor. Catalogue Raisonné,* entry 279. Tricot notes that there was another work on the same theme the current location of which is unknown. It is not known if this was another painting of 1888, or a later replica. See p. 255.

101 Referenced, with only one illustration: sketchbook of drawings (c. 1881, private collection, Brussels), Delevoy, de Cröes, and Ollinger-Zinque, no. 28; and sketchbook (1882, Musées Royaux des Beaux-Arts de Belgique, Brussels inv. N 7283), Delevoy, de Croes, and Ollinger-Zinque, no. 35.

102 The painting is listed as *En passant boulevard du Regent* in the Delevoy, de Cröes, and Ollinger-Zinque catalogue, entry 32, page 212; in a contemporary review ("M. V.," 56), the painting is referred to as "the large pastel which he [Khnopff] titles: *En Passant.*"

103 Delevoy, de Cröes, and Ollinger-Zinque, 212.

104 Baedeker, 1891, 80.

105 Buls, as reproduced in *L'Art moderne* (January 28, 1894), 29. See also Chapter 1, n. 48 of this book.

106 See Henry Lawrence, 355–74.

107 Ibid.

108 *Invitation to the Young European Architects,* 29.

109 A study of the largest twenty cities in 1750 and 1950 identifies about two-thirds of the group as stable. Brussels, however, would have been on the list in 1750, dropped from it by 1800, and back on the list only during the last half of the nineteenth century, when the Symbolists were working there. See Hohenberg and Lees, 228–9. Statistics provided earlier by Adna Weber's 1899 study reveal that cities in Belgium already showed agglomeration in 1846 but had greatly increased because the role of suburbs in Belgian cities was becoming crucial for proper identification of nonrural populations. The charted rural growth (1846: 2,921,329; 1880: 5,520,009; 1890: 6,069,321) reveal that population there tripled during the last half of the century. Urban population, not counting suburbs, merely doubled (1846: 1,415,867; 1880: 2,376,777; 1890: 2,894,694). With a breakdown by cities, however, the consistent move to urban spaces becomes evident: for cities with populations over 100,000, Belgium went from having none c. 1815, to 5–6 percent of the population in such cities by midcentury, and to 17.5 percent in 1890 (including suburbs).

110 Baedeker, 1901, 115.

111 The Bois de la Cambre and the Forêt de Soignes became in the 1870s and 1880s the most fashionable places for the public to stroll. See *Invitation to the Young European Architects,* 29.

112 Emile Verhaeren, "Exhibition annuelle de L'Essor," reproduced in Aron, *Emile Verhaeren,* 28.

113 Emile Verhaeren, "Silhouettes d'artistes." Reproduced, with additions and editing, as a brochure titled *Quelque notes sur l'oeuvre de Fernand Khnopff* (Brussels: Madame Veuve Monnom, 1887). The latter is reproduced in Aron, *Emile Verhaeren,* 253–66. The phrase "modernité pure" was

used in the October 10, 1886, portion of the "Silhouettes" article but was cut from the brochure version.

114 Verhaeren, "Silhouettes d'artistes," October 10, 1886, as reproduced in Aron, *Emile Verhaeren,* 259.

115 Hamsun, 15.

116 Simmel, in Sennett, *Classic Essays,* 47. See Arne Eggum, *Munch und die Photographie,* 29–32.

117 Simmel, in Sennett, *Classic Essays,* 48.

118 Discussion of the theme of silence occurs in Chapter 6 of this book.

119 Paul Gauguin, "Diverses Choses, 1896–1897," trans. in Chipp and Rookmaaker, 65.

120 As translated, dated c. 1890, and cited by Heller, *Munch: his Life and Work,* 42 and 228.

121 Emile Verhaeren, in Dorra, 61–2.

CHAPTER 4

1 de Maeyer, 41–4.

2 See Lesko, "Ensor and His Milieu," 62, as well as her excellent tracing of iconographic prototypes in art and literature, in *James Ensor,* 78–82.

3 Health Fairs were regular occurrences in most countries in the late nineteenth century; the 1888 one in Ostend featured not only information for the individual but was a conference for public health officials; see the list of new plans for various cities reported in *Le Globe Illustré* (June 24, 1888), 457. Ernest Rousseau Jr., Ensor's close friend, studied medicine and became a doctor; Mariette Rousseau was an amateur mycologist (her portrait by Ensor pictures her with a microscope). I thank Sue Canning for reminding me of this connection. See also Heymans, which analizes in detail Ensor's "hypochondria."

4 For an excellent survey of medical discoveries in late nineteenth century, emphasizing their public forum, see Christine Bluard, "L'Art de Guerir: Les progres du XIXe siècle," in Heymans, 109–14.

5 Anonymous, "Le Belgica-morbus," 209.

6 Van Langehendonck, "Biographie," 5.

7 Letter to Albert Croquez, cited in Juin, *Histoires étranges,* 14.

8 The drawing was repeated, in reverse, as a print dated 1904.

9 Etching on China paper; colored as well as black-and-white versions exist.

10 These same specks appear more clearly as mucus and saliva in Ensor's 1891 *The Wise Judges* (private collection), in which the lawyer, with red nose and dripping beard, shares both his opinions and his germs with the judges he addresses.

11 This is the translation offered in German; see *James Ensor,* exh. cat., 174.

12 Canning, in Goddard, 223, suggests this ambiguity which "allows the audience to determine which of the groups is the true pest."

13 For good examples of this represented in German art, see *Die Gesellschaftlich Wirklichkeit der Kinder,* exh. cat., 168–71.

14 See Bynum, 142–56.

15 Emile Verhaeren, "London," from *The Evenings* (1887), as translated by Friedman, 73.

16 Even Paris, known for its municipal sewers, remained engaged in the "everything in the sewer" (or not) debate from the 1870s through World War I; until the latter time there were still public cesspools and direct dumping of waste into rivers in most cities. Aisenberg, 105–12.

17 Although neurasthenia was, like tuberculosis, linked both to city life and hypersensitivity as well as to accompanying images of weakness (also, most often, in women), it was diagnosed with a complex host of often contradictory symptoms such as headache, sleeplessness, and lethargy, all of which differed from those for consumption. Stott has identified a visual code for neurasthenia. This is based primarily on a pose, that of Dürer's *Melancholia* (used most overtly in Munch's several versions of *Melancholy,* for example, 1894–5, Bergen, Rasmus-Meyer

Collection), signifying the total enervation that became one of the most commonly recognized symptoms of the condition. As such, the image of neurasthenia differed significantly from that of tuberculosis and emphasized the malaise that was believed to characterize the victim, rather than the spiritualized "other-worldliness" of the consumptive. And, of course, neurasthenia was not usually fatal, although tuberculosis almost invariably was. I thank Annette Stott for her clarification of these ideas.

18 Mühlestein and Schmidt, 5.

19 *The Sick Child*: 1885–6 and 1893; National Gallery, Oslo. Draft of a letter to Jens Thiis, c. 1932. Munch Museum Archives, as cited and trans. by Heller, *Munch: His Life and Work,* 35. For a survey of Munch's death images see Eggum, "Theme of Death," in *Edvard Munch. Symbols and Images,* exh. cat., 143–83.

20 Boeckl, 147.

21 *Le Diablotin* (September 11, 1892), cover.

22 Kent, 122 and 125.

23 There was a certain visual fascination with these public vaccinations, which became a new mass event, especially for families with young children. See, for example, *The Free Vaccination, Paris,* and engraving by J. Scalbert from 1890 (available in image database, United States National Library of Medicine).

24 Nicholas Jabbour, "Syphilis from 1880 to 1920: A Public Health Nightmare and the First Challenge to Medical Ethics," *Essays in History* (University of Virginia: Corcoran Department of History, vol. 42, 2000), online printout 5–6.

25 For an excellent survey of many of these discoveries and their relationship to art of the late nineteenth century, see Barbara Larson, "Microbes and Maladies. Bacteriology and Health at the Fin-de-Siècle," in *Lost Paradise: Symbolist Europe,* exh. cat., 385–93.

26 Larson, in *Lost Paradise: Symbolist Europe,* exh. cat., 389. For the gift to Pasteur, she cites André Mellerio, *Odilon Redon: peintre, dessinateur et graveur* (Paris: Henri Flour, 1923), 155, n. 3.

27 Redon, 115.

28 See, for example, Foucault, *The History of Sexuality,* trans. vol. I, especially part 3 on the managing of sex, and part 4 on the power and control of sex and heredity issues in the late nineteenth century. See also Foucault's *The Birth of the Clinic.*

29 For an interesting discussion of the increasing governmental control over these issues in France, see Aisenberg, Introduction and ch. 3.

30 Fernand Khnopff, "Lettre," 2.

31 For example, *The Infirmary at Helgelandsmoen* (c. 1882, Munch Museum, Oslo); and *Hazeland Dead* (1888/90, private collection), which Munch was commissioned to paint in the morgue. See Eggum, "Theme of Death," in *Edvard Munch. Symbols and Images,* exh. cat., 167.

32 An exception to this is *By the Deathbed* (1895, Rasmus Meyers Collection, Bergen); in the drawings and sketches for this oil, Munch included the apparitions presumably envisioned by the patient himself as forms vaguely floating above the death bed. See especially OKK T 286 and OKK M 121 Munch Museum, Oslo, in which the figure of death appears lurking behind the family.

33 Given Munch's interest in the Monistic theories of generation and metamorphosis, his interest in family trees is not surprising; he made several drawings of a symbolic family tree featuring his own family. See, for example, OKK T 387 Munch Museum, Oslo.

34 In Maeterlink's play, only the grandfather and the youngest of the family gathered have any idea of the presence of death, a continuation of Romantic belief in the spiritual awareness of the very young and old. See Gerould, 51–66.

35 The *danse de la mort* was a depiction of death coming to claim a sequence of different people; the *danse macabre* showed the dead rising out of their graves to celebrate. For an explanation of these traditions in late-nineteenth-century art, see Hirsh, "Arnold Bocklin," 84–9.

36 Identification of four of these appears on one of Ensor's prints, based on this painting, made in Tricot, *James Ensor: Catalogue Raisonné,* 321. The fifth doctor, who appears only in the painting,

has been identified by Heymans, 63, and short biographies of the physicians are offered, 87–97. This latter source is the most complete analysis of Ensor's painting, including a report of a technical study conducted in 1996, 67–71.

37 This lettering is difficult to read in reproduction and is my translation of the reading of Heymans, 63.

38 As Heymans has demonstrated (74 n. 33–6) three of the physicians portrayed in the painting wrote treatises about cholera, the epidemic of which broke out in Brussels in September 1892.

39 The satirical and stereotypical nature of Ensor's painting is the conclusion of Heymans (73), who points out that Ensor would have known about the five doctors through his friend Ernest Rousseau Jr., and would have been fascinated by their cumulative specializations (especially Dr. Rommelaere, whose work focused on urine and excrement analysis, always of interest to the scatologically inclined artist).

40 Rilke, *Die Aufzeichnungen,* 7.

41 Ibid., 10.

42 Ibid., 41. Rilke's word for outcasts is Fortgeworfenen.

43 For an excellent discussion of Taine's and others' metaphors for the crowd, see Barrows, 77.

44 Taine, 133. Le Bon repeated this idea in *The Crowd,* asserting that "in a crowd every sentiment and act is contagious" (27).

45 Trachsel, *Réflexions,* 34.

46 Trachsel, *Quelques réflexions,* 19. For a further discussion of Trachsel's views and their relationship to Hodler's painting, see Hirsh, "Hodler as Genevois, Hodler as Swiss," in *Ferdinand Holder: Views and Visions* exh. cat., 89–101. His concerns by that time took a desperate turn: at one point he suggested that any new hospitals be built far from the roads, in "self-isolation," so that no unsuspecting (healthy) Swiss need risk getting too near to them, and to their infection, 20.

47 Perhaps not coincidentally, Ensor's original source for the central group was, in fact, a photo taken of himself, his sister Mitch and friends while they were on holiday to the nearby tourist town of Bruges. The photograph is titled *Voyage à Bruges* (1888, Museum voor Schone Kunsten, Ostende). For the drawing, however, Ensor took the figures out of the staged interior of the photograph and placed them before the sea, perhaps in an effort to site them in one of the few restorative places available to Belgians at that time.

48 Sontag, 15, has pointed out about the early "travel cures" for tuberculosis, for example, that the two most recommended healing escape locations were the mountains of the north and the warming seas of the Mediterranean, two diametrically opposed locations, except that both areas were far from major urban centers.

49 Hansen. Pages by proposition 1: 147; 2: 150; 3: 196–202; 4: 28; and 5: 27.

50 Adna Weber, ix.

51 Ibid., 369.

52 Adna Weber, for example, established that many of the country people Hansen had polled in wealthy areas were in fact servants, clerks, and other dependents of city-bred rich; also some wealthy, although not born in the polled city were born in other cities, a factor not considered by Hansen. Weber concludes that in fact the main reason for poorer cities was not country migration but immigration of poor from other countries. He therefore disagreed with Hansen that most country-bred new city populations became degenerates; Weber claimed that instead they usually moved in the next generation to a more advanced social position (370–87).

53 Ibid., 368. Weber's citations were Rousseau, *Emile,* vi, 61; and George, 317, n. 1.

54 Weber here quoted the *Journal of Statistics Society,* 1893, 416.

55 Adna Weber, 392.

56 Ibid., 393.

57 Ibid., 414.

58 Adna Weber and others could easily have recourse in their own recent memory to diseases like cholera in the city. Of all the "fever epidemics," which included malaria, typhoid, and dysentery,

cholera was known as the most urban illness and seemed to spread most vociferously by means of poor hygiene (see Kent, 135, n. 48, for an explanation of why this was not a problem in many northern countries). Following six major epidemics of cholera between 1819 and 1866, a First International Cholera Sanitary Congress was held in Constantinople. A second, held in Vienna in 1874, established new international protocol for general quarantine regulations and set up international offices with the intention of tracing the disease to its source (Macnamara, 368–9). But consensus by that time already held that cholera was "communicated by contaminated water" (Macnamara, vii), and that cities – no matter how recently updated their sewers were and no matter how many new homes were being fitted with proper water closets – would be helpless to repel the disease. In 1883, microbe research had been spurred by the threat of an outbreak in Egypt spreading to western Europe, but the isolation of the bacillus by Koch that year proved, in fact, not sufficient to stop the insidious spread: the epidemic swept again through Europe in 1892–3 (see Larson, in *Lost Paradise,* exh. cat., 387–8).

59 Sharpe and Wallock, 36.

60 One example is London: in 1847 a Metropolitan Commission for Sewers was founded; it soon abolished all cesspits. The following year a public health act required fixed sanitary arrangement of some kind to be established by every house owner. In 1859 the Metropolitan Board of Works began the huge project of laying new sewer system throughout the city. Lambton, 10.

61 Trachsel, *Quelques réflexions,* 63.

62 Donald Reid, 49.

63 Adna Weber, 117.

64 Favre, 86.

65 The Plainpalais area was the site of most of the science and art buildings, as mapped in Société d'Histoire et d'Archaeologie de Genève, 333. The village itself was built out in the direction of the woods of the Batie, and led up to a very small (human-made) mountain, into which one could walk in order to contemplate a panorama of the Bernois Alps (336).

66 Favre, 87. This was despite extremely bad weather that in most situations would have been ruinous. See Favre, 89–90; see also Société d'Histoire et d'Archaeologie de Genève, 336, which described the weather in 1896 as the "most humid year of the century."

67 Société d'Histoire et d'Archaeologie de Genève, 334, offers exact locations of the bridge and other major structures of the new water system.

68 Hirsh, "Hodler as Genevois," in *Ferdinand Hodler. Views and Visions* exh. cat., 90, n. 67. For a friendly review of Trachsel's proposal, see Anonymous, "Albert Trachsel," 76.

69 See Vire, 185–99, for a survey of the politics of water issues from c. 1850, which of course resurfaced with the cholera epidemic of 1892.

70 Mannekin-Pis is a young boy who, legend has it, put out a fire that threatened Brussels by urinating on it. About "The Pisser" and other precedents, see Canning, "James Ensor. *Le Pisseur*" in Goddard, 193–4.

71 See Jordanova, 51–2, for a discussion of this idea of the legible human body. For an example of ancient and medieval use of body parts as signs, see *Writing on Hands,* exh. cat.

72 Séon's work (current location unknown) was illustrated as plate 53 of the 1892 catalogue. See also Charles Filiger's *Prayer,* plate 46, depicting a child almost identical to that of Hodler. See Hirsh, *Hodler's Symbolist Themes,* figs. 65 and 37.

73 As had been his custom since 1890, Hodler showed his major work of the previous year, *The Consecrated One,* first in the Geneva Bâtiment Electoral Exhibition in March 1894, and then sent the painting on to Paris, where it was shown, along with several other artists represented in the Rose + Croix esthétique Exhibition, at the Champ-de-Mars Exhibition (May 1894).

74 Morhardt, 207.

75 For example, Soulier, n.p., termed the child "le divine Enfant"; Geffroy, n.p., simply refers to "Christ."

76 Gsell, 205.

77 "E. D." (Edouard Duchosal), 2.

78 Anonymous, "Chronique artistique. L'Elu," 1.

79 Specifically, the reviewer was addressing Hodler's *Worship* (1893–1894, Kunsthaus, Zurich), a small painting that featured only the kneeling child of *The Consecrated One*. Three versions of *Worship* exist; see Brüschweiler, 21–7. I have elsewhere dated Brüschweiler's version II as version III, c. 1895.

80 Anonymous, "F. Hodler."

81 By the 1880s, Baedecker's *Switzerland* had a whole section devoted to Sanitoria in the Alpine village of Davos, and by the 1890s, the Alps as a whole were internationally renowned as health resorts.

82 Ferdinand Hodler, letter to Büzberger, August 1887 (Geneva). Reproduced in Loosli, 55.

83 See Hirsh, "Ferdinand Hodler's 'The Consecrated One,'" 122–33.

84 This began with an important article by Philippe Burty in the *Gazette des Beaux-Arts* in 1860. For an excellent review of earlier studies of French critical reception of English Pre-Raphaelite work, as well as significant new information, see Casteras, "The Pre-Raphaelite Legacy to Symbolism: Continental Response and Impact on Artists in the Rosicrucian Circle," in Casteras and Faxon, 33–49, especially 35–9.

85 Edvard Munch, in Munch, 47, as translated and cited by Heller, *Munch: His Life and Work,* 35. Robinson's photograph became itself a source of later adaptations: see, for example, the canvas of the same title attributed to E. Kennedy (London, Institute for the History of Medecine), illustrated in Gilman, *Picturing Health and Illness,* fig. 2.

86 It is significant that this early stage of illness is that which, in the attitudes of nineteenth-century tuberculosis patients themselves, most closely fits their own acceptance of the aesthetic codes of the disease. Herzlich and Pierret analyze, in the writings of four tuberculosis victims at the turn of the century, a complete change in self-identity in each victim: initially in complete denial of the dangerousness of their diagnosis, these victims gradually exulted in the fashionable myth of the "beauty" of their disease and only in its very last stages come to recognize the inevitable horror (as well as the pain and the blood) of it. "They had not believed in its material nature, yet it turned out to be all matter. They had believed that it was their creation, yet they were profoundly changed by it" (37).

87 Pollack, 173. Although some were shocked to find tragic subject matter in a seemingly "real" photograph, most applauded Robinson's efforts to make "art photography": in fact, *Fading Away* was purchased by the Royal House, and the prince consort made a standing order for all of Robinson's subsequent composite photographs.

88 Dubos, 33–4. Throughout the Romantic period, research suggested, but never proved, different causal theories, the most common of which were heredity (and therefore a kind of genetic defect) and contagion (communicated through the air, or by physical contact). Acceptance of these two causation theories differed from country to country. In particular, much has been written about the battle between contagionism and anticontagionism theories and their proponents in the nineteenth century. One prototype theory was in Ackerknecht's article, 562–593, which sought to explain the debate by means of social and political factors and linking contagionism with component need for quarantines and other procedures that went against social and economic growth. Ackerknecht's theories were much later debated, however, by studies such as Pelling, which established that most nineteenth-century anticontagionists were in actuality contingent contagionists – who held that epidemic diseases had to have several causes, not simply one contagious carrier. See also Roger Cooter, "Anticontagionism and History's Medical Record," in Wright and Treacher.

89 Jules and Edmond de Goncourt, *Madame Gervais,* as cited by Dubos, 53, n. 9.

90 Sontag, 43.

91 Dubos, 59–65.

92 Dubos, 58, offers the only reference to this Romantic image of the consumptive in painting, and it is to the Pre-Raphaelite type of woman. There is no further discussion of this type, as it continued into the end of the century in English, Italian, and French art.

93 The quote is from Deborah Cherry and Griselda Pollock, "Woman as Sign in Pre-Raphaelite literature: the representation of Elizabeth Siddall," in Pollock, *Vision and Difference,* 103. See also Ehrenreich and English, 15 -23, and Lorna Duffin, "The conspicuous consumptive: woman as invalid," in Delamont and Duffin, 26–56. See also Bronfen, who elaborates on all of these earlier studies. For a related discussion of literature utilizing "eroticization of sickness" (but not tuberculosis), see Spackman, 152–210.

94 Delamont and Duffin, 26.

95 Athanassoglou-Kallmyer. See her thesis statement, 689.

96 Ibid., 695, 693, and 689. Kallmyer's real life Romantic examples of these associations, with a final link of wasted distorted bodies to artistic creation (including at least one example of a tuberculosis victim) are notably all male (702).

97 It is also the case that the symptomatic aspects of this visual code were not, in fact, the symptoms of most children and adolescents (the victims most commonly portrayed), who usually contracted bovine tuberculosis, which resulted in bone and gland malformations. Cartwright, 120. For some of these children, symptoms could be relatively slight, and the disease was not only recoverable but also believed to be advantageous because it could effectively inoculate the child against later and more serious tubercular infection. For others, however, it resulted in very painful deaths.

98 An early example of this is Dante Gabriel Rossetti's *Ecce Ancilla Domini! (The Annunciation)* of 1849 (Tate Gallery, London), in which the two figures are taken from the New Testament rather than the consumption clinic. The Virgin is intended to appear ethereal and not "of this world," and is as thin as the annunciate angel. The painter stresses in this work the spiritual strength rather than the physical robustness of Mary; therefore, he imposed onto the appearance of his models the same physical characteristics as those commonly signifying the consumptive. Already in *The Annunciation,* the code of consumption had not only blended with the image of the subservient female but had been completely inverted in its own signification, from portraying the consumptive as ethereal to portraying the ethereal as consumptive. For more information on this and other precursors to the Symbolist use of a code of consumption, see my article "Codes of Consumption: Tuberculosis and Body Types in Fin de Siècle" in Laurinda Dixon, ed., *In Sickness and in Health: Disease and Decadence* (Delaware University Press, 2004).

99 Gilman, *Picturing Health and Illness,* 65.

100 Villemin's *Etude sur la Tuberculose* was published in 1868. Both Villemin and Pasteur are, according to various sources, credited with the inventing the term for "germ."

101 Letter of 1887, as cited and translated by Cummins, 146. In France, by contrast, the fight against tuberculosis actually slowed; a Parisian study of 1903 admitted that France shared with Russia the "sad honor" of heading the list of highest tuberculosis mortality. See Bernheim, 35. By World War I, the situation was so critical that the United States, as an ally of France, was prompted to intervene. Shryock, 179–81.

102 In the north, however, Koch's discovery prompted immediate responses which included new emphases on health and prevention. When he announced, before the Tenth International Congress of Medicine, in Berlin in 1890, that he had a possible cure for the disease, Koch was hailed internationally, but especially in Germany, Switzerland, Belgium, and England. The British *Review of Reviews* (December 1890) devoted its December issue to the event, telling of booked trains of consumptives already on their way to Germany. Although Koch's announcement of a cure proved sadly premature, it led to the founding of numerous groups against tuberculosis. However, all but the German groups had to contend with Koch's efforts to keep the nature of his "remedy" secret. Although Koch claimed that his secrecy was a reasonable medical precaution, there were rumors that it was Germany's attempt to gain a monopoly on the production or sale of the cure (see Dubos, 253, n. 8). Perhaps because of this intrigue, when a multinational community organized the first International Anti-Tuberculosis Association, it was established in Berlin, with the central office maintained there until the beginning of World War I in 1914.

103 Villari, 183.

104 See a further discussion of this work in ch. 5.

105 Villari, 173. The author, who was the son of the Italian education minister and who himself would continue his father's rhetoric about a healthy art for a strong nation, kept his belief in body codes of illness. He became a spokesperson for Mussolini and continued his father's encouragement of art as a carrier of national character. See Kate Flint, "Blood and Milk: Painting and the State in Late Nineteenth-Century Italy," in Adler and Pointon, 112.

106 Quétel, 127.

107 At the St. Louis Hospital in Paris. See Quétel, 296 n. 10.

108 Cover page, signed "Julio," *Le Diablotin* year 1, no. 6 (October 2, 1892).

109 Belgians started to go to Ostend in June, many more made it by July, and by August "all of Belgium" was on the Ostend beach. Anonymous, "Hygiène et Santé," 603–605.

110 Florizoone, 113.

111 See Florizoone, 109 for examples of the press coverage in 1890.

112 Italics mine. Verhaeren,"Les Salon des XX," 52–53.

113 See Gilman, *Difference and Pathology,* ch. 3.

114 In a Félicien Rops' etching entitled *The Husbands' Train* for example, a train speeds by in the far distance while an amorous couple hides in a tangle of trees, kissing, in the foreground. The composition leaves uncertain whether the husband is on the train or in the bushes, and who the woman is with regard to him. On a side of the paper used for one pull/imprint (Musée Félicien Rops, Namur), however, Rops drew the skeletal figure of a woman seen from the back as she coyly turns to leer, with her death's head, at the viewer: this drawing Rops labeled "The Death of the Sinner."

115 Benner's version, exhibited at the 1900 Exposition Universelle, has been recently described as exploring "sexual anxieties and fantasies brought to the surface by falling birth rates and the rising toll of syphilis deaths." Claire O'Mahoney, "Jean Benner," in Stevens and Dumas, 368.

116 Robert Rosenblum "Art in 1900: Twilight or Dawn," in Stevens and Dumas 37–8.

117 Wilde, *Salome,* 64.

118 Engraving, 20.5 × 26.8 cm. Musée des Beaux-Arts, Marseilles.

119 For an excellent analysis of the "missing nose" as a visual code of syphilis and venereal disease in general, see Gilman, *Picturing Health and Illness,* ch. 4 "The Phantom of the Opera's Nose," 67–92.

120 Jabbour, online p. 4–5.

121 By August von Wassermann and others; see Quétel, 141.

122 See Hall, online p. 3.

123 OKK T 2800, published in *Edvard Munch: Tegninger, skisser og studier* (Oslo: Kommunes Kunstsamlinger Katalog A-E, Munch Museum 1973) 4, as trans. by Heller, *Munch: His Life and Work,* 63.

124 Haeckel, *Riddle of the Universe,* 80.

125 Haeckel, *The Evolution of Man,* vol. I, 2–3.

126 For a discussion of this notion see Pick, 28–9.

127 These bodies are much more fetal-like in the 1894 print version of *Death and the Maiden* (Munch Museum, Oslo); here their legs are completely truncated and they are reduced to large, staring heads.

128 Spongberg, 168.

129 Rosenblum, "Art in 1900: Twilight or Dawn," in Stevens and Dumas, 37.

130 Both citations by Ballard, 1.

131 Kent, 138.

132 Ballard, 21. Ballard's claim of finding these conditions in homes of every class was therefore different from the bias of many of his peers who were prone to overlook the possibility of venereal disease in poor children because they assumed that such children were simply "dirty." See Spongberg, 113.

133　"Diagnosis and Management of Maternal and Congenital Syphilis," online p. 2.

134　The second version dates from 1903–5 (oil on canvas, Munch Museum, Oslo).

135　See Fournier.

136　Spongberg, 151.

137　Kertzer, 15.

138　Diday, 138–9.

139　*Madonna*, drypoint 1894 for example, hand-colored with reddish wash on paper, Munch Museum Oslo MM G 15-4) was Munch's first translation of the image into print media. It shows the mother figure only from the breasts up, but swirling in the semen-fluid that occurs in the frames of the other lithographic versions. To her right in the drypoint are two fetus figures, the lower crouched in a semifetal position, the upper one floating with his legs stretched out below him, in each case closely resembling the infected child of *Inheritance*.

140　Quétel, 169.

141　Curator's notes to the painting (M28), as noted in the *Munch Museum Guide*, n.p.

142　Margit Rosenberg, 49–50. The first such maternity hospital in Munch's native Norway was in Oslo (Christiania) in 1818.

143　Indications of middle or upper class in the mother of the first version are perhaps even more apparent in one of the few extant drawings for the painting (T 422, Munch Museum, Oslo), in which the woman wears a more elegant hat and neck scarf and looks with downcast eyes to the side of her little boy. In the painting, the hat has been stiffened and given the addition of a feather, while the woman's face is reduced to baggy eyes and a handkerchief covering the mouth. Munch only says – in a much later writing – that he saw the mother, "she who had just learned that her child was doomed from birth," at the "Hospital for Venereal Diseases" (T 2800, Munch Museum ms.)

144　Jörg Vögele, "Urbanization, Infant Mortality and Public Health in Imperial Germany," in Corsini and Viazzo, 121–122.

145　Grand, 300. See the discussion of congenital syphilis as a feminist issue in the introduction by Carol A. Senf, xiii–xv. For syphilis in literature, see Wald-Lasowski, and Quétel, 23–130.

146　Curator's notes to the painting, *Munch Museum Guide*.

147　Ibsen, *Ghosts*, 333.

148　This was a major theme in fin de siècle literature. For a review of some of these, see Lloyd, *J.-K. Huysmans*, 57–63.

149　Spongberg, 6.

150　Panizza, 18.

151　Maria Makela has noted that Lovis Corinth's illustration to Panizza (c. 1896–7; Münchner Stadtbibliothek, Handschriften-Abteilung), changes the deliverer, since it illustrates Satan having sex with an angel. She correctly identifies this iconographic shift as making Corinth's sketch a more biting satire of Catholicism; it does, however, reduce the overt connection between syphilis and the prostitute that Panizza's all too human Salome expressed. See Maria Makela, "The Politics of Parody: Some Thoughts on the 'Modern' in Turn-of-the-Century Munich," in Forster-Hahn, 197, and illustration, 200.

152　Plate ten of the *La Femme (The Woman)* etched series, 1886. (engraving, 310 × 243 mm.).

153　1905, etching, 22.2 × 26.5 cm. Rops's work, which is discussed in Chapters 5–7, is at times a more literary illustration than truly Symbolist. As such, however, his early work of the 1870s and 1880s introduced numerous visualizations of themes that would serve as inspirations to the slightly later and more evocative Symbolists. He was well regarded by them, and served as a major connecting friend between the Belgian Symbolists and their Parisian colleagues in particular. While living primarily in Paris, he was a member of both the Belgian exhibition societies Société Libre and La Chrysalide and, after exhibiting with Les XX in Brussels in 1884, was named a member of that group in 1886.

154　This dating agrees with Siebelhoff, *The Early Development of Jan Toorop*, 119.

155 The homage may also have been to Rops's *Pornocratie* (1878), whose harlot walking a pig on
 a leash had become one of Rops's well-known images. Reference to illicit sex abounds here: a
 sculpted image of Leda and the Swan appears at the foot of the organ, for example.

156 The earliest identification of this inspiration, "the commemoration of the tragic death of a
 Brussels musician," was offered by W. Vogelsang, *Onze Kunst,* 1904, 184, as cited by Siebelhoff,
 The Early Development of Jan Toorop, 118 and 330. Siebelhoff has further connected this source
 as well as *Woman with a Parrot* to another work titled by Toorop "Damnation of the Artist"
 in a letter to Octave Maus (Bundel 1893; Inv. 6754). But Toorop writes that he is working on
 "Damnation" hoping to complete it within two or three months. Thus the work in progress
 mentioned in 1893 could not be the same as the watercolor illustrated and discussed here,
 however, becase the latter was already listed in the catalogue to the exhibition of Les XX in 1892
 (exh. cat. 4; p. 184). Phil Mertens, noting this discrepancy, has speculated that perhaps there was
 more than one version of the work, all about the same theme but titled by Toorop differently.
 See Mertens, "De brieven van Jan Toorop," 184–5, and n. 2. Rieta Bergsma, "Man and Nature –
 The Nature of Man," in *The Age of Van Gogh,* exh. cat., 54, agrees with the connection between
 both works and Toorop's syphilitic friend who committed suicide.

157 Conversation with Prof. Robert Siebelhoff April 30, 2001. Prof. Siebelhoff's contention that
 Toorop believed himself to be syphilitic is based on reading coded but nonetheless easily
 discernable inquiries and responses in letters between the artist and his father. I am grateful to
 Robert Siebelhoff for sharing so much of his research on this painting with me.

158 Huysmans, *À Rebours,* 129.

159 Paul Verola, *L'Inflamant,* as cited by Quétel, 146. This image of the syphilitic was already
 stereotyped by Verola's time; see the eighteenth-century illustration of the head of a syphilitic
 prostitute, illustrated without further identification by Sander L. Gilman, "AIDS and Syphilis:
 the iconography of Disease," in Crimp, 96, as well as numerous illustrations in Gilman, *Picturing
 Health and Illness,* ch. 4, 67–92.

160 This title defies translation, as it seems to be a neologism based on "les morpions," a vulgar word
 for syphilitic skin condition, and "mort," the ultimate end of the disease. The last part, "cole"
 is a pejorative ending that was established by Rabelais and used from his time in polemical
 discourse. I am grateful to Professor Sylvie Davidson for this analysis.

161 Daudet, 303–6.

162 Evelyn Hunt, "The Cry of the Unborn," *Shafts* (October 2, 1894), 344, as cited by Spongberg,
 161.

163 Foucault, *The History of Sexuality,* vol. 1, 118.

164 Morel, *Traité des dégénérescences physiques; Traité des maladies mentales,* and *De la Formation du
 type.*

165 Nye, *Crime, Madness, and Politics in Modern France,* 57 and n. 23. The connection between
 syphilis and degeneration appeared in print as early as 1841 (see "Rapport fait au conseil de
 salubrité de la ville de Marseille, sur l'Etat et les besoins du service, au dispensaire des filles
 publiques de cette ville, au nom d'une commission, par M. Pelacy, rapporteur," in *Annales
 d'hygiène publique, industrielle et sociale* (Paris, 1841) XV, as quoted and cited by Quétel, 166),
 but this was not widely discussed or accepted until the 1890s.

166 Ferri, 44–45. Ferri calls criminology the "sad and somber department" of the new science, 44.
 Ferri's early publications included *Socialismo e criminalità,* and *Discordie positiviste sul socialismo.*

167 Morel, as cited by Eric T. Carlson, "Medicine and Degeneration: Theory and Praxis," in Gilman
 and Chamberlain, 122.

168 Max Nordau, *The Conventional Lies of Our Civilization,* 1.

169 Pick, 50.

170 Balzac, *Le Médecin de Campagne,* 44.

171 Pick, 47.

172 Spongberg, 157.

173 Spongberg, 169 and 172.

174 Alfred Fournier in 1904, as cited by Spongberg, 160.

175 Max Nordau, *Degeneration,* 17.

176 George Bernard Shaw, 81, as cited by West, 17.

177 Patricia Mathews devotes an excellent chapter to the connection between "Creative Genius and Madness," particularly in French discourses. See her ch. 3, especially 48–53. Mathews's distinctions between various writers about this issue (what she terms "Philosophers of Degeneracy" – who viewed genius and madness as both pathological and interdependent) and "Positivists" (who separated the two concepts) are helpful to understanding the distinct impulses and themes at work in the long process of maturation of ideas through the century. As pointed out in the introduction to this section, by the 1890s these "scientific" or philosophical debates had entered a larger, and much vaguer arena of common cultural construction of illness to which, I believe, the Symbolists were most responsive. See also Gilman, *Difference and Pathology,* 224–8, for an explanation of the shift in mental health studies in late nineteenth century from an emphasis on the physiology of the mind to analyses of emotions; this change was accompanied by an increased interest in visual art (rather than literature) of the insane.

178 Max Nordau, *Degeneration,* 114. He also offers lengthy analyses of Charles Morice, Paul Verlaine, and Jean Moréas, while often quoting Edouard Rod, Gustave Kahn, Mathias Morhardt, and René Ghil.

179 Ibid., 101.

180 Ibid., 118

181 Ibid., 131.

182 Ms T 2759 (EM III), Munch Museum Archives, c. 1905–8, as dated as trans. by Heller, *Munch: His Life and Work,* 15.

183 Georg Voss, "Kunst und Wissenschaft," copy from Munch Museum Archives. I am grateful to Prof. Dieter Rollfinke for help with this translation.

184 Aaron Sheon, "Van Gogh's Understanding of Theories of Neurosis, Neurasthenia and Degeneration in the 1880s," in Masheck, 175–84, offers evidence from a variety of sources including Van Gogh's own letters; Sheon establishes that Van Gogh read Lombroso's book in a French translation.

185 Nordau, *Degeneration,* 17–19.

186 Patricia Mathews, 49. She also credits Morel with the first linkage in this respect.

187 See Roger Williams, 105–7.

188 Scherb, 625–31.

189 Hamsun, 22–25; 4.

190 Rilke, *Die Aufzeichnungen,* 40; last quote 112.

191 Ibid., 7–8.

192 Ibid., 62.

193 Ibid., 54.

194 Syphilis can cause inflammation to the optic nerve; it can also cause deterioration to the eyes (as to the nose and parts of the cranium).

195 Huysmans, *À Rebours,* 247.

196 Ibid., 259.

197 Ibid., 131–5. For the first direct reference to syphilis, Huysmans uses the term "Grande Vérole" (132), which might also be translated as "the Pox"; for the second, however, he uses the term "la Syphilis."

198 For example, Arnold Böcklin, *Pestilence* (1898, Kunstmuseum Basel). See also Ensor's *Death Pursuing the Crowd* (drawing 1887; print 1896).

199 For a review of the numerous literary interpretations of this dream, see Lloyd, *J.-K. Huysmans,* 96–9.

200 August Strindberg, in *Revue Blanche* (June 1, 1896), as translated and cited by Delevoy, *Symbolists and Symbolism,* 100.

201 Huysmans, *À Rebours,* 27–8.

202 Patricia Mathews discusses this phenomenon as well, 14–15, 20–21, and ch. 3.
203 *Dangerous Cooks* (1896, Museum Plantin-Moretus, Anvers)
204 Hamsun, 157.
205 For these and additional examples, see Pick, 25–6.
206 Draguet, *Khnopff,* 79.
207 By contrast, Khnopff's later *Decadence* (c. 1914; private collection) is a female figure whose proportions are Mannerist in their distortions and seem to emphasize animalism in her pose. In addition, her face is shown in an awkward near-profile, with hair to one side and forehead cropped, large somewhat slanted eyes and fuller nose and lower lips than those of his established "ideal."
208 Florizoone, 61–5.
209 Larson, in *Lost Paradise,* 385–393, offers examples of the work of Maurin as well as two other Symbolist artists, Redon and Carrière, whose interests, like Maurin, were in recent medical discoveries. None of these artists, however, addresses tuberculosis.
210 In 1905, Trachsel produced an image that summed up his most idealistic imagery of health, *An Adoration of the Sun* (Solothurn Museum). In this drawing, eight women in classically timeless robes climb a heroic staircase to a huge yellow sun. In the baskets that rest on their shoulders, they carry healthy fruits, for absolution of the sun.
211 "A straight line leads from *Spring* to the Aula Paintings. The Aula paintings are humanity as it strives towards the light, the sun, revelation, light in times of darkness. *Spring* was the mortally ill girl's longing for light and warmth, for life." Edvard Munch, *Farge på trykk* (Oslo: Kommunes Kunstsamlinger and Munch Museum, 1968), 26–27, as cited and translated by Heller, *Munch: His Life and Work,* 209.
212 The most well known of these are *The Bathers Triptych,* 1907–8: *Youth* (Rasmus Meyers Samlinger, Bergen), *Maturity* (Ateneum, Helsinki), and *Old Age* (Munch-Museet, Oslo).
213 *View of the Paris World's Fair* (1867, National Gallery, Oslo).
214 A more obvious version of the city-café Temptation of St. Anthony, possibly inspired by Ensor, was drawn by Adolphe Willette for the cover of the Parisian periodical *Le Courier Français* in 1906.
215 Lombroso and Ferrero, ch. 5 and 6, with plates.
216 See Berman, *James Ensor. Christ's Entry,* 62–5.
217 See the caricature by Grand-Jouan, titled "L'Assiette au beurre," 9 May 1903, Bibliothèque Municipale de Caen, depicting a French sailor attacking an African woman. Reproduced, with commentary, in Quétel, 195.
218 See Pick, 20–2.
219 Berman was the first to identify this strong strain of anti-Semitism in Ensor's satires; see Berman, *James Ensor. Christ's Entry,* 59–60. For examples of 1890s caricatures featuring offensively anti-Semite caricaturizations, see issues of Brussels' *Le Globe Illustré.* One example can be found in "By the Lake," (Fig. 9, in this text): the "hook-nosed" Jew who leans out from the new hotel in the scene from "today," representing the supposed Jewish takeover of commerce.
220 Nordau, *Degeneration,* 18–22.
221 The French aesthetician Charles Blanc ascribed "the uniform" of "our age" for males to the further principles of equality and liberty (Blanc, *Art in Ornament and Dress,* 136, as cited by Garb, 35).
222 Ibid., 9
223 Pick, 4.
224 Ibid., 33.
225 Nordau, *Degeneration,* 30–2.
226 The first version of Lombroso's book was called *L'Uomo delinquente;* here, he established his theory that crime is caused by hereditary – anthropological – characteristics of the criminal. The book went through several editions, however, and by the later versions, Lombroso put more emphasis on social rather than fully hereditary causes of crime.

227 Van Langhendonck, "James Ensor," 9.

228 Haesaerts, 339, reproduced a detail of Ensor's work next to a reversed reproduction of Rubens' *Self-Portrait* of 1623–4, establishing a very close correlation between the two self-portraits (figs. 11 and 12).

229 It was also popularly suggested that there existed a "syphilitic genius"; see Quétel, 172–3.

230 See also Patricia Mathews, 55–63. Mathews (51) considers only the theoretical dimensions of these definitions, however, and therefore categorizes Lombroso's "abnormal genius" as completely opposed to the Symbolist "superior genius." See also Spackman, 33, who makes a distinction based on the self-determination of the genius: while Symbolist (Baudelairean) "rhetoric converts symptoms into signs that the subject himself is able to read, the Lombrosian rhetoric reduces psychic activity to the tyranny of the symptoms."

CHAPTER 5

1 See van der Woud, 162–4.

2 Writers included Willem Kloos, Albert Verwey, Frederik van Eeden and Lodewijk van Deyssel; artists were Jan Veth, Willem Witsen, and R. N. Roland. They were further influenced by the philosophies of G. J. P. J. Bolland. See Carel Blotkamp, "Kund von der Neuen Mystik: Niederländischer Symbolismus und frühe Abstraktion," in *Symbolismus in den Niederlanden*, exh. cat., 11.

3 See Siebelhoff, "Jan Toorop and the Year 1892," 84–91 for a detailed and entertaining account of Verlaine's tour, Péladan's involvement, and Toorop's full participation in it.

4 Ibid, 12.

5 See Dierick, 29. Toorop gave the poet one of his drawings and she dedicated six sonnets to him in return. See also Siebelhoff, "Jan Toorop and the Year 1892," 72–3.

6 Of the significant literature on this subject, Bram Dijkstra's *Idols of Perversity* and Patrick Bade, *Femme Fatale* are most well known; see also Heller, *The Earthly Chimera and the Femme Fatale,* exh. cat.; Gay, *The Bourgeois Experience,* 197–213; and Patricia Mathews, ch. 5, as well as other sources listed in notes to this chapter.

7 Sparrow, "Herr Toorop's Three Brides."

8 Letter to Octave Maus from The Hague, 29 January 1894, as transcribed by Mertens, "De brieven van Jan Toorop aan Octave Maus," 192.

9 See the description quoted but not cited by Victorine Hefting, 80.

10 For a discussion of the New Woman in art, see Casteras, 144–51.

11 The quote is from the *New York Tribune,* 1866: "The sure panacea for such ills. . . . is a wickerwork cradle and a dimple-cheeked baby," as cited by Gay, *The Bourgeois Experience,* 192–3.

12 A good argument for the definition of this as a socially constructed disease, as well as the mechanics of its development, is offered by Theriot, 75–89 and 225–31. See also Marland, "Destined to a Perfect Recovery, " in Melling and Forsythe, 137–53.

13 Theriot, 80. See also Quinn, 195–203, for further symptoms and definitions.

14 The "cure" included confinement (to bedrooms or an asylum), denial of company of friends or family, force-feeding, and rest (usually induced by tranquilizers). Cured women were those able to return to their families and resume wifely and maternal duties. See Theriot, 88–9. For an explanation of the role of puerperal insanity as a defense for infanticide, see Marland, "Getting Away with murder? Puerperal insanity, infanticide and the defense plea," in Mark Jackson, especially 172–78. As Quinn (200) summarizes, "The pathologization of the disease saw the 'crime' of infanticide being reduced to a 'symptom' of puerperal insanity." See also T. Ward.

15 Theriot, 89.

16 Marland, "Destined to a Perfect Recovery," in Melling and Forsythe, 152–153.

17 See Gay, *The Bourgeois Experience,* 213–25.

18 Rops was living full time in Paris at this time; Siebelhoff, *The Early Development of Jan Toorop* (61–2 and n. 203) suggests that Toorop would have known him through their mutual regular visits to the home and "Salon" of Edmund Picard in Brussels.

19 Siebelhoff, *The Early Development of Jan Toorop*, 60.

20 He subsequently wrote to a friend asking if the original parable about the sower could be found in the old or the new testament. Rops, "Dix-huit lettres de Félicien Rops a Poulet-Malassis," 58. The oil painting is on wood, Musée Félicien Rops, Namur.

21 In Rop's description, written on several proofs for the print, as cited by Robert Hickerson and Sura Levine, entry 118 in Goddard, exh. cat., 324.

22 Lombroso.

23 The book, never completed, was titled *The Satanic Ones*. See Hickerson and Levine, in Goddard, exh. cat., 234.

24 Huysmans, "Félicien Rops," 397.

25 In just one of numerous advice books for women, for example, Dr. Richard Weber, originally published in 1889 and enjoying a tenth edition by 1898, established its scientific authority with a first chapter on "Anatomical Notes about the Female Body" and then continued with chapters on every phase of the woman's "career," from "Preparation for Marriage" through "Pregnancy, a Natural Condition."

26 Grand, grand comme le mal, ce géant infins,
 Et laid comme le Vice à la grimace obscène,
 Sous sa chapeau de gueux, le tison de la haine
 Met d'acides lueurs dans son oeil de banni,

 Notre-Dame résiste à son pied racorns
 Mais l'Opéra s'écroule, et sa fureur malsaine
 Confond aveuglément le Ciel et la Géhenne,
 Le temple sans pudeur et le temple béni.

 Il s'en va donc semant, dans les sillons fertiles
 De Paris corrompu, le grain empoisonné
 Qui produira la ronce (brambles) et les herbes subtiles.

 Il sème, dur tyran après l'homme acharné,
 Les stupides bourgeois, les ingrats (ces reptiles),
 Les femmes les meilleures complices, Damné!

 The poem was preceded by an "air connu.":

 Un jour Satan, ivre d'orgueil
 Prit dans sa grande chaudière
 Des démons qu'avaient l'mauvaisoeil
 Et les envoya sur la terre.

 Pierre, 475–6. I am very thankful to my colleague Professor Sylvie Davidson for her assistance with this translation.

27 Weber's 1889 study, for example, had a chapter (VI) on natural movement of population, with a section on "fecundity" addressing lower birth rates in cities. Interestingly, his charts showed a relatively small rate of illegitimate children overall (for the sixteen great cities, out of 100 women (aged sixteen–fifty) there were 22.8 legitimate births and 2.6 illegitimate), but he did not address the role of birth control in his statistics. Overall infant mortality, on the other hand, was firmly proven higher in urban areas. The highest such mortality was to be found in Germany, with the Netherlands a close second. See chart, 362.

28 Aisenberg, 3. See also Schafer.

29 Weber, 388.

30 "[T]he Salon de la Rose + Croix wants to *ruin realism,* reform Latin taste and create a school of idealist art" (emphasis his), specifically rejecting "all representations of contemporary, private or public life," Rule two proclaimed. The rules are translated and listed by Robert Pincus-Witten, appendix II, 211–16.

31 Péladan, "Les Maîtres Contemporains," 426.

32 See Hutton, 36–44.

33 Prince Pierre Kropotkin, *Paroles d'un Revolte* (1885), as cited by Hutton, 41–2.

34 In the story "Edelburge-Nina," the author declares that "When a woman is neither fit for gallantry or marriage,...she will become a woman of letters," thus condemning "blue-stockingism." Josephin Péladan, *Femmes Honnêtes* (Paris: Camille Dalou, 1888), as quoted by Elizabeth K. Menon, "Images of Pleasure and Vice," in Weisberg, *Montmartre and the Making of Mass Culture,* 59–61.

35 Patricia Mathews, 69.

36 Pollock, *Avant-Garde Gambits,* 7–8.

37 Ibid., 41.

38 Jordanova (19) offers numerous sources from scientific discourse to support this claim.

39 These terms are derived from German nineteenth-century dictionaries and encyclopedias, by Hausen, 55–6.

40 Bonnie G. Smith, 75.

41 Renee Pigeaud, "Woman as temptress: Urban morality in the 15th century," in Vignau-Wilberg and Pigeaud, 39.

42 Patricia Simons, "Women in Frames: The Gaze, The Eye, The Profile in Renaissance Portraiture," in Broude and Garrard, 39–57.

43 Pollock, "Modernity and the Spaces of Femininity," in Broude and Garrard, 245–68.

44 As Michael Miller points out, "selling consumption" was then, as now, selling a way of life. "There is [in the department store advertisements, for example] no hint of the failings of middle-class marriages, no sign of the pressures or anxieties that could weigh upon middle-class lives," 179–80.

45 Patricia Mathews, 163–4 and n. 9 cites Gauguin, the critic Diego Martelli, and Engels using similar phraseology.

46 Nordau, *Conventional Lies of Our Civilization,* 279.

47 Hutton, 5, n. 93.

48 Hansen, 27.

49 Anonymous, "Esthétique du contact humain," 311–13. The quote on cities is from Anonymous, "Les Villes et la Femme," 247.

50 Morrisey, *Fernand Khnopff,* 127.

51 Draguet, 105–6. His interpretation is based in part on the argument offered by de Palacio, 117, note 70.

52 Exceptions to this composition for female portraits do exist, and Khnopff does seem to abandon it altogether around 1898. It is still a significant approach, however, and notably one that was used only twice in male depictions, in two portraits of little boys, Henry de Woelmont (1884; location unknown) and Henry Lambert de Rothschild (1892; coll. Baron Lambert, Brussels).

53 See Gay, "The Castrating Sisterhood," in *The Bourgeois Experience,* 197–213. Silverman also discusses the image of the New Woman as one who takes on maleness in *Art Nouveau in Fin-de-Siècle France,* 67. A telling caricature appearing in *La Plume* (January 1, 1896 – for the "New Year") shows the new woman, on a bicycle, running over a cupid on the street; the bike's front tire has deadly aim and appears to be castrating the tiny male angel. Patricia Mathews, 68.

54 For a discussion of this phenomenon in France, see Garb, 33, and more thoroughly in Robert Nye, *Masculinity and Male Codes of Honor in Modern France.*

55 George L. Mosse, "Masculinity and the Decadence," in Porter and Teich, *Sexual Knowledge,* 251–257. Mosse's example for the last linkeage was that of Oscar Wilde, who in 1892 encouraged

friends to wear a green carnation as an emblem of "subtle artistic temperament, in nations of laxity, if not a decadence of morals"; yet many saw this as a symbol of outright homosexuality (257).

56 Praz, 332, and A. J. L. Busst, "The Image of the Androgyne in the Nineteenth Century," in Fletcher, 38–40.

57 Patricia Mathews, 75. See also her discussion of the Androgyne in this regard, 73–4.

58 See Garb, 34, and Nye, 58.

59 Ms. T2776, Munch Museum, Oslo, archives, as cited and translated by Heller, *Munch: His Life and Work*, 174.

60 Van Gogh at one point reminded Emile Bernard to curtail sex in order to make his paintings "all the more spermatic." Van Gogh, *The Complete Letters*, vol. 3, 509–10, LT14. See also Silverman's excellent analysis of this notion for Van Gogh, 244–7.

61 Jayne, 13–19. Slatkin's article, broader in scope, includes (Parisian) literary comparisons.

62 For an excellent account of parallels between Munch's conception of natural and human life and Haeckel's system of "Monism," see Heller, *Munch: His Life and Work*, 63ff.

63 See Drake, 86.

64 Originally suggested by Eggum, in *Edvard Munch: Symbols and Images*, exh. cat., 49.

65 Jayne, 33.

66 Jayne (33 and n. 27), cites Heller, *Munch: His Life and Work*, 129, who translated from ms T 2547, Munch Museum, Oslo.

67 As Brown and Guinnane, intro; 2 and 31, point out, the exact nature and full causes of fertility transition in Western Europe in the late nineteenth century have yet to be completely identified. The numbers indicating the decline are clear, but factors such as wealth, occupation, religion and migration history still need to be disentangled. For the purposes of this chapter, however, the fact that both the decline and fears about the decline were evident in fin de siècle society is important.

68 Przybyszewski, "Psychischer naturalismus," 152. This translation is that of Schloesser, in House, *Munch*, 96–97, who offers a very different interpretation of the critic's commentary.

69 Amanda Anderson, 16.

70 Magraw, 369–70.

71 Linda Nochlin, "Lost and Found," 139–53. Casteras, 131; she cites among others the comment offered in the 1868 *Westminster Review:* "Prostitution is as inseparable from our present marriage customs as the shadow from the substance. They are two sides of the same shield" (n. 2 p. 183). A similar, unidentified remark is cited in Cominos, "Late Victorian Sexual Respectability and the Social System," p. 230. I am deeply indebted to Casteras's study of the fallen woman in this chapter.

72 Hood, 468–9. For a full list of other Victorian examples see Casteras, *Images*, 132.

73 "The Bridge of Sighs," etching and engraving from *Passages from the Poems of Thomas Hood*, 1858. Casteras, figs. 107, 133.

74 Dickens, 770.

75 Acton, 24.

76 Parent-Duchâtelet, 338.

77 Alan Krell, "Dirt and Desire: troubled waters in Realist practice," in Hobbs, 141. See also Bernheimer, who suggests that "[t]he particular fascinations, repulsions, methods, and manias of Parent's professional life reveal the social and psychological bases of contemporary male fantasies linking female sexuality, excrement, and disease" (72).

78 Note to the study, in Edward Morris, 466.

79 Casteras (183 n. 11) cites Mrs. E. L. Barrington, Catalogue of Paintings by George F. Watts of London on Exhibition at the Metropolitan Museum of Art (New York, 1884–5), 27. The suicide as a final "solution" for the mother is also briefly discussed, in light of eugenics and the work of Muzio Pazzi, in West, 99.

80 For a discussion of these, see Krell, in Hobbs, *Impressions*, 139–40.

81 Van Gogh, *Letters,* Vol. 1, 21–2; LT20 and LT21. For further explanation of Van Gogh's sources and an excellent analysis of his drawings of Sien, as changing from the "fallen woman" (victim) to "whore" (unredeemable), see Zemel, "Sorrowing Women, Rescuing Men," 351–68. Specific connections to the *Graphic* are established by Zemel, 352 and 359.

82 Zemel, 357–8. See Michelet.

83 Van Gogh painted five versions of *La Bercuse* between December 1888 and May 1889. Silverman, *Van Gogh and Gauguin,* 313–15 offers a close analysis of this composition as a "consolation painting" reflecting the painter's Dutch Protestantism and, ironically, local Catholic popular religious traditions in Arles.

84 See, for example, Howe, *The Symbolist Art of Fernand Khnopff,* 8.

85 This is generally accepted (see entry in Delevoy, DeCröes, and Ollinger-Zinque, *Fernand Khnopff,* 1979, no. 191, p. 269), despite the fact that the work was reviewed in its first 1891 exhibition, under the title "Qui me délivera" in "Exposition du Cercle artistique" *L'Art moderne,* Brussels, 26 April 1891, no. 17, p. 135, and Emile Verhaeren, "L'Exposition du Cercle," *La Nation* (May 2, 1891), as reproduced in Aron, *Emile Verhaeren,* 432.

86 Some connection between Khnopff's painting and the study for Rossetti's *Found* has been noted by Susan P. Casteras, "The Pre-Raphaelite Legacy to Symbolism," in Casteras and Faxon, 46; here, she notes that both have "a red haired protagonist, urban backdrop with a brick wall, and gutter," although she finds "Khnopff's creature is more seer than harlot."

87 See for example William Burke Ryan, 49–50, who claimed that in London between 1856 and 1861, more than 500 bodies of children were found, most commonly under railway arches or in the Thames, ponds, or canals (sewers). This connection was made stronger by the numerous reports of abandoned bodies being left in the "privy," where many concealed births occurred. Pauper women went to poorhouses to deliver; these places had a high incidence of births, and subsequent deaths, in the "privy," the only place of privacy to which the mother might go. See Hilary Marland, "Getting Away with Murder?" in Mark Jackson, 183; also her suggestion that these may have been linked to what she terms "the phenomenon of birth into excrement," which would further connect infanticide with the sewer (Ibid.).

88 In this reading of the small brown shape as the child, I agree with many, but disagree with some who think that the fetus remains hidden, such as Hess (44) who suggests that the manhole is "hiding its tragedy." The most careful and frank reading of the work is that of Donald Gordon, who also points to the bright red purse lying between the woman's thighs (127). This composition can be directly compared to the contemporary image of *The Child Murderer* by J. Mammen (Ill.: *Eva und die Zukunft,* exh. cat., 225, plate 6.)

89 Kestner, 174. Ill. of the Dicksee painting, 188.

90 Anonymous, "Exposition du Cercle Artistique," *L'Art moderne* (April 26, 1891), 135.

91 Khnopff's ambiguity resembles that of Dicksee's *Confession,* which was part of a four-painting group of "modern life subjects." As Kestner (188) points out, although these images presumably establish a male gaze, "the canvases are each so conflicted, so subject to myriad interpretations, so encoded with ambiguity, that the male gaze, rather than being empowered, is being sabotaged and deconstructed."

92 Emile Verhaeren, "L'Exposition du Cercle," *La Nation* (May 2, 1891), as reproduced in Aron, ed., *Emile Verhaeren,* 432.

93 For example, the well-known three-part narrative series by Augustus Egg, known as *Past and Present* (1862, Birmingham Museum of Art). Here, the story is told in three parts which follow the faithless wife to her final demise, as she cowers, destitute and hopeless, below London Bridge, while holding her love child in her lap.

94 For Klinger, the ability of prints in particular to express social or political, or even psychological issues made them a special type of art work (different from painting and sculpture, for example, which are better for the expression of eternal truths). See his *Malerei und Zeichnung: Tagebuchaufzeichnungen und Briefe* (Leipzig, 1885). For an analysis of the importance of Klinger's

theories, see Elizabeth Pendleton Streicher, "Max Klinger's *Malerei und Zeichnung:* The Critical Reception of the Prints and their Text," in Forster-Hahn, 229–49.

95 This drawing has been subject to numerous titles, including "Death and the Girl," or "Young Girl," which would seem to ignore her pregnancy (see *Max Klinger. Bestandskatalog der Bild-werke,* exh. cat., entry C275, p. 174; or (*Max Klinger,* Ferrara, Nr. 13, p. 275). The drawing has no exhibition history prior to 1907 (Leipzig, Nr. 98) however, but was called in its first publication "Death at the Grave," a title that leaves the identity of the victim open, despite the fact that the woman is clearly pregnant (Vogel, n.f. 8, p. 157).

96 Klinger related the story on the title page of the fifth edition of the cycle. Varnedoe, with Streicher, 83.

97 Streicher, in Forster-Hahn, 241.

98 He moved the series to the Friz Gurlitt Gallery. See Streicher, in Forster-Hahn, 242.

99 Varnedoe, 86, cites the basin and sponge as suggestions of possible abortion.

100 Patricia Mathews, 203–5, discusses onset of puberty as "a very charged moment in the life of the bourgeois woman" (203) and compares Munch's work to Gauguin's *Loss of Virginity* (1890–91, Chrysler Museum of Art, Norfolk, Virginia), and to Suzanne Valadon's *The Abandoned Doll* (1921, National Museum of Women in the Arts, Washington, D.C.), as differently gendered constructions of this "moment," but as a transitional stage in sexual self-images of the adolescent girl rather than connecting it to societal and medical expectations of motherhood. For an interesting collection of fetus images in Symbolist art, including the one by Klinger, see Howe, *Edvard Munch,* 64–5.

101 The quoted term is from Chavasse, 88. This book was extraordinarily popular; see Attar, 48, and Hardyment, 42–3. For the concentration on women's fertility in medicine, see Smith-Rosenberg, 23–37.

102 A good argument for the Besnard source is offered in *Munch et la France,* exh. cat., 21–2, suggesting that the Frenchman's series was much closer in concept to Munch's *Frieze* than the Klinger series that are more often cited. Besnard was a founder of a Parisian exhibition group, the Société des XXXIII, which was clearly based on Les XX and included several Vingtists (Khnopff, Rops, etc.) in its membership.

103 Catalogue to Goupil exhibition, 1898, as cited by Godfroy, n.p.

104 For example, the 1890 *Turpitudes Sociales* by Camille Pissarro, a series of pen-and-ink studies, had the explicit purpose of visually proposing Pissarro's anarchist notions about the ills of the current political state and the role of women in them; Pissarro intended to send these as an educational tract to his nieces. Hutton, 34.

105 "In the Water," in *Simplicissimus* (vol. 11, no. 37), 599. As a subject for satirical and social protest caricatures, these seemed to peak in number and degree of dark, brutal humor between 1905 and 1910, especially in *Simplicissimus*. See Eugen Roth. See also *Die Gesellschaftliche,* exh. cat., 168–71.

106 "Ein Menschenleben," nos. 22–50 in *Edvard Munch Gemaldeaustellung.* exh. cat. Unter den Linden 19 [1893], as cited by Heller, in *Edvard Munch. The Frieze of Life,* exh. cat., 29 and 37. See also Eggum, *Edvard Munch,* 98, 100–1.

107 It has been further suggested that Munch's setting for *The Scream* was influenced specifically by Besnard's Plate XI, *Le Suicide* (Rudolphe Rapetti, "Munch et Paris: 1889–1891," in *Munch et la France,* exh. cat., 121. It is likely, however, that the entire French series would have been well known; Besnard shared many Symbolist friends with Munch in Paris at the time. Munch's drawing titled "Woman in Aura" – in which the woman appears attended by her bearded escort and surrounded by other dancers at a fancy society "ball," is thematically reminiscent of Besnard's "Social Triumph" (plate VII of *La Femme*), in which the woman enjoys all of the attention of the high-fashion gathering, bathed in the light of her own "triumph."

108 See, for example, Keown; F. B. Smith, 73–78; Knight, 57–68. Lionel Rose asserts that abortion was 'very widely practiced' in *The Massacre of the Innocents* (London: 1986), 86. See also Stormer, and Linda Gordon, "Voluntary Motherhood: The Beginnings of Feminist Birth Control Ideas

in the United States," as well as Daniel Scott Smith, "Family Limitation, Sexual Control, and Domestic Feminism in Victorian America," in Harman and Banner, eds., 54–71 and 119–136. The last, although offering a flawed economic argument, offers interesting statistics.

109 Peter Quennell, ed., "London's Underworld: being selections from Those That Will Not Work,'" in Mayhew, 52.

110 Knight, 57.

111 *Lancet* I (1858), 346, as cited by Behlmer, 403.

112 Mrs. M. A. Baines, "A few thoughts concerning infanticide," *Journal of Social Science* vol. 10 (1866), 535, as cited by Marland, "Getting Away with Murder?" in Mark Jackson, 169.

113 Margaret L. Arnot, "The Murder of Thomas Sandles: Meanings of a Mid-Nineteenth-Century Infanticide," in Mark Jackson, 133.

114 Ryan, 20–1; also Rose, ch. 15.

115 Ryan, 53–62.

116 Foucault, *The History of Sexuality*, vol. 1, 123–5. Whereas Foucault focused on control regulations designed to curb homosexuality, it has been argued that this same vulnerability of the bourgeois might have easily found further cause for concern with abortions (Stormer, 8–10). I would add that this is certainly the case for venereal disease.

117 Contrasting "deployment of alliance" (constructs such as marriage) with "deployment of sexuality." Foucault, ibid., vol. 1, part 4.

118 Sauer, 81–93. See also Shorter, 191–9.

119 Andrew McLaren, "Policing Pregnancies: Changes in Nineteenth-Century Criminal and Canon Law," in Dunstan, 187–8.

120 Keown, 47–8.

121 Marleen Temmerman, Jean-Jacques Amy, and Michel Thiery, "Belgium," and Hans Skjelle, "Norway," in Sachdev, 49–50 and 380. For other Scandinavian statistics, see Potts, Diggory, and Peel, 383–5.

122 The Malthusian League, which sought to promote birth control as a safe alternative to abortion, was not successful in seeing abortion decreasing due to increased contraceptive use until after 1914. See Knight, 58–61; also Ledbetter. For a brief history of birth control efforts in the second half of the nineteenth century (including condoms, manufactured with the invention of rubber products by midcentury), see Gay, *The Bourgeois Experience*, 255–77.

123 Andrew McLaren, "Not a stranger: A Doctor: Medical Men and Sexual Matters in the Late 19th Century," in Porter and Teich, *Sexual Knowledge*, 267 and 271.

124 *British Medical Journal*, December 2, 1899, as cited by Knight, 59, n. 7.

125 *British Medical Journal*, March 10, 1906, as cited by Knight, 60.

126 Huysmans, *À Rebours*, 225.

127 Lionel Rose, "'Churchyard luck': Midwives and murder," ch. 10 in *The Massacre of the Innocents*.

128 *British Medical Journal*, December 21, 1895, as cited by Knight, 61.

129 Some municipalities and regional law accomplished this; in 1892 Munich's general law (Lex Heinze) was enlarged to cover both advertisement and display of contraceptives. See Maria Makela, "The Politics of Parody: Some Thoughts on the 'Modern' on Turn-of-the-Century Munich," in Forster-Hahn, 193.

130 Leroy-Allais, 11–15. See also Fox, 39–53, especially 45.

131 McLaren, "Policing Pregnancies," in Dunstan, 189–95. The Church law changes are listed (203).

132 Abortion information spread to poorer and illiterate women by means of what Rachel G. Fuchs and Leslie Page Moch call "invisible" cultures – washhouses, wells, and community spigots, where women could meet on their own. See their "Invisible Cultures: Poor Women's Networks and Reproductive Strategies in Nineteenth-Century Paris," in Greenhalgh, 86–107.

133 McLaren, "Policing Pregnancies," in Dunstan, 201, cites French perceptions in particular as an indictment of the middle-class abortion as a major cause for France's declining birth rate.

134 Knight, 58.

135 Ibid., 57.

136 There are several late-twentieth century studies on abandonment. See, for example, J. Boswell, *The Kindness of Strangers* (New York, 1988), M. Capul, *Abandon et Marginalité* (Toulouse, 1989), G. Damolin, *Nati e Abbandonati* (Bari, 1993), R. Fuchs, *Abandoned Children* (Albany, 1984), V. Hunecke, *I trovatelli di Milano* (Bologna, 1989), D. Laplaige, *Sans Famille à Paris* (Paris, 1989), D. Ransel, *Motthers of misery: Child abandonment in Russia* (Princeton, 1988), J. Robins, *The Lost Children: A Study of Charity Children in Ireland, 1700–1900* (Dublin, 1989); these are all noted by Kertzer, 1–41, and n. 8.

137 *Journal des mères* (December 1898), 3. There were actually two Belgian magazines called *Journal des mères* by 1901; this was the short-lived of the two (issued 1898–1900 only), the other being published by "Union des femmes belges contre l'alcoolisme," which ran 1901–34.

138 Kertzer, 14. The author here offers several alarming case histories, and cites statistics for cities in Italy, 21. In the 1890s, the besieged Foundling Hospital of Bologna decided that it would not send out any infants until they had reached their third month (and were symptom-free of syphilis); the 1898 medial report confirmed that of those who were by this act left to bottle-feeding for their first three months, 74 percent died before age one (40).

139 For a fuller study of the influences of Geneva cantonal and Swiss national politics on the work of Hodler, see Hirsh, "Hodler as Genevois, Hodler as Swiss," *Ferdinand Holder: Views and Visions,* exh. cat., 66–107. The Geneva Council law is discussed 82, and n. 43.

140 Adam, 390–3.

141 As in the article "Dénaturée"[meaning both unnatural and cruel], *Journal des mères* (July 1, 1901), 2, reporting a mother found "spread out, dead-drunk" while her two children starved.

142 See for example, George de Feure's female personifications of *Experience* (or *Vice*) and *Innocence* (or *Virtue*), both 1899 and published in *Le Figaro illustré* (Feb, 1900), in which *Experience/Vice* appears before a city setting, with a murder being committed on the street, and *Innocence/Virtue* is shown in the country. Ill., Millman, 56, pls. 39–40.

143 Godleski, 2.

144 Having adjusted to the small rural life of Laethem-Sait-Matin, Woestijne had just experimented with monasticism. Mertens, "Gustave van de Woestijne," 95.

145 His family was never fully accepted into the Swiss community of Maloja. Lüthy, *Die Welt das Giovanni Segantini,* 35–6.

146 See Léonard, "Eugénisme et Darwinisme," 147–50.

147 Also called *Love at the Source of Life* (Milan: Museum of Modern Art, 1896).

148 "Announcement of the New Words" (St. Moritz: Segantini Museum, 1896).

149 Several versions of this composition exist; see Quinsac, *Segantini. Catalogo generale,* 402–3.

150 Several versions exist; see ibid., 446–8. See also Segantini's *Consolation through Faith* (discussed in Chapter 4 of this book).

151 Already by the 1870s, images of illness in the city had begun to place an emphasis on the interventionary role of the family and physician. Frank Hall, a Royal Academician who was known for his sympathetic images of impoverished mothers, painted maternal responsibility as well as grief over the death of a child (*Her First Born,* 1872; *Hushed,* 1877). See also the numerous illustrations identified with this theme in the visual archives of the United States National Library of Medicine.

152 Several versions of this composition exist; see Quinsac, *Segantini. Catalogo generale,* vol. 2, 409–18.

153 See Quinsac, *Segantini. Catalogo generale,* 466–8, and ills., 467. Quinsac calls the motif Madonna of the barren tree, despite the fact that one of her examples, by Cavalier d'Arpino, shows a tree in full flower.

154 For an excellent discussion of this motif in Renaissance Florence and its relationship to women's roles in early capitalist society, see Margaret Miles, "The Virgin's One Bare Breast. Nudity, Gender, and Religious Meaning in Tuscan Early Renaissance Culture," in Broude and Garrard, 27–38.

155 Several versions of this composition exist; see Quinsac, *Segantini. Catalogo generale,* 449–51.

156 Jayne, 32. For Darwin's ideals, explained in his *Descent of Man and Selection in Relation to Sex* (London, 1871), see the thesis presented by Dijkstra. See also Eveleen Richards, "Darwin and the Descent of Women," in Oldroyd and Langham.

157 See Nochlin, "Léon Frédéric and *The Stages of a Worker's Life*," in *The Politics of Vision*, 133. Although Nochlin says that the woman "has fallen asleep nursing her child in the barn side by side with the cow nursing her calf," the calf is merely asleep, and the mother must have fallen asleep after (or not) nursing, because she is fully dressed.

158 Sherrif.

159 Barker, 257–8.

160 Ibid., 261 and 292.

161 As Segantini wrote (at the time of *The Two Mothers*), "When an animal bears an offspring, a possessive love for the newborn develops within it, and love acquires a second level of beauty, the most beautiful of beauties, the sentiment of maternal love." As cited by Budigna, 101.

162 Lemonnier, "Peintres de la Femme," 377–80.

163 Matthews, 69, 100–11, and 130–1. Matthews (115) even notes scholarly interest in the phenomenon: a pamphlet published in 1898 by J. P. Taintor titled "The Evolution of the Madonna."

164 Anonymous, "Champ-de-Mars," *L'Art moderne* (12 June 1892) year 12, nr. 24, 186.

165 Claude Roger-Marx, "Eugène Carrière," *Mercure de France* (June 1891), as cited in French by Matthews, n. 328.

166 Marius, 97–99.

167 Nursing came to be a major signifier of the mature time of a woman's life, not only in medical literature but also in imagery. See, for example, Auguste Donnay, *The Three Ages of Life,* triptych, 1889 (Tiliff, City Hall). Ill: *Splendeurs de l'Idéal,* exh. cat.

168 As in Degas' *A Carriage at the Races* (Boston: Museum of Fine Arts, 1869) in which the nursing woman in the carriage is clearly the wet nurse/nanny, not the upper-class mother who checks on her progress, as the baby falls asleep.

169 Anonymous, "Congrès Féminins: Ce que pensent les Vaches," *L'Art moderne* (September 19, 1897), 303.

170 Review, in *Pages amies* May 1908, 47 (extract without other reference from the Fonds O. Maus. Donation Van der Linden. A. A. C. B. Dossier 1908], reproduced and cited in *Les XX; La Libre Esthétique,* exh. cat. entry 550.

171 Little is known of Bouten (1870–1895), who lived and worked exclusively in Amsterdam. I am grateful to Rob Smolders, director of de Wieger Museum, for this information.

172 Pollock, "The Dangers of Proximity," 1.

173 Bordo, 208 and 335, n. 31.

174 At least two painted versions of this composition exist; see Quinsac, *Segantini. Catalogo generale,* 476–481.

175 There has been much confusion about the poem source of this work; it is often simply listed as the Indian *Pangiavahli* itself (see, for example, Fiorella Minervino, "Les mauvaises mères (châtiment des mauvaises mères ou Les Infanticides," in *Symbolisme en Europe,* 208). It has also been called a translation of the poem by Illica; what is certain is that Illica's poem "Nirvana" was popular in Italy at the time of Segantini's work; Illica is also claimed as a friend of Segantini by Friedrich Gross, "Die bösen Mütter," in *Eva und die Zukunft,* 249. As Kate Flint, "Blood and milk: painting and the state in late nineteenth-century Italy," in Adler and Pointon, 114, points out, "Nirvana" contained the phrase 'la Mala Madre,' which echoed the common phrase 'la mala femmina' or prostitute. It should be noted that this is a different phrase from that of "Cattive madre," interestingly a phrase in Italian that specifically means "bad mothers."

176 Flint, in Adler and Pointon, 114.

177 Ibid., 118. According to Lombroso and Ferrero, these crimes forged yet another link between the woman and animals (119).

178 Ritter, 308.

179 Laermans did several youthful drawings based directly on Rops compositions, including *The Temptation of Saint Anthony* and the *Satan Sowing* series. Ill: Draguet, *Eugene Laermans,* 79–82.

180 Eggermont, 29.

181 Ibid., 29–30.

182 Draguet (71) relates this image to both Notre Dame and specifically to the Rops image of Satan sowing weeds.

183 It is difficult to determine precisely the size of the coffin due to the distortions and exaggerations of size elsewhere in the composition. If the length of the coffin is compared with the portal – itself outsized – then it might be that of an adult; if compared to the figure of the woman, however, it is definitely child-sized.

184 Dr. Edouard Toulouse, in *Les Causes de la folie* (1896), named "low voices, hirsute bodies, and small breasts" as primary symptoms of "degenerate women" who were no longer feminine, as cited by Barrows, 49–50.

185 This argument is concisely summarized by Widge, 38–50.

186 Draguet, "L'Eden et le progres," in *Khnopff,* 80–1.

187 A speech on the subject was offered by Robert Stellwagen at the lunch held November 13, 1892. See Siebelhoff, "Jan Toorop and the Year 1892," 90.

188 This reading is that of Zemel, "Sorrowing Women," 357.

189 Siebelhoff, *The Early Development of Jan Toorop,* 64.

190 Translation and citation by Siebelhoff, *The Early Development of Jan Toorop,* 67.

191 Marijn Schapelhouman, "Net-menders," in *Van Gogh to Mondrian. Dutch Works on Paper,* 120.

192 Several works of the 1890s are devoted to images of the beach, often with children playing on them; numerous village scenes were the subject of Toorop's prints of the late 1890s. See, for example, *Village Houses,* drypoint, 1897 (Fogg Art Museum).

193 Siebelhoff, "The Three Brides," 213, has related *Katwijk* to *The Three Brides* by virtue of its connection to Ms. Van der Schalk (who appears in *The Three Brides* and to whom *Katwijk* was given by Toorop) as well as by means of this centralized small grouping surrounded by other activity to either side and in the background.

194 Kalidasa, 58, 60, 76–7.

195 The article was by Maurice Frison and told the usual tale of an unhappy aristocrat's son who inherited the family secret of "lust," uncontrollable by humanity, that would be his doom. See *La Basoche,* 14–20.

196 As Siebelhoff has clarified, Toorop wrote on at least three occasions his interpretation of *The Three Brides:* in a letter to Octave Maus (in which he describes the drawing as part of a "cycle" of work but discusses only his use of pattern and design for emotional impact), in a letter of June 1894 (in which he does attempt a definition of symbols), and in a much later (variously dated 1904–1910) written explanation that offers a Catholic interpretation. In addition, his friend Jan Veth wrote an interpretive article, presumably based on discussions with the artist, for the drawing's first exhibition ("De Drie Bruiden: een teekening van Jan Toorop," *De Nieuwe Gids* 8, part 1, no. 3 [February 1893]: 432–34). When Veth's article was reprinted in *Die Kunst für Alle,* vol. IX, issue 3, November 1, 1893, it openly acknowledged that these were the artist's ideas. See Siebelhoff, "The Three Brides," 226–38. The original Veth article, translated into English by Josina Van nuis Zylstra, is reproduced in Siebelhoff, "The Three Brides," 257–9.

197 Siebelhoff, "The Three Brides," 233.

198 Jan Toorop, letter written from "Villa Libau," Beeklaan, The Hague, June 24, 1894 (Archives of the Rijksmuseum Kröller-Muller, Otterlo), as cited by Siebelhoff, "The Three Brides," 233. See his n. 48, p. 252. The full letter is reproduced, translated by Siebelhoff, 259–61. It should be noted that this letter, reproduced in part in Dutch in *J. Th. Toorop. De Jaren 1885 tot 1910.* exh. cat. (Otterlo: Rijksmuseum Kröller-Muuller, 1979), 41, was cited by means of a few phrases and trans. by Goldwater, 51, and repeated in West, 95; these phrases' translations are very unlike the full translation of Siebelhof, however, which seems closer to the original Dutch.

199 Biermé, 8, 100.

200 According to a passage underlined by Toorop; see Siebelhoff "The Three Brides," 225, as well as Toorop's own *Disintegration of Faith,* in which the "mire" of materialism is clearly responsible for the destruction of religion.

201 Toorop letter (see n. 181). On this matter, Siebelhoff questions whether the houses are "a sign of modern progress" or "the spiritual death of modern times"; I agree with the latter interpretation. See Siebelhoff, "The Three Brides," 252–3, n. 50.

202 Toorop letter (see n. 196 of this chapter), reproduced Siebelhoff, "The Three Brides," 260.

203 See Siebelhoff, "The Three Brides," 238–40. Although Siebelhoff characterizes this wedding gift (for painter Floris Verster and his bride Jenny Kamerlingh Onnes) as a "friendly guide for the newly-wed couple," he does not offer my earlier interpretation.

204 Toorop letter (see n. 196), reproduced in Siebelhoff, "The Three Brides," 260.

205 Siebelhoff, "The Three Brides," 239, cited and trans. by him from *Paintings and Drawings by Jan Toorop. The Hague* exh. cat. (Artibus Sacrum, Logegebouw, Rijnstraat, Arnhem, June 1894).

206 Siebelhoff, "The Three Brides," 253, n. 52.

207 Janet Wolff, "Reinstating Corporeality: Feminism and Body Politics," in *Feminine Sentences,* 130 and 124, as cited by Patricia Mathews, 117.

208 Jordanova, 55.

209 Ibid., 89. She cites Leo Steinberg, 147–8. Jordanova's example of the "unveiling" is the well-known sculpture by L. Barrias (1899; Musée d'Orsay, Paris). See also Kessler.

210 Ludwig Hevesi, as cited by didactic, *Art Nouveau* exhibition (Washington, D.C.: National Gallery of Art).

CHAPTER 6

1 Anonymous, "Xavier Mellery," 1.

2 Anonymous, "La Regne du Silence," 140.

3 Ibid.

4 See Freud, 354, and 360–1. This connection was reiterated, with an emphasis on the top hat as phallus symbol as defense against castration by J. C. Flügel, *The Psychology of Clothes* (London, 1930, 105), as cited by Garb, 38.

5 By this time, it was increasingly possible to have separate bedrooms for the husband and wife in most upper-class newer homes, in emulation of aristocratic practice; rarely would there have been, however, a "gentleman's room" in modest homes such as that of Mellery's drawing. See Eleb and Debarre, ch. VI: "La Chambre," especially 143–53.

6 Foucault, "The Eye of Power," in Colin Gordon, 149.

7 Donald Friedman, "Belgian Symbolism and a Poetics of Place" in Goddard, 126.

8 Rodenbach, *Règne du Silence* 1891, in *Oeuvres.* Khnopff's *Isolation/Solitude,* (1894) *Silence* (1890), (both Musées Royaux des Beaux-Arts de Belgique, Brussels); *Secret* (1902, Groeningemuseum, Stedelijk Museum voor Schone Kunsten).

9 Newnham-Davis, 88.

10 Friedman, in Goddard, 126. Remouchamps is quoted from the January 1894 issue of *Le Réveil,* 25.

11 Stewart, 28–9.

12 Patricia Mathews (11–14) discusses the notion of "l'isolé" in French Symbolist criticism as a need to reject material life and to seek out inner strength. The term used for Van Gogh by Aurier, however (in 1891), was not appreciated by the artist because of its problematic positing of the artist as hermit (which the Symbolists were not).

13 In this respect, I am disagreeing with most past assessments of Symbolism that consider the elitist rhetoric of the artist as priest or seer, as a key to "disengagement" from and disdain for the middle class person. See, for example, Patricia Mathews, who while admitting the Symbolists' protests against the middle class was "illusory"(45), maintains nevertheless that Symbolism held

an ideology of disengagement (13–15) and elitism (21). Although the Symbolists do rail against the business and commerce types of the new metropolis, it is exactly these individuals who are, for the Symbolists, still capable of reviving individualism.

14 See Creese, 299–314 for the significance of these two models and their dissemination throughout western Europe. See Ogata, 64–5 for the Belgian importance of owning a detached, individual home.

15 See discussion, Chapter 5.

16 Ruskin, *Sesame and Lilies,* 108.

17 Richard Sennett, *The Conscience of the Eye,* 21. A history similar to that traced in this chapter, identifying the late-nineteenth-century development of separated spaces in homes (which will be discussed later in this chapter) and attention to interior design as a consequence of seeking an order and calm no longer found in city streets, has been made by Sennett, 5–21 and 24–8. Sennett cites this fin de siècle phenomenon, however, as part of a longer history of segregation of spiritual and secular places, and of inner versus exterior spaces that was encouraged primarily by Christianity (9–19) and which continues today, with the increase in solitude a "perverse consequence" of such a history (29). Ultimately, he considers the need for "secular sanctuary" – his example is not middle-class but rather working-class tenements, specifically the "railroad" style of interiors with doors to separate spaces leading to one long corridor – a failure because it maintained, rather than dissolved, class differences within the home (28). Sennett's interests lie in the psychology and sociology of such developments, whereas my interests are primarily in the depictions of these new sacred interiors – which in their representation offer the "perfect solitude" to the viewer – regardless of class; in this respect, the Symbolist portrayals of the interior as interiority are, of course, idealizations for the Symbolist goal of providing in art the refuge that so many felt lacking. For the idea of switching from sacred to secular spaces in the nineteenth century, see also Houghton, 347, and Matthews, 105.

18 Anonymous, "Exposition du cercle artistique," 127.

19 Verhaeren ["e.v."], "Silhouettes d'Artistes" (Oct. 10, 1886), 323.

20 Howe, *The Symbolist Art of Fernand Khnopff,* 122.

21 Vanhamme, 16 and n. 7.

22 Many early biographers imply that Mellery never moved from his parents' house; see, for example, Goffin, 6. The move is reported, however, in Stevens and Hoozee, 174 and 178.

23 Mellery, 366.

24 Anonymous, "La Décoration du Palais de Justice," 402.

25 Vanhamme, 19, establishes that Mellery was at Marken for a longer time than most accounts allow.

26 See Vanhamme, 21–3, for a discussion of this project. This book (published 1887) appeared in serial form in the *Tour du monde* between 1881 and 1884.

27 Anonymous, "Décoration du Palais," 402–3.

28 This is another quote cited by most of Mellery's biographers. One citation that offers the source is Hellens, 9.

29 Goffin, 2 and 6.

30 Goffin, 8; see also Hellens, 5.

31 Goffin (8) cites Mellery's writing in the *Ligue Artistique* with no additional bibliographic information.

32 Goffin, 11.

33 Hellens, 9.

34 Paul and Luc Haesaerts, n.p. The notion that Mellery suffered from neurasthenia has continued to the present day: see Danielle Derrey-Capon, "Un étrange et obsédant Silence," in Vahamme, 85.

35 The group met informally at studios rented (from the manufacturer of art supplies Félix Monnier) by several of the artists (including Mellery) on the rue de la Charité at St.-Josse-ten-Noode. See Vanhamme, 13, and n. 1.

36 See Vanhamme, 18 and n. 11.

37 Lemonnier, "Xavier Mellery," 425.

38 Octave Maus, *Trente années de lutte pour l'art 1884–1914* (Brussels: L'Oiseau bleu, 1926), 194; see also Vanhamme, 35.

39 Jules Destrée, in *La Jeune Belgique,* 1889, 211, as cited by Stevens, 176.

40 Sarah Faunce, "Seurat and 'the Soul of Things,'" in *Belgian Art 1880–1914* exh. cat., 50. As Faunce points out in her excellent study, Verhaeren was early associated with the *Jeune Belgique* and would in any case have been a regular reader of this leading literary magazine in Brussels (50); Vanhamme, 34.

41 See *La Jeune Belgique* 6 (1887), 335–44.

42 Verhaeren, "Aux XX," 34.

43 Perrot, 343.

44 François Bédarida, "La Vie de quartier en Angleterre. Enquêtes empiriques et approaches théoriques," *Le Mouvement social* I (1982), 14, as cited by Perrot, 361.

45 For discussion of the socialism-based role of Art Nouveau in interior design, see Ogata, 18–20, and all of her ch. 1.

46 See especially Ruskin, "The Nature of Gothic."

47 Eastlake, 18.

48 Morris, "Lesser Arts," in *Hopes & Fears,* ch. 1.

49 As Lesley Hoskins points out, Eastlake's *Hints on Household Taste* (1868) was a costly sixteen pounds; later books such as *Suggestions for House Decoration in Painting, Woodwork and Furniture* by Agnes and Rhoda Garret (1876) or *The Drawing Room* by Lucy Orrinsmith (1877) cost less than three pounds each and "were clearly intended for a much wider readership." See Gere and Hoskins, 109–110.

50 Henry Van de Velde, lecture given to the Libre Esthétique, Brussels, 1893, and published as a booklet titled *Déblaiement d'art* (1894) as reprinted and trans. by Dorra, 123.

51 Susan Canning, "'Soyons Nous' : Les XX and the Cultural Discourse of the Belgian Avant-Garde," in Goddard, 43. She cites in particular *L'Art moderne* (August 12, 1883), 253.

52 Stevens and Hoozee, 279 and 282.

53 See Ogata, 75 and n. 85.

54 Canning, in Goddard, 44.

55 These included *L'Art appliqué* in Brussels, *Art et décoration* in Paris, *Dekorative Kunst* in Munich, *Deutsche Kunst und Dekoration* in Darmstadt, and *The Dome* in London. See Stevens and Hoozee, 283.

56 Schaffer. See also Draguet, *Khnopff.*

57 Thornton, 312. Thornton claims, however, that the craze for antiques was prevalent only in England and North America (312–13); this seems disproved by the thriving markets in areas such as Belgium, as noted in the text.

58 The illustration, signed "M. Hagemans, 1885" appeared in the *Le Globe Illustré* III, no. 40 (July 1, 1888).

59 See, for example, George Le Feure's *Bruges mystique et sensuelle,* a c. 1898 album of lithographs, published by *La Plume,* depicting the various sites and sensations of the dead city. One print is "the Flea Market," depicting two sellers and one well-dressed lady buyer; wares include an old trunk and mostly old pottery, glassware, and silver.

60 See "Soziologische Aesthetik," *Die Zukunft* 17 (1896): 204–16, and "A Chapter in the Philosophy of Value," translated into English in *The American Journal of Sociology* V (1900): 577–603; both reprinted in Etzkorn, 47–67 and 68–80. The latter essay is close in content to Part II of ch. 1 of the 1907 edition of Simmel's *Philosophie des geldes.*

61 Simmel, "A Chapter in the Philosophy of Value," in Etzkorn, 56.

62 The health issue was debated, primarily by climatotherapists who found the air to be too warm and wet. See Rees, 156–7.

63 For greenhouses and the nature-light trend, see Eleb and Debarre, ch. XI "L'Extérieur Intériorisé," 251–87. See also the fascinating discussion of flower cultivation in the late nineteenth century in Draguet, *Khnopff,* 65–9.

64 By the master architect of greenhouses, Alphonse Balat.

65 Sennett, *Flesh and Stone,* 343–8.

66 Rodenbach, "Sweet is the room . . ." trans. into English and reprinted in French by Friedman, 32–3. As Sennett, *Flesh and Stone,* points out, even defecation had become a comfortable, private occupation, with separate baths and toilets that included cup and newspaper holders (343).

67 Sennett, *Flesh and Stone,* 340.

68 Trachsel, *Quelques réflexions,* 49, complains that even in country houses, fresh healthy air is not allowed in, as in past (saner) times, because it is the fashion, according to contemporary hygenists, to have them closed.

69 "German Domestic Architecture, and Its Influence on the Social Condition of the Country," translation in *Builder* 11 (1853), 598, as quoted by Olsen, 102.

70 For example, moving beds from the common room to separate the bedrooms was one of the first eighteenth-century interior home modifications.

71 Kerr, 67–8.

72 Ibid., 114.

73 The fireplace has also been related to Christian Symbolism for the Virgin as well as the Victorian illustration of the work-at-home woman. See O'Meara, 75–88, and Casteras, *Images of Victorian Womanhood,* 50–63.

74 Several examples of these are illustrated in Gere and Hoskins.

75 See Aisenberg, ch. 4. Aisenberg claims that this renewed emphasis on the home (started by hygenists themselves during the cholera epidemic of 1832) was in part prompted by a defense of Haussmann's sewer system – now implicated as a possible disease-carrier – and thus all of the public works accomplished in the late nineteenth century. As the Parisian engineer Marie-Davy, himself involved in public sanitation works, came to concede in 1885, "It is necessary [above all else] to purify the dwelling where our wives and children live." (Marie-Davy, in a speech given at a March 25, 1885, meeting of the Society of Engineers, minutes reprinted in *Revue d'hygiene* 7, 1885, 337, as cited by Aisenberg, 109).

76 See, for example, the discussion of the "International Health Exhibition" held in London in 1884, which included tours of the "insanitary house" followed by a tour of the "sanitary house," in which everything from safety factors to building materials and ventilation were on display, in Adams, chs. 1 and 2.

77 Tim Hiles, "Gustave Klimt's *Beethoven Frieze,* and *The Birth of Tragedy,*" in Kemal and Gaskell, 176 n. 1. Hiles cites Klinger's *Malerie und Zeichnung,* a portion that was reprinted in the fourteenth exhibition catalogue of the Vienna Secession. He also cites for the idea of Raumkunst and the exhibition design of the Vienna Secession that year Josef August Lux, "Klinger's Beethoven und die moderne Raum-Kunst," *Deutsche Kunst und Dekoration* 10, 1 (1902), 475–518.

78 Mellery's drawings established prototypes for numerous other Belgian artists throughout the turn of the century; see, for example, the work of Georges LeBrun (1873–1914), *Interior: A Man Passing through* (1900), in *Belgian Art 1880–1914,* exh. cat., 115. Other examples, as distant as Norway, prove the ubiquity of this motif. In Asor Henrik Hansen's 1904 *Lamplit Interior* (Bergen: Rasmus Meyers Collection), the prints and paintings on the wall of this deserted hallway of a bourgeois home take on significance far beyond their artistic merit. *The Staircase in the Rosendahl Manor* of 1903, by Marcus Grønnvold (Bergen: Rasmus Meyers Collection), takes the netherworld of the stairway (leading to higher "purer" air) of a well known baroque mansion a few hours south of Bergen and transforms it into an area of warmth, shadow, and meaning.

79 Silverman, *Art Nouveau,* 79.

80 See Bergdoll, ch. 9.

81 Vischer, 3.

82 Vischer, "Uber das Optische Formgefühl," in *Drei Schriften zum ästhetischen Formproblem* (Halle, 1927; orig. pub. 1873), as cited by Van de Ven, 79–80.

83 Van de Ven, 80.

84 Vischer, 43.

85 Maeterlinck.

86 Cézanne, 71 ff.

87 Jamme, 36.

88 Rainer Marie Rilke, "Briefe" (Weissbaden, 1950), 816f and 898f., as cited by Jamme, 36.

89 The philosophy of Vico, published in his *Scienza nuova* (1725 and 1730), but little known in his own time, was reappreciated by nineteenth-century philosophers such as Benedetto Croce (see his *Die Philosophie Giambattista Vicos*. Tübingen, 1927); he has even been called "the father of sociology." See Barasch, 7–16.

90 Schnog and Pfister, Introduction, 3–62.

91 Richard S. Lowry, "Domestic Interiors: Boyhood Nostalgia and Affective Labor in the Gilded Age," in Schnog and Pfister, 119.

92 T. J. Jackson Lears, *No Place of Grace*, 146, as cited by Lowry, in Schnog and Pfister, 119.

93 For a beginning list of articles addressing the painting, see the literature entries in Delevoy, DeCröes, and Ollinger-Zinque, *Fernand Khnopff*, 263–4.

94 Morris, *News from Nowhere*, ch. XXXI, 218.

95 Ibid., ch. XI, 166.

96 Verhaeren, "Les XX," *La Nation* (February 12, 13, 17, 1892), as reproduced in Aron, *Emile Verhaeren*, 521.

97 Georges Rodenbach, "The chamber, sad and weary . . ." ("La chambre triste et lasse . . .") from *The Enclosed Lives* (*Les Vies Enclosés*), 1896. Trans. and reproduced in French by Friedman, 20–1.

98 For a listing and an analysis of the various interpretations of this object, see Howe, *The Symbolist Art of Fernand Khnopff*, 106.

99 Verhaeren, "Conte Gras," in *Contes de Minuit*. See also the Frontispiece by Théo Van Rysselberghe (Bibliothèque Royale Albert 1er, Cabinet des Estampes, Quarto S iii 46148), in Goddard, 361.

100 Rilke, *Brigge* 38.

101 Ibid., 35–6.

102 Ibid., 68.

103 Hamsun, 37.

104 As Des Esseintes was known to repeat, "Nature has had her day; she has finally exhausted, through the nauseating uniformity of her landscapes and her skies, the sedulous patience of men of refined taste." "Artifice," however, "was the distinguishing characteristic of human genius." Huysmans, *À Rebours* 20.

105 Huysmans, *À Rebours*, 69.

106 See, for example, White, xvi.

107 About a friend, later enemy Léon Bloy, Huysmans later referred to his child as "the miserable fetus issued from his repugnant sperm," Lettres to Prins, September 3, 1888, cited by Lloyd, *J.-K. Huysmans*, 2.

108 Segantini, the father of four, never formally married his common law wife; Hodler married twice and had two children, neither of whom was mothered by his wives.

109 Canning, "In the Realm of the Social," 79.

110 This observation is well made by Hausen, 64–5.

111 K. Biedermann, *Frauen-Brevier, Kulturgeschichtliche Vorlesungen* (Leipzig, 1856), as cited and trans. by Hausen, 79 n. 49.

112 Rilke, *Aufzeichnungen*, 37–38.

113 This was Ekely, named by the previous owner, a horticulturist who left the property beautifully landscaped with gardens and fruit trees.

114 Loosli, vol. I, 220.

115 Poe, 102.

116 This is clear from Ensor's listings of categories as he would like to have them exhibited, or published. See, for example, letter to Rodenbach July 31, 1898 (Ostend), reproduced in Ensor, *Lettres,* 662.

117 Full identification of the various works in the painting can be found in Dorine Cardyn-Oomen, "Mein Lieblingszimmer," in *James Ensor. Belgien um 1900,* exh. cat., 118.

118 Ensor suggested, at a time when he was set against Whistler being admitted to Les XX, that Braekeleer, "if you absolutely want someone old," be taken into the group instead. See letter November 1886, reproduced in Legrand, "Les lettres de James Ensor," 25–26.

119 Ensor's first address was 21 Rampe de Flandre, Ostend. It was not until 1917 that Ensor moved into his last house, at Vlaanderenstraat (Rue de Flandre, as Ensor signed his letters) 27, inherited from his uncle who had kept a souvenir shop in it. This is now the Ensor Museum in Ostend.

120 See Marshall, 47.

121 Anonymous, "Bois de Cambre," 122.

122 Comparison of Pelseneer's contemporaneous but traditional designs with Khnopff's avant-garde Villa has been made by Howe, *The Symbolist Art of Fernand Khnopff,* 144. For my discussion here, I have relied extensively on Howe's ch. 9 ("The Palace of Art: Khnopff's Villa"), as well as the reconstruction efforts of Patrice Neirinck for the Khnopff catalogue raisonné (see Delevoy, DeCröes, and Ollinger-Zinque, *Fernand Khnopff,* 1979). See also Draguet, *Khnopff,* 337–48, and *Fernand Khnopff et ses Rapports,* exh. cat., 106–11, both of which also illustrate photographs and plans.

123 Howe, *The Symbolist Art of Fernand Khnopff,* 143.

124 Draguet, *Khnopff,* 339–41. Khnopff authored an article on Hoffmann, just as his house was being built, for *The Studio* (May 1901).

125 Laillet, 201.

126 Howe, *The Symbolist Art of Fernand Khnopff,* 145, recounts the collecting of turtles, and bronzed turtles, as an aesthete's fad in the 1890s (Gustave Moreau as well as Sarah Bernhardt owned one).

127 Maria Biermé, *Les Artistes de la pensée et du sentiment,* 31.

128 Laillet, 202.

129 For a reconstruction of the dining room, see Patrice Neirinck's (Archives d'Architecture Moderne, Brussels) drawings, in Delevoy et al., 50–1. It should be noted that the dining room in middle- and upper-class houses was, around 1900, still a fairly flexible room, often serving as "salon" as well as eating area, so that the table was often placed to one side of the room until needed. It was rarely, however, completely removed so that the room retained no reminder of its practical nature. See Monique Eleb and Anne Debarre, the chapter "L'évolution du statut de la salle à manger," 106–37.

130 Howe, *The Symbolist Art of Fernand Khnopff,* 148 notes that the idea for these "altars" may have come from Franz von Stuck's villa, known for its "Kunstleraltars."

131 Khnopff's phrase, as quoted with an explanation of the ritual, by Josef Engelhart, *Ein Wiener Maler erzäht. . . . Mein Leben und meine Modelle* (Vienna: 1943), as cited by Howe, *The Symbolist Art of Fernand Khnopff,* 148, and Draguet, 344–5. Engelhart's article is translated into Dutch and reproduced in *Fernand Khnopff et ses rapports,* 164.

132 Howe, *The Symbolist Art of Fernand Khnopff,* 149, has called this arrangement a kind of "familial altar," since the table below the painting holds a vase with a flower and a tennis racquet, an obvious reference to his sister's role as sole model for the six figures in *Memories.*

133 Biermé, "Fernand Khnopff," 112.

134 Two tramways were built as part of the development; one line led to Brussels center from each entrance-exit of the woods plan. Anonymous, "Bois de Cambre," 122.

135 This drawing has been ascribed a variety of titles, but the one here is that of the 1889 check list (no. 89 of *Société royale belge des Aquarellistes. Vingt-neuvième Exposition annuelle,* Brussels), as cited by Vanhamme, 89, n. 7.

136 Lent, 8, and Thornton, 319. For a survey of domestic lighting developments in the late nineteenth century, see Eleb and Debarre, 399–401; also Rybczynski, 138–43.

137 Thornton, 319.

138 Maus, 194.

139 Stewart, 29.

140 Baudrillard, *Le Système des Objets,* 43, as cited by Stewart, 29.

141 I refer here to Bakhtin's theory of the crowd and carnival, as outlined in his *Rabelais and His World;* see ch. 3, n. 84.

142 Henri Matisse, "Notes d'un peintre," *La Grande Revue* (Paris), 25 December 1908, as trans. and reprinted in Harrison and Wood, 76.

143 Charles Baudelaire, *Salon de 1846,* in *Curiosities esthétiques,* 78–9. See Levine, 139, and Masheck, 97; also Roger Benjamin, 208–9.

CHAPTER 7

1 Lowenthal, 25.

2 Lowenthal, 96–7. The author considered the British by this time to have "consummated the ancients-moderns distinction [of seventeenth-century academic battles] between forward-looking sciences and backward-looking arts" (102).

3 Nietzsche, *Use and Abuse of History,* does believe that in some ways "history can serve life" (22), but finds most of what one knows of the past worth forgetting, especially for the "modern man" who has too much history (23). One of Nietzsche's main concerns was the devotion to the past that prevented action in the present: if one (an antiquarian) has an "insatiable curiosity for everything old," then he hinders his own impulse to any new deed and is therefore paralyzed (20–1).

4 The full title contains a homage to *Grégoire Le Roy* (1862–1941), a Belgian Symbolist writer.

5 Lowenthal, 49.

6 Thomas Hardy, *A Laodicean* (1881), 3:202, as cited by Lowenthal, 49.

7 Olof Sager-Nelson (1868–96) was the first Swedish artist with Symbolist leanings to visit Bruges, in 1894; he was completely overcome by the melancholic, mood-inducing atmosphere of the already well-known medieval canal city. He therefore served as an important link for colleagues in the new appreciation for Visby. See Facos, especially ch. 2. I am grateful to Professor Facos for her helpful information about Visby and its connection to Bruges, in "Olof Sager-Nelson and Symbolist Bruges," unpublished ms., 1998.

8 Letter to Paul Schultze-Naumburg, February 1899, reproduced in Delevoy, DeCroës, and Ollinger-Zinque, *Fernand Khnopff* (Brussels), 27. Translated by Ollinger-Zinque, 111.

9 These are reproduced in Delevoy, DeCroës, and Ollinger-Zinque, *Fernand Khnopff* (Paris), 430.

10 Sennett, *Flesh and Stone,* 324–5.

11 Rodenbach, *Bruges-la-Morte,* 1986, 8.

12 Rodenbach, *Bruges-la-Morte,* 1986, 1.

13 Ibid.

14 Simmel, "Die Grosstädt," trans. by Kurt H. Wolff in Harrison and Wood, 130–5.

15 Anonymous, "Récréations populaires," *L'Art moderne* (June 28, 1891) 11.26, 205.

16 Mosley, in Rodenbach, *Bruges-la-Morte,* 1986, vi.

17 Rodenbach's *Le Mirage. Drame en 4 actes* was published in Paris in 1901. The German theater of Berlin production opened September 15, 1903, as noted by Pudles, LXXIV, 4, 638, n. 6.

18 This emphatic Belgian interpretation can be instructively compared to the images of Bruges by the French artist Georges de Feure (*pseud.* Georges Joseph van Sluÿters), the son of a Belgian mother and Dutch father, who seems to have first come to know Bruges on a trip to Belgium in order to exhibit with the "Pour l'Art" exhibition in Brussels in 1895. He subsequently produced paintings based on *Bruges-la-Morte* that were true depictions of the narrative action of the story.

When he returned to Bruges in 1896, it was in part to produce illustrations to Rodenbach's *Petites Nocturnes de Bruges* (published in the Parisian *L'Image* in May 1897). At the same time, he made an album of lithographs titled *Bruges mystique et sensuelle* (published by *La Plume* 1898–99). As Millman has argued (77) the album does not simply address the "silent city" of the Belgian Symbolists. Rather, two sides are shown, the "mystical" place encouraging reverie and the "sensual" city with "concrete, material elements" such as a flea market and a view of prostitutes awaiting their clients at the foot of a Bruges bridge. In all of these, however, human action and interaction is central to the narrative presented. De Feure, although captivated by the medieval appearance of Bruges, never fully interpreted it as the "dead" city.

19 *Bruges* (three drawings), c. 1892. Charcoal, graphite, pen and black ink (Spencer Museum of Art, Spencer Fund 89.69 –71) in Goddard, 283.

20 du Jardin, 98, cited in *Les XX. La Libre Esthétique.* exh. cat., 286.

21 Dumont, 1.

22 Coiseau, 2.

23 Denduyver and J. Marechal, 19.

24 Colette (*pseud.*, Eugene Landoy), 1847, as cited by Marechal and Denduyver, 15.

25 Ibid.

26 Rodenbach, *Bruges-la-Morte*, 1986, 8.

27 Newnham-Davis, 88.

28 Omond, 35.

29 Ibid., 37.

30 Tombu, 93.

31 An excellent list of all prior sources that interpret the city as being invaded, or swallowed up by the sea is offered by Pudles, 641, n. 23.

32 Ibid., 641.

33 Van Houtryve, 25. This exhaustive list establishes the steady publications beginning 1878 and increasingly through the opening of the port, but peaking in the late 1890s, in Brussels as well as small town presses.

34 Coiseau and Cousin, 3.

35 Marechal, in Denduyver and Marechal, 33.

36 Ibid., 51.

37 de Maere-Limnander, 1.

38 See, for example, the pamphlet-length report of the two engineers, Coiseau and Cousin. See also the full bibliography of public letters and pamphlets in Denduyver and Marechal, 149–57, which includes twelve such publications by de Maere alone.

39 Marechal, in Denduyver and Marechal, 57. "Je sais que vous êtes l'auteur d'un très beau livre, Bruges-la-Morte. Eh! Bien, soyez tranquille, ce ne sera pas longtemps Bruges-la-Morte: nous allons mettre des tramways et de la vie là dedans." Unfortunately, in an otherwise well-researched and cited study, this quote is given without a noted source. This story has been also cited, with a reference to Rodenbach's *Le Carillonneur,* by Marechal in a short note "Memling als Symbool," 125.

40 Coiseau, 40.

41 Ibid., 43.

42 *Liederen,* n.p. (collection of songs).

43 Omond, 81; also Denduyver and Marechal, 74. Netherlandish painting was a topic about which Khnopff wrote and lectured.

44 Marechal, "Bruges Painting and Europe," 381.

45 Ill.: Denduyver and Marechal, 51.

46 The photograph was by Henry Gecele, intended to show a typical indigent of the struggling city.

47 Anonymous, "La Presse."

48 The same insignia is worn by the female figure of the city as she appears in *Homage* by Rousseau, discussed later.

49 It is listed as 4.5 meters in a commentary to a photograph of the work, *Le Globe Illustré* (vol. IX no 18, May 5, 1894), 273.

50 Pickery, 134. For a full listing of the people most involved in the project in the 1890s, see Coiseau, 9.

51 *Le Globe Illustré,* 1894, 280.

52 The sculpture was one of many tributes carried through the Bruges streets on the occasion of the opening of the new canal; from there it returned to a place of honor in Pickery's studio; but upon the sculptor's death, it went to the Hotel, and to its destruction. Letter from Rev. Karel Pickery to the author, November 21, 1996.

53 A full description and identification of portraits is given by Pauwels, entry 262, 212–13. The portrait identifications are also listed on the back of the four side panels.

54 Van Hecke and Langui, 32.

55 Ironically, this transformation into modernity did not occur rapidly. The first huge hotel for Seebrugge opened in 1914, on the eve of a financially disastrous and physically damaging World War. Restoration had only been recently completed in time for the economic troubles of the 1930s, and the port's problems continued through World War II. Zeebrugge only began to be the major European port that its planners had intended in the 1960s, with further work to remove built-up silt. In 1990, it handled more than 30 million tons of goods. See Marc Ryckaert, "Bruges, a European Port," in Vermeersch, 29–30. Today it is home to the Seafront Zeebrugge Maritime Theme Park.

56 Duncan in Rodenbach, *Bruges-la-Morte,* 1903, 13–14.

57 Ibid., 14–15. Howe, in his "Fernand Khnopff's Depictions of Bruges," 158–69, accepts Duncan's suggestions about this. On page 131, n. 21, he further notes this reaction to Rodenbach in context of the building of a new seaport, but does not further relate this event to Khnopff's *Abandoned City* or to Rodenbach's *Le Carillonneur.*

58 It is notable that this book was never, unlike almost all of Rodenbach's other novels, translated into other languages; it remained a very particular novel for a specialized audience.

59 Rodenbach, *Le Carillonneur,* 22, explains that death and sadness are "the secret of the beauty of Bruges."

60 Marechal only briefly notes a possible connection between Khnopff's drawing and Rodenbach's *Le Carillonneur,* in Vermeersch, 51. The book has also been mentioned in relation to Khnopff's images of Bruges, but with no analysis, by Draguet, *Khnopff ou l'ambigu poétique,* 353 and 363.

61 Rodenbach's last novel, *L'Arbre,* is about the destruction of an idyllically primitive area, in a remote island of Zealand, by the intrusion of modernity, in the form of a railway. Mosley, in Rodenbach, *Bruges-la-Morte* (1986), 33, calls it "virtually an arraignment of modern progress, [as] it portrays graphically the introduction into a pastoral Eden of all that which debases the residuum of a large manufacturing town."

62 "Les Plantations Urbaines et les reconstructions à Bruges," *L'Art moderne* (May 22, 1892), 165.

63 James Ensor, Letter to August Vermeylen 30 August 1894, transcript in Ensor, *Lettres,* 770.

64 Rodenbach, *Le Carillonneur,* 20.

65 This phrase – "au-desus de la vie" – is reiterated throughout the novel as a kind of battle cry against the mercantile, materialistic life that Borluut, as he ascends the Bell Tower, leaves far below.

66 Rodenbach, *Le Carillonneur,* 243.

67 Ibid., 235. This is the final sentence of the novel.

68 *Le Carillonneur* has been termed Rodenbach's "most convincing work of fiction" because of its blending of Realism and Symbolism (Mosley, vi). An interesting and almost direct comparison can be made, for example, between Rodenbach's literary account of the celebration in Bruges in 1895 on the occasion of the Belgian Parliament's final approval of the Port with another contemporary account – almost identical – offered by Robinson, 310.

69 Rodenbach, *Le Carillonneur,* 95–6. Others soon agreed with Rodenbach. In *The Story of Bruges,* Gilliat-Smith concluded his historical tour of the city by lamenting, "If the projected sea canal should fulfill the expectation of its promoters there can be no doubt that Bruges will lose much of her charm. She will no longer be a city of sleepy streets . . . she will become a second Ghent, a second Antwerp," 396–7.

70 Rodenbach, *Le Carillonneur.* Paris, Fasquelle *L'Art moderne* (April 18, 1897), 124. This antagonistic relationship continued for some time. The Bruges business paper *La Patrie* carried on a lengthy battle with the Ostend *Carillon* editors about the Bruges seaport's humane and good rationales. Ironically, both sides of this paper "war" used the term *Bruges-la-Morte* to serve its own ends. See *La Patrie* (Bruges) April 28–29, 1906, and July 26, 1907 (both responding to Ostend).

71 Rodenbach, *Le Carillonneur,* 258.

72 This was a free newspaper, established in Brussels in 1887.

73 Lemonnier, "Le Songe et la Vie," 8.

74 *Portrait of Georges Rodenbach.* 1896. Pastel. Paris: Musée d'Art Moderne.

75 Verhaeren, "An Aesthetic Interpretation of Belgium's Past" (second annual lecture on art in relations to civilization), 85.

76 *Journal de Bruges/Brugge,* beginning with the June 30, 1892 issue.

77 In order of discussion, this paragraph, *Journal de Bruges/ Brugge* April 20, 1893, 4; January 15/16, 1893, 1; July 14/15, 1995, 3.

78 In order of discussion, this paragraph, *Journal deBruges/ Brugge* July 3/4, 3; December 18/19, 4; and July 8, 3, all 1904.

79 It is interesting to note that the Symbolists' desires for Bruges to remain a medieval city have now been officially echoed by city leaders. In the 1992 expansive and celebratory book *Bruges and Europe,* edited by Vermeersch, recommendation is made to deny any further construction of modern industrial facilities, such as a proposed power plant, in the area between Zeebrugge and the town, pleading that "future generations are entitled to some 'surviving' nature'" (408). Such building restrictions would also ensure the intact and still medieval appearance of Bruges (the tourist town) to survive as well.

Abeels, G. *Bruxelles 1900*. Brussels: Meddens, 1980.

Abraham, Karl. *Giovanni Segantini – Ein Psychoanalytichen Versuch*. Leipzig and Wein: F. Deuticke 1911.

Ackerknecht, Erwin Heinze. "Anticontagionism between 1821 and 1867." *Bulletin of History of Medicine* 22 (1948): 562–93.

Acton, William. *Prostitution, Considered in Its Moral, Social and Sanitary Aspects*. London: John Churchill & Sons, 1870.

Adam, Paul. "Les Mères futures (critique des moeurs)." *La Revue blanche* X (May 1, 1896): 390–3.

Adams, Annmarie. *Architecture in the Family Way*. Montreal and Kingston, Canada: McGill-Queen's University Press, 1996.

Adler, Kathleen, and Marcia Pointon, eds. *The Body Imaged*. Cambridge: Cambridge University Press, 1993.

The Age of Van Gogh, Dutch Painting, 1880–1895, ed. Richard Bionda and Carel Blotkam, exh. cat. Zwolle: Waanders, 1990.

Aisenberg, Andrew R. *Contagion. Disease, Government, and the "Social Question" in Nineteenth-Century France*. Stanford: Stanford University Press, 1999.

Altermatt, Urs. "Conservatism in Switzerland: A Study in Anti-modernism." *Journal of Contemporary History* 14 (1979): 581–610.

Amen, P. "Amiel and the Paradox of the *Journal Intime*." *Europe: Revue Litteraire Mensuelle* 64 (1987): 693.

Amiel's Journal, trans. Mrs. Humphrey Ward. New York: Macmillan, 1923.

Amiel, Henri-Frédéric. *Journal Intime*. Geneva: H. Georg, 1883.

Anderson, Amanda. *Tainted Souls and Painted Faces: The Rhetoric of Fallenness in Victorian Culture*. Ithaca: Cornell University Press, 1993.

Anderson, Mark, ed. *Reading Kafka: Prague, Politics and the Fin de Siècle*. New York: Schocken, 1989.

Anderson, Stanford, ed. *On Streets*. Cambridge: MIT Press, 1978.

Anderson, Wayne. *Gauguin's Paradise Lost*. New York: Viking Press, 1971.

Andre, Edouard. *Alexandre Lunois – Peintre, graveur et lithographe*. Paris, 1914.

Anonymous. "Albert Trachsel." *Le Sapajou* (February 13, 1896): 76.

Anonymous. "Le Belgica-morbus." *L'Art moderne* (July 1, 1888): 209.

Anonymous. "Bois de Cambre." *La Belgique illustrée* (1891): 122.

Anonymous. "Chronique artistique. L'Elu." *Carillon de St.-Gervais* (March 24, 1894): 1.

Anonymous. "La Décoration du Palais de Justice de Bruxelles." *L'Art moderne* (December 1892): 402–3.

Anonymous. "Denaturée." *Journal de mères* (July 1, 1901): 2.

Anonymous. "Esthétique du contact humain: L'amour." *L'Art moderne* (September 26, 1897): 311–13.

Anonymous. "Esthétique du contact humain: en tram." *L'Art moderne* (May 2, 1897): 139.

Anonymous. "Exposition du cercle artistique." *L'Art moderne* (April 22, 1883): 127.

Anonymous. "F. Hodler." *Berner Bund* (April 19, 1984): 1–2.

Anonymous. "Hygiène et Santé: Les Bains de Mer Ostende." *Le Globe illustré* (June 22, 1890): 603–5.

Anonymous. "Paysages Urbains." *L'Art moderne* (January 14, 1894): 12.

Anonymous. Paul Adam (Felix Fénéon, Oscar Méténier, and Jean Moréas). *Petit Bottin des lettres et des arts*. Paris: E. Giraud et Cie, 1886.

Anonymous. "La Presse." *La Patrie* (July 26, 1907): 2.

Anonymous. "Récréations populaires." *L'Art moderne* (June 28, 1891).

Anonymous. "La Regne du Silence." *L'Art moderne* (May 3, 1891): 139–41.

Anonymous. "Ville de Bruxelles. Projet de chemin de fer funiculaire." *Le Globe illustré* (October 25, 1891): 51.

Anonymous. "Les Villes et la Femme." *L'Art moderne* (August 1, 1897): 247.

Anonymous. "Xavier Mellery." *L'Art moderne* (December 29, 1890): 1–2.

Aron, Paul. *Les Ecrivains Belges et le socialisme (1880–1913)*. Brussels: Editions Labor, 1985.

　Emile Verhaeren: Ecrits sur l'art. Brussels: Editions Labor, 1997.

　"Le Symbolisme belge et la tentation de l'art social: une logique littéraire de l'engagement politique." *Les Lettres romanes* 40 (1986): 316ff.

Ashworth, William. *The Genesis of Modern British Town Planning*. London: Routledge and Paul, 1954.

Athanassoglou-Kallmyer, Nina. "Blemished Physiologies: Delacroix, Paganini, and the Cholera Epidemic of 1832." *Art Bulletin* LXXXIII (December 2002): 686–710.

Attar, Dana. *Household Books Published in Britain 1800–1914*. London: Prospect, 1987.

Aubrey, Pierre. "The Anarchism of the Literati of the Symbolist Period." *French Review* 42 (1968–9): 39–47.

Aurier, G.- Albert. "Les Isolés – Vincent Van Gogh." *Mercure de France* I (January 1890): 24–9.

　"Le Symbolisme en peinture: Paul Gauguin." *Mercure de France* (1891): I, 155–65; II, 211–18.

Bade, Patrick. *Femme Fatale. Images of Evil and Fascinating Women*. New York: Mayflower Books, 1979.

Baedecker, Karl. *Belgium and Holland*. Leipsic: Karl Baedeker, 1891, 1894, 1897, 1901, 1910.

Baguley, David. *Emile Zola: L'assommoir*. Cambridge: Cambridge University Press, 1992.

Bailin, Miriam. *The Sickroom in Victorian Fiction: The Art of Being Ill*. Cambridge: Cambridge University Press, 1994.

Bairoch, Paul. "Population urbaine et taille des villes en Europe de 1600 a 1970: Presentation de series statistiques," in *Demographie urbaine, XVe–XXe siècle*. Lyon: Centre d'Histoire Economique et Sociale de la Region Lyonnaise, 1977.

Baker, Robert B., Arthur L. Caplan, Linda L. Emanuel, and Stephen R. Latham. *The American Medical Ethics Revolution: How the AMA's Code of Ethics Has Transformed Physicians' Relationships to Patients, Professionals, and Society*. Baltimore: The Johns Hopkins University Press, 1999.

Bakhtin, Mikhail Mikhailovich. *Rabelais and His World*, trans. Hélène Iswolsky. Bloomington: Indiana University Press, 1984.

Balakian, Anna. *The Symbolist Movement in the Literature of European Languages*. Budapest: Akademiai Kiado, 1984.

Ball, Robert H., and W. Bowman. *Theater Language*. New York: Theater Art Books, 1961.

Ballard, Thomas. *An Enquiry into the Value of the Signs and Symptoms Regarded as Diagnostic of Congenital Syphilis in the Infant*. London: J. & A. Churchill, 1874.

Balzac, Honoré de. *Le Médecin de campagne*. Paris: Garnier-Flammarion, 1965.

　Seraphita. New York: Thomas J. Crowell, 1900.

Banham, Martin, ed. *The Cambridge Guide to World Theater*. Cambridge: Cambridge University Press, 1988.

Baradat, Charles Joseph. *La Tuberculose et les médications nouvelles*. XIII Congrès International des Sciences Médicales, August 2–9, 1900, Paris.

Barasch, Moshe. *Modern Theories of Art*, vol. 1. New York: New York University Press, 1990.

Barber, Fionna, "Caillebotte, Masculinity, and the Bourgeois Gaze," in Paul Wood, ed., *The Challenge of the Avant-Garde*. New Haven: Yale University Press, 1999.

Barker, Granville. *Waste: A Tragedy, in Four Acts*. London: Sidgwick and Jackson, 1910.

Barrows, Susanna. *Distorting Mirrors: Visions of the Crowd in Late Nineteenth-Century France*. New Haven: Yale University Press, 1981.

Barthes, Roland. *Writing Degree Zero*, trans. Annette Lavers and Colin Smith. London: Cape, 1967.

La Basoche. Revue de littérature et d'art (Brussels), 1884–6.

Baudelaire, Charles. *Curiosités esthétiques.* Paris: Calman Lévy, 1885 (original 1868).

Baudson, Michel. "Scènes Belges." *Art Press*, no. 153 (December 1990): 31–6.

Baum, Andrew, Jerome Singer, and Stuart Valins, eds. *Advances in Environmental Psychology,* Vol. 1: *The Urban Environment.* New Jersey: Lawrence Erlbaum Associates, 1978.

Behlmer, George K. "Deadly Motherhood: Infanticide and Medical Opinion in Mid-Victorian England." *Journal of the History of Medicine* 34 (1979): 403–27.

Belgian Art 1880–1914, exh. cat. Brooklyn: The Brooklyn Museum, 1980.

Belli, Gabriella. *Segantini,* exh. cat. Trento: Museo Provinciale d'Arte, sezione contemporanea, 1987.

Bellonzi, F., and T. Fiori. *Archivi del divisionismo.* Rome: 1968.

Below the Surface of Edvard Munch. Technical Examination of Four Paintings by Edvard Munch, exh. cat. Oslo: Natjonalgalleriet, 1994.

Bender, Thomas, and Carl E. Schorske. *Budapest and New York: Studies in Metropolitan Transformation, 1870–1930.* New York: Russell Sage Foundation, 1994.

Benedetti, Maria Teresa. *Dante Gabriel Rossetti.* Florence: Sansoni Editore, 1984.

Benevolo, Leonardo. *The History of the City.* Cambridge: MIT Press, 1981.

Benjamin, Roger. *Matisse's "Notes of a Painter."* Ann Arbor: UMI Research Press, 1987.

Benjamin, Walter. "On Some Motifs in Baudelaire," in *Illuminations.* trans. Harry Zohn. New York: Harcourt, Brace & World, 1968.

Bentham, Jeremy. *Le Panoptique.* Paris: Belfond, 1791.

Bergdoll, Barry. *European Architecture 1750–1890.* Oxford: Oxford University Press, 2000.

Bergsma, Rieta, and Paul Hefting, eds. *George Hendrik Breitner. Schilderijen, tekeningen, foto's.* Amsterdam, 1994.

 et al. *G.H. Breitner Fotograaf en Schilder van het Amsterdamse Stadsgezicht,* exh. cat. Amsterdam: Gemeentearchief, 1997.

Berlin um 1900, exh. cat. Berlin: Berlinischen Galerie, 1984.

Berman, Patricia. "Body and Body Politic in Edvard Munch's *Bathing Men,*" in *The Body Imaged: The Human Form and Visual Culture Since the Renaissance,* ed. Kathleen Adler and Marcia Pointon. Cambridge: Cambridge University Press, 1997.

 "Edvard Munch's *Self Portrait with Cigarette:* Smoking and the Bohemian Persona." *Art Bulletin* LXXV (December 1993): 627–46.

 James Ensor: Christ's Entry into Brussels in 1889. Los Angeles: J. Paul Getty Museum, 2002.

 "Norwegian Craft Theory and National Revival in the 1890s," in *Art and the National Dream: The Search for Vernacular Expression in Turn of the Century Design,* ed. Nicola Gordon Bower. Dublin: Irish Academic Press, 1993.

 "(Re)-Reading Edvard Munch: Trends in the Current Literature." *Scandinavian Studies* 66, 45–67.

 "TB Tourism: Urban Hygiene in the Age of the Spas." Paper presented at the International Society for the Study of European Ideas conference, Bergen, 2000.

Bermani, Eugenio. *Commemorazione di Giovanni Segantini Tentua in Milano per invito della famiglia Artico,* Milan, November 26, 1899.

Bernadini, M. G. "Les Salons de la Rose-Croix." *Storia dell'arte*, no. 26 (1976): 94–105.

Bernheim, Samuel. *La Tuberculose. Ses causes, ses treatment. Les Moyens de s'en préserver.* Paris: Librarie Medicale et Scientifique, 1903.

Bernheimer, Charles. "Of Whores and Sewers: Parent-Duchâtelet, Engineer of Abjection." *Raritan*, no. 6 (1987): 72–90.

Bhatia, Kavita. "Reconstruction of Womanhood in the Nineteenth Century," in *The Family in a Changing World: Women, Children and Strategies of Intervention,* ed. Rudolf C. Heredia and Edward Mathias. New Dehli: Indian Social Institute, 1995.

Biermé, Maria. "Fernand Khnopff." *La Belgique Artistique et Littéraire.* 8 (1907): 96–113.

 Les Artistes de la pensée et du sentiment. Brussels: Editions de la Belgique artistique et littéraire, 1911.

Bilski, Emily, ed. *Berlin Metropolis. Jews and the New Culture, 1890–1918.* Berkeley: University of California Press, 1999.

Bionda, Richard, and Carel Blotkamp, eds. *The Age of Van Gogh: Dutch Painting 1880–1895,* exh. cat. Glasgow: Glasgow Museum and Art Galleries, 1990–1.

Biucchi, Basilio M. *The Industrial Revolution in Switzerland: 1700–1914,* vol. 4, Great Britain: Collins Clear-Type Press, 1969.

Blockhuys, Joseph. *Réflexions sur le caractère. La mission, les droits et l'education de la femme.* Termonde, 1867.

Block, Jane. *Les XX and Belgian Avant-Gardism 1868–1894.* Ann Arbor, Mich.: UMI Research Press, 1984.

Blondel, L. *Le Développement urbain de Genève à travers les siècles.* Geneva, 1946.

Boeckl, Christine M. *Images of Plague and Pestilence: Iconography and Iconology.* Kirksville, Mo.: Truman State University Press, 2000.

Bonnier, Bernadette, and Veronique Leblanc. *Félicien Rops. Life and Work.* Bruges: Stichting Kunstboek, 1997.

Bordo, Susan. *Unbearable Weight. Feminism, Western Culture, and the Body.* Berkeley: University of California Press, 1993.

Boswell, John. *The Kindness of Strangers.* New York: Pantheon Books, 1988.

Bourget, Paul. "Essai de psychologie contemporaine: Charles Baudelaire." *La Nouvelle Revue* 13 (1881): 98–417.

Bradbury, Malcolm, and James McFarlane. *Modernism 1890–1930.* Sussex: Harvester Press, 1978.

Brandes, Edouard. "Théâtre de la maison d'art." *L'art moderne* (December 20, 1896): 403.

Brandes, Georg. *An Essay on the Aristocratic Radicalism of Friedrich Nietzsche,* trans. A. G. Chater, 1909 (orig., 1889).

Brändström, Anders, and Lars-Göran Tedebrand, eds. *Society, Health and Population during the demographic Transition.* Stockholm: Almqvist and Wiksell International, 1986.

Brettel, Richard. "The Impressionist Landscape and the Image of France," in *A Day in the Country,* exh. cat. Los Angeles: Los Angeles Country Museum of Art, 1984–5, 27–49.

Bronfen, Elisabeth. *Over Her Dead Body. Death, Feminity and the Aesthetic.* New York: Toutledge, 1992.

Broude, Norma, and Mary D. Garrard. *The Expanded Discourse. Feminism and Art History.* New York: HarperCollins, 1992.

Brown, John, and Timothy Guinnane. *Fertility Decline in Nineteenth Century Munich: Background, Issues, and some Preliminary Results.* Princeton: Office of Population Research Paper Series, paper no. 91. November 14, 1991.

Brugge, Stedelijke Musea. *Catalogus van de Brugge Stadsgezichten.* Schilderijen XVIIe–XXe eeuw. Bruges: Stedelijke Musea, 1977.

Brunetiere, Ferdinand. "Henri-Frederic Amiel." *Revue des deux mondes* LXXIII (January 1886): 214–24.

Brüschweiler, Jura. *Ferdinand Hodler und Sein Sohn Hector.* Zurich: Zürcher Kunstgesellschaft, 1967.

Bruxelles, Construire et reconstruire. Architecture et amenagement urbain 1780–1914. Brussels: 1978.

Budigna, L. *Giovanni Segantini.* Milan: Bramante Editrice, 1962.

Buls, Charles. *Esthétique des villes.* Brussels: Bruylant-Christophe, 1893.

Bürger, Peter. *Theory of the Avant-Garde,* trans. Michael Shaw. Minneapolis: University of Minnesota Press, 1984.

Burhan, Filiz Eda. *Vision and Visionaries: Nineteenth Century Psychological Theory, the Occult Sciences and the Formation of the Symbolist Aesthetic in France.* Ph.D. diss., Princeton University, 1979.

Burns, Sarah. "A Symbolist Soulscape: Fernand Khnopff's *I Lock My Door upon Myself.*" *Arts Magazine* LV/ 5 (January 1981): 80–9.

Bykhovsky, Bernard. *Shopenhauer and the Ground of Existence,* trans. Philip Moran. Amsterdam: Grüner, 1984.

Bynum, William. *Science and the Practice of Medicine in the Nineteenth Century.* Cambridge: Cambridge University Press, 1994.

Cachin, Françoise. *1893. L'Europe des peintres,* exh. cat. Paris: Musée d'Orsay, 1993.

Calinescu, Matei. *Five Faces of Modernity: Modernism, Avant-Garde, Decadence, Kitch, Postmodernism.* Durham, N.C.: Duke University Press, 1987.

Callie, Andre van. *Ovd Ostend in Beeld.* Ostend: Toulon, 1989.

Canning, Susan M. "Fernand Khnopff and the Iconography of Silence." *Arts Magazine* LIV/ 4 (December 1979): 170–6.

 "The Ordure of Anarchy: Scatological Signs of Self and Society in the Art of James Ensor." *Art Journal* 52, no. 3: 47–53.

 "In the Realm of the Social." *Art in America* (February 2000): 75–80.

The Capitals of Europe. Les Capitales de l'Europe. Munich: K. G. Saur, 1980.

Capul, Maurice. *Abandon et Marginalité.* Toulouse: Privat, 1989.

Carluccio, Luigi. *Fernand Khnopff,* exh. cat. Milan: Galleria del Levante, 1970.

 The Sacred and Profane in Symbolist Art, exh. cat. Toronto: Art Gallery of Ontario, 1969.

Cartwright, Frederick. *A Social History of Medicine.* London: Longman, 1977.

Cassou, Jean. *The Concise Encyclopedia of Symbolism.* trans. Susie Saunders. Paris: Aimery Somogy, 1979.

Casteras, Susan. *Images of Victorian Womanhood in English Art.* Rutherford, N.J.: Fairleigh Dickinson Press, 1987.

 and Allicia Craig Faxon. *Pre-Raphaelite Art in Its European Context.* London: Asssociated University Presses, 1995.

Cate, Phillip D., ed. *The Graphic Arts and French Society, 1871–1914.* New Brunswick, N.J.: Rutgers University Press, 1988.

Cattier, Edmond. *Idées d'un bourgeois sur l'architecture.* Brussels: J. Lebègue et Cie., c. 1891.

Cézanne, Paul. *Uber die kunst,* ed. W. Hess. Munich: Mäander, 1980.

Chadwick, Edwin. *Inquiry into the Sanitary Condition of the Labouring Population of Great Britain of 1842.* Great Britain: Poor Law Commissioners, 1842.

Champavier, Maurice. "Une Peintre de la Montagne." *L'art français,* no. 549 (October 30, 1897): n.p.

Chandler, T., and G. Fox. *3000 Years of Urban Growth.* New York: Academic Press, 1974.

Chapman, J. M., and Brian Chapman. *The Life and Times of Baron Haussmann: Paris in the Second Empire.* London: Weidenfeld and Nicholson, 1957.

Chavasse, Henry. *Advice to a Wife.* London: Churchill, 1886.

Chessex, Pierre. "Gustave Courbet et la vie artistique en Suisse Romande 1873–1877." *Etudes de lettres, Lausanne* (January–March 1975): 37–53.

Chevalier, Louis. *Laboring Classes and Dangerous Classes.* New York: Howard Fertig, 1973.

Chipp, H. B., and H. R. Rookmaaker, eds. *Theories of Modern Art.* Berkeley: University of California Press, 1968.

Choay, Françoise. *The Rule and the Model. On the Theory of Architecture and Urbanism.* Cambridge: MIT Press, 1997.

Chouet, Idelette. "Le Tourisme a Genève au Siècle Dernier." *Musées de Genève* 18 (1977): 3–6.

Chretien, J. L. "Amiel et la parole donnée." *Critique* 38 (1982): 418.

Christian, John. *Symbolists and Decadents.* New York: St. Martins Press, 1977.

Ciardi, Nives. "Variations of the Theme of the Maternity." *Domus,* no. 652 (1984): 74.

Clapham, John. *The Economic Development of France and Germany: 1815–1914.* Cambridge: Cambridge University Press, 1949.

Clark, T. J. *The Painting of Modern Life: Paris in the Art of Manet and his Followers.* New York: Knopf, 1984.

Clayson, Hollis. *Painted Love: Prostitution in French Art of the Impressionist Era.* New Haven: Yale University Press, 1991.

Clerbois, Sébastien. "James Ensor. L'art, et la politique," in *Arts, Antiques Auctions: Ensor.* Brussels: Société de la Propriété Artistique et de des Dessins et Modele, 1999, 36–7.

Cohen, Sheldon. "Environmental Load and the Allocation of Attention," in *Advances in Environmental Psychology,* ed. Andrew Baum, Jerome Singer, and Stuart Valins. Hillsdale, N.J.: Lawrence Erlbaum Associates, 1999.

Coiseau, M. L. *Les ports et le canal maritime Bruges* (Extrait des memoirs de la société des ingenieurs civils de France). Paris, 1905.

 and J. Cousin. *Bruges Port de Mer. Reponse.* Brussels: Weissenbruch, 1892.

Corbin, Alain. *La prostitution a Paris au XIX eme siècle.* Paris: Editions du Seuil, 1981.

Corday, Michel. *Vénus ou les deux risques.* Paris: Modern Bibliothèque, Arthème Fayard, Éditeur, n.d.

Corn, Wanda. "The Artist's New York," in *Budapest and New York. Studies in Metropolitan Transformation: 1870–1930,* ed. Thomas Bender and Carl E. Schorske. New York: Russell Sage Foundation, 1994.

Corsini, Carlo, and Pier Paolo Viazzo, eds. *The Decline of Infant and Child Mortality. The European Experience: 1750–1990.* The Hague: Kluwer Law International, 1997.

Coser, Lewis A. *Masters of Sociological Thought. Ideas in Historical and Social Context.* New York: Harcourt Brace Jovanovich, 1977.

Crary, Jonathan. *Suspensions of Perception: Attention, Spectacle, and Modern Culture.* Cambridge: MIT Press, 1999.

Cravens, Hamilton, Alan I. Marcus, and David M. Katzman, eds. *Technical Knowledge in American Culture: Science, Technology, and Medicine since the Early 1800s.* Tuscaloosa: University of Alabama Press, 1996.

Creese, Walter L. *The Search for Environment. The Garden City: Before and After.* Baltimore: The Johns Hopkins University Press, 1992.

Crimp, Douglas. *AIDS: Cultural Analysis, Cultural Activism.* Cambridge and London: MIT Press, 1988.

Crimpen, Han van. *Brief Happiness. The Correspondence of Theo Van Gogh and Jo Bonger,* ed. Leo Jansen and Jan Robert. Amsterdam: Van Gogh Museum, 1999.

Cummins, S. Lyle. *Tuberculosis in History.* London: Baillière, Tindall and Cox, 1949.

Dacier, Emile. "Artistes contemporains-Alexandre Lunois." *Revue de l'Art Ancien et Moderne* 8 (July–December 1900): 410–21; vol. 9 (January–June 1901): 36–48.

Damolin, Giovanna. *Nati e abbardonati.* Bari: Cacucci, 1993.

Dampt, J. *Catalogue des oeuvres de M. Dagnon-Bouveret.* Paris: Chez Maurice Rousseau, 1930.

Daudet, Léon. *Les Morticoles.* Paris: Bibliothèque Charpentier, 1894.

Dauthendey, Max. Letter of 5 June 1891, in *Ein Herz im Lärm der Welt. Briefe an Freunde.* Munich: A. Langen G. Müller, 1933.

A Day in the Country: Impressionism and the French Landscape, exh. cat. Los Angeles: Los Angeles County Museum of Art, 1984–5.

DeBord, Guy. *La Société du spectacle.* Paris: Buchet/Chastel, 1967. Trans. *The Society of the Spectacle,* rev. ed. Detroit: Black and Red, 1977; and New York: Zone Books, 1994.

De Grafiek van Jan Toorop, exh. cat. Amsterdam: Rijksmuseum/Rijksprentenkabinet, 1968.

Delamont, Sara, and Lorna Duffin, eds. *The Nineteenth-Century Woman. Her Cultural and Physical World.* London: Croom Helm, 1978.

De la question. Gard: Im Annoot-Braeckman, 1889.

Delevoy, Robert L. "Fernand Khnopff and Bruges." *Oeil,* no. 29 (October 1979): 42–7.

 Symbolists and Symbolism. New York: Rizzoli, 1982.

 Catherine DeCröes, and Gisèle Ollinger-Zinque. *Fernand Khnopff.* Brussels: Cosmos Monographies, 1979.

 Catherine DeCröes, and Gisèle Ollinger-Zinque. *Fernand Khnopff,* exh. cat. Paris: La Bibliothèque des Arts, 1987.

Denduyver, J. and J. Marechal, *Havencomplex Brugge-Zeebrugge.* Bruges, 1964.

Deneke, Bernward, and Rainer Kahsnitz, eds. *Das kunst und kulturgeschictliche Museum im 19. Jahrhundert.* Munich: Prestel Verlag, 1977.

Denis, Maurice. "De Gauguin et Symbolisme et de Gauguin au Classicisme." Originally published in "*L'occident*" (May 1909), in *Théories 1890–1910. Du symbolisme et de Gauguin vers un nouvel ordre classique,* 4th ed. Paris: L. Rouart et J. Watelin, 1920.

Dennie, Charles Clayton. *A History of Syphilis.* Springfield, Ill: Charles C Thomas, 1962.

Deuchler, Florens, Marcel Roethisberger, and Hans A. Lüthy. *La peinture Suisse du Moyen Age à l'Aube du XXe siècle*. Geneva: Editions d'Art Albert Skira, 1975.

"Diagnosis and Management of Maternal and Congenital Syphilis." Tertiary Care Council of the Wisconsin Association for Perinatal Care. Available: *www.execpc.com/-wapc/practd.html*.

Dickens, Charles. *David Copperfield*. London: Bradbury and Evans, 1886.

Diday, P. *Traite de la syphilis des nouveau-nés et des enfants à la mamelle*. Paris: Masson, 1854.

Dierick, A. "Modernist Tendencies in the Literature of the Low Countries 1880–1920." *Canadian Journal of Netherlandic Studies (The Low Countries Fin de Siècle)* IX and X (Fall 1988–Spring 1989): 9–32.

Dijkstra, Bram. *Idols of Perversity, Fantasies of Feminine Evil in Fin-de-siècle Culture*. Oxford: Oxford University Press, 1986.

Dorra, Henri. *Symbolist Art Theories: A Critical Anthology*. Berkeley: University of California Press, 1994.

Draguet, Michel. *Eugene Laermans*. Brussels: Snoeck-Ducaju & Zoon, 1995.

 Khnopff ou l'ambigu poétique. Brussels: Snoeck-Ducaju & Zoon, 1995.

Drake, Michael. *Population and Society in Norway 1735–1865*. Cambridge: Cambridge University Press, 1969.

Dresen-Coenders, Lène, and Petty Banqe. *Saints and She-Devils: Images of Women in the 15th and 16th Centuries*. London: Rubicon Press, 1987 (orig. ed., Dutch 1985).

Dubos, René, and Jean. *The White Plague. Tuberculosis, Man and Society*. Boston: Little, Brown, 1952.

Duclos, Ad. *Bruges. Histoire et souvenirs*. Bruges: Vyvre-Petyt, 1910.

Dumont, Jaques. *Bruges et la mer (Brugge end de Zee)*. Brussels: Charles Dessart, Nauwelaerts, 1972.

Duncan, Carol. "Happy Mothers and Other New Ideas in French Art." *Art Bulletin* (December 1973): 570–83.

Dunstan, G. R. ed. *The Human Embryo. Aristotle and the Arabic and European Traditions*. Exeter: University of Exeter Press, 1990.

Eastlake, Charles L. *Hints on Household Taste in Furniture, Upholstery and Other Details*. London: Longmans, Green, 1872 (orig. 1868).

"E. D." (Edouard Duchosal). "Exposition de M. Ferdinand Hodler." *Genevois* 66 (March 20, 1894): 2.

Edvard Munch. The Frieze of Life, exh. cat. London: National Gallery, 1992.

Edvard Munch. Symbols and Images, exh. cat. Washington, D.C.: National Gallery, 1978.

Eekhoud, Georges. Review of "La Fin des Bourgeois" [by Camille Lemonnier]. *L'Art moderne* (May 22, 1892): 162–3.

Eemans, Nestor. *Fernand Khnopff*. Anvers: De Sikkel, n.d. [1950s].

Egbert, Donald D. *Social Radicalism and the Arts: Western Europe. A Cultural History from the French Revolution to 1968*. New York: Knopf, 1970.

Eggermont, Auguste. *La Vie et L'oeuvre d'Eugene Laermans*. Brussels: Office de Publicité, 1943.

Eggum, Arne. *Edvard Munch: Paintings, Sketches, and Studies,* trans. Ragnar Christophersen. New York: Clarkson N. Potter, 1984.

 Munch und die Photographie. Bern: Benteli, 1991.

Ehrenreich, Barbara, and Deirdre English. *Complaints and Disorders: The Sexual Politics of Sickness,* Glass Mountain Pamphlet no. 2. New York: The Feminist Press, 1973.

Ehrhardt, Ingrid, and Simon Reynolds, eds. *Kingdom of the Soul. Symbolist Art in Germany 1870–1920*. Munich: Prestel Verlag, 2000.

Eleb, Monique, and Anne Debarre. *L'Invention de l'habitation moderne. Paris 1880–1914*. Paris: Archives d'Architecture Moderne, 1995.

Engels, Friedrich. *The Condition of the Working Class in England,* trans. W. O. Henderson and W. H. Chaloner. Oxford: B. Blackwell, 1971.

Ensor, James. *Les Ecrits de James Ensor*. Brussels: Editions "Selection," 1921.

 Lettres, ed. Xavier Tricot. Brussels: Editions Labor, 1999.

 Mes ecrits. Liege: Editions Nationales, 1974.

Escholier, Raymond. "Peintres-graveurs contemporains – Alexandre Lunois." *Gazette des Beaux Arts* (March 1912): 215–24.

Estrade, J. B. *Les Apparitions de Lourdes: Souvenirs intimes d'un témoin.* Lourdes: Imprimerie de la Grotte, 1911.

Etzkorn, Peter, ed. and trans. *Georg Simmel. The Conflict in Modern Culture and Other Essays.* New York: Teacher's College Press, 1968.

Eugene Laermans, exh. cat. Brussels: Galerie du Credit Communal, 1995.

Eva und die Zukunft. Das Bild der Frau seit der Französischen Revolution, exh. cat. Werner Hofmann, ed. Munich: Prestel Verlag, n.d.

Fabbri, Dino. *Giovanni Segantini,* exh. cat. Milan: Fratelli Fabbri Editori, 1965.

Facos, Michelle. *Swedish and National Romanticism.* Berkeley: University of California Press, 1998.

Faille, J. B. de la. *The Works of Vincent Van Gogh,* rev. ed. Amsterdam: Reynal, 1970.

Fanelli, Giovanni. *Fin de siècle. La vita urbana in Europa,* exh. cat. Florence: Cantini, 1991.

Favre, Edouard. *Theodor Turrettini, 1845–1916.* Geneva: A. Kundig, 1923.

Fénéon, Félix. "Inédits de Laforgue" (notes written c. 1885). *La Revue Blanche* (April 15, 1896): 371–4.

"Inédits de Laforgue," *Entretiens* (January 1891): 10.

Au-déla de l'impressionisme. Paris: Hermann, 1966.

Ferdinand Hodler: Views and Visions, exh. cat. Zurich: Swiss Institute for Art Research, 1994.

Fernand Khnopff. and the Belgian Avant-Garde, exh. cat. Chicago: David and Alfred Smart Gallery, 1983.

Fernand Khnopff, exh. cat. Paris: Musée des Arts Decoratif, 1979–80.

Fernand Khnopff 1858–1921, exh. cat. Hamburg: Hamburger Kunsthalle, 1980.

Fernand Khnopff et ses rapports avec la secession viennoise. Brussels: Musées Royaux des Beaux-Arts de Belgiques, 1987.

Fernand Khnopff. Symboliste, exh. cat. Brussels: L'Ecuyer Galerie, 1971.

Ferri, Enrico. *Discordie positiviste sul socialismo. Ferri contro Garofalo.* Palermo: R. Sandron, 1895.

Positive School of Criminology: Three Lectures by Enrico Ferri, ed. Stanley Grup. Pittsburgh: University of Pittsburgh Press, 1968. (Lectures originally delivered 1901).

Socialismo e criminalità. Rome: Fratelli Bocca, 1883.

Fin de Siècle, exh. cat. London: Louise Whitford Gallery, 1980.

Fin de Siècle. Zu Literatur und Kunst der Jahrhundertwende. Frankfurt am Main: Vittorio Klostermann, 1977.

Fletcher, Ian. *Romantic Mythologies.* London: Routledge and K. Paul, 1967.

Florizoone, Patrick. *James Ensor. Les bains à Ostende.* Gand: Snoeck-Ducaju & Zoon, 1996.

Fontainas, Andre. *Constantin Meunier.* Paris: Librarie Felix Alcan, 1923.

Mes souvenirs du symbolisme. Paris: La Nouvelle Revue Critique, 1928.

Forley, Ruth. *Camille Pissarro's "Turpitude Sociales" Documents of History.* Unpublished master's thesis, Adelphi University, 1981.

Forster-Hahn, Françoise, ed. *Imagining Modern German Culture: 1889–1910.* Hanover, N.H.: University Press of New England; Washington, D.C.: The National Gallery of Art, 1996.

Foucault, Michel. *The Birth of the Clinic; An Archaeology of Medical Perception,* trans. A. M. Sheridan Smith. New York: Pantheon Books, 1973.

Discipline and Punish: The Birth of the Prison. New York: Pantheon Books, 1977.

The Foucault Reader, ed. Paul Rabinow. New York: Pantheon Books, 1984

The History of Sexuality, trans. Robert Hurley, 3 vols. New York: Pantheon Books, 1978.

Madness and Civilization; A History of Insanity in the Age of Reason. New York: Pantheon Books, 1965.

"Of Other Spaces," trans. Jay Miskowiec, in Nicholas Mirzoeff, *The Visual Culture Reader.* London: Routledge, 238–44.

Power/ Knowledge: Selected Interviews and Other Writings, 1972–1977. New York: Pantheon Books, 1980.

Fournier, Jean Alfred. *La Syphilis héréditaire tardive.* Paris: G. Masson et Cie, 1886.

Fox, Sylvia. "Witch or Wise-Woman? – Women as Healers through the Ages." *Lore and Language* 9, no. 2 (1990): 39–53.

Fraser, Derek, and Anthony Sutcliffe, eds. *The Pursuit of Urban History*. London: Edward Arnold, 1983.

"Fred, W." (pseud. Alfred Wechler). *Giovanni Segantini*. Vienna: Weiner Verlag, 1901.

Freud, Sigmund. *The Interpretation of Dreams*, trans. and ed. James Strachey. New York: Basic Books, 1953.

Friedman, Donald. *An Anthology of Belgian Symbolist Poets*. New York: Garland, 1992.

Frisby, David. *Fragments of Modernity. Theories of Modernity in the Work of Simmel, Kracauer and Benjamin*. Cambridge: MIT Press, 1986.

From Liotard to Le Corbusier: 200 Years of Swiss Painting, 1730–1930, exh. cat. Zurich: Coordinating Commission for the Presence of Switzerland Abroad and Swiss Institute for Art Research, 1988.

Fuchs, Rachel Ginnis. *Abandoned Children*. Albany: State University of New York Press, 1984.

 and Leslie Page Moch. "Invisible Cultures: Poor Women's Networks and Reproductive Strategies in Nineteenth-Century Paris," in *Situating fertility. Anthropology and demographic inquiry*, Susan Greenhalgh, ed. Cambridge: Cambridge University Press, 1995, 86–107.

Gagnebin, Bernard. "Les Fragments rejetés du Journal Intime d'Amiel." *Cahiers de l'Association Internationale des Etudes Françaises* 17 (1965): 123–32.

Galeries Nationale du Grand Palais. *Peintres de l'imaginaire: symbolistes et surrealistes Belges*, exh. cat. Paris, 1972.

Gamboni, Dario, ed. *Zeichen den Freiheit*, exh. cat. Bern, 1991.

Garb, Tamar. *Bodies of Modernity. Figure and Flesh in Fin-de-Siècle France*. London: Thames and Hudson, 1998.

Gardiner, Patrick. *Schopenhauer*. Middlesex, England: Penguin, 1967.

Garnier, Charles, and A. Amman. *L'habitation humaine*. Paris: Hachette, 1892.

Gauguin, Paul. *The Writings of a Savage*, ed. Daniel Guerin, trans. E. Levieux. New York: Viking, 1978.

Gay, Peter. *Art and Act: On Causes in History – Manet, Gropius, Mondrian*. New York: Harper & Row, c. 1976.

 The Bourgeois Experience. Victoria to Freud. Vol. I: Education of the Senses. Oxford: Oxford University Press, 1984.

Gee, Malcolm, Tim Kirk, and Jill Steward. *The City in Central Europe. Culture and Society from 1800 to the Present*. Hants, England: Ashgate, 1999.

Geffroy, Gustave. "Exposition Champ de Mars." *Le Journal* (May 1894): n.p.

Geiger, Raymond. *Hermann Paul*. Paris: Henry Babou, 1929.

Geison, Gerald, ed. *Professions of the French State*. Philadelphia: University of Pennsylvania Press, 1984.

George, Henry. *Social Problems*. New York: Doubleday, Page, 1883.

Georges Lacombe 1868–1916, exh. cat. Versailles: Musée Lambinet, 1984.

Georges Lacombe, Albert Besnard, Preface by Gustave Geffroy. Paris: Editions Nilsson, 1925.

Gere, Charlotte, and Lesley Hoskins. *The House Beautiful. Oscar Wilde and the Aesthetic Interior*. London: Lund Humphries and Geffrye Museum, 2000.

Gerould, Daniel, ed. *Doubles, Demons, and Dreamers. An International Collection of Symbolist Drama*. New York: Performing Art Journal Publications, 1985.

Die Gesellschaftlich Wirklichkeit der Kinder in der Bildenden Kunst, exh. cat. Berlin: Neue Gesellschaft für Bildende Kunst und Staatlische Kunsthalle Berlin, 1979.

Gibson, Michael. *Le Symbolisme*. Cologne: Taschen, 1994.

Gilliat-Smith, Ernest. *The Story of Bruges*. London: J. M. Dent, 1901.

Gilman, Sander L. "AIDS and Syphilis: The Iconography of Disease," in *AIDS: Cultural Analysis, Cultural Activism*, ed. Douglas Crimp. Cambridge and London: MIT Press, 1988, 87–107.

 The Case of Sigmund Freud: Medicine and Identity at the Fin de Siècle. Baltimore: Johns Hopkins University Press, 1993.

and Edward J. Chamberlain, eds. *Degeneration: The Dark Side of Progress.* New York: Columbia University Press, 1985.

Difference and Pathology: Stereotypes of Sexuality, Race, and Madness. Ithaca: Cornell University Press, 1985.

Picturing Health and Illness: Images of Identity and Difference. Baltimore: Johns Hopkins Univeristy Press, 1995.

Sexuality: An Illustrated History: Representing the Sexual in Medicine and Culture from the Middle Ages to the Age of AIDS. New York: Wiley, 1989.

Ginneken, Jaap Van. *Crowds, Psychology, and Politics. 1871–1899.* Cambridge: Cambridge University Press, 1992.

Giovanni Segantinis Panorama und andere Engadiner Panoramen, exh. cat. St. Moritz: Segantini Museum, 1991.

Girouard, Mark. *Cities and People. A Social and Architectural History.* New Haven: Yale University Press, 1985.

Goddard, Stephen H. *Les XX and the Belgian Avant-Garde,* exh. cat. Lawrence: Spencer Museum of Art, University of Kansas, 1992–3.

Godfroy, Louis. *Albert Besnard.* Loys Delteil, ed. *Le Peinture Graveur Illustré XIX et XXe siècles.* Vol. XXX, Paris, 1926.

Godleski, Dr. "Untitled" (on nursing). *Journal des mères* (Brussels) (December 1898): n.p.

Goffin, Arnold. *Xavier Mellery.* Paris-Brussels: G. van Oest, n.d.

Gogh, Vincent van. *The Complete Letters of Vincent Van Gogh.* Greenwich, Conn.: New York Graphic Society, 1958.

Goldwater, Robert. *Symbolism.* New York: Harper and Row, 1979.

de Goncourt, Edmund and Jules. *Pages from the Goncourt Journal,* trans. Robert Baldick. London: Folio Studio, 1980.

Gorceix, Paul. *Réalités Flamandes et Symbolisme Fantastique. Bruges-La-Morte et la Carilloneur de Georges Rodenbach.* Paris: Lettres Moderns, 1992.

Gordon, Colin, ed. *Power/Knowledge. Selected Interviews and Other Writings 1972–1977 [of] Michel Foucault.* New York: Pantheon Books, 1980.

Gordon, Donald. *Expressionism. Art and Idea.* New Haven: Yale University Press, 1987.

Gossman, Lionel. "Basle, Bachofen and the Critique of Modernity in the Second Half of the Nineteenth Century." *Journal of the Warburg and Courtauld Institutes* 47 (1984): 136–85.

Gozzoli, Maria C., and Francesco Arcangeli. *L'Opera Completa di Giovanni Segantini.* Milan: Rizzoli, 1973.

Grad, Bonnie L., and Timothy A Riggs. *Visions of City and Country.* Worcester, Mass.: Worcester Art Museum, 1982.

Grand, Sarah (Frances Bellenden-Clark). *The Heavenly Twins.* Ann Arbor: University of Michigan Press, 1995 (orig. 1894).

Graubunden im Plakat: Eine Kleine Geschichte der Tourisneuswerbung von 1890 bis heute, exh. cat. Bunder: Kunstmuseum Chur, 1983.

Greenhalgh, Michael, and Vincent Megaw, eds. *Art in Society: Studies in Style, Culture and Aesthetics.* New York: St. Martin's Press, 1978.

Greenhalgh, Susan, ed. *Situating Fertility. Anthropology and Demographic Inquiry.* Cambridge: Cambridge University Press, 1995.

Gribble, Francis Henry. *Geneva.* London: Adam and Charles Black, 1908.

Grieve, A. I. *The Art of Dante Gabriel Rossetti.* Norwich: Real World, 1976.

Gruner, Erich. *Die Arbeiter in der Schweiz im 19. Jahrhundert. Soziale Lage, Organisation, Verhaltnis zu Arbietgeber und Staat.* Bern: Franke, 1968.

Gsell, Paul. "Le Salon du Champ de Mars." *La Revue parisienne* (May 10, 1894): 205.

Guiber, Joseph. *Le Cabinet des Estampes de la Bibliothèque Nationale.* Paris: Maurice Le Garrec, 1926.

Gustave Caillebotte: The Unknown Impressionist, exh. cat. London: Royal Academy of Arts, 1995.

Gutkind, E. A. *Urban Development in Western Europe,* vols. II, IV, V, VI. New York: Free Press, 1971.

Haeckel, Ernst. *The Evolution of Man: A Popular Exposition of the Principal Points of Human Ontogeny and Phylogeny,* vols. I and II. New York: D. Appleton, 1897.

Die Welträtsel. The Riddle of the Universe. New York and London: Harper, 1900 (orig. 1899).

Haesaerts, Paul. *Ensor.* New York: Harry N. Abrams, 1959.

Gustave de Smet. Amsterdam: Het Kompas, 1940.

De School Van Sinte Martens- Laethen. Amsterdam: Het Kompas, 1940.

and Luc Haesaerts. Preface to *Xavier Mellery,* exh. cat. Brussels: Palais des Beaux-Arts, 1937.

Hall, Lesley A. "The Great Scourge: Syphilis as a Medical Problem and Moral Metaphor, 1880–1916." Available: *http://homepages.nildram.co-uk/lesleyah/grtscrge.html#'TheGreatScourge.*

Halperin, Joan U. *Felix Fénéon: Aesthete and Anarchist in Fin de Siècle Paris.* New Haven: Yale University Press, 1988.

Hamsun, Knut. *Hunger,* trans. Robert Bly. New York: Farrar, Straus and Giroux, 1967.

Hand, Marla. "Carlos Schwabe's Poster for the Salon de la Rose + Croix: A Herald of the Ideal in Art." *Art Journal* (Spring 1984): 40–5.

Handlin, Oscar, and John Burchard, eds. *The Historian and the City.* Cambridge: MIT Press and Harvard University Press, 1963.

Hansen, George. *Die Drei Bevolkerungsstufen, ein Versuch, die Ursacjen für das lhen und Altern der Voller nachzuweisen.* Munich: J. Lindauer, 1889.

Hardyment, Christina. *Dream Babies: Child Care from Locke to Spock.* London: Cape, 1983.

Harman, Mary S., and Lois Banner, eds. *Clio's Consciousness Raised. New Perspectives on the History of Women.* New York: Harper and Row, 1974.

Harrison, Charles, and Paul Wood, eds. *Art in Theory 1815–1900. An Anthology of Changing Ideas.* Oxford: Blackwell, 1998.

Harrison, Frederic. *The Meaning of History.* New York and London: MacMillan, 1894.

Hartnoll, Phyllis, ed. *The Oxford Companion to the Theater.* Oxford: Oxford University Press, 1983.

Hauptman, William. *La Suisse Sublime: vue par les peintres voyageurs, 1770–1914,* exh. cat. Milan: Electa Fondation Thyssen-Bornemisza, 1991.

Hausen, Karin. "Family and Role-Division: The Polarization of Sexual Stereotypes in the Nineteenth Century – an Aspect of the Dissociation of Work and Family Life," in Richard J. Evans and W. R. Lee, *The German Family.* London: Croom Helm, c. 1981.

Haussmann, Georges Eugène. *Mémoires du Baron Haussmann.* Paris: Havard, 1893.

Hecke, G. van, and Emile Langui. *Gustave de Smet; sa vie et son œuvre.* Brussels: Éditions Lumière, 1945

Hefting, Paul. *De Foto's van Breitner.* Haarlem: SDU Uitgeverij's-Gravenhage, 1989.

Hefting, Victorine. *Jan Toorop. Een Kennismaking.* Amsterdam: Uitgeverij Bert Bakker, 1989.

Hellens, Franz. *Xavier Mellery.* Brussels: Cahiers de Belgique, 1932.

Heller, Reinhold. "The Art Work as Symbol," in *Fernand Khnopff and the Belgian Avant-Garde,* exh. cat. New York: Barry Friedman, 1983.

"Concerning Symbolism and the Structure of Surface." *Art Journal,* special issue on "Symbolist Art and Literature," ed. Sharon Hirsh (Summer 1985): 146–53.

The Earthly Chimera and the Femme Fatale: Fear of Woman in Nineteenth-Century Art, exh. cat. Chicago: David and Alfred Smart Gallery, 1981.

"Edvard Munch's 'Night,' the Aesthetics of Decadence, and the Content of Biography." *Arts Magazine* (October 1978): 80–105.

Edvard Munch: The Scream. London and New York: Viking Press, 1973.

Munch: His Life and Work. Chicago: University of Chicago Press, 1984.

Henriques, Fernando. *Prostitution in Society,* vol 2: *Prostitution in Europe and the New World.* London: Macgibbon and Kee, 1963.

Herbert, Eugenia. *The Artist and Social Reform: France and Belgium, 1885–1898.* New Haven: Yale University Press, 1961.

Herbert, Robert. *Impressionism.* New Haven: Yale University Press, 1988.

Herold, Luzius. "Laie und Wissenschaftlicher Fortschritt," *Schweizer Monatshefte; Zeitschrift fur Politik, Wirtschaft und Kultur*, 55 (1976): 853–8.

Herzlich, Claudine, and Janine Pierret. *Illness and Self in Society*, trans. Elborg Forster. Baltimore and London: The Johns Hopkins University Press, 1987 (orig. *Malades d'hier, malades d'aujourd'hui: De la mort collective au devoir de guérison*. Paris: Payot, 1984).

Hess, Hans. *Lyonel Feininger*. New York: Harry N. Abrams, 1959.

Heugten, Sjraar van, and Marije Vellekoo. *Vincent Van Gogh Drawings. vol. 3: Antwerp & Paris 1885–1888*. Amsterdam: Lund Humphries, 2001.

Hevesi, Ludwig. *Acht Jahr Sezession* (March 1899–June 1905). Vienna: Verlagsbuchhandlung Carl Konegen, 1906.

Heymans, Vincent. *Ensor et les médecins. Un Diagnostic,* Cahier d'Etudes V. Catheline Périer D'Ieteren. Brussels: Annales d'Histoire de l'Art et d'Archéologie de l'Université de Bruxelles, 1997.

Heywood, Ian. *Social Theories of Art. A Critique*. New York: New York University Press, 1997.

Hiles, Timothy. *Thomas Theodore Heine: The Early Informative Years*. Ph.D. diss.: Pennsylvania State University, 1992.

Hirsch, August. *Handbook of Geographical and Historical Pathology,* vols. I and II, trans. Charles Creighton. London: The New Sydenham Society, 1885.

Hirsh, Sharon, "Arnold Bocklin: Death Talks to the Painter." *Arts Magazine* 55, no. 6 (Feburary 1981): 84–9.

ed. *Art Journal*, special issue on "Symbolist Art and Literature" (Summer 1985).

"Ferdinand Hodler's 'The Consecrated One.'" *Arts Magazine* (January 1978): 122–33.

From Imagination to Evocation: Symbolist Drawings and Sketches, exh. cat. Carlisle, Penn: Trout Gallery, Dickinson College, 1984.

Hodler's Symbolist Themes. Ann Arbor: UMI Press, 1983.

Hobbs, Richard. "Catalog of Drawings by Camille Pissarro in the Ashmolean Museum." *Art History* 4 (1981): 1.

ed. *Impressions of French Modernity. Art and Literature in France 1850–1900*. Manchester: Manchester University Press, 1998.

Hofmann, Werner, ed. "Eva und die Zukunft," in *Das Bild der Frau seit der Französischen Revolution*. Munch: Prestel-Verlag, 1986.

Turning Points in Twentieth Century Art: 1890–1917. New York: George Braziller, 1969.

Hohenberg, Paul M., and Lynn Hollen Lees. *The Making of Urban Europe 1000–1950*. Cambridge: Harvard University Press, 1985.

Hood, Thomas. *Poetical Works of Thomas Hood*. New York: G. Putman, 1881.

Hoozee, Robert, Sabine Bown-Taevernier, and J. F. Heiljbroek. *Moi James Ensor,* trans. Catherine Warnant, John Rossbach, and Marnix Vincent. Brussels: Albin Michel, 1987.

Hougen, *Farge pa Trykk,* exh. cat. Oslo: Munch Museum, 1968.

Houghton, Walter E. *The Victorian Frame of Mind 1830–1870*. New Haven: Yale University Press, 1957.

Houtryve, A. van, *Zeehaven brugge bibliografie*. Zwevezele: Gevaert, 1998.

Houtte, J. A. van *Bruges. Essai d'histoire urbaine*. Bruxelles: La Renaissance du Livre, 1967.

Houtryve, Marcel van, and Karel Puype. *Stitching Kunstboek*. 1994.

Howe, Jeffrey. *The Symbolist Art of Fernand Khnopff*. Ann Arbor, Mich: UMI Research Press, 1982.

Edvard Munch. Psyche, Symbol and Expression, exh. cat. Boston: McMullen Museum of Art, 2001.

"Fernand Khnopff's Depictions of Bruges: Medievalism, Mysticism and Socialism." *Arts Magazine* LV/4 (December 1980): 126–31.

"Mirror Symbolism in the Work of Fernand Khnopff." *Arts Magazine* LIII/1 (September 1978): 112–18.

"The Sphinx and the Other Egyptian Motifs in the Work of Fernand Khnopff: The Origins of the Caresses." *Arts Magazine* LIV/4 (December 1979): 158–69.

Hughes, Christopher. *Switzerland*. London, 1975. *Invitation to the Young European Architects. Reconstruction of a Historic Street in the Centre of Brussels,* trans. Pamela Johnston. Brussels: Archive d'Architecture Moderne, 1990.

Hunecke, Volker. *I trovatelli di Milano: Bambi esposti e famiglie espositrici dal XVII and XIX secolo,* trans. Benedetta Heinemann. Bologna: Il Mulino, 1989.

Hutton, John, "Pissarro and Anarchist Anti-Feminism." *History Workshop Journal* 24 (1987): 32–61.

Huysmans, Joris-Karl. *Certains.* Paris: Tresse & Stock, 1889.

"Félicien Rops." *La Plume,* no. 172 (June 15, 1896), 397.

À Rebours. Paris: Editions Fasquelle, n.d. (orig. Paris: G. Charpentier, 1884).

Ibsen, Henrick. *Ghosts,* in *A Doll's House/Ghosts.* New York: Charles Scribner's Sons, 1917.

Idealistes et Symbolistes, exh. cat. Paris: Galerie G. C. Gaubert, 1973.

Invitation to the Young European Architects. Reconstruction of a Historic Street in the Centre of Brussels, trans. Pamela Johnston. Brussels: Archives d'Architecture Moderne, 1990.

J. Th. Toorop: De jaren 1885 tot 1910, exh. cat. Otterlo: Rijksmuseum Kröller-Müller, 1979.

Jackson, Holbrook. *The Eighteen Nineties. A Review of Art and Ideas at the Close of the Nineteenth Century.* New York: Knopf, 1922.

Jackson, Mark, ed. *Infanticide. Historical Perspectives on Child Murder and Concealment, 1550–2000.* Aldershot, England: Ashgate, 2002.

Jacobs, Roel. *Brussels: A City in the Making.* Bruges: Marc Van de Wiele, n.d.

James Ensor, exh. cat. Zürich: Kunsthaus Zürich, 1983.

James Ensor. Belgien um 1900, exh. cat. Munich: Kunsthalle der Hypo-Kulturstiftung, 1989.

Jamme, Christoph. "The Loss of Things: Cézanne – Rilke – Heidegger." *Kunst & Museum Journal,* no. 1 (1990): 568–83.

Jardin, Jules du. "Le Salon des XX." *La Fédération Artistique* (February 14, 1892).

Jayne, Kristie. "The Cultural Roots of Edvard Munch's Images of Women." *Women's Art Journal* (Spring/Summer 1989): 28–34.

Jensen, Robert. *Marketing Modernism in Fin-de-Siècle Europe.* Princeton: Princeton University Press, 1994.

Jessup, L., ed. *Antimodernism and Artistic Experience: Policing the Boundaries of Modernity.* Toronto: University of Toronto Press, 2000.

Jirat-Wasiutyński, Vojtech et al. *Vincent van Gogh's Self-Portrait Dedicated to Paul Gauguin: An Historical and Technical Study.* Cambridge: Center for Conservation and Technical Studies, Harvard University Art Museums, 1984.

Johnson, Pamela. *The Journal of Decorative and Propaganda Arts,* exh. cat. Miami: Wolfsonian Foundation of Decorative and Propaganda Arts, 1993.

Jones, R. "Arpenteurs d'un Domaine Enchante," in *Peintres de l'Imaginaire. Symbolistes et Surrealistes Belges.* Bruxelles: Imprimerie Laconti, 1972

Jordanova, Ludmilla. *Sexual Visions. Images of Gender in Science and Medicine between the Eighteenth and Twentieth Centuries.* New York: Harvester Wheatsheaf, 1989.

Judd, Dennis and Susan Fainstein. *The Tourist City.* New Haven: Yale University Press, 1999.

Juin, Herbert. *Ferdinand Khnopff et la littérature de son temps.* Brussels: Editions Lebeer Hossmann, 1980.

ed. *Histoires étranges et récits insolites.* Paris: Livre Club du Librairie, 1965.

Julio, Cav. N. De. *L'Arte e l'opera di Giovanni Segantini.* Genova, 1926.

Junod, Philippe, and Philippe Kaenel, eds. *Critiques d'art de Suisse Romande de Töpffer à Budry.* Lausanne: Editions Payot, 1993.

Kaganov, Grigory. *Images of Space: St. Petersburg in the Visual and Verbal Arts,* trans. Sidney Monas. Stanford: Stanford University Press, 1997.

Kahn, Gustave. "Difficulté de Vivre," in *Le Symboliste.* Paris: L'Arche du Livre, 1886.

"Reponse des Symbolistes." *L'Evénement,* (September 28, 1886).

Symbolistes et Décadents. Geneva: Slatkine Reprints, 1977 (orig. 1902).

Kalidasa. *Shakuntala and Other Writings,* trans. Arthur W. Ryder. New York: E. Dutton, 1959.

Kearns, James. *Symbolist Landscapes.* London: Modern Humanities Research Association, 1989.

Kedward, Roderick. *The Anarchists.* London: American Heritage Press, 1971.

Kemal, Salim, and Ivan Gaskell, eds. *Nietzsche, Philosophy and the Arts*. Cambridge: Cambridge University Press, 1998.

Kendall, Richard. "Evangelism by Other Means: Van Gogh as a Painter," *Van Gogh's Van Goghs,* exh. cat. Washington, D.C.: National Gallery of Art, 1999.

Kent, Neil. *The Soul of the North*. London: Reaktion Books, 2000.

Keown, John. *Abortion, Doctors and the Law*. Cambridge: Cambridge University Press, 1988.

Kerckhoven, Marc van. "Fernand Khnopff and Music," *Bulletin des Musées Royaux des Beaux Arts de Belgique* XXX–XXXIII, nos. 1–3 (1981–4): 165–76.

Kern, Stephen. *The Culture of Time and Space 1880–1918*. Cambridge: Harvard University Press, 1983.

Kerr, Robert. *The Gentleman's House*. London: John Murray, 1865.

Kertzer, David I. "Syphilis, Foundlings, and Wetnurses in Nineteenth-century Italy." *Journal of Social History* (Spring 1999): 1–41.

Kessler, Marni. "Unmasking Manet's Morisot," *Art Bulletin* (September 1999): 473–89.

Kestner, Joseph A. *Masculinities in Victorian Painting*. Haunts, England: Scolar Press, 1995.

Khnopff, Fernand. *Annuaire de la section d'art et d'enseignement de la Maison du Peuple, Brussels*. Brussels, 1893.

"Fashion in Art." *Magazine of Art* (November 1896–April 1897): 242.

"Lettre addressée à *La Réforme*." *La Réforme* (February 25, 1885).

"In Memorium: Sir Edward Burne-Jones, Bart. A Tribute from Belgium." *Magazine of Art* (1898): 522.

Klinger, Max. *Malerei und Zeichnung: Tagebuchaufzeichnungen und Briefe*. Leipzig: Insel, 1885.

Knapp, Terry J., and Michael T. Schumacher. *Westphal's "Die Agoraphobie."* New York: University Press of America, 1988.

Knight, Patricia. "Women and Abortion in Victorian and Edwardian England." *History Workshop* 4 (Autumn 1977): 57–69.

Koop, R. "Baudelaire: mode et modernité." *La Revue du Musée d'Orsay* 14, no. 4 (Spring 1997): 50–5.

Kostof, Spiro. *The City Shaped: Urban Patterns and Meanings through History*. Boston: Little, Brown, 1991.

Krauss, André. *Vincent Van Gogh. Studies in the Social Aspects of His Work*. Atlantic Highlands, N.J.: Humanities Press International, 1987.

Kursaal 100. 1875–1975. Ostend, 1975.

La France. Images of Woman and Ideas of Nation 1789–1989, exh. cat. Hayward Gallery, London: South Bank Center, 1989.

Laillet, Hélène. "M. Fernand Khnopff's Villa at Brussels." *The Studio (London)* 1, no. 57 (1912): 201.

Lambton, Lucinda. *Temples of Convenience*. New York: St. Martin's Press, 1978.

Lampart, Eric E. "The Nature of Urbanization," in *The Pursuit of Urban History,* ed. Derek Fraser and Anthony Sutcliffe. London: Edward Arnold, 1983.

Langhendonck, Ingrid van. "Biographie," in *Arts, Antiques Auctions: Ensor*. Brussels: Société de la Propriété Artistique et des Dessins et Modèle 1999.

"James Ensor. L'entrée du Christ a Bruxelles." *Arts, Antiques Auctions: Ensor*. Brussels: Société de la Propriété Artistique et des Dessins et Modèle 1999.

Langui, Emile, and Paul Gustave Van Hecke. *Gustave de Smet. Sa vie et son oeuvre*. Brussels: A. Manteau, 1945.

Laplaige, Danielle. *Sans Famille à Paris*. Paris: Centurion, 1989.

Lardelli, Dora, and Beat Stutzer. *Das Engadin Ferdinand Hodlers und arderer Künstler des 19. und 20 Jahrhunderts.* exh. cat. Bunder Kunstmuseum Chur, Segantini Museum St. Moritz, 1990.

Lawrence, Henry W. "Origins of the Treelined Boulevard," *Geographical Review* 78, no. 4 (October 1988): 355–74.

Lawrence, Peter A. *Georg Simmel: Sociologist and European*. New York: Barnes and Noble Books, 1976.

Leblicq, Yvon. *Bruxelles ville basse: Cartes postales d'autrefois*. Brussels: Editors Culture and Civilization, 1973.

Bruxelles ville haute: Cartes postales d'autrefois. Bruxelles: Editors Culture and Civilization, 1973.

Le Bon, Gustave. *The Crowd: A Study of the Popular Mind.* New York: Macmillan; London: T. Fisher Unwin and Ernest Benn, 1896.

Leclerq, Jacqueline. "Le Paysage Symboliste. Du Réel à l'Imaginaire," *Revue Belge d'Archeologie et d'Histoire de l'Art* LVII (1988): 67–76.

Ledbetter, Rosanna. *A History of the Malthusian League, 1877–1927.* Columbus: Ohio State University Press, 1976.

Lees, Andrew. *Cities Perceived. Urban Society in European and American Thought, 1820–1940.* New York: Columbia University Press, 1987.

Legrand, Francine-Claire. "Fernand Khnopff – Perfect Symbolist." *Apollo* 85 (April 1967): 178–87.

 "Les lettres de James Ensor à Octave Maus." *Bulletin-Musées Royaux des Beaux-Arts de Belgique* 15 (1966): 17–54.

 Le Symbolisme en Belgique. Brussels: Laconti, 1972.

Lemonnier, Camille. "Peintres de la Femme." *L'Art Moderne* 24 (November 1888): 377–80.

 Les Peintres de la Vie. Paris: Nouvelle Librairie Parisienne, 1888.

 "Le Songe et la Vie." *Le Soir* (March 1907): 8.

 "Xavier Mellery." *Gazette des Beaux-Arts* (1885): 425.

Lent, Frank T. *Sound Sense in Suburban Architecture.* Cranford, N.J.: Frank Lent, 1893.

Léonard, Jaques. "Eugénisme et Darwinisme," in *Médecins, Malades et Société dans la France du XIXe siècle.* Paris: Sciences en Situation and Centre National des Lettres, 1992.

Leroy-Allais, J. *Une Campagne criminelle. Avolement neo malthuseanisme.* Paris: Maloine Ed., 1909.

Les XX. La Libre Esthétique. Honderd Jaar later; cent ans apres. exh. cat. Brussels: Musées Royaux des Beaux-Arts de Belgique, 1993.

Lesko, Diane. "Ensor in His Mileu," *Artforum* 15 (May 1977): 56–62.

 James Ensor: The Creative Years. Princeton: Princeton University Press, 1985.

Lesthaeghe, Ron J. *The Decline of Belgian Fertility, 1800–1970.* Princeton: Princeton University Press, 1977.

Letts, Malcom. *Bruges and its Past.* Bruges and London: 1924.

Lévêque, Jean-Jacques. *Les Années de la Belle Epoque. 1890–1914.* Paris: ACR Edition, 1991.

 Les Années Impressionistes. Paris: ACR Edition, 1990.

Levi, Primo. *Segantini.* Rome: Societa Editrice Dante Aligheri, 1900.

Levin, Miriam R. *When the Eiffel Tower Was New: French Visions of Progress at the Centennial of the Revolution,* exh. cat. South Hadley, Mass.: Mount Holyoke College Art Museum, 1990.

Levine, Steven. *Monet and His Critics.* New York: Garland Press, 1976.

Leymaire, Jean, Geneviève Monnier, and Bernice Rose. *Drawing.* New York: Skira/Rizzoli, 1979.

Liederen: Gezongen ter gelegenheid van het Bezoek van Hunne koninklijke Hoogheden den Prins Prinses Albrecht van Belgie, op 3 juli 1902. Brugge: Herreboudt en zoon, 1902.

Littré, Emile. *Dictionnaire de la langue française.* Paris: Hachette, 1883.

Lloyd, Christopher Hamilton. *Camille Pissarro.* Geneva: Skira; New York: Rissolil, 1981.

 J.-K. Huysmans and the Fin-de-siècle Novel. Edinburgh: Edinburgh University Press, 1990.

Loevgren, Sven. *The Genesis of Modernism: Seurat, Gauguin, van Gogh & French Symbolism in the 1880's.* Bloomington: Indiana University Press, 1971.

Lombroso, Cesare. *La Femme criminelle et la prostituée,* trans. Guglielmo Ferrero. Paris: Alcar, 1896.

 and William Ferrero. *The Female Offender.* New York: Philosophical Library, 1958.

 L'Uomo delinquènte. Milan: Hoepli, 1876.

Loos, Wiepke, and Guido Jansen. *Breitner and His Age,* exh. cat. Rijksmuseum Amsterdam, n.d.

Loosli, Carl Albert. *Ferdinand Hodler: Leben, Werk, und Nachlass,* vol. I. Bern: R. Suter, 1921.

Lormel, Louis. "L'Art et l'anarchisme." *L'Art littéraire,* nos. 3, 4 (March–April 1894): 33–5.

Lost Paradise: Symbolist Europe, exh. cat. Montreal: Montreal Museum of Fine Arts, 1995.

Louis, E. "Le salon de la société d'encouragement des Beaux Arts d'Anvers." *La Federation Artistique,* no. 1 (October 12, 1913): 2.

Love, Isolation, Darkness. The Art of Edvard Munch, exh. cat. Greenwich, Conn.: Bruce Museum, 1996–7.

Lowenthal, David. *The Past Is a Foreign Country*. Cambridge: Cambridge University Press, 1985.

Luck, Murray J., et al., ed. *Modern Switzerland*. Palo Alto, Calif.: Society for the Promotion of Science and Scholarship, 1978.

Lüthy, Hans A. "Review of Two Books by Annie-Paule Quinsac," *Art Bulletin* 69, no. 2 (June 1987): 307–11.

 Die Welt des Giovanni Segantini, exh. cat. Zurich: Schweizerisches Institut für Kunstwissenschaft, 1976–7.

Lynch, Kevin. *The Image of the City*. Cambridge: Technology Press and Harvard University Press, 1960.

Macnamara, Charles Nottidge. *History of Asiatic Cholera*. London: Macmillan, 1876.

Maere-Limnander, Auguste de. *Bruges Port la Mer (Solution de la Question)*. Gand: Im Annoot-Braeckman, 1889.

Maeterlinck, Maurice. *Serres chaudes*. Paris: Léon Vanier, 1899.

Maeyer, Marcel de. "Ensor au chapeau fleuri." *L'Art belge* (December 1965), 41–4.

Magraw, Roger. *France 1814–1915. The Bourgeois Century*. Oxford: Oxford University Press, 1983.

Mai, Ekkehard, and Stephan Waetzoldt, eds. *Kunstverwaltung Bau- und Denkmal – Politik im Kaiserreich*. Berlin: Gebr. Mann Verlag, 1981.

Mallgrave, Harry Francis, and Eleftherios Ikonomou, trans., *Empathy, Form and Space. Problems in German Aesthetics, 1873–1893*. Santa Monica, Calif.: Getty Center for the History of Art and the Humanities, 1994.

Malvert, Octave. "Symbolistes et Décadents." *La Vie moderne* (November 20, 1886): 741–3.

Marcade, Bernard. "Dans le Moule Belge." *Beaux Arts Magazine*, no. 85 (December 1990): 92–9.

Marechal, Dominique. "Bruges Painting and Europe, from Mannerism to Symbolism," in *Bruges and Europe,* ed. Valentin Vermeersch. Antwerp: Mercator, 1992.

 "Memling als Symbool. 'Une Ville Abandonnée' van Khnopff in het licht van Rodenbachs Brugge," in *Hans Memling,* ed. Dirk De Vos, exh. cat. Brugge: Stedelijke Musea and Ludion Press, 1994.

Maret, François. *Eugene Laermans*. Brussels: Editions et Ateliers d'Art Graphique Elsevier, 1959.

Marius, G. H. "H. J. Haverman." *Onze Kunst*, no. 7 (July 1902): 97–9.

Marsh, Jan. *The Legend of Elizabeth Siddal*. London and New York: Quartet Books, 1989.

Marshall, Roderick, *William Morris and His Earthly Paradises*. Tisbury, Wiltshire: Compton Press, 1979.

Martin, William, and Pierre Beguin. *Switzerland. From Roman Times to the Present*. New York: Praeger, 1971.

Masheck, Joseph D. "The Carpet Paradigm: Critical Prolegomena to a Theory of Flatness." *Arts Magazine* LI (September 1976), 82–109.

 ed. *Van Gogh 100*. Westport, Conn: Greenwood Press, 1996.

Mathews, Andrew Jackson. *La Wallonie, 1886–1892: The Symbolist Movement in Belgium*. New York: King's Crown Press, 1947.

Mathews, Patricia. *Passionate Discontent. Creativity, Gender, and French Symbolist Art*. Chicago: University of Chicago Press, 1999.

Mathieu, Pierre-Louis. *The Symbolist Generation 1870–1910*. New York: Rizzoli/Skira, 1990.

Matthews, Nancy Mowll. *Mary Cassatt and the "Modern Madonna" of the Nineteenth Century*. Ph.D. diss., New York University, Institute of Fine Arts, 1997.

Mauclair, Camile. *Albert Besnard. L'homme et l'oeuvre*. Paris: Librairie Delagrave, 1914.

Maus, Octave. "Chronique bruxeloise," *La revue independante de littérature et d'art* (September 1887): 278.

 Trente années de lutte pour l'art 1884–1914. Brussels: L'Oiseau bleu, 1926.

Max Klinger, exh. cat. Ferrara: Palazzo dei Diamanti, 1996.

Max Klinger. Bestandskatalog der Bildwerke, Gemalde und Zeichnungen im Museum der bildenden Künste Leipzig. Leipzig: E. A. Jeeman, 1995.

Mayhew, Henry. *London Labour and the London Poor,* 4 vols. New York: Dover, 1968 (orig. 1861).

Mazzoline, Renato G, ed. *Non-Verbal Communication in Science Prior to 1900.* Firenze: Istituto e Museo di Storia della Scienza, 1993.

McDougall, John B. *Tuberculosis. A Global Study in Social Pathology.* Baltimore: Williams and Wilkins, 1949.

McGough, Stephen. *James Ensor's "The Entry of Christ into Brussels in 1889,"* Ph.D. diss., Stanford University, 1981.

Mellery, Xavier. "Une Lettre de Xavier Mellery." *L'art moderne* (November 13, 1898): 366.

Melling, Joseph, and Bill Forsythe, eds. *Insanity, Institutions and Society, 1800–1914.* London: Routledge, 1999.

Melot, Michel. *Graphic Art of the Pre-Impressionists.* New York: Harry N. Abrams, 1978.

Merriman, John M., ed. *Consciousness and Class Experience in Nineteenth Century Europe.* New York: Holmes & Meier, 1979.

Mertens, Phil. "De brieven van Jan Toorop aan Octave Maus." *Bulletin des Musées Royaux des Beaux-Arts de Belgique, Brussels'* (1969): 157–209.

"Gustave van de Woestijne sur le chemin de l'intériorisation et de la mystique," in *Le premier groupe de Laethem-Saint-Martin, 1899–1914,* exh. cat. Brussels: Musées Royaux des Beaux-Arts de Belgique, 1988.

Meuriot, Paul. *Des agglomérations urbaines dans l'Europe contemporaine. Essai sur les causes, les conditions, les conséquences de leur développement.* Paris: Belin Frères, 1898.

Michaud, Guy. *Message Poetique du Symbolisme.* Paris: Nizet, 1951.

Michelet, Jules. *Woman (La Femme),* trans. J. W. Palmer. New York: Rudd & Carleton, 1860.

Miller, Michael. *Le Bon Marché: Bourgeois Culture and the Department Store, 1869–1920.* Princeton: Princeton University Press, 1981.

Millman, Ian. *Georges de Feure 1868–1943,* exh. cat. Amsterdam: Van Gogh Museum, 1993.

Mirzoeff, Nicholas. *An Introduction to Visual Culture.* New York: Routledge Press, 1999.

Mohr, James C. *Abortion in America. The Origins and Evolution of National Policy, 1800–1900.* New York: Oxford University Press, 1978.

Monnier, M. "The Amiel Dossier. Evaluation and Perspectives of a Century of Research." *Romantisme* 11, no. 32 (1981).

Montandon, M. *Segantini.* Bielefeld and Leipzig: Verlag von Velhagen & Klafing, 1911.

Moréas, Jean. "Un Manifeste littéraire," *Supplement Littéraire du Figaro* (Paris), September 18, 1886. Reprinted as "Le Symbolisme Manifeste de Jean Moréas," in *Les Premières armes du Symbolisme.* Paris: Leon Vanier, 1889.

Morel, Bénédict-Augustin. *De la Formation du type dans les variétés degénérées ou nouveaux éléments d' anthropologie morbide.* Paris: J. B. Bailliére, 1864.

Traité des dégénérescences physiques, intellectuelles et morales: de l'espèce humaine et des causes qui produisent ces variété maladives. Paris: J. B. Bailliére, 1857.

Traité des maladies mentales. Paris: Librarie V. Masson, 1860.

Morhardt, Mathias, "Le Salon du Champ-de-Mars, II: Les artistes suisses." *La Semaine Littéraire,* no. 18 (May 5, 1894): 207.

Morris, Edward. *Victorian and Edwardian Paintings in the Walker Art Gallery and at Saddle House.* London: Her Majesty's Stationery Office, 1996.

Morris, William, *Hopes & Fears for Art, Five lectures.* London and New York: Longmans and Green 1929.

News from Nowhere. Or, An Epoch of Rest: Being Some Chapters from a Utopian Romance, ed. James Redmond. New York and London: Monthly Review Press, 1966 (orig. 1890).

Morrisey, Leslie D. *Fernand Khnopff: The Iconography of Isolation and of the Aesthetic Woman,* Ph.D. diss., University of Pittsburgh, 1974.

"Isolation and the Imagination's Fernand Khnopff's *I Lock My Door upon Myself.*" *Arts Magazine* LIII/ 4 (December 1978): 94–7.

Mosele, Elio. *Sotto il segno di Saturno: malinconia, spleen e nevrosi nella letterature dell'ottocento.* Fasano: Schena Editore, 1994.

Mourey, Gabriel. *Albert Besnard.* Paris: Henri Davoust, n.d.

Mühlestein, Hans, and Georg Schmidt. *Ferdinand Hodler, 1853–1918, sein Leben und sein Werk.* Erlenbah: E. Rentsch, 1942.

Munch et la France, exh. cat. Paris: Editions de la Réunion des Musées Nationaux, 1991.

Munch, Inger, ed. *Edvard Munch's brev: Familien, Munch-museets skrifter I.* Oslo: Johan Grundt Tanum, 1949.

Munch und Deutschland, exh. cat. Hamburger Kunsthalle, 1994.

Munch Museum Guide. Oslo: Munch Museum, 1998.

Murphy, Alexandra R. *Millet, Jean-François,* exh. cat. Boston Museum of Fine Arts. Boston: Little, Brown, 1984.

Muther, Richard. *Die Belgische Malerei im neunzehnten Jahrhundert.* Berlin: S. Fischer, Verlag, 1904.

Muthesius, Hermann. *Style-Architecture and Building-Art: Transformations of Architecture in the Nineteenth Century and Its Present Condition.* Santa Monica, Calif.: The Getty Center, 1994.

"M.V." "L'Exposition de L'Essor." *La Jeune belgique* 1 (1881): 56.

Nadel, Ira Bruce, and F. S. Schwarzbach. *Victorian Artists and the City.* New York: Pergamon Press, 1980.

Naerup, Carl. *Ilustreret norsk Literaturhistorie.* Kristiana: Norske Aktieforiag, 1905.

Nasgaard, Roald. *The Mystic North: Symbolist Landscape Painting in Northern Europe and North America 1890–1940.* Toronto: University of Toronto Press, 1984.

 Willumsen and Symbolist Art 1888–1910. Ph.D. diss., New York University, 1973.

Neild, Keith. *Prostitution in the Victorian Age.* London: Gregg International, 1973.

Newnham-Davis, Lieut-Col. *The Gourmet's Guide to Europe.* London: Grant Richards, 1903.

Nietzsche, Friedrich. "Schopenhauer as Educator," in *Unmodern Observations,* trans. and ed. William Arrowsmith. New Haven: Yale University Press, 1990, 163–5.

 Use and Abuse of History, trans. Adrian Collins. New York: Bobbs-Merrill, 1957 (orig. 1873–6; orig. trans. 1909–13).

Nochlin, Linda. "Lost and Found: Once More the Fallen Woman." *The Art Bulletin,* no. 60 (March 1978): 139–53.

 The Politics of Vision. New York: Harper and Row, 1989.

Noel, Richard. *A L'Aube du Symbolisme: Hydropathes, Fumistes, Décadents.* Paris: Nizet, 1961.

Nord, Philip G. *Paris Shopkeepers and the Politics of Resentment.* Princeton: Princeton University Press, 1986.

Nordau, Anna, and Maxa Nordau. *Max Nordau.* New York: Nordau Committee, 1943.

Nordau, Max, *The Conventional Lies of Our Civilization.* Chicago: Laird and Lee, 1886 (orig. 1883).

 Degeneration. New York: G. Moose, 1968 (orig. 1892).

 Malady of the Century. New York: F. Tennyson Neely, 1898.

Nosea, Irma, and Bernhard Wiebel. *Segantini: ein verlorenes Paradies?* exh. cat. Zurich: Schweizersches Institut für Kunstwissenschaft, 1976.

Nunn, Pamela Gerrish. *Problem Pictures. Women and Men in Victorian Painting.* Hants, England: Scolar Press, 1995.

Nurdins, J. "Jacob Burckhardt et le Refus de la Modernité." *Revue d'Allemagne* 14, no. 1 (1982): 88–96.

Nye, Robert. *Crime, Madness, and Politics in Modern France: The Medical Model of National Decline.* Princeton, N.J.: Princeton University Press, 1984.

 Masculinity and Male Codes of Honor in Modern France. Oxford: Oxford University Press, 1993.

Ogata, Amy F. *Art Nouveau and the Social Vision of Modern Living. Belgian Artists in a European Context.* Cambridge: Cambridge University Press, 2001.

Ojetti, Ugo. *Elògio di Giovanni Segantini.* Trento, 1900.

Olander, William R. "Fernand Khnopff's Art of the Caresses." *Arts Magazine,* no. 10 (June 1977): 116–21.

Oldroyd, David, and Ian Langham. *The Wider Domain of Evolutionary Thought.* Dordrecht: D. Reidel, 1983.

Ollinger-Zinque, Gisèle. *Belgian Art 1880–1914,* exh. cat. Brooklyn: Brooklyn Museum, 1980.

Olsen, Donald J. *The City as a Work of Art. London, Paris, Vienna.* New Haven: Yale University Press, 1986.

O'Meara, Carra F. "In-the-Hearth-of-the-Virginal-Womb: The Iconography of the Holocaust in late Medieval Art." *Art Bulletin* 63, no. 1 (1981): 75–88.

Omond, George W. T. *Belgium.* London: A&C Black, 1908.

Ott, Katherine. *Fevered Lives. Tuberculosis in American Culture since 1870.* Cambridge and London: Harvard University Press, 1996.

Paepe, Jean-Luc de. *La reforme organe de la democratie liberale.* Paris: Nauwelaerts, 1972.

Palacio, Jean de. *Messaline décadente ou la figure du sang. Figures et formes de la décadence.* Paris: Seguire, 1994.

Panizza, Oscar. *Das Liebeskonzil: Eine Himmelstragödie in fünf Aufzügen.* Frankfurt-am-Main: Fischer Taschenbuch Verlag, 1976 (orig. 1895).

Parent-Duchâtelet. A-J.-B. *De la prostitution dans la ville de Paris.* Paris: J.-B. Bailliere et Fils, 1857.

Pauwels, Henri. *Musée Groeninge Catalogue.* Bruges: Musée Communal des Beaux-Arts, 1963.

Péladan, Josephin. "Les Maîtres Contemporains." *La Plume* (June 15, 1896): 426.

 Salon de la Rose + Croix, Régle et Monitoire. Paris: Dentu, 1891.

Pelling, Margaret. *Cholera, Fever and English Medicine 1825–1865.* New York: Oxford University Press, 1978.

Perrot, Michelle, ed. *A History of Private Life: IV. From the Fires of Revolution to the Great War,* trans. Arthur Goldhammer. Cambridge: Belknap Press of Harvard University Press, 1990.

Phillips, R. *Family Breakdown in Late Nineteenth Century France.* 1981.

Picard, Edmond. "La Socialisation de l'art." *L'Art moderne* (March 31, 1895): 98–100; (April 7, 1895): 109–110; (April 14, 1895): 116.

Pick, Daniel. *Faces of Degeneration. A European Disorder, c. 1848–c. 1918.* Cambridge: Cambridge University Press, 1989.

Pickery, Karel. *Hendrik en Gustaaf Pickery. Brugge Beeldhouwers.* Bruges: St. Andris, 1982.

Pickvance, Ronald. *Van Gogh in Arles,* exh. cat. New York: Metropolitan Museum of Art, 1984.

Pierre, J. "Une Clef de L'Art Moderne: Le Symbolisme." *L'Oeil,* no. 178 (October 1969): 80.

Pierrot, Jean. *The Decadent Imagination, 1880–1900,* trans. D. Coltman. Chicago: University of Chicago Press, 1981.

Pinckney, David H. *Napoleon III and the Rebuilding of Paris.* Princeton: Princeton University Press, 1958.

Pincus-Witten, Robert. *Occult Symbolism in France: Josephin Péladan and the Salons de la Rose + Croix.* New York: Garland Press, 1976.

Pissarro, Camille. *Turpitudes Sociales.* Geneva: Skira Ed., 1972.

Plasschaert, A. *Jan Toorop.* Amsterdam: J. H. de Bussy, 1914.

Poe, Edgar Allen. "The Philosophy of Furniture," in *Essays, Miscellanies.* New York: Thomas Y. Crowell, 1902 (orig. in *Burton's Gentleman's Magazine,* May 1840).

Pollack, Peter. *The Picture History of Photography, from the Earliest Beginnings to the Present Day.* New York: Abrams, 1969.

Pollock, Griselda. *Avant-Garde Gambits, 1888–1893. Gender and the Color of Art History.* London: Thames and Hudson, 1992.

 "The Dangers of Proximity: The Spaces of Sexuality and Surveillance in Word and Image." *Discourse* 16 (1993–4).

 Vision and Difference. London: Routledge, 1988.

Porter, Roy, and Mikulàs Teich. *Fin de Siècle and Its Legacy.* Cambridge: Cambridge University Press, 1990.

 Sexual Knowledge, Sexual Science: the History of Attitudes to Sexuality. Cambridge: Cambridge University Press, 1994.

The Positive School of Criminology: Three Lectures by Enrico Ferri, ed. Stanley E. Grup. Pittsburgh: University of Pittsburgh Press, 1968.

Potter, Frans de. *De Redding Van Brugge. Brugge-Zeehaven.* Ghent: A. Siffer, 1891.

Potts, Malcolm, Peter Diggory, and John Peel. *Abortion.* New York: Cambridge University Press, 1977.

Praz, Mario. *The Romantic Agony.* New York: Meridian Books, 1956.

Prelinger, Elizabeth, and Michael Parke-Taylor. *The Symbolist Prints of Edvard Munch. The Vivan and David Campbell Collection,* exh. cat. Toronto: Art Gallery of Ontario, 1996.

Le premier groupe de Laethem-Saint-Martin 1899–1914, exh. cat. Brussels: Musées Royaux des Beaux-Arts de Belgique, 1988.

Przybyszewski, Stanislaw. "Overboard," in *Homo Sapiens: A Novel in Three Parts,* trans. T. Seltzer. New York: AMS Press, 1915.

 "Psychischer naturalismus." *Die neue deutsche Rundschau* (February 1894): 152.

Pudles, Lynn. "Fernand Khnopff, Georges Rodenbach, and Bruges, the Dead City." *Art Bulletin* (December 1992): 637–53.

Quelque notes sur l'oeuvre de Fernand Khnopff. Brussels: Madame Veuve Monnom, 1887.

Quennell, Peter, ed. *London's Underworld* (being selections from "Those That Will Not Work"), vol. 4 of *London Labour and the London Poor* by Henry Mayhew (1862). London: W. Kimber 1950.

Quétel, Claude. *History of Syphilis,* trans. Judith Braddock and Brian Pike. Baltimore: The Johns Hopkins University Press, 1990.

Quinn, Cath. "Images and impulses: Representations of puerperal insanity and infanticide in late Victorian England," in *Infanticide. Historical Perspectives on Child Murder and Concealment, 1550–2000,* ed. Mark Jackson. 193–215. Aldershot, Hants: Ashgate, 2002.

Quinsac, Annie-Paule. *Segantini. Catalogo generale,* 2 vols. Milan: Electa, 1982.

 Segantini. Trent'anni di vita artistica europea nei carteggi inediti dell'artista e dei suoi mecenati. Oggiono-Lecco: Cattaneo, 1985.

Rackham, Oliver. *The Illustrated History of the Countryside.* London: George Weidenfeld & Nicolson, 1994.

Ransel, D. *Mothers of Misery: Child Abandonment in Russia.* Princeton: Princeton University Press, 1988.

Rapoport, Amos. *Human Aspects of Urban Form.* Oxford: Pergamon Press, 1977.

Ravenal, Carol. Introduction to *Edvard Munch. Paradox of Woman,* exh. cat. New York: Aldis Browne Fine Arts, 1981.

Redon, Odilon. *A Soi-même.* Paris: Librairie José Corti, 1961.

Rees, Ronald. *Interior Landscapes. Gardens and the Domestic Environment.* Baltimore and London: The Johns Hopkins University Press, 1993.

Reff, Theodore. *Manet and Modern Paris.* Washington, D.C.: National Gallery of Art, 1982.

Reid, Alice. "Locality or Class? Spatial and Social Differentials in Infant and Child Mortality in England and Wales, 1895–1911," in *The Decline of Infant and Child Mortality. The European Experience: 1750–1990.* Florence: Martinus Nijhoff, 1997.

Reid, Donald. *Paris Sewers and Sewermen: Realities and Representations.* Cambridge: Harvard University Press, 1991.

Reynolds, Dee. *Symbolist Aesthetics and Early Abstract Art.* Cambridge University Press, 1995.

Ribot, Theodule. *Philosophie de Schopenhauer.* Paris: Librairie Germer Baillière, 1874.

Rilke, Rainer Maria. *Die Aufzeichnungen des Malte Laurids Brigge.* Frankfurt-am-Main and Leipzig: Insel Verlag, 1996.

 Ausgewahlte Werke. Leipzig: Insel-Verlag, 1938.

Ritter, William. "Giovanni Segantini," *Gazette des Beaux-Arts* (Apr. 1, 1898): 302–14.

Roberts-Jones, Philippe. *L'alphabet des circonstances. Essais sur l'art des XIXe et XX siècles.* Brussels: Academie Royale de Belgique, 1981.

 Beyond Time and Place: Non-Realist Painting in the Nineteenth Century. Oxford: Oxford University Press, 1978.

 ed. *Brussels – Fin de Siècle.* Cologne: Taschen Verlag, 1999.

Robinson, Wilfrid C. *Bruges. An Historical Sketch*. Bruges: Louis de Plancke, 1899.

Rodenbach, Georges. *L'Arbre*. Paris: Ollendorff, 1899.

 Bruges-la-Morte. Paris: Librairie Marpon & Flammarion, 1892.

 Bruges-la-Morte, trans. by Phillip Mosley. Paisley, Scotland: Wilfion Books, 1986.

 Bruges-la-Morte, trans. and Introduction by Thomas Duncan. London: Swan Sonnenschein, 1903.

 Le Carillonneur. Paris: Bibliothèque-Charpentier, 1917 (orig. 1897).

 Oeuvres. Geneva: Slatkine Reprints, 1978 (orig. 1923).

Rops, Félicien, "Dix-huit letters de Félicien Rops à Poulet-Malassis." *Mercure de France* (Paris): 1933.

Rose, Lionel. *The Massacre of the Innocents. Infanticide in Britain 1800–1939*. London: Routledge, 1986.

Rosenberg, Margit. "Birth Weight, Breast-Feeding, Postpartum Amenhorrhea and Infant Mortality in Three Norwegian Cities during Late Nineteenth and Early Twentieth Century," in *Society, Health and Population during the Demographic Transition,* ed. Anders Brändström and Lars-Göran Tedebrand, Stockholm: Almqvist and Wiksell International, 1988, 49–59.

Rosenblum, Robert. "Art in 1900: Twilight or Dawn?" in *1900: Art at the Crossroads,* ed. Maryanne Stevens and Ann Dumas. New York: Harry N. Abrams, 2000.

Rosner, David, ed. *Hives of Sickness: Public Health and Epidemics in New York City*. New Brunswick, N.J.: Rutgers University Press, 1995.

Roth, Eugen. *Simplicissimus. Ein Rückblick auf die satirische Zeitschrift*. Hannover: Fackelträger-Verlag, 1959.

Roth, Michael S., ed. *Rediscovering History. Culture, Politics, and the Psyche*. Stanford: Stanford University Press, 1994.

Rousseau, Jean-Jacques. *The Confessions,* trans. and introduction by J. M. Cohen Harmondsworth: Penguin Books, 1954 (orig.: Lausanne: Chez Francois Grassert, 1782).

 Emile. Paris: Touquet, 1821.

Ruchon, François. *Histoire politique de Genève, de la restauration a la suppression du budget des cultes (1813–1907),* vol. 1. Geneva: A Jullien, 1953.

 and Lucien Fulpius. *Georges Favon, 25 ans de politique genevoise*. Geneva, 1927.

La rue Bruxelloise vers 1900, exh. cat. Galerie Ciger, 1979.

Ruskin, John. "The Nature of Gothic," in *The Stones of Venice,* vol. 2, *The Works of John Ruskin,* ed. Cook and Alexander Wedderburn. London: George Allen, 1903–12 (orig. 1853).

 Sesame and Lilies. London: George Allen, 1893 (orig. 1871).

Ryan, Frank. *The Forgotten Plague: How the Battle Against Tuberculosis Was Won – and Lost*. Boston: Little, Brown, 1992.

Ryan, William Burke. *Infanticide: Its Law, Prevalence, Prevention, and History*. London: Churchill, 1862.

Rybczynski, Witold. *Home. A Short History of an Idea*. New York: Viking Penguin, 1986.

Sachdev, Paul, ed. *International Handbook on Abortion*. New York: Greenwood Press, 1988.

Sadler, Simon. *The Situationist City*. Cambridge: MIT Press, 1998.

Safranski, Rüdiger. *Schopenhauer and the Wild Years of Philosophy,* trans. Ewald Osers. Cambridge: Harvard University Press, 1990.

Salmon, Blandine, and Olivier Meslay. *Georges Lacombe. Sculptures-Peintures-Dessins*. Paris: Charles et Andre Bailly, n.d.

Sarlet, Claudette, ed. *Les ecrivains d'art en Belgique 1860–1914*. Brussels: Editions Labor, 1992.

Sauer, R. "Infanticide and Abortion in 19th-Century Britain." *Population Studies* 32, no. 1 (1978): 81–93.

Schafer, *Children in Moral Danger and the Problem of Government in the 3rd Republic France*. Princeton: Princeton University Press, 1997.

Schaffer, Talia. "There Is No Place Like Home: Inventing Interior Design, 1870–1900." Paper presented at the Interdisciplinary Nineteenth-Century Studies conference. Santa Cruz: University of California, 1995.

Scharf, Aaron. *Art and Photography*. Baltimore: Penguin, 1974.

Scherb, Dr. G. "Quelle était la maladie de Jules de Goncourt?" *La Chronique Médicale* 8 (1901): 625–31.

Schnog, Nancy, and Joel Pfister. *Inventing the Psychological: Toward a Cultural History of Emotional Life in America.* New Haven: Yale University Press, 1997.

Schopenhauer, Arthur. "On Noise," in *The Pessimist's Handbook,* trans. T. Bailey Saunders, ed. Hazel E. Barrus. Lincoln: University of Nebraska Press, 1964, 217–19.

Studies in Pessimism, trans. T. Bailey Saunders. Lincoln: University of Nebraska Press, 1964 (orig. trans. 1893).

World as Will and Representation. Indian Hills, Colo.: Falcon Wing Press, 1958.

Schrumpf, Ellen. *Abortsakens historie.* Norway: Tiden Norsk Forlag, 1984.

Scott-Chandler, Mary. *The Dance of Death in the Works of Strindberg, Ensor, and Mann: A Study in the Grotesque.* Ph.D. diss., Athens: Ohio University, 1981.

Segantini, Gottardo. *Giovanni Segantini und die Schweiz.* Bern: Lang Cie, 1942.

Sennett, Richard, ed. *Classic Essays on the Culture of Cities.* New York: Appleton-Century-Croft, 1969.

The Conscience of the Eye. New York: Alfred A. Knopf, 1990.

Flesh and Stone. The Body and the City in Western Civilization. New York: W. W. Norton, 1994.

The Psychology of Society. New York: Vintage Books, 1977.

Shapiro, Barbara S. *Pleasures of Paris: Daumier to Picasso,* exh. cat. Museum of Fine Arts, Boston, Boston: David R. Godine, 1991.

Sharpe, William, and Leonard Wallock, eds. *Visions of the Modern City.* New York: Columbia University Press, 1983.

Shaw, George Bernard. *The Sanity of Art.* New York: B. R. Tucker, 1908.

Shaw, Jennifer Laurie. *Dream States. Puvis de Chavannes, Modernism, and the Fantasy of France.* New Haven: Yale University Press, 2002.

Shaw, Walter Sparrow. "English Art and Fernand Khnopff." *The Studio* (March 1894): 204.

Sherrif, Mary. "Fragonard's Erotic Mothers and the Politics of Reproduction," in *Eroticism and the Body Politic,* ed. Lynn Hunt. Baltimore: John Hopkins University Press, 1991.

Shikes, Ralph E. and Paula Harper. *Pissarro: His Life and His Work.* New York: Horizon Press, 1980.

Shorter, Edward. *A History of Women's Bodies.* London: Peguin Books, 1982, 191–9.

Shryock, Richard Harrison. *National Tuberculosis Association, 1904–1954: A Study of the Voluntary Health Movement in the United States.* New York: National Tuberculosis Association, 1957.

Siebelhoff, Robert. *The Early Development of Jan Toorop 1879–1892.* Unpublished Ph. D. diss., University of Toronto, 1973.

"Iets over de persoon Jan Toorop." *The Low Countries Fin de Siècle* (Fall 1988–Spring 1989): 65–71.

"Jan Toorop and the Year 1892," *The Low Countries Fin de Siècle* (Fall 1988–Spring 1989): 72–91.

"The Three Brides," in *Overdruk uit Nederlands Kunsthistorisch Jaarboek.* Haarlem: Fibula-Van Dishoeck, 1977.

Silbermann, Von Alphons. *Empirische Kunstsoziologie.* Stuttgart: Ferdinand Enke Verlag, 1973.

Silverman, Debora L. *Art Nouveau in Fin-de-Siècle France: Politics, Psychology and Style.* Berkeley: University of California Press. 1989.

Van Gogh and Gauguin. New York: Farrar, Straus and Giroux, 2000.

Simmel, Georg. *The Conflict in Modern Culture and Other Essays.* New York: Teachers College Press, 1968.

Essays on Interpretation in Social Science. Totowa, N.J.: Rowman and Littlefield, 1980.

"Die Grosstädt: Vorträge und Aufsätze zur Städteaustellung," *Gehe-Stiftung zu Dresden* (Winter 1902–3).

On Individuality and Social Forms. Selected Writings. Chicago: University of Chicago Press, 1971.

Philosophie des Geldes. Leipzig, Duncker und Humblot, 1900. English translation: *The Philosophy of Money.* Boston and London: Routledge/Kegan Paul, 1978.

Philosophische Kultur. Potsdam: Gustave Kiepenheuer Verlag, 1923.

Schopenhauer and Nietzsche. Amherst: University of Massachusetts Press, 1986.

Simmons, Geoffrey. "Fernand Khnopff and Ver Sacrum." *The Low Countries Fin de Siècle* (Fall 1988–Spring 1989): 33–51.

Simplicissimus. Eine satirische Zeitschrift. Munchen 1896–1944, exh. cat. Munich: Haus der Kunst, 1977–8.

Singer, Hans W. *Zeichnungen von Albert Besnard.* Leipzig: A. Schumann's Verlag, 1912.

Slatkin, Wendy. "Maternity and Sexuality in the 1890's." *Women's Art Journal* (Spring/Summer 1988): 13–19.

Smith, Bonnie G. *Ladies of the Leisure Class: The Bourgeoises of Northern France in the Nineteenth Century.* Princeton: Princeton University Press, 1981.

Smith, F. B. *The Peoples' Health 1830–1910.* London: Croom Helm, 1979.

Smith, William Jay. *Selected Writings of Jules Laforgue.* New York: Grove Press, 1956.

Société d'Histoire et d'Archeologique. *Histoire de Genève de 1798–1931.* Geneva: Alexander Jullien, ed. vol. 951, 1956.

Somville, Pierre. "Khnopff et le Sphinx." *Art and Fact,* no. 1 (1982): 85–87.

Sontag, Susan. *Illness as Metaphor.* New York: Farrar, Straus and Giroux, 1978.

Soulier, M. "Champ de Mars." *Art et la vie* (May 1894): n.p.

Spaanstra-Polak, Bettina. *Symbolism.* Amsterdam: J. M. Meulenhoff, 1967.

Spackman, Barbara. *Decadent Genealogies: The Rhetoric of Sickness from Baudelaire to D'Annunzio.* Ithaca: Cornell University Press, 1989.

Sparrow, W. Shaw. "Herr Toorop's Three Brides." *The Studio* 1 (September 15, 1893): 247–8.

Splendeurs de l'Ideal. Rops, Khnopff, Delville et leur temps, exh. cat. Musée d'Art Wallon de la Ville de Liege, 1997.

Spengler, Oswald. *The Decline of the West,* trans. Charles Francis Atkinson. New York: Alfred A. Knopf, 1926.

Spongberg, Mary. *Feminizing Veneral Disease: The Body of the Prostitute in the Nineteenth-Century Medical Discourse.* New York: New York University Press, 1997.

Starobinski, Jean. "The Idea of Nostalgia." *Diogenes,* no. 54 (Summer 1966): 81–103.

Steinberg, Jonathan. *Why Switzerland?* Cambridge: Cambridge University Press, 1978.

Stevens, MaryAnne, ed. *Impressionism to Symbolism: The Belgian Avant Garde 1880–1900,* exh. cat. London: Royal Academy of Arts, 1994.

 and Ann Dumas, eds. *1900: Art at the Crossroads.* New York: Harry N. Abrams, 2000.

 and Robert Hoozee, eds. *Impressionism to Symbolism: the Belgian avant-garde 1880–1900,* exh. cat. London: Royal Academy of Arts, c. 1994.

Stewart, Susan. *On Longing: Narratives of the Miniature, the Gigantic, the Souvenir, the Collection.* Baltimore: Johns Hopkins University Press, 1984.

Stormer, Nathan Edward. *The Body of Abortion's Memory: Medical Anti Abortion Rhetoric of the Nineteenth Century.* Ph.D. diss., Twin Cities: University of Minnesota, 1997.

Stott, Annette. "Thomas Eakins's *Portrait of Amelia Van Buren:* 'New Woman' or Neurasthenic?" Paper presented at the College Art Association annual meeting, New York, 1997.

Streicher, Elizabeth Pendleton. "Max Klinger's *Malerei und Zeichnung:* The Critical Reception of the Prints and their Text," in *Imagining Modern German Culture: 1889–1910.* Francoise Forster-Hahn, ed. Hanover, N.H.: University Press of New England; Washington, D.C.: The National Gallery of Art, 1996.

Strong, Josiah. *The Twentieth Century City.* New York: Baker and Taylor, 1898.

La Suisse Romande entre les Deux Guerres: 1919–1939. Lausanne: L'Université et Musées Lausannois, Editions Payot Lausanne, 1986.

Sully, James. *Sensation and Intuition: Studies in Psychology and Aesthetics.* London: Henry S. King & Co., 1874.

Summers, David. "Jonathan Crary. *Suspensions of Perception*" (book review). *The Art Bulletin* (March 2001): 83, no. 1, 157–60.

Sweetman, David. *Paul Gauguin: A Complete Life.* London: Hodder and Stoughton, 1995.

Le Symbolism en Europe, exh. cat. Rotterdam: Museum Boymans-van Beuningen, 1975.

Symbolismus in den Niederlanden. Von Toorop bis Mondrian, exh. cat. Museum Fridericianum Kassel, 1991.

Szreter, Simon. *Urbanisation, Mortality and the Standard of Living Debate in Britain in the Nineteenth Century: New Estimates of the Expectations of Life at Birth in Large British Cities.* Canberra: Australian National University, 1996.

Taeye, Edmond Louis de. *Les artistes belges contemporaire.* Brussels, 1894.

"Introduction to Leon Tombu," in *Peintres et sculpteurs belges a l'aube du XXme siècle.* Liege: Leon Tombu, 1907.

Taine, Hippolyte. *La Révolution.* Paris: Librairie Hachette et Cie, 1878.

Teller, Michael E. *The Tuberculosis Movement. A Public Health Campaign in the Progressive Era.* New York: Greenwood Press, 1988.

Tetel, Marcel, ed. *Symbolism and Modern Literature: Studies in Honor of Wallace Fowlie.* Durham, N.C.: Duke University Press, 1978.

Theriot, Nancy M. "Diagnosing Unnatural Motherhood: Nineteenth-Century Physicians and 'Puerperal Insanity,'" in Hamilton Cravens, Alan I. Marcus, and David M. Katzman, eds., *Technical Knowledge in American Culture. Science, Technology, and Medicine Since the Early 1800s.* Tuscaloosa: University of Alabama Press, 1996.

Thomson, Richard. "Camille Pissarro – *Turpitudes Sociales* and the Universal Exhibition of 1889." *Arts Magazine* 56, no. 8 (1982): 82–8.

Seurat. Oxford: Phaidon, 1985.

Thoreau, Henry David. *Walden: or, Life in the Woods.* Boston: Tecknor and Fields, 1854.

Thornton, Peter. *Authentic Decor. The Domestic Interior 1620–1920.* London: Weidenfeld and Nicolson, 1984.

Thrahard, Pierre. *Henri-Frederique Amiel, juge de l'esprit français.* Paris: Champion, 1978.

Tissot, Victor. *Unknown Switzerland,* trans. M. Wilson. New York: A. D. F. Randolph, 1894. (original 1889).

Tøjner, Poul Erik, *Munch in His Own Words.* Munich: Prestel Verlag, 2001.

Tombu, Leon. *Peintres et sculpteurs belges a l'aube du XXe siècle.* Liege: A. Benard, 1907.

Tönnies, Ferdinand. *Community and Civil Society (Gemeinschaft und Gesellschaft),* trans. Jose Harris and Margaret Hollis. Cambridge: Cambridge University Press, 2001 (original 1887).

Trachsel, Albert. *Quelques réflexions sur l'Oberland Bernois.* Geneve: Paul Richter, 1912.

Réflexions à propos de l'art suisse à l'exposition nationale de 1896. Geneva: Imprimerie Suisse, 1896.

Tricot, Xavier. *James Ensor. Catalogue Raisonné of the Paintings.* Antwerp: Pandora, 1992.

"James Ensor et Ostende." *Arts, Antiques, Auctions,* Brussels: Société de la Propriété Artistique et des Dessins et Modele, 1999.

"Les Trois Moustiquaires" (Louis Dumont-Wilden, Georges Garnir, Leon Souguenet). "M. Fernand Khnopff." *Pourquoi Pas?* I, no. 35 (December 15, 1910): n.p.

Tumiati, Domenico. "Giovanni Segantini." *L'Arte Contemporanea* I (1898): 304–14.

Ulrich, Jost. "La Nation, La Politique et Les Arts." *Revue Suisse* 39, no. 3 (1989): 293–303.

Vachon, Marius. *La Crise industrielle et artistique en France et en Europe.* Paris: La Librairie Illustré, 1886.

Valbert, George. "L'Age des machines." *Revue des deux mondes,* 93 (1889): 692–7.

Van Gogh à Paris, exh. cat. Paris: Musée d'Orsay, 1988.

Van Gogh to Mondrian. Dutch Works on Paper, exh. cat. Rijksmuseum, Amsterdam. Zwolle: Waanders, 2000.

Van Gogh's Van Goghs, exh. cat. Washington, D.C.: National Gallery of Art, 1999.

Vanhamme, Vincent. *Xavier Mellery. L'Ame des choses,* exh. cat. Amsterdam: Van Gogh Museum, c. 2000.

Vanor, Georges. *L'Art symboliste.* Paris, 1889.

Varnedoe, Kirk. *Gustave Caillebotte.* New Haven and London: Yale University Press, 1987.

and Elizabeth Streicher. *Graphic Works of Max Klinger.* New York: Dover, 1977.

Vellekoop, Marije, and Sjraar van Heugten. *Vincent Van Gogh Drawings. Antwerp & Paris, 1885–1888,* trans. Michael Hoyle. Amsterdam: Van Gogh Museum, 2001.

Ven, Cornelis van de. *Space in Architecture.* Assen/Maastricht, The Netherlands: Van Gorcum, 1987.

Verhaeren, Emile. "An Aesthetic Interpretation of Belgium's Past" (presented March 21, 1917). *Proceedings of the British Academy 1917–1918,* vol. 8. London: Oxford University Press, n.d.

 Les Aubes. Brussels: E. Deman, 1898.

 "Aux XX." *L'Art moderne* (February 3, 1889): 34.

 Les Campagnes hallucinées, Les Villes tentaculaires, ed. Maurice Piron. Paris: Gallimard, 1982 (orig. 1893, 1895).

 Contes de Minuit. Brussels: Finck, 1884.

 Ecrits sur l'Art, ed. Paul Aron. 2 vols. Brussels: Editions Labor, 1997.

 "Exhibition annuelle de L'Essor." *Journal des Beaux-Arts et de la Littérature* (January 15, 1882): 1.

 "Exposition du Cercle Artistique." *La Revue Moderne* (May 1883): n.p.

 James Ensor. Brussels: Jacques Antoine, 1980 (orig. 1908.).

 "Les Salon des XX." *L'Art moderne* (Feburay 12, 1888): 52–3.

 "Silhouettes d'artistes. Fernand Khnopff." *L'Art moderne* (September 5, 1886): 289–90; (September 12, 1886): 281–90; (October 10, 1886): 321–3.

 "Un peintre symboliste." *L'Art moderne.* (April 24, 1887).

Vermeersch, Valentin, ed. *Bruges and Europe.* Bruges: Fonds Mercator, 1992.

Vidler, Anthony. *Rediscovering History. Culture, Politics, and the Psyche,* ed. Michael S. Roth. Stanford: Stanford University Press, 1994.

 "The Scenes of the Street: Transformations in Ideal and Reality, 1750–1871," in *On Streets,* Stanford Anderson, ed. Cambridge: MIT Press, 1978.

 Warped Space: Art, Architecture, and Anxiety in Modern Culture. Cambridge: MIT Press, 2000.

Vignau-Wilberg, Thea, and Renee Pigeaud. *Hoofse Minne En Burgerlijke Liefde in De Prent Kunst Rond 1500.* Dordrecht: Nijhoff, 1983.

Villari, L. *Giovanni Segantini.* New York and London: E. Dutton, 1901.

La Ville. Art et architecture en Europe 1870–1933, exh. cat. Paris: Centre Georges Pompidou, 1994.

Vincent Van Gogh and His Time, exh. cat. Tokyo: Seiji Togo Memorial Yasuda Kasai Museum of Art, 1997.

Vincent Van Gogh Painting and Drawing, exh. cat. Baltimore: Baltimore Museum of Art, 1970.

Vire, Liliane. *La Distibution publique d'eau à Bruxelles 1830–1870.* Bruxelles: Pro Civitale, 1973.

Vischer, Robert. *Uber das Optische Formgefühl: Ein Beitrag zur Aesthetik.* Leipzig: H. Credner, 1873.

Vogel, Julius. "Altes und Neues von Max Klinger." *Zeitschrift für bildende Kunst, N.F.* VII (1897): 153–66.

Vögele, Jörg. "Urbanization, Infant Mortality and Public Health in Imperial Germany," in *The Decline of Infant and Child Mortality. The European Experience 1750–1990,* ed. Carlo Corsini and Pier Paolo Viazzo. The Hague: Kluwer Law International, 1997, 109–27.

Vos, Dirkde, de, ed. *Hans Memling,* exh. cat. Bruges: Stedelijke Musea, 1994.

Voss, Georg. "Kunst und Wissenschaft," in *Freising Zeitung* (Berlin, 1892). Oslo: Munch Museum Archives.

Vyncke, Yvonne. *Kent u nog . . . de Ostendenaars.* Zalt bommel, Netherlines Europese Bibliotheek, 1975.

Wald-Lasowski, Patrick. *Syphilis – essaie sur la littérature française du XIXe siècle.* Paris: Gallimard, Series: Les Essais, 1982.

Warburton, T. Rennie. "The Rise of Nationalism in Switzerland." *Canadian Review of Studies in Nationalism* 7, no. 2 (1980): 274–98.

Ward, Mrs. Humphrey, trans. *Amiel's Journal.* New York: Macmillan, 1923.

Ward, T. "The Sad Subject of Infanticide: Law, Medicine and Child Murder, 1860–1938." *Social and Legal Studies* 8 (1999): 163–80.

Weatherall, David. *Science and the Quiet Art: The Role of Medical Research in Health Care.* New York: W. W. Norton, 1995.

Weber, Adna Ferrin. *The Growth of Cities in the Nineteenth Century: A Study in Statistics*. Ithaca: Cornell University Press, 1967.

Weber, Richard. *Das Weib als Gattin und Mutter*. Berlin: Verlag Hugo Steinitz, 1889.

Wegemann, Peter. *Caspar David Friedrich to Ferdinand Hodler,* exh. cat. Los Angeles: Los Angeles County Museum of Art, 1993.

Weisberg, Gabriel. "Georges de Feures's Mysterious Women: A Study of Symbolist Sources in the Writings of Charles Baudelaire and Georges Rodenbach." *Gazette des Beaux Arts* (October 1974): 227.

 Images of Women: Printmakers in France From 1830 to 1930, exh. cat. Salt Lake City: Utah Museum of Fine Arts, University of Utah, 1978.

 Montmartre and the Making of Mass Culture. New Brunswick, N.J.: Rutgers University Press, 2000.

Welsh-Ovcharov, Bogomila. *Vincent van Gogh and the Birth of Cloisonism,* exh. cat. Toronto: Art Gallery of Ontario, 1981.

Wentworth, Michael. *James Tissot*. New York: Oxford University Press, 1984.

West, Shearer. *Fin-de-Siècle: Art in an Age of Anxiety*. Woodstock, N.Y.: Overlook Press, 1994.

Westerbeck, Colin, and Joel Meyerowitz. *Bystander: A History of Street Photography*. Boston: Little, Brown, 1994.

Westphal, Carl Friedrich Otto. *Die Agoraphobie. Eine neuropathische Erscheinung*. Berlin, 1871.
 Carl Westphal's Gesammelte Abhandlungen. Berlin: A. Hirschwald, 1892.
 and Terry Knapp. *Westphal's "Die Agoraphobie" with Commentary: The Beginnings of Agoraphobia*. Lanham, Md.: University Press of America, 1988.

White, Nicholas. "Introduction," *Against the Grain,* trans. Margaret Mauldon. Oxford: Oxford University Press, 1998.

Whitford, Frank. "From The Twenty to the Twenties; the Development of Modernism in Belgium." *Studio International,* CLXXXVIII, no. 970 (October 1974): 124–7.

Wick, Rainer, and Astrid Wick-Kmoch, eds. *Kunstsoziologie. Bildende Kunst und Gesellschaft*. Cologne: Dumont Buchverlag, c. 1979.

Widge, Anjali. "Patriarchy, Social Control and the Female Body," in *The Family in a Changing World: Women, Children and Strategies of Intervention,* Rudolf C. Heredia and Edward Mathias, eds. New Dehli: Indian Social Institute, 1995.

Wilde, Oscar. *Salome. A Tragedy in One Act*. New York: Dover, 1967 (orig. 1894).

Wilderotter, Hans, and Michael Dorrmann. *Das Grosse Sterben: Seuchen Machen Geschichte*. Berlin: Jovis, 1995.

Williams, Raymond. *Keywords. A Vocabulary of Culture and Society*. New York: Oxford University Press, 1983.

Williams, Roger L. *The Horror of Life*. Chicago: University of Chicago Press, 1980.

Williams, Rosalind. *Dream Worlds: Theories of Mass Consumption in Late Nineteenth-Century France*. Berkeley: University of California Press, 1981.

Wilson, Robert N., ed. *The Arts in Society*. Englewood Cliffs, N.J.: Prentice Hall, 1964.

Wolff, Janet. *Feminine Sentences. Esssays on Women and Culture*. Berkeley: University of California Press, 1990.

Wolk, Johannes, van der. *The Seven Sketchbooks of Vincent Van Gogh,* trans. Claudia Swan. New York: Harry N. Abrams, 1987.

Wood, Paul, ed. *The Challenge of the Avant-Garde*. New Haven: Yale University Press, 1999.

Wordsworth, William. *The Prelude, Book VII: "Residence in London."* Oxford: Clarendon Press, 1926 (orig. 1805–6).

Woud, Auke, van der. *The Art of Building. From Classicism to Modernity: The Dutch Architectural Debate, 1840–1900,* trans. Yvette Bankvoort and Bard Janssen. Hants, England: Ashgate, 2001.

Wright, Peter, and Andrew Treacher, eds. *The Problem of Medical Knowledge. Examining the Social Construction of Medicine*. Edinburgh: Edinburgh University Press, 1982.

Writing on Hands: Memory and Knowledge in Early Modern Europe, exh. cat. Carlisle, Penn.: Trout Gallery, 2000.

Wuarin, Louis. "La crise des compagnes et des villes." *Revue des deux mondes.* LIX (1900).

Zehder, Bianca, ed. *Giovanni Segantinis Schiften and Briefe,* trans. G. Biermann. Leipzig: Klenkhardt and Biermann, 1912.

Zemel, Carol. "Sorrowing Women, Rescuing Men: Van Gogh's Images of Women and Family." *Art History* 10, no. 3 (September 1987): 351–68.

 Van Gogh's Progress. Berkeley: University of California Press, 1997.